GOTHIC

Four Hundred Years of Excess, Horror, Evil and Ruin

GOTHIC

FOUR HUNDRED YEARS OF EXCESS, HORROR, EVIL AND RUIN

Richard Davenport-Hines

North Point Press/Farrar, Straus and Giroux/New York

North Point Press
A division of Farrar, Straus and Giroux
19 Union Square West, New York 10003

Copyright © 1998 by Richard Davenport-Hines
All rights reserved
Printed in the United Kingdom
Designed by Robert Updegraff
First published in 1998 by Fourth Estate, Great Britain
First North Point Press edition, 1999

Library of Congress Cataloging-in-Publication Data

Davenport-Hines, R. P. T. (Richard Peter Treadwell). 1953–
 Gothic: four hundred years of excess, horror, evil, and ruin /
Richard Davenport-Hines. – 1st North Point Press ed.
 p. cm.
 Includes bibliographical references and index.
 ISBN 0-86547-544-X (alk. paper)
 1. Gothic revival (Art) 2. Arts, Modern. I. Title
NX449.7.G68D38 1999
700′.4164–dc21

 98–40556
 CIP

For June Pearson

Contents

To name a sensibility, to draw its contours and to recount its history, requires a deep sympathy modified by revulsion.
Susan Sontag

I sell here, Sir, what all the world desires to have – POWER.
Matthew Boulton, showing Boswell his engineering works, 22 March 1776

There is nothing which so generally strikes the imagination and engages the affections of mankind as the rights of property.
Sir William Blackstone

Born *Originals*, how comes it to pass that we die *Copies*?
Edward Young

Man is a make-believe animal—he is never so truly himself as when he is acting a part.
William Hazlitt

Everybody has his own theatre, in which he is manager, actor, prompter, playwright, sceneshifter, boxkeeper, doorkeeper, all in one, and audience into the bargain.
Julius and Augustus Hare

Only animals who are below civilization and the angels who are beyond it can be sincere. Human beings are, necessarily, actors who cannot become something before they have first pretended to be it; and they can be divided, not into the hypocritical and the sincere, but into the sane who know they are acting and the mad who do not.
W. H. Auden

Prologue

'The death of Satan,' according to Wallace Stevens, 'was a tragedy for the imagination.' But it has been the saving of twentieth-century gothic. As credence in the devil and hell have receded along with Christianity, people have played at being the devil or have devised new forms of hell. Humanity's transgressive state, which Christians so usefully indicated in the doctrine of original sin, has needed a new set of indicators – particularly since psychotherapy and other versions of the inner-child counselling craze have so insistently taught that everyone is born good but is injured into badness by bad parenting or abusive adults. As the gothic novelist Patrick McGrath has declared, his *genre* is 'supple, resilient . . . [and] capable of infinite renewal'. Gothic has always had the versatility to provide imagery to express the anxieties of successive historical epochs. It has provided fantasies of dystopia – invoking terror, mystery, despair, malignity, human puniness and isolation – which since the seventeenth century have gratified, distressed or chilled consumers of paintings, ornaments, buildings, literature, cinema and clothes. With such antecedents it has easily filled the imaginative vacancy left by the death of Satan.

Some definitions of 'goths' and 'gothic' are needed, and some disclaimers. The tribes originally from Scandinavia and eastern Europe which broke Roman power and sacked the capital in AD 410 were called Goths by Greek and Roman writers. They became synonymous with warlike barbarism, 'carrying Destruction before them as they advanced, and leaving horrid Desarts every where behind them,' as Edmund Burke wrote in 1756. Their love of plunder and revenge ushered in a dark age, and the word 'goth' is still associated with dark powers, the lust for domination and inveterate cruelty. The fear and antagonism aroused by the Goths' ferocity were similar to the extreme reactions raised in medieval people by the phenomenal world. God was conceived as a power requiring propitiation: medieval gothic art originated in this extremity of fear, which was the antithesis of classical optimism

looking forward to a happy reconciliation between humanity and its surroundings. 'Gothic' came to denote the architectural style that flourished in France, Germany and north-western Europe in the mid-thirteenth century, reaching some of its finest glories in cathedrals such as Reims and Cologne. Christian architects, using stones scarcely larger than bricks, covered vast spaces with lofty vaults supported on slender pillars. From this rich architectural and ornamental flowering, gothic music, gothic liturgy and gothic metaphysics prevailed until the Renaissance brought its resurgence of Italian culture. Medieval gothic's intentions soared like the roofs, towers and spires of its churches to elevate the human spirit and celebrate the living God. The urge to reach the sky raised the vaults from 114 feet at Chartres and 125 feet at Reims to 139 feet at Amiens and over 157 feet at Beauvais.

Yet Beauvais proved too vaunting: the great vaults of its choir crashed down after twelve years in 1284, and their fall broke the confidence of the early gothic age. The flamboyantly gothic cathedral at Chartres is arguably Europe's supreme monument to the medieval world, and a miraculous expression in stone and craftwork of the symbolism of Christian theology. By the seventeenth century 'Gotic barbarity' was a decried style: John Evelyn deplored King Henry VII's chapel at Westminster with 'its sharp *Angles, Jetties*, Narrow Lights, lame *Statues, Lace* and other *Cut-work* and *Crinkle Crankle* . . . the Universal and unreasonable Thickness of the Walls, Clumsy Buttresses, Towers, sharp pointed Arches, Doors . . . Turrets, and Pinacles . . . and abundance of buisy Work.' The intense reverent passions of medieval cathedral-builders, and of the great patrons of Victorian church-building, fall outside the concerns of my book. The Goths who terrified Europe in the fifth century, rather than church craftsmen and architects, represent the cultural moods which have resurged since the death of Satan. I explore the fascination with twisted and punished desires, barbarity, caprice, base terrors and vicious life which has underlain the revival of gothic since the eighteenth century.

This revival was an expression of the Counter-Enlightenment, the emotional, aesthetic and philosophical reaction against the prevalent eighteenth-century belief that by right reasoning humankind could achieve true knowledge and harmonious synthesis, and hence obtain perfect virtue and felicity. Enlightenment philosophers sought to dispense with the prejudices, errors, superstitions and fears which they believed had been fostered by a selfish priesthood in support of tyrants; but their theories of knowledge, human nature and society seemed dire and dismal to those

who believed that fear could be sublime. The Enlightenment's almost apprehensive vision of the universe governed by law, with its emphasis on the need for rationality, order, sanity and first principles, recognised the rarity of these phenomena under the piecrust of civilisation. Scepticism and philosophical dogmas were given meaning by the surrounding credulity. The generalisation that the eighteenth century was the Age of Reason in which human happiness and achievement rested on the mastery of passion, and on calm, confident regulation, rested on the opposing half-truth that humankind needs passion and fear. Indeed, as Isaiah Berlin demonstrated, thinkers like Vico and Herder dissented so vehemently from rationalism as to constitute a Counter-Enlightenment.

The gothic revival has developed in a historical continuum reflecting irrationalism, pessimism and latterly anti-humanism. Images of power have always been paramount to the meanings of gothic revival symbolism: the power of natural forces over man, man's power over nature, the power of the autocrat, the mob, the scientist; for much of the twentieth century, the power of inward goblins to torment one's psyche, and in the 1990s the invasive power of health police, religious fundamentalists and child-care vigilantes. The suggestion that submission is empowering is often reiterated by goth writers. Dominance and subordination – the interdependence and mutuality of 'tops' and 'bottoms' – provide one of gothic's themes. So does inversion, as signalled by the fact that the pagination of a recent collection of essays, *Gothic: Transmutations of Horror in Late-Twentieth-Century Art*, runs back to front. Gothic's estrangement from the dominant cultural values of every age produces both its protean qualities and the obsession of its practitioners with transgression: all goth writers worth any attention are forever returning to that immorality which defies or subverts ruling authority, and thus provides power-systems' necessary dark antitheses.

Decay provides its subject-matter too. The original British goths were fascinated by architectural ruins, erecting sham-medieval abbeys and castles as dilapidated features of landscape gardening intended to evoke the effects of Salvator Rosa's landscape pictures. Later goths have focused on the ruin that seemed most pressing in their age: moral ruin, as in those evil monks created by Ann Radcliffe and Matthew Lewis; corporeal ruin, as in the stories of Sade and the etchings of Goya; hereditary emotional ruin, as in Poe or Faulkner; the socio-political ruin represented by Frankenstein's monster or the ethical void of Edward Hyde. Gothic's obsession

with decay, and its tradition of political negativity, makes it at the end of the twentieth century an aesthetic of defacement. It produces graffiti – sometimes uncouth, in other instances witty or intelligent – defying or decrying complacently rationalistic social controls which, though ostensibly intended to restore an idealised humanist harmony, actually enforce a regime of trivialised sameness.

Power, transgression, ruin and the death-instinct all arouse dread. Gothic connotes dreadful supremacies. For the Duke of Argyll, who built at Inveraray the first gothic revival castle, the newly revived aesthetic provided the imagery for a power house to awe Scottish peasantry after the 1745 Jacobite rebellion. The Inveraray model was imitated by the Irish nobility, particularly after the unrest of the Roman Catholic peasantry became more menacing in the 1790s; but gothic symbolism proved futile at resisting new economic and political forces. These castles instead became theatres for sham-feudal melodramas played out by mad Anglo-Irish goths. Horace Walpole with his toy gothic fort, Strawberry Hill, and his camp gothic novel about the futility and helplessness of tough-guy castle-owners had already inverted gothic to mock power. In other sites and other moods during the eighteenth century Piranesi and William Beckford used gothic imagery to express notions of punishment. Gothic is nothing if not hostile to progressive hopes. Lewis and Radcliffe were social conservatives who, like Mary Shelley, deplored revolutionary excess and achieved their most dramatic effects when depicting the horror of mob rule. The fearful ugliness of Frankenstein's monster recalls the images of horrific revolutionary monsters engendered by Edmund Burke and other commentators on French proletarian excess. Similarly, Charles Brockden Brown's *Wieland* (1798) – 'our premier American-gothic novel', as Joyce Carol Oates calls it – constitutes a painful repudiation of progressive ideals and revolutionary hopes; and Wordsworth, admiring neo-gothic Lowther Castle, built for Lord Lonsdale during the Napoleonic Wars, had no doubt that 'ye Towers and Pinnacles' symbolised 'the strength of backward-looking thoughts' in an epoch of futile, deluded democratic hopes.

Visual and literary depictions of vampires provided another line of gothic imagination. These culminated in 1897 in Bram Stoker's Count Dracula, who connotes every kind of transgressive excess, not only sexual but those of monopoly capitalism, according to Franco Moretti's brilliant *Signs Taken for Wonders*. McGrath too sees Stoker's creation as specially, magnificently threatening:

Dracula is committed to nothing less than the breakdown of the distinction between life and death, and the creation of a race of undead beings whose relationship to time, to nourishment, and to sunlight mirrors his own. Like Satan, his real father, Dracula's argument is with God, and with the biological arrangements God made for humanity.

Correspondingly, the undead in a gothic novel of the 1990s defy God's arrangements for humanity:

> All three bodies bore the marks of various piercings, tattoos and scarifications. Living so long in the same unchanging flesh made them restless; they were compelled to change it themselves. Age did its own decorating of human bodies – wrinkles, wattled flesh, random sproutings of coarse yellowish hair. Molochai, Twig and Zillah were much more pleased with their own methods of decoration: silver rings, intricate patterns in ink, or raised flesh.

The late-twentieth-century gothic preoccupation with fetishistic body mutilation or transgressive decoration of body surfaces is not just a counter-cultural version of cosmetic surgery (though it is certainly that). It also registers dissent from God's arrangements for humankind; it expresses our self-disgust and death-wish; it recognises that demoralisation is one of the most effective modes of seduction; it declares that adult acts of self-reinvention are ultimate acts of freedom, certainly as enriching and liberating as searching for an inner true self through anxious introspection, or seeking a heavily mediated identity based on childish experience and childish perception.

Schlock has always been a part of gothic too. The German *schauerromantik* literature of the eighteenth century was trash; so were the multitude of English gothic stories and novels written under the influence of the Germans or of Walpole's much misunderstood novel. Edmund Burke might extol pain, danger and terrible objects as sources of the sublime, and thus of higher ethical forces, but most gothic output has been soap-operatic. It has supplied entertainment, shocks, facile emotional thrills and factitious intensity by manipulating stereotypical characters in mechanistic plots. The television soap-opera *Melrose Place* has been called 'a gothic serial for the cyber age', but there have been tens of thousands of dismal pre–cyber age equivalents in printed form. Occasionally, the direness of the times has provoked a

painter or writer to use gothic effects to express fear, horror, disintegration or per-versity, even if the greatest of the artists who have sometimes gothicised elements of their work have always been much more than goth artists: Goya or Faulkner, say. The gothic style pursued for its own sake – for its distinct atmosphere, vocabulary and furniture – is not just ephemeral, but calamitously boring.

Revival gothic's preoccupations with power, excess and inversion enlist [melo]drama and artifice. Salvator Rosa, the sometime street-actor who provided the visual imagery of caves, storms, remote places and withered trees that inspired English gothic landscaping, understood life as a performance. The eighteenth cen-tury, when the gothic revival began in Britain under Rosa's indirect influence, was rightly called 'the age of dressing up' by the biographer of Lord Le Despencer, the play-acting transgressive better known as Sir Francis 'Hell-Fire' Dashwood, who founded the notorious club for libertines at neo-gothic Medmenham Abbey. The theatricality of Edmund Burke, whose essay *A Philosophical Enquiry into the Origin of Our Ideas of the Sublime and Beautiful* (1757) provided the earliest theoretical text of the gothic revival, was noticed by such contemporaries as Fanny Burney and Hazlitt. Gothic effects began with a mild theatricality – the landscapes laid out by Vanbrugh and William Kent around Esher for Henry Pelham and the Duke of Newcastle, the prime minister brothers, were backdrops for *fêtes champêtres* – but in literature and painting gothic soon became an intense, stressful genre intended to compel a vehement response. Gothic's excess is almost operatic; its intensity, its atmosphere, its décor are all theatrical. Two of the most important gothic revival architects, William Kent in the eighteenth century and Augustus Welby Pugin in the nineteenth, both worked on stage scenery, and used its techniques to powerful the-atrical effect in their buildings. (In this book, Pugin is counted as a goth because he displayed the true excess of passionate character, and was an overdrawn self-cre-ation acting out a tragic destiny: his buildings and interiors, by contrast, hark back to a medievalist's Christian utopia rather than a dystopia of transgression and decay; his aesthetics elevated the human spirit rather than celebrating secular power or feasting on human degradation.)

The exhibition of new gothic curated by Christoph Grunenberg at the Institute of Contemporary Art in Boston in 1997 collected together numerous goth pho-tographs, pictures and installations of the last decade, all by turns beautiful, macabre or intellectually exciting. One characteristic is shared by all the most

impressive exhibits – a quality fundamental to revival gothic since Kent meticu-lously planted dead trees on the grounds of Kensington Palace – theatricality. Abigail Lane's 'The Incident Room', with its wax body of a murdered woman lying almost submerged in soil, and the thrilling installations of Tony Oursler, Sheila Pepe and Jeanne Silverthorne are as immaculately contrived pieces of stage-setting as houses like Milton Abbey (designed for Lord Dorchester by Chambers) or Ashridge (designed by Wyatt for Lord Bridgwater). The suicides of goths have been theatrical too. With careful stagemanship James Whale, Hollywood's earliest and greatest gothic film director, drowned himself by hurling himself into the shallow end of his swimming-pool in 1957 after leaving on his bedside table a book entitled *Don't Go Near the Water*. In a paroxysm of self-contempt Ian Curtis, the lead singer of Joy Division, a post-punk industrial goth band, hanged himself from a clothes rack in 1980 to the sound of Iggy Pop's *The Idiot* playing over and over again, stuck in a record groove.

Gothic is an evasive *genre*. From the earliest period of its revival it has displayed burlesque traits. Goths reject the bourgeois sense of human identity as a serious business, stable, abiding and continuous, requiring the assertion of one true cohe-sive inner self as proof of health and good citizenry. Instead goths celebrate human identity as an improvised performance, discontinuous and incessantly re-devised by stylised acts. 'It is by imitation far more than by precept, that we learn every-thing,' Edmund Burke declared in his essay on the sublime: 'this forms our man-ners, our opinions, our lives.' Like a true goth, he recognised that human existence is constructed out of innumerable acts of social, emotional and stylistic imitation: whether high-minded emulation, or low-grade histrionic stunts, or some intermedi-ate form of copying. He welcomed this mimetic existence as 'a species of mutual compliance with which all men yield to each other', and thus 'one of the strongest links of society'.

Goths believe in mistrust. They feel like Goya's caption to plate 6 of *Los Caprichos* that 'the world is a masquerade; face, dress, voice, everything is feigned. Everybody wants to appear what is not; everybody deceives, and nobody knows anybody.' Burke recognised too that 'pain is always inflicted by a power in some way supe-rior, because we never submit to pain willingly', and that death represented the highest idea of pain of all. For Burke and the goths who have imitated his thinking, pain is inseparable from power, and our attitude to our superiors should always

include an element of dread. In consequence, revival gothic is a *genre* which acknowledges that paranoia can be a sane response. 'It was most important to remain secretive, and a little afraid,' reflects the vampire who is one of the few survivors in the most captivating of the many novels of the 1990s about drinking human blood. It is a goth intuition that one has few chances of sanity or fulfilment pretending to be an integrated part of humanity; happiness and survival depend upon vulnerable, hopelessly isolated individuals deploying evasive tactics. The dissimilation of Sade's characters shows this goth trait at its most ruthless and horrific; its mildest, most seductive expressions lie in the camp concealments of Walpole and Beckford.

Goths unfortunately seldom rank sanity or calm among the highest aesthetic achievements; nor do gothic's millions of contemporary artistic consumers. They like carefully staged extremism, and vicarious or strictly ritualised experiences of the dreadful Other. This taste connects gothic to sado-masochism. Too much has been made in the twentieth century of the erotic meanings of gothic; earlier centuries knew that there were more enduring, variable and life-enhancing acts than sexual acts. Despite its interest in unbridled or extreme passions, revival gothic's central focus was power relationships; as in Sade's *120 Journées de Sodome*, sexual acts were merely means to display economic authority, class control and superior status. Their chief purpose was acting out roles of domination and subordination rather than erotic fulfilment. Walpole understood this when he regaled his friends with gossip about an aristocratic contemporary called Delaval, who surprised his mistress in bed with a young man; Delaval punished his usurper with contempt by forcibly buggering the young man in an act of domination which had not eroticism but the assertion of superior power as its purpose.

More recently Foucault claimed that S&M was 'not a name given to a practice as old as Eros' but 'a massive cultural fact which appeared precisely at the end of the eighteenth century, and which constitutes one of the great conversions of Western imagination'. The American critic Mark Edmundson has argued that the simultaneous emergence of S&M and gothic literature was not coincidental: 'you cannot have Gothic without a cruel hero-villain; without a cringing victim; and without a terrible place, some locale, hidden from public view, in which the drama can unfold . . . S&M is where Gothic, in a certain sense, wants to go.' The truth is that gothic imagery has often been used to illustrate the power relationships which have preoc-

cupied philosophers. Universal principles of order – the necessity for rulers and subordinates, the interdependence of superiority and inferiority – rested for centuries on the Aristotelian paradigm of master and slave. In the eighteenth century that monstrously self-absorbed philosopher Jean-Jacques Rousseau reformulated the traditional antithesis of vice and virtue into a new opposition of Self against Others in varying degrees of dependence and antagonism.

At the turn of the eighteenth century into the nineteenth Hegel propounded a new theory of the relationship between Master and Slave. He argued that the tyrant extorts recognition of his powers by threatening violence on the slave, but that this domination is only theoretical or superficial. In practice the Master cannot enforce his superiority by constraining or killing others without outraging proprieties and risking what he desires most: recognition. The Master believes himself free and in control, but actually depends upon the Slave for his status; once the Slave becomes aware of this dependence, their power-relationship is inverted. The Hegelian Slave's fear of the Master – like the S&M 'bottom' cringing before the 'top' – develops into more empowering and exhilarating emotions. Horace Walpole's pioneering gothic novel *The Castle of Otranto* (1764) is an extended camp joke; but it is shot through with ideas about power-relationships which recall those developed in the altogether less frivolous works of Rousseau and Hegel.

The distance between Hegelian philosophy and mass culture of the late twentieth century may seem enormous, although at least one pop band, Depeche Mode, adapted a phrase from *Phenomenology of Mind* for a song title, 'Master and Servant'. Still, in the 1990s, gothic has sustained a strong revival. It provides graffiti denouncing 'today's moral climate (cloudy, with a fascist storm front threatening)', as the southern gothic novelist Poppy Z. Brite in 1993 described the post-Reaganite culture in which *Tomb of the Unborn* is the title of not a goth fantasy but anti-abortion propaganda, 'complete with color shots of shredded fetuses in puddles of their own gore'. Since the 1980s Britain and the USA have been increasingly influenced by fundamentalist groups representing not just decerebrated, evangelical Christianity, but therapeutic religions and harsh, exclusive sects like Kleinianism. (Mark Edmundson in *Nightmare on Main Street: Angels, Sadomasochism and the Culture of Gothic* has a provocative section on recovered memory syndrome as gothic melodrama.) American fundamentalists, as Christoph Grunenberg has described, have fought to ban from museum displays, gallery exhibitions, television, the Internet, magazines,

CD lyrics and videos 'everything that disturbs the uncompromising doctrine of an imaginary nuclear family, the dream of a caring, non-violent society, the Puritan repugnance of sex (or better even: no sex at all – "Just say no!") and an obsessive preoccupation with physical and mental cleanliness'. They fear the fragmentation of human experience and recoil from the reality of human isolation. Like old exploitative hell-fire preachers, they suffer an intolerable perplexity when confronted by the diversity of rules, loves, fears and play by which other people prefer to live. They hate soaps like *Melrose Place* where there is no homeliness, no reconciliation, only serial disruption (*Sunset Beach* even had a long-running storyline about a villainous 'top' trapping a victimised 'bottom' in traditional gothic subterranean confinement and another about a generous millionaire called Ben haunted by an evil doppelgänger named Derek). For them, all excess is deviant: they want to extirpate smoking, alcohol, secrets. Their cultural aim is to infantilise, cleanse and control.

New gothic's resurgence has been provoked by the fundamentalists' sanitary controls. Gothic art has always disclosed the terrors of a world where there is a constant risk and nothing is protected. It demonstrates the trick of turning anguish into delight. It delivers an enduring message about the existence of original sin at a time when even practising Christians are reluctant to mention this doctrine of innate human wickedness. It has supplied consumers with choices as varied as the 'gothic western' of Richard Brautigan's novel *The Hawkline Monster* (1974), the rap-album *Ghetto Gothic* (1995) made by the pioneering black film-maker Melvin Van Peebles, the gothic murk of *Batman* films, the metallic shades of Hard Candy nail varnish brand-named 'Porno' and 'Pimp', or innumerable goth sites on the Internet. The incorporation of serial killers into the gothic aesthetic which began in the 1880s has become almost the leading characteristic of the *genre* since the 1980s (Anne Rice's vampires and witches are serial killers, after all). This preoccupation with serial homicide is just one example of gothic's cultural infiltration: in the last twenty years satanic ritual murders and serial killers have attained an iron hold on mainstream entertainment in the USA. Stephen King has nearly 250 million copies of his books in print; his commercial supremacy, as Edmundson notes, is challenged only by R. L. Stine, author of fright novels for adolescents with such gratifying titles as *Cheerleaders: The First Evil*. Gothic consumers prefer art and entertainment to be morale-sapping, not bracing or comforting. Does this mean that humanity has become sick and sad, as the family-values and child-centred controllers plaintively reiterate, or that their brand of

sanitised infantilism is insufficient for the human spirit? 'We can no longer speak of Evil,' as Jean Baudrillard has recently complained:

> All we can do is discourse on the rights of man – a discourse which is pious, weak, useless and hypocritical, its supposed value deriving from the Enlightenment belief in a natural attraction of the Good, from an idealized view of human relationships . . . All the talk is of the minimizing of Evil, the prevention of violence: nothing but *security*. This is the condescending and depressive power of good intentions, a power that can dream of nothing except rectitude in the world, that refuses even to consider a bending of Evil, or an intelligence of Evil.

Goths choose to stand on the giddy edge of things: they take the riskiest path up the volcanic slopes to peer into the crater. Like satirists, they are reactive, seek to provoke reactions, and seldom respect progressive ideals. Their great literary horrors, from Matthew Lewis and Ann Radcliffe in the 1790s, through Shelley's post-Napoleonic *Frankenstein*, to the late-Victorian climax of Stevenson's *Strange Case of Dr Jekyll and Mr Hyde* and Stoker's *Dracula*, have proved the most resounding and pervasive British literary influences on global culture and mass entertainment in the twentieth century. In the USA, too, American literary gothic's obsession with family secrets and hereditary doom has altered – arguably poisoned – the mainsprings of people's emotions and domestic peace. At the end of a century when the therapeutic claims of affirming loudly and shamelessly one's personal truth have become so hackneyed, goths still offer exciting but uncomfortable alternatives. They ceaselessly insist that there is much that should make us ashamed. The gothic imagination continues to haunt us all.

The spectre still will haunt us

Except for us, Vesuvius might consume
In solid fire the utmost earth and know
No pain (ignoring the cocks that crow us up
To die). This is a part of the sublime
From which we shrink. And yet, except for us,
The total past felt nothing when destroyed.
Wallace Stevens

The St Gotthard, like other catastrophes, becomes unbearable slowly
and seems never to be over. For some time they blinked in and out of minor tunnels;
suffocation and boredom came to their climax and lessened; one was in Switzerland,
where dusk fell in sheets of rain. Unwilling, Cecilia could not avert her eyes from all that
magnificence in wet cardboard: ravines, profuse torrents, crag, pine and snow-smeared
precipice, chalets upon their brackets of hanging meadow.
Elizabeth Bowen

NAPLES: AN EVER-MOVING PICTURE

Vesuvius has always evoked terror. The only interlude in its intimidation lasted from 1500 until 1631. The volcano had been somnolent for almost five centuries, quiescent since 1500, and it was believed by many that its fires were extinct. Neapolitans descended daily by tortuous paths to the luxuriant green bottom of the crater. Woodmen worked the dense woods flourishing on the lava soil; wild boar roamed there; herdsmen tended animals grazing on succulent grass. The crater walls at the bottom of the abyss were pierced with caverns through which wind whistled eerily. Late in 1631 there were earthquakes in the vicinity and water in adjacent wells fell mysteriously. Around 1 December an early visitor to the summit found the woods gone and the chasm level to the brim with volcanic matter. He walked across from one side to the other apparently neither awed at the magnitude

of the event nor apprehensive of danger. A few nights later local peasants were alarmed by demons growling in the mountain whom they tried to placate with religious ceremonies. On the night of 15 December, a bright star appeared glinting above the volcano; later that evening a lightning flash struck the mountain while its summit glowed with a deep red. Then smoke billowed out of the mountain; its pastures ignited in flames; huge stones were hurled from the crater. In Naples on the morning of the sixteenth the populace saw an extraordinary cloud shaped like a gigantic pine tree hanging over Vesuvius.

Still no one understood the terror threatening them, until the abbot Braccini, who had made a long study of the volcano, went to his library and read them Pliny's first-hand account of the Vesuvian eruption of AD 79. 'There,' said Braccini, as he shut the book, 'there, in the words of sixteen centuries ago, is depicted what you see today.' Earthquake shocks came faster, concussions boomed ever more loudly, people choked on the sulphurous stenches; their fear was all the worse for having had no premonition of danger. Around noon the city was enveloped in darkness; the houses, according to Braccini, swayed like ships at sea; there was a roaring sound like the blast of many furnaces; tongues of lightning flashed continuously; the crashes became appalling; Naples went wild with terror. Its Cardinal Archbishop ordered the Sacrament to be celebrated throughout the city. A solemn procession was organised to venerate the city's patron saint, but when the priests went to his relics, his blood was found to be liquefied and bubbling. The suffocation of Naples was, however, supposedly halted by the miraculous intervention of San Gennaro at the moment when his relics were being carried out to the cathedral square. The authorities sent drummers round the city beseeching the people to forsake the pollution of gross pleasures and selfish vices. Next day the sea receded for nearly half a mile from the coast, and then swept back in a huge wave to a point high above its usual level. Seven tongues of lava poured down the mountainside at terrible speed, destroying villages, killing thousands of people (one wiping out a religious procession). The lava flow soon reached the sea, which for days resembled a boiling cauldron.

Pliny's account of the destruction of Pompeii ensured the enduring notoriety of the Vesuvian eruption of AD 79; but the violent paroxysm in 1631 hugely impressed contemporary imagination: the terrible violence of Nature, the symbolism of storms and lightning, the puniness of humanity in everything except its fears, the horrors

from whose ghastliness humanity is protected by proscription and custom. John Evelyn's emotions fourteen years later on beholding Vesuvius were typical: 'I layd my selfe on my belly to looke over & into that most frightfull & terrible Vorago, a stupendious pit . . . Some there are who maintaine it the very Mouth of hell it selfe, others of Purgatory, certainely it must be acknowledged one of the most horrid spectacles in the World.' The volcano's fascination, its power to excite emotion, its parabolic implications about human existence were continuous. In the early nineteenth century Lord Lytton wrote a similarly momentous description of Vesuvius:

> From the crater arose a vapour, intensely dark, that overspread the whole background of the heavens; in the centre whereof rose a flame, that . . . might have been compared to a crest of gigantic feathers, the diadem of the mountain, high-arched, and drooping downward, with the hues delicately shaded off, and the whole shifting and tremulous as the plumage on a warrior's helmet. The glare of the flame spread, luminous and crimson, over the dark and rugged ground . . . An oppressive and sulphurous exhalation served to increase the gloomy and sublime terror of the place. But on turning from the mountain, and towards the distant and unseen ocean, the contrast was wonderfully great; the heavens serene and blue, the stars still and calm as the eyes of Divine Love. It was as if the realms of the opposing principles of Evil and of Good were brought in one view.

At the time of the 1631 eruption Naples was the capital of the Kingdom of the Two Sicilies and the second European city after Paris. It had been ruled since 1503 by Spanish viceroys after incorporation into the Hapsburg empire. The Spaniards drew the lawless provincial nobility away from their estates and enmeshed them in the duties and rituals of the viceregal court rather as Louis XIV later drew the French aristocracy into the elaborate etiquette and political impotence of court life at Versailles. These nobles built fine palaces, kept rich retinues about them, bickered over protocol and adopted the austere black clothes of their masters. As well as being a centre of political power and aristocratic display, Naples was a rich port (its inhabitants were exempt from many taxes) set among some of the most exciting vistas in Europe and celebrated for the beauty of its gardens. One consequence of the destruction of 1631 was an outburst of sumptuous rebuilding and ornamentation of Neapolitan churches with an attendant flowering of the arts. The Spanish authori-

ties were, however, unable to suppress the bands of brigands swarming through the surrounding countryside in search of plunder and leaving desolation in their trail.

Naples excited raptures and fears in visiting Englishmen, fed their veneration of antiquity and gave them a new way to use their eyes. The castle of St Elmo, occupied by the garrison enforcing Spanish power, was visited in 1645 by John Evelyn: 'built on an excessive high rock, whence we had an intire prospect of the whole Citty, which lyes in shape of a Theatre upon the Sea brinke'. Mounting a steep hill he 'considerd the goodly Prospect towards the Sea, and Citty; the one full of Gallys, and ships, the Other of stately palaces, Churches, Monasteries, Castles, Gardens, delicious fields and meadows, Mount Vesuvius smoaking . . . doubtlesse one of the most divertisant & considerable Vistas in the World'. This pictorial power and theatrical quality were persistently associated with Naples by the English. In the century after Evelyn's visit 'the city and bay of Naples' were to Ann Radcliffe 'an ever-moving picture'. To John Meade Falkner, a Victorian who visited the district for the prosaic reason that he was interested in a naval arsenal at Puzzuoli on the north of the bay, 'the panorama of the most beautiful spot on earth, the Bay of Naples, with Vesuvius lying on the far side . . . was unreal as a scene in some brilliant dramatic spectacle'.

Naples and its surrounding vistas enriched the English visual imagination in the late seventeenth century and gave a new gothic aesthetic to the English-speaking world. The antecedent imagination in this process is that of a proud, scornful Neapolitan painter called Salvator Rosa (1615–73). After Rosa's death his creative ideas were intellectualised by an artistic, invalid English nobleman, Anthony Ashley Cooper, third Earl of Shaftesbury (1671–1713). Shaftesbury's ideas were popularised by the poet Alexander Pope (1688–1744), who disseminated a new sense of the visual and the picturesque; Pope's version of Shaftesbury's doctrines and Rosa's images were then given solid form by the architect and landscape artist William Kent (1686–1748). This process would have been impossible without the new taste for Continental travel that developed among the English of the seventeenth century and without the new fortunes that enabled them to collect works of art.

SALVATOR ROSA: THE FASCINATION OF HORROR

Salvator Rosa was born in the small village of Arenella, situated high above the Bay of Naples, in 1615. He retained the Neapolitan dialect and mannerisms all his life, and always regarded Naples as a paradisiacal place, though he reviled some of its customs. After his father's early death, he was deserted by his mother and endured uncongenial charity schooling. He had a truant disposition, and used to sketch with burnt sticks on the walls of his bedroom. Once he was severely whipped for thus decorating the walls of a chapel. He was simultaneously estranged and tempted by the sumptuous sybaritism in Naples – 'all tinsel and frippery, like its population,' as Sade later wrote, 'every other people have used the Neapolitans to establish a power; they alone have remained weak-willed and listless.'

Destined for the priesthood, Rosa became a novice in a local monastery, where he acquired the classical learning later manifest in his paintings and poems, but earned the enmity of the priests. At the age of sixteen, in 1631 (the year of the great

An engraving of Salvator Rosa's Landscape with Cave, *owned by William Kent.*

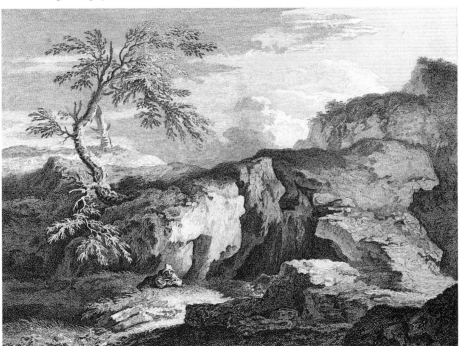

Vesuvian eruption), he abandoned his novitiate and took to the Calabrian hills: 'If there is no other religion than this of pope and cardinals, let us to the dragon's ambush and the dragon's den,' he is quoted as saying. It was fundamental to the English admiration of Rosa that he had repudiated monkish submission by vanishing into 'wild but splendid regions . . . which modern art had not yet violated', to quote his Irish Protestant biographer Lady Morgan in 1824. 'Full of difficulty and peril . . . they were alluring to one, who, lonely and proud in spirit, could find in the trackless solitude of Nature, magnificent and endless combinations of the sublime and the terrific.' Many romantic stories have been invented about Salvator Rosa. He is rumoured to have joined a bandit gang. Dumas represented him as an intimate friend of Masaniello, the handsome and reckless young fisherman who in 1647 led an insurrection against the Viceroy and was briefly installed as an arbitrary sovereign in Naples. After a few days' rule, the fisherman-prince suffered a nervous paroxysm, tearing off his clothes during a diatribe from the pulpit, and was killed in a volley of assassins' bullets. Rosa praised Masaniello, but the story of the Compagna della Morte, a band of Neapolitan artists including Salvator Rosa which roamed the city murdering Spanish soldiers, appears to be mythical.

Rosa began painting before leaving Naples for Rome about 1635; later he moved to Florence. In both places he was a poet, satirist, *salonnaire* and street actor as well as a painter. Like every ambitious baroque artist, he chiefly produced portraits and sacred or classical history paintings. To the latter he imparted coded messages: his picture of Diogenes the Cynic crouched in his barrel rejecting the conversational overtures of Alexander the Great, conqueror of the world, was a declaration of his own misanthropy and contemptuous independence of patrons. Literary images were important in his work. He asked poet friends for ideas, and pillaged the writings of Stoic historians for images to paint. Indeed, he called himself a Stoic and identified himself with Timon of Athens: his satire *La Guerra* is constructed as a dialogue between himself and Timon on the subject of despotism. His famous self-portrait in the garb of a philosopher emphasises that he was in earnest about moral philosophy. In keeping with this character, he was keen to praise Virtue and the triumphs of the virtuous. His scorn was that of a man anguished by the prevailing corruption, and his ethical ardour contributed to his isolation. Fellow painters resented his courting of literary intellectuals who in turn mistrusted his ethical pretensions.

Moreover, his artistic ambitions were baffled by contemporary consumer tastes.

He avidly desired commissions to paint complex allegorical and historical paintings – *Fortune* and *The Death of Regulus* are ambitious examples of this line of work – but the papacy's prestige was declining in his lifetime and Roman patronage was unreliable. Failing to find powerful patrons, he popularised his work by selling pictures to what would now be called the middle classes. The traditional forms of landscape painting which had emerged from the Middle Ages – decorative, with historic allusions – were being superseded by new styles in the seventeenth century. A few artists produced paintings in which the landscape looked more important than the people or objects. Claude Lorrain (1600–82) gave the genre of landscape painting parity with historical figure painting; though a keen student of nature, he seldom painted directly from life, preferring idealised poetic landscapes evoking a Virgilian golden age removed from the crudities of nature or of the *bamboccianti* (painters of condescending little pictures of everyday life). Rosa's supreme gift, though, was in painting savage and desolate scenery. He saw the misery of the earth and of humanity represented in the harsh Calabrian landscape, and scorned the clients of the *bamboccianti* as sentimental fakers: 'what they abhor in real life they like to see in a picture.' The Roman connoisseurs exasperated him too: 'always they want my small landscapes, always, always, my small ones.' The success of these pictures seemed a mockery of his high intellectual ambitions, and entrenched him in a lifetime habit of angry disdain. He despised some of the best of his own works and raged at their admirers. He insulted his clients, telling one who made suggestions for a picture 'to go to a brickmaker as they work to order'. Although by the late 1660s the demand for his work was international, Englishmen started buying his pictures only after his death, whereupon he became a specifically English, or perhaps British, taste.

His *Scene of Witchcraft*, for example, was bought by the first Lord Spencer and hung at Althorp (it is now in the National Gallery in London). In Rosa's lifetime it was owned by the Roman collector Carlo de'Rossi and provided the climax when he took his friends round his private gallery. De'Rossi kept it covered with a curtain, which he would draw aside with a flourish at the end of each tour. It is the quintessence of a gothic image, excessive yet evasive. On its far left a foul hag is directing a blindfolded young innocent to the centre of the picture; nearby an old man supports a skeleton half-dragged from its coffin so that a sinister confederate can force the skeletal fingers to write a forgery or inscribe a prophecy. In the background a coolly menacing white veiled figure holds candles. This last figure recalls the shrouded, festooned people

who surround the Virgin Mary in the frescos of Mantegna; but the clothing of Rosa's figure also evokes the wrappings of a mummy and a leper. The hag, the old man and the shrouded attendant are villainous-looking figures constituting a tableau of deception and betrayal. They are oblivious to everyone surrounding them: indeed, though there are several distinct groups of people in the picture, none pays the slightest attention to any other. This is Salvator Rosa's reminder of the inwardness of people's fears and fantasies, and their potential for secret tawdriness.

The centre of the picture is dominated by a withered tree-trunk with a grimacing corpse hanging from its bough; this central image presents a total inversion of Christian values. The dead tree is a negative of the tree of life. There is a skull lying near its base, as there was in most pictures of the Crucifixion, for Christ's cross was grown from a sapling taken from the tree of life which had been planted in Adam's mouth after his death. The corpse evokes the traitor Judas who hanged himself; though, as a suicide, the dead man is damned, his remains are being offered incense by a woman who represents an inversion of Mary Magdalene. A witch meanwhile is severing the hanged man's toe-nails for use in her potions. In the foreground under the corpse a naked girl gazes into a mirror before which she holds a little wax model man which is reflected opaquely in its glass; behind this girl an uglier naked woman gapes and gasps with stupid prurience at the distorted reflection of the miniature. The women are hunched and intent figures engaged in acts of manipulative possession, their envy and slyness more repellent than their lust. Illicit desire, which subsumes much gothic literature, is the power commanding their attention. To their right, a crone squeezes entrails into a mortar and grinds with a bone as her pestle. Behind the crone a knight in armour sets fire to a white rabbit crouching in a magic circle; the knight, though, is bowed in submission, and is being beaten with a broomstick by a man wreathed as a poet, who in turn takes a bloody heart pierced on a swordpoint held out to him by a bearded necromancer. Behind the poet there rears a hideous predatory bird skeleton. On the right of the picture two witches approach riding bizarre monsters; they are the bad women who disrupt fertility and nurture: one with a vicious face clutches a swaddled innocent baby who must be sacrificed. The approach of dawn is signalled by lurid blue and golden streaks on the horizon.

Rosa perhaps had burlesque intentions in *Scene of Witchcraft*: the viciousness is so busy in this picture, and the old people and crones such potentially comical figures, with their grimacing faces reminiscent of the speciality of Neapolitan street theatre.

Even in the direst extremities of the gothic imagination the evasiveness of burlesque and parody is never far away. There is certainly a burlesque element to Salvator Rosa's witchcraft poem. 'La Strega', or 'The Witch', tells of Phyllis, who threatens to use infernal spells on the lover who has forsaken her. 'I'll try magic plots, unholy lays, strange herbs and nuts that stop the celestial wheels.' She lists the ingredients for her spells to summon the forces of iniquity: 'A magic ring, icy streams, fish, alchemic draughts, black balsam, ground powders, mystic gems, snakes and owls, putrid blood, oozing guts, dried mummies, bones and grubs, fumigations that will blacken, horrid cries that terrify.' She intends to burn the wax image of her lover, for 'when the false image burns/so burns the real one'. This poem was set to music, and 'sung on a dark evening by a powerful soprano or, perhaps, by a counter-tenor, it may have tingled the spine'. Spine-tingling is a prime gothic effect; or rather a prime effect of gothic in the modern world.

Rosa was the precursor of every gothic revivalist down to the end of his millennium. 'He had not the sacred sense . . . he saw only what was gross and terrible,' Ruskin wrote of him. 'I should not suspect Salvator of wantonly inflicting pain. His constantly painting it does not prove he delighted in it; he felt the horror of it, and in that horror, fascination.' When New York gallery glitterati in the 1990s stand before Joel Peter Witkin's photograph of an old, bald man's severed head, taken from a hospital mortuary, lying neatly in the centre of a salver of salad, they feel the horror of it, and in that horror, fascination. They become part of the gothic experience: Witkin's photographs are like Rosa's witchcraft paintings in twentieth-century accents. Rosa provided images for feelings that were too ubiquitous and fundamental to originate in any epoch or nation. They were irrational, pessimistic, fearful and uncanny. 'Of all men whose work I have ever studied, he gives me most distinctly the idea of a lost spirit,' Ruskin continued. 'I see in him, notwithstanding all his baseness, the last traces of spiritual life in the art of Europe. He was the last man to whom the thought of a spiritual existence presented itself as a conceivable reality.' This spiritual awareness entailed both inescapable, oppressive mystery and a sense of the puniness of human power. As the English connoisseur Lord Shaftesbury wrote, 'The *Specter* still will haunt us, in some shape or other: and when driven from our cool Thoughts, and frighted from *The Closet*, will meet us even *at Court*.' Rosa's interest in the supernatural was reflected in his personal response to landscape. 'The famous waterfall of the Velino', he enthused in 1662, was 'enough to inspire

the most fastidious brain with its horrid beauty: the sight of a river hurtling down a half-mile mountain precipice and raising a column of foam fully as high'.

Rosa was crucial to the emergence of a new sense of the pictorial in late-seventeenth-century England. As Margaret Jourdain described, 'The works of Salvator Rosa, with their savage scenery of rocks, cascades and blasted trees, opened English eyes to the picturesque qualities of the wilder kind of scenery; and the wide landscapes of Claude Lorrain, diversified by ruined temples and other fragments of the antique world, were adopted as setting the standard for the pictorial qualities of park landscape.' Rosa's precipices, withered trees, pitiless outlaws and bold, strangely armed solitaries never delighted French collectors, with their national affinity for Watteau, Fragonard and Boucher. Claude-Joseph Vernet, the French artist who settled in mid-eighteenth-century Italy to paint Salvatorian views of the Neapolitan coast, sold much of his work to British tourists: Philippe-Jacques de Loutherbourg, who painted Salvatorian *banditti*, moved to live in his best market, London, in 1771. Supposedly it was during his bandit adventures that Rosa learnt this landscape style that the English so relished: it is typified by *Attack by Bandits*, an early Rosa picture sold to the Duke of Dorset in 1770 (and still at Knole), in which three travellers are maltreated and robbed while riding through a narrow rocky crevice: characteristically there are stunted trees and trailing ivy on the surrounding crags, and on the high outcrop there is a remote and desolate building.

At one level such pictures could be read as literal exercises in story-telling. Attacks by bandits were a real menace. Brownlow Colyear, the young heir to two rich grandfathers, Lord Portmore and the last Duke of Ancaster, who was fatally wounded by *banditti* at Gensano while on the grand tour, was one of their most poignant English victims. But Salvatorian bandit landscapes produced more complicated evocations. Ann Radcliffe's ode 'Superstition' connects Salvatorian landscape with spiritual fears, its human figures with lost souls:

> Enthron'd amid the wild impending rocks,
> > Involved in clouds, and brooding future woe,
> The demon Superstition Nature shocks,
> > And waves her sceptre o'er the world below.
>
> Around her throne, amid the mingling glooms,
> > Wild – hideous forms are slowly seen to glide,

> She bids them fly to shade earth's brightest blooms,
> And spread the blast of desolation wide.

Lord Lytton's account of Rosa similarly presented the little *banditti* figures as parabolic: 'His images have the majesty, not of the god, but the savage; . . . he grasps the imagination, and compels it to follow him, not to the heaven, but through all that is most wild and fantastic upon earth.' In more conventional painters, Lytton declared in his gothic novel *Zanoni* (1842), set largely in Naples, 'the living man, and the soul that lives in him, are studiously made the prominent image; and the mere accessories of scene kept down, and cast back, as if to show that the exile from paradise is yet the monarch of the outward world'. By contrast

> in the landscapes of Salvator, the tree, the mountain, the waterfall, become the principal, and the man himself dwindles to the accessory. The matter seems to reign supreme, and its true lord to creep beneath its stupendous shadow. Inert matter giving interest to the immortal man, not the immortal man to the inert matter. A terrible philosophy in art!

THOMAS BURNET AND THE SUBLIMITY OF MOUNTAINS

Until the late seventeenth century literary evocations of landscape remained, with few exceptions, descriptive lists with little evocative power, individuality or observation. Landscape in seventeenth-century poetry was used to symbolise character or to indicate the amenities that came from property and power. Limitations on travel meant that Shakespeare and Dryden probably never saw a mountain in their lives. Dryden's opinion of rugged landscape suggests that his knowledge was theoretical rather than direct; he seems entrenched in the contemporary view that wild Nature must be tamed. 'High objects', he wrote in 1667, 'attract the sight; but it looks up with pain on craggy rocks and barren mountains, and continues not long on any object, which is wanting in shades of green to entertain it.' His revulsion was shared by travellers too. John Evelyn in 1746 found the Alps 'strange, horrid & fire-full', and their mountain people with their goitres 'ougly, shrivel'd & deform'd . . . of gigantic stature, extreamly fierce and rude'.

The English response to mountain scenery was drastically revised under the influence of Thomas Burnet (1635–1715). Early in the reign of King Charles II, as a young Cambridge clergyman, he left England as the travelling companion of Lord

Wiltshire (afterwards first Duke of Bolton). It cannot have been an easy journey. Wiltshire 'would take a conceit not to speak one word, and at other times he would not open his mouth till such an hour of the day, as he thought the air was pure; he changed the day into night, and often hunted by torchlight, and took all sorts of liberties to himself, many of which were very disagreeable to those about him.' One consolation for Burnet came when their party crossed the Alps and Apennines, for those wild, vast mountains captivated his imagination. A stranger

> would think himself in an inchanted Country, or carri'd into another World; Every thing would appear to him so different to what he had ever seen or imagin'd before . . . Rocks standing naked round about him; and the hollow Valleys gaping under him; and at his feet it may be, an heap of frozen Snow in the midst of Summer. He would hear the thunder come from below, and see the black Clouds hanging beneath him.

After long meditation, in the 1680s he published *The Sacred Theory of the Earth* (expanded and influentially republished in 1691). The passion and intensity of his treatise remain impressive. It has a *fin de siècle* quality: 'We are almost the last Posterity of the First Men, and faln into the dying Age of the World,' he declares early on. His subject is 'the greatest thing that ever yet hapned in the world, the greatest revolution and the greatest change in Nature'.

Burnet argued that the earth had originally resembled a giant, unblemished, smooth egg:

> In this smooth Earth were the first Scenes of the World, and the first Generation of Mankind; it had the beauty of Youth and blooming Nature, fresh and fruitful, and not a wrinkle, scar or fracture in all its body; no Rocks nor Mountains, no hollow Caves, nor gaping Chanels, but even and uniform all over. And the smoothness of the Earth made the face of the Heavens so too; the Air was calm and serene; none of those tumultuary motions and conflicts of vapours, which the Mountains and the Winds cause in ours: 'Twas suited to a golden Age, and to the first innocency of Nature.

But the catastrophe described in the Bible, the immense inundation to cleanse human sin, when God destroyed the human race save for Noah, crushed the earth's shell, according to Burnet. The shell fragments were scattered as mountain ranges,

whose first appearance was 'very gastly and frightful'. To Burnet mountains were 'nothing but great ruins; but such as show a certain Magnificence in Nature; as from old Temples and broken Amphitheatres of the *Romans*'. The moral for human vanities was clear: 'What a rude Lump our World is, which we are so apt to dote upon.' Burnet's explanation identified mountain scenery in all its horror as product and symbol of the Fall: such terrain was punitive of desire, a reminder of how God obliterates the perverse and the transgressive.

Half a century later, mountain scenery was still terrifying in its potential for accidents, but already touristic – a terrain for jaunts and cultural associations. 'Mount Cenis . . . carries the permission mountains have of being frightful rather too far; and its horrors were accompanied by too much danger to give me time to reflect upon their beauties,' Thomas Gray wrote from the French Alps in 1739; but at other moments among the crags and thundering waterfalls he relished 'the most solemn, the most romantic, and the most astonishing scenes I ever beheld'. Horace Walpole, who was travelling with Gray, described them as 'lonely lords of glorious desolate prospects': the 'prodigious' mountains of Savoy as 'precipices, mountains, torrents, wolves, rumblings, Salvator Rosa'. William Beckford felt 'seized by the genius of the place' when travelling to La Grande Chartreuse in 1778:

> The woods are here clouded with darkness and the torrents rushing with additional violence are lost in the gloom of the caverns below; every object, as I looked downwards from my path, that hung midway between the base and summit of the cliff, was horrid and woeful. The channel of the torrent sunk amidst frightful crags, and the pale willows and withered roots spreading over it, answered my ideas of those dismal abodes, where, according to druidical mythology, the ghosts of conquered warriors were bound.

Mountain scenery excited the philosopher in Beckford: 'I am filled with Futurity. That Awful Idea is attended by mystery and sublimity – They make me tremble. What will be my Life? what misfortunes lurk in wait for me? what Glory?'

Salvator Rosa inspired a new perception of trees as well as of mountains. In the lamentation of the naturalist William Lawson in 1618, 'How many forests have we, wherein you shall have for one lively, thriving tree, three, four, nay sometimes twenty-four evil-thriving, rotten, and dying trees: what rottenness! what hollowness! what dead arms! withered tops! curtailed trunks! what loads of mosses!

drooping boughs and dying branches.' Lawson deplored dead wood; but the next century's Englishmen were taught by Rosa to see decay differently. 'What is more beautiful', asked the clergyman William Gilpin, 'than an old tree with a *hollow trunk*? or with a *dead arm*, a *drooping bough*, or a *dying branch*?' He cited 'the works of Salvator Rosa' as proof of the beauty of ruined trees:

> These splendid remnants of decaying grandeur speak to the imagination in a style of eloquence which the stripling cannot reach; they record the history of some storm, some blast of lightning, or other great event, which transfers its grand ideas to the landscape and, in the representation of elevated subjects, assists the sublime.

Shakespeare had used forest imagery memorably, but forestry had a special role in the gothic imagination. Thus the woods of Ann Radcliffe personified the misery and hope of her heroine incarcerated at Udolpho:

> Their tall heads then began to wave, while, through a forest of pine, on the left, the wind, groaning heavily, rolled onwards over the wood below, bending them almost to their roots; and as the long-resounding gale swept away, other woods, on the right, seemed to answer the 'loud lament'; then others, further still, softened it into a murmur, that died in silence.

Rosa's images became the staple landscape of gothic literature, as in Sheridan Le Fanu's story 'Mr Justice Harbottle': 'under a broad moonlight, he saw a black moor stretching lifelessly from right to left, with rotting trees, pointing fantastic branches in the air, standing here and there in groups, as if they held up their arms and twigs like fingers, in horrible glee at the Judge's coming'.

THE AESTHETE EARL OF SHAFTESBURY

Salvatorian landscapes excited the literary imagination. It is a commonplace of literary history that James Thomson's poem *Autumn* (1730) is Salvatorian. Smollett in 1766 imagined a picture that he wished Salvator Rosa had painted: 'amidst the darkness of a tempest, he would have illuminated the blasphemer with a flash of lightning by which he was destroyed: this would have thrown a dismal gleam upon his countenance, distorted by the horror of the situation, as well as by the effects of the fire, and rendered the whole scene dreadfully picturesque'. Two generations later, Hartley Coleridge (1796–1849) admired the Salvatorian style:

Such shaggy rocks, – such dark and ruinous caves, such spectre-eyed, ser-
pent-headed trees, wreathed and contorted into hideous mimicry of human
shape, as if by the struggles of human spirits incarcerated in their trunks, –
such horrid depths of shade, – such fearful visitations of strange light, – such
horrid likenesses

> Of all the misshaped half-human thoughts
> That solitary nature feeds

were surely never congregated in any local spot.

Later, during the early-twentieth-century nadir of the gothic imagination, Rosa's
reputation suffered an eclipse, and he was associated by the intelligentsia with the
facile sensationalism of mass culture. 'Salvator Rosa's romanticism is pretty cheap
and obvious,' Aldous Huxley wrote in 1949. 'He is a melodramatist who never pen-
etrates below the surface. If he were alive today, he would be . . . the indefatigible
author of one of the more bloodthirsty and adventurous comic strips.' Huxley saw
only the histrionics in Rosa, and never noticed the spirit.

The most influential literary imagination caught by Salvatorian images is that of
Anthony Ashley Cooper, third Earl of Shaftesbury. In 1688 he left on a European
tour and recorded his peregrinations in a diary. It opens with a detailed description
of the vistas surrounding the Piedmontese city of Turin with the Alps to the north-
west and the great plain of Lombardy to the north-east. He climbed churches to
view the panoramas from the top: a Milanese church roof offered another Alpine
horizon and from the dome of Florence cathedral he encompassed 'a Country of a
Vast extent with a Multitude of Buildings of all sorts Lying so Pleasantly to the Eye
& so amazing to my Consideration that I must esteem it as one of the finest sights I
ever had'. Naples provided the climax of his Italian explorations. About the cata-
combs and Vesuvius he was especially graphic. On approaching the volcano he felt
how macabre it must be for peasants to occupy lava houses which 'may put 'em in
mind of being Buried alive . . . & may yet serve them for their grave stones'. The
summit of the volcano filled him with horror. 'The terriblest of all was to see in the
Middle of this Bottom another Hill rising from it Exactly Round and prodigiously
steep within which was the Raging Mouth.' Some of his companions retreated in
fear at this sight, but he descended 'the mighty precipice' and stood awestruck. The

significance of the sight stayed with him always; indeed he returned to Naples in a desperate attempt to recover his health in 1711 and two years later, on his deathbed, arranged for Paolo de Matteis to paint him as a dying philosopher, lying on a divan with a calm but melancholy look, surrounded by busts, antiquities and drawings, the room dark except for a window through which one can see Vesuvius, his hand falling from a book as he recognises the spectre of death advancing on him.

Shaftesbury became the foremost English theoretician of aesthetics of his generation. He desired a broad readership and set himself this rule when planning his final work on aesthetics: 'Nothing in the text but what shall be easy, smooth and polite reading, without seeming difficulty, or hard study; so that the better and gentler rank of painters and artists, the ladies, beaux, courtly gentlemen, and more refined sort of country and town wits, and notable talkers may comprehend, or be persuaded they comprehend, what is there written in the text.' Shaftesbury enjoyed the way that images from one art enriched those of another and watched their associations combining to form a greater aesthetic. He preached that the arts civilise societies, believed that a good society would produce good art and devised an ethical system which had a paramount influence on attitudes to art, beauty and nature in the early eighteenth century. He proposed beauty of form as complementary to moral virtues; hence, the finer a man's artistic taste, the higher his ethical superiority. For Shaftesbury the aristocracy were the elect; the aristocrat who aspired to ideal good must acquire sensitive appreciation and discrimination in all matters of taste. His opinion can be summarised in a phrase of Ann Radcliffe's: 'Virtue and taste are nearly the same, for virtue is little more than active taste.' Like many of his generation Shaftesbury regarded with dismay the sectarian fanaticism that had brought his country to civil war in the seventeenth century, and inveighed against 'Enthusiasm' as a corrosive, ugly sentiment leading to intolerant miseries. He thought that ill humour caused atheism, and that good humour was not only the foundation of piety but a bulwark against Enthusiasm. Shaftesbury would seem a self-indulgent, timid philosopher, rejoicing too visibly in the large, smooth, unctuous movements of his own mind, if his benevolence had been essentially political; but religious feelings and visual sensibility were equally integrated in his system.

Shaftesbury's favourite seventeenth-century painter was Nicolas Poussin, who was exempted from Shaftesbury's mistrust of Frenchmen by having

fled to Rome with detestation of his country, which made him and Salvator Rosa (as I have been assured by the old virtuosos and painters there) so good friends: the latter being a malcontent Neapolitan dissatisfied with his countrymen as his satires show. Both these by the way were honest moral men, the latter over-soured and mortal enemy of the priests.

Shaftesbury bought two pictures by Salvator Rosa from the estate of Lorenzo Onofrio, Grand Constable of Naples. He gave a long analysis of one of them, describing how its landscape came to be dominated, after false starts of drafting, by a 'rock in the most stupendous manner . . . majestic, terribly impending, vast, enormous as it should be.' Rosa's 'natural ambition', to quote Shaftesbury, was 'to adorn' his pictures 'with those wild savage figures of banditti, wandering gypsies, strollers, vagabonds, etc., at which he was so excellent'. Shaftesbury's disjointed but influential philosophical treatise *Characteristicks of Men, Manners, Opinions, Times* (1711) was ostensibly the quintessence of reason, moderation and calm sense; yet it has passages with both the excitement of Burnet and Salvatorian menace. 'See! with what trembling Steps poor Mankind tread the narrow Brink of the deep Precipices!' he exclaimed of the Alps (which here were emblematic of human anxieties). 'From whence with giddy Horror they look down, mistrusting even the Ground which bears 'em; whilst they hear the hollow Sound of Torrents underneath, and see the Ruin of the impending Rock; with falling Trees which hang with their Roots upwards, and seem to draw more Ruin after 'em.' He stressed how 'the wasted Mountains shew them the World itself only as a noble Ruin, and make them think of its approaching Period'. He believed that as the world was only the flawed ruins of the Garden of Eden, the beauties of nature should be chequered with irregularities and deformities. His philosophy was deistic and thus heretical: he believed that the deity is revealed through natural phenomena, and that human reason can therefore form an adequate notion of God. The God revealed by Nature was wild, ardent and punitive. Shaftesbury acknowledged

the Passion growing in me for Things of a *natural* kind, where neither *Art* nor the *Conceit* or *Caprice* of Man has spoil'd the *genuine Order*, by breaking in upon that *primitive State*. Even the rude *Rocks*, the mossy *Caverns*, the irregular unwrought *Grotto's* and broken *Falls* of waters, with all the horrid Graces of the *Wilderness* itself, as representing Nature more, will be the more

engaging, and appear with a magnificence beyond the formal Mockery of princely Gardens.

COLLECTORS AND GRAND TOURISTS

Shaftesbury's decision to collect art was not unusual in his time. In the seventeenth century art-collecting became virtually obligatory for European men of high position. Indeed, a new *genre* of painting, the 'gallery picture', celebrating individual collectors standing among their collections, was inaugurated at this time. Monarchs like Christian IV of Denmark (ruled 1588–1648), Philip IV of Spain (ruled 1621–65) and Charles I of England (ruled 1625–49) and their powerful citizens spent fortunes collecting artefacts. Cardinal Mazarin shortly before his death was seen shuffling in a fur-lined dressing-gown through his gallery, gazing in turn at his Correggios and Titians. 'He stopped at every step, for he was very weak, and turned first to one side, then the other, and casting a glance on the object that caught his eye, he said from the depth of his heart, "All this must be left behind [*Il faut quitter tout cela*] . . . What trouble I suffered to acquire these things! I will never see them again where I am going . . . Farewell dear pictures that I loved so well and which have cost me so much".' In England, Thomas Howard, fourteenth Earl of Arundel (among others), amassed a notable collection of pictures in the seventeenth century. An international traffic in valuable, beautiful or venerable objects developed. John Evelyn was taken by Lord Mulgrave to the sale of the Earl of Melfort's collection of Italian pictures at the Banqueting House in Whitehall in 1688: 'Divers more of the greate Lords &c were there who bought pictures, deare enough: There were some very excellent Paintings of V: Dikes, Rubens, Bassan.' Collections were neglected, dispersed, lost or re-formed. A visitor to Lord Pomfret's house, Easton Neston, in 1736, found an 'old greenhouse' containing remnants of Arundel's collection, including 'a wonderful fine statue of Tully, haranguing a numerous assembly of decayed emperors, vestal virgins with new noses, Colossuses, Venuses, headless carcasses, and carcassless heads, pieces of tombs and hieroglyphics'. The prime minister, Sir Robert Walpole, spent over £100,000 collecting pictures, including four by Salvator Rosa, two by Claude and five by Gaspard Poussin. The potential economic benefits of these transactions were trumpeted in the art world. 'This country is many thousand of pounds the richer for Vandyke's hand, whose works are as current money as gold in most parts of Europe,' wrote Jonathan Richardson in *An Essay on the Theory*

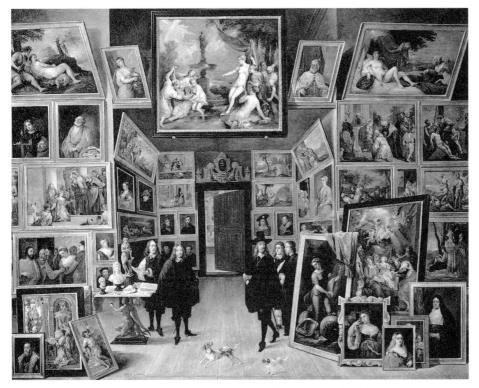

A gallery picture of a seventeenth-century collector displaying his possessions:
Archduke Leopold William, the Hapsburg governor of the Netherlands, with the Count of
Fuensaldana, painted by David Teniers.

of Painting (1715). In *The Science of a Connoisseur* (1719) Richardson anticipated tourism:

> We know the advantages that Italy receives from her possession of so many
> fine pictures, statues and other curious works of art: If our country becomes
> famous in that way, as her riches will enable her to be, if our nobility and
> gentry are lovers and connoisseurs, we shall share with Italy in the profits
> arising from the concourse of foreigners for the pleasure and improvement
> that is to be had from the seeing and considering such rarities.

This process was accelerated and enriched in the aftermath of the Treaty of Ryswick
(1697), terminating the war that had been waged since 1689 between France on one
side and a grand alliance of the Holy Roman Empire, England, Spain and Holland. In
the temporary conditions of European peace, the grand tour became part of an

English gentleman's preparation for life. Some went abroad seeking only sensual pleasures, and drank or copulated until they dropped. A few fell in with gamblers, and were ruined at cards; some youths met musicians, and pretended to compose; still more conscientiously studied the manners, politics or economies of the foreign countries they visited, and returned home to become prim, wearisome parliamentarians. A good number spent their time preoccupied with their health. 'Lady Spenser is returning worse than she came out; Lady Charlemont has not enjoyed one day's health since she arrived at Rome; Lord Leitrim all but died at Florence; & both Sir Charles and I myself have had billious attacks,' Lady Morgan reported from Naples, where she found 'dull, dreary Dandies that yawn one's path at every step, who affect to be *blasé sur tout* before they have either felt or observed'.

Grand tourists grew insular or vindictive, and devoted their energies to the false friendships of holidaymakers. 'Lord Garlies leaves me for Rome,' the Duke of Buckingham and Chandos noted in his Naples diary. 'The society there is wholly English, and of course made up of very different and contending elements, all counteracting and jealous of each other – all intriguing, caballing, whispering and tale-telling among themselves – all endeavouring to lay hold of any unfortunate Englishman who may come there, and drag him within the vortex.' Other intelligent and enquiring travellers became captivated by the foreign treasures which they found. These virtuosi were the new emblem of British cultivation: gentlemen connoisseurs, with a taste for fine arts and antiquities, whose collections of paintings, statuary and medals were formed with an attempt at aesthetic values. Of course, their taste was erratic: some collectors were pretentious, gullible or mediocre; but others enriched their houses in a style which enriched the national culture too. Pictures, prints and drawings, as well as sculptures, manuscripts and books, were collected by the new tourists and sent back to England. This influx of foreign art familiarised people with sights and views they would never see, and excited the anticipation of intending travellers. Italian landscape art was a provocative novelty: English visitors to Italy returned with a taste for views.

Charles Talbot, Duke of Shrewsbury (1660–1717), was one of the earliest to set forth with the intention of making a special study of the arts. Repeatedly during the 1690s he sought permission from King William III to resign his high responsibilities, and was finally permitted to go abroad in 1700. For three and a half years, from 1701 until 1705, he was based in Rome. He studied the buildings and spectacles around

him and developed a taste for the picturesque. Visiting, for example, an artificial lake, he recorded, 'standing at the edge of Piazza Navona we saw all the coaches go the round, some in the shape of boats, other coaches standing on the brink as spectators . . . this is a fine sight, it would make a good effect in a picture.' Shrewsbury collected Italian art for his English houses – 'I bought 3 pictures of Sal. Rosa and some of Luca Giordan [and] a landskip of Poussin' – and for such connoisseurs as Lord Somers and Lord Halifax, who was, so he told Shrewsbury, 'very glad to hear you are becoming such a virtuosi'. In Rome, Shrewsbury employed an 'Architect Master' to teach him about the monuments and palaces, and to guide him about the villages of Campagna. He was older than most English visitors, and took his studies more seriously than Captain Richard Howe (afterwards Admiral Earl Howe) and a friend called Damer at the Uffizi: 'two true-born Englishmen were in the great gallery at Florence; they submitted quietly to be shewn a few of the pictures. But seeing the gallery so immensely long, their impatience burst forth, and they tried, for a bet who should hop first to the end of it.' (The Uffizi Gallery by 1819 was a 'noisy English lounge, filled with the *desoeuvres* of a Brighton circulating library'.)

Shrewsbury was also taught the Italian language by a Florentine. He studied and analysed the views carefully, and after returning to England, remodelled his house at Heythrop in Oxfordshire on the Villa Borghese and the grounds partly on those of the Villa Aldobrandini at Frascati. Building began around 1706; some of the designs for his baroque palace were by Thomas Archer, who was then the only English architect to have studied in Italy. Shrewsbury's example was widely imitated: by 1718 it was unexceptional that a minor Northumberland baronet, Sir Carnaby Haggerston, planned his visit to Italy so as to discuss with local architects the improvement of his house and grounds. The broken magnificence which was to become integral to the gothic imagination fascinated the English in Italy. The morbidness in their approach was exemplified by two young gentlemen called Blathwayt, whose grand tour in 1707 took them to Rome, where they were 'assiduous . . . in visiting . . . the remains of the superb Monuments of the Grandeur and of the Magnificence of the Ancient Romans'. The Catacombs held a horrible fascination for the English brothers:

that is not very surprising for young Men who had heard it said, that a Company of four German Gentlemen were lost there for some time,

previously, with their Guide: who would not have appeared again, had it not been that Trumpeters and Drummers were led there several times; to see if the sound of these instruments of war would enable them to find the right way again to get out, but all that had been done in vain.

Dark and gloomy caves, subterranean labyrinths, the despair of incarceration – all these are staples of the gothic imagination.

THE SCIENCE OF THE CONNOISSEUR

The Englishmen journeying to Italy, and the landscape art they brought back, enlarged the imagination. 'Would to God,' exclaimed the painter Jonathan Richardson in his *Essay on the Art of Criticism* (1719), 'I had seen, or could yet see Italy.' Bishop Berkeley similarly recommended travel to Alexander Pope as a way for any poet

> to store his mind with strong images of nature. Green fields and groves, flowery meadows, and purling streams, are no where in such perfection as in England; but if you would know lightsome days, warm suns and blue skies, you must come to Italy; and to enable a man to describe rocks and precipices, it is absolutely necessary that he pass the Alps.

Imaginative men began to conceive designs of buildings and parkland that emulated pictorial art. Sir John Vanbrugh, writing in 1709 about the parkland seen from the north front of Blenheim Palace ('has Little Variety of Objects . . . It therefore Stands in Need of all the helps that can be givenn'), advised, 'were the inclosure fill'd with Trees (principally Firrs, Yews and Hollys) Promiscuously Set to grow up in a Wild Thicket so that all the Buildings . . . might Appear in Two Risings amongst 'em, it wou'd make One of the Most agreable Objects that the Best of Landskip Painters can invent'. The taste for the pictorial that cultivated Englishmen brought back from Italy had its opponents. Lewis Theobald, the poet and dramatist whose stupidity provoked Pope to write *The Dunciad*, complained in 1717 that artworks were 'but poor Bunglings and imperfect Representations of Nature; but the Pride is that they were made by his *Fellow-Creature Man*. How often shall we see a rational Soul hung as it were by the Eyes, and fox'd with Admiration, upon a *fine Piece of Painting*?'

Such ignorance exasperated Jonathan Richardson. 'The great and chief ends of

painting are to raise and improve nature; and to communicate ideas,' he declared in his *An Argument in Behalf of the Science of a Connoisseur*. He preferred 'pleasing ideas . . . pleasing, whether by their novelty or variety, or by consideration of our own ease and safety, when we see what is terrible in themselves, as storms and tempests, battles, murders, robberies'. For Richardson, the new aesthetic was a manifestation of 'a natural tendency to reform our manners, refine our pleasures, and increase our wealth, power and reputation'. Painting was first among the arts: 'history begins, poetry raises higher, not only embellishing the story, but by additions purely poetical: Sculpture goes yet farther, and painting compleats and perfects, and . . . is the utmost limit of human power in the communication of ideas'. Human imagination, for his generation, was a faculty to be trained and cultivated; it enlarged and strengthened intelligent people, though it might scare or humiliate the stupid. Richardson was neither the greatest promoter of the new aesthetic nor its most effective populariser. This role was taken by an altogether quirkier and greater man, Alexander Pope.

The symbolic power of Naples endured into the twentieth century. Curzio Malaparte's superb account of soldiers stationed there at the end of the Second World War presents the city as the 'very spirit of Europe – that *other*, secret Europe of which Naples is the mysterious image, the naked ghost'. Watching a gaggle of ragged, hungry boys seated on a parapet, with Vesuvius looming in the distance, the Italian narrator talks with his American friend about the inscrutable, impersonal, uncanny powers that underlie human suffering:

> That cruel, inhuman scene, so insensible to the hunger and despair of men, was made purer and less real by the singing of the boys.
>
> 'There is no kindliness,' said Jack, 'no compassion in this marvellous Nature.'
>
> 'It is malignant,' I said. 'It hates us, it is our enemy. It hates men.'
>
> 'Elle aime nous voir souffrir,' said Jack in a low voice.
>
> 'It stares at us with cold eyes, full of frozen hatred and contempt.'
>
> 'Before it,' said Jack, 'I feel guilty, ashamed, miserable. It is not Christian. It hates men because they suffer.'
>
> 'It is jealous of men's sufferings,' I said.
>
> I liked Jack because he alone, among all my American friends, felt guilty,

ashamed and miserable before the cruel, inhuman beauty of that sky, that sea, those islands far away on the horizon. He alone realized that this Nature is not Christian, that it lies outside the frontiers of Christianity, and that this scene was not the face of Christ, but the image of a world without God, in which men are left alone to suffer without hope.

Naples in the last half of the twentieth century still delivered its insistent message.

Stark mad with gardens

There is no excellent *Beauty,*
that hath not some Strangeness in the Proportion.
Francis Bacon

Nature, then, in the sense in which it is imitated, must signify
not the conclusive, mean appearance of natural phenomena,
but rather what we might wish there to be, or – identifying
human desire with the will of the Creator – the otherwise
unfulfilled intentions of God. This means that art must imitate
the *ideal* world and not the *real.*
Sir Joshua Reynolds

When nature looks natural, that is the end . . .
It is the beginning of something else.
Pier Paolo Pasolini

ALEXANDER POPE

Around 1705 visitors to the London rooms of the dramatist William Wycherley began to meet a 'little Aesopic sort of animal in his own cropt hair, and dress agreeable to the Forest he came from'. They supposed he was the son of some tenant of Wycherley seeking continuance in his lease on the death of his rustic parent. Instead they were surprised to discover that he was a fledgling poet called Alexander Pope (1688–1744). Pope later came to personify Augustan culture, and though his poetry was resolutely ungothic, he was destined to become as great an imaginative source for the British gothic revival as Salvator Rosa.

Pope's adored father was a prosperous London linen draper. As a Roman Catholic, the father was prohibited from owning land near London and settled his family on a small, pleasant estate at Binfield in Berkshire, where he enjoyed tree-

planting to improve the views. As a youth, Alexander Pope explored the hidden glades and mazy paths of the nearby royal forest of Windsor and evoked the pleasures of the place in his poem 'Windsor Forest', which he described in 1712 as 'a painted scene of woods and forests in verdure and beauty, trees springing, fields flowering, Nature laughing'. His boyhood amid forest scenery imbued Pope with a specially arboreal imagination: 'A tree is a nobler object than a prince in his coronation robes,' he said. When he was twelve his health was wrecked and his body deformed by spinal tuberculosis. For the rest of his life he endured atrocious suffering made more bitter by his enemies who depicted him as an ugly, dwarfish hunchback. 'His poor, crazy, deformed body was a mere Pandora's Box, containing all the physical ills that ever afflicted humanity,' wrote Lord Chesterfield. 'This, perhaps, whetted the edge of his satire, and may in some degree excuse it.' In time he became so weak that he needed help dressing and undressing. He showed precocious poetic gifts by the age of sixteen, and was taken up by Wycherley, who introduced him to London life. His *Essay on Criticism* (1711) commended him to Addison's literary set; 'Windsor Forest' (1713), with its Tory sentiments, won the admiration of Swift; and the frivolity of *The Rape of the Lock* (1712–14) made him a darling of high society. He translated Homer's *Iliad*, and then the *Odyssey*, before writing his coruscating satire on dullness, *The Dunciad* (1728), and squibs which wounded his enemies and estranged his friends. Other poems expressed his passionate ethical beliefs: two epistles to his landscaping friends Lord Bathurst and Lord Burlington in the early 1730s explore the proper use of riches, extol the virtues of pastoral life and discuss political virtue and virtuosi sensibility in terms derived from Shaftesbury. His *Epistle to Dr Arbuthnot* (1735) achieved powerful rhetorical effects.

Pope was a child of strange erudition certain to grow into a man of superb intelligence. He was most active in the mind and senses: his ideal existence would have been that of a disembodied intelligence. 'I feel no thing alive but my heart and my head,' he declared in 1712, and a year later described 'lying in wait for my own imagination this week and more, and watching what thoughts of mine came up in the whirl of fancy that were worth communicating'. Such reverence for imaginative inspiration was an Augustan novelty. Imagination had been dismissed by Shakespeare as characterising the 'seething brains' of 'lovers and madmen'. Dryden's literary generation had mistrusted inspiration, and sympathised with Hobbes's dismissal of imagination as the imperfectly recalled memory of receding

images: 'the Greeks call it *Fancy* . . . Imagination therefore is nothing else but decaying sense.' But Pope was almost proud that external realities became muddled and shrunken in his mind. 'My Days & Nights are so much alike, so equally insensible of any Moving Power but Fancy, that I have sometimes spoke of things in our family as Truth and real accidents, which I only Dreamt of; & again when some things that actually happen'd came into my head, have thought (till I enquired) that I had only dream'd of them.' For Pope and many contemporaries the function of imagination was to descry the tendency towards universal perfection in nature. Nature and art were akin in this impulse to perfection. As the *Spectator* observed in 1712, 'there are as many kinds of gardening as of poetry: your makers of pictures and flower-gardens, are epigrammatists and sonneteers in their art; contrivers of bowers and grottos, treillages and cascades, are romance writers.'

Poets and dramatists after the Restoration in 1660 were fortunate far beyond those of Shakespeare's day in their relaxed relations with noblemen. Pope, the Roman Catholic tradesman's son whose romantic curiosity led him to cultivate the aristocracy not only as patrons but as friends, was the apotheosis of the poet as social climber. His amities strengthened and extended his aesthetic influence over the peerage. 'Pope in conversation was below himself; he was seldom easy and natural, and seemed afraid that the man should degrade the poet, which made him always attempt wit and humour, often unsuccessfully, and too often unseasonably,' wrote Lord Chesterfield. 'I have been with him a week at a time at his house in Twickenham, where I necessarily saw his mind in its undress, when he was both an agreeable and an instructive companion.' The stupidity of other people, and the mean and graceless courses in which they chose to live, disgusted Pope. Indeed he found their attention, with its emotional demands, amounted almost to persecution. His vivacity diminished with age. 'I have not half the taste I once had of any thing pleasing in this world,' he wrote in 1720. 'I find few left that are worth loving.' Visual beauty, however, was less disappointing.

THE POET IN THE GARDEN

Pope settled at Twickenham in 1719, where he pursued 'very innocent pleasures, building, planting and gardening'. Twickenham, lying on the Thames just west of London, fulfilled many of the desiderata of dedicated gardeners. 'The true region of gardens in England', wrote Sir William Temple, who in 1666 had settled at nearby

Sheen in Surrey, was 'the compass of ten miles about London; where the accidental warmth of air, from the fires and steams of so vast a town, makes fruits, as well as corn, a great deal forwarder than in Hampshire or Wiltshire, though more southward by a full degree'. During the sixteenth century the certainties of English gardening fashions had gradually been challenged. At a time when many Englishmen still believed that the perfection of the Garden of Eden had been exemplified by the unflawed symmetry of its square, oblong and oval shapes, Milton imagined how the brooks in the Garden of Eden ran

> With mazy error under pendent shades
> . . . visiting each plant, and fed
> Flow'rs worthy of Paradise, which not nice art
> In beds and curious Knots, but Nature boon
> Poured forth profuse on hill and dale and plain.

Sir Henry Wotton (1568–1639) recommended 'a certain contrariety between *building* and *gardening*: For as Fabricks should be *regular*, so *Gardens* should be *irregular*, or at least cast into a very wild *Regularity*' so as to achieve the beauty of 'delightfull confusion'. Similarly, Temple, after praising the garden at Moor Park as 'the sweetest place . . . that I had ever seen in my life' because of the 'proportions, symmetries and uniformities' of its planting, conceded that irregular gardens might 'have more beauty than any of the others; but they must owe it to some extraordinary dispositions of nature in the seat, or some great race of fancy or judgment in the contrivance'.

In England the formal lines of Italian Renaissance gardens or Tudor knot gardens were superseded from the 1660s by the French pattern of wide alleys, mathematical symmetry, formal sheets of water and parterres (magnificently exemplified by Versailles). Lord Pembroke's gardens at Wilton were described in the late seventeenth century by Celia Fiennes: 'very fine, with many gravel walkes with grass squaires set with fine brass and stone statues, with fish ponds and basons with figures in the middle spouting out water, dwarfe trees of all sorts and a fine flower garden, much wall fruite'. When Defoe visited Chatsworth, which was rebuilt from 1687 by the first Duke of Devonshire, he saw nothing wondrous about the new house and gardens except their situation in a 'houling wilderness'; it was impressive to see the high, exposed site in Derbyshire domesticated to assert the mastery of human order over natural chaos. But by the early eighteenth century Nature pre-

sented less of a danger over which men asserted their superiority; beauty was recognised more in the wild fields of nature than in the precise, stately embellishments of geometrical garden design with topiaries and formal water-gardens. 'Our forefathers looked upon nature with more reverence and horror, before the world was enlightened by learning and philosophy,' Addison observed. As W. H. Auden later concluded, 'during the early part of the eighteenth century in England, the relation between Man and Nature seems to have been happier than ever before or since. Wild Nature had been tamed, but machines had not yet debased and enslaved her.'

Among professional gardeners, Pope's friend Charles Bridgeman (together with Vanbrugh) took the 'leading step', in Horace Walpole's phrase, towards deformalising garden design. Bridgeman introduced the French sunken fence, or ditch, which came to be known in England as the ha-ha. This device kept cattle and sheep from adjoining fields out of parkland without the visual disjunction of walls; the garden was thus freed from prim regularity to merge with the wilder surrounding countryside. It was not only walls that became obsolete, or unfashionable, as a result of the ha-ha. 'Hedges', thought the gardening-poet Shenstone, 'are universally bad. They discover art in nature's province.' Pope's preference in landscape was not romantic wilderness but the picturesque. Indeed, he is credited with introducing this word, meaning the pictorially pleasing or graphic vividness, from the French language. To Joseph Spence around 1728 he defined 'that idea of "picturesque" – from the swan just gilded with the sun amidst the shade of a tree over the water on the Thames'. Six years later he was standing with Spence looking through the frame of a Roman triumphal arch into a formal botanical garden in Oxford when he said: 'All gardening is landscape-painting. Just like a landscape hung up.' It was as a result of this remark that Shenstone coined the word 'landscape-gardening'. Pope once called himself 'stark mad with gardens'. Out of this madness he refined English concepts of the picturesque: the sham medievalism of some ornaments of the new landscaped gardens soon inspired the revival of gothic styles for domestic architecture.

In his Twickenham garden Pope installed a shell temple, a vineyard, an obelisk commemorating his mother, a bowling-green and an orangery, together with numerous urns and statues. 'My Building rises high enough to attract the eye and curiosity of the Passenger from the River, where, upon beholding a Mixture of Beauty and Ruin, he enquires what House is falling, or what Church is rising,' he

reported in 1720. The garden was separated from his house by the road from Hampton Court to London; he fashioned the connecting subterranean passage as a grotto, which was much admired. After the original grotto collapsed, he rebuilt his tunnel in the 1740s 'with all the varieties of Natures works under the ground – Spars Minerals & Marbles', so he told Bolingbroke: 'this Musaeum . . . is now a Study for Virtuosi, & a Scene for Contemplation.' Sir Hans Sloane in 1742 gave two pieces of the Giant's Causeway; the Duchess of Cleveland and Lords Edgcumbe and Orrery donated marbles from quarries on their estates; Lord Godolphin sent Cornish diamonds from his copper-works; Dr Oliver, inventor of perhaps the finest biscuit ever baked (the Bath Oliver), sawed off stalactites from Wookey Hole to ornament the grotto. Pope was as proud of his shell temple as of his grotto:

> From the River *Thames*, you see thro' my Arch up a Walk of the Wilderness to a kind of open Temple, wholly compos'd of Shells in the Rustic Manner; and from that Distance under the Temple you look down through a sloping Arcade of Trees, and see the Sails on the River passing suddenly and vanishing, as thro' a Perspective Glass.

Pope believed, like Shaftesbury, in the unity of the arts and in the perfectibility of artistic taste. Though supremely a writer, he studied art as a pupil of the fashionable portrait-painter Charles Jervas and his imagination was enormously enriched by paintings. In his 'Epistle to Mr Jervas', written about 1715, Pope celebrated how 'images reflect from art to art'. Indeed, his literary imagination incorporated pictorial images drawn from paintings, landscape gardening, theatrical scenery and architecture. He described his early pastoral eclogues as 'each of them a design'd scene or prospect . . . presented to our view' and also likened them to the painted stage scenery of theatres. 'Nothing can do it but a Picture', he began a description of the view over the river at Clifton, which he visited in 1739: 'the Sea nor the Severn you do not see, the Rocks & the River fill the Eye, and terminate the View, much like the broken Scenes behind one another in a Playhouse'. Pope's emphasis on the congruence of poetry and painting, and more particularly of pastoral poets and landscape artists, became a commonplace of this period. Uvedale Price attributes to Vanbrugh the advice, when consulted about designing the grounds at Blenheim, 'You must send for a landscape painter.' Pope's friend Walter Harte (1709–74) in his 'Essay on Painting' began:

> Whatever yet in *Poetry* held true,
>
> If truly weigh'd, holds just in *Painting* too.

Hildebrand Jacob (1693–1739), a clever poetic amateur, similarly advised, 'The nearer the *Poet* approaches to the *Painter*, the more perfect he is; and the more perfect the *Painter*, the more he imitates the *Poet*.'

These aesthetics were not apolitical. 'The Gardens are so Irregular,' Pope enthused while visiting Lord Digby at Sherborne. 'Their beauty rises from this Irregularity, for not only the Several parts of the Garden itself make the better Contraste by these sudden Rises, Falls, and Turns of ground; but the Views about it are lett in, & hang over the Walls, in very different figures and aspects.' Pope's tour through the groves, parterres and river valley culminated at the highest of the terraces:

> On the left, full behind these old Trees, which make this whole Part inexpressibly awful & solemn, runs a little, old, low wall, beside a Trench, coverd with Elder trees & Ivyes; which being crost by another bridge, brings you to the Ruins, to compleat the Solemnity of the Scene. You first see an old Tower penetrated by a large Arch, and others above it thro which the whole Country appears in prospect.

The beauty of these ruins was enhanced for Pope by the thought that they were the remnants of Sherborne Castle, which had been demolished in the English civil war of the 1640s, when the royalist Digby of the day had been besieged by parliamentarians and driven into exile. 'I would sett up at the Entrance of 'em an Obelisk, with an inscription of the Fact: which would be a Monument erected to the very Ruins.' Pope felt that Sherborne's continuity in the Digby family sanctified the principles of romantic Toryism, which were the antithesis of Robert Walpole's corrupt regime of placemen and jobbery. 'I cannot make the reflection I've often done upon contemplating the beautiful Villa's of other Noblemen, rais'd upon the Spoils of plundered nations, or aggrandiz'd by the wealth of the Publick.' Buildings and landscaping, as we shall see in the next chapter, always had a political symbolism, even when their owners protested only aesthetic interests.

The Staginess of Melancholy

Stage scenery was another form of painting that stimulated Pope's imagination. Until the early eighteenth century, English scenic painting for the stage was undertaken by men of talent such as Inigo Jones. It was highly symmetrical, with an emphasis on perspective. The audience's attention was funnelled to the rear of centre-stage: in an urban scene, for example, the backcloth might picture two sides of a straight street diminishing into the distance with a shrunken eye-catching object like a church-spire at the end of the street; for a rural scene, the painted scenery might feature distant hills or mountains, small on the horizon, again suggesting

A stage design by Inigo Jones. The uses of perspective in seventeenth-century theatrical backdrops inspired some of the effects in eighteenth-century landscape gardening; yet it was still a wild leap from the carefully staged tableaux of the picturesque to the histrionic excesses of gothic literature.

long perspectives. Cave openings, or the suggestion of subterranean depths, were another device. These mock-heroic landscapes, with their baroque thunderclouds smouldering behind canvas crags, were crucial in forming the gothic imagination. Pope's interest in theatrical scenery influenced his principles of gardening. The abandonment of strict symmetry in stage backcloths recalled his pleasure in the irregular gardens at Sherborne. 'You may distance things by darkening them and by narrowing the plantation more and more towards the end, in the same manner as they do in painting,' he told Spence. Similarly, his contemporary Philip Southcote said, 'There shd. be Leading Trees or Clumps of Trees to help the eye to any more distant Clump, Building or View.'

Nature might be offered in the eighteenth century as the great analogy of Creation, providing a model for human action, but clumps of trees do not feel sad: even lonely crags, under thunderclouds, never feel miserable. Yet the eighteenth century was the Age of Melancholy. Addison, for example, dwelt on the pleasures of 'gloominess and melancholy', and the 'pleasing kind of horror' of demons and ghosts evoking 'those secret terrors and apprehensions to which the mind of man is naturally subject'. He thought it arrogant of 'men of cold fancies, and philosophic dispositions, [to] object to this kind of poetry'. Melancholy was a demon by whom some Augustans desired to be haunted and others feared to be overwhelmed. It was the preoccupation of so-called graveyard poets, including Pope's friend Thomas Parnell (1679–1718), who wrote 'A Night-Piece on Death', and Robert Blair (1699–1746), author of *The Grave*. Typically, Thomas Warton's *Pleasures of Melancholy*, written in 1745, attributed 'elegance of soul refin'd' to those who prefer 'Melancholy's scenes' – 'mould'ring caverns dark and damp', 'Gothic vaults' and 'ruin'd seats', those poetic places 'Where, with his brother Horror, Ruin sits' – to 'the dull pride/Of tasteless splendor'.

Gothic, as it revived in Britain, was partly a taste for the theatrically picturesque; but a sort of dramatised decay and a self-tormenting play with the fears and melancholies of the graveyard were also incorporated in it. Mountains, as the fragments of a ruined world, wrecked buildings and withered trees were all emblems of transience, scary impersonal forces and carefully cultivated melancholy. Pope had a taste for such things. One of his surviving drawings, which was used as the frontispiece to the 1745 edition of his *Essay on Man*, depicts a scene of broken buildings and derelict monuments, including the wrecked colonnades of an arena: a broken

pediment is inscribed '*Roma Aeterna*' (eternal Rome); the broken limbs of a statue of a great Caesar are scattered on the ground beneath a pillar inscribed '*Viro Immortali*' (immortal man). Melancholy in 'Eloisa to Abelard' is represented by dark, decaying buildings:

> These moss-grown domes with spiry turrets crown'd,
> Where awful arches make a noon-day night

or the 'mould'ring tow'r' around which 'ivy creeps'.

Pope's garden was much imitated, sometimes maladeptly, as by his neighbour, the 'Lord Radnor that plants trees to intercept his own prospect, that he may cut them down again to make an alteration', or by the grotto-maniac Lord Donegal, who by 1788 had '£10,000 of shells not yet unpacked'. Richard Graves in 1779 caricatured a Mr Nonsuch, who 'was not a little conceited' about his grounds:

> As the situation was in the village, they were necessarily confined within a wall of less than an acre in circumference: within this compass however they had contrived to introduce every individual article of modern taste. There was a large shrubbery, a small serpentine river, over which was thrown a Chinese bridge of a considerable diameter; there was a Chinese pagoda, a Gothic temple, a grotto, a root-house or hermitage, a Cynic tub or two by the water-side; at one corner of the garden was a summer-house with a gilded ball, which Mr. Nonsuch boasted to be seen twenty miles round, and at the opposite corner was a barn-end converted into a Gothic spire, which he would impose upon strangers for the parish church, though the real church-tower, which peeped over the wall, discovered the deception, and constantly gave him the lie.

More positively, Pope's example encouraged Philip Southcote, whose famous *ferme ornée* was surrounded by grazing land itself encircled by a belt of uncultivated land, partly wooded, with rivulets, grottos and other picturesque devices. Southcote's designs were judged a success because they did not flout the rules of nature.

PASTORAL IDYLLS

It is important to recognise that Pope's sense of the picturesque and his response to the new taste for irregularity in gardens was both pastoral and suburban. He knew

that city life was seldom dull – 'No people in town ever complained that they were forgotten by their friends in the country,' he told Swift in 1714 – but considered 'a true town life of hurry, confusion, noise, slander and dissension, . . . a sort of apprenticeship to hell'. His desire for the simple charms of a pretty countryside did not blind him to the muddied oafishness of country life, as shown by his depiction of Stanton Harcourt: dirty, damp, mouldering and draughty, its bedsteads like cider-presses, with pigeons nesting in the drawing-room, mustard-seeds in the parlour and rats feasting on 'the few remaining Books in the Library', this Oxfordshire country seat was a hilarious deterrent to country life. His preference was for pastoral surroundings within easy reach of urban amenities. He despised pretentious grandeur in architecture too. Blenheim Palace, recently designed for the first Duke of Marlborough by Vanbrugh, was a 'most expensive absurdity', he judged after a visit. 'I never saw so great a thing with so much littleness in it . . . it is the most inhospitable thing imaginable.' Its hereditary proprietors found Blenheim as boring and inconvenient as Pope. In the 1730s the third Duke of Marlborough was so keen to escape from Blenheim's cold impersonality that he bought a 'little island' on the Thames at Bray. 'He has a small house upon it, whose outside represents a farm, the inside what you please; for the parlour, which is the only room in it, except a kitchen, is painted upon the ceiling in grotesque, with monkeys, fishing, shooting &c. and its sides are hung with paper,' reported a visitor in 1733. 'Except six or eight walnut-trees, and a few orange trees in tubs, there is not a leaf upon the island.' There was one other building, called a temple but resembling a covered market. The duke 'cannot move upon the island without being seen by all the bargemen who pass; neither can he get out of the reach of their conversation, if they are disposed to talk'. At Bray the duke found a humane scale of life. Under Pope's influence, pastoralism has become an entrenched English taste.

Since King George III's reign it has been an affectation of the royal family that they represent British bourgeois values at their sturdiest. When that least middle-class of monarchs, George IV, determined to transform the Duke of Buckingham and Normandy's house into a London palace, the old 'mansion suitable only for the moderate requirements of a junior branch or a Queen Dowager had to be metamorphosed into a huge metropolitan palace for the reigning sovereign'. The king commanded John Nash to design a wide-fronted country house rather than the metropolitan palace so familiar in Paris, Vienna or Berlin. Buckingham Palace's eastern façade,

although now best known to the public, was originally its rear and moreover pre-
sented a backside of 'dingy meanness' until it was redesigned in 1913. The real front
of the palace overlooks not the public park of St James's to the east, but westwards
over the private pleasure gardens laid out by Capability Brown with spacious lawns,
winding paths and a serpentine lake with an island. Even in the 1830s Buckingham
Palace expressed an ideal that was, if not suburban, certainly pastoral.

The pastoral tastes of monarchs and noblemen were not the most important or
enduring sequel to Pope's picturesque garden at Twickenham. The *embourgeoisement*
of his ideas proved even more momentous: they constituted a part of the national
taste in which the gothic revival was only a component. In the century after Pope's
death Britain became the forerunner of European industrialisation: by 1870 the bru-
tal ugliness of manufacturing districts had incited new picturesque ideals. The
English ideal developed not into suburbs like Neasden, garden suburbs like
Hampstead, garden cities like Welwyn or overspill dormitories like Stevenage, but a
Hertfordshire town like Harpenden. Under thirty miles from Buckingham Palace,
Harpenden represented 'the country town of great delight, unspoilt by the
Industrial Age, with a touch of gold for ever on its gorse-clad common, lovely walks
through woods and fields, trees in its streets, and an air as sweet and pure as any
corner of the British Isles; its very name means Valley of the Nightingales, and it is
worthy of it,' wrote Arthur Mee. 'The finest area, in which to make a serious study
of the fashions in middle-class house building of the first three-quarters of the twen-
tieth century, is Harpenden,' according to another authority. 'Its houses range from
the markedly well built and quite attractive to rather terrible monstrosities.'
Elizabeth Bowen, who was educated in Edwardian Harpenden, devised a character
who was 'born in a house called Elmsfield near Chislehurst', then 'lived in another
house called Meadowcrest, outside Hemel Hempstead', next tried 'a house called
Fair Leigh outside Reigate', and finally settled at Holme Dene, near a commuting
town which may be Harpenden ('*here* no one did anything but keep home'). Holme
Dene is a large, gabled, half-timbered house dating from about 1900 with a pro-
fusion of French windows and balconies. 'On the fancy-shaped flower-beds under
the windows and round the sweep the eye instinctively sought begonias . . . A back-
drop of trees threw into relief a tennis pavilion, a pergola, a sundial, a rock garden,
a dovecote, some gnomes, a seesaw, a grouping of rusticated seats and a birdbath.'
This was one culmination of Pope's theory of the picturesque.

Pope's talents were enlisted by gardening noblemen, including Archibald Campbell, Earl of Islay and later third Duke of Argyll, and Lord Bathurst, with both of whom he collaborated in laying out a villa and grounds at Twickenham for the Prince of Wales's mistress (1724). Bathurst was an energetic, high-spirited and impetuous man who remained robust and pleasure-loving beyond the age of ninety. A friend of Congreve, Prior and Swift, he was Pope's financial adviser, co-publisher of *The Dunciad* and described by the poet in 1735 as 'almost my only Prop'. Bathurst was determined to surpass the radiating avenues of trees laid out at Badminton by his fellow Gloucestershire Tory, the Duke of Beaufort. Staying as Bathurst's guest in 1718, Pope gaily wrote, 'I write an hour or two every morning, then ride out a hunting upon the Downes, eat heartily, talk tender sentiments with Lord B or draw plans for Houses and Gardens, open Avenues, cut Glades, plant Firrs, contrive waterworks, all very fine and beautiful in our own imagination.' He became the self-styled 'Magician' of Bathurst's woods, which by the early 1720s were cut through with rides, serpentine walks and unexpected glades, like the Windsor Forest of his boyhood. 'The finest surviving example of plantation in the pre-landscape model,' according to Christopher Hussey in 1950, 'Cirencester Park is a forest on the Fontaiebleu and Compiègne model.'

Bathurst's other important collaboration with Pope was a sham castle. Though Vanbrugh designed a castellated folly at Castle Howard around 1719, the piece of garden architecture by Bathurst and Pope eventually known as Alfred's Hall was the progenitor of all the castellated follies that ornamented eighteenth-century park-lands. Pope's celebrity enhanced the significance of this building, which influenced other shams put up in Midlands counties, such as those designed in mid-century by Sanderson Miller at Edgehill for himself, at Hagley for Lord Lyttelton and at Earls Croome for Lord Coventry. Alfred's Hall, with its irregular castellated walls, stumpy round tower and historically inaccurate doorways and windows, seemed clumsy to Viscount Torrington in 1787, when rococo gothic was fashionable ('there is an intention of deceit by old dates; but why should the outside be dirty, and in filthy nastiness?'), yet 'very romantic in its secluded clearing' to James Lees-Milne in 1962. 'The ruin is draped with ivy and enclosed by a grove of appropriately melan-choly yews. Its round tower has one pointed window, which should not deceive the least discerning antiquary.'

Bathurst was not the only important gardener befriended by Pope. Charles

Bridgeman, who was appointed royal gardener in 1727, designed gardens for two prime ministers, the Duke of Newcastle at Claremont and Sir Robert Walpole at Houghton. Although Vanbrugh also laid out the gardens at Claremont, Castle Howard, Eastbury and elsewhere with lakes, woodlands and vistas in the manner of landscape-painting, and pioneered the substitution of the fence with the ha-ha, in the genealogy of ideas the less versatile Bridgeman now seems more important. This is because Pope cited Bridgeman's work for Lord Cobham at Stowe (1714–38) in a famous passage that encapsulated the new gardening principles:

> Let not each beauty ev'ry where be spy'd,
> Where half the skill is decently to hide.
> He gains all points, who pleasingly confounds,
> Surprizes, varies, and conceals the Bounds.
> Consult the Genius of the Place in all;
> That tells the Waters or to rise, or fall;
>
> . . .
>
> Calls in the country, catches op'ning glades,
> Joins willing woods, and varies shades from shades;
> Now breaks, or now directs, th'intending lines,
> Paints as you plant, and as you work, designs.

The recommendation in this passage of discreet and well-judged evasion ('half the skill is decently to hide') might incidentally apply to gothic authors. These lines come from Pope's 'Epistle to Richard Boyle, Earl of Burlington', and it was through his acquaintance with Burlington that he became a profound imaginative influence on William Kent, the painter, architect, designer, book illustrator and landscape artist who inaugurated the English gothic revival.

WILLIAM KENT AND LORD BURLINGTON

William Kent (1686–1748) was born at Bridlington in Yorkshire, for which reason Pope teasingly described him to Burlington (whose title was a corruption of Bridlington) as a 'wild Goth . . . from a country which has ever been held no part of Christendom'. His formal education was limited (as his incoherent letters testify), but he showed such early aptitude at drawing that several Yorkshire country

gentlemen paid for him to train in London. After a year, in 1709, his patrons sent him to Rome with instructions to buy antiquities and paintings on their behalf (and more mundane items such as soap, greyhounds and treacle), as well as to make copies of original paintings such as Correggio's *Leda*. These patrons were connoisseurs with a passion for classical antiquities whose hopes of Kent as a painter were encouraged when in 1713 he won a prize for young painters offered by Pope Clement XI. He travelled and studied extensively in Italy, and in 1717 painted the ceiling of the Flemish community's church in Rome.

In Italy in 1716 Kent met Burlington, a rich young nobleman who was a passionate proselytiser on behalf of Palladianism. Kent returned to London in 1719 with a commission to paint murals in the magnificent new Palladian mansion, Burlington House, built in Piccadilly on the model of Italian palace architecture with a spacious forecourt and colonnade. He was disenchanted by London's climate and aesthetic values: 'only twice a week I go to the Operas where I am highly entertain'd, and then think of myself out of this Gothick country', he wrote shortly after his return. Kent was frank rather than fawning with great men: he became Burlington's most intimate companion and was known in the earl's circle as the Signior or Kentino as a tease on his Yorkshire–Italianate ways. Their friendship has raised loose and inconclusive fancies: it was certainly not soulful or intense, still less crypto-erotic, but a bond based on conversations and aesthetic judgments, and especially on exchanging ideas about the pleasures of the senses and the mind. Burlington and Kent savoured intellect and imagination as enriching devices of self-cultivation. Both men had taken unexpected courses for their lives: Kent boldly had broken his apprenticeship to a Yorkshire coach-painter to study art; Burlington's devotion to architecture was so earnest that his fellow earl, Chesterfield, feared he had 'lessened himself' by learning 'the minute and mechanical parts' of architecture 'too well'. They were perfect foils for each other: Burlington austere, dutiful and methodical, the architectural theoretician; Kent superficial, lazy, charming, exuberant, responsive and practical.

Burlington, so George Vertue wrote in the early 1730s, 'had been so vastly generous to Mr. Kent in all kinds of favours or subsistence or recommendations every way that lay in his power it being Judg'd by some that Mr. Kent had *greater favours* than Meritt'. King George I commissioned Kent to decorate the new state apartments at Kensington Palace in 1722, partly because he offered to do it more cheaply than the

court painter and partly by Burlington's advocacy. Kent was recommended by Burlington to the Duke of Chandos and to Viscount Castlemaine (afterwards Earl Tylney) who employed him as a mural-painter at their palaces of Canons and Wanstead. Kent's other commissions include landscaping and estate buildings for Burlington's son-in-law, the Duke of Grafton, at Euston, a superb gatehouse and other work at Badminton for the Duke of Beaufort, monuments for the Duke of Marlborough at Blenheim, Devonshire House in Piccadilly (later demolished to make way for a motor-car showroom) and decorations at Chatsworth for the Duke of Devonshire, domestic buildings for Lord Pomfret at Easton Neston, work for Sir Robert Walpole at Houghton and 10 Downing Street. His most successful country-building was Holkham for Lord Leicester; his best town house for a cousin of Lady Burlington's at 44 Berkeley Square. Often he issued his architectural orders when full of claret, and had to countermand or amend them in sobriety. Kent's friendship with Burlington was enduring; he remained at Burlington House until his death in 1748.

His protean gifts were resented or mistrusted by specialists during and after his lifetime. It is true that his portrait-painting was clumsy, but he was a superbly versatile designer. He designed a triumphal arch erected at Westminster Hall for King George II's coronation in 1727, monuments to Shakespeare and Isaac Newton in Westminster Abbey, gowns and petticoats for society ladies, and a rustic hermitage (1731) and Merlin's Cave (1735) for Queen Caroline's grounds at Richmond. The latter was a roof-lit chamber planned like a circular Templar church supported on columns suggestive of trees; it contained a gothic showcase displaying wax figures, including Minerva, Merlin and a sorcerer's assistant. For Frederick, Prince of Wales, he designed a magnificent barge and elaborate uniforms of blue hose with black velvet caps for the bargemen. In 1731 Prince Frederick held a masquerade in which he dressed as a shepherd and was flanked by eighteen huntsmen in 'antico-moderno accoutrements', as Lord Hervey described: 'dressed after a drawing of Kent's, in green waistcoats, leopard-skins, and quivers at their backs, bows and arrows in their hands, tragedy buskins upon their legs, breeches trussed up like rope dancers, antique gloves with pikes up to their elbows, and caps and feathers upon their heads like a Harry the 8th by Holbein'. Royal masquerades were turned into another form of gothic expression by King Gustavus III of Sweden, the most aesthetically and intellectually original, and the most temperamentally attractive, of eighteenth-century monarchs.

LITERARY INSPIRATIONS FOR KENT'S IDEAS

'Kent,' wrote Burlington to Pope in 1724, 'is much your servant'; Pope described Kent to Burlington as 'the greatest man I know, ever knew, and shall know'. There is no doubt that Pope shaped Kent's appreciation of the picturesque. According to Philip Southcote in the 1750s, 'Mr Pope and Kent were the first that practiced painting in gardening. But Lord Petre carried it farther than either of them, for Kent had little more than the idea of mixing lighter and darker greens in a pleasing manner.' If Pope devised the fashion for practising painting in gardening, Kent was the first *professional* gardener to practise his ideas fully. Kent had an impressionable and receptive imagination which readily diverted other men's ideas to his own original uses. He had the talent that quickly assimilates what it hears and sees, and readily retails it in his own version. Like Pope, he found that images reflected from art to art. Thus he spent many years preparing thirty-two illustrations for an edition of Spenser which was eventually published in 1751. To Kent, the *Faerie Queene* was an

Many of the early gothic revivalists harked back to the imagined purity and romance of gothic chivalry, as in this illustration by William Kent for an edition of Spenser's Faerie Queene.

essentially romantic tableau of giants, monsters, magicians and castles, evoking the ideals of love and honour that Cervantes had mocked. Such romance was perhaps more enjoyable for Kent if strained (like Salvator Rosa) towards the burlesque. Reportedly Kent 'frequently declared he caught his taste in gardening from reading the picturesque descriptions of Spenser'. There are few descriptions of landscape in Spenser's cantos, but some appeal to the gothic taste:

> Low in a hollow cave,
> Farre underneath a craggy clift ypight
> Darke, dolefull, drearie, like a greedie grave,
> That still for carrion carcases doth crave,
> On top whereof aye dwelt the ghastly Owle,
> Shrieking his balefull note.

Kent's pseudo-medieval illustrations transformed Birch's 1751 edition of Spenser into a key gothic text. Some are architecturally suggestive. 'The House of Pride', illustrating the first book, fourth canto, first stanza, shows an exotic palace background that resembled some of Kent's more gothic rococo metropolitan buildings. His design for Book I, Canto vii, captioned 'Prince Arthur Slays the Giant Orgoglio and Releases the Redcross Knight', depicts an isolated, castellated, ruined tower in a forest glade before which fantastically armoured warriors are slaying a giant and a monster. His illustration for Book V, Canto ii, captioned 'Arthregal Fights the Sarazin Polente', is a romantic scene of a horse-backed joust on a castellated moat-bridge. In 'Britomart with her Nurse consulting Merlin', for Book III, Canto iii, Kent drew with verve and zest a set of horrifying gothic monsters. There are several Salvatorian references in these images. Kent's depiction of Timon of Athens and Merlin educating Prince Arthur suggests not only Rosa's identification with Timon of Athens, but also a contrast with his picture of Diogenes spurning an approach from Alexander the Great. The landscape, dead trees and human images of Kent's 'The Redcross Knight over ruled by Dispair but timely saved by Una' are intensely Salvatorian. The background of his 'Guyon Leaves the Palmer and crosses the Idle Lake with Phedria' shows Pope's sense of the picturesque, with an idealised landscape reminiscent of Stowe but so perilously crowded as to evoke the Nonsuch garden derided by Richard Graves.

Walpole denounced as 'execrable' Kent's illustrations with their 'awkward

knights, scrambling Unas, hills tumbling down themselves, no variety of prospect, and three or four perpetual spruce firs'. His antiquarian pedantry was offended by 'figures issuing from cottages not so high as their shoulders, castles in which the towers could not contain an infant, and knights who hold their spears as men do who are lifting a load sideways. The landscapes are the only tolerable parts, and yet the trees are seldom other than young beeches, to which Kent as a planter was accustomed.' Walpole did not recognise that the artificiality of these images, at which Kent worked with love and enthusiasm, was deliberate. Some are intended to evoke Salvatorian burlesque. As Michael Wilson has written, 'the costumes and backgrounds – especially the castles, which have about them the flat, cardboard-cut look of stage scenery – impart to the whole allegorical fantasy a further dimension of pantomime, and once again we are reminded of Kent's continuing interest in the theatre.' This interest, of course, he shared with Pope.

Trees were Pope's most momentous influence on Kent. Arboreal gothic had been pioneered by German church-builders for two centuries: pillars had been raised and roofs built to suggest the strength of German forests. Such images delighted Pope. 'I have sometimes had an idea of planting an old Gothic cathedral, or rather some old Roman temple, in trees,' he observed. 'Good large poplars, with their white stems, cleared of boughs to a proper height, would serve very well for the columns, and might form the different aisles . . . These would look very well near; and the dome rising all in a proper tuft in the middle, would look as well at a distance.' Pope's gothic forest theory led Kent to one of the great defining acts in the revival of gothic: the decision, when improving the grounds of Kensington Palace, to plant a dead tree. 'He had followed nature, and imitated her so happily, that he began to think all her works were proper for imitation,' according to Walpole. 'In Kensington-garden he planted dead trees, to give a greater air of truth to the scene – but he was soon laughed out of this excess.' Among later visitors to Kensington Gardens, Benjamin Disraeli averred that its 'rich glades' and 'sublime sylvan solitude' provided 'almost the only place that has realised his idea of the forests of Spenser', while Margaret Jourdain believed that Kent 'was attempting a scene after Salvator' when he planted the dead trees there. Kent painted few landscapes on canvas, and seldom mentioned landscape painting in his letters, but was an immensely receptive and impression-able magpie who found ideas in every sort of place. His garden designs were influ-enced by the memory of Italian gardens which he had visited when young and by

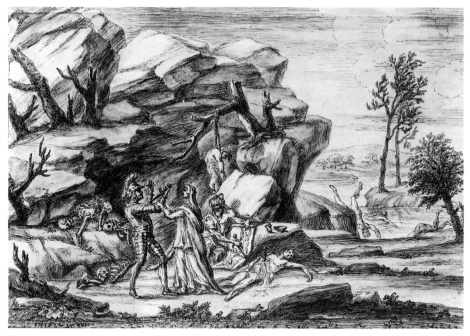

The withered trees, bleached bones and despondent suicide in another of Kent's illustrations for the Faerie Queene *display a more Salvatorian gothic of the macabre, sinister and uncanny.*

the landscape paintings of seventeenth-century artists like Claude Lorrain, Nicolas Poussin and Salvator Rosa. It is incontestable that Kent admired the latter's work. The engraving of Rosa's picture (possibly a romantic self-portrait) of a solitary bandit reading a book while lying in a high, lonely landscape, complete with blasted tree – which was published by Arthur Pond as a print in 1744 – is inscribed 'in the collection of William Kent'. As to Kent's innovation in Kensington, 'who but a student of painting', asked William Marshall in *A Review of Landscape* (1795), 'one who had been accustomed to seeing dead stumps sticking out of canvas, could have thought of planting dead trees in a living landscape?'

A NEW NATIONAL TASTE

'Mr. Kent was the sole beginner of the national taste,' wrote Spence in 1757: 'At Kensington Gardens (below Bayswater) and Chiswick.' This taste was never exclusively gothic, and many tendencies in the new landscape gardening ran contrary to

goth principles; but the progress from picturesque gardens via sham medieval land-scape ornaments to gothic revival houses was close and continuous. Kent disposed of the sumptuousness of Versailles (represented in England by Boughton as improved by the Duke of Montagu, who had been Ambassador in Paris) by intro-ducing a well-bred rusticity to English gardening and a humanised landscape to England's countryside. He never treated gardens as places to grow plants that are rare, curious or delicate: horticulture as a precise science held no interest for him. Like Bridgeman and sometimes Vanbrugh, Kent wanted his gardens to be pic-turesque vistas set without boundaries. He discarded formal canals and cascades in favour of more naturalistic streams and lakes. Following Vanbrugh, he added archi-tectural features as part of the landscaping effect. Sometimes these were for pictorial or visual effect: eye-catchers like the obelisks at Houghton and Rousham, or gothic extravaganzas like the sham castle at Shotover (visited by Pope in 1734) or Merlin's Cave. By adopting the ha-ha, or concealed ditch, he was able to avoid fencing and widen the visual boundaries of his gardens. His aim in the Vale of Venus at Rousham in Oxfordshire or the Elysian Fields at Stowe in Buckinghamshire was to create areas of landscape which could be looked at as pictures, or walked through as theatrical tableaux. Kent was a master of tree architecture. He celebrated the free form of great trees; 'where any eminent oak, or master beech has escaped maiming and has survived the forest, bush and bramble were removed; and all its honours were restored to distinguish and shade the plain', as Walpole praised. A smooth lawn surrounding a country-house was regrettable: 'in a picture it becomes a dead and uniform spot, incapable of chiaroscuro, and to be broken insipidly by children, dogs, and other unmeaning figures'. Kent's trick for relieving the uniformity was to plant clumps of trees.

Landscapes and buildings conceived in such a pictorial spirit became the subjects of paintings: a decade after Kent's work at Badminton, Canaletto in 1750 painted both the north front of Badminton House (to which Kent added an extra storey, with a pediment flanked by two cupolas) and the corresponding view out of the house over the parkland. 'How picturesque the face of the country!' Horace Walpole exclaimed:

Every journey is made through a succession of pictures . . . Enough has been done to establish such a school of landscape, as cannot be found on the rest of

the globe. If we have the seeds of a Claude or a Gaspar amongst us, he must come forth. If wood, water, groves, vallies, glades can inspire a poet or painter, this is the country, this is the age to produce them. The flocks, the herds, that now are admitted into, now graze on the borders of our cultivated plains, are ready before the painter's eyes, and group themselves to animate his picture.

Pope's new habit of thought was soon deeply entrenched. 'An open country is but a canvas on which a landscape might be designed,' Walpole wrote in his account of Kent. 'Landskip should form variety enough to form a picture upon canvas; and this is no bad test, as I think the landscape painter is the gardener's best designer', wrote Shenstone, who also thought 'in designing a house and gardens . . . there was room for it to resemble an epic or dramatic poem'. This method of landscape gardening was, as Margaret Jourdain suggested, 'England's greatest contribution, perhaps, to the visual arts of the world'.

Imitation of Kent's gardening ideas was sometimes as maladept as the gardening emulators of Pope. Arthur Weaver, 'possessed by the very demon of Caprice', inherited Morville in Shropshire, 'an Old Mansion that commanded a fine view down a most pleasing Vale', as Thomas Percy, later Bishop of Dromore, described in 1760:

He contrived to intercept it by two straight rows of Elms that ran in an oblique direction across it, and which led the Eye to a pyramidical Obelisk composed of one single board set up endways and painted by the Joiner of the Village: this obelisk however was soon removed by the first puff of wind. In view of one of his windows grew a noble large Spreading Ash, which tho' the spontaneous gift of Nature, was really a fine object: and by its stately figure and chearful Verdure afforded a most pleasing relief to the Eye . . . Mr. W. had this Tree painted *white* – leaves and all: it was true the leaves soon fell off, and the tree died, but the Skeleton still remains, as a Monument of its owner Wisdom and Ingenuity.

There were rebels such as Capability Brown's pupil who laid out the grounds of Duddingston near Edinburgh for the eighth Earl of Abercorn. 'The place was flat, though surrounded by many distinguished features,' as Sir Walter Scott recalled. 'A brook flowed through the grounds, which, by dint of successive dam-heads, was

arrested in its progress, twisted into the links of a string of pork-sausages, flung over a stone embankment, and taught to stagnate in a lake with islets, and swans *quantum sufficit*. The whole desmesne was surrounded by . . . a formal circuit of dwindled trees.' Abercorn's designer blocked a vista of the beautiful ruins of Craigmillar Castle because it 'was a common prostitute' visible all over the surrounding countryside and excluded Duddingston loch because it was not owned by the earl.

'KENT INVENTED EIGHTEENTH-CENTURY GOTHIC'

Influenced more by Spenser than by Pope, Kent in the 1720s experimented with his own brand of romanticised medieval architecture. First he designed one of the earliest gothic follies, at Shotover in Oxfordshire, a castellated façade pierced by three arches with a tower at each end. His design for the Courts of Chancery and King's Bench in the 1730s was probably the first gothic revival proposal for a public building. His Royal Mews (1732), demolished so that the National Gallery might be built on its Trafalgar Square site, featured two gothicised towers. He gave gothic embellishments to the library at Rousham. But the climax of his architectural gothic was for Henry Pelham, prime minister from 1743 until 1754, for whom he built a town house overlooking Green Park, painted an unsuccessful portrait and, most important, created Esher Place. Around 1730 Kent was extending the east range of the Clock Court at Hampton Court Palace in a manner that was sympathetic to the existing Tudor buildings. His ideas for the royal palace work stimulated his simultaneous efforts for Pelham at nearby Esher. The site was near Claremont, the new house of Pelham's elder brother, the Duke of Newcastle, which originally had been designed with battlements by Vanbrugh and had a dramatic castellated belvedere on the grounds. A house had been built at Esher for the Bishop of Winchester around 1480. Kent's first idea was to build Pelham a neo-Palladian villa with the Tudor tower of the bishop's residence forming a picturesque ruin in the valley below.

His next design for Esher has been described by the historian John Harris as 'something quite extraordinary in the history of the European country house'. Kent joined the two surviving semi-octagonal towers of the fifteenth-century gatehouse and added on each side three-storey wings with three bays each; the west front was inspired by the main gateway at Hampton Court. The house was arranged looking

down on the river valley of what Pope called the 'sullen *Mole*'. Kent enclosed several surrounding fields in his scheme, but also retained some formal gardens. 'Kent invented C 18 Gothic as we know it, an affair of incorrect ornament incorrectly applied,' Pevsner wrote in his description of Esher. 'At worst this was jolly: at best it could be splendidly witty, and this is what Kent made it, mixing classic and gothic details to a point which makes the job of disentangling them from a design rather like unravelling a skein of wool.' As much as the dead tree in Kensington, Kent's building at Esher inaugurated the gothic revival: within a generation British architecture was enriched by the rococo gothic of such houses as Arbury and Enville, the picturesque gothic of such ducal castles as Inveraray and Alnwick, the romantic gothic of Milton Abbey and Fonthill, and ecclesiological gothic.

Pope praised 'Esher's peaceful Grove' as a 'Scene' where 'Kent and Nature vye for Pelham's Love' and other contemporaries admired the effect. Supremely Kent's design of the site was pictorial. In it, human beings seemed to ape the figures in art

An Inigo Jones backdrop, or a William Kent sketch, transmuted into stone: the gothic eye-catcher Alfred's Hall raised in Gloucester with advice from Alexander Pope.

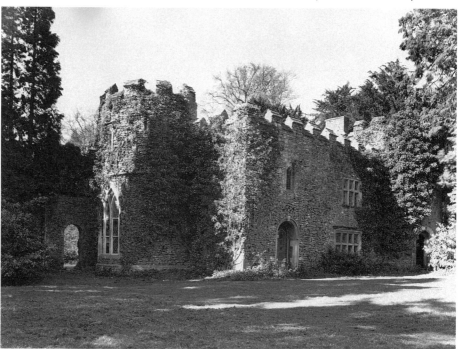

just as Canaletto's pictures of Badminton were those of landscape design aping art. Horace Walpole's rhapsodies about a fête at Esher are those of a man saturated with the mentality of the picturesque. 'The day was delightful, the scene transporting, the trees, lawns, concaves, all in the perfection which the ghost of Kent would joy to see them,' he rejoiced in 1763.

> At twelve we made the tour of the farm in eight chaises and calashes, horsemen and footmen, setting out like a picture of Wouverman. We walked to the belvedere on the summit of the hill, where a threatened storm only served to heighten the beauty of the landscape, a rainbow on a dark cloud falling precisely behind the tower of a neighbouring church, between another tower, and the building at Claremont . . . From thence we passed into the wood, and the ladies formed a circle on chairs before the mouth of the cave, which was overhung to a vast height with woodbines, lilacs and laburnums, and dignified by those tall, shapely cypresses. On the descent of the hill were placed the French horns; the abigails, servants and neighbours wandering below the river – in short, it was Parnassus as Watteau would have painted it.

Usually life imitates bad art; but it was the glory of the English picturesque to provide tableaux in which, briefly and blessedly, lives could be absorbed into the beauty of great art and subordinated to the impersonal power of Nature.

The strength of backward-looking thoughts

A great man, did you say? All I see is the actor creating his own ideal image.
Friedrich Nietzsche

Being rich is about acting, isn't it? A style, a pose, an interpretation that you force upon the world? Whether or not you've made the stuff yourself, you have to set about pretending that you merit it, that money chose right in choosing you, and that you'll do right by money in your turn.
Martin Amis

Forme is power.
Thomas Hobbes

POWER HOUSES

'The Gothic stile of building could produce nothing nobler than Mr Allworthy's house,' Henry Fielding wrote of the rich squire in *Tom Jones* (1749). 'There was an air of grandeur in it that struck you with awe.' Fielding then described its surroundings in theatrical and pictorial terms ('the left-hand scene presented the view of a very fine park') with the underlying *credo* of Shaftesbury and Pope ('very unequal ground . . . agreeably varied with all the diversity that hills, lawns, woods and water, laid out with admirable taste, but owing less to art than to nature') and a Salvatorian background ('Beyond this, the country gradually rose to a ridge of wild mountains'). Six paragraphs describing the house and grounds end with the observation, 'one object alone in this lower creation could be more glorious, and that Mr Allworthy himself presented – a human being replete with benevolence, meditating in what manner he might render himself most acceptable to his Creator, by doing

most good to his creatures'. The rich man standing in his property and dominating his tenants symbolised the preservation of order. Buildings even more than their surrounding gardens represented a system of power and ethics.

Fielding in 1749 already conceived the roles of awe and beauty in architecture, and of grandeur and infinity in displaying pleasing objects, which Edmund Burke famously systematised a decade later in *A Philosophical Enquiry into the Origin of Our Ideas of the Sublime and Beautiful* (1757). These ideas circulating among the middle-class literati were reproduced in aristocratic activity, and specifically in the mimic-medieval architectural forms enlisted to serve the forces of economic hegemony.

Country houses were, supremely, the 'power houses', in Mark Girouard's phrase, 'of a ruling class'. This class ranged from squires who ruled their villages to territorial magnates who ruled their counties and sat in the House of Lords. Their power was based on the rents from the tenants on their land, but as Girouard notes,

> land provided the fuel, a country house was the engine that made it effective
> . . . It was the headquarters from which land was administered and power
> organised. It was a show case, in which to exhibit and entertain supporters
> and good connections . . . It was an image-maker, which projected an aura of
> glamour, mystery or success around its owner. It was the visible evidence of
> his wealth. It showed his credentials – even if the credentials were sometimes
> faked. Trophies in the hall, coats of arms over the chimney-pieces, books in
> the library and temples in the park could suggest that he was discriminating,
> intelligent, bred to rule and brave.

The unnaturally elegant fields and woods laid out around country houses were constant visual reminders that the domain was the possession of a privileged man. Grandeur intimidated and gave the illusion of permanence. Edward Seymour, the Wiltshire gentleman who as a result of his sister's marriage to King Henry VIII became in 1546–47 Duke of Somerset and Protector of the Realm during the minority of his nephew King Edward VI, used the fortune he amassed from the confiscation of monastic estates to erect solid reminders of his power: he tore down the cloister of St Paul's Cathedral to use its stones to build London's first Renaissance palace, Somerset House in the Strand; in Devon he raised a romantic castle on the edge of an inland cliff, Berry Pomeroy; and he started another ambitious palace in the Savernake Forest. In 1552 he was beheaded.

Towers and fortifications continued to be built in Tudor and early Stuart times, long after their military purpose had ended with the Middle Ages. Towers remained superb symbols of power, visible over the countryside, impressing outsiders rather than fortifying the inmates of great houses. In some cases towers served as belvederes, providing an owner with a view from his power house over his domain. The battlemented prospect tower built for Giles Strangways's house at Melbury in Dorset around 1540 was pioneering. Mount Edgecumbe, built in 1546 overlooking Plymouth Sound, differed from preceding fortified homes by having its principal rooms looking outward with a high, covered hall instead of the customary central, open courtyard. The triangular Longford Castle in Wiltshire, completed in 1591 by Sir Thomas Gorges, courtier and astrologist, was the supreme example of an Elizabethan castellated house; Pevsner calls it 'Spenserian'. The early Jacobean fad for chivalric buildings resulted in Lulworth Castle in Dorset (c. 1608; gutted 1929), Bolsover Castle in Derbyshire (1613–16) and Ruperra Castle in Glamorganshire (c. 1626; gutted c. 1942).

Dynastic rivalry provided another motive for building power houses. In the mid-eighteenth century the leader of the Tories in Derbyshire, Lord Scarsdale, rebuilt and enlarged his house at Kedleston (employing Robert Adam) so as to challenge the Whig leader of the county, the Duke of Devonshire, who lived in his palace of Chatsworth. The conspicuous effects of a building spree were a high recommendation. 'If your Grace will please to consider of the Intrinsique vallew of Tytles and Blew Garters, and Jewells and Great Tables and Numbers of Servants & in a word all those things that distinguish Great Men from small ones, you will confess to me, that a Good house is at least upon the Levell with the best of 'em,' the architect Vanbrugh wrote to the Duke of Newcastle in 1703. The duke's reluctance to spend a fortune on rebuilding Welbeck seems saner than the example of Lord Stawell, who, on turning twenty-one in 1690, demolished his ancestral home, and began a sumptuous replacement, four hundred feet long and a hundred deep, which he intended as the greatest house in England. When he died aged only twenty-three, it stood unfinished, surrounded by half-fabricated terraces, and was left by his trustees to fall into ruins. When he began work he owned twenty-eight rich manors in Somerset; three years later, only two survived for his impoverished heirs. The ambitions of Lord Stawell were extreme but not exceptional.

Grandeur and pompous solitude did not satisfy every taste. Despite routine avowals of the superiority of country life, noble families preferred the attractions of

towns and cities to the dirt and monotony of rural life. The Marquis of Halifax wrote in 1679 of his abbey in Sherwood Forest, 'I dream of the country, as men do of small beer when they are in a fever; and . . . poor old Rufford with all its wrinkles hath more charms for me than any thing London can show me.' Yet in 1686 he acquired Berry Mead Priory, a villa at Acton, a few miles west of London, and probably never visited Nottinghamshire again. Halifax, as one of the finest politicians of his generation, needed to be near the Court and Parliament; similarly, his subtle intelligence needed the stimulation of metropolitan society. It was in this spirit that Pope's friend Lord Bathurst railed at the 'accursed mediocrity' of his Gloucestershire neighbours, 'people who were not fools enough to be laughed at and yet were far from having sense enough to make a conversation'. Great aristocrats spent only a small part of the calendar at their power houses: Archibald, third Duke of Argyll, visited his gothic revival castle at Inveraray for only two months of each year. 'As king of Goths I do not so much envy him; a cold climate, rude inhabitants, a soil uncultivated, and all the accomplishments of savage greatness may please surly and solitary pride, but I think his Grace of Argyle is much in the right to rule there by a viceroy, the greatest part of the year, and enjoy the comforts of being a subject of England for the rest,' Elizabeth Montagu wrote in 1759.

Harsh weather, which rivalled boredom as the worst deterrent to rural life, made some eighteenth-century architectural fashions seem peculiarly unsuitable. Mereworth Castle in Kent, modelled around 1720 on a villa at Vicenza built by Palladio, with a central circular hall rising high into a dome, had a deeply projecting portico on each façade which kept most rooms in permanent shadow and therefore freezing cold. 'We get sore throats and agues with attempting to realize these visions,' Horace Walpole complained. 'The best sun we have, is made of Newcastle coal . . . How our ancestors would laugh at us.' The inconveniences of Italian models contributed to the reaction which popularised eighteenth-century sham-medieval buildings. The timing was crucial. The baroque of Vanbrugh and Archer had receded during the 1720s as Burlington's influence predominated, but by the 1740s English architects and noblemen were chafing at twenty years of Palladianism. Feudal times provided one source of new architectural inspirations. Motifs and details like the pointed arch had been prevalent in English architecture until the early seventeenth century, but were not thought special enough to be denoted by a distinct word such as 'gothic'.

Seventeenth-century antiquarians raised interest in the feudal past by publishing engravings of medieval abbeys and castles which became an imaginative source for architects and their clients. Arguably the earliest example of revival gothic was the self-consciously mimic-medieval windows of the library at St John's College, Cambridge (1624). A generation later, Wren designed a gothic addition, Tom Tower, at Christ Church, Oxford, and ornamented some London churches with medieval spires. Another early instance of the rising sympathy for the medieval occurred in 1679 when a boy born to the Darcy family, which held a Plantagenet barony dating from 1344, was christened with the then unknown forename of Norman to indicate his antecedents. Norman Darcy died young, but it was the same spirit of Plantagenet commemoration that in the 1750s prompted his nephew, the fourth Earl of Holdernesse, to commission a sham hill-top castle and 'a very pretty Gothic room' on his estates. But generally medievalism's attractions were still inhibited in the seventeenth century by its distasteful, even menacing association with Roman Catholicism. In 1680 Halifax wrote from Rufford Abbey, which originated in a Cistercian abbey founded in 1148 and had lately been repaired by his orders: 'It looketh now somewhat better . . . than when it was so mixed with the ruins of the abbey that it looked like a medley of superstition and sacrilege, and, though I have still left some decayed part of old building, yet there are none of the rags of Rome remaining.'

THE SYMBOLISM OF CASTLES

Eighteenth-century landowners felt less anxious than Halifax's contemporaries if old buildings were partly decked in papist rags. There arose a new desire to repair magnificent ruins associated with one's ancestors in acts of sincere historical reverence. In many cases the taste for medievalism showed a hankering for the old territorial supremacy of the Plantagenet barons, and a distaste for the perceived commercialism, social fluidity and political jobbery that had followed the Glorious Revolution of 1688. Tories particularly associated the new monied interests with support for their Whig opponents. When, however, the Tories came into power in the reign of Queen Anne, they were no less prone to jobbery than the Whigs, and perhaps less reverent or protective of the privileges of the old aristocracy, for they swamped the House of Lords with new creations. Piety about one's ancestors is an emotion for people who mistrust the future and therefore idealise the past. 'I am always glad', wrote the Countess of Pomfret in 1740,

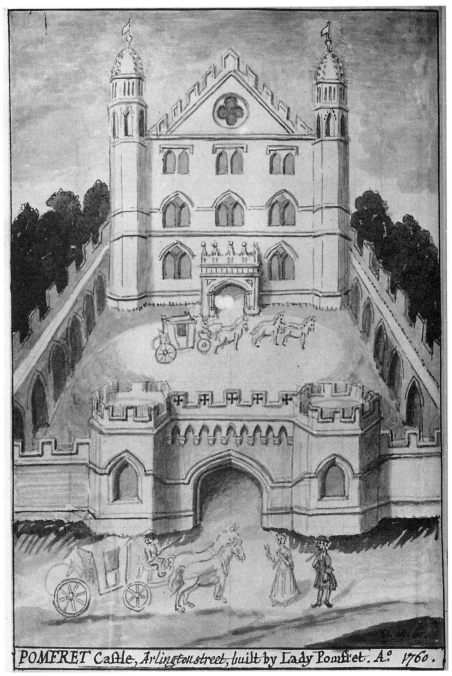

POMFRET Castle, *Arlington street*, built by Lady Pomfret. A° 1760.

The marvellously regressive, implacably reactionary town house erected on the edge of Green Park, London, by a noblewoman who admired 'the old English grandeur'. Her husband had inherited a great house in Northamptonshire, Easton Neston, Hawksmoor's masterpiece.

to hear of any remains of the old English grandeur; and am both amazed and provoked when I hear of people destroying those magnificent structures (made to last for ages) in order to erect some trifling edifice, whose chief merit consists in the vast expence, which often renders the builder unable to inhabit it when he has done; – whereas to repair an abbey or castle in the same way as it was first built, is a worthy monument both of the owner's piety to his ancestors, and care to his posterity. But these are worn-out virtues, and hardly live even in memory.

The Pomfrets were a Tory family, and for the countess the genealogical respect underlying the old grandeur connoted stability and continuity in a debased epoch. Her historic sympathies were expressed in her commission of a gothic fort called Pomfret Castle, which was built in Arlington Street off Piccadilly in 1760 and heartbreakingly was demolished as recently as 1934.

The British Isles were full of inspiring remnants of medievalism. 'The situation is noble, and it stands upon a rock of considerable height,' wrote Pope's friend Lord Lyttelton after visiting Conway Castle on the north coast of Carnarvonshire in 1756: 'three sides of it are defended by an arm of the sea, and four turrets that rise above the towers . . . The walls between are battlements, and look very strong; they are, in some places, fourteen or fifteen feet thick . . . The whole together hath the grandest appearance of any building I ever beheld.' The Conways' estates were in Warwickshire, but Edward, Earl of Conway (1623–83), 'would have lived in this castle, could he have purchased any lands in the country about; but, finding none to be sold, he dropt the design'. It was futile to live in a castle without extensive acreage upon which one's power could be imposed. The seventeenth-century Conways were pioneers in recognising the possibilities of restoring an ancestral ruin, but after the popularisation of Shaftesbury's ideas on the virtuous sensibility, landowners who neglected their medieval amenities seemed despicable. Bayham Abbey's broken remnants disappointed Lord Torrington in 1788:

Adjoining is a neat house of Mr. P[ratt] the owner, built out of the ruins; we saw him, and may presume him to be, from his manners, as deficient in good breeding, as does everything around, prove a want of taste. The ruins, sadly dilapidated, and disfigured, from being used as a garden, are yet of great beauty; with many arches, remains of chapels, and some fragments of tombs:

– a proprietor of Gothic taste wou'd render it solemn and pleasing; whereas at present it is glaring and fantastic.

The aesthetic attractions of new, or renewed, castles differed between the genders. For Lady Pomfret, and other peeresses such as the Duchess of Northumberland, new gothic forts symbolised the assertion of patrician culture over the manners, habits and ambitions of the burgeoning middle class. The primacy of old families was for them a matter of superior sentiments and taste. For many men, the symbolism of castles evoked more material forces. The style of a man's house sent an eloquent message to his dependents, his rivals and his monarch. In 1707 Vanbrugh recommended to the first Duke of Manchester giving Kimbolton a 'Castle Air' rather than 'a Front with Pillasters', promising 'this will make a very Noble and Masculine Shew; and is of as Warrantable a kind of building as Any'. Vanbrugh built a castellated house for himself at Blackheath, and for the grounds at Castle Howard designed a heavy wall with eleven fortified towers, some with gothic windows and castellations. The 'Castle Air' nevertheless did not suit everyone's political purpose. The newly created Duke of Beaufort, who in the 1680s abandoned Raglan Castle as his seat and built a sumptuous new palace at Badminton, 'a great part of the country, which was his own, lying round about him', desired not only a new house that was a model of domestic efficiency but also a modern power house which would make his family seem less like turbulent marchland warlords.

'To be entirely engrossed by antiquity, and as it were eaten up with rust, is a bad compliment to the present age', as Shenstone observed. In a century of perceived constitutional depravity, gothic became identified by political malcontents with both Tory and Whig liberties. A writer in the *Gentleman's Magazine* of 1739 declared:

Methinks there was something respectable in those old hospitable Gothick halls, hung around with the Helmets, Breast-Plates, and Swords of our Ancestors; I entered them with a Constitutional Sort of Reverence and look'd upon those arms with Gratitude, as the Terror of former Ministers and the Check of Kings. Nay, I even imagin'd that I hear saw some of those good Swords that had procur'd Magna Carta, and humbled Spencers and Gavestons. And when I see these thrown by to make way for Tawdry Gilding and Carving, I can't help considering such an Alteration as ominous even to

our Constitution. Our old Gothick Constitution had a noble strength and Simplicity in it, which was well enough represented by the bold Arches and the solid Pillars of the Edifices of those Days. And I have not observed that the modern Refinements in either have in the least added to their Strength and Solidity.

Men of every political type appropriated the purity of gothic political institutions to their cause. 'My notion of a Whig', declared Robert Molesworth, 'is one who is exactly for keeping up to the Strictness of the old Gothick constitution.' Pope's friend Lord Bolingbroke, however, claimed the Goths for the Tories when he praised the Saxons for retaining 'the freedom of their Gothic institution of government'. Henry Brooke, whose play *Gustavus Vasa* (1739) was attacked by Sir Robert Walpole's censors, protested: 'I took my subject from the history of Sweden, one of those Gothic and glorious nations, from whom our form of government is derived.' This phenomenon was not exclusively English. In Bohemia at this time Santini-Aichel was reviving a medieval gothic style intended to evoke a lost national purity: Kladruby abbey church; Sedlec mortuary chapel near Kutra Hora; and Zdar na Sazaron pilgrimage church are examples of the eighteenth-century politicised Bohemian gothic revival. In England, too, the ornamentation of landscapes was imbued with political meanings: Burlington erected statues at Chiswick to honour such enemies of tyranny as Socrates; the Temple of Worthies installed by Kent at Stowe honoured the supporters of British freedoms and Protestantism; the gothic temple at Stowe was dedicated to Liberty; the Whig eleventh Duke of Norfolk honoured American independence and the cause of liberty in the 1780s by improving the grounds of Greystoke Castle in Cumberland with a castellated farmhouse sporting gothic windows called Bunker's Hill and the more ambitiously gothic-picturesque Fort Putnam. The sham medievalism in country-house architecture had an equally political meaning.

An important stage in the politicisation of gothic forms began around 1745–47 when a Warwickshire country gentleman and architectural amateur named Sanderson Miller built a sham-medieval tower on a high and windy site at Edgehill, the first battleground of the English civil war (1642). The upper room of this tower, which could be seen from Miller's house, Radway Grange, was 'highly finish'd in ye Gothick taste; antique shields blazoned on ye Ceiling; Painted Glass in ye Windows,

Gothick Niches, & Gothick Cornice.' Miller added a turret 'which is in *reality* some Poor body's chimney and a Magnificent stone Arch.' Elsewhere he designed other Midlands houses in his picturesque style, nowadays called 'rococo gothic'. His work includes Adlestrop Park in Gloucestershire, the gothic front at Lacock Abbey in Wiltshire, and improvements in the vicinity of Wroxton Abbey in Oxfordshire, where he installed a cascade and turret with slit windows in the grounds and remodelled the chapel and parish church for the Tory first Earl of Guilford.

Sanderson Miller's effects were emulated by Sir Roger Newdigate (1719–1806), who after 1748 added battlements, pinnacles, oriel windows and other rococo gothic features at Arbury. His 'revived gothic style', according to Sir Roy Strong, was 'appropriate to a man who was a Tory and looked back to the Middle Ages'. Newdigate was a baronet with valuable estates in Warwickshire and Middlesex who was interested in developing Midlands coal-mines, canals and turnpike roads.

The east front of Arbury Hall, the gothic revival house in Warwickshire which better deserved the admiration and publicity given to Walpole's curiosity at Strawberry Hill. It is a Tory baronet's idealisation of an uncorrupted epoch of slumbering masculinity.

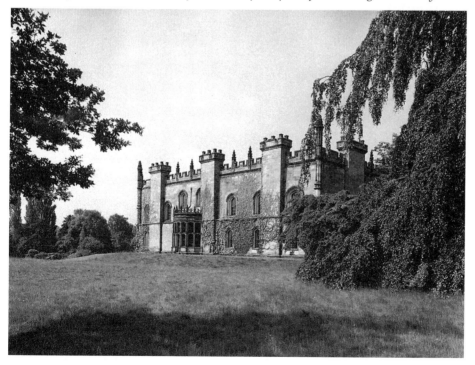

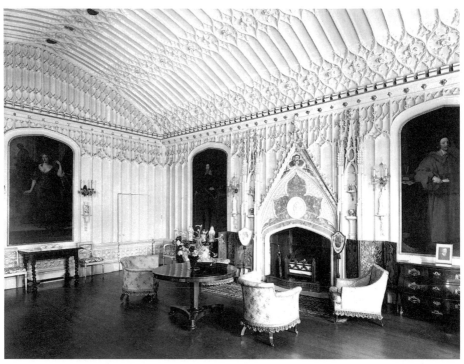

The chimney-piece in the drawing room at Arbury was based on the tomb in Westminster Abbey of the Plantagenet nobleman Aymer de Vallance.

A cultivated man, he endowed the Newdigate Prize for English Verse at Oxford University, and for nearly thirty years represented the rigidly Tory university in the House of Commons: he mistrusted the royal family as foreigners, deplored the unpatriotic diplomacy of successive governments and resolutely opposed meddling with the liturgy or privileges of the Church of England. 'Arbury is one of the finest examples of the early Gothic Revival in England – some may say *the* finest, and the finest in England of course implies anywhere,' in Pevsner's judgment. 'Sir Roger, who started gothicizing the house about the year that Horace Walpole started at Strawberry Hill, kept at it longer, and in any case could work on a larger scale . . . His Gothic, like Horace Walpole's, is gay, amusing, pretty – not at all venerable, as Gothic architecture is for us and has been ever since the Romantics.'

LORD LYTTELTON AT HAGLEY

Another crypto-political example of gothic architecture is the ruined castle designed in 1747 by Miller for his neighbour Sir George Lyttelton, a courtier and politician who received a peerage in 1756 after his retirement as Chancellor of the Exchequer. Lyttelton published a poetic epistle to his friend Pope and enjoyed the poet's Twickenham picturesque. He equally admired Bathurst: the Doric temple and Ionic rotunda with which Lyttelton improved his Worcestershire estate at Hagley were in friendly emulation of the effects of Pope and Bathurst at Cirencester. He was a patron of Henry Fielding, who dedicated *Tom Jones* to him, but was caricatured by

Hagley Hall sham feudal ruins - like this erected for Lord Lyttelton at his seat at Hagley - were intended to evoke the mood which Webster expressed in The Duchess of Malfi:

> *I do love these ancient ruins:*
> *We never tread upon them but we set*
> *Our foot upon some revered history:*
> *And, questionless, here in this open court,*
> *Which now lies naked to the injuries*
> *Of stormy weather*

Smollett as Gosling Scragg in *Peregrine Pickle*. 'His face was so ugly, his person so ill made, and his carriage so awkward, that every feature was a blemish, every limb an encumbrance, and every motion a disgrace,' wrote Lord Hervey, who expected better of a fellow courtier. 'He had a great flow of words that were always uttered in a lolling monotony, and the little meaning they had to boast of was generally borrowed from the commonplace maxims and sentiments of moralists, philosophers, patriots and poets, crudely imbibed, half digested, ill put together, and confusedly refunded.' Yet Lyttelton was an imaginative man for whom history was a solace. He despised 'the Corruption, and Hardness of the present Age' and recognised that England owed more to its own medieval history than to ancient Greek or Roman civilisation: indeed he sought in feudalism a political purity.

Living several generations after the Lord Halifax who had rebuilt Rufford Abbey to discard the rags of Rome, Lyttelton had few inhibitions about the Roman Catholicism of the medieval period. As early as 1741 he began researching a biography of King Henry II which, after its eventual publication in four volumes after 1767, was decried by Walpole as 'such a load of dull lumber . . . so crowded with clouds of words'. As he began this book Lyttelton confided to Pope his desire 'to draw something like History out of the Rubbish of Monkish Annals' to bring 'some Instruction and Pleasure to my Countrymen'. Revealingly he described his book to Pope in building terms: 'Certain I am, that such an Architect as You . . . cou'd out of these Gothick Ruins, rude as they are, Raise a new Edifice, that wou'd be fitt to Enshrine the Greatest of our English Kings, and Last to Eternity.'

Lyttelton's interest in Plantagenet monarchs and his passion for the picturesque led him to visit several great medieval fortresses. In 1757 he commissioned Miller to design a sham ruin for a prominent hill visible from Hagley House. This consisted of a tower, three stumps of tower, and a ruined wall between them. The window frames were taken from the ruined abbey nearby at Halesowen. Large mossy stones were tumbled around the ruins to suggest decay and confusion. It was not a power house, but symbolised broken power and the transience of human glories. A hermitage and a macabre alcove, with morbid inscriptions, ornamented with sheepbones, jaws and skulls, were also laid out in Hagley's grounds. The results were supremely picturesque. 'There is extreme taste in the park,' Walpole reported. 'There is a ruined castle built by Miller that . . . has the true rust of the Barons' Wars' together with a hermitage 'on the brow of a shady mountain, stealing peeps into the

glorious world below'. Lord Torrington in 1781 was less enthusiastic: 'Lord Lyttelton had more genius for poetry (and that not very great) than for improving a country seat,' he judged. 'The ground on the back of the house is pleasingly wooded, and the hills happily sloped; but it is marr'd by staring temples and obelisks, which savor too much of Strombolo gardens.' Contrivance, theatricality and the air of a tourist's memento were all potential pitfalls in striving for picturesque effects.

WILLIAM SHENSTONE

A few miles north-west of Hagley, 'over a wild and almost barren heath' in Staffordshire, stood Enville Hall, the seat of the Grey family, Earls of Stamford. Lyttelton and Stamford stimulated each other's architectural and landscaping effects. At both sites the minor local poet William Shenstone (1714–63) was a more direct influence even than Pope. A farmer's son, Shenstone was educated at Solihull Grammar School and Oxford University, where he was thought crankish because he refused to cut his hair and wear a wig, but wore his own hair drawn back into a bow. He was physically ungainly, and perhaps socially clumsy, too; after leaving Oxford, his life was reclusive though his nature was affectionate. Often he complained of nervous ill-health in a depressed and self-absorbed way. His pastoral odes, with their rusticity and arcadianism, were ephemeral. In 1745 Shenstone settled on a small estate called The Leasowes near Halesowen in Worcestershire (near to Hagley and Enville). This property he transformed into a *ferme ornée* with grottoes, inscribed urns, winding walks and vistas. Torrington, reaching The Leasowes straight from Hagley, reflected, 'it is from writing that they are become so celebrated; for penmanship has the power of puffing inferior places and rendering them visitable by the curious, and admired by the ignorant.' Certainly Shenstone delighted to show fashionable visitors his grounds: 'A Coach with a Coronet is a pretty kind of Phaenomenon at my Door; – few Things prettier.'

Lord Foley at Witley, Lord Plymouth at Hewell Grange and Lord Dudley at Halesowen Grange all sought Shenstone's advice on landscape-gardening. Though 'sick of the word taste', he thought 'the thing itself the only proper ambition, and the specific pleasure of all who have any share in the faculty of imagination'. He had a pictorial approach to laying out grounds. Inherently anxious, gloomy and pensive, he favoured melancholy. 'A ruin, for instance, may be neither new to us,

nor majestic, nor beautiful, yet afford that pleasing melancholy which proceeds from a reflexion on decayed magnificence.' Accordingly in the grounds at The Leasowes he built a small ruinated priory with armorial shields decorating the cornice (installing a tenant, as he needed the rent). Though he had minutely studied Pope's ideas as both poet and gardener, Shenstone had a bolder taste than could be accommodated in a pastoral idyll. 'A rural scene to me is never perfect without the addition of some kind of building: Indeed I have known a scar of rock-work, in great measure, supply the deficiency,' Shenstone wrote: 'Offensive objects, at a proper distance, acquire even a degree of beauty.' There was a gravel-pit, surrounded by hazels, of which he made a pictorial focus by scooping out a cave, covering its entrance with a door to which he affixed a little wooden cross, and calling it a hermitage. More degenerate examples of the frippery of Shenstonian gothic were provided by the baronet's daughter who in mid-century covered a portico of Battle Abbey with cockleshells and by Lord Rockingham's improvements at Wentworth Woodhouse: 'The bowling-green behind the house contains no less than four obelisks, and looks like a Brobdignag ninepin-alley . . . there are temples in cornfields; and in the little wood, a window-frame mounted on a bunch of laurel, and intended for a hermitage.'

A contemporary description of Shenstone's grounds by Robert Dodsley resembles the catalogue of a picture gallery as it points the scenes and prospects from different vantage-points; this characteristic recurs in accounts of Shenstone's finer masterpiece, the grounds he laid out at Enville (where a gothic greenhouse had already been built in 1749–50 by Sanderson Miller). Harry, third Earl of Stamford (1685–1739), had begun eccentric improvements to the grounds in the 1720s, including a little house made of wood and straw and roofed with a stout cotton cloth called dimity with raised stripes and fancy figures, and 'another odd piece of building upon a sandy bank upon the common, which till then was a rabbit-burrough', with a central octagonal room lit only by a skylight. His son, Harry, fourth Earl (1715–68), married the heiress of the last Earl of Warrington and used her fortune to beautify Enville. The house, which stood on a steep, lofty hill broken into furrows and watered by rills, was remodelled with Shenstone's help to incorporate two octagonal towers, pointed gothic arches to the windows and a battlemented roof.

Shenstone's supreme design was the scenery at Enville: verdant sloping lawns and luxurious woods which, surrounded by meagre, bleak stretches of

Staffordshire, precisely demarcated where the earl reigned. His effects were so successful that William Marshall in 1795 wished that Gainsborough had painted the 'delicious grounds of Enville, not as a Landscape, but as the *interior of an embellished ground*', and had thus celebrated 'with enthusiastic rapture, the transcendent charms of ornamented Nature'. Stebbings Shaw in 1801 described the 'Shenstonian cascade' at Enville as 'better seen through a large window in a whimsical room over the boat-house, which being thrown open, the most brilliant scene imaginable presents itself': the torrent 'in its fullest force, dashing over impending rocks into a deep glen, whose ragged sides are scarcely hid by the thick laurel and tufted shrubs which overhang its edge; the foam and spray mixing with the foliage of the evergreens; while the view which we catch of the building, beyond the lake, considerably relieves the whole, which is rendered one of the most sublime productions the hand of art has effected'. Shaw also admired Shenstone's chapel surrounded on three sides by overhanging trees, creating an effect of 'deep gloomy umbrage'. A more cheerful building was the gothic shepherd's lodge, its interior full of rustic ornaments, the walls 'stuck o'er with Christmas carols, ancient ballads, and such congenial embellishments, [as] preserve the idea of the shepherd's residence'. There were other picturesque effects, including 'an artless bridge, composed of a single plank', a rotunda, a cave with a domed roof, an eye-catcher of three castellated archways (the central one with flanking turrets and a portcullis), a hermitage made of bark and a graceful gothic outhouse serving as a billiard-room.

INVERARAY AND THE DUKE OF ARGYLL

The designs at Arbury and Enville were a frivolous rococo gothic which achieved an alluring elegance. Other amateurs, who were less gifted than Newdigate, Stamford and Shenstone, produced effects that were merely gimcrack; but the apogee of eighteenth-century gothic architecture was reached by the power houses which invoked the imposing, even intimidatory grandeur of the feudal barons. These houses mark the emergence of English gothic revival architecture from its first stage, the Rococo, into its second stage, the Terrible and the Picturesque. There was at least an implication – sometimes a robust intention – of Tory political dissidence in rococo gothic, but the Terrible and the Picturesque were an aggressive assertion of political power. The Terrible and the Picturesque castles were not intended as a teasing rejection of the prevailing political powers; they were

This nineteenth-century view of Inveraray shows recently pinnacled roofs on its turrets that accentuated the castle's air of Brighton Pavilion artificiality.

uncompromising buildings intended to force their owners' interpretations upon the world. Significantly, the finest examples were in Scotland, or near England's Scottish border, or in Ireland.

The first aristocrat to restore the ancient grandeur in this way was Archibald Campbell, Earl of Islay, who in 1743 succeeded his brother John as third Duke of Argyll. The Argylls were clan chiefs bearing the Celtic title Mac Cailein Mor (son of Great Colin). Their long enmity with the royal house of Stuart had been bloody and violent. The brothers' grandfather, the ninth Earl of Argyll, had been executed in 1685 for taking arms against King James II; their great-grandfather, the eighth Earl, had been beheaded for high treason in 1661. John, 'the great Duke of Argyll', was a flamboyant military commander on whom was bestowed the dukedom of Greenwich and a Field Marshal's baton. He spent much of his career in England (being born and dying in Surrey) and was seldom at Inveraray. 'Archibald, bred a lawyer, was cool, shrewd, penetrating, argumentative – an able man of business, and a wary, if not crafty, politician,' according to Lady Louisa Stuart. Horace Walpole's description of Archibald evokes an anti-hero in a gothic novel: 'mysteri-

ous, not to say with an air of guilt, in his deportment, slow, steady, where supple-
ness did not better answer his purpose, revengeful, and, if artful, at least, not ingra-
tiating.' Born in 1682, Duke Archibald had been educated at Eton, then studied law
at Glasgow University, and later at Utrecht. As early as 1706 he was one of the com-
missioners for the treaty of the Union of Scotland with England, for which service
he was created Earl of Islay at the age of twenty-four. Together with his brother, he
promoted the Hanoverian succession in 1714. During the Stuart uprising of 1715 he
defended Inveraray and was lamed at this time by a wound he received at the Battle
of Sheriffmuir. He became a steadfast supporter of Sir Robert Walpole, who left him
for many years to manage the elections, patronage and governance of Scotland. He
was nicknamed 'King of Scotland', and certainly his shrewdness saved Walpole
from many Scottish embarrassments.

Islay was a member of Pope's gardening circle and had an architectonic outlook
on the world. In the 1720s he was associated with Pope and Bathurst in planning
Marble Hill, the house at Twickenham built for Mrs Howard at the instigation of
her lover, the future King George II. Islay meanwhile made a small estate for him-
self nearby at Whitton 'out of a piece of Hounslow Heath, on purpose to try what
shrubs and trees he could bring the barrenest soil to bear'. Buying the property in
1722, he first erected a greenhouse, next a house and finally a high, triangular, three-
turreted brick gothic tower which (standing at the end of a long, oblong expanse of
water lined with trees) served as an eye-catcher. Islay's gardeners at Whitton grew
from seed some magnificent cedars, and seeds of other trees sent from North
America were raised there and sent to the nurseries of Islay's friends. Such was
Islay's pleasure at Whitton that in 1729 he began as a second experiment cultivating
a bleak moorland tract known as Blair Bogg 900 feet above sea-level in Peebleshire.
He drained the bog, raised a nursery of trees, dug ornamental lakes and mocked
himself by calling his new property 'The Whim'. Argyll's whims were imitated and
popularised. A gentleman in Thomas Holcroft's *Anna St Ives* (1792) complained of
his grounds, 'I have the wilderness very much at heart, but the soil is so excellent,
and I scarcely know how we shall make the land sufficiently barren. I have planted
one year, and grubbed up the next; built and pulled down; dug and filled up again,
removed hills, and sent them back to their old stations.'

As soon as he inherited the Argyll properties, Duke Archibald determined to visit
Inveraray: 'curiosity alone if it were not my Love of laying out Grounds and

Gardning would draw me thither, especially considering, that I have now done with Political Ambition'. There were many obstacles to his visit. The journey from London was long, slow and difficult; moreover Inveraray was unfit for a visit by the party he proposed. 'Except kitchen furnitur, Peuter, four beds with Blankets Pillows & Coverings, and a dozen of Chairs for the dineing room . . . there is little else here, but old Remnants. The late good Dutchess of Argyll left here a long time agoe, and . . . Her Grace was not very modish in things of that kind.' Argyll's visit was planned with the minute care of a military expedition. His cavalcade finally left Whitton on 6 July 1744, and reached his crumbling castle five weeks later. The duke had earlier asked for a mason's report on the castle, which was disintegrating irreparably, and Roger Morris, the English architect who had worked at Whitton, travelled to Inveraray with him. William Adam, who had worked for the duke on The Whim, was chosen to supervise the implementation of Morris's ideas on the site: he and his famous sons were thus architects of Inveraray by devolution. Robert Adam's youthful imagination was impressed by this inauguration of the gothic picturesque.

Site excavations having begun during 1744, the duke returned to Scotland in July 1745, but on 4 August the Young Pretender (son of the titular King James VIII of Scotland, and the last of the Campbells' ancestral enemies, the royal house of Stewart) landed in Inverness-shire and called out the clans. Having been delayed by rain, the duke abandoned his efforts to reach Inveraray: 'If the matter grows serious I will not be in safety there.' The Jacobites indeed threatened to kidnap Argyll as their chief political enemy in Scotland, and he returned to London so hurriedly that his carriage's axle-tree caught fire from friction. The duke found the government recklessly complacent about the uprising even after the Young Pretender occupied Edinburgh in September and proclaimed his father as King of Scotland. Using information sent to him by clandestine informants, Argyll brought the London politicians to their senses. He wrote not only in a secret cypher, possibly of his own devising, but in invisible ink of his own experimentation, the words appearing from the heat of a candle flame. Inveraray was garrisoned with the Scots Fusiliers commanded by his cousin and heir, General Campbell, who in March 1746 ordered the erection of earth ramparts with gun replacements to protect the town and castle. A month later the Jacobites were defeated at the Battle of Culloden.

Duke Archibald's role as the Scotsman most identified with Hanoverian power, the Jacobite invasion of Scotland and the subsequent outlawing of the Gaelic lan-

guage, clan tartans and pipes provides the cultural and political context for the rebuilding of Inveraray. The duke desired a new power house to serve as administrative headquarters, showcase and image-maker for the Argyll estates, which were about a hundred miles long and eighty across (though with a low rental value, for his tenantry scraped only a subsistence from Black Highland cattle). Tobias Smollett, describing the Inveraray area, wrote: 'This country is amazingly wild, especially towards the mountains, which are heaped upon the backs of one another, making a most stupendous appearance of savage nature . . . All is sublimity, silence, and solitude.' Argyll, as a gardening colleague of Pope, of course consulted the genius of the place. 'By refining upon the Gothic form, every thing possible has been done to reconcile it to its new situation,' Lord Kames wrote in commendation of Argyll's schemes. 'The profuse variety of wild and grand objects about Inveraray demanded a house in the Gothic form; and every one must approve the taste of the proprietor, in adjusting so finely the appearance of his house to that of the country where it is placed.' The castle's foundations were laid in October 1746.

> Besides the masons and labourers at the castle, a host of wrights with their own labourers were making sheds to house men, tools, carts and barrows; the smith and his men at the forge turned out quarry-tools and other ironwork, and there were a wheelwright's shop, a shed full of sawyers making planks and scaffolding, lime-burners at the kilns, carters hauling up stones from the quarries, not to mention the increased staff of gardener's men improving the parks.

The Duke also required an informer who reported on such matters as illicit sales of home-distilled whisky by the overseers, the theft of tools and frauds.

'Morris, a minor architect of this country, designed a castle for the duke of Argyll at Inveraray – not a Barons' castle nor even in the Queen Elizabeth Style, but a Gothick one – not what he wished it to be but what he was ignorant how to accomplish', according to Robert Adam's brother-in-law. Though Kent had achieved proto-gothic at Esher, and Batty Langley had recently published *Gothic Architecture Improved*, the modern baronial castle of Inveraray was unprecedented. Faced in blue-grey stone, rectangular, 118 feet by 100 feet, with a tower at each corner, and approached by gothic bridges over a fosse, Inveraray's wallheads were battlemented and its windows pointed. It was 'meticulously symmetrical, the longer sides

with seven windows, the shorter with five. Few houses of its date were so nearly identical on each facade, with each of the four elevations entirely sufficient in itself. The design is so neat and perfect that its general form irresistibly suggests comparison with a vast toy fort rather than a medieval castle.' The interior, apart from a central hall with high gothic windows, is classical.

After its completion in 1758 the new castle became the West Highlands equivalent of Versailles in its attraction of sightseers. Sir William Burrell, one of the earliest visitors, considered that it was 'built in the Manner of the Old Castles in the Time of Henry 2nd, & in some particulars it is said to bear a strong Resemblance to Solomon's Temple'. Lord Lyttelton, Hagley's proprietor, inspecting the castle in 1759, reported, 'The House deserves to be call'd, as it was stil'd by Lord Leicester, "the Royall Palace of the King of the Goths". He [Argyll] reigns here in great state, but Nature reigns in still greater. I have scarce seen her more sublimely majestick.' The goth-castle picturesqueness was agreed by all of this generation. The letters of Lyttelton's son, Tom, describing Inveraray to Elizabeth Montagu, proved him to be 'a charming painter; his views of Scotland appear as the scenes of Salvator Rosa would do, were they copied by Claude,' she judged. By the nineteenth century, however, Inveraray's hybrid theatricality displeased purist visitors. Sir David Wilkie, visiting in 1817, reported, 'The castle itself is a complete importation, and disappointed me much; I expected a Highlands residence, in place of which it is Bond Street or Brighton, both within and without.'

Inveraray's 'peasants live in wretched cabins, and seem very poor', according to Smollett, though the town outside the castle walls 'stands immediately under the protection of the duke of Argyle, who is a mighty prince in this part of Scotland'. It was to remedy this privation and to assert their princely might that Duke Archibald and his successor conceived a project to demolish the old town east of the castle and to build new housing with model industries and fisheries. Medieval castles had been erected to control and intimidate a countryside; the new castles that were most effective as power houses were integrated with nearby exercises in town development. Inveraray spawned many imitations. Even before Douglas Castle in Lanarkshire burnt down in 1758, the Duke of Douglas, who had fought beside Argyll at the Battle of Sheriffmuir in 1715 and remained a political ally, had instructed the Adam brothers to design a new castle on the model of Inveraray, but (supposedly) ten feet larger in every dimension (its demolition was completed as recently as 1961 by the future

prime minister, Lord Home). After 1770 Robert Adam developed a Roman castel-
lated style of architecture influenced by his early work at Inveraray: Culzean Castle
for Lord Cassilis in Ayrshire and Mauldslie Castle in Lanarkshire for Lord Hyndford
are examples. His unexecuted design for Brampton Bryan in Herefordshire is a
marchlands fortress with none of the toy-fort frivolity of Inveraray.

ALNWICK AND THE DUCHESS OF NORTHUMBERLAND

A more flippant border fortress than the Brampton Bryan project is the
Northumbrian castle at Alnwick. This had been owned continuously by the Percy
family since William de Percy came to England as part of the Norman Conquest
before dying on the First Crusade in 1096. A descendant was summoned to
Parliament as a baron in 1299, and the fourth baron was created Earl of
Northumberland at the coronation of King Richard II in 1377. This earl's son, Harry

*Canaletto's view of the dereliction at Alnwick before the Northumberlands'
restoration of the old border castle. The newly created Duke and Duchess undertook
a sumptuous act of reverence to their ancestors even if it was historically incorrect.*

Percy, nicknamed Hotspur, was a great military commander whose exploits were celebrated by Shakespeare in *King Henry the Fourth, Part One*. The male line of the family became extinct in 1670. The last earl's heiress married the sixth Duke of Somerset, known as the Proud Duke. He was so inflated with rank and genealogies that when, in old age, his second wife tapped him with her fan to gain his attention, he rebuked her: 'Madam, my first Duchess was a Percy, and she never took such a liberty.' He insisted that his children always stand in his presence, and disinherited a daughter whom he discovered to have sat while he was asleep. The Proud Duke's granddaughter married in 1740 Sir Hugh Smithson, a Yorkshire baronet, whose family had been ennobled as recently as 1660 on the basis of money originating from a haberdasher's shop in Cheapside. Four years later her brother's unexpected death transformed her into a great heiress. In 1749 the ancient Northumberland earldom was revived for her father, with a special remainder so that it passed on his death in 1750 to Smithson, who took the name of Percy. In 1753 the reinvented Smithson became Lord-Lieutenant of Northumberland, and afterwards of Middlesex too; having been Viceroy of Ireland in 1763–65, he was created Duke of Northumberland in 1766. 'They live in a most princely manner', James Boswell wrote after attending a sumptuous reception for over 300 guests at Northumberland House in London in 1762. 'They keep up the true figure of old English nobility.'

The pretensions of these new Northumberlands as authentic Percys were much mocked. 'That great vulgar Countess has been laid up with a hurt on her leg,' Horace Walpole gossiped in 1759:

> The Duchess of Grafton asked if it was true that Lady Rebecca Poulett kicked her? – 'Kicked me, Madam! When did you ever hear of a Percy that took a kick?' . . . Lord March making them a visit this summer at Alnwick-castle, my Lord received him at the gate, and said, 'I believe, my Lord, this is the first time that ever a Douglas and a Percy met here in friendship' – think of this from a Smithson to a true Douglas.

The building of Northumberland Avenue connecting Whitehall to the Thames led to her being teased in some newspapers as 'the Duchess of Charing Cross'. This butt of metropolitan mockery had a taste for Salvatorian views and gothic excitement. Visiting the Northumbrian Dunstanburgh Castle in 1760, she wrote, 'Tho almost entirely a Ruin there is from its immense Size . . . and its situation on a high Black

perpendicular Rock over the Sea, which washes three sides of it, something stupendous, magnificent in its appearance.' Dunstanburgh's 'Grandeur' that day 'was greatly augmented by a stormy NE Wind which made the waves Mountain High clash foaming and soaring against its Walls & made a scene of Glorious Horror & terrible Delight!' Her reaction may have been excited by a famous passage in Edmund Burke's *Philosophical Enquiry into the Origin of Our Ideas of the Sublime and Beautiful*, which had caused a great stir in society on its publication three years earlier:

> Whatever is fitted in any sort to excite the ideas of pain and danger, that is to say, whatever is in any sort terrible, or is conversant about terrible objects, or operates in a manner analogous to terror, is a source of the *sublime*; that is, it is productive of the strongest emotions that the mind is capable of feeling,

Burke declared:

> When danger or pain press too nearly, they are incapable of giving any delight, and are simply terrible; but at certain distances, and with certain modifications, they may be, and they are, delightful, as we every day experience.

Hence the novelty of a duchess standing on a storm-blasted promontory of the North Sea enraptured by terror.

The Percy estates had been neglected for half a century, and their castles at Warkworth and Alnwick were as decayed as Inveraray. The newly created Northumberlands began reinstating Alnwick soon after inheriting the property. By 1756 a full scheme of renovation was under way. The site and intentions of the owners alike required a venture in picturesque gothic. They sought to restore the prestige of savagery. 'The Castle is very gracious, and stands on the brow of a hill; it was formerly very strong,' Tom Lyttelton reported in 1759. 'Instead of using the modern stile of architecture' it had been restored 'for the most part as it was in Harry Percy's time', but with a few rooms 'much enlarged and fitted very handsomely in the Gothick stile'. Robert Adam undertook the gothic ornamentation of the interiors: as at Inveraray, its frivolity was uncongenial to the Victorians; after 1854 the fourth Duke spent a quarter of a million pounds rebuilding and redecorating with a more historically correct interior. The improvements and public buildings in the town

begun by the Northumberlands at this time have ensured that in appearance and actuality Alnwick in the twentieth century has remained a ducal town standing outside the ducal castle gates. The castle grounds were adorned with a gothic bridge over the Aln, the Brizlee Tower (designed by Robert Adam) erected in 1777 on the highest point of the park and other superb ornamentation in a landscape refashioned by Capability Brown. The duchess's satisfaction with Alnwick's new gothic imagery is clear from her own description of 'a Grand Entertainment . . . where the number of dishes served up was 177 exclusive of the Desert' held in 1770 for a visiting royal prince, the Duke of Cumberland: 'the magnificence and Hospitality display'd on this occasion at Alnwick Castle by its present illustrious possessors, gave a striking picture of the state & Splendor of our ancient Barons & revived the remembrance of their great progenitors the former Earls of Northumberland.'

The Comtesse de Boigne, who admired the new castle, noted that the Northumberlands 'used to ring a large bell to give notice they were at Alnwick and that their hall was open to any guest who had a claim to sit at their table'. As a Frenchwoman of the *ancien régime*, she reflected, 'notwithstanding the equality which the English law professes, England is the one country in the world where feudal customs are most readily maintained and seem to be held in affection'. This was exactly the impression the Smithson Northumberlands wanted their new power house to create, but other English aristocrats were not so easily duped. Lady Holland in 1798 reported:

> Alnwick, on the outside, revives the recollection of all one has heard of baronial splendour, battlements, towers, gateways, portcullis, etc., immense courts, thick walls, and everything demonstrative of savage, solitary, brutal power and magnitude. The late Duchess *built* the present fabric upon the site of the primitive castle, but much is from traditional guess. The inside corresponds but feebly with the outward promise; the whole is fitted up in a tinsel, gingerbread taste rather adapted to a theatrical representation.

The spirit of emulation that had stimulated Lyttelton and Stamford at Hagley and Enville, and the harsher needs of county magnates from their power houses, resulted in a spate of castle-building in late-eighteenth-century Northumberland. The second family of the county after the Percys were the Delavals. Sir John Hussey Delaval had his seat, Ford Castle, gothicised in emulation of Alnwick in the 1760s; his cousin Sir

Francis Blake converted the tower house at Fowberry into a gothic mansion after 1776. There were also more domestic imitations, such as the irregular castellated house, Ewart Park, designed in 1787–90 by Count Horace St Paul for himself.

LORD DORCHESTER'S MILTON ABBEY

Medievalism was enlisted to provide political legitimacy for the Smithsons based on their Percy lineage. Napoleon Bonaparte's coronation as Emperor in 1804, with its 'mummery' and abuse of the insignia of Charlemagne, is perhaps the most grotesque attempt of a *nouveau riche* to establish bogus credentials and fictional hereditary rights. With the arrogance of the self-made man, Napoleon, after he was anointed by the Pope, placed the crown on his own head as emphasis that sovereignty, as a power originating in itself, is self-determined and admits no controls. Eighteenth-century English gothic architecture had its own petty Napoleon in

The medieval abbey church at Milton, with Lord Dorchester's eighteenth-century gothic revival mansion attached, resembles a tableau set in a Dorset valley. The market town demolished by Lord Dorchester lay in the slopes behind the abbey.

Joseph Damer (1718–98). The Damer family was launched by a Cromwellian soldier who made a fortune in Ireland by usury and land speculation. His nephew and heir married the niece of Awnsham Churchill, MP for Dorchester and the greatest stationer of his time, and later also represented Dorchester in Parliament. His son Joseph Damer in 1742 married the daughter of the Duke of Dorset. When the couple visited Italy in 1750, Walpole wrote of them: 'He is moderately sensible, immoderately proud, self-sufficient and whimsical. She is very sensible, has even humour, if the excessive reserve and silence that she draws from both father and mother would let her . . . show it.' Damer adored his wife, was bereft by her death in 1775 and erected a dramatic, almost histrionic monument to her memory in the church at Milton Abbas in which he is depicted lying beside her recumbent effigy, half-raised by leaning on his elbow, gazing down inconsolably at her. There is a touching epitaph to 'the wisest and most lovely, the best and most virtuous of women'.

In 1752 Damer bought the Milton Abbey estate in Dorset, and the following year was created Baron Milton in the Irish peerage. He obtained a seat in the English House of Lords under a new patent as Baron Milton, of Milton Abbey, in 1762, but a few years later 'endeavoured to erect himself into the representative of the ancient Barons Damory', a Plantagenet peerage that had been dormant since the fourteenth century. Sir Nathaniel Wraxall wrote of this Lord Milton that 'his very appearance conveyed an idea of "dry and bald antiquity", misanthropy and inaccessibility; but when he occasionally unbent himself in select society, his conversation was interesting, often witty, and sometimes cheerful'. Eventually he was created Earl of Dorchester in 1792, but was frustrated in his dynastic ambitions: his eldest son shot himself in a tavern in Covent Garden, having partied until three in the morning with four whores and a blind fiddler; the next son, George, the second and last earl, commemorated by Wraxall as 'one of the most engaging, lively but eccentric noblemen of his time', never married. Indeed, while drinking in Rome in 1765 George Damer was involved with Sir Thomas Gascoigne in a scandal caused by their sexual overtures to a servant. 'Exacting such offices from their coachman as the *valets de place* only are used to render, and meeting with an opposition that wine and lust could not bear, a violent skirmish ensued.' One Roman was killed; George Damer's reputation would have been destroyed if the dead man had not been Italian.

Lord Dorchester's first architectural venture (when he was still Lord Milton) was a town house on Park Lane, where he lived such a secluded life that it was nick-

named 'Milton's Paradise Lost'. The Dorchester Hotel now stands on the site. Oscar Wilde's description of another plutocrat with a house in Park Lane gives a vivid sense of a London power house:

> he led me through his wonderful picture gallery, showed me his tapestries, his enamels, his jewels, his carved ivories, made me wonder at the strange loveliness of the luxury in which he lived; and then told me that luxury was nothing but a background, a painted scene in a play, and that power, power over other men, power over the world, was the one thing worth having, the one supreme pleasure worth knowing, the one joy one never tired of.

When Dorchester's Hyde Park palace was completed in 1770, he began improving his country property. 'At his seat of Milton Abbey in Dorsetshire, where he maintained a gloomy and sequestered splendour,' as Wraxall described, 'he had made immense landed purchases, which, exhausting his pecuniary means, extensive as they were, reduced him to a species of temporary distress.'

He employed William Chambers (who had worked on the Park Lane house) to create a romantic mansion which was a mixture of gothic, perpendicular and 'Hindoo'. It is possible, even probable, that Chambers adapted plans previously made for Lord Dorchester by an architect called John Vardy, who had been a close associate of William Kent. Certainly, as John Harris has noted, there are unexecuted designs for Milton Abbey bearing a striking resemblance to Kent's work at Esher. Chambers was a suave conservative architect with little affinity for the gothic style, which was surely chosen by Dorchester to reflect his fabulous pedigree from the Damorys and to emphasise his connections with the Dukes of Dorset. The gothic exterior harmonised with the abbot's hall dating from 1498, which was appended to the new mansion as one side of a pretty inner courtyard. Chambers resigned in 1774 – 'unfortunately for me', he lamented to Lord Pembroke, 'I have these three or four years past been building a Cursed Gothick house for this unmannerly, Imperious Lord, who has treated me as he does everybody ill' – and was replaced by James Wyatt. Though Wyatt restored the old abbey, its monastic buildings were demolished, monuments were removed, inscriptions were erased, stonework was whitewashed and the graveyard was levelled before its incorporation into Lord Dorchester's garden.

The churchyard at the south end of the abbey opened into the streets of Milton

Abbas, a little market town which seemed a disagreeable encroachment to Lord Dorchester. For over twenty years he strove with all the aggression of *arriviste* nobility towards commoners to acquire all the leases so he could demolish the town. Finally, in the early 1780s, the inhabitants were forcibly moved to a new site running up an adjacent hill but hidden from the house by a well-planted ridge. One inhabitant, a lawyer, refused to leave, and Lord Dorchester ordered that the hatches of the abbot's pond above the town be opened so as to flood him out. The old town was then obliterated. Such behaviour was not unprecedented, for Lord Cobham had removed the inhabitants of Stowe to a neighbouring village, and in the 1760s Lord Harcourt had shifted the villagers of Nuneham Courtenay from proximity to his new house; but Lord Dorchester stamped his power on his surroundings more aggressively by appropiating a town. When the old Tregonwell almshouses were re-erected on the new site in 1779, Dorchester replaced the founder's coat of arms with his own. Vexed by the boys of the grammar school adjacent to his house who raided his fruit-gardens, threw stones down his chimneys and stole fowl eggs to rear cocks for cock-fighting, in 1784 he introduced a bill in the House of Lords to force the removal of the school to Dorchester ten miles away; eventually it was resettled at Blandford, thus destroying its foundation purposes. Materials from the old abbey tithe barn were used to build a new gothic church designed by Wyatt and completed in 1786. The site of the townsmen's houses was dug into a fish-pond designed by Capability Brown, who refashioned the landscape into a picture of sylvan beauty. By 1790 the estate was surrounded by over five miles of park wall and contained more than ten miles of carriage drives. Around that date Dorchester erected a new ruin on the edge of a wood across the lawn from his house, complete with a turret and a dead Salvatorian tree. The overall effect was so impressive that King George III was twice drawn to visit the house (in 1794 and 1804). Dorchester's taste has a cinematic quality: his house was used as the film location of *The Browning Version* (1994); the film-set artificiality of the new town, with its thatched cottages originally set among chestnut trees, looks so carefully staged that it is used for television advertisements evoking stereotypical small-town perfection (though advertisers exclude the sumptuously aristocratic view down the main street towards Brown's lake and woodland).

Goldsmith's poem *The Deserted Village* was published in 1770, before Dorchester had made his impact on Milton Abbas, and was chiefly inspired by the poet's obser-

vations in Ireland. Its famous attack on 'unwieldy wealth and cumbrous pomp' was nevertheless often directed at Lord Dorchester:

> Ill fares the land, to hastening ills a prey,
> Where wealth accumulates and men decay;
> Princes and lords may flourish or may fade;
> A breath can make them as a breath has made;
> But a bold peasantry, their country's pride,
> When once destroyed, can never be supplied.

There are two extenuations of Dorchester's behaviour. The old market town of Milton Abbas was certainly damp, and probably foul, and understandably he preferred sham but picturesque medievalism over the authentic and sordid. As Arthur Young noted when travelling in the Dordogne: 'The view of Brive from the hill is so fine, that it gives the expectation of a beautiful little town, and the gaiety of the environs encourages the idea; but on entering, such a contrast is found as disgusts completely. Close, ill-built, crooked, dirty stinking streets exclude the sun, and almost the air, from every habitation.' In other ways Dorchester showed foresight in moving the town. The Marquess of Lincolnshire's decision in 1896 to sell his theatrically gothic Wycombe Abbey in Buckinghamshire (also James Wyatt's work), and to move a few hundred yards to Daws Hill House on higher ground, was surely prompted by the encroachments of the town of High Wycombe: his rose-garden has since been appropiated for a *périphérique* which has never succeeded in alleviating traffic-jams.

Inveraray and Alnwick were in the castle style, but the more literary minded gothic architecture of Walpole or Shenstone inclined to cloistered monasticism. The havering among eighteenth-century gothic revivalists between emulating the medieval castle or the medieval abbey was never more excruciating than at Milton Abbey. Pevsner found a 'glaring disparity' between the horizontality of Milton Abbey and the adjacent lofty church. He thought too that the stone-colours and windows of the two buildings jarred so that Dorchester's gothicisms looked irrelevant. These strictures underestimate the visual power of Dorchester's scheme. Arthur Oswald considered Milton Abbey 'one of the best examples of 18th-century Gothic', and described its impact on a visit in 1957: 'a medieval abbey, deprived of its original context and left to stand in romantic isolation beside an 18th-century

Gothick mansion, was made the centrepiece of a contrived landscape of breathtaking beauty . . . One rubs one's eyes and asks: "Can this be real, or is it a piece of stage scenery?"' The soft Dorset plain where Milton Abbey lies prevents it from being as potent a symbol as Inveraray or Alnwick of the dominance of a warring nobility; but it is sublimely theatrical.

THE LOWTHERS

Lord Dorchester is a gothic figure: an absolutist who required untrammelled power in his demesne and whose unbridled passion for domination brought destruction. A similarly ruthless proprietor was Sir James Lowther, afterwards created Earl of Lonsdale, for whom in 1766 Robert Adam undertook Whitehaven Castle. He had been reckoned the richest commoner in England, with huge mineral-rich estates in Westmorland and Cumberland as well as plantations in Barbados. Nicknamed 'Wicked Jimmy', the 'Bad Earl', the 'Tyrant of the North' and 'Jimmy Grasp-All, Earl of Toadstool', he pursued with furious tenacity his ambition to control all the parliamentary seats of Cumberland and Westmorland, of both of which counties he was lord-lieutenant. He was, however, in Wraxall's description, 'tyrannical, overbearing, violent, and frequently under no restraint of temper or reason'. Lonsdale was both as capricious and as extravagant in his grief as Dorchester: he constructed a mausoleum for his mistress at Paddington, where he often went to gaze at her embalmed corpse in its coffin with a glass placed over her face. He resembled Mrs Radcliffe's villain Montoni in *The Mysteries of Udolpho*, projecting 'a decisive and haughty air, which, while it imposed submission on weak and timid minds, roused the fierce hatred of strong ones. He had, of course, many and bitter enemies; but the rancour of their hatred proved the degree of his power; and, as power was his chief aim, he gloried more in such hatred, than it was possible he could in being esteemed.'

His castle was used to enforce his power and to glory in arousing enmities: the 'earth, air, fire and water at Whitehaven' belonged to him, so he boasted. When the town's electorate did not vote as he had directed in a notorious election of 1768, he threatened to shut the collieries on which it depended for prosperity before settling on a more theatrical punishment. He resolved to leave his new castle vacant and undecorated. Tradesmen waited in vain for orders; their neighbours languished without employment serving the castle and its grounds. Whitehaven's townsfolk

learnt their lesson from this, and in the election of 1774 redeemed themselves in their lord's favour. He signalled his victory, and assured the future prosperity of the townsfolk, by summoning his French cook and commanding the horrified man to serve dinner for sixty guests at Whitehaven Castle next day.

Lonsdale's heir William Lowther inherited the estates in 1802, and in 1806 (shortly before the earldom was revived in his favour) commissioned Smirke to design a new Lowther Castle. Smirke's building was influenced by Inveraray and gloriously apostrophised by Wordsworth:

> Lowther! in thy majestic Pile are seen
> Cathedral pomp and grace, in apt accord
> With the baronial castle's sterner mien;
> Union significant of God adored,
> And charters won and guarded by the sword
> Of ancient honour; whence that goodly state
> Of polity which wise men venerate,
> And will maintain, if God his help afford.
> Hourly the democratic torrent swells;
> For airy promises and hopes suborned
> The strength of backward-looking thoughts is scorned.
> Fall if ye must, ye Towers and Pinnacles,
> With what ye symbolise.

Modern castle-building had come a long way from the teasing dissent of Newdigate's rococo gothic at Arbury to this implacable modern power house for the Lowthers.

They are come to tear me to pieces

To be feared is to fear: no one has been able to strike terror into others
and at the same time enjoy peace of mind himself.
Seneca

When God makes a great man he intends all others to crush him.
Arthur Hugh Clough

A leader is a man who needs others.
Paul Valéry

IRISH GOTHIC

Ireland had a specially gothic atmosphere under the last 150 years of English rule
until 1922. 'If I possess any talent, it is that of darkening the gloomy, and of deepen-
ing the sad; of painting life in extremes, and representing those struggles of passion
when the soul trembles on the verge of the unlawful,' the Irish gothic novelist
Maturin wrote in the dedication of *The Milesian Chief* (1812).

> I have tried to apply these powers to the scenes of actual life: and I have cho-
> sen my own country for the scene, because I believe it is the only country on
> earth where, from the strange existing opposition of religion, politics and
> manners, the extremes of refinement and barbarism are united, and the most
> wild and incredible situations of romantic story are hourly passing before
> modern eyes.

There was no more intense demand for flamboyantly romantic castles, with towers
symbolising the strength of backward-looking thoughts, than in Ireland. Yet there
was no country where the gothic revival was less enduring in its effects. 'The craze
for building sham castles . . . caught on there with special intensity, and the Irish

countryside is still liberally scattered with the results, some burnt out, some crumbling, and only a few still privately lived in,' as Mark Girouard wrote in 1962. 'It is a common enough experience to see, through a gap in the hedge along these long empty roads, a crazy distant silhouette of towers and battlements that develops, on further inspection, into a gutted carcass, heavy with ivy and inhabited only by rooks and crows.'

Ireland was an extreme case. 'The whole power and prosperity of the country has been conferred by successive monarchs upon an English colony, composed of three sets of English adventurers, who poured into this country at the termination of three successive rebellions,' as the eighteenth-century Irish Lord Chancellor John FitzGibbon, Earl of Clare, described. 'Confiscation is their common title, and from their first settlement they have been hemmed in on every side by the old inhabitants of the island, brooding over their discontents in sullen indignation.' The Earl of Moira, an Irish landowner who became a great military commander, colonial administrator and finally Marquess of Hastings, told his fellow peers in 1798 that Ireland was suffering 'the most absurd as well as the most disgusting tyranny that any nation ever groaned under'. In this environment the sovereignty symbolised by crenellations and towers was rejected; Irish tenants would not accept that landowners deserved their power and attacked the image of the power house.

Foul weather in 1796 foiled the attempted landing in Ireland of a French invasionary force led by the Irishman Theobald Wolfe Tone which intended to support a revolutionary uprising and expel the English from Ireland. This abortive revolution was followed by the Irish uprising of 1798 which members of both Irish houses of parliament strove to make into a religious war. The fact that in the general distress 30,000 people (mainly peasantry) lost their lives, a death-rate nearly as severe as in the French terror of 1793–94, was, according to the Irish viceroy, Marquess Cornwallis, only partly attributable to the 'ferocity of our troops who delight in murder'. As Cornwallis reported to the Duke of Portland in July 1798:

The principal persons of this country . . . would pursue measures that could only terminate in the extirpation of the greater number of the inhabitants and in the utter destruction of the country. The words Papists and Priests are for ever in their mouths, and by their unaccountable policy they would drive four-fifths of the community into unreconciliable rebellion; and in their

warmth they lose sight of the real cause of the present mischief, of that deep-laid conspiracy to revolutionize Ireland on the principles, which was originally formed . . . by men who had no thought of religion but to destroy it.

Reprisals after the rebellion took as many lives as the civil war itself. Cornwallis had forty-five British generals under his command and 140,000 troops (of whom about half were regular soldiers) at his disposal. This represented huge military power: the Duke of Wellington commanded only 26,000 British troops at the battle of Waterloo. 'All good Protestants', wrote the Marquess of Buckingham, who had been one of Cornwallis's predecessors, considered Catholic extermination 'the only cure for the present and the only sure preventive for the future'.

The naïve fantasies surrounding the Irish nobility were encapsulated by a church epitaph recalled by Lord D'Abernon:

> Bland, passionate and deeply religious
> He was second cousin to the Earl of Cork
> And of such is the Kingdom of Heaven.

But fantasies – whether architectural or genealogical – were inadequate for the exigent reality of military occupation. 'The castle is of that modern antique so much followed in these days, though not quite appropriate to modern times,' wrote a tourist in 1814, describing Slane in County Meath, built to the designs of James Wyatt for Lord Conyngham in the 1780s. 'Feudal grandeur had a sort of wild magnificence in its abode we can no longer see. The powdered footman ill replaces the armed esquire, or soldier ready for war. The private gentleman, or the noble modestly dressed, are not substitutes for the war-like and haughty baron in armour, and his dames gorgeously apparelled. The ancient picturesque of the inhabitants, and of the interior and environs of the castle, no more exists. A century or two hence some of these buildings may make fine ruins.' The castle effect at Slane was chiefly exterior; the interior was classical and symmetrical except for a library which is notable as the first gothic interior in a neo-gothic Irish castle. (Castleward and Moore Abbey, both built in the 1760s, contained gothic rooms, but were houses influenced by gothic revivalism rather than sham fortresses.)

CHARLEVILLE FOREST

Francis Johnston designed Ireland's most spectacular gothic-picturesque castle, Charleville Forest, near Tullamore, built in 1800–12 for Charles William Bury, first Earl of Charleville (1764–1835). With estates in Offaly producing rents annually from ten to fifteen thousand pounds, this nobleman's importance in the Anglo-Irish ascendancy was indicated by his being created Baron Tullamore in 1797, Viscount Charleville in 1800 and earl in 1806. He was an amiable dilettante who caused a thrill in the late 1790s by translating a licentious poem by Voltaire about Joan of Arc. His studious temper was indicated by his election as a Fellow of the Royal Society in 1803 and as President of the Royal Academy of Ireland in 1812. Lady Sarah Lennox was unimpressed by the earl's 'whimsical capricious mind' but admired his wife: 'tho' her manners were Irish & not exactly the *sort* that pleased my sister & me, but after many years' acquaintance the excellence of her heart, her sense, her wit, & friendship, has compleatly attached us to her . . . They are *very rich*, tollerably *recherché* in London, & want no help in worldly affairs.' Lady Charleville's sister had married into the Languedoc nobility, and she herself spent some time in the vicinity of Carcassonne and Toulouse around 1779. Her whimsically distorted memories of Carcassonne and the Cathar castles of southern France perhaps influenced the design of her husband's castle.

It was the Charlevilles' intention, as the earl recorded,

> to exhibit specimens of Gothic architecture, as collected from Cathedrals and Chapel-tombs, and to show how they may be apply'd to Chimney Pieces, Ceilings, windows, balustrades, &c . . . I did not mean to make my House so Gothic as to exclude convenience and modern refinements in luxury. The design of the inside and outside are strictly ancient, but the decorations are modern.

(Typically, what was intended by the earl as a memorandum to record his architectural ideas digresses into rambling remarks on Irish wolfhound breeding and on the dangers of eating French mushrooms.) After receiving his earldom in 1806, Charleville aspired to the higher rank of a marquessate: the glamour of his castle-building was partly intended to serve this aspiration. His reasons for castle-building were similar to those of Argyll at Inveraray at the time of the 1745 uprising. During

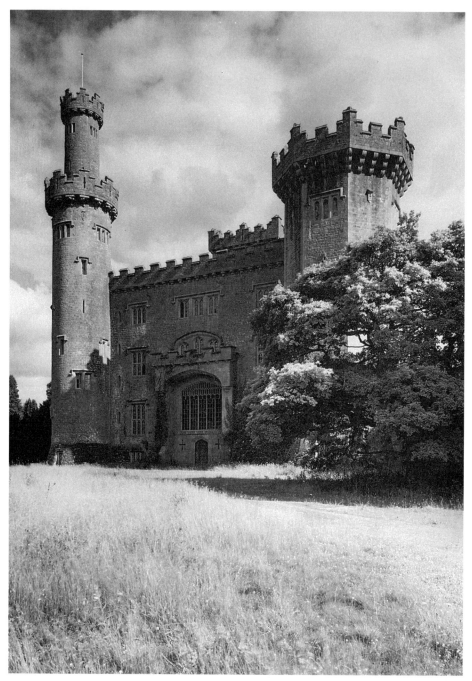

The entrance of Charleville Forest. Unlike many Irish gothic revival castles, it has both exterior stonework and interior decoration of superb quality. The cathedral pomp and grace of some of its details alleviate the stern baronial brutality of its towers and castellations.

the rebellion of 1798 the earl had acted as a district general; in 1806 another 'affray at Tullamoore' gave continuing 'proof of the discontented spirit of poor Paddy'. Charleville's presence in his district supposedly 'saved much mischief' at a time when, as one of his wife's friends noted, 'Buonaparte's extraordinary successes on the Continent make one fear everything, and . . . he is not without a squint towards Ireland'.

Approached by a bridge over the sluggish river Clodiagh, the castle stands in level country about a mile from Tullamore. The surrounding countryside was dull and unprolific, so that Lord Charleville's rich parkland, 'which unites all the essentials for landscape gardening in wood [and] ornamental water', was a constant visual reminder of his lordship over nature, his power, privilege and discrimination. The castle itself is a high, square, battlemented block with a tower at each corner. That in the north-west corner is a high octagonal tower crowned by a heavily machicolated battlements supported by four massive corbels. The north-east tower

The gallery at Charleville Forest is just one component in the interior.
Overall, it remains the superior gothic revival castle of all Ireland.

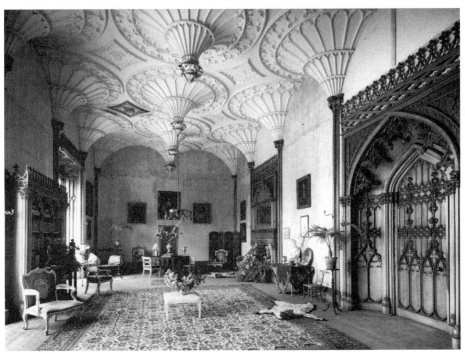

is slender, graceful and round, rising to a height of 125 feet and resembling a castellated lighthouse. From the centre of the block rises a lantern-like tower crowned with battlements reminiscent of Inveraray. The entrance door of the northern front is under a massive, battlemented porch, rising half the height of the building and including a large gothic window. The entire building is of beautiful stone hewn from a quarry in the castle grounds. As Mark Bence-Jones described after a visit,

> to the right of the entrance front, and giving picturesque variety to the composition, is a long, low range of battlemented offices, including a tower with pinnacles and a gateway. The garden front is flanked by square turrets. The interior is as dramatic and well-finished as the exterior . . . a vast saloon or gallery running the whole length of the garden front . . . is one of the most splendid Gothic revival interiors in Ireland.

According to another twentieth-century visitor, the massive octagonal tower rears up like some 'diplodicus or arsinoitherium of many million years back, intent to break, uproot or swallow the lighter, seemlier, more recent fabric just beyond it . . . preluding a carnival of brute force'.

The Charlevilles, like Argyll, Northumberland and Lonsdale in their domains, developed the nearby town of Tullamore, showing (unlike Lord Dorchester at Milton) a proprietorial willingness to compromise their property interests. The second earl, nicknamed Lumpy, was an eager young man who degenerated, in Creevey's words, into 'by far the greatest bore the world can produce'. By the time of his inheritance in 1835 Irish landowners were being edged into dispossession and often retreating into solitary obsessions. Lumpy suffered a more macabre doom. He not only endured bankruptcy in 1844, but also contracted syphilis which, like the hereditary taints in the American gothic of Poe and Faulkner, led to the extinction of his race. Lumpy Charleville died at the age of fifty under a mad-doctor's restraint, at Moorcroft House, Hillingdon, in 1851, of certified 'Mania 1¼ years General Paralysis Epilepsy 1 year'. General paralysis was a description of the cerebral disease characteristic of tertiary syphilis, which he evidently transmitted to his descendants: his eldest son, Charles, the third earl, died in 1859 at Charleville Forest, aged thirty-six (and had sons who died aged twenty-two and seventeen); the second son, John James Bury, also died aged thirty-six, at St Thomas's Hospital for Lunatics in Devon in 1864 of certified 'Brain Disease'; and the third and youngest son, Alfred,

who had recently succeeded his nephew as fifth and last earl of Charleville, died at 2 Oriental Terrace, Brighton, of certified 'gouty degeneration of the kidneys' and a dropsy which had grotesquely puffed up the flesh of his limbs, in 1875. This heavy mortality among the male Charlevilles is highly suggestive of congenital syphilitic infection: it was a tragedy which nothing could mitigate, a waste of human life that no powers could relieve, and during that quarter century, as the Charlevilles one by one died out, haunted like gothic victims by some historic transgression, the bitterness of their experiences must have been made all the more poignant by the beauty of their surroundings.

Just as Hagley had inspired the emulative efforts of Lord Stamford at Enville, so Charleville Forest was locally imitated. Sir Laurence Parsons had in 1620 been granted the castle, fort and land of Birr (the town was later renamed Parsonstown), which descended to his namesake Laurence Parsons (after 1807, second Earl of Rosse). This Parsons supported Roman Catholic emancipation and opposed the Act of Union with England. He so interested Theobald Wolfe Tone in the cause of Irish independence that in 1795 the young lawyer sailed for America and then Paris in order to organise resistance to English control of Ireland; with French support, Tone started an Irish rebellion in 1798, but was captured and cut his throat in prison. Laurence Parsons, more discreetly, turned to architecture to sweeten his political bitterness. After 1801, prompted by the rising masterpiece nearby at Charleville Forest, he enlarged and gothicised his castle according to his own ideas. The resultant Birr Castle is immortalised as 'Kinalty Castle', the scene of Henry Green's novel *Loving* (1945), a vast grey building of blind gothic windows, filled with treasures, threatened with arson by the IRA, the setting for adulterous episodes and the domain of sly, conspiring servants. Birr Castle was a perfect setting for this melancholy, amorous, poetic yet grimly realistic novel, as Rosamond Lehmann noted in 1954 in a paean to Henry Green: 'What a world of human reality in terms of human passions he gradually discloses; what intrigues, pathos, lunacy, moral squalor, homesickness; what passes, grim and comic, his characters are brought to by their fears and guilts and loyalties; how dementedly they struggle for security, and above all, for love!' Green gives Kinalty, too, the little residual exoticisms that suit the gothic picturesque: a gold-wire hammock suspended between black marble columns, a cow byre of gilded wood and a miniature Leaning Tower of Pisa dovecot.

MITCHELSTOWN CASTLE

Castles indeed are places for intrigues, pathos, lunacy, ignominy and illusory security. The family inhabiting the gothic revival castle of Mitchelstown in County Cork exemplifies the gothic degeneration of Poe's *The Fall of the House of Usher* and the enlistment of gothic architecture in fantasy power houses. Sir Robert King, the fourth baronet, a rich, vicious rake, eloped in 1747 with a girl just sixteen. Her father caught up with them and, holding a pistol to King's head, swore to kill him unless they instantly marry. A parson was ready, but King's servants broke in and gave him a pistol, with which he forced his escape. Two years later, in 1749, at the episcopal palace of Elphin in Roscommon, King, recently created Lord Kingsborough, importuned a little girl called Nancy Mahon: 'I was not by,' reported the bishop, 'Gothic' Synge. 'Her father was and run for it.' This debaucher's brother and heir Edward was promoted to be Earl of Kingston in 1768. Edward's son Robert, afterwards second Earl of Kingston (1754–99) but known as Lord Kingsborough until his father's death in 1797, married his cousin, Caroline FitzGerald, heiress of a tract of land around Mitchelstown in County Cork sixteen miles long and up to ten miles wide. This property was inherited from her grandfather, the last Lord Kingston of the first creation, to whom it had descended through the female line from Edmund FitzGibbon, known as the White Knight, a cruel and vindictive Geraldine chieftain who had been confirmed in the land during the reign of Queen Elizabeth. Robert Kingsborough's bride was possibly as young as twelve when they married; he was sixteen. 'The tutor and governess received the strictest instructions to watch the young couple most narrowly, and to prevent every possibility of a tête-à-tête,' according to gossip in 1828 at the Mitchelstown inn. 'But somehow or other . . . three years afterwards they found means to elude their vigilance, and the present Lord was the result of this little *équipée*.'

The agrarian writer Arthur Young, who was land agent to the Mitchelstown estates from 1777 until 1779, experienced his first journey to Mitchelstown like a spectator in a gallery of Salvator Rosa: 'The road leads immediately to the northern foot of the Galtees, which form the most formidable and romantic boundary imaginable; the sides are almost perpendicular, and reach a height, which, piercing the clouds, seems formed rather for the boundaries of two conflicting empires, than the property of private persons.' The culmination of the journey was his sudden view of

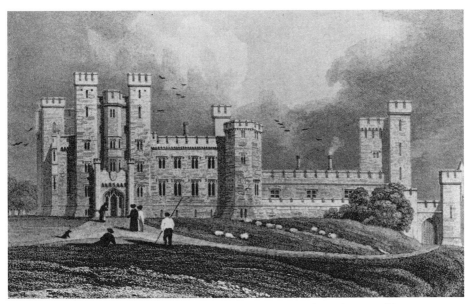

A view of Mitchelstown Castle from the east, made in the year of its completion (1825). This 'huge, ungainly and uselessly extensive' castle, as Trollope called it, failed in its feudal pretensions.

a long plain, bounded by mountains, with rivers winding through it, joining in the centre near Mitchelstown; 'I had been informed that this was a miserable place; it has at least a situation worthy of the proudest capital.' Elizabeth Bowen, who lived nearby, described the countryside in terms evoking Kent's gothic debts to Spenser: 'the *Faerie Queene* landscape stretches dazzling, etched with valleys, watched by ruins, shadow-patched by woods'. Both Young and Kingsborough were optimistic that Mitchelstown could become one of the finest properties in Europe. Young was impressed that Kingsborough, who might have been lured by metropolitan gaieties, preferred to be so constructive:

> In a country changing from licentious barbarity into civilized order, building is an object of perhaps greater consequence than may first be apparent. In a wild, or but half cultivated tract, with no better edifice than a mud cabin, what are the objects that can impress a love of order on the mind of man? He must be as wild as the roaming herds; savage as his rocky mountains; confusion, disorder, riot, having nothing better than himself to damage or destroy: but when edifices of a different solidity and character arise; when great sums

are expended, and numbers employed to rear more expressive monuments of industry and order, it is impossible but new ideas must arise, even in the uncultivated mind [so that] in proportion as the country becomes more decorated and valuable, licentiousness will be less profitable, and more odious.

Kingsborough first built a large mansion perched on a bold rock with a large walled pleasure garden, hothouses and twelve acres of nursery. A new town at Mitchelstown, which was laid out in the 1780s (and extended in the 1820s), was described by Elizabeth Bowen in 1942: 'The plan is fairly spacious – the Kingstons' taste – there are two squares and some fine perspectives of trees; almost all the houses are painted – pink of all shades, buff, lemon, pistachio green, chalk blue. When sun blazes onto the town and the mountain is in full colour, all this dazzles the eye. Mountain rains, more frequently, blot the whole scene out.'

Mary Wollstonecraft was governess to the Kingsboroughs' daughters in the late 1780s. 'Now to introduce the *castle* to you and all its inhabitants,' she wrote on arrival, her sequence reminding us how the impressiveness of a castle reduces its inhabitants. 'The castle . . . commands the kind of prospects I most admire – Near the house, literally speaking, is a cloud-capt hill.' She was less gratified by the Kingsborough daughters:

> wild Irish, unformed and not very pleasing . . . their boisterous spirits and unmeaning laughter exhausts me, not forgetting, hourly domestic bickerings – The topics of matrimony and dress take their turn – Not in a very *sentimental* style – alas, poor sentiment it has no residence here – I almost wish the girls were novel readers and romantic, I declare false refinement is better than none at all.

The absolutism of the Kingsboroughs at Mitchelstown was equally displeasing. 'The family pride which reigns here produces the worst effects – They are in general proud and mean, the servile respect that is universally paid to people of quality disgusts me, and the minute attention to propriety stops the growth of virtue.'

This meticulous attention to propriety was outraged when in 1797 the Kingsboroughs' daughter Mary eloped with a married man, Colonel Henry FitzGerald, the illegitimate son of her mother's brother. 'If all the portraits of all the heroes in all the novels that were ever written were combined to produce ideal per-

fection, the result would be inadequate as a picture of Colonel FitzGerald', according to the Comtesse de Boigne. 'His handsome face, his noble bearing, his mild and expressive features, were merely the outward signs of the admirable qualities of his heart.' Mary King fell in love with FitzGerald; he reciprocated. While journeying together from London to Ireland 'they both gave way to the passion which dominated them. I say both, for I am certain that FitzGerald no more intended to seduce Mary than she desired this flagrant abuse of confidence.' Their situation soon plummeted into one of macabre gothic tragedy. Some months later, realising that she was pregnant, she eloped with FitzGerald while staying with Lady Harcourt. 'Twelve hours afterwards Lady Harcourt, with true Methodistical zeal, had advertised her name and description on every hoarding and in every newspaper', justifying this cruel publicity with the remark, 'as she has sinned, morality demands that she should pay the penalty'. Her father and his sons discovered FitzGerald and Mary (the latter disguised as a boy) preparing to embark on the river Thames for America. 'Mary allowed herself to be taken away, but neither of them offered any answer to the abuse with which they were overwhelmed, except to say, "I am very guilty."' She was carried off at her father's command to be kept in custody awaiting the birth of her child.

Colonel FitzGerald, 'perhaps only irritated by the resistance of the family', possibly lured by a letter asking him to take the child when it was born, went in disguise to Mitchelstown, where he suspected her to be detained. He was soon recognised; Kingsborough, informed of his arrival, 'received the communication with perfect apparent indifference, and only enjoined on the informer absolute secrecy'. The next morning he went to the inn at eight, 'and desired the stranger's servant to open his master's door instantly. The man refused; on which he broke open the door with his foot, walked up to the bed in which F[itzGerald], awakened by the noise, had just raised himself, looked intently at him . . . drew a pistol from his pocket, and with perfect coolness blew out the brains of this modern Don Juan, who sank back in the bed without a groan.' This peremptory act was possible only to an absolutist: the White Knight, Lady Kingsborough's ancestor, had once hanged a personal enemy from a tree in his demesne, and had placed the Earl of Desmond in irons after seizing him in the Mitchelstown caves. 'Lady Mary', according to the Comtesse de Boigne, 'was delivered of a still-born child, and went raving mad; it was necessary to place her under forcible restraint. These fits alternated with a kind of apathetic

imbecility, but the sight of a member of her family produced an outburst of violence.'

There was much sympathy for the punitive father among the ruling class, but he was excoriated by the poor. He was still a commoner, bearing only the courtesy title of Kingsborough at the time of FitzGerald's death, but shortly afterwards his father died and when, as the second Earl of Kingston, he was prosecuted for murder, he chose trial before his peers in the form of the seventy-one members of the Irish House of Lords. His trial was such a high occasion (attended by the viceroy, the Lord Chancellor and Irish ministers) that the revolutionary National Directory of United Irishmen considered attacking the building and taking its powerful occupants as hostages. The theatricality of the trial was enhanced by Kingston dressing in deep mourning to honour the nephew he himself had shot. Sir Jonah Barrington's description of Kingston's awe-inspiring yet pantomimic trial belongs in a gothic novel:

The Peers entered, according to their rank, in full dress, and richly robed. Each man took his seat in profound silence: and even the ladies (which was rather extraordinary) were likewise still. The Chancellor, bearing a white wand, having taken the chair, the most interesting moment of all was at hand, and its approach really made me shudder.

Sir Chichester Fortescue, king-at-arms, in his parti-coloured robes, entered first, carrying the armorial bearings of the accused nobleman emblazoned on his shield: he placed himself on the left of the bar. Next entered Lord Kingston himself, in deep mourning, moving with a slow and melancholy step. His eyes were fixed on the ground; and, walking up to the bar, he was placed next to the king-at-arms, who then held his armorial shield on a level with his shoulder.

The supposed executioner then approached, bearing a large hatchet with an immense broad blade. It was painted black except within about two inches of the edge, which was of bright polished steel. Placing himself at the bar on the right of the prisoner, he raised the hatchet about as high as his Lordship's neck, but with the shining edge averted; and thus he remained during the whole of the trial. The forms, I understood, prescribed that the shining edge should be averted, until the pronouncing of judgment, when, if

it were unfavourable, the blade was instantly to be turned by the executioner *towards* the prisoner, indicating at once his sentence and his fate.

No witnesses would appear for the prosecution; accordingly every peer, by rank, in turn arose and walking slowly to the Chancellor's chair, placed his hand solemnly on his heart, and repeated 'Not guilty, upon my honour'. This ceremony took an hour, after which the Chancellor stood up, declared Kingston 'not guilty' and broke his wand.

BIG GEORGE

According to one story, Kingsborough's eldest son, George, afterwards the third earl (1771–1839), 'had married, while yet a minor, in Sicily; had already three children by his young wife, and lived completely separated from his country; when suddenly he received a most affectionate invitation from his father, who promised to forget and forgive the past'. In another version he had eloped to the West Indies with an Irishwoman. Either way, when he returned, unsuspecting, to Mitchelstown, his father sent the young mother away and disposed of their children in England. George was then quickly married to the only daughter of Stephen, first Earl Mountcashell, who lived nearby at Moore Park. Mountcashell's eldest son, Lord Kilworth, had earlier married the Kingsboroughs' eldest daughter, Margaret, commemorated as 'The Lady' by Shelley in *The Sensitive Plant*. As a young officer in the Mitchelstown Light Dragoons and a colonel of the North Cork Militia – notorious, according to Thomas Pakenham, 'for the way they had tortured and murdered their prisoners' – Big George was captured by the rebels in 1798 and in such danger of being put to death by the mob that he had to be secreted in a waterlogged hulk in Wexford harbour (Wexford at this time had declared itself an independent republic). In the following year the murderous Earl of Kingston died. The widowed countess, Big George's mother, had impressed Mary Wollstonecraft as 'very proud, and ready to take fire on the slightest occasion – her temper is violent, and anger entirely predominates in her mind'. She had become embroiled in hate-ridden litigation with her husband, and perpetuated the feud with her son, living on at Mitchelstown for nearly a quarter of a century and excluding George's powers from the place.

Big George was determined to maintain his political dominance in south-west Ireland. In 1819, when the government supported the candidature of the Earl of

Listowel's son in preference to his son, he warned Lord Clare, the Lord-Lieutenant of Limerick, that he 'must solicit *my friends* to oppose those who are friendly to the ministers in every county where I have any influence'. His mother's ancestor the White Knight grew into an obsession with him. In 1259 Thomas FitzGerald, Lord of Decies and Desmond, had created three of his sons by his second marriage hereditary knights, and thus originated the titles of the White Knight, the Knight of Glyn and the Knight of Kerry. These titles were held as prescriptive knights from medieval times, but were never regal honours. John Trotter, who visited the White Knight's tomb at Kilmallock in 1817, noted that 'the rude magnificence of these chieftains yet dazzles the people'. Big George saw his descent from the White Knight as a means to enforce his power. In 1822 he combined with two FitzGerald kinsmen in petitioning King George IV to recognise formally and make hereditary the titles of White Knight, Knight of Kerry and Knight of Glin. This was the heyday of newly ennobled men taking titles of sham antiquity. The first instances were in 1776, when the Anglo-Irish Sir Thomas Maude became Lord De Montalt and the Anglo-Irish Lord Knapton was transformed into Viscount De Vesci. There were soon other bogus-medieval peerage titles: Grey de Wilton in 1784, De Dunstanville in 1796, De Blaquiere and FitzHarris in 1800, Frankfort de Montmorency in 1816, De Tabley in 1826, before largely petering out in the 1830s with De Saumarez, De L'Isle and Dudley, De Mauley and De Freyne (Stratford de Redcliffe in 1852 and Talbot de Malahide in 1856 were final eccentric medleys of this sort). The British government, however, resisted the claims of these Irish Geraldine knights. 'One of the difficulties in the way', Sir Robert Peel warned Kingston in 1823, 'is the formal recognition by the Crown of a new species of Distinction, which it appears to me can neither be considered as a surname, or known name or Title of Dignity, nor a name of Office'. Peel thought Kingston's claim to be the White Knight through the female line was particularly bogus. This rebuff hurt Kingston. 'These old Hereditary Titles of White Knight Knight of Kerry & Knight of Glynn will remain attached to our families as long as tradition exists in Ireland & the recognizance of them by His Majesty would have been gratifying to the feelings of the people of Ireland,' he retorted to Peel in 1823. 'I shall be satisfied with the recognition of the people & that nothing can deprive me of – I am proud of the title & of the affection of the lower classes of the people to it.'

His mother finally died in January 1823, whereupon Big George took possession of Mitchelstown. He sent for the Pain brothers, former apprentices of Nash who had

been the builders when Nash designed Lough Cutra Castle in Galway for Viscount Gort (1811). 'Build me', he said, 'a castle. I am no judge of architecture; but it must be larger than any house in Ireland, and have an entrance tower named the White Knight's Tower. No delay! It is time for me to enjoy.' Big George stipulated that the new Mitchelstown Castle, which cost £100,000, be finished in two years so as to be ready if King George IV repeated his visit of 1821 to Ireland. To impress the king with his claims to feudal distinction, Kingston insisted that the main entrance, at the south end of the east front, be surmounted by a tall gatetower and this became the emphatically titled White Knight's Tower. The entrance hall itself was 93 feet long and adorned with a groined roof. Despite these architectural temptations George IV never returned to Ireland. The buildings formed three sides of a court; the open side comprised several towers, linked by a terrace, overlooking the Galtees. The interior was gothic with long galleries and chains of brocaded *salons*; but despite the earl's orders, his castle was far from the largest house in Ireland.

The German tourist Prince von Püchler-Muskau was 'sorely disappointed' by 'this much lauded edifice' on a visit in 1828. 'We were certainly shown a huge heap of stone,' he reported,

> but one ingredient was unluckily forgotten, – good taste. The building is, in the first place, much too high for its extent; the style is confused without variety; the outline, heavy, and the effects small, though the mass is great. It stands, too, on the bare turf, without the slightest picturesque break, which castles in the Gothic or kindred styles particularly need; and the inconsiderable park possessed neither a handsome group of trees nor a prospect worth describing.

Mitchelstown Castle provided the unlovely model for Desmond Court in Anthony Trollope's Irish novel, *Castle Richmond* (1860):

> It is the largest inhabited residence known in that part of the world, where rumours are afloat of how it covers ten acres of ground; how in hewing the stones for it a whole mountain was cut away; how it should have cost hundreds of thousands of pounds, only that the money was never paid by the rapacious, wicked, bloodthirsty old earl who caused it to be erected; – and how the cement was thickened with human blood.

With a gothic power house the image matters more than the reality, and Mitchelstown Castle's image was fit for an ogre:

> It is a huge place – huge, ungainly, and uselessly extensive; built at a time when, at any rate in Ireland, men considered neither beauty, aptitude, nor economy. It is three stories high, and stands round a quadrangle, in which there are two entrances opposite to each other. Nothing can be well uglier than that great paved court, in which there is not a spot of anything green, except where the damp has produced an unwholesome growth upon the stones; nothing can well be more desolate. And on the outside of the building matters are not much better.

Big George lived there in opulent splendour with a host of servants, including an under-cook called Claridge, who later founded the great Mayfair hotel. Like the Northumberlands in their new Alnwick castle, he was a baronial host. His hospitality was ritualised and theatrical, turning every visitor to his district into a guest, hoping to make strangers and foreigners at least temporarily his dependents.

Sometimes as many as 100 guests were entertained simultaneously. One of these was Lady Chatterton, who recorded an expedition to Kingston's Mountain Lodge (also known as Galty Castle). 'A most merry, scrambling party, some in carriages, some on horseback, all anticipating pleasure, and laughing at the idea of danger' started out from Mitchelstown at noon. 'The cloudy mists . . . imparted to the scene

Part of the menacing underground world once owned by Mitchelstown earls - Kingston Caves - which provided tourists with all the sensations of the gothic sublime.

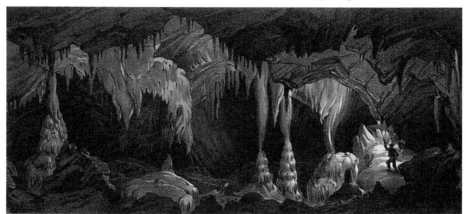

a vague and mysterious gloom in perfect keeping with its grandeur and severity.' From Mountain Lodge the party proceeded to a labyrinth of caves owned by the earl: these were perhaps the most striking caverns in the United Kingdom until the famine of 1847 when they were despoiled by stricken peasantry breaking off stalactites for sale to the gentry. The caverns had names that were picturesque – Lot's Wife, Demon's Cave, the Gallery of Arches – or proprietorial: the most beautiful chamber, perfectly straight and eighty-two yards long, with gothic-like arching and strangely coloured spar glazing, was called the Kingston Gallery. Caves called the House of Commons and the House of Lords were reminders of English political hegemony. Lady Chatterton's guide stood the pleasure party in the centre of the House of Commons and dispersed torch-bearing peasants around its edges before shouting 'to the men in Irish; and their voices reverberating in the recesses of the cavern, sounded most wild and unearthly; indeed, I have always found, that the wild eagerness of the Irish gestures and tones, inspires with a feeling of fear those who are not accustomed to them; it is almost impossible to imagine they are not quarrelling'. While the rest of the party proceeded 'to a higher tier of caves, which have been named Lord Kingston's Halls', Lady Chatterton stayed behind in the House of Commons. 'There was something peculiarly awful in the dead, still darkness of the place. The solitude was so deep – all around was so totally unlike anything I had before seen, that I almost felt as if I had been transported to some other planet, and condemned to eternal loneliness.' These terrifying subterranean passages enhanced the gothicism of Mitchelstown Castle and the Kingstons.

Around this time a manufacturer erected a chimney near the town square which was obtrusively visible from the castle. The earl sent him orders that he must demolish the chimney or go; but the manufacturer ignored this ultimatum. The new man was the first person capable of making his own fortune whom Big George had encountered: his powers had to be broken, for he presented authentic strength rather than the shadow-boxing of a man acting the part of power. Big George behaved as theatrically as Lord Lonsdale at Whitehaven. He drove into the town to speak to its men. 'I am come to wish you goodbye, boys. This place is but a small place, and there is not room in it for me and that man (pointing to the factory). He says the law is on his side, and I daresay it is. Consequently, I go to England tomorrow.' The townspeople needed Kingston in occupation at his castle as pressingly as those at Whitehaven had needed Lonsdale. As Aubrey de Vere says, 'during the

night the lord of industry received a visit from uninvited guests; the next morning no smoke went over the woods and towers, and on the third day he had taken his departure'. In gratitude Big George built a waterworks, paved the market square, built a church for the Protestants and an equally fine one for the Catholics.

Big George might as credibly have imagined himself as a Spenserian knight in combat with a monster as to have thought he could sustain his pose of feudal absolutism over his restless tenantry. Indeed, rather than making himself a figure of awe by building his new castle, he converted himself into a conspicuously alien figure to be despised, rejected, hated, even exterminated. The evocation of absolutism in Mitchelstown Castle's gothic was destroyed by the parliamentary by-election at Limerick in 1830. Kingston supported as candidate a local country gentleman who had lately built a new house suitable to his income of £10,000. It did not impress Kingston as a power house. Visiting it, he told its owner, 'The house is pretty, but what is the use of it? It is too large to hang on your watch-chain, and too small to live in.' Someone asked him how his tenants would vote. 'That matter is settled', he replied decisively. He ordered them all to ride into Limerick city on the first day of the election, and to set an example in their voting that the other fellows would follow. On election morning Kingston, with the candidate he favoured, sat in the open window of Lord Limerick's town house, quaffing champagne and chaffing the crowd. Gentlemen surged round the back of his chair. As the church bells rang and the mob cheered, the Kingston tenantry, in a mile-long procession, rode down Limerick's main street. But a few hours later the news filtered in to the throng of gentlemen behind Big George's chair that his tenants had ratted: they had voted *against* Kingston's candidate. His hangers-on did not at first dare tell him, but he sensed the tension. 'You are hiding something from me,' he exclaimed, 'something has gone wrong.' As Aubrey de Vere heard from an eye-witness, 'The Earl travelled back to his castle all night; at early dawn he reached it; . . . during the whole of that day he sat alone, speaking to none, and seen by none. Late the second night the bell of his bedroom rang without intermission, and a short time afterwards mounted couriers were scouring all parts of his estates.'

The Kingston tenantry from three counties were commanded to attend a meeting. They found Big George sitting on a dais at the end of the 93-foot-long castle gallery flanked on both sides by his agents. As more and more tenants pressed in at the door, the front of their crowd was pressed more and more up towards him. Big

George fixed them with his stern eyes and stared in dreadful silence. 'They were there to hear him: he must speak. He did not: he took the alternative, and went mad. Leaping out of his seat he threw his arms wide. *"They are come to tear me to pieces; they are come to tear me, to tear me to pieces!"* Forty-eight hours later he had been taken away.'

Committed to the care of a mad-doctor in Somerset, he was described in 1833 as 'labouring under various delusions and erroneous ideas, saying that Ireland no longer existed – that he had no property there, and that Daniel O'Connell would be with an army in the neighbourhood of Bristol in a week or two. He was unwilling to conform to any regulations, but . . . could give an opinion on the value of cattle.'

The sense of dislocation was everywhere. It destroyed Big George's sons too.

THE RUIN OF MITCHELSTOWN CASTLE

The eldest, Edward, Viscount Kingsborough, was a scholar who in 1831 published six volumes on the antiquities of Mexico; but in 1837, when his mad father was being pursued for debt, he selflessly entered a debtors' prison in Dublin, where he contracted a fatal bout of typhus. The next son, Robert, succeeded Big George as fourth earl in 1839. One night in 1848, while walking down Oxford Street in London, he bought a cigar for a young painter and glazier named George Cull, whom he then took to a gateway in Marylebone Lane. There he pounced on Cull, who afterwards charged him with indecent assault. As *The Times* reported, 'Complainant then described acts of a filthy and disgusting nature to which it is impossible for us, with regard to any decency, further to allude.' Kingston was acquitted, but became increasingly distracted. One Sunday morning in 1860 he was detained, after persistently walking down the Holyhead railway tunnel, and on his release went to Chester Cathedral, from which he was ejected after refusing to remove his hat. He was taken into police custody, and then installed in the Royal Hotel, from which on Monday morning he went naked into the street. At noon he went to the Bishop of Chester's palace where he was again insulting and again arrested. In court he made 'a long rambling statement' in which he threatened the bishop and the railway company, and boasted of powerful political friends. 'He then went on to say that his brother wanted to be married, and he had perpetrated a fraud upon him in taking possession of his estates, worth about £50,000 a year, and settled upon him a miserable pittance. It was enough, he said, to make any man insane.'

This hated brother James, who had so recently married for the first time at the age of sixty, inherited in 1867 and died in 1869, bequeathing Mitchelstown and its reduced estate to his widow, who survived another forty years. The widow soon remarried a man called William Webber, and after her death in 1909, he continued living there in indigent grandeur with his companion Minnie Fairholme. In 1912 Mitchelstown Castle still seemed 'one of the finest residences in Ireland', but the town had become notorious: during the Home Rule agitation in 1887 the police fired from their barracks on a demonstration in the square, killing three of the crowd. Crosses in the pavement marked the spots where they fell; 'Remember Mitchelstown!' became a war-cry. As a young woman Elizabeth Bowen attended a macabre garden party at Mitchelstown Castle on the day that Britain declared war on Germany, 5 August 1914: 'Wind raced around the Castle terraces, naked under the Galtees; grit blew into the ices; the band clung with some trouble to its exposed place. The tremendous news certainly made that party, which might have been rather flat.' This was not the last exciting day at Mitchelstown Castle: eight years later, in July 1922, when Willie Webber was nearly ninety, the castle was seized by Irish irregulars and burnt down. The ruin was later demolished. All that remained were a few bleached stumps on the flat ground.

Mitchelstown was a gothic power house that failed.

The dead have exhausted their power of deceiving

The most elegant, superficial, fickle and futile milieu is the one best
suited for a proper judgment of things at large.
Paul Valéry

All passions exaggerate: it is only because they exaggerate that they are passions.
Sébastien-Roch Chamfort

I lack what the English call character, by which they mean the power to refrain.
Brian Howard

MASTERS AND SERVANTS

Horace Walpole, who was a prime minister's son and the harbinger of gothic fiction, was certain that the lust for power was the most voracious and destructive of impulses. 'I have long doubted which of our passions is the strongest,' he wrote in 1780, 'but I have no doubt but that ambition is the most detestable, and the most inexcusable; for its mischiefs are by far the most extensive.' As he told Lord Strafford, 'an ambitious man must be divested of all feelings but for himself. The torment of others is the high road to happiness.' Walpole was unimpressed by images of omnipotence, and knew that power was better sustained by supple compliance than by the actions of autocratic men. 'Learn to command, by learning to obey,' he adjured. It was Walpole who subverted gothic imagery from celebrations of territorial autocracy to derision of the man of force; it was Walpole, too, who made the gothic style a mode of expressing human disaffection. He did this by inverting gothic. He knew that all truths need to be balanced with their inverse. 'Providence,'

he wrote, 'wisely gave us reflection to combat our passions, but passions to combat our reflections.'

Gothic castles had been built as symbols of enduring power; they were an uncompromising declaration of dynastic ambition resting on their owners' control of others. Intended to evoke feudal powers, they were images of force, hierarchy, stability and command – although in Ireland, as we have seen, an illusory image. Gothic literature, by contrast, provides constant reminders that power is ephemeral, that controls fail and hierarchies totter. In gothic literature the ambitious man is a tyrant before whom others must be abased, but all the same he succumbs to the power of others. Moreover it was Walpole's experience that although ambition was the most detestable passion, the strongest power affecting human lives is the power of other people's indifference. Most of us die not by one deadly, premeditated, focused attack but by succumbing to the small cuts of other people's negligence. Every important episode rests on the apathy or selfishness of people who scarcely realise we exist.

Rousseau's most famous sentence in *The Social Contract* (1762) reads, 'Man is born free, and everywhere he is in chains', but the next sentence is less well known: 'Many a man believes himself the master of others, and yet is a greater slave than they.' Forty years later, Hegel's paradigm of the power relations between Master and Slave (summarised on page 9) recognised that the Master's autocracy is only theoretical, and that his dependence on the Slave leads to his enslavement. One cannot understand the impotence of power unless one understands this image: Napoleon as he advances on his enemies thinks he is the most powerful man in the world. He issues orders to his marshals, and commands his armies' obedience. He knows his men are drilled; he thinks they love or fear him; he exults in his power, and awaits victory. Yet as Tolstoy realised, 'power is merely the relation that exists between the expression of someone's will and the execution of that will by others'. Napoleon depends on his orders being obeyed by subordinates; in the chaos of war he is forced to trust a chain of command. Some of his men are brave; others are fools, cowards, or sullen incompetents. They have the free will to run away; his dependence on them strips him of free will. He above all men is lost. It shows the depths of Napoleon's madness that even in the enormous ruins of his life he never understood this.

Abraham Lincoln, by contrast, seems sane, possibly approaching political genius, in his understanding of power: 'I claim not to have controlled events but confess plainly that events have controlled me,' he said of his political career and the

American Civil War. Only geniuses, as W. H. Auden wrote of Lincoln, 'are conscious of how little depends upon their free will and how much they are vehicles for powers they can never fully understand but to which they listen'. For people of ordinary weakness the pattern of their lives comes merely as a reaction to what other people do to them or expect of them. In the final paragraph of *The Castle of Otranto*, the gothic novel written by Horace Walpole in 1764, its hero, Theodore, marries not from love or with the expectation of happiness but because it is what people expect of him. Throughout the novel, even at moments of courage, he has seemed the plaything rather than the master of other people's stronger feelings and more emphatic behaviour. The novel's villain, Manfred, is a passive figure too: apparently dynamic, tenacious, decisive and implacable, his formidable powers are constantly and ludicrously betrayed by his inability to master his servants, by whose stupidity, cowardice, gossiping and laziness all his strategies are foiled and his secrets revealed. Manfred resembles Napoleon in *War and Peace*: seemingly the masterful protagonist, he resolves nothing by his own efforts.

HORACE WALPOLE

Most people write autobiographical first novels which glorify, inflate or degrade themselves in obvious ways, but Walpole's method was more oblique and evasive. He exaggerated his idea of himself by exaggerating his castle. The hero of his novel is the castle itself. This castle he imagined at Otranto is an immoderate inflation of his own villa, Strawberry Hill. The novel opens with an enigmatic prophecy about the castle's ownership, which almost seems to imply that it controls its lords. The battlements, cloisters, galleries, dungeons, underground vaults and trapdoors of Otranto provide the heroics. It is the same with Walpole himself. His romantic conception of Strawberry Hill made him the best-known eighteenth-century gothic revivalist. Its arches and ornaments provided the heroics of his life, which otherwise took a passive, reactive course: his own deliberate choices were less important to its overall pattern than the casual, indifferent behaviour of other people. The first indifferent power in Walpole's life was Henry Fiennes-Clinton, ninth Earl of Lincoln, and the second was Henry Seymour Conway, Walpole's cousin.

Born in 1717, Horace Walpole was the youngest son of Sir Robert Walpole, who was continuously prime minister from 1721 until 1742, when he was created Earl of Orford. Horry was the one poetically disposed member of a resolutely practical

family, and this political background rooted his life when he was young and saved him at an age when his fantasies were potentially most destructive. Predestined to enter Parliament, he sat in the House of Commons continuously from 1741 (when he was aged twenty-four) until 1768. Personalities, rather than principles, fixed him, though he had higher standards of political loyalty than was realistic: his lifelong indignation with those of his father's allies who he thought had betrayed him was sincere. He did not just conform to his father's image but raised his prestige: his first sustained literary effort was an annotated catalogue of his father's great art collection at Houghton. He published this catalogue – the filial tribute of an aesthete son – after his father's death. In 1747 he settled at Twickenham, living on rich sinecures with which at the age of twenty-one he had been endowed by his father (it is estimated that he cost the public funds a quarter of a million pounds over his lifetime). From 1757 he ran a printing-house at Strawberry Hill from whose presses he issued Gray's 'The Bard' and 'The Progress of Poesy', followed by his own *Catalogue of the Royal and the Noble Authors of England* (1758) and *Historic Doubts on the Life and Reign of King Richard III* (1768).

In 1756 he bought from George Vertue's widow forty notebooks of gossip, from which hoard he compiled his *Anecdotes of Painting in England* (1762–71). He published *The Castle of Otranto* in 1764 and a blank-verse tragedy, *The Mysterious Mother*, in 1768, but his literary fame rests upon his record of the social and political history of his times: as, in his own words, 'a person who collects the follies of the age for the information of posterity'. At his death in 1797, he left his memoirs in a sealed chest which was opened, as he had instructed, twenty-one years after his death. These were published to great acclaim; his voluminous correspondence subsequently appeared in an edition of forty-eight volumes between 1937 and 1983. Their joyous provocations have secured his position as the earliest and perhaps the greatest of English aesthetes. 'It is in the tradition of the great aesthetes, though not necessarily of the great artists, to be social critics', as Richard Wollheim has demonstrated:

> For whereas the latter can sometimes succeed so omnipotently in the creation of their own universe that reforms in the one we inhabit come to seem petty or even superfluous adjustments, it is the distinguishing characteristic of aestheticism to have a heightened awareness of the power of the environment upon us, and hence of its significance for us. Psychologically the aesthete is in

a kind of middle position: he requires an environment that will be adequate as the vehicle of his fantasies, without these fantasies being powerful enough to distort for him the true character of the environment.

This is the root of Walpole's supremacy as a chronicler of his times and his persistent insinuating power in the history of the gothic imagination.

WALPOLE'S LOVE FOR LORD LINCOLN

His schoolboy interests set his emotional destiny. At Eton he savoured 'little intrigues, little schemes, and policies', and first discovered 'the titillation of love [and] the budding passions'. Lord Lincoln, described by Walpole as a 'very dark thin young nobleman', became his 'first dear object', around whom he wove intrigues and schemes. The fatherless youth (three years Walpole's junior) was nephew of the prime minister Henry Pelham, for whom William Kent designed Esher Place, and of Pelham's brother and successor as prime minister, the Duke of Newcastle, to whose dukedom Lincoln succeeded in 1768. Having contrived their meeting while on the grand tour in 1741, Walpole owed his life to Lincoln's intervention when he was ill at Reggio in May that year, and in July they returned together from Venice to Paris. Walpole travelled in a chaise, but Lincoln 'rode most of the way', brooding on the Earl of Pomfret's daughter, as Walpole wrote from Genoa on 19 July. 'He is quite melancholy, and . . . talked to me the whole time of Lady Sophia.' Lincoln's interest in Lady Sophia Fermor was an attraction, or an attractive torment, to Walpole. He admired robust masculinity, but despised soppiness. Italians, he thought, understood marriage better than the English. 'One . . . very seldom hears of unhappy matches in these parts. They set out better, and certainly understand the conduct of it better; separate apartments, and less fondness and cuddling are quite necessary.'

Walpole was an intelligent, lively youth whose clothes never exhaled any odour of harness-room or hunting-field; there was no soupçon of the athlete in his constitution. 'I here every day see men, who are mountains of roast beef,' he wrote in 1743 from his father's power house in Norfolk. 'I shudder when I see them brandish their knives in act to carve, and look on them as savages when they devour one another . . . I'll swear I see no difference between a country gentleman and a sirloin; whenever the first laughs, or the latter is cut, there runs out just the same streams of

gravy.' He was affected: 'I have played off *épuisements*, nerves, headaches, and aversions, all to no purpose: nay, I have been laid up two days with *a pain in my voice*, without having one card to inquire how I did.' Always he was highly strung, 'so nervous that the sudden clapping of a door makes me shudder all over'. He lived the delicate, luxurious life of a man of birth and fortune, exempt from sordid care; he would have preferred life to have been a round of ceremonies and visits, centred on ordained points of view, sanctified by custom. As he wrote to Lady Hervey,

> I wake with a sober plan, and intend to pass the day with my friends – then comes the Duke of Richmond, and hurries me down to Whitehall to dinner – then the Duchess of Grafton sends for me to loo in Upper Grosvenor Street – before I can get thither, I am begged to step to Kensington, to give Mrs Anne Pitt my opinion about a bow-window – after the loo, I am to march back to Whitehall to supper – and after that, am to walk with Miss Pelham till two in the morning, because it is moonlight and her chaise has not come. All this does not help my morning laziness; and, by the time I have breakfasted, fed my birds and squirrels, and dressed, there is an auction ready.

There were always men with male lovers in his set, such as John Chute, who lived in Italy for many years with his cousin Francis Whithed, whom he called 'my other half'. Though Walpole affected epicene sentiments, his humour was robust. He relished the story of a spunky 'hero', Theobald Taaffe, 'who having betted Mrs. Woffington five guineas on as many performances in one night, and demanding the money which he won, received the famous reply, *double or quits*'. He also admired Sir Francis Blake Delaval, who surprised his mistress, an Italian singer called Caterina Tedeschi, with an alto called Gaetano Guadagni. Dragging them out of bed, he horse-whipped the woman. 'After that execution, he takes Guadagni, who fell on his knees and cried and screamed for mercy – "No, Sir," said Delaval, "I have another sort of punishment for you," and immediately turned up that part, which in England indeed is accustomed to be flogged too, but in its own country has different entertainment – which he accordingly gave it. The revenge sure was a little particular!'

Walpole's feelings for Lincoln were intense and self-dramatising. Like many people who fancy themselves in love, he thought overwhelmingly of his own feelings and the fascinating figure he cut. Where Lincoln was concerned, he was excitable, histrionic and silly. 'We had a great scuffle t'other night at the opera,' he reported in 1742:

Lord Lincoln was abused in the most shocking manner by a drunken officer, upon which he kicked him, and was drawing his sword . . . I saw the quarrel from the other side of the house, and rushing to get to Lord Lincoln, could not for the crowd: I climbed into the front boxes, and stepping over the shoulders of three ladies, before I knew where I was, found I had lighted into Lord Rockingham's lap.

Such admiration might amuse Lincoln in small bouts, but must soon have palled. In February 1743 Walpole went to a masquerade where he was sure to see Lincoln. 'I dressed myself in an Indian dress, and after he was come thither, walked into the room, made him three low bows, and kneeling down, took a letter out of my bosom, wrapped in Persian silk, and laid it on my head: he stared violently! They persuaded him to take it.' Written as a mock Persian letter, it was full of ingratiating affirmations of Lincoln's virility.

Lincoln's supposed potency impressed Walpole as much as that of five-times-a-night Theobald Taaffe. 'You my dearest Lord, are just as clever, as handsome, as well-made and as vigorous,' he flattered Lincoln; clearly Lincoln's success with women delighted him. There is an important letter to Lincoln, dating from 1743–44, which the puritanical editor of Walpole's correspondence, Wilmarth Sheldon Lewis, asserted without evidence was 'written in the character of one of Lincoln's mistresses'. It is conversely a declaration by Walpole of his feelings for Lincoln, though there is no evidence that it concerns sexual experiences rather than emotional self-dramatisations:

I have changed my mind: instead of desiring you to have done loving me, I am going to ask something much more difficult for you to comply with – pray continue to love me: I like it vastly. I could never have imagined there were half so many *agréments* in having a lover. You can't conceive how I regret the time I have lost. How strangely dull you was never to think of it before – though I can't blame my fortune, for to be sure out of the millions that there are of both sexes, it was a vast chance that it did not come to my turn these twenty years . . . Women generally try to persuade men to constancy, in return for their loving them – now my reason for desiring yours, is from the direct contrary. My satisfaction arises from your passion, not from my own . . . You have all the whims and follies that can entertain one,

without any of the lamentable languishings and insipidness that consume three parts of the time of other lovers. Therefore do tell me, what it is can secure you to me: point out – if you can guess, what sort of turn and behaviour could fix you – . . . I assure you, there is no part I won't act to keep you.

These are the pleas and assurances of a man for whom emotional passivity is more important than sexual acts: a dependent who fixes on the strength that he imagines he sees in others, a scavenger for love or respect. Walpole realised that he depended upon Lincoln's will for happiness, that his best chance of commanding Lincoln's affections was by learning to obey. This was an early lesson for Walpole in gothic inversion.

His friendship with Lincoln was severed shortly after the latter's marriage in October 1744. The teasing admiration had presumably become irksome for the younger, married man. Twenty years later Walpole managed to revive their contacts, but had learned little in the management of his affections, and was still too demanding and submissive to appeal to a middle-aged nobleman. 'I had hoped that as you had admitted me to a renewal of our friendship, I was to have the satisfaction of sometimes seeing you; but I begin to think you only meant to tantalize me with the prospect of a happiness you do not intend I should possess,' he complained to Lincoln in 1764. 'It would make me seriously happy to pass some of the remaining hours of my life with you. I will not be troublesome, and you may get rid of me whenever you please.' Not surprisingly these effusions did not attract Lincoln, who evaded Walpole's approaches.* By 1768 the rejected supplicant (ostensibly writing of Lincoln as a politician, but really as a love object) was deploring his 'ingratitude' and 'exceeding pride [that] kept him secluded from the world'. One result of Walpole's disillusion with Lincoln was partly that, in his own words, he 'constantly ridiculed' Lincoln's uncle, Newcastle, but his loss brought with it enlightenment; he learnt that it is glorious as well as painful to be an exception. He grew a carapace, and invested his passions in objects, which provided him with values that were variously aesthetic, historical, spiritual, snobbish but above all controllable; objects presented the bright, safe surface of things.

*This undated letter is conventionally attributed (by loose deduction) to January or early February 1764, but can just as plausibly be dated to the autumn of 1764, after Walpole's sentimental brand of homosexuality was publicly outed (see pp. 124–7), in which case Lincoln's reticence is all the more understandable.

After Lincoln's marriage, Walpole sought affection rather than the lacerations of love. 'Perhaps those, who, trembling most, maintain a dignity in their fate, are the bravest: resolution on reflection is real courage,' he later wrote – a consolation of which every epicene man has tried to persuade himself on many occasions. More than ever he gave his sympathies and imaginative powers to corresponding with friends and celebrities. These letters became almost a substitute for living. Sometimes he refrained from visiting the Countess of Upper Ossory so that he would not waste in conversation stories that could be recorded in a letter. Yet he never thought of himself as a literary man. 'Literature,' he wrote to George Montagu in 1765, 'is very amusing, when one has nothing else to do. I think it rather pedantic in society; tiresome when displayed professedly.' Still less did he crave to be thought a scholar. 'Learning never should be encouraged, it only draws out fools from their obscurity.' The vitality, gaiety and versatility of his letters is constant, but he reserved his subjects (politics, literature, society gossip) for different recipients. It is a sign of maturity in a man like Walpole to keep his life divided into bulkheads between which there is no connection. His moods vary, his instincts are diverse, and he knows the delusion of pursuing with narrow, self-absorbed intensity the chimera of a true self rather than the pleasure of contradictory selves.

As the critical appraiser and arbiter of eighteenth-century aristocracy, Walpole's deference was as elaborate as Proust's, and as romantically snobbish. His submissiveness in his closest emotions made it easy for him to slide into sycophancy. 'How, Sire, can I ever recover any humility after receiving so distinguished an honour, as that of Your Majesty not only condescending to read, but commanding me to send you any work of mine?' he addressed King Stanislaus II of Poland in 1786: 'I will not, Sire, steal more of those precious moments which your Majesty consecrates to all the virtues of beneficence, nor attempt to paint the sentiments with which I am penetrated.' He was so aware of rank that in the interval after the death of his mad nephew on 5 December 1791 he did not care to assume his title until after the burial on 20 December, and in the interval signed letters 'The Uncle of the late Earl of Orford'. Yet Walpole was not a frivolous idiot. His common-sense integrity is shown in his labours to settle the affairs of his nephew, and in his sound advice to other families. His prescience is shown in his comments of 1783 on the experimental hot-air balloon of the Montgolfier brothers:

I hope these new mechanic meteors will prove only playthings for the learned and idle, and not be converted into new engines of destruction to the human race, as is so often the case of refinements or discoveries in science. *The wicked wit of man always studies to apply the result of talents to enslaving, destroying, or cheating his fellow creatures.* Could we reach the moon, we should think of reducing it to a province of some European kingdom.

Slavery he loathed, and he expressed 'horror' rather than irony at the bequest of Christopher Codrington, who founded the library at All Souls College in Oxford. Codrington bequeathed his Barbadian plantations to the Society for the Propagation of the Gospel in Foreign Parts with instructions that they maintain a perpetuity of 300 slaves, who were branded with 'Society' on their chests. 'Religion has often been the cloak of injustice, outrage and villainy.' He resented aristocratic insolence; the roll of the war-drum dismayed him, for he believed in force only as an ultimate resort. Fools sprawling in Parliament and lauding themselves as the makers of their own distinction never impressed him.

WALPOLE'S FINAL DISILLUSION

For years he tried to swell the progress and advance the political power of his cousin Henry Seymour Conway (1719–95). He was attracted by the virility of Conway, who became a soldier at the age of eighteen, later Commander-in-Chief of the Army and finally a Field Marshal. 'I always want to begin acting like a man and a sensible one,' he told Conway in 1744. 'I have always loved you constantly: I am willing to convince you and the world, what I have always told you, that I have loved you better than anybody.' Walpole's tediously emphatic affections were scarcely tolerated by Conway. 'My dearest Harry, how could you write me such a cold letter as I have just received from you, and beginning *Dear Sir*!' Walpole expostulated in 1761. 'Since I was fifteen, have I not loved you unalterably?' After Conway entered Parliament in 1741, Walpole's promotion of his political interests was vigorous, ingenious and persistent. 'There was no one from whom I received so just accounts of the various factions,' the Duke of Grafton wrote of Walpole's part in a political crisis of 1767. 'His . . . attachment to Mr Conway had been constant, and . . . his zealous desire, that we two should be more closely united, urged him to sift out the designs of those who were counteracting his active endeavours and no per-

son had so good means of getting to the knowledge of what was passing, than himself.'

Conway nevertheless endured reverses in his political career. A failed military expedition in 1757 led to his temporary eclipse despite Walpole's trumpeting that he was 'one of the bravest men in the world'. Then, in April 1764, Conway was dismissed at King George III's insistence from his regiment and from his post as Groom of the Bedchamber for voting in the Commons against the government's persecution of the radical politician John Wilkes. Walpole was mortified at this check to his hero's progress: he secluded himself at Strawberry Hill for three days until he had conquered the first ebullitions of his rage. Then he spent a fortnight from 29 May writing fifteen thousand words defending Conway and attacking the government of George Grenville. His *Counter-Address to the Public* was well received on its publication but had a painful sequel. On 28 August 1764 William Guthrie published a *Reply to the Counter-Address* implying that Walpole's affection for Conway constituted at the very least sentimental sodomy. In it Walpole was characterised as 'by nature maleish, by disposition female, so halting between the two that it would very much puzzle a common observer to assign to him his true sex'. The *Counter-Address* was stigmatised as having 'a weakness and an effeminacy in it which seems to burlesque even calumny itself. The complexion of the malice, the feeble tone of the expression, and the passionate fondness with which the *personal* qualities of the officer in question are continually dwelt on, would tempt one to imagine, that this arrow came forth from a female quiver.'

The implication that Walpole's feelings for Conway had degenerated into a one-sided, obsessional habit was cruel but just; he resented the 'scurrility' deeply. 'They may ruin me, but no calumny shall make me desert you,' he promised Conway (who had never given signs of wanting such promises) on 1 September. 'They have nothing better to say, than that I am in love with you, have been these twenty years.' It is a measure of Walpole's distress, and possibly of his fear, that he made no other reference to Guthrie's *Reply* in all his correspondence. To Lincoln twenty years earlier he had written, ''Tis amazing how little real anger I feel at the moments that I ought to hate you most – when you expose me to the greatest dangers.' He was aware of the danger to which he was exposed by a reputation as a sodomite – committing a crime, in the cant phrase of the period, not to be named among Christians – but did not rage against Conway yet. Walpole claimed that in June 1764, after

completing his *Counter-Address to the Public,* he still needed to find emotional surcease by literary work and began writing a fantastic tale which he completed on 6 August. 'This dating, imposed by Horace long after the events, is suspect,' according to his biographer Timothy Mowl. There is no mention in his letters between June and August 1764 that he was writing a novel. 'What is far more likely is that he wrote *Otranto* after 28 August, probably over September and October, in a state of febrile excitement, a first stage of the nervous collapse that was to afflict him for at least the next two years.'

After his enemies were dislodged from power in 1765, Conway was appointed to a high post in Lord Rockingham's administration. With laudable discretion after Guthrie's recent innuendoes, he snubbed Walpole's hints that his fidelity to Conway should be rewarded with an offer of a government post. This rejection mortified Walpole, who again realised that he had loved Conway, as he had Lincoln, with a love that was burdensome. 'I had command enough of myself not to drop a syllable of reproach on a friendship so frozen; but without a murmur, and with my wonted cheerfulness, as soon as my strength was tolerably recruited, I declared my intention of making a visit to Lord Hertford at Paris.' Conway's rebuff permanently jaded Walpole's taste for politics ('I have done with the world'), and in 1768 he retired from Parliament (though he remained a political busybody for some time longer).

After Conway froze their friendship, Walpole's misanthropy increased. 'My heart is not like yours, young, good, warm, sincere, and impatient to bestow itself,' he wrote to John Crauford in 1766.

> Mine is worn with the baseness, treachery and mercenariness I have met with. It is suspicious, doubtful and cooled. I consider everything around me but in the light of amusement, because if I looked at it seriously I should detest it. I laugh, that I may not weep.

He considered that he lived in '*an age of abortions*'. The future he mistrusted as likely to be a pompous imposture. Like so many others whose love affairs have burnt out, leaving them chilled and tired and void, he found his consolation in objects. On different occasions Walpole acquired Cardinal Wolsey's scarlet hat, Queen Mary's comb, the pipe smoked by Van Tromp in his last naval engagement, the spur worn by King William III at the Battle of the Boyne and gloves worn by King James I. He slept with King Charles I's death warrant on one side of his bed, and Magna Carta

on the other. He could resist trumpery objects no more than *objets d'art*. From the sale of an eccentric midwife's effects, for example, he bought 'Brobdignag combs, old broken pots, pans, and pipkins, a lanthorn of scraped oyster-shells, scimitars, Turkish pipes, Chinese baskets, etc.', but 'was outbid for Oliver Cromwell's night-cap'. Retiring with his dogs to his library he found imaginative solace from the age of abortions and purged himself in imagination of the past:

> There is no wisdom comparable to that of exchanging what is called the realities of life for dreams. Old castles, old pictures, old histories, and the babble of old people, make one live back into centuries, that cannot disappoint one. One holds fast and surely what is past. The dead have exhausted their power of deceiving – one can trust Catherine of Medicis now.

STRAWBERRY HILL

Walpole had in the 1740s acquired 'a little plaything house' overlooking the Thames at Twickenham which he called Strawberry Hill: 'the prettiest bauble you ever saw . . . set in enamelled meadows, with filigree hedges'. Ennui was precluded by the view: 'two delightful roads . . . supply me continually with coaches and chaises; barges as solemn as Barons of the Exchequer move under my window; Richmond Hill and Ham Walks bound my prospect; but, thank God! the Thames is between me and the Duchess of Queensbury'. He determined 'to build a little Gothic castle', and spent forty-four years improving the house (James Wyatt was the last of his ten architects). Walpole adored the business and excitement. His happiness in 1753 was manifest: 'I have carpenters to direct, plasterers to hurry, paper men to scold, and glaziers to help: this last is my greatest pleasure: I have amassed such quantities of painted glass, that every window in my castle will be illuminated with it: the adjusting and disposing of it is vast amusement.' Overall he strove for monastic effects:

> Imagine the walls covered with . . . paper printed in perspective to represent Gothic fretwork, the lightest Gothic balustrade; lean windows fattened with rich saints, in painted glass, and a vestibule open with three arches, on the landing place, and niches full of trophies of old coats of mail. India shields made of rhinoceros hide, broad-swords, quivers, long-bows, arrows, and spears.

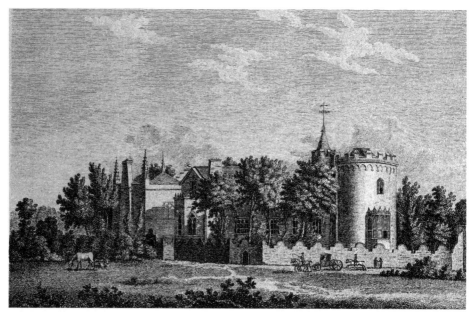

Strawberry Hill (its north front pictured here in 1784) displayed gothic revival architecture at its most irreverent, jocose and unpatriarchal. Walpole in both his architecture and his novel mocked the pretences at baronial mastery of men like Lord Kingston. Walpole's aesthetic system reflected Rousseau's overwhelming insight: 'Many a man believes himself the master of others, and yet is a greater slave than they.'

Thomas Gray described a newly completed bedroom in 1759:

> you enter by a peaked door . . . into an Alcove, in which the bed is to stand, formed by a screen of pierced work opening by one large arch in the middle to the rest of the chamber, wch. is lighted at the other end by a bow-window . . . whose tops are of rich painted glass in mosaic: the ceiling is coved and fretted in star and quatrefoil compartments, with roses at the inter-section all in papier mache: the chimney on your left is the high altar in the cathedral at Rouen . . . consisting of a low sur-based Arch between two octagon Towers . . . the chairs and dressing-table are real carved ebony, pick'd up at auctions, the hangings uniform purple paper.

Walpole twice visited Henry Pelham's house at Esher, designed by Kent. In his set, Kent's achievement there was equivocally admired: Gray thought Kent 'introduced a mix'd style, wch now goes by the name of the Batty Langley Manner'. Batty

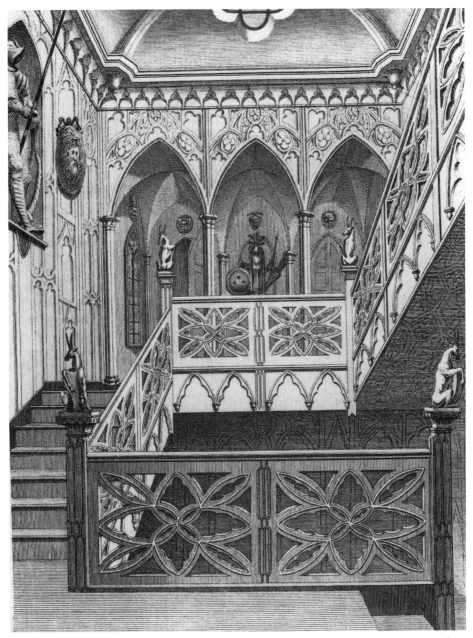

The teasing chivalric staircase at Strawberry Hill, which inspired its greatest fictional counterpart in Otranto. *Walpole's novel was a fast-paced, hectic, high-camp comedy, which most of its eighteenth-century middle-class readership took seriously.*

The chapel in Walpole's garden at Strawberry Hill represents the idyll of a gentleman who had learnt that his best chance of controlling men's affections was in learning to submit. The rewards of a submissive life, and the consolations of placidity, were evident throughout Walpole's castle and its grounds.

Langley was a Twickenham landscape and nursery gardener who compiled several pattern books of gothic styles copied from feudal monuments for the use of architectural amateurs and journeymen builders. Though Langley's ornaments were condemned as 'bastard Gothic' by Walpole, they began an ephemeral fashion in the 1740s. 'A few years ago,' William Whitehead reported in 1753, 'everything was Gothic; our houses, our beds, our book-cases, and our couches, were all copied from some parts or other of our cathedrals . . . Tricks and conceits got possession everywhere.' This eccentricity of taste was, Whitehead concluded, 'congenial to our old Gothic constitution, which allows everyone the privilege of playing the fool, and of making himself ridiculous in whatever way he pleases'. Significantly Walpole himself wrote in 1765, 'it is not everybody that may in this country play the fool with impunity', and took this part both as castle-builder and novelist. He expressed what was serious in his life in terms of artifice, elegance and mocking laughter: a mode which in the twentieth century became known as camp. 'He liked gothic architecture,' declared Lytton Strachey, 'not because he thought it beautiful, but because he found it queer.' He had no need of the illusion of power created by an immense Palladian architrave surmounting wide, symmetrical steps towering over arriving visitors: 'the Grecian is only proper for magnificent and public buildings', he explained to Horace Mann in 1753. 'Columns, and all their beautiful ornaments, look ridiculous when crowded into a closet or cheese-cake house. The variety is little, and admits no charming irregularities.'

The response of his friends was gratifying. 'I have resumed little flights to Strawberry', Walpole told his architectural adviser Bentley, 'I carried G. Montagu thither, who was in raptures, and screamed, and whooped, and hollaed, and danced, and crossed himself a thousand times over.' Gray similarly congratulated Bentley on his influence at Strawberry Hill: 'I do not know a more *laughing* scene.' All castle-owners, from the Northumberlands and Charlevilles downwards, played a part before the eyes of the crowd, but Walpole repudiated the doctrine of personal invincibility favoured by men of action like Argyll, or the masquerade of mastery played by weaker men like Lord Dorchester and Lord Kingston. One can say of Walpole at Strawberry Hill, as Thom Gunn wrote of Elvis Presley,

> He turns revolt into a style, prolongs
> The impulse to a habit of the time.

His postures in his toy castle, with its towers, galleries and cloisters, were jokes through which he drew visitors into complicity; they were a revolt against the power house, and against the detestable passion of ambition which spoils the happiness of those it scarcely notices. 'Strawberry Hill is the puppet-show of the times,' he declared in 1755. He wanted visitors who would be accomplices in his joke and repulsed the undiscriminating hordes by limiting visitors to parties of four and to one party a day (children excluded). After a French princess in 1764 criticised Strawberry Hill as lacking 'digne de la solidité anglaise', Walpole was indignant. 'They allot us a character we have not, and then draw consequences from that idea, which would be absurd even if the idea was just. One must not build a Gothic house because the nation is *solide* . . . 'Tis the marvellous, the eccentric, that characterizes Englishmen.'

INFLUENCES ON WALPOLE'S GOTHIC NOVEL

The marvellous and eccentric, together with the babble of old centuries, were Walpole's only consolations in the months after Guthrie's public sneers at his affection for Conway. Walpole's account of his novel-writing in that period declares how much his literary imagination was excited by his castle and acknowledges that the imaginative self-absorption required of a novelist was a salve at this time. 'I waked one morning in the beginning of last June from a dream, of which all I could recover was, that I had thought myself in an ancient castle (a very natural dream for a head filled like mine with Gothic story) and that on the uppermost bannister of a great staircase I saw a gigantic hand in armour,' Walpole described in 1765.

> In the evening I sat down and began to write, without knowing in the least what I intended to say or relate. The work grew on my hands, and I grew fond of it – add that I was very glad to think of anything rather than politics – In short I was so engrossed with my tale, which I completed in less than two months, that one evening I wrote from the time I had drunk my tea, about six o'clock, till half an hour after one in the morning, when my hands and fingers were so weary, that I could not hold the pen to finish the sentence.

This account of his creativity is itself artful: his claim to have written the novel after his *Counter-Address to the Public* in June 1764 is doubtful, for he probably wrote it in his distress after the publication of William Guthrie's *Reply to the Counter-Address* in

August 1764. Nevertheless the speed with which he wrote is reflected in the whirling pace of the plot.

Walpole did not conceive the tone and structure of his novel in a literary vacuum. He had strong views on fiction, for example damning Samuel Richardson's *Clarissa* (1747–48) and *Sir Charles Grandison* (1753) as 'pictures of high life as conceived by a bookseller and romances as they would be spiritualised by a Methodist teacher'. His dislike of tales cramped by literalism had distinguished precedents. A century earlier Sir William Temple had praised Norse poetry, which he called 'Gothic runes', for its imaginative power to raise storms, terrorise enemies, conjure spirits, 'make women kind or easy, and men hard or invulnerable'. Temple identified such runers as the inspiration of later tales 'that serve not only to fright children into whatever their nurses please, but sometimes, by lasting impressions, to disquiet the sleeps and the very lives of men and women'. Pope too had hankered after gothic literary excitements. 'I have long had an inclination to tell a Fairy tale; the more wild and exotic the better, therfor a *Vision*, which is confined to no rules of probability, will take in all the Variety and luxuriancy of Description you will,' he had written in 1723. 'Perhaps if the Scenes were taken from Real places that are known, in order to compliment particular Gardens & Buildings of a fine Taste . . . it would add great beauty to the whole.'

The medieval symbolism that had motivated many gothic revival builders – Newdigate, Lyttelton, the Northumberlands and others – had a literary counterpart. The publication in the 1760s of James Macpherson's Gaelic epic poems, falsely ascribed by him to Ossian, and Thomas Percy's *Reliques of Ancient English Poetry* was evidence of a new, widespread literary-historical interest. Bishop Hurd's *Letters on Chivalry and Romance* (1762) stressed the similarities between heroic and feudal times, for example between the martial games of ancient Greece and the tournaments of medieval warriors. Hurd admired the energy and extravagance of medieval romance; gothic literature he judged edifying. 'For the more solemn fancies of witchcraft and incantation, the horrors of the Gothic were above measure striking and terrible. The mummeries of the pagan priests were childish, but the Gothic Enchanters shook and alarmed all nature.' Hurd extolled Spenser, stressing that *The Faerie Queene* was 'a Gothic, not classical poem', and declared of Shakespeare, 'even he is greater when he uses Gothic manners and machinery, than when he employs classical: which brings us again to the same point, that the former

have, by their nature and genius, the advantage of the latter in producing the *sublime*'. There were thus no revolutionary disjunctures in literary sensibility required to revive gothic literature: instead it drew on the paraphernalia of graveyard poetry, written by eighteenth-century melancholics on themes of human mortality; the cultivation of the sublime recommended by Burke; and the chivalric imagery that enchanted Hurd.

These connections are exemplified by James Beattie, whose first visit to London in 1763 was a pilgrimage to Pope's villa at Twickenham. Beattie was a graveyard poet who applied touches of Spenserian imagery:

> There would he dream of graves, and corses pale;
> And ghosts, that to the charnel-dungeon throng,
> And drag a length of clanking chain, and wail,
> Till silenc'd by the owl's terrific song,
> Or blasts that shriek by fits the shuddering isles along.
>
> Anon in view a portal's blazon'd arch
> Arose; the trumpet bid the valves unfold;
> And forth an host of little warriors march,
> Grasping the diamond lance, and targe of gold:
> Their look was gentle, their demeanour bold,
> And green their helms, and green their silk attire;
> And here and there, right venerably old,
> The long-rob'd minstrels wake the warbling pipe.

In his essay 'Fable and Romance' Beattie also showed himself as an antiquarian goth attracted by

> the castles of the greater barons, reared in a rude but grand style of architecture; full of dark and winding passages, of secret apartments, of long uninhabited galleries, and of chambers supposed to be haunted with spirits; and undermined by subterranean labyrinths as places of retreat in extreme danger; the howling of winds through the crevices of old Walls, and other dreary vacuities; the grating of heavy doors on rusty hinges of iron; the shrieking of bats, and the screaming of owls.

The last English trial for witchcraft was held in 1712, but the accused, though convicted, was not put to death; the last execution of a witch in Scotland occurred in 1722 and in Germany in 1793. Anxieties about the uncanny were, however, never laid to rest. 'The impulses of fear, which is the most violent and interesting of all the passions, remain longer than any other upon the memory,' as Smollett announced in his preface to the proto-gothic *Adventures of Ferdinand Count Fathom* (1753). A later gothic novelist, Maturin, was equally explicit. 'I question whether there be a source of emotion in the whole mental frame so powerful or universal as *the fear arising from objects of invisible terror*,' he wrote in 1807. 'Who is there that has never feared? Who is there that has not involuntarily remembered the gossip's tale in solitude or in darkness? . . . It is absurd to depreciate this passion, and deride its influence. It is *not* the weak and trivial impulse of the nursery, to be forgotten and scorned by manhood. It is the aspiration of a spirit.'

THE CASTLE OF OTRANTO

Walpole's intentions in his novel were far more sportive than those of Smollett or Maturin. The key to reading *The Castle of Otranto* is its sonnet dedication to Lady Mary Coke. She was born Lady Mary Campbell, a niece of the Duke of Argyll, who rebuilt Inveraray, and was the widow of Viscount Coke, whose family had employed Kent at Holkham. Because of the dead whiteness of her skin, fierce eyes and lack of eyebrows she was nicknamed The White Cat. Mocked for her exaggerated emotions – she 'loves grief', jibed Conway's brother, Lord Hertford – she longed for supernatural experiences. When in 1770 she travelled from Nîmes to Château de Grignan, where France's greatest letter-writer had lived a century earlier, she aroused herself into characteristically self-absorbed raptures: 'my imagination is so totally imploy'd about Madame de Sévigné that I am persuaded by and by I shall think She appears to me.' Having conceived an unrequited passion for a royal duke, it was her affectation after his death to forbid Westminster Abbey, where he was buried, from being mentioned in her presence. Walpole proved his affection for her by joking about her: 'She was sententious about a christening, talked with raptures of a pedigree, and shed tears if a Duchess's perroquet was moulting.' Aside from its dedicatory targeting of Lady Mary Coke, the irony and burlesque of *The Castle of Otranto* are indicated by Thomas Gray's remark to Walpole that his novel made 'some of us cry a little, and all in general afraid to go to

bed o' nights'. This has been taken seriously by some people; but Gray was teasing Walpole, and using a tease to gratify and flatter. After he had outgrown his youthful passion for Lord Lincoln, Walpole's preference for comedy over histrionics was consistent. 'This world is a comedy to those that think, a tragedy to those that feel,' he told the Countess of Upper Ossory after the suicide of Lord Dorchester's son John Damer, the heir to Milton Abbey. He admired aristocratic fortitude, as witnessed by his account of the beheading of Lord Lovat: 'died extremely well, without passion, affectation, buffoonery, or timidity: his behaviour was natural and intrepid'. The vigour and intrepidity which Walpole discerned in Lincoln, Taaffe and Conway were the attributes of manhood he admired.

Of his novel he told Madame du Deffand, 'presque tout le monde en fut le dupe'. Everybody who takes the book seriously has been duped. Comedy is its basis. It contains no romantic indulgence in unhappiness. The comic scenes were long, calculated and intrinsic to the action; indeed laboriously justified by Walpole in both the prefaces he wrote for it. Comedy united Walpole's set. As John Chute demanded, 'What's the reverse of weeping, and wailing and gnashing of teeth? Why undoubtedly laughing, and giggling, and cracking of sides.' Walpole was equally explicit. 'We shall not tire one another; we shall laugh together,' he told George Montagu in 1765.

> I desire to die, when I have nobody left to laugh with me. I have never yet seen or heard anything serious, that was not ridiculous. Jesuits, Methodists, philosophers, politicians, the hypocrite Rousseau, the scoffer Voltaire, the Encyclopedists, the Humes, the Lytteltons, the Grenvilles, the atheist-tyrant of Prussia, and the mountebank of history, Mr. Pitt, are all to me but imposters.

Walpole asserted in his first preface that his novel was written to a retributive scheme, and Manfred indeed is punished for his lust and abuse of power; but earnest moral intentions are swamped by burlesque derision. Walpole wrote the book to amuse – it was just 'fancy's gale', he told Lady Mary Coke – rather than to frighten: he never considered it serious in the way of his play about incest, The *Mysterious Mother*.

The Castle of Otranto was initially presented as having been printed at Naples in 1529, the volume discovered 'in the library of an ancient catholic family in the north of England' and only recently translated. This presentation 'duped' several of

Walpole's readers who 'took it for an original work'. The novel was thus a proto-type for many later gothic stories which were presented as taken from medieval manuscripts and were prefixed with proofs of antiquity and authenticity. It is set in a medieval Italian principality called Otranto, ruled by a harsh and irritable tyrant named Manfred. Naples as the original *locus* of Salvatorian gothic was carefully chosen by Walpole; he studied a map of Naples, and adopted the place-name of Otranto for its euphony. The setting is crucial. The castle of Otranto was Strawberry Hill, but Walpole swelled the sham medievalism of his pretty Surrey fantasies into an intimidating Neapolitan immensity.

His operatic plot of domestic perversion and misappropriated property opens with Manfred's only son and heir, Conrad, hastening across the castle courtyard to marry the Marquis of Vicenza's daughter, Isabella. He is abruptly 'dashed to pieces, and almost buried under an enormous helmet, an hundred times more large than any casque ever made for human beings, and shaded with a proportionable quantity of black feathers'. This miraculous helmet is a hugely magnified version of that on the black marble figure on the tomb of Alfonso the Good, a previous prince of Otranto (who, unbeknown to anyone except Manfred, had been poisoned and usurped by Manfred's grandfather). With this begins a hectic story of supernatural relics, gigantic ghosts, dark prophecies, usurpation, dynastic pride, sacrilegious murder, foul lust, spectral visions, swooning humans and slammed doors. Manfred affects indifference to his position as a castle-owner after Conrad's death. 'Power and greatness have no longer any charms in my eyes', he lies to a knight who challenges his family's usurpation. 'If I were ambitious, I should not for so many years have been a prey to the hell of conscientious scruples.' But Manfred's ambition is inexpungible.

After Conrad's death, he determines to preserve his family's hold on the property by fathering a new male heir. He proposes to divorce his sorrowing wife and to marry Conrad's fiancée, Isabella, instead. Revolted by this scheme, Isabella flees with the assistance of a young peasant called Theodore, whose honesty results in his incarceration by Manfred. Manfred's surviving child, Matilda, releases Theodore, who falls in love with her. Manfred, however, suspects Theodore and Isabella of an amour. During these complications a good friar called Jerome appears, who is discovered to be the father of Theodore; there later arrives a courtly knight, whom Theodore wounds in combat before it is realised that he is Frederic, Marquis of Vicenza, Isabella's lost father. Eventually Manfred, who is distracted by super-

natural menaces and inflamed with alcohol, surprises Theodore conferring with a woman at Alfonso's tomb and stabs her before discovering that she is his own daughter. The gigantic ghost of Alfonso then destroys the castle, and Manfred confesses his family's usurpation before abdicating in favour of Theodore. This climactic scene begins in this way:

> What! is she dead? cried he in wild confusion – A clap of thunder at that instant shook the castle to its foundations; the earth rocked, and the clank of more than mortal armour was heard behind. Frederic and Jerome thought the last day was at hand. The latter, forcing Theodore along with them, rushed into the court. The moment Theodore appeared, the walls of the castle behind Manfred were thrown down with a mighty force, and the form of Alfonso, dilated to an immense magnitude, appeared in the centre of the ruins. Behold in Theodore, the true heir of Alfonso! said the vision: and having pronounced these words, accompanied by a clap of thunder, it ascended solemnly towards heaven, where the clouds parting asunder, the form of St. Nicholas was seen; and receiving Alfonso's shade, they were soon wrapt from mortal eyes in a blaze of glory.

Yet it is the comedy rather than supernatural atmospherics that matter most. 'Walpole's comic scenes', notes one of his shrewdest critics, Elizabeth Napier, 'cast ridicule on Walpole's villain Manfred, rendering him a victim of his servants' incompetence – laughable and powerless, not tragic. Repeatedly, Manfred's domestics step in (or out) at inopportune times, officiously revealing information Manfred has sought to keep hidden or insisting with stupid persistence on a fact that immediately reveals Manfred's dark designs. Manfred's inability to control himself in such scenes heightens their ridiculous impact.' It is impossible to read aloud the prolonged dialogue of Diego and Jaquez about their view of the ghost's foot as the supposedly omnipotent Manfred expostulates, rages and loses his control over events without imagining the shrill shrieks of hilarity as it was read aloud by such friends of Walpole as Chute or Montagu. Manfred's inability to master his own servants represents his failure to command his own emotions and conduct; his moments of masculine decisiveness can only have been burlesque to Walpole and his friends. In chapter one, when the portrait of Manfred's grandfather comes alive to reproach him for impious lust, it 'uttered a deep sigh and heaved its breast'

before stepping out of its frame; the wicked marquis reacts with an exaggeration that can never have been serious: 'Speak, infernal spectre!' he shouts. 'I will follow thee to the gulph of perdition.' Manfred is magnificent and autocratic so long as he is not opposed, but blundering and block-headed when everyone does not immediately submit. He is as helpless as a person without hands: his existence depends upon the devotion, assent and support of his castle servants, yet they have that lethal combination in subordinates of being both tractable and perverse.

Helplessness is a supreme gothic theme: the shiftlessness of apparently omnipotent men often recurs, though Walpole's burlesque was assimilated by less sensitive writers into a style that was serious in intention though risible in effect. In 'The Story of Fitzalan', a sensationalist mediocrity first published in the *Monthly Visitor*, the eponymous hero is kidnapped by the servants of Lord Fitzurban, who a generation earlier had killed Fitzalan's father in the north tower of the castle and usurped his lands. Now Fitzurban lusts after Fitzalan's wife, Edith. 'Well, my trusty friends,' Fitzurban asks his servants Hugo and Walter, 'is Fitzalan in my power beyond the possibility of escape?'

> 'He is, my Lord,' answered Walter, 'as safe as locks, bolts, and the dungeon under the north tower, can keep him.' 'The north tower! the north tower!' repeated the baron in a hurried tone, pressing his hands forcibly against his forehead, while his hands flashed with all the wildness of phrenzy. His minions looked first at their lord, and then at each other, with an expression of surprise. In a few moments the baron recovered himself, and continued the discourse. 'Do not be alarmed, my friends,' said he, 'a violent pain shot through my head, but it is gone.'

But Fitzalan has been placed in the tower where his own father was done to death, and the paternal ghost arms him with the murderer's dagger. The usurper is then confronted by his latest victim. 'As soon as he saw Fitzalan, he shrieked, dropped the sword, and before he could call for mercy, felt the dagger in his bosom.'

Walpole delighted in writing the scenes in which Manfred's servants make fools of themselves; these were modelled, he pretended, on the gravedigger and Roman mob scenes of *Hamlet* and *Julius Caesar*. Garrulous, unreliable servants remained stock figures of gothic amusement: Ludovici is captured, blindfolded and maltreated by pirates in Ann Radcliffe's *Mysteries of Udolpho*; afterwards he tells

Annette that he had longed for death. '"Well, but they let you talk," said Annette; "they did not gag you after they had got you away from the chateau, so I don't see what reason there was to be so weary of living."' Otranto's theatricality (reminiscent of the pasteboard artificiality of Wyatt's gothic houses like Milton Abbey and Wycombe Abbey), coupled with the slapstick comedy, is pantomimic; indeed, as Elizabeth Napier notes, Walpole's novel was adapted into a Christmas pantomime, performed at Covent Garden in 1840–41 with huge burlesque props, entitled *The Castle of Otranto; or, Harlequin and the Giant Helmet*. Walpole (who always enjoyed harlequinades) devised exclamatory dialogues which were consistently camp – 'Oh, transport!' cries Isabella when she finds the trapdoor which enables her to escape from Manfred's pursuit; 'Amazement!' cries Theodore at yet another coincidence. These comic passages set out ideas which later gothic novelists misunderstood by treating seriously. Matilda's death throes, after being stabbed by her father, are often read as the pathetic climax of Walpole's novel; but it is burlesque from her first cry ('Ah me, I am slain!' cried Matilda sinking') to her last gasp ('I would say something more, said Matilda struggling . . . – oh! – She expired'). This absurdity prefigures numerous gothic death-scenes intended to make dire rather than frivolous impact. Thus Fitzurban *in extremis* pleads with Fitzalan:

> 'O speak pardon and peace to my guilty soul. Yet a short time, O spare me, heaven! – O I am lost! – they seize me – Mercy, Lord, mercy!' He faintly shrieked, averted his head, as if to shun the sight of something dreadful, and expired before Fitzalan could pronounce the intreated forgiveness.

Henry de Montmorency in Nathan Drake's 'Objects of Terror' is witness to a similar deathbed: 'every mark of horror was depicted on the pale and ghastly features of the dying knight; his black hair, splashed with gore, stood erect . . . struggling for speech, his agony became excessive, and groaning, he dropped dead.'

Bad weather introduced every Otrantan crisis and catastrophe. This device was not original to Walpole, for Smollett in *Ferdinand Count Fathom* used Salvatorian scenery – 'the silence and solitude of the place, the indistinct images of the trees that appeared on every side, stretching their extravagant arms athwart the gloom' – and stormy weather as a prelude to the horrible scene in which, taking refuge in a lonely cottage, Fathom finds a murdered corpse concealed in his bedroom. But after *Otranto*, no young, usurped hero of a gothic story could approach a forest without

the weather breaking. Thus Henry Fitzowen 'toward the sunset of a very fine day' has no sooner reached 'the edge of a thick and dark forest' than 'the thunder rolled at a distance, and sheets of livid lightning flashed across the heath' as a prelude to his encounter with a vile hag who lures him to a haunted castle. Walpole deployed all the theatrical scenery and stereotypes that were to characterise gothic stories for a generation: Salvatorian landscape evoking the primordial battles of good and evil; wild weather and lonely ruins evoking the puniness of human powers; gentler, more theatrical contrivances of Pope's picturesque; a castle which oppresses, intimidates and frightens, as a power house must; a tyrant who ruins the lives of the young but whose dominion is broken by the uncontrolled excesses of his own passions; the villain more interesting than the hero. *The Castle of Otranto* has many familiar subordinate themes: usurpation; the discovery of obscured family relations; incest; monastic institutions, charnel houses or mad-houses; death-like trances or uncanny dreams; enclosed, subterranean spaces where live burial is a metaphor for human isolation.

READING WALPOLE

In the history of gothic fiction Walpole's burlesque is only a by-way leading towards Oscar Wilde's 'The Canterville Ghost'. Its camp mockery was, however, wasted on many of its readers. George Hardinge, a barrister who became attorney-general – a grave, officious, incurious MP (doubtless a fast, superficial reader) who bored Walpole – told him: 'I could have cried (*once in my life*)' at the love passages between Matilda and Theodore: 'I could have loved such tears, and felt a sensual kind of enjoyment in shedding them.' Hardinge's intended compliment proved how he had misread the author's intentions; but the mentality of the two men was irreconcilable. The sentimental interludes admired by Hardinge in *The Castle of Otranto* (though stressed by later illustrators) are perfunctory, and Theodore's marriage is a cold resolve. For Walpole, the emotional excesses of his characters were ludicrous if not mad; as the successes of his own life showed, it is preferable to be a collector, giving your love to artefacts. Although Walpole's successors in gothic novel-writing developed the *genre* as a form of romantic literature, in which love affairs between young people were blighted by their vicious seniors, he was interested in young love only in so far as it was entangled with the transmission of property.

Walpole's depiction of Manfred ruining the lives of his young people while scheming to preserve his family's hold on Otranto was made pertinent by the Marriage Act of 1753, which had been devised to prevent clandestine marriages (including parentally defiant love-matches) and thus protect the powers of ambitious or controlling parents. 'A wretched piece of policy', Earl Nugent called this legislation in 1779, 'tending to prevent a union of willing hearts, and to hinder young girls from giving their hands to such hearty young men as they could like and love, in order that miserly parents might couple youth with age, beauty with deformity, health with disease'. The notably unerotic romantic passages in Walpole's tale serve his preoccupation with confused paternity and the usurpation of power houses. Walpole knew that a princely fortune has its own laws, and its own exemption from laws. There was nothing more shocking to the eighteenth-century imagination that the alienation of property from its rightful line by adulterous deception. 'A due regard for his posterity was to every man a near and dear object; to nobility, the most important,' Lord Thurlow told the House of Lords from the woolsack in 1779. 'The purity of the blood of their descendants was, and must necessarily be, an essential consideration in the breast of all the peers of the kingdom': legitimacy was Britain's primary law and principle. The abomination of adultery 'by contaminating the blood of illustrious families' facilitated usurpation by illegitimate children (a 'violation of natural duties and of legal claims', as a bastard child is told in Maturin's *Melmoth the Wanderer*). Indeed the system of divorce in England had evolved in the late seventeenth century to protect the patrilineal descent of titles and property in the ducal families of Rutland and Norfolk from bastard children (the result of wives' affairs after marital separations). There were notable mysteries of paternity in Walpole's family: Horace was sometimes thought to be the result of an affair between his mother and Lord Hervey; his nephew George, the mad third Earl of Orford whom he eventually succeeded, was believed by Horace and others to be the result of his sister-in-law's intrigue with a lusty baronet called Sir George Oxenden, in which case his tenure of Houghton usurped Horace. The theme of legitimacy and usurpation in *The Castle of Otranto* and its more prosaic, mechanical imitators reflected anxieties that were acute in the eighteenth century.

The revelation of secret paternity also provoked the climax of Walpole's five-act drama about incest, *The Mysterious Mother*, published at Strawberry Hill in 1768.

The plot turns upon the Countess of Narbonne's premeditated incest with her son, and its long deferred but catastrophic aftermath. Among women before the late twentieth century, widows had the most free will: certainly more than virgin brides or wives. The widow was free to fall in love, had the experience and understanding to choose lovers, might have the financial independence of a man, and was expected to fulfil a masculine as well as a feminine role as a parent. Yet in *The Mysterious Mother* the Countess of Narbonne's first major act with her new authority as a rich widow proves disastrous. Her version of the feudal lord's *droit de seigneur*, her emulation of the adamant and unscrupulous sexual male, unleashes forces which ultimately prove her to be powerless. Early in her widowhood, longing for the luxury of her husband beside her, she tricks her son Edmund into her bed; and when years later she reveals her secret to Edmund, who has married the child produced of this incest, the truth is so destructive that she stabs herself and Edmund goes to his death in the wars. The climax is a warning that there is much dire knowledge that cannot be shared: instead of common experience binding people together, it rends them apart. A few gothic writers after Walpole connected confusions of paternity with incest rather than the usurpation of property. Matthew Lewis's *Monk* provides one case. Another notable example is the climax to Sade's gothic tale 'Flourville and Courval' with its brutal revelation to Senneval that the woman standing before him is not only his sister, but the girl whom he had seduced in Nancy, the rape victim and murderess of the son born of this incestuous seduction, their father's second wife and 'the hateful creature who dragged your mother to the scaffold' without realising that it was her mother too. Hearing this revelation, 'the wretched woman leapt upon one of Senneval's pistols, impetuously drew it and shot herself'.

Confused paternities, improbable coincidences, melodrama, sudden death, cheap ideas, trivially stereotyped characters – these seem disconcertingly familiar: television soap-opera provides the twentieth-century equivalent of gothic novels (in Britain, at least, the first great television soap-opera, *Coronation Street*, dating from the 1960s, was as camp and clumsily imitated as *The Castle of Otranto*). Both *genres* provided their consumers with devices by which they could pretend to be passionate. Their success rests on the understanding that human beings learn to become adults by acting imitative or emulative parts; in consequence much human interaction is theatrical, and the private emotions of most human beings are

sustained by inner dialogues of martyrdom, self-pity, fake heroics and gaudy, mawkish histrionics. 'Love, supposed to be the most general of passions, has certainly been felt in its purity by very few, and by some not at all,' as Maturin wrote in 1807. People who have never loved, or cannot love reciprocally, satisfy themselves instead with sentimental spectacles or the delirious inanity which relishes emotional crises. Love to them is an overruling disorder rather than a quiet fulfilment without which nothing makes any sense.

There is a passage in Lady Holland's journal for 1798 which shows the emotional roots of gothic's sensational extremism. She begins by describing a newly married woman, Mrs Bobus Smith:

> Mrs. S. is a superannuated, prudish beauty. She has survived her *attraits* without perceiving their dereliction, and . . . is what a lively Frenchman called 'demoiselle froide'. She has no conversation . . . Those who live with her say she has wonderful capacity, but as it is known to only 2 or 3 persons, she must submit to the aspersion of being suspected of great dullness . . . Her eagerness to marry Smith, and delight at having done so, betray more warmth than by her cold exterior one might presume. She likes to be suspected of feeling. I suspect there is not a more inveterate lover of pleasure than a well-matured prude.

Having given this account of her friend, Lady Holland moved immediately to report on the popular arts. 'The rage for German plays still continues. The stage abounds with them, and the press is loaded with translations.' She had no doubt why they were 'relished' in Germany and Britain: 'The same dull apathy of character that demands something extraordinary to rouse it subsists in both countries, as we have nothing to boast on the score of liveliness beyond the good, dull Germans.' Lady Holland had seen her first *schauerromantik* play at Innsbruck:

> the incidents diverted me as much as the pantomime in a harlequin farce. Ye first four acts were crowded with murders by poisoning, strangling, stabbing, occasional screams, starts, and trapdoors; the fifth had all the solemn parade of *bourgeois* death, the exposition of a corpse in a coffin, with all the relations . . . crying around. But mark the catastrophe. Just as the mournful attendants were going to assign the apparently breathless heroine to her peaceful man-

sion, up she jumped, to the great discomfiture of the surrounding parties, and to ye admiration of the audience strutted about in her shroud.

Much revived gothic fiction satisfied people's desire for shallow histrionics that enabled them to pretend they were replete rather than emotionally famished; bad writing enabled them to warp their dull wits with disproportionate stories.

Gothic fiction had a second line of popular appeal. Nathan Drake, a Suffolk physician who wrote a gothic novel, *Henry FitzOwen*, and other scary fragments in the 1790s, was certain of the necessary ubiquity of fear: 'even in the present polished period of society, there are thousands who are yet alive to all the horrors of witchcraft, to all the solemn and terrible graces of the appalling spectre. The most enlightened mind, the mind free from all taint of superstition, involuntarily acknowledges the power of Gothic agency.' The country people to whom Drake ministered as a doctor were engaged in a constant battle for physical survival against the appalling spectres and invisible terrors of inclement weather, poor agricultural prices and their own weak physiques. Their fears were more concrete than Burkean notions of awe and the sublime, less spurious than the passions of Mrs Bobus Smith and less histrionic than the *schauerromantik* players at Innsbruck. For these consumers the reams of stories written in clumsy, exploitative imitation of Walpole provided parables of their own existence. 'More than four times the number of books are sold now than were sold twenty years since,' the London bookseller James Lackington wrote in his *Memoirs* (1791). 'The poorer sort of farmers, and even the poor country people in general, who before that period spent their winter evenings in relating stories of witches, ghosts, hobgoblins, &c., now shorten the winter nights by hearing their sons and daughters read tales, romances, &c.'

The qualities which distinguish *haute gothique* from soap-operatics are evasiveness and derision. Walpole was nonchalant; he had the air of holding back, under ironic restraints, so much more romance and incident in reserve. Vulgar gothicists cannot refrain; they have no undertones of excitement; they go straight to a high, explicit consternation and keep it at a pitch; they are so emphatically committed to sensationalism that they constitute the annihilation of intelligence. It is silly to seek subtle meanings in the impoverished characterisation and plots of soap-opera gothic. One must not treat seriously, say, the climax of Mrs Barbauld's melodramatic short story 'Sir Bertrand's Adventures in a Ruinous Castle':

Sir Bertrand went to it, and applied the key to a brazen lock – instantly the doors flew open, and discovered a large apartment, at the end of which was a coffin rested upon a bier, with a taper burning on each side of it. Along the room on both sides were gigantic statues of black marble, attired in the Moorish habit, and holding enormous sabres in their hands. Each of them reared its arm, and advanced one leg forward, as the knight entered; at the same moment the lid of the coffin flew open, and the bell tolled. The flame still glided forward; and Sir Bertrand resolutely followed, till he arrived within six paces of the coffin. Suddenly a lady in a shroud and black veil rose up in it, and stretched out her arms toward him – at the same time the statues clashed their sabres, and advanced. Sir Bertrand flew to the lady, and clasped her in his arms – she threw up her veil, and kissed his lips; when instantly the whole building shook as if in an earthquake, and fell asunder with a horrible crash. Sir Bertrand was thrown into a sudden trance; and, on recovering, found himself seated on a velvet sofa, in the most magnificent room he had ever seen, lighted with innumerable tapers, in lustres of pure crystal.

Such writers have none of the ambition to satirise themselves that distinguished Walpole; their excesses are stylistic bad taste rather than the deliberate inflations of Beckford's *Vathek*. The deathbed scene in 'The Ruin of the House of Albert' in Everhard Ryan's *Reliques of Genius* provides the final example of what Lady Holland herself stigmatised as 'trash':

Edwin neither averted nor avoided the deadly blow. The keen weapon cleft his breast, and was tinged in the purple springs of his heart . . . 'Farewel' he cried, 'Adela! lady peerless! and dearly beloved . . . I die a sacrifice to thy repose, with my hands red with thy husband's blood, could I ever aspire to thy love?' . . . He heaved a sigh, and died. 'Inhuman deed!' cried Adela, tearing her lovely tresses, and beating her snow-white breast. She ran, she threw herself on the lifeless body. 'O stay!' she exclaimed. 'O leave me not in my woe! Return fleeting spirit! . . . I heard a voice! a dreary voice! It was Edwin! He summons me away! I come! I come! Let the nuptial-bed be prepared! The clay cold bed!' So saying, she clasped the corpse, and expired. Instantly the page, who had been corrupted by Edgar, seizing a dagger, rushed behind

that treacherous baron, and pierced him to the heart. 'Perish!' he cried, 'author of my ruin, and of the ruin of the house of Albert.' He grew immediately frantic: he ran forth, furious and screaming: the memory of his crimes pursued him and his reason was never restored.

Disregarding both Walpole's camp and the hacks' soap-operatics, the gothic novel after Smollett developed in two traditions: the historical, initiated by Clara Reeve and culminating in the Waverley novels of Sir Walter Scott, emphasised chivalric romance; and the terrifying, which reached its genteel apogee in the work of Ann Radcliffe (1764–1823). She started writing novels at home in the evenings while her husband was out at work managing a newspaper. Her first book, *The Castles of Athlin and Dunbayne* (1789), was not impressive; derived from Reeve's *The Old English Baron* (1777), it is a formulaic tale of usurpation. *A Sicilian Romance* (1790) was more successful. *The Romance of the Forest* (1791) showed further sophistication. *The Mysteries of Udolpho* (1794) was her most celebrated achievement, though perhaps not her best book. Matthew Lewis admitted that he wrote *The Monk* under the influence of reading *Udolpho*, and it seems that her romance of the inquisition, *The Italian, or the Confessional of the Black Penitents* (1797), was written as a self-vindicating reaction to Lewis's success. *The Italian* achieves her best effects. For *Udolpho* she was paid £500 and for *The Italian* £600 – great sums for a novelist in those days – but she recoiled from commercialism and celebrity. 'She had been educated among members of the old school, in manners and morals,' an admirer wrote in 1833, ten years after her death. 'A scrupulous self-respect, almost too nice to be appreciated in these days, induced her sedulously to avoid . . . her literary fame. The very thought of appearing in person as the author of her romances shocked the delicacy of her mind . . . nothing could tempt her . . . to sink for a moment the gentlewoman in the novelist.' Her life was so outwardly calm that Christina Rossetti had to abandon an attempt to write a biography for lack of material. Radcliffe's heroine, Emily, in *The Mysteries of Udolpho* is a woman who combines sensuous distaste or disinclination with a predilection for extreme feelings and frantic statements: her masochistic submission to the order to burn her father's papers, though this destroys the possibility of solving the nameless, oppressive mystery which haunts her life, exemplifies the exasperating delicacy and passive manners that characterised Radcliffe as a gentlewoman.

Landscape was Radcliffe's paramount interest, although her ideas of terrain were taken from pictures of countries which she never visited. In *The Mysteries of Udolpho*, set in pre-Renaissance southern France and Italy, she incongruously wrote: 'This was a scene as *Salvator* would have chosen, had he then existed, for his canvas; St. Aubert, impressed by the romantic character of the place, almost expected to see banditti start from behind some projecting rock.' Her novels closed with a formal, emphatic, ladylike restoration of moral and social equilibrium; they were charac- terised by subdued interludes and happy resolutions. Contemporaries like Nathan Drake praised Radcliffe as 'the Shakespeare of Romance Writers . . . who to the wild landscape of Salvator Rosa has added the softer graces of a Claude', producing 'many scenes truly terrific in their conception, yet so softened down . . . by the inter- mixture of beautiful description, or pathetic incident, that the impression of the whole never becomes too strong, never degenerates into horror, but pleasurable emotion is ever the predominating result.' Always in her conclusions Radcliffe punctured supernatural happenings with flat, prosaic explanations. It was as if, Sir Walter Scott complained, the three witches were revealed at the end of *Macbeth* to have been three of his wife's chamber-maids disguised to impose on the Thane's credulity. Later critics have been no more patient. Jane Austen famously satirised her in *Northanger Abbey* (1818): 'Charming as were all of Mrs Radcliffe's works, charming even as were the works of all her imitators, it was not in them, perhaps, that human nature, at least in the midland counties of England, was to be looked for.' The antithesis between good people and evil that sustained her plots was reflected in Radcliffe's final apportionment of rewards and penalties.

Walpole often mocked the moralists' faith in virtue's triumph over vice. 'Virtue is an arrant strumpet, and loves diamonds as well as my Lady Harrington and is as fond of a coronet as my Lord Melcomb,' he averred shortly before writing *The Castle of Otranto*. 'She will set to cutting throats, and pick their pockets at the same time.' His gothic-novelist imitators, however, resolutely enlisted in the cause of virtue. There was no irony in the promise with which Charles Brockden Brown began *Wieland* that he would 'show the immeasurable evils that flow from an erroneous or imperfect discipline'. Clara Reeve was in earnest when she ended *The Old English Baron* by declaring it 'a striking lesson to posterity, of the over-ruling hand of Providence, and the certainty of RETRIBUTION'. Radcliffe was equally vehement in concluding *A Sicilian Romance* with a denunciation of vice: 'In reviewing this story,

we perceive a singular and striking instance of moral retribution. We learn, also, that those who only do THAT WHICH IS RIGHT, endure nothing in misfortune but a trial of their virtue, and from trials well endured derive the surest claim to the protection of heaven.' Trashier popular goths closed their narratives in similarly virtuous tones. 'His family, which he sought to enrich and ennoble by the crime of murder, had all descended to the grave . . . and [he] was himself now hastening to that gloomy dwelling; not with the satisfaction of having passed a life of purity and virtue, but with the reproaches of a heart tainted with every vice,' James Bacon wrote of the usurping baron in *Raymond's Castle*.

> May this tale impress on the mind of the reader the important truth it is intended to convey – that what is begun in vice cannot end in peace; and that however successfully the cunning and artifice of narrow-minded mortals may plan the concealment of their crimes from their fellow men, they are still visible to the all-searching eye of *Providence*!

Walpole never wished to moralise in this humourless, unaristocratic way.

Yet even Radcliffe and lesser goths of her generation could not shirk the discovery forced upon them by Walpole: the uncomfortable, insistent need of inversion. Gothic stories return again and again to the inversion of roles symbolised by young Walpole assuring Lord Lincoln, 'there is no part I won't act to keep you', a promise of subordination which masks his desire to control their friendship. In William Godwin's *Adventures of Caleb Williams* (1794) there is a tautly ambiguous relationship between squire Falkland and his secretary, Williams, who rightly comes to suspect his employer of murder and is in turn persecuted by Falkland. The two men become each other's pursuer: it is the nub of the book that their roles become inverted and interchanged. Such inversion – where the subordinate characters and submissive people attain a power which the powerful never realise – recurs throughout gothic horror. As Maturin observed, 'the drama of terror has the irresistible power of converting the audience into its victims'. Radcliffe's Inquisition guard in *The Italian* knew this too: 'to be a guard over prisoners was nearly as miserable as being a prisoner himself. "I see no difference between them", said he, "except that the prisoner watches on one side of the door, and the sentinel on the other."' This persists as arguably the most interesting theme of twentieth-century gothic: like Henry Sutpen and Charles Bon in Faulkner's novels, 'the man and the

youth, seducer and seduced, who had known one another, seduced and been seduced, victimised in turn each by the other, conqueror vanquished by his own strength, vanquished conquering by his own weakness'. Submission, the gothic imagination insists, is empowering, impervious, heroic.

A race of devils

Out of the tomb of the murdered monarchy in France has arisen a vast,
tremendous, unformed spectre, in a far more terrific guise than any which ever yet
overpowered the imagination, and subdued the fortitude of man. Going straight forward to
its end, unappalled by peril, unchecked by remorse, despising all common maxims and
all common means, that hideous phantom overpowered those who could not
believe it was possible she could at all exist.
Edmund Burke

The face of evil is always the face of total need.
William Burroughs

un rêve × 1,000,000 = chaos.
Le Corbusier

THE FRENCH REVOLUTION

On 14 July 1789 a mob captured the Bastille, an old Paris garrison symbolising all
the inept brutality of the French monarchy. Presaging the future, a scullery boy cut
off the prison governor's head with a clasp-knife and paraded it on a pike. When
the Duc de La Rochefoucauld-Liancourt gave this news to King Louis XVI at
Versailles, the king remarked, 'Why, this is a revolt!' 'No, Sire,' the Duke replied, 'it
is a revolution.' The anniversary of the Bastille's fall continues to be celebrated by
the French as the birthday of their liberties, and indeed its immediate sequel – the
Declaration of the Rights of Man in August – seemed auspicious. But the overthrow
of the *ancien régime* in France had catastrophic consequences. The French monarchy
had often enlisted the power of the crowd to celebrate military victories or the birth
of a prince, to attend religious festivals and witness public executions; but the peo-
ple's sovereignty proved to be an ugly, uncontrollable monster. In the long, bloody
sequel to the fall of the Bastille, Paris, and then France, was condemned to the arbi-
trary viciousness of mob rule. The citizenry as well as the aristocracy were massa-
cred, churchmen were persecuted and the king executed in 1793. The French were

almost continuously at war from the declaration against Austria in 1792 until the defeat of Napoleon in 1815; during that period their armies fought all over Europe, as well as in Egypt, Russia and on the seas, with appalling mortality.

Rousseau provided some philosophical theories that contributed to this disaster. In his *Discourse on the Origins and Foundations of Inequality Amongst Men* (1754) he denied the doctrines of original sin and Christian salvation by asserting that humankind was born naturally good, and was only made bad by institutions, a view which achieved imperishable sway among non-goths in the twentieth century. He attributed the ills of society to private property and extolled the cultural lives of savages. Later he asserted in *The Social Contract* (1762) that sovereignty was located in the general will of the people: although this general will was not identical with the will of the majority, its sovereignty was infallible, so Rousseau declared, thus providing a theoretical pretext for tyrannous brutality.

There were other literary influences besides Rousseau. In 1791, for example, Constantin, Count Volney, published his declamatory, overblown *Ruins; or a Survey of the Revolutions of Empires*. It had a great vogue in France during the revolutionary period and, as Volney's *Ruin of Empires*, was admired by English radicals for hailing atheistic humanism as the future's great hope. Volney pictured the legislators of a 'free people', applauded by 'the multitude', establishing progress, democracy and brotherhood to the 'consternation' of tyranny. He imagined a scene in which these legislators assembled representatives of 'every race of man from every different climate' to hear a progressive proclamation: 'Let us form one society, one vast family; and since mankind are all constituted alike, let there henceforth exist but one law, that of nature; one code, that of reason; one throne, that of justice; one altar, that of union.' In response to this absurd speech, 'the multitude rended the skies with applause and acclamation; and in their transports made the earth resound with the words *equality, justice, union*'. The mystique of French absolutism had been sustained by ceremonial spectacle since the Sun King had built his palace at Versailles. Similarly, for Volney world revolution was a theatrical affair of stagey speeches, histrionic gestures and wildly applauding audiences; later revolutionary leaders had an equally derivative need of spectacle, devising a new French state in which they acted out theatrical imitations of the Roman republic before Napoleon created an even more inauthentic version of the Roman empire.

Rioting was not peculiarly French. 'I have seen, within a year,' Benjamin Franklin

wrote of England in 1769, 'riots in the country about corn; riots about elections; riots about workhouses; riots of colliers; riots of weavers; riots of coalheavers; riots of swayers; riots of Wilkesites; riots of government chairmen; riots of smugglers.' As Lord Gilmour of Craigmillar, the historian of English riots, has written,

> in the eighteenth century Englishmen (and Englishwomen) rioted against turnpikes, enclosures and high food prices, against Roman Catholics, the Irish and the Dissenters, against the naturalisation of Jews, the impeachment of politicians, press gangs, 'crimp' houses and the Militia Act, against theatre prices, foreign actors, pimps, bawdy houses, surgeons, French footmen and alehouse keepers, against the gibbets in the Edgware Road and public whippings, against the imprisonment of London's chief magistrates, against the Excise, against the Cider Tax and the Shops Tax, against workhouses and industrial employers, against the rumoured destruction of cathedral spires, even against a change in the calendar.

This turbulence was spasmodic, random, usually intended to achieve specific objectives, unvarnished by intellectual pretensions and almost always directed against property. English rioters were sometimes killed, but were themselves seldom killers.

The French Revolution, by contrast, was literary as well as personally bloodthirsty. It was not just that France had no uncensored newspapers before 1789 and that over 500 journals of news and opinion appeared in the two years after the fall of the Bastille. The power of words was tied to revolutionary power: the King of France was first renamed the King of the French, then Citizen Capet; a new word was coined in 1789 for political crime, *lèse-nation*, to replace the *ancien régime*'s term for treason, *lèse-majesté*; as Edmund Burke observed in 1794,

> the whole compass of language is tried to find synonyms and circumlocutions for massacre and murder. Things are never called by their common names. Massacre is sometimes *agitation*, sometimes *effervescence*, sometimes *excess*; sometimes . . . an exercise of *revolutionary power*.

Burke's *Reflections on the Revolution in France* (1790) was another literary phenomenon. Recommended by George III as a book which every gentleman ought to read, it was a reminder of the cosmopolitanism of eighteenth-century European readers:

it sold 2,000 copies in Paris in two days, and had eleven editions in less than a year. Burke believed in a governing élite composed of a hereditary aristocracy supported by a natural aristocracy of intellectuals: it was the duty of this élite to inculcate prudence, religious order, tolerance and temperate liberty on the peoples of the world. He enjoined self-control and sacrifice of personal interests on all classes, and, regarding civil society as a work of art, he hated the iconoclasts who broke it. He feared cultural extinction. Dignity was integral to his aesthetics, and prudence to his political philosophy. His revulsion at the events of 1789 was vehement and profound. Its expression in his *Reflections* coloured all British attitudes to the French revolutionaries in the decade after 1790. He shattered complacency about the invulnerability of the British political system and, as much as any individual, initiated a new conservatism, allied to a revival of piety and religious interests.

Horace Walpole said of the Jacobins, 'If Macbeth murdered sleep, they have murdered hyperbole, for it is impossible to exaggerate in relating their horrible crimes; nor can the dictionaries of all nations furnish words enough to paint them in the colours they deserve.' New vocabulary and images were needed to represent the destructive horrors of an angry, vengeful mob. Gothic is peculiarly suited to moments when human experience reaches the limits of intelligibility, and the French disorders after 1789 were just such an occasion. The excesses of the mob seem exemplified by the excesses of gothic: both involve the uncontrol of unruly passions. English horror at the French Revolution was almost universal and stretched to the highest pitch. Writing in 1792 of the French queen, Marie Antoinette (a year before her execution), Walpole was typical:

> No Christian martyr was ever tortured so inhumanly for three years together – nor is there on record any memorial of such over-savage barbarities as have been committed by that atrocious and detestable nation! – a nation as contemptible as it is odious – and when La Fayette called them *cowardly cannibals*, he gave but a faint idea of half their detestable qualities.

Lafayette's phrase about cannibalism was picked up in James Gillray's print *Un petit souper à la Parisienne* (1792) depicting a family of Sans-Culottes (all without breeches) 'refreshing after the fatigues of the day' by cannibalising aristocrats whose mutilated corpses lie everywhere. Later, the greatest literary metaphor for the French Revolution, Frankenstein's monster, was literally made from cannibalised

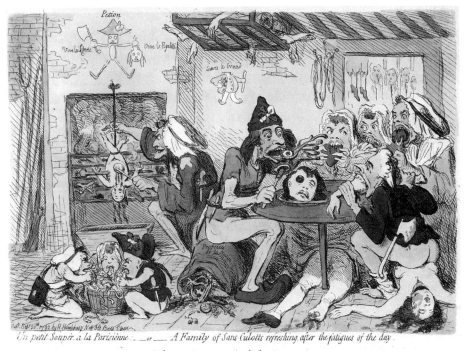

Gillray's Un petit souper à la Parisienne *or* A Family of Sans-Culottes Refreshing after the Fatigues of the Day *(1792) depicts French revolutionaries as cannibalistic monsters. The defilement of the human body, seen as the ultimate act of irreverence and savagery, became a persistent gothic obsession.*

human parts. Volney had idealised the legislators of a free people instructing the world in their progress, but the reality of French populism was better represented by Sir Samuel Romilly in 1792:

[Revolutionaries] who can deliberately load whole waggons full of victims, and bring them like beasts to be butchered in the metropolis; and then (who are worse even than these) the cold instigators of these murders, who, while blood is streaming round them on every side, permit the carnage to go on, and reason about it, and defend it, nay, even applaud it, and talk about the example they are setting to all nations. One might as well think about establishing a republic of tigers in some forest in Africa, as of maintaining a free government among such monsters.

Romilly was not the only European to feel that French ideas attracted, or created, monsters. Revolutionary excesses provoked a strong reaction against the Enlightenment. Lady Holland was a woman of sceptical temper and radical political allegiance. 'Absurd and unjust as most of the attacks are against *philosophy* . . . one must admit that these free principles and the spirit of investigation which pervades all Voltaire's writings, tended very much to induce people to attempt eradicating prejudices and making reforms before they had well examined into the abuses,' she reflected in 1799. 'One can scarcely say it has been for the better when the devastation of France is now before our eyes.' One consequence of this reaction against the *philosophes* was the rise of romanticism.

REBELLION IN IRELAND

There were attempts 'to revolutionize Ireland on the principles of France', as its English viceroy Marquess Cornwallis reported to the Duke of Portland in 1798. In that year the Irish nationalist Theobald Wolfe Tone projected his revolt against English control of his native land with French support. Such men as Tone, according to Cornwallis, were turning 'the passions and prejudices of the different sects to the advancement of their horrible plot for the introduction of that most dreadful of all evils, a Jacobin revolution.' In his estimation, 'the great author and contriver of all the mischief and treason which has already cost so many lives, and which has nearly reduced to ruin and beggary the wives and families of every man of property, and deluged the whole island with blood' was a child of the French *philosophes*, Lord Edward FitzGerald. The younger brother of Ireland's only duke, FitzGerald was a mischief-maker who treated politics as an expressive personal quest, personified the tradition of revolution as a romantic anti-authoritarian gesture, and confused publicity with originality. His mother, the Duchess of Leinster, had tried to recruit Rousseau as her children's tutor and, when he declined, educated them in a French chateau on the model of Rousseau's *Emile* with amateur theatricals substituted for book-learning. FitzGerald's life became positively operatic. At a time when he was supposed to be studying Blackstone's *Commentaries* in preparation for a parliamentary career, he instead devoured Rousseau's *Confessions*. The outbreak of the French Revolution excited him so much that he went to Paris, renounced his title and married the illegitimate daughter of Philippe Egalité, the royal revolutionary and former duc d'Orleans, and seemed oblivious to the guillotining of his fellow

aristocrats. FitzGerald discussed the possibility of an Irish revolution as early as 1792 with Tom Paine, and in 1798 led the rebellion which Cornwallis so despised. His early theatricals proved helpful in his freedom-fighting: on different occasions he disguised himself as a woman in shawls, a pikeman and a pigtailed bumpkin. This stagy life, in which he acted the part of a dashing aristocratic renegade in order to become a national hero, acquired the inexorability of a tragedy, for he was fatally injured in the 1798 uprising.

After 1798 the association of French ideas with Irish political violence was ineradicable. Thus, when the Lord Chief Justice, Viscount Kilwarden, together with a clergyman nephew, was dragged from his carriage and killed by a Dublin mob in 1803, 'the ruffians violently contended and even fought for the distinction of stabbing with their pikes the prostrate and defenceless victims', according to a contemporary report, which saw the homicidal rabble as 'brutalized by misrule, and maddened and depraved by that combination of all vice, and the source of every popular perversion – jacobinism'. The killing of Kilwarden had a direct influence on British gothic culture, for Charles Maturin in *Melmoth the Wanderer* (1820), acknowledged to be among the *genre*'s finest novels, wrote a terrible account of a ferocious mob battering the Chief Inquisitor to death, which he explained in a footnote was 'drawn' from the facts of Kilwarden's death 'related to me by an eye-witness'.

GOYA

The supreme artistic depiction of the European violence after 1789 was undertaken not by an Irishman but by a Spaniard. Francisco José de Goya y Lucientes (1746–1828) is the greatest painter to have had gothic moods. His gothicisms are an expression of the depravity of his times. It is too reductive to view his paintings biographically, especially as he stressed the universal significance in his work rather than the merely personal ingredients. Nevertheless, much of his work reflected his historical predicament.

French Jacobinism provoked a strong counter-reaction in Goya's Spain. At the insistence of its stupid king, Carlos IV, war was declared against France after the execution of his cousin Louis XVI in 1793. The consequences of its military defeat were disastrous. Spain was forced into an alliance with the French regicide government (1795) and consequently a war against Britain (1796). In the ensuing years the enlightened reforms of the Spanish *ilustrados* were baffled and foiled by monarchical

repression, reactionary populist revolts, nationalism, foreign interventions, war and famine. Goya's crowd scenes from the early 1790s show not a multiplicity of individuals but a mass in which the faces and bodies are merged, or submerged, together in an impersonalised, insensate and thus potentially monstrous entity. This reflected the regressive impact of *la plebe, la multitud, el vulgo* on Spanish life. In 1793 the populace rose up to defend the Roman Catholic Church against French revolutionary atheism. In 1808 a conservative-instigated mob forced Carlos IV to abdicate in favour of his son Ferdinand. Napoleon used the ensuing constitutional crisis as a pretext to install his brother Joseph Bonaparte on the Spanish throne. Some of Goya's friends hailed French intervention as a means of instituting long-needed reforms (Bonaparte briefly suppressed the Inquisition), but there were patriotic insurrections against the new rulers: for the first time Napoleon was confronted by an infuriated people rather than a scared monarch. Until 1814 there was savage resistance to the French by patriotic *guerrillos* supported by the armies of Arthur Wellesley, afterwards Duke of Wellington. It was during this war that Goya began recording his reaction to the French invasion, and consequent horrors of the peninsular battlefields, in a series of etchings, *Los Desastres de la Guerra* (Disasters of War, first published in 1863).

Goya, like Salvator Rosa and William Kent, adopted idioms from the other arts and borrowed from popular as well as high culture. He was energetic, impulsive and ferociously intelligent, with a despairing outlook. The horrific violence of Goya's Spain was perhaps magnified in his mind because he was isolated from human contact by acute deafness, which increasingly afflicted him after 1792–93. Following the destruction of Napoleonic power in 1814, Ferdinand VII was restored to the Spanish throne. The populace had idealised him during Joseph Bonaparte's rule, but he proved a cruel, cowardly and inept despot; he epitomised the arch-reaction against Enlightenment philosophy provoked by the calamities that fell upon Europe after the storming of the Bastille. In 1823 Ferdinand reneged on a promised amnesty to his opponents and massacred his own subjects with hateful savagery; the following year Goya (court painter to this brute, whom he depicted in several superb portraits) entered voluntary exile in Bordeaux.

Goya enjoyed a close friendship, based on profound mutual admiration, with the writer, jurist and humanist intellectual Gaspar Melchor de Jovellanos, who for a long period was incarcerated or exiled by their Spanish rulers. Jovellanos in the

1790s had befriended the English Whig Lord Holland, who afterwards was strenuous in attempting to obtain his liberty. Holland, who was a frequent visitor to Spain and wrote a critical biography of the Spanish playwright Lope de Vega, gave Jovellanos the novels of Ann Radcliffe. Gothic novels and poems became prized among the intelligentsia of Goya's set. Matthew Lewis's play *The Castle Spectre* (1797) was translated into Castilian under the title *El Duque de Visco* (but with the monk and ghost omitted) for performance in 1803, and it is probable that Holland, who knew Lewis socially, also gave a copy of his novel *The Monk* to Jovellanos. This English literary gothic sensibility that was so fashionable among Spaniards of Jovellanos's set seems to have influenced Goya, though he transformed its moods and images with his own magnificent imaginative vision.

Goya's superbly original drawings called *Los Caprichos* (the Caprices), published in 1799, show that gothic effects reach their apotheosis when enlisted to convey ideas at the frontiers of human comprehension: gothic effects are minor when their technique is elevated into a self-sufficient, exclusive aesthetic. It was not just English literary sensibility that enriched Goya's gothic imagery. Fred Licht has noted that Salvator Rosa's *Witches' Sabbath* (plate 2; described on pages 19–21) contains four motifs that were later used by Goya. To take one example, Goya's cartoon *Hunting for Teeth* (plate 12 of *Los Caprichos*) shows a woman averting her face in terror as she tries to pull a tooth from the mouth of a hanged man for use in potion-making or as a talisman against ill-fortune. (He is possibly the same man pictured in an earlier scene of Salvatorian banditry.) The woman's horror at what she is doing, the compulsiveness of her superstitions, produce a look of utter distraction, which impression is enforced by the nightmarish oddity of her surroundings. In Goya's drawings there are no frontiers or bulwarks against excess.

LOS CAPRICHOS

Sadean dissimulation and personal isolation are keys to Goya's vision as they are to all the higher manifestations of gothic. His drawings are often in obscure form because they express political or religious allusions which it would have been dangerous to make explicit; his character, in any case, was drawn to nightmarish symbolism. He was oppressed too by a sense that human beings are, necessarily, mummers in a show who are lost unless they realise that their existence is part of a charade played by the hypocritical and the mad. This comfortless view of humanity

is represented in plate 6 of *Los Caprichos* entitled *Nobody Knows Anybody*, given the caption by Goya: 'The world is a masquerade; face, dress, voice, everything is feigned. Everybody wants to appear what he is not; everybody deceives, and nobody knows anybody.' This personal evasiveness is central to the gothic imagination; so too is the inversion of roles, and interdependence of opposites. Plate 24 shows a whore being humiliated by the righteous before a mindless plebeian mass. Goya draws an analogy between the harassment of the whore and the Roman Catholic hierarchy's process of beatification or canonization with his sardonic caption: 'This sainted lady is being persecuted to death. After writing her life, they take her out in triumph. She deserves everything, and if they do it to shame her they are wasting their time. Nobody can shame her who is shameless.'

Los Caprichos not only satirised Spanish superstitions but raged against the brute stupidity which had been so nightmarishly empowered by the European revolutionary crisis of the 1790s. Goya's idiots, bawds, demons, monsters, hateful visions and haunting terrors were not images of personal imaginative perversion but represented the evil powers that surrounded him in Bourbon Spain. Superstition is represented as a way of enslaving the people from childhood onwards and of keeping adults in a state of idiotic infantilism. Plate 13, for example, is an image of insatiable monks with huge mouths gobbling food; the phallic nose of one monk is a reminder that their greed is for sex as well as for food; so is the punning caption 'Estan calientes' ('They are hot'), meaning that their food is hot but also that they are sexually excited. A human head is being served on a platter to the monks, and the metaphor of the church as an exploiter of the faith of the credulous multitude is stressed by Goya's caption, 'Dream of some men who were eating us up'.

The aristocracy are attacked in many cartoons. Plate 50, *The Chinchilla Rats*, is a nightmarish vision of two senseless, helpless, useless noblemen in armorial tunics being spoon-fed in a pathetic, repulsive way; they are so stupid that their ears are padlocked. Its early pencilled caption, now partly indecipherable, read: 'Nightmare dreaming that I could not wake up nor disentangle . . . of nobility'. The final caption reads, 'He who does not listen to anything, nor knows or does anything, belongs to the numerous family of the Chinchilla-rats who never have been good for anything.' The cartoon is notable for its contribution to twentieth-century gothic iconography; Goya's recumbent aristocrat is an arresting image that Hollywood and Hammer film-makers have adopted for Frankenstein's monster.

5o.

Los Chinchillas.

There was no strength or grave beauty about the monstrous aristocrats in Goya's Los Chinchillas. *They are closed off from the world of ideas, and are devoid of that fortitude which is the highest virtue of aristocracy. By a perverse process, Goya's degenerate noblemen provided Hollywood with the imagery for gothic literature's most enduring parable of French revolutionary excess, Frankenstein's monster.*

Bourbon bureaucrats are not spared in *Los Caprichos*. Plate 76 depicts a strutting uniformed official above Goya's comment: 'The cockade and the baton of command make this blockhead believe that he is a superior being. He abuses the power entrusted to him in order to annoy everybody who knows him. He is haughty, insolent, and conceited with his inferiors in rank, and abject and base with those who have greater power.'

One pervading theme of *Los Caprichos* (others could be picked out) is parasitism: plates 8, 43, 46, 64 and 72 contain vampiric figures. Perhaps the most important single image for an historian of the gothic imagination is plate 43, inscribed 'The Sleep of Reason Produces Monsters', in which blood-sucking bats hover over a male sleeper. As Ronald Paulson has shown, the image can be read as meaning – similar to Fuseli's *Nightmare* (see plate 5) – that when one sleeps, reason relaxes its vigilance, thus disastrously releasing monsters, or that the Enlightenment's dreams of reason resulted in monstrosities. It was brutally evident in the Europe of the 1790s that release from oppression could result in something just as destructive and nightmarish as enslavement. Oppressed people unleash monstrous powers too. As Paulson says, 'Like the monsters, the oppressed are both hated and feared, like our own unconscious, our lower, sexual instincts.' The monstrous forms introduced in plate 43 first seem horrifying but gradually become familiar and less threatening; Goya warns that dehumanising brutality can inure us to evil.

Goya refined such imagery to a horrendous climax in his cartoon series *Desastres de la Guerra* (1810–20), often known in English as *Disasters*. These drawings constitute a furious accusation against the carnage in Spain resultant from the French revolutionary wars, as Paulson has brilliantly analysed. The sequence of battlefield scenes, rape and pillage, murder, torture and mutilation features French soldiers armed with rifles, muskets and bayonets pitted against Spanish guerillas equipped with stakes, daggers and hatchets. No soldiers from Wellington's English armies are ever shown. There are scenes of savage retaliations until the war crimes pile one upon another without any retrievable meaning or cause. The countryfolk in Goya are not Rousseau's noble savages, but uglier, more deprived, needy, brutal and stupid. They are a reminder that the face of evil has the dull ugliness of banal stupidity. The cartoons representing the famine of 1810–12 reduce the slaughter to the level of a natural phenomenon conceding no distinction between French and Spanish, men or women, with only a satisfied profiteer in plate 61 breaking the depersonalised

The Sleep of Reason Produces Monsters *is superbly emblematic of its own and succeeding ages. Goya's image incorporates the terrors and insecurities that have sustained goths' literary imagination.*

images of slaughter. *Desastres* constitutes the gothic imagination at its highest ethical pitch. Salvatorian trees and macabre corpses are only incidental in scenes of the casual cruelty of the epoch. Only a few images can be mentioned. Plate 37 shows a stupid soldier brandishing his sword, heedless of a nearby impaled corpse with its mouth still rigid in its last agonised scream. Goya sees horror as the badge of humanity, depicts a new brotherhood among the tortured bodies, perhaps too (like his contemporary Sade) indicts God, or human ideas of godliness, in these appalling images taken from his battlefield tours.

The brutalised corpses of *Desastres* rob humans of the comfort that, being made in the image of God, they incarnate or retain his goodness and beauty. In plate 39 the disintegration of the times is conveyed by a dismembered, needlessly mutilated corpse: as Fred Licht summarises in *Goya: The Origins of the Modern Temper in Art*,

The Pantomime of life is near its close;
The Stage is strewn with ends and bits of things,
With mortals maim'd or crucified and left
To gape at endless horror through eternity.
 Osbert Sitwell, Twentieth Century Harlequinade

'the body of man, for untold centuries represented as an object of reverence, is for the first time rendered as corrupt and repulsive, bereft of nobility'. This, though, was not just the product of a brutal war; Lady Holland, travelling in Spain in 1803, was 'stopped to be shown the head of a notorious robber . . . placed in an iron grating, little but the skull remained; the other parts of the body were sent off to the different places where he had offended.' Her experience is a reminder that war atrocities and mob brutalities had equivalent evils in the instruments of oppression wielded by monarchies and aristocracies. The strength of every revolutionary opinion is partly drawn, as Orwell knew, from a secret conviction that nothing can be changed. In plate 69, which Goya captioned 'Nothing, he will tell you so himself', a dead man returns to life to write his cruel conclusion on the meaning of it all, 'Nothing'. Stupidity and violence do not deserve differentiation. Intelligence and imagination deserve respect. Goya, in the remorselessly unconsoling conclusion to *Desastres*, provides his own commentary on that moment of high Christian symbolism when Jesus Christ declares that he came into the world to bear witness to the truth and Pontius Pilate replies with his despondent, contemptuous question, 'What is truth?' before offering to spare Jesus's life (the Jews instead call out the name of Barabbas the robber). Goya's final post-Baraban plates, 79 and 80, are entitled *Truth Is Dead* and *Will She Ever Come to Life Again?*

Saturn Devouring One of His Children (painted by Goya in 1820–23) depicts a giant gripping a child in his fists, using his mouth to tear the child apart, one of the bleeding, mutilated stumps entering the giant's maw. The giant has a face of total evil, because, in the phrase of William Burroughs used as an epigraph to this chapter, it is a face of total need. (The title reference to Saturn was invented long after Goya's death, and attaches the image to classical mythology with a precision which simplifies the artist's intentions.) In a speech shortly before his execution in 1793, Pierre Vergniaud, the Girondin orator whose greatest early speeches pledged patriotic self-immolation, uttered his fear that 'the Revolution, like Saturn, devouring each of its children in turn, will finally engender despotism with all accompanying calamities'. Whether or not Goya knew of this famous prophecy, his intensified, convulsive image of Saturn's unintelligible atrocity has resonated through the twentieth century, with the despotisms and calamities of the Communist revolutions in China and Russia, the Nazi coup in Germany and African tribal nationalisms. According to Fred Licht, Goya's *Saturn* is 'essential to our understanding of the human

condition in modern times, just as Michelangelo's Sistine ceiling is essential to understanding the tenor of the 16th century'. The royal picture gallery in Madrid contained an earlier representation of the Saturn myth by Peter Paul Rubens which is classical and conventional. Rubens's child shrieks for help; there is an unambiguous judgement that cannibalism is ethically repellent and that moral order must be maintained. 'Goya's version of the myth makes no allowance for anything but madness and ferocity,' as Licht describes:

> Goya doesn't portray a single normal or foreseeable reaction to what is happening. Not only is the savage ogre in his painting totally unrelated to the appearance of human beings; his victim is similarly ambiguous . . . Everything is inexplicable, everything is enigmatic and menacing, speechless with horror . . . The instinct of attack is raised to a universal principle: Chaos is the origin and the end of life. Madness is rendered in the distraught vocabulary of madness.

Saturn Devouring One of His Children indicates one direction of gothic excess after the French Revolution had forced the gothic imagination beyond the gentilities of Ann Radcliffe and the camp of Horace Walpole.

The cruelty of eighteenth-century entertainments and the savagery of its punishments – the spectacle of public executions and ritual humiliations of transgressors as well as the arcane investigations of the Inquisitors – were transformed by Goya's courage both into searing social satire and into images of universal horror. *Los Caprichos* were sought by foreign artists and collectors within a few years of their publication in 1799. Goya's reputation was international – he painted several portraits of the Duke of Wellington during the Peninsular War – but his truths proved hard to bear. Ruskin flinched from the self-knowledge which they bring. Seeing a copy of *Los Caprichos* in 1872, he announced that it 'was only fit to be burnt' and helped to light an empty grate (it was in August) to turn the book to ashes. The implacable, comfortless power of Goya's imagination, however, excited J. K. Huysmans, who likened the images to stories by Edgar Allan Poe. Des Esseintes, the protagonist of Huysmans's novel *À Rebours* (1884), admired Goya's drawings as 'unique' because 'most of them exceeded the normal limits of painting, inventing their own fantasies of the morbid and the mad'. Des Esseintes especially 'lost himself' in *Los Caprichos*, 'following the artist's fantasies, totally absorbed by his

bewildering imagination, – witches riding black cats, a woman pulling out the teeth of a man hanging at the gallows, bandits, succubi, demons and dwarfs'; but overall it was 'the savage energy, the uncompromising, reckless talent of Goya [that] captivated him'. André Malraux celebrated Goya as 'the greatest exponent of anguish Western Europe has ever known'. Goya was for Malraux modern art's great precursor who destroyed the necessity for decoration in art, made beautification obsolete and created works devoid of ethical values other than those contained in his creation. Goya's influence was colossal: his admittedly ungothic 'Scenes of the Third of May 1808' was taken as a model by Manet for his *Execution of the Emperor Maximilian of Mexico* (1867) and for Picasso's *Massacre in Korea* (1951).

THE MARQUIS DE SADE

Goya's chief contemporary counterpart was Donatien Alphonse François, Marquis de Sade (1740–1814). They had the same relationship to their age as Dante, Shakespeare, Tennyson and Kafka had to theirs. Though emphatically Goya's creative inferior, de Sade's ideas (so often tinged with gothicisms) have been as essential to understanding the human condition in the twentieth century as Goya's imagery. They have both served urgent imaginative needs of the modern world. On the few occasions when ordinary people are intensely, immediately aware of their own passionate emotions, it feels like a personal apocalypse for them. The passion with which Goya and Sade depicted the cruelty they saw in the universe was like a general apocalypse and elicited the outraged revulsion that derives from fear. One can as easily ask of Sade as of Goya: had he not existed, when would it have been necessary to invent him? The answer is that Sade was needed in the decade before the First World War – Apollinaire predicted in 1909 that 'this man who appeared to count for nothing during the whole of the nineteenth century may dominate the twentieth' – and Goya would have been devised in the 1930s, when Spain was again ruined by civil war and the industrial tyrannies were preparing for genocide and world conquest.

Sade's life and ideas were suppressed throughout the nineteenth century, and have been conscientiously distorted throughout the twentieth. He was the only surviving child of a meticulous, austere, frigid and pompous nobleman. His family's properties were a strong imaginative influence on him. Their chateau of La Coste stood in a beautiful, fertile plain between the Lubéron Mountains to the south and

Mont Ventoux on the northern border of Provence. As Donald Thomas describes, 'The chateaux of the Sades at La Coste and Saumane were perched high above the river valleys and terraced vineyards, suggestive . . . of a dramatic study by Salvator Rosa or the opening pages of a gothic novel.' Like Horace Walpole using Strawberry Hill for *The Castle of Otranto*, or William Beckford using features of his house in *Vathek*, de Sade drew on his family home when he imagined the sinister castle at Silling in *Les 120 Journées de Sodome*.

> The mountain range, the steep wooded gorges and the swift rivers of the Vaucluse were infused by the excitement and promise of pleasure, tyranny and that uncontrolled self-indulgence in which the villains of remote chateaux might relieve their compulsions . . . the chateau at Saumane – its underground vaults, fine stairway, gallery, apartments, casements piercing the massive lower walls above the valley – were to be characteristic features and furnishings of Sade's novel.

His mother was attached to the household of the orphan Bourbon prince de Condé. In 1744, when he was aged four, Sade beat up the prince de Condé (four years his senior), and was sent away to his grandmother's fifteenth-century gothic house at Avignon, then to the ancestral chateau of Saumane and finally to the decaying abbey of Ebreuil. In 1754, at the age of fourteen, following the eruption of the Seven Years' War, he went as a young army officer to Germany, where he saw various scenes of carnage.

He was first arrested in 1763 for terrifying a Paris prostitute with threats of flagellation accompanied by satanic rituals. Encouraged by the police, many Paris brothels refused him service. At Easter of 1768 he subjected the middle-aged widow of a pastry-cook to an ordeal of flagellation. Her complaints raised such a high scandal that within ten days the Parisian Madame du Deffand was sending an account of the affair to her devoted London friend, Horace Walpole. Sade's preference for violent, consensual sexual rituals in private made him a notorious object of popular hatred, though the intensity of reactions seemed to him hypocritical, given the prevailing taste for violent, non-consensual public punishments. Following the denunciation of 1768 Sade was imprisoned for some months before royal exile from Paris to La Coste. In 1772, after an orgy in Marseilles, he was convicted of poisoning (having administered non-fatal doses of an aphrodisiac to two women) and of being

sodomised by his valet. He was sentenced to be beheaded at Aix, but instead the executioner decapitated an effigy, Sade having moved to safety in the kingdom of Sardinia. His property was seized and his wife was given guardianship of their children. He had a rich, ruthless and resourceful mother-in-law who had never forgiven him for eloping with her daughter and persecuted him at civil law. At her instigation, in 1777 he was consigned to Vincennes prison without trial by the unjust legal device of Bourbon France known as *lettres de cachet*.

Vincennes was a grim, towered fortress with damp, tiny, airless, ill-lit cells. Sade was kept there in solitary confinement; his name was suppressed (he was known as 'Monsieur le 6' after the number of his cell), and his food was pushed through a hole in the door as if he was a wild, caged beast. The governor imposed the strictest rules of silence upon the inmates, and enforced a regime of severe institutionalised cruelty. Sade was enraged and horrified by his incarceration, but did not go mad. His obsessions grew in the solitude of prison, where he began writing letters of great vigour, passion and logic, often addressing philosophical ethics. It was only after his transfer in 1784 to the Bastille that he began to write for publication. (His Bastille prison-cell was in the Tower of Liberty, reminding one that political prisoners of Fidel Castro's tyranny in Cuba were confined in the unspeakable Campo Libertad.) He was removed from the Bastille a few days before its storming, having shouted from its towers to passers-by that he and the other inmates were being slaughtered, and was committed at gunpoint to Charenton asylum. He thought that the only manuscript of his first fiction, *Les 120 Journées de Sodome*, was lost at this time, and never knew of its ultimate retrieval. In 1790 there was a general amnesty for those, like Sade, imprisoned by *lettres de cachet* and he regained his freedom.

He recognised the possibility that he might be executed in a fit of democratic zeal and worked as a pamphleteer, vapidly propagandizing for the new regime. For a time he was a magistrate in his section of Paris but made himself objectionable to the revolutionaries by his leniency: he always opposed capital punishment, arguing that the only ethical punishments were those offering a possibility of the culprit's reform; one might commit crimes for pleasure, he believed, but one should not murder in the name of justice. His radical sympathies were sincere. The *ancien régime* had treated him as an enemy, and even after the horrors of Jacobinism were evident, he continued to despise

that dirty, morbid village called Versailles, where kings intended for adoration in their capital flee from the subjects who want them, where ambition, avarice, revenge and pride daily unite a host of unfortunates flying on the wings of boredom to offer sacrifices to the idol of the day, where the highest French nobility, who could give responsible leadership on their estates, submit to humiliation in antechambers.

His hopes of political reform were annihilated in September 1792. During that month the reception rooms of his chateau at La Coste were mindlessly vandalised during its looting by a mob. Having despoiled La Coste, the thieves began circulating lurid exaggerations about its erotic frescos and a frieze depicting the administration of an enema. Their allegations could have brought Sade to the guillotine if the Committee of Public Safety had heard or chosen to believe them. Yet he was repelled by the September Massacres even beyond the assaults on his property and safety. In one instance the Princesse de Lamballe, who was imagined to be the partner of Queen Marie Antoinette in sapphic delights, was lynched by a mob. Decapitated with one stroke of a sabre, her head was impaled on a pike and paraded before the queen's windows, her heart was torn out while the rest of her corpse was abused by the mob. After cutting off her breasts, the executioner sliced off her vulva, which he wore as a moustache to the joy of the mob. Despite his reputation, Sade never desired to participate in such cruelties and understood that the mob was being manipulated by hypocrites with a lust for power. Arrested again in 1793 because his name mistakenly appeared on a list of men denounced for conspiracy, he escaped the guillotine by another bureaucratic error. His moderation – particularly about executions – made him suspect to the prevailing powers, and he spent ten months in four revolutionary prisons. At the last, over 1,800 people were guillotined in a beautiful garden outside his window during the course of one month there; he possibly had to help in the mass-burials.

Such experiences were as searing as Goya's tours of the Peninsular War battlefields with their heaps of broken and powerless dead. The mass blood-lust which signalled the failure of the revolution led Sade to revise his existing work and extend his ideas, to demonstrate that hypocrisy and the lust for power were not the worst of humanity: its blood-thirst and cruelty were more terrible than those of wild beasts. A political pamphlet ridiculing Napoleon and the Empress Josephine was in

1801 attributed to Sade; as a result, he was again committed without trial to Charenton asylum, where he remained until his death in 1814. He spent all but ten of his last thirty-two years in confinement. The small-mindedness of the Puritans never abated: in 1805 the chief of police protested at Sade taking Communion and the collection in church. During these last years Sade diverted himself by instituting a theatre for madmen at Charenton. Sometimes he procured actors and actresses from outside, but mostly he trained amenable lunatics to act, wrote his owns plays for them or directed them in other repertory works. This spectacle was a superb inversion of Auden's principle that human beings are actors who can only reach a new identity or personal attainment by first pretending to be it or imitating it, with the distinction that the sane know they are acting but the mad do not. Sade found himself controlling actors who both knew they were acting and were mad.

Imprisonment provided Sade with his vocation: to be a ruined man. It was his triumph to turn this ruin into statements about the human condition as resonant for the twentieth century as Goya's. In his early life he acted out the horrors that maintained the political control of the *ancien régime*: in later life he never betrayed any wish to emulate the atrocities that accompanied popular sovereignty, though his behaviour had the fatality of a hero *manqué* in Strindberg or O'Casey. Real or symbolic enjoyment of pain, fear and atrocities had been at the heart of literary gothic since Edmund Burke's definition of the sublime and Horace Walpole's trashiest imitators: Sade's fictionalised sexual atrocities were a new refinement of the English gothic sensibility intended as metaphoric of French power systems. They were also an angry, deliberately distorted image of contemporary reality. As his biographer Donald Thomas demonstrates, eighteenth-century European societies devised vile acts of judicial cruelty staged as ceremonial spectacles for the mob. At the start of the century Ned Ward recognised the flogging of young prostitutes in London's Bridewell prison before crowds of visitors as 'design'd rather to feast the eyes of the spectator, or stir up the appetites of lascivious persons, than to correct vice or reform manners'. The death sentence on Scotland's Jacobite rebels in 1746 was that they should be hanged 'but not till you be dead, for you are to be cut down alive; your bowels to be taken out, and burnt before your faces'.

Death was a spectacle, and the corpses of those murdered by the state were commodified after death. For example, in 1801 the Royal Academy bought the remains of a murderer, James Legge, whose corpse had been dissected by anatomists and

sewn together again. At the Academy he was pinned to a wooden cross, plaster was poured on him, and he became a model for art students practicising Crucifixion pictures. Coventry Patmore's poem 'A London Fête' describes such spectacles:

> The rabble's lips no longer cursed
> But stood agape with horrid thirst;
> Thousands of breasts beat horrid hope;
> Thousands of eyeballs, lit with hell,
> Burnt one way all to see the rope
> Unslacken as the platform fell
>
> . . .
>
> That clatter and clangour of hateful voices
> Sickened and stunned the air, until
> The dangling corpse hung straight and still.
> The show complete, the pleasure past,
> The solid masses loosened fast;
> A thief slunk off, with ample spoil,
> To ply elsewhere his daily toil;
> A baby strung its doll to a stick;
> A mother praised the pretty trick;
> Two children caught and hanged a cat;
> Two friends walked on, in lively chat;
> And two, who had disputed places,
> Went forth to fight, with murderous faces.

Nor are such spectacles impossible in the modern industrialised world: in the 1990s university students in Texas hold festive barbecues outside the state penitentiary on the evenings of executions. In the France of Sade's youth, in 1757, Robert Damiens, a religious eccentric who had inflicted a slight stab wound on Louis XV, was publicly executed in Paris with such devilish cruelty (involving the application of fire, brimstone, hot pincers, melted lead and scalding oil) that his hair stood erect and had turned white before the dismembered body (slowly torn apart by horses) was lifeless. The chief difference between such realities and Sade's fiction is that his nightmarish cruelties are heaped on one another in such quick succession that they always

seem fantastic; their richness rapidly cloys. Real-life cruelties are broken up by the monotonous routines of their perpetrators' daily lives: the audience at Damiens's spectacle went off to eat or walked dully away. Sade was indignant at the banal stupidity of the people who inflicted or watched institutionalised atrocities: 'Murderers, jailers, fools of every country and every government, when will you prefer the science of knowing man to that of incarcerating him and killing him?'

Like other cultivated Frenchmen of his epoch, Sade was widely read in philosophy. Like Machiavelli, whom he ardently admired and whose theories he explored in his novels, he united remorseless logic with ardent feelings. He challenged Rousseau and other Enlightenment theorists with his insistence that nature was even more ominous than Salvator Rosa's depictions, always brutal, murderous and vicious. 'The true laws of Nature are crime and death,' declares Saint-Fond, the most powerful man in France, in Sade's *Juliette*. 'Personal interest,' says Saint-Fond's coadjutor Noirceuil, is 'the most sacred of the laws of Nature.' Sade fulminated against the institutions and teachings of organised religions – 'bigotry, mummery or futilities all the time, and never a sound moral maxim', he complained in his gothic tale 'The Self-Made Cuckold' – but perhaps thought more about God than sex. As a passionate idealist, he never forgave God for the evil and misery of Creation. 'I raise up my eyes to the universe: I see *evil, disorder, crime* reigning as despotic everywhere,' declares Saint-Fond. 'Evil is indispensable to the vicious organisation of this sad world. The God who articulated it is a very vindictive being, very barbarous, very wicked, very unjust, very cruel.' Sade did not accept the Christian view that because the universe is monstrous by human standards, its appalling power is divine and to be worshipped. Nor could he forgive religious people for the submission of their faith. 'The pious are weaker than most, especially when you offer them boys. Seldom sufficiently stressed, often not even realized, there exists a powerful analogy between believers in God and buggers.' He shared Goya's view of superstition as a retarding political force and prefigured a famous communist phrase when his fictional Juliette told King Ferdinand of Naples, 'You keep the people in ignorance and superstition because you fear them if they are enlightened; you drug them with opium so that they shall not realise the way you oppress them.'

120 Days of Sodom

Sade was a voracious novel-reader who found that his own powers of fantasy were so vigorous that they had supremacy over his intellectual activity and physical impulses, and rashly generalised that all people were like him. When he began writing fiction as a prisoner in the Bastille, he used all the gothic effects of terror, brutality, coincidence and histrionics; but, suitably for someone incarcerated in prison, he maintained strict control over the apparent chaos. There is little humour in his fiction except in *Les Crimes de l'Amour* (1800), bawdy gothic tales of cuckoldry, libertinism and sexual deception which teased rather than outraged public opinion. To many readers (not just puritans who recoil from his imagery) he seems a feeble imaginative writer tricking out long, implausible fantasies of cruelty and sexual excess in clumsy language. Sade determined that the roots of evil, and the cause of his own miseries, were the principal human institutions of private property, class distinction, religion and family life. His libertines exemplified his belief that since absolute power was impossible to achieve, the only powers worth possessing were those of the private imagination: concealment was the great erotic power-game. His earliest fiction, *Les 120 Journées de Sodome*, served the purpose of private prison-cell pornography (equivalent to Jean Genet's prison classic *Notre-Dame-des-Fleurs*), but Sade was too much of an eighteenth-century Frenchman to discard an interest in social issues, and sex is used in his writings as a way of describing power relations. He was not unique among contemporaries in politicising pornography: there was an eruption of obscene pamphlets about orgies involving Queen Marie Antoinette in 1789–91 among other instances.

Sade's gothic fictions describe the urgent, ruthless way humans use and exploit each other; he identified sexual repression as analogous to political repression, with each likely to result in revolutionary eruptions. His gothic tale 'Emilie de Tourville' concerns a young girl whose two brothers discover that she has been making clandestine sexual assignations, and confine her with orders that she be bled on both her arms as many times a week as she had met her lover. Sade's conclusion about this blood-letting could stand for the revolutionary blood-letting too:

> such infamous behaviour is reserved to those frenzied and clumsy supporters of Themis who, brought up in ridiculous severity, hardened from childhood to the cries of unhappiness, soiled with blood since the cradle,

criticising everything and allowing themselves everything, imagine that the only way of concealing their secret shame and their public prevarications is to reveal a rigid severity which . . . has no other object, in covering them with crime, than to impose on fools and to make wise men detest their hateful principles, their sanguinary laws and their despicable personalities.

Les 120 Journées de Sodome was written by Sade in the Bastille in 1784–85. In it he created an imaginary landscape so much more spacious than his cell (to add to its secretive fantasy, it was hidden in the cell's wall). Stolen after the ransacking of 14 July 1789, it was never seen again by Sade and only resurfaced in the late nineteenth century as the property of the Marquis de Villeneuve-Trans. After the manuscript's sale to a German collector, an abridged version was first published in 1904 by the Berlin sexologist Iwan Bloch in an edition with a stated circulation limited to scientists, medical men and jurists. The manuscript was bought by a French viscount in 1929, and published in its entirety in an edition by Maurice Heine in three volumes (1931–35). Sade's narrative opens in 1715, when the armies commanded by the Duke of Marlborough had routed the French at Blenheim and Malplaquet and destroyed French military hegemony in Europe. King Louis XIV had just died, and during the childhood of his great-grandson Louis XV (1715–23) there was a council of regency presided over by Philippe, Duc d'Orleans, a man of many brilliant qualities, but a libertine and reputed poisoner, who vested himself with absolute power and ruled with flagitious corruption. Sade's first chapter begins:

> The great wars which imposed so heavy a burden on Louis XIV drained the wealth of the Treasury and the people alike, but provided the secret means of prosperity to a swarm of bloodsuckers. Such men are always alert for public calamities which, instead of mitigating, they create or promote so that they can exploit the miseries of others. The end of Louis XIV's sublime reign was one of the periods in French history when one saw the mysterious emergence of the greatest numbers of those fortunes whose origins are as obscure as the lust and debauchery that accompany them.

He then names four middle-aged or elderly men who had amassed corrupt fortunes in this way: the Duke de Blagis, his brother the Bishop of X, a judge called de Curval and a financier, Durcet.

This evil quartet determine to spend a portion of their ill-gotten gains on a pro-longed orgy in the sequestered castle of Silling, a place that in the course of his story moves from being a picturesque, remote chateau, as beloved by Ann Radcliffe, to something nearer to Belsen or Dachau. 'Caves, underground passageways, mysterious castles, all the props of the Gothic novel take on a particular meaning in his work,' as Simone de Beauvoir noted. 'The places he evokes are not of this world, the events which occur in them are *tableaux vivants* rather than adventures, and time has no hold on Sade's universe.' In such extreme estrangement from other people's senses and conventions he found perfection. Sade's structure resembles Boccaccio's *Decameron* and Queen Marguerite of Navarre's once popular and now unjustly neglected *Heptaméron*, but the text lacks the delicious irony of Queen Marguerite. He had three intentions: to provide himself with sexual excitement in his prison cell; to provide a sexologist's catalogue of all possible sexual activity; and to use the increasingly revolting murders to indicate the loathsomeness of humanity. The four ageing debauchees begin by marrying each other's daughters, unite their fortunes to consummate their expensive project, hire procurers, kidnap 150 boys and girls from the best families, have preliminary orgies, keep the most alluring sex-objects and put the rest to atrocious deaths with the customary unbridled gusto of plutocrats. The buggery and paraphernalia of semi-satanic rituals which Sade attributes to the debauchees of Silling resemble the fantasies encouraged in their clients by therapists in the 1990s who believe in recovered memory syndrome.

Justine, ou, les Malheurs de la Vertu (*Justine, or the Misfortunes of Virtue*) was drafted in 1787 with the intention of publication and appeared in its first version in 1791. It stands as an antidote to the Enlightenment optimism of Voltaire's *Candide* and is narrated by an orphan with a naïve faith in virtue and its just rewards who is brutally initiated into reality by rapes and cruelties. She never realises that virtue would cease to be virtue if it was consistently rewarded: it is only possible in an unethical universe. Justine's expectations that virtue will be rewarded are mocked when she is killed by a bolt of lightning: a reminder that Nature is cruelly indifferent whereas human beings have a choice between cruelty and indifference. There is not space to analyse *Justine* in detail (the story was twice revised by Sade with increasing elaboration). Its most notable character, the Marquis de Bressac, is a machiavellian comparable to de Blamont, a cold, calculating, sybaritic power-figure who dominates *Aline et Valcour*, Sade's epistolary novel influenced by Richardson

and Choderlos de Laclos written in the Bastille about 1788, published in 1795, but prohibited in 1815 and 1825 as politically subversive.

In the seven years after the cancellation of his *lettre de cachet*, Sade saw such evil that in 1797 he published a revised supplement to *Justine*. The bloodthirsty erotica of *La Nouvelle Justine, ou, Les Malheurs de la Vertu; suivie de, L'Histoire de Juliette, sa Soeur, ou, Les Prospérités du Vice* are narrated by Justine's depraved sister Juliette, who represents gothic excess at its most extreme: 'for those with an imagination like mine, the question is never whether this or that is repulsive, irregularity is the sole consideration, and anything is good provided it be excessive', she boasts during an early episode with Saint-Fond: 'Something told me he had a burning desire to have me eat his shit, I sought permission to do so, obtained it, he was in ecstasies.' Having survived initiation by the most wicked debauchees in France, Juliette tours Europe in a frenzy of homicidal erotomania, devastating its political institutions, ethics and aesthetics. Written with a public message rather than as a private fantasy, *Juliette* was well characterised by Geoffrey Gorer as 'the final vomiting of de Sade's disgust and disappointment'. Though there is a super-abundance of perversion, its central preoccupation is not sexual fetishism but the power of money, admittedly often represented by fetishism: Saint-Fond's shit, which he is ecstatic to have eaten by Juliette, represents a metaphor for the fortune which makes him France's richest man.

Saint-Fond is Sade's greatest machiavellian, 'a man of some fifty years: endowed with a keen wit, with much intelligence and much duplicity, his character was very traitorous, very ferocious, infinitely proud; it was in the supremest degree he possessed the art of robbing France, and that of distributing warrants for arbitrary arrest which he sold at a good price . . . over 20,000 persons of both sexes and all ages were by his orders languishing in the royal dungeons with which the kingdom is studded.' His sexual tastes mirror his political policies, as Juliette makes clear. 'He degraded me unutterably; when it was a question of lust, he was truly the filthiest man conceivable, the most despotic, the cruellest.' He is the leader of a libertine set boasting opinions which now seem prototypically Fascist: the paeans to murder, torture and machiavellian statecraft are an uncannily exact anticipation of Nazi theory. Saint-Fond proposes to starve two-thirds of the population to death. 'As for famine, the corner in grain at which we're working will cover us in riches and soon reduce the masses to cannibalising one another. The Cabinet has resolved on famine

because it is prompt, infallible, and will cover us in gold.' Noirceuil, Saint-Fond's fellow orgiast, praises his statecraft: 'he is bloodthirsty, he is rapacious, fierce is his grip, he considers murder indispensable to good government'; Noirceuil cites Machiavelli's principles and numerous historical examples to justify their view: 'there must be bloodshed if any regime, especially a monarchy, is to survive; the throne of a tyrant must be cemented with blood'. *Juliette* is heavily anti-aristocratic and anti-monarchical – 'kings are nothing in today's world, the common masses everything' – but as a debauchee named Borchamps declares of the incipient uprising of Swedish parliamentarians against their monarch, 'it is not from the horror of tyranny but from envy at seeing despotism in other hands than their own; once they have seized power, you can be sure they will no longer hate despotism but on the contrary will use it to perfect their own pleasures'.

Sade in his preface to the gothic tales *Les Crimes de l'Amour* (1800), 'Idées sur les Romans', praised 'the new novels in which sorcery and phantasmagoria constitute the chief merit'. He judged Matthew Lewis's *The Monk* (1796) 'far superior in every respect to the strange flights of Mrs. Radcliffe's brilliant imagination'. He thought their 'merit was the inevitable artistic result of the revolutionary upheavals which shocked all Europe.' After the French Revolution, according to Sade,

> For anyone knowing the miseries with which evil-doers can afflict humanity, novels became as difficult to write as dull to read. There was no-one who had not experienced more misfortune in four or five years than the finest novelist could depict in a century. One could only sustain interest by invoking Hellishness.

Sade was correct. In the quarter century after the publication of *The Castle of Otranto*, gothic fiction (misunderstanding Walpole's intentions) was for the most part a matter of mediocre sensationalism. Radcliffe's *Castles of Athlin and Dunbayne* (1789) is a conventional story of usurpation and murder, and her second novel *A Sicilian Romance* (1790) is equally forgettable; but by the publication in 1794 of *The Mysteries of Udolpho* both her own creative impulses, and her readers' expectations, had been supercharged by events in France. The real terrors aroused in Britain by the excesses of the French Revolution created a context which suddenly made gothic fiction seem important. French revolutionary horrors – and in particular the monstrous destructive rampages of French mobs in the 1790s – provoked at least two gothic fables of enduring

power, Matthew Lewis's *The Monk* and Mary Shelley's *Frankenstein* (1818). When gothic imagery provides all the emotions and structure of a work of art – when it is gothic for gothic's sake – it may achieve a brief climax of emotional excess in the reader or spectator; but the climax soon dies, and is seldom memorable. If, however, the gothic imagination is enlisted not as a mechanistic technique but as an aesthetic to help convey other sensations or philosophies, then it may deserve lasting attention, as in the cases of Goya and Sade, of Mary Shelley and perhaps 'Monk' Lewis.

MATTHEW LEWIS AND HIS MONK

Matthew Lewis (1775–1818) was the son and heir of a rich official at the War Office. When he was six, his mother eloped with a music master, by whom she had a child. Lewis senior introduced a bill in the House of Lords to obtain a divorce in 1783, but it was rejected; the Lewis parents were thereafter bound by marriage for life, though they lived separately and continued to cause one another trouble. This experience proved beneficial as it gave Lewis a lifetime's exemption from syrupy

A contemporary illustration (1846) of the bleeding nun scene in Matthew Lewis's The Monk. The violent carnality of the novel rather than its supernatural uncanniness shocked Lewis's contemporaries: instead of idealising the past, gothic revival culture began to trash it.

sentimentalisation about family life. The imprisoning monastic repressions from which his villain, Ambrosio, erupted into a destructive monster can stand as easily for the oppressive insularity of families as for any literal monastery or political regime. From boyhood Lewis was a crashing snob – 'the two duchesses are extremely affable and condescending; and we have nothing but balls, suppers and concerts,' he boasted at the age of eighteen – yet he was unpopular in society. According to a young lady in 1808,

> M.G.L. (*Esquire!*) is a slim, skinny, finical fop, of modish address, with a very neatly-rounded pair of legs, and a very ugly face. His looks have nothing manly in them; but he *looks*, by his airs, as if he thought himself a little Arthur Wellesley; he seems so dapper, so jaunty, so sprack, pert, and lively. His eyes are small, and, in general, watery; but, at tea-time (particularly if the glass has been pushed about a little by papa after dinner) they sparkle, roll and twinkle away most merrily, at every woman around the table. His language, then, grows rude and impudent, and he tries to be particular with any one of us who may happen to sit near him; spouting forth glibly French, Italian, Spanish, and German *fadaises*, in a lack-a-daisy kind of way, with an ill-breath; and 'grinning horribly a ghastly smile', as if to show us all his jagged and slovenly teeth.

After leaving Oxford Lewis was (by his father's influence) nominated in 1794 as an attaché at the British Embassy at The Hague. The dullness of the Netherlands was overpowering: 'Lord Kerry, being the other night at one of the Dutch assemblies, and quite overcome with its stupidity, yawned so terribly that he fairly dislocated his jaw,' Lewis reported. It was partly in reaction to smug domesticated Dutch bores that he began writing *The Monk* as a boy of twenty-one. He was stimulated too by reading Radcliffe's *Mysteries of Udolpho* and drew on other inspirations. He steeped himself in the techniques of *Schauerromantik* and assimilated the prevailing Continental taste for *Sturm und Drang* literature. German macabre was joined with a sadistic sensuality to produce a novel that was scurrilous, comic and disgusting as well as both allegory and pastiche. The literate people of Europe in the late eighteenth century were a small, multilingual and cosmopolitan group which quickly knew of one another's doings (Horace Walpole in London was told within ten days of Sade's first arrest in Paris) and were much more receptive to foreign cultural

influences than their twentieth-century equivalents. Maurice Heine and Mario Praz both suspected that Lewis obtained a copy of Sade's *Justine* while visiting Paris in 1792: certainly there seem strong traces of Sade's influence in *The Monk*. Lewis, as we have seen, was probably an influence (through Lord Holland and Jovellanos) on Goya's imagination. Sade and Goya were the two greatest artistic (and quasi-gothic) depicters of the consequences of the French Revolution: it is perfectly possible that Goya was working under Sade's indirect influence.

The sub-plot of *The Monk* is a conventional affair worthy of Radcliffe in which two lovers, Agnes and Raymond, are separated by evil, powerful enemies who have Agnes secluded in a nunnery. There are the customary trappings of romantic horror, including a nun's bleeding ghost, but the real power of the novel derives from the eponymous monk, Ambrosio, by whose machinations Agnes is incarcerated among rotting corpses in the underground vaults of the convent. The languishing of Sade's Justine in a monk's harem may have contributed to Lewis's ideas. Ultimately Agnes is reunited with Raymond while Ambrosio's villainies are revealed. Her tortures meanwhile are pitilessly detailed. She gives birth in the cold, pestilential catacombs to Raymond's child, which soon dies:

> I rent my winding-sheet, and wrapped in it my lovely Child. I placed it on my bosom, its soft arms folded round my neck, and its pale, cold cheek resting upon mine. Thus did its lifeless limbs repose, while I covered it with kisses, talked to it, wept, and moaned over it without remission, day or night . . . I vowed not to part with it while I had life: Its presence was my only comfort . . . It soon became a mass of putridity, and to every eye was a loathsome and disgusting Object . . . My slumbers were constantly interrupted by some obnoxious Insect crawling over me. Sometimes I felt the bloated Toad, hideous and pampered with the poisonous vapours of the dungeon, dragging his loathsome length along my bosom: Sometimes the quick cold Lizard rouzed me leaving his slimy track upon my face, and entangling itself in the tresses of my wild and matted hair: Often have I at waking found my fingers ringed with the long worms, which bred in the corrupted flesh of my Infant.

The Monk seems a typical Protestant cautionary tale against Romanist hypocrisy in which the saintliest preacher in Madrid proves to be 'a Monster of Hypocrisy'. In Lewis's presentation (with which Sade sympathised) Ambrosio has been corrupted

by his repressed upbringing, which made him vulnerable to seduction by a wicked girl called Matilda, who insinuates her way into his cell disguised as a young novice. 'Ambrosio rioted in delights till then unknown to him . . . his only fear was lest death should rob him of enjoyments for which his long fast had only given a keener edge to his appetite.' Though Matilda remains enthusiastic about their clandestine romps, Ambrosio soon wearies of her body and lusts after fifteen-year-old Antonia, to whose noblewoman mother, Elvira, he has recently become confessor. Matilda abets his sexual viciousness by summoning demonic power to their aid. The Devil appears in the guise of a fallen angel:

> It was a youth seemingly scarce eighteen, the perfection of whose form and face was unrivalled. He was perfectly naked: A bright Star sparkled upon his forehead; Two crimson wings extended themselves from his shoulders; and his silken locks were confined by a band of many-coloured fires, which played around his head, formed themselves into a variety of figures, and shone with a brilliance far surpassing those of precious Stones. Circlets of diamonds were fastened round his arms and ankles, and in his right hand he bore a silver branch imitating Myrtle.

Using this myrtle wand Ambrosio bewitches Antonia into deep slumber and begins to assault her, 'his desires . . . raised to . . . frantic height'. He is interrupted before full consummation by Antonia's mother, Elvira, whom he suffocates with a pillow. Antonia in her stupefaction is taken for dead and consigned to a tomb, where in sepulchral gloom he rapes her among the rotting dead. Afterwards, when a search-party is approaching, he murders her to prevent her screaming.

Soldiers of the Inquisition nevertheless capture Ambrosio. He escapes from prison by selling his soul to the Devil, not knowing that the soldiers who he thinks are coming to execute him in fact bring a reprieve. He is carried by demons to a mountain top, where he is tormented with the revelations that Elvira (whom he murdered) was his mother and Antonia (whom he violated, then killed) his sister. Finally, he is thrown by the demons to a slow, sadistic death. As he is dying on the mountain-side, insects drink the blood from his wounds,

> darted their stings into his body, covered him with their multitudes, and inflicted on him tortures the most exquisite and insupportable. The Eagles of

the rock tore his flesh piecemeal, and dug out his eye-balls with their crooked beaks. A burning thirst tormented him; He heard the river's murmur as it rolled beside him, but strove in vain to drag himself towards the sound. Blind, maimed, helpless, and despairing, venting his rage in blasphemy and curses, execrating his existence, yet dreading the arrival of death destined to yield him up to greater torments, six miserable days did the Villain languish.

Ambrosio's cruelty, hypocrisy and aggression are the result of his repressed upbringing within the Roman Catholic Church. Despite all his masterful conduct, he is, like Walpole's Manfred, an oddly passive victim of other people's power. He is seduced by the demonic Matilda, who in crisis proves the stronger character; he is duped, betrayed and destroyed by devils who masquerade as rescuers and allies but encompass his ruin. Though sexual passion and the dangers of repression provide much of the story's force, the book also represents repressive social regimes and the horrific mindless violence of the vengeful mobs that attack reactionary authority.

The power of the book comes from both individual and collective violence. Ambrosio's sexual awakening makes him an implacable figure, a matricide and incestuous rapist, whose behaviour is destructive of everyone and every institution with whom he has contact. The collective violence is perpetrated by the furious, vengeful, mindless mob that tears apart Ambrosio's ally, the prioress who incarcerates Agnes and murders nuns who behave sexually. (The prioress is a particularly Sadean figure, whose characterisation supports the suggestion that Lewis had read *Justine.*) Ambrosio's revolt against repression, and the mob's rage against injustice, seem understandable, even laudable; but they reach an excess which is both vile and self-destructive. Thus the bloodthirsty mob which liberates the convent where Agnes has been confined and lynch the oppressive prioress:

> They forced a passage through the Guards who protected their destined Victim, dragged her from her shelter, and proceeded to take upon her a most summary and cruel vengeance. Wild with terror, and scarcely knowing what She said, the wretched Woman shrieked for a moment's mercy: She protested that she was innocent of the death of Agnes . . . The Rioters heeded nothing but the gratification of their barbarous vengeance. They refused to listen to her: they showed her every sort of insult, loaded her with mud and filth, and

called her the most opprobrious appellations. They tore her from one another, and each new Tormentor was more savage than the former. They stifled with howls and execrations her shrill cries for mercy; and dragged her through the Streets, spurning her, trampling her, and treating her with every species of cruelty which hate or vindictive fury could invent. At length a Flint, aimed by some well-directing hand, struck her full upon the temple. She sank upon the ground, bathed in blood, and in a few minutes terminated her miserable existence. Yet though she no longer felt their insults, the Rioters still exercised their impotent rage upon her lifeless body. They beat it, trod it, and ill-used it, till it became no more than a mass of flesh, unsightly, shapeless and disgusting.

Yet, like many among the French revolutionary mob, the prioress's killers destroy themselves by setting fire to the convent:

The Rioters poured into the interior part of the Building, where they exercised their vengeance upon everything which found itself in their passage. They broke the furniture into pieces, tore down the pictures, destroyed the reliques, and in their hatred of her Servant forgot all respect to the Saint . . . The consequences of their action were more sudden, than themselves had expected or wished. The Flames rising from the burning piles caught part of the Building, which being old and dry, the conflagration spread with rapidity from room to room. The walls were soon shaken by the devouring element: The Columns gave way: The Roofs came tumbling down upon the Rioters, and crushed many of them beneath their weight. Nothing was to be heard but shrieks and groans; the Convent was wrapped in flames, and the whole presented a scene of devastation and horror.

Such words resonated for a readership horrified by stories of French mob violence.

The Monk reached the public in March 1796 and sold well. Shortly afterwards Lewis was elected to Parliament for the pocket borough of Hindon through his father's influence with the prime minister, Pitt. When a second edition was issued in October, Lewis acknowledged his authorship by placing his name on the title-page, with MP after it. (Lewis remained an MP until 1802.) 'Did you ever read a strange thing . . . called Vathek?' enquired Hester Thrale Piozzi. 'There is a stranger Thing

and a wickeder about the World now – called The Monk . . . written by a forward Baby of nineteen years, and the Girls . . . take to it hugely.' Similarly William Wilberforce recorded being the guest of Lord Loughborough, the Lord Chancellor, together with Pitt, and the Earls of Chatham and Westmoreland, respectively First Lord of the Admiralty and Lord Lieutenant of Ireland: 'talk rather loose . . . Much talk about "The Monk"'. A notice by Coleridge in the *Critical Review* raised a storm of abuse on *The Monk* as voluptuous, corrupting, obscene and complacent. Supposedly the novel was thought so contaminating of public morals that about a year after its publication the Attorney-General was prompted by a society for the suppression of vice to seek an injunction restraining its sale. The prosecution, which Lewis did not resist, was abandoned, but as a result he expunged passages in his second edition and undertook other later purifications. For the fourth edition of 1798 he excised the word 'lust'; Ambrosio the 'ravisher' became a 'betrayer'; 'indulged in excesses' became 'committed an error'; 'prostitution' became 'what should be her shame'. Even so, the novel was thought inflammatory: Isaac Cruikshank's engraving *Luxury* (1801) shows a woman reading *The Monk* while her arse is heated by a symbolic fire and she masturbates in front.

Lewis published other gothic tales, none of them as salacious or successful as *The Monk*; he translated several German horror stories and adapted others for the London stage. Dramatized versions of *The Monk* and other works were produced, though without much acclaim. His dungeons in such plays as *The Castle Spectre* (1797) were celebrated among contemporary theatre-goers because of the parallels they offered with the mass incarcerations in France: audiences resembled the character in Radcliffe's *Romance of the Forest* (1791) who exclaimed: 'O exquisite misery! 'tis now only I perceive all the horrors of confinement – 'tis now only that I understand the value of liberty!' Lewis pursued these literary activities partly in order to supply funds to his improvident mother. After inheriting his father's property in 1812, he abandoned literary life, together with his hopes of theatrical glory, in his determination to improve the Jamaican sugar plantations on which his family fortune rested.

Twice he visited the Caribbean. Just before he died at sea while returning from Jamaica in 1818, he wrote his will on his servant's hat. With a macabre gothic touch, his body was put in an improvised coffin which was wrapped in a sheet with weights and dropped overboard; but the weights fell out and the coffin floated on

the surface, the sheet acting as a sail in the wind, and he floated across the waves back towards Jamaica, where he had spent both the happiest and most effective period of his life. His plantation reforms excited the resentment of other slave-owners and his *Journal of a West India Proprietor*, published posthumously in 1834, is his only significant work after *The Monk*. Lord Holland's assessment of Lewis was fair and shrewd:

> his mind was vitiated with a mystical, though irreligious, philosophy; his taste in reading, writing and thinking, corrupted by paradox; and his conversation disfigured by captious perverseness in controversy or sickly affectation in sentiment. His efforts at pleasantry, which were continual, were very unsuccessful. He had no talent for humour. He was sincere, affectionate, and generous; but his vanity was inordinate and more troublesome than diverting.

MARY SHELLEY

Volney's *Ruin of Empires* (1791), which so effectively expressed the early hopes of the French revolutionaries, was, as has been said, a voguish book praised by such English radicals as William Godwin. At about the time that Burke, Romilly, Sade and Goya produced their images of revolutionary monsters, two cottagers were overheard by a stranger discussing Volney's *Ruin of Empires*. 'I heard of the slothful Asiatics, of the stupendous genius and mental activity of the Grecians, of the wars and wonderful virtue of the early Romans – of their subsequent degenerating – of the decline of that mighty empire, of chivalry, Christianity, and kings.' The ethical implications of history seemed overwhelming. 'Was man, indeed, at once so powerful, so virtuous, and magnificent, yet so vicious and base?' One point struck the eavesdropper very hard: the emphasis on 'high and unsullied descent united with riches. A man might be respected with only one of these advantages, but without either he was considered, except in very rare instances, as a vagabond and a slave, doomed to waste his powers for the profits of the chosen few!' It caused the eavesdropper 'agony' to think of this for he had all the proletarian traits intensified and exaggerated. 'Of my creation and creator I was absolutely ignorant, but I knew that I possessed no money, no friends, no kind of property. I was, besides, endowed with a figure hideously deformed and loathsome . . . Was I, then, a monster, a blot

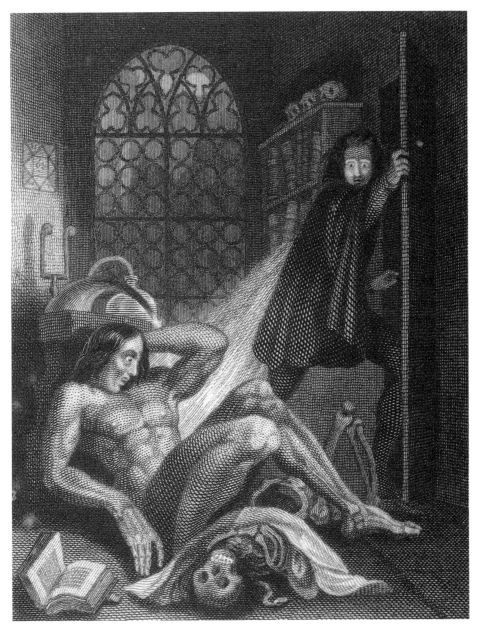

For Frankenstein's monster education and the reading of books were like inhaling poison gas. They ruined his nerves and left him enslaved to rage and resentment which could never be appeased. The monster became a figure of protean evil.

upon the earth, from which all men fled and whom all men disowned.' The answer is yes, for the eavesdropper is Frankenstein's monster.

Frankenstein was written in 1816 by Mary Wollstonecraft Shelley (1797–1851), then aged eighteen. Her most famous novel certainly contains autobiographical influences. She was the daughter of two famous radicals, William Godwin and Mary Wollstonecraft. One theme of *Frankenstein* is mothering and the absence of mothers: Mary Shelley's own mother was heavily pregnant with her when her parents married; her mother died as a result of her birth. She was reared in an atmosphere of chilly rationalism by her father, who in *An Enquiry Concerning Political Justice* (1793) predicted a future human race produced without coition and was a leading English theorist of the French Revolution. 'Most people felt of Mr. Godwin', wrote Thomas De Quincey, 'the same alienation and horror as of a ghoul, or a bloodless vampyre or the monster created by Frankenstein.' He was intellectually acute but emotionally obtuse. At the age of sixteen Mary eloped with a baronet's son, Percy Shelley, whom she married in December 1816 after the death of his wife. Previously she had given birth, in 1815 and 1816, to two Shelley children who both died young, before bearing a son who survived in 1819. The loss of her children grieved her, as she recorded after the first death in 1815: 'Dream that my little baby came to life again – that it had only been cold, & that we rubbed it before the fire, & it lived – I awake and find no baby – I think about the little thing all day.'

The Shelleys after their elopement in 1814 travelled in France and Switzerland. On their journey she saw the havoc brought to France by Austrian and Russian troops pursuing Napoleon's army in retreat from Moscow. 'Nothing could be more entire than the ruin which these barbarians had spread as they advanced,' she recorded in her *History of a Six Weeks' Tour* (1817). 'The distress of the inhabitants whose houses had been burnt; their cattle killed, and all their wealth destroyed, has given a sting to my detestation of war, which none can feel who have not travelled through a country pillaged and wasted by this plague.' Such experiences confirmed the Shelleys as children of Romanticism: the conceited fancies of the Enlightenment, the pride of the French *ancien régime*, its provocation of the bloody French revolutionary monsters, the destruction brought upon France by Napoleon's hateful monstrosities were all equally deplorable to Mary Shelley. Shunned by many of her husband's radical friends after he drowned near Naples in 1822, she maintained a lifelong political scepticism based on her mistrust of political egotism. 'I was nursed

and fed with a love of glory. To be something great and good was the precept given me by my father: Shelley reiterated it.' The two chief men in her life both had 'a passion for reforming the world', but she was 'not a person of opinions' and felt a 'horror of pushing'. She opposed 'violent extremes, which only bring on an injurious reaction' and despised activists. 'Since I had lost Shelley I have no wish to ally myself to the Radicals – they are full of repulsion to me – violent without any sense of Justice – selfish in the extreme – talking without knowledge – rude, envious and insolent.'

In the summer of 1816 she and Shelley congregated with Byron at Villa Diodati on the shores of Lake Geneva. Her stepsister Claire Clairmont, who accompanied them, afterwards bore Byron's child. Their visitors included 'Monk' Lewis, who told the house-party a series of ghost stories which were treated not as primitive superstition but as a way of addressing the great issues of life, death, good and evil. 'We talk of Ghosts – Neither Lord B nor MGL seem to believe in them, & they both agree in the very face of reason, that none could believe in Ghosts without also believing in God,' she reflected. 'I do not think that all the persons who profess to discredit these visitations, really discredit them, or if they do in the daylight, are not admonished by the approach of loneliness and midnight to think more respectfully of the world of shadows.' The rain confined the party to the villa on many days, and they diverted themselves by reading German gothic stories translated into French. 'We will each write a ghost story,' Byron announced one day (probably 16 June), and his proposition was accepted. Byron himself, his young physician, John Polidori, and Mary Shelley entered a competition to write something frightening. Byron at the age of thirty was the eldest; the author of *Frankenstein* was still a teenager. It is significant that she, like Lewis and Beckford, was young when she wrote her gothic horrors: they all desired to shock their elders.

FRANKENSTEIN

Mary Shelley's novel begins with an epistolary section in which a polar explorer, Robert Walton, writes self-indulgent letters to his sister, Margaret Saville, in England. For six years he has planned to sail to the North Pole to discover the secret of the magnet. Trapped in Arctic ice floes, Walton and his crew glimpse a giant speeding past on a dog-sled. Soon afterwards they pick up a man dying of exhaustion who has evidently been pursuing the giant. This is Victor Frankenstein, a

bourgeois reared in that cradle of Enlightenment thought, Voltaire's adopted home of Geneva (though born in that gothic *locus*, Naples). As a student of chemistry, he had united medieval arcana and contemporary science to construct and animate a creature supposedly intended to be an idealised model of a human being but actually so monstrous-looking that it appals all who see it. Certainly its creator repudiates his monstrosity as soon as he has given it life – 'unable to endure the aspect of this being I had created, I rushed out of the room' – and will take no responsibility for what he has made. The lonely monster harasses Victor Frankenstein to build a female to alleviate his misery. The scientist agrees, but, becoming anxious that two such monsters would propagate a new 'race of devils', he destroys his second humanoid. Denied kinship with the human race, and forbidden its own domestic comforts, the monster embarks on an orgy of destruction: eventually it kills Frankenstein's beautiful little brother, his dearest friend and his bride on their wedding night. Indirectly, too, a virtuous family servant and Frankenstein's father are killed as a result of the monster's acts. It wrecks the community from which it has been excluded; finally it is pursued across Russia to the Arctic wastes by its creator, who dies in the attempt. The monster then drifts away on an ice-raft, seeking death in the northernmost extremities of the planet.

Why was *Frankenstein* such an immediate bestseller? It is the first novel in which the gothic effects of castles, mountains, storms and violence have any ambitious symbolism. Shelley did not intend her generalised gothic effects to excite silly readers with a cultivated, factitious sense of the sublime. Her scenes are heavily symbolic, without sentimentality or cheap sensationalism. She changed the sources of horror and mystery from supernatural effects into scientific power. As always, power is the great explicatory word; for her book is a parable about the abuse of power, and the revenge of the abused. Though her language was plain, shorn of gothic apostrophes and exclamations, she maintained suspense. Like other gothic fiction, the plot rested on ludicrous coincidences which few readers notice because of the pace of the plot. Yet the reciprocity which had already been a feature of gothic fiction reaches an apotheosis of meticulous elegance in her plot. Originally it is the monster who pursues his creator, but Frankenstein becomes the hunter after finding his bride murdered on their wedding night. One recalls that premonitory moment of gothic literature when young Horace Walpole assured Lord Lincoln, 'there is no part I won't act to keep you'. One recalls the Inquisition guard in Radcliffe's *The*

Italian recognising that dominant relationships have their reciprocal dependence: there is 'no difference', he decides, between a prisoner and his guard 'except that the prisoner watches on one side of the door, and the sentinel on the other'. There is no part the monster won't act to keep his creator; no difference between their predicaments in the end. The monster goads Frankenstein in the latter's pursuit: 'he left marks in writing on the barks of the trees, or cut in stone, that guided me and instigated my fury'. The messages say such things as 'You will find near this place, if you follow not too tardily, a dead hare; eat and be refreshed. Come on, my enemy.' Frankenstein regards his monster 'nearly in the light of my own vampire, my own spirit let loose from the grave'.

Shelley's plot contains details of profound personal authenticity which the reader could not guess: she called Frankenstein's beautiful little brother, who is strangled in a wood by the monster, William, the name of her favourite baby. Despite her resentment of her father's bleak rationality, she acknowledged her deep intellectual debts to his novels by dedicating *Frankenstein* to him. There are strong consonances between the ideas of father and daughter. In Godwin's psychological thriller *Caleb Williams* (1794) his characters Falkland and Williams are locked in a bitter enmity, like Victor Frankenstein and his monster, and engage in a complicated pursuit in which it is sometimes ambiguous who is the pursuer and who is pursued. In *St Leon* (1799) a self-absorbed intellectual abandons domestic happiness in favour of pursuing the power and aggrandisement that derive from alchemical knowledge and the secret of eternal life. Godwin's admiration for Rousseau contributed to Shelley's account of the primitive monster's awakening self-awareness: the monster, after its first abandonment by Frankenstein, lives in the wild like a noble savage of Rousseau's; it achieves self-civilisation (learning language, and entering the world of ideas) by emulating the De Lacy family, who are living a life of idealistic contemplation in Nature. Like the monster, Rousseau was himself a monstrosity of self-absorption, obsessed with his own uniqueness: 'Oh why did Providence have me born among men and make me of a different species?' The monster is as emotionally excessive as Rousseau, who once discovered his waistcoat soaked in tears though he was unaware that he had been weeping.

Marilyn Butler has demonstrated that Shelley and her husband were keenly interested in a contemporary medical controversy as to whether 'electricity, or something analogous to it, could do duty for the soul' and that this inspired the means

for Frankenstein to infuse the vital spark of life into his monstrous creation. The centrality of electricity to physical life was also being debated by Shelley's contemporaries. As a result of hearing John Dalton lecturing on electricity in 1807, the fashionable physician Sir James Murray devoted his research career to establishing the role of 'Voltaic agency on the laws of life', argued in *Electricity as a Cause of Cholera or Other Epidemics* (1849) that '*nervous energy* and *electric power* seemed to be *identical*' and developed a new range of therapeutics suitable to his doctrines about the spark of life. Many readings of Shelley's novel have been anti-scientific, and its influence is still resented by some scientists: 'Thanks to *Frankenstein*, it is impossible to have an intelligent discussion about genetics,' complained the University of London's Professor of Biology as Applied to Medicine, Lewis Wolpert FRS, in 1997. 'Mary Shelley is the evil fairy godmother of genetics.' *Frankenstein* is also a critique of masculinity. Walton, the polar explorer, is a Faustian individualist determined to achieve scientific greatness by reaching the North Pole regardless of the survival of his crew. Like his lieutenant, Walton 'is madly desirous of glory: or rather, to word my phrase more characteristically, of advancement in his profession'. The outlook of Walton and Frankenstein is Sadean: there is in *Justine* a surgeon intending to dissect his daughter to promote scientific knowledge whose desire of intellectual glory isolates him from the human race: 'My neighbour is nothing to me; there is not the slightest relationship between him and myself.' Ambition is an evil in Shelley's book; as Walpole indicated in *Otranto*, the most powerful evil is the ambition of power.

'We hear much of *knowledge* of the world,' an anonymous Methodist remonstrated in the *Gentleman's Magazine* of 1801,

> but, if it be that knowledge of licentiousness which makes licentiousness familiar; if it be that knowledge of wickedness which renders the practice a callous habit; if it be that knowledge which inclines us to palliate offences in others, that we may with impunity commit them ourselves, which violates the peace of families and substitutes for the laws of God and man a loose and fashionable theory of morals, protected by wealth and encouraged by corresponding connexions; it is then that knowledge which overthrew France, and from which may God preserve a nation hitherto the most moral and religious in the world.

Shelley's indictment of human presumption and intellectual hubris belongs to the same tradition as the Methodist's complaints. The ultimate result of Victor Frankenstein's excessive trust in knowledge is that he creates a monster which rampages around Europe – in the Alps, Ireland, eastern Europe, Russia, the North Pole – leaving a swathe of death and destruction. (The significance of the Irish section of *Frankenstein* cannot be missed by those who remember Lord Edward FitzGerald, the perceived Jacobinism of Kilwarden's murderers, or the defensive castle-building of the Kingstons and Charlevilles. Such was the ultimate result of the French Enlightenment, almost everyone thought.)

Frankenstein's fatal passivity is another example of the selfish ineffectuality of intellectuals. He allows the maidservant, Justine, to be executed for the murder of his little brother, though he knows his monster did the killing; he does not protect his bride, though the monster has vowed to kill her. When his best friend, Clerval, is killed, he falls apart, retreats into illness and is taken away to be cared for in his father's household. He is always cancelling out his earlier resolves.

The fearful, isolating ugliness of Frankenstein's creation recalls the images of horrific, revolutionary monsters engendered by Edmund Burke in his *Reflections on the French Revolution* and other commentators on the French catastrophe. As the monster himself insists, he is provoked to insurrectionary violence by the exclusion, pain and oppression to which he is condemned. 'I ought to be thy Adam; but I am rather the fallen angel, whom thou drivest from joy for no misdeed', the monster tells his maker. 'Everywhere I see bliss, from which I alone am irrevocably excluded. I was benevolent and good; misery made me a fiend. Make me happy, and I shall again be virtuous.' The monster is at once self-pitying and menacing. 'All men hate the wretched; how, then, must I be hated, who am miserable beyond all living things!' He desires equal citizenship with humankind, but can only ask for it with threats. 'Do your duty towards me, and I will do mine towards you and the rest of mankind. If you comply with my conditions, I will leave them and you at peace; but if you refuse I will glut the maw of death, until it be satiated with the blood of your remaining friends.' He tries to propitiate Frankenstein with promises of subordination – 'I will not be tempted to set myself in opposition to thee. I am thy creature, and I will be even mild and docile to my natural lord and king' – but his resolve breaks down when Frankenstein refuses to create a female for him: 'a fiendish rage animated him . . . his face was wrinkled into contortions too horrible for human eyes to behold'.

The monster wants to reproduce, but his creator is terrified of the monstrous mob that might be unleashed: 'a race of devils would be propagated on the earth who might make the very existence of the species of man a condition precarious and full of terror'. Walpole and James Gillray regarded the French revolutionaries as cannibals; Goya and Sade represented the devilry of their times by images of bodily mutilation; the monstrous neediness in the face of Goya's Saturn has its counterpart in the face of Frankenstein's monster. When the monster tries to befriend the woodland idealists who have unwittingly awakened his consciousness, they find him so ugly that they run away and abandon their house. The monster's reaction is that of a vengeful proletariat after frightened liberal reformers have rejected their mass excesses: 'I, like the arch-fiend, bore a hell within me; and, finding myself unsympathized with, wished to tear up trees, spread havoc and destruction around me, and then to have sat down and enjoyed the ruin.' The insatiable neediness of monsters is why they present the ultimate face of evil. If mankind could dream collectively, its dreams would be like Frankenstein's monster.

Wild passion for wounding

The worship of pain has far more often dominated the world. Medievalism, with its saints and martyrs, its love of self-torture, its wild passion for wounding itself, its gnashing with knives, and its whipping with rods – Medievalism is real Christianity and the medieval Christ is the real Christ.

Oscar Wilde

It is strange that the association of desire, religion and cruelty should not have immediately attracted men's attentions to the intimate relationship which exists between them, and to the tendency which they have in common.

Novalis

While people think it worth their while to torment us, we are never without some dignity, though painful and imaginary. Even in the Inquisition I belonged to someone.

Charles Maturin

RACKS OF ENCHANTMENT

There was nothing sublime about the atrocities recorded by Goya and Sade. In the fate of the monk Ambrosio or Frankenstein's monster one can find no redemptive power. Yet the fascination with fear, the belief that pain might be sublime, the high valuation of submission – none of these gothic powers was ever diminished. 'It is actually possible to become *amateurs in suffering,*' says a character in Maturin's *Melmoth the Wanderer* (1820), which is often ranked as one of the purest gothic texts. 'I have heard of men who travelled into countries where horrible executions were to be daily witnessed, for the sake of that excitement which the sight of suffering never fails to give, from the spectacle of a tragedy . . . down to the writhings of the meanest reptile on whom you can inflict torture, and feel that torture is the result of your own power.' Moreover in the nineteenth century the gothic imagination was enlisted to express new ideas about suffering, punishment and redemption. Pain,

too, was instilled with a new aesthetic: Rimbaud had a phrase about 'racks of enchantment'.

The fact that the Austrian nobleman Leopold von Sacher-Masoch in his boyhood swooned with pleasure contemplating the tortures endured by Christian martyrs is a reminder of the coexistence of pain with Christianity. Despite the rising powers of nineteenth-century industrialisation and agnosticism, the fable of man's Fall described in Genesis, in which Adam and Eve transgressed and were punished with the loss of sexual innocence, retained its hold. Swinburne ('as from thee the primal curse comes forth/So comes the retribution') and Tennyson ('Remember the words of the Lord when He told us, "Vengeance is mine"') testify to the prevalence of this view. Christianity was a religion of reprisal: the transgression of Adam and Eve was followed by a curse that burdened humanity forever; the God who flooded a wicked world, promulgated the laws from Mount Sinai, and destroyed Sodom was terrible in his vengeance. Thomas Chalmers, the theologian who wrote one of the *Bridgwater Treatises* illustrating the Goodness of God as manifested in the Creation, was emphatic that 'the severity of the divine character' must not be shirked.

> It is this disposition to soften the menaces of the Lawgiver – it is this ten-dency to reduce, or rather to obliterate, the vindictiveness of His nature – it is this perpetual gloss that, by means of the argument of His goodness, is attempted to be thrown over the truth, and the holiness, and the justice, and the high Sovereign state which compose the severity or the awfulness of His character – it is this, in fact, which serves in practice to break down the fences between obedience and sin.

Punishment – serving the ends of both retribution and deterrence – was central to human experience. Hurting people was right. This attitude was even more entrenched by admiration for male pugnacity and horror of effeminacy (a phrase indicating a state far beyond sexual acts). 'Has it been sufficiently considered', the future prime minister Gladstone mused in 1843, 'how far pain may become the ground of enjoyment? How far satisfaction and even an action delighting in pain may be a true experimental phenomenon of the human mind. May not such virtue often exist, as shall find when the lower faculty is punished or straightened, a joy in the justice and in the beneficial effects of that chastisement?'

Original sin – humanity's state after transgression in the Garden of Eden – gave

the devil his work on earth. Satan in Coleridge's poem 'The Devil's Thoughts' visits London to relish its examples of original sin; then

> As he went through Cold-Bath fields he saw
> A solitary cell;
> And the Devil was pleased, for it gave him a hint
> For improving his prisons in Hell.

It was a corollary of the Christian mentality that prisons and hell stood as parables for one another. Dungeons were always among the most popular *loci* of the gothic imagination, but their connotation shifted from general horror into a retributive claustrophobic isolation that represented more specific images of hell. Though the belief in pain persisted, and perhaps increased, in the nineteenth century, another Christian belief – in the devil – was gradually disempowered. 'Go to the devil!' a man might swear at his enemy, or 'I'll see you in hell!', but these were figures of speech rather than living beliefs. It was a challenge for the gothic imagination when humanity ceased to believe in the devil: 'It is harder for men of this century to believe in the Devil than for them to love him,' Baudelaire observed in 1855; Robert Musil, who was born later in the same century, wrote, 'I don't believe in the Devil, but if I did, I should picture him as the trainer who drives Heaven on to record achievements.' Instead of believing in the devil, people played at devilry or at devising new infernal forms. This provided new opportunities for the gothic imagination.

PIRANESI

One source of gothic ideas of punishment is the series of prints known as *Carceri* undertaken around 1745 by the draughtsman and etcher Giovanni Battista (Giambattista) Piranesi (1720–78). The son of a Venetian mason, Piranesi received his earliest training in art from an uncle who was a distinguished architect and engineer in Venice. There were few funds for new buildings in eighteenth-century Venice; in consequence Piranesi's visual imagination and architectural senses had to rely on the stimuli of theatrical scenery. The Venetian state compensated for its political and economic decline by luring rich foreigners with the pleasures of pageantry, opera, gambling and whores. Venice's opera houses attracted audiences 'by the ingenious contrivance of their scenery', as Hyatt Mayor has described. 'The floors of their stages sloped up to backdrops painted with endless flights of

balustraded stairs and domes beyond domes. Since the glimmering of the candles killed most colour and revealed only lines and masses, the illusion of immensity depended upon adroit rendering of light and shade and a mastery of the mathematics of perspective'. As a young man Piranesi painted stage sets, and from this work 'learned to focus light and shade with dramatic effect, to draw buildings from the most imposing angle, to sketch with accurate boldness, and to dare any stunt in perspective'. Stage design proved as significant in developing Piranesi's aesthetics as it was for Alexander Pope and his friends among early English landscape gardeners, or indeed the theatricality of English gothic revival designers.

In 1740 Piranesi settled in Rome, where he remained for most of his adult life. His

By placing puny figures among the wooden galleries of the Carceri, *Piranesi depicted the hells which humans devise for themselves. This is an image of (probably self-inflicted) punishment and despair. The damned souls of those engravings are like neurotics clinging to their suffering. 'It is our being. It is our all in all. Things that have nobler and richer characters may just denounce us, but it is unnatural that we should despise and nullify ourselves. It is the peculiar human infirmity, not evident in any other creature, to hate and disdain our self.' (Montaigne)*

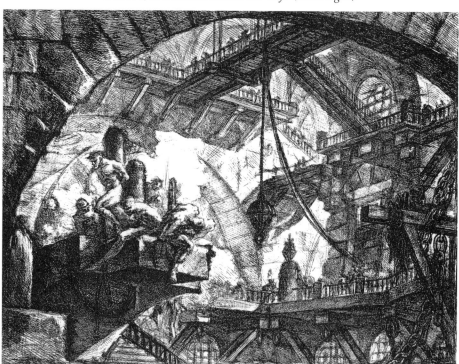

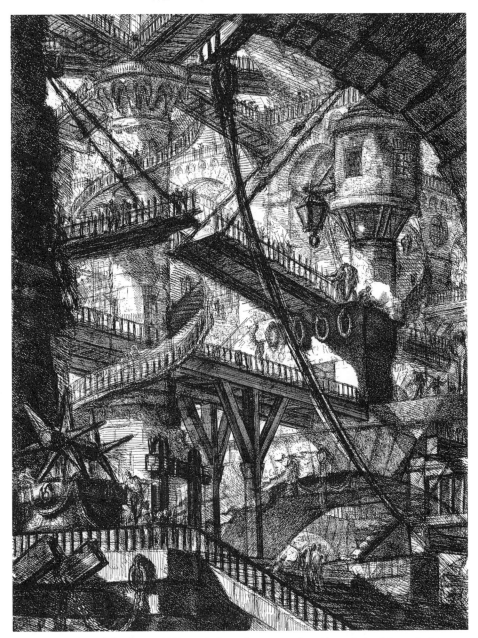

In another of the Carceri *Piranesi showed a group of captives chained to posts for torturing. 'Let us imagine a number of men in chains, and all condemned to death, and some of these men having their throats cut every day in the sight of others, and those who remain recognising their own condition in those of their companions, and as they wait their turn, staring at each other in anguish and without hope. Such is the picture of the condition of mankind.' (Pascal)*

first employers there were probably the Valeriani brothers, ruin painters and stage scenery designers. He had boyish hopes of designing vast buildings to rival the Roman ruins there, and always retained his grandiose ambitions: 'If I were given the planning of a new world, I would be mad enough to undertake it,' he later said. Though he continued for years to describe himself as 'Architetto Veneziano', he resolved to express his ideas through pictures. He learned etching from a Sicilian whom he tried to murder (or threatened to kill) for withholding professional secrets from him. Such fierceness was characteristic. He worked in solitude and was only interested in the outer world for the uses to which his imagination could turn it. His vision was strange, frightening and inclement; his life tumultuous. Poverty forced his return in 1745 to Venice, where he probably painted stage scenery and reputedly worked in Tiepolo's studio. It was at this time that he achieved his first success by adapting some etchings of opera scenery by Daniel Marot dating from 1702 to produce a series of fourteen plates entitled *Invenzioni Capric di Carceri all Acqua Forte* (Capricious Inventions of Prisons), which appeared in Rome around 1745. These romantic fantasies of Piranesi's mid-twenties constitute his masterpiece. Lord Mancroft described them in his biography of Piranesi as 'designs for prisons as the instrument of retributive justice'. They represented 'a nightmare of maniacs, of dungeons, of prisons, of torture chambers, of endless staircases in league-high bedlams, where the culprit groped along galleries leading to edifices which were always a staircase farther on beyond the gallery he had just crossed . . . the hopelessness of these interminable ladders of stairs with the figure advancing continually, without, however, appearing to make any progress, seems to paralyse the vitality of the onlooker'.

The design of European stage sets was permanently altered by *Carceri*, and Piranesi's prints of Roman classical ruins and post-classical buildings created a sensation among connoisseurs. Some of his 135 *Vedute di Roma* (Views of Rome), intended for foreign tourists, were enlivened with macabre, gothicised figures. His earliest biographer wrote that 'instead of studying the nude or beautiful Greek statues, which are the only good models, [he] set himself to draw the most gangrenous cripples and hunchbacks in all Rome. He loved to sketch twisted legs, broken arms, dislocated hips, and whenever he found one of these misfit horrors by a church door, he imagined he had discovered a new Apollo Belvedere . . . and rushed home to draw it.' The Roman ruins in Piranesi's later work are 'infested with tubercular wrecks, as though the race of Romans had decayed as utterly as their old buildings'.

Hyatt Mayor has shown the influence on Piranesi of Salvator Rosa's etchings of 'soldiers in fanciful "antique" armor acting with unsoldierly volatility – pointing to faraway disasters, striking attitudes with lances, whispering together, or plunging their desperate heads in both their hands'. Piranesi owned a painting by Salvator Rosa, and the trees growing sideways from the ruined masonry of his *Vedute di Roma* seem as Salvatorian as some of the human figures. Piranesi had a Salvatorian estrangement from his fellow Italians, insisting that the English were the only people who cared for the arts. This admiration was reciprocated. George Dance, who afterwards redesigned Newgate Prison, was impressed by Piranesi's ideas during a visit to Rome in 1758. William Chambers courted him; Robert Adam drew Roman ruins with him in the 1750s, and they afterwards collaborated on English commissions; the distinguished architect Robert Mylne later acted as his London agent. Royal dukes bought *Vedute di Roma* in his lifetime; later Sir Walter Scott hung them in his dining-parlour. The *Carceri* were equally admired by the nineteenth-century English: Lord Kimberley was delighted at acquiring a set, even without 'authentic pedigree', at a Christie's auction in 1862.

For the early English goths, Piranesi's *Carceri* provided treasured images. The connoisseur Sir Roger Newdigate, who built the earliest English rococo gothic revival house at Arbury, admired him. In the Strawberry Hill set he was equally extolled. 'Salvator Rosa might, and Piranesi might dash out Duncan's Castle,' Horace Walpole wrote of potential illustrators for an edition of *Macbeth*. 'Piranesi has a sublime savageness in his engravings like Salvator Rosa. He sees Rome in its glory and in its decay, with the same eyes with which Salvator considered nature.' Moreover, in one of the *Carceri* dwarfed men are menaced by a huge plumed helmet hanging above their heads amid gigantic ramshackle ladders – an image which surely influenced Walpole's famous account of dreaming of a giant staircase and thus being inspired to write his novel about Otranto beginning with a gigantic plumed helmet falling into a courtyard and killing a young nobleman. Piranesi, who incidentally dedicated a plate to Walpole's early love, Lord Lincoln, appealed to English writers from Smollett onwards; his interchanges with English virtuosi were surely reciprocal, and Jonathan Scott has suggested that some of the later revisions of *Carceri* may have been influenced by Piranesi's discussions with discerning visitors to Rome who had read Burke's *Philosophical Enquiry into the Origin of our Ideas of the Sublime and Beautiful*.

Among Piranesi's murals in the English coffee-house at Rome was an Egyptian desert scene crowded with ancient ruins constituting the first revival of Egyptian images for decoration. It was conceived long before Napoleon's Egyptian campaign of 1799 raised a fashion for sphinxes, and even longer before the American propensity for incorporating Egyptian *motifs* into the despairing entrances to prisons and graveyards: the notorious Tombs prison in New York City (designed 1834) derived its name from its Egyptian façade. Yet it is with prisons – specifically his *Carceri* – that Piranesi achieved transcendent importance. In them he turned the images of baroque opera scenery into a new nightmare. The most famous testimony to his impact was given in Thomas De Quincey's *Confessions of an English Opium-Eater* (1821–22):

> Many years ago, when I was looking over Piranesi's *Antiquities of Rome*, Mr. Coleridge, who was standing by, described to me a set of plates by that artist, called his *Dreams*, and which record the scenery of his own visions during the delirium of a fever. Some of these (I describe only from memory of Mr. Coleridge's account) represented vast Gothic halls: on the floor of which stood mighty engines and machinery, wheels, cables, pulleys, levers, catapults, etc., expressive of enormous power put forth, and resistance overcome. Creeping along the sides of the walls, you perceived a staircase; and upon this, groping his way upwards, was Piranesi himself: follow the stairs a little further, and you perceive it come to a sudden abrupt termination, without any balustrade, and allowing no step onwards to him who had reached the extremity, except into the depths below. Whatever is to become of poor Piranesi, you suppose, at least, that his labours must in some way terminate here. But raise your eyes, and behold a second flight of stairs still higher: on which again Piranesi is perceived, by this time standing on the very brink of the abyss. Again elevate your eye, and a still more aerial flight is beheld: and again is poor Piranesi busy on his aspiring labours: and so on, until the unfinished stairs and the hopeless Piranesi both are lost in the upper gloom of the hall.

Piranesi's influence was enduring in western art. Victor Hugo undertook pen-drawings inspired by *Carceri* and in his poem 'Le Destin' (1839) powerfully evokes the Piranesian domain of half-light and haunting shadows among a sinister chaos of dungeons, chambers, stairs and landings. Melville's epic poem *Clarel* (1876) contains

Piranesian imagery too. Later Aldous Huxley identified *Carceri* as '*metaphysical prisons*, whose seat is within the mind, whose walls are made of nightmare and incomprehension, whose chains are anxiety and their racks a sense of personal and even generic guilt'. The luxurious inferno in Beckford's *Vathek* (like Kafka's castles, courtrooms and penal colony) was a comparable vision of metaphysical prison. It was 'the perfect pointlessness which reigns throughout' the dungeons that disturbed Huxley. Although they are colossal structures, conceived by artistic genius, raised by slave labour, Piranesi's dungeons are purposeless: 'for the staircases lead nowhere, the vaults support nothing but their own weight and enclose vast spaces that are never truly rooms, but only ante-rooms, lumber rooms, vestibules, out-houses'. A few puny, faceless figures stand in shadows, doing nothing, paying attention to no one. Moreover,

> this magnificence of cyclopaean stone is everywhere made squalid by wooden ladders, by flimsy gangways and cat-walks. And the squalor is for squalor's sake, since all these rickety roads through space are manifestly without destination. Below them, on the floor, stand great machines incapable of doing anything in particular, and from the arches overhead hang ropes that carry nothing except a sickening suggestion of torture.

Perhaps this magnificent futility represents the human condition.

As Huxley indicated, Piranesi's prison imagery had a famous impact on William Beckford (1760–1844). In his *Dreams, Waking Thoughts and Incidents* (1783) Beckford described his reaction as a boy of twenty visiting the ducal palace in Venice:

> The walls are covered in most places with grim visages sculptured in marble, whose mouths gape for accusations, and swallow every lie that malice and revenge can dictate. I wished for a few ears of the same kind, dispersed about the Doge's residence, to which one might apply one's own, and catch some account of the mysteries within; some little dialogue between the three Inquisitors, or debate in the Council of Ten. This is the tribunal which holds the wealthy nobility in continual awe; before which they appear with trembling and terror; and whose summons they dare not disobey. Sometimes, by way of clemency, it condemns its victims to perpetual imprisonment, in close, stifling cells, between the leads and beams of the palace; or, unwilling

to spill the blood of a fellow-citizen, generously sinks them into dungeons, deep under the canals which wash its foundations; so that, above and below, its majesty is contaminated by the abodes of punishment . . . Impressed by these terrible ideas, I could not regard the palace without horror, and wished for the strength of a thousand antediluvians, to level it with the sea, lay open the secret recesses of punishment, and admit free gales and sunshine into every den . . . I left the courts, and stepping into my bark, was rowed down a canal over which the lofty vaults of the palace cast a tremendous shade. Beneath these fatal waters the dungeons I have also been speaking of are situated. There the wretches lie marking the sound of the oars, and counting the free passage of every gondola. Above a marble bridge, of bold majestic architecture, joins the highest part of the prisons to the secret galleries of the palace: from whence criminals are conducted over the arch to a cruel and mysterious death . . . Horrors and dismal prospects haunted my fancy upon my return. I could not dine in peace, so strongly was my imagination affected; but snatching my pencil, I drew chasms, and subterranean hollows, the domain of fear and torture, with chains, racks, wheels, and dreadful engines in the style of Piranesi.

The spiritual excitement aroused in Beckford by the reality of the Venetian dungeons and the fantasy of Piranesi's torture-chambers was of no passing significance. His novel *A History of the Caliph Vathek* (written in the early 1780s) concluded with a scene of a Piranesian hell.

WILLIAM BECKFORD

Beckford was the only legitimate son of William Beckford, a licentious plutocrat who amassed a fortune from plantations in Jamaica, became a powerful Lord Mayor of London and was an irrepressible radical politician. At the age of nine, in 1770, Beckford inherited his father's huge properties together with an income of some £100,000 a year, making him the richest commoner (and one of the richest subjects) in England. His mother was a granddaughter of the sixth Earl of Abercorn and niece of Charles Hamilton, the landscape gardener whose grounds at Painshill in Surrey emulated Claude Lorrain's landscape-paintings. Hamilton lived in retirement at Bath from 1773 until his death in 1786, and may have influenced his great-nephew

nearby; certainly the younger Beckford created notably picturesque gardens both in England and Portugal. To promote his political ambitions, Alderman Beckford in 1745 had bought an estate in Wiltshire on which he built a great neo-classical power house with the *nouveau riche* name of Splendens.

His son's education there by tutors was unusually stimulating. At the age of five the Beckford heir was taught music by Mozart, who was himself aged only nine. He had architectural lessons from William Chambers, from whom he may have acquired an early interest in orientalism. Several rooms at Fonthill Splendens were decorated in a high oriental style; his drawing-master, who had been reared in St Petersburg, interested him in the glamour of the east and instilled a fine apprecia-tion of the visual arts; the alderman's well-stocked library included a copy of the *Arabian Nights*, which quickened the boy's interest in eastern fables; he learnt Persian. These aesthetic privileges produced a boy of spectacular precocity. The

William Beckford was surrounded by chaos, triumph, pain and glamour. Some of it was beyond his control; some of it he created himself. This view shows the west and north fronts of Fonthill in 1824.

imagery and secrets of his private world were further enriched when in 1777, at the age of sixteen, he began a sumptuous grand tour, culminating in Naples. Though Piranesi captured his imagination at this time, he responded to other painters too. In The Hague he visited the art collection of the Prince of Orange:

> Amongst the pictures which amused me the most is a St Anthony, by Hell-fire Brughel, who has shewn himself right worthy of the title; for a more diabolical variety of imps never entered the human imagination. Brughel has made his saint take refuge in a ditch filled with harpies and creeping things innumerable . . . Castles of steel and fiery turrets glare on every side, whence issue a band of junior devils; these seem highly entertained with pinking poor St Anthony, and whispering, I warrant ye, filthy tales in his ear. Nothing can be more rueful than the patient's countenance; more forlorn than his beard, more piteous than his eye, forming a strong contrast to the pert winks and insidious glances of his persecutors.

Anthony remained Beckford's favourite saint.

After returning to England in 1781, he began an amorous adventure with an older woman, Louisa Beckford, wife of his cousin Peter (author of *Thoughts upon Hare and Fox Hunting* and nicknamed 'The Great Dolt'). This affair was sufficiently complicated, but he also became infatuated with thirteen-year-old William Courtenay, whom he nicknamed 'Kitty', son and heir of Viscount Courtenay, the proprietor of Powderham Castle in Devon. At Christmas 1781, Beckford staged a spectacular three-day celebration of his majority in the Egyptian Hall at Splendens. Castrati sang, and Philippe de Loutherbourg, the post-Salvatorian painter, designed exotic scenery. Beckford later claimed that the visual effects of the party inspired him to begin writing *Vathek* early in 1782. His idiosyncrasies were already notable: his voice, whether natural or feigned, was as high-pitched as a eunuch's; the painter Fuseli called him 'an actor and no gentleman'. Apparently to separate him from Louisa Beckford and William Courtenay, his mother (whom he nicknamed 'the Begum') and his guardians (who included the former prime minister William Pitt the Elder) sent him abroad. After returning from this journey, he compiled his *Dreams, Waking Thoughts and Incidents*.

In 1783 he married Lady Margaret Hamilton, daughter of the fourth Earl of Aboyne. Her calmness, good sense, prettiness and loyalty all delighted him; he fell

deeply in love, and their first daughter was born in 1785. Beckford was elected MP for Wells in March 1784 as the antecedent step to his promotion to the peerage: in the event he was condemned to keep his House of Commons seat for thirty years; his ennoblement became impossible after he was ensnared in a sexual scandal. While visiting Powderham in September 1784, Beckford was accused by the family tutor of sexual relations with sixteen-year-old William Courtenay. Lord Loughborough, a brutally ambitious lawyer who had married Courtenay's aunt and was an implacable enemy of Beckford's guardians, publicised the accusations with all the vindictiveness of a Scottish puritan. At the urging of his mother and guardians, but against his own instincts, Beckford went abroad with his wife and baby daughter. During the following year, to his intense distress, his wife died shortly after giving birth to a second daughter. The Powderham scandal and the death of his wife broke Beckford's life into a handful of splinters.

He remained in exile (travelling in princely style) for twelve years. In 1787 he visited Portugal, where he came to love Gregorio Franchi, a handsome young seminarian who shared his delight in music. Beckford's long intimacy with Franchi was the most satisfying of his life. Much of the next ten years he spent in Portugal, though he was in Paris when the Bastille was stormed in 1789 and escaped from France with difficulty when war was declared in 1793. He had other emotional adventures after the Powderham crisis, but was too hardened to let them bruise him. Throughout he was treated as a sexual heretic. 'I have been hunted down and persecuted these many years,' he complained. 'No truce, no respite have I experienced since the first licenses were taken out . . . for shooting at me. If I am shy or savage, you must consider the baitings and worryings to which I allude – how I was treated in Portugal, in Spain, in France, in Switzerland, at home, abroad, in every region.'

The example of his social ruin scared other men whose tastes put them at risk, including Lord Byron, who apostrophised 'Unhappy Vathek' in *Childe Harold's Pilgrimage*:

> thou wert smitten with unhallowed thirst
> Of nameless crime, and thy sad day must close
> To scorn, and Solitude unsought – the worst of woes.

Leaving Portugal for the last time in 1798, Beckford returned to Wiltshire, where he began replacing his father's house with the huge neo-gothic Fonthill Abbey. In

Wiltshire he was ostracised by his county neighbours. When Byron's poet friend Thomas Moore was invited to the abbey, 'Phipps bid me take care what I did, for Sir Richard Hoare was called to account *seriously* by his brother magistrates for having visited Beckford; and was obliged to explain that it was for purposes of information, and *not* a visit of ceremony' (significantly, Beckford detested the scandal-mongering of 'impudent Phipps'). The Wiltshire gentry had indeed gone in a great deputation to Hoare of Stourhead, who had met Beckford while visiting Fonthill, and threatened a social boycott of him unless he undertook never to speak to Beckford again. Beckford's life became a living version of Huxley's description of Piranesi's prison: 'hopeless spectators of this pomp of worlds, this pain of birth – this magnificence without meaning, this incomprehensible misery without end and beyond the power of man to understand'. For eighteenth-century moralists he incarnated the outcast aesthete with his 'imprudence in common necessary affairs . . . vanity, self-conceit, censoriousness, moroseness, jealousy and envy'. The postures of aesthetic sensuality were easily acted out: 'the dwarf (making a frightful grimace at the pornography you sent me) has just brought in some wild strawberries which fill the room with the sweetest smell', as he wrote to Franchi in 1811. Still his protective poses became claustrophobic. 'How tired I am of wearing a mask,' he noted in his Lisbon diary, 'how tight it sticks – it makes me sore.'

In the aftermath of his twenty-first birthday celebrations, Beckford began writing his Arabian tale, *Vathek*. It is uncertain when it was completed, but after an unauthorised English version was published in London in 1786 with the implication that it was the translation of an Arabic original, he hastily issued a more accurate French edition published at Lausanne. It is significant of Beckford's sophistication that he chose to write the original in French. Lush detail and rich imagery pervaded his novel, which was a revolt against good sense. As a teenager in 1777 he had anticipated with horror his personal future:

> To pay and to receive fulsome Compliments from the Learned, to talk with modesty and precision, to sport an opinion gracefully, to adore Buffon and d'Alembert, to delight in Mathematics, logick, Geometry and the rule of Right, *the mal morale* and *the mal physique,* to despise poetry and venerable Antiquity, murder Taste, abhor imagination, detest all the charms of Eloquence unless capable of mathematical Demonstration, and more than all

to be vigorously incredulous, is to gain the reputation of good sound Sense. Such an Animal I am sometimes doomed to be.

Just as *The Castle of Otranto* reflected and magnified Strawberry Hill, and Sade's Silling was a version of his chateau La Coste, so *Vathek* contained a romantic distortion of Fonthill Splendens. 'I had to elevate, exaggerate, and orientalise everything. I was soaring on the Arabian bird roc, among genii and enchantments, not moving among men.' The women characters of the book were fashioned on his imperious, possessive mother and her servants. 'You could scarcely find anything like the Hall of Eblis in the Eastern writings, for that was my own,' Beckford later said. 'Old Fonthill had a very ample, lofty, loud-echoing hall, one of the largest in the kingdom. Numerous doors led from it into the various parts of the house, through dim, winding passages. It was from that I introduced the hall – the idea of the Hall of Eblis being generated from my own. My imagination magnified and coloured it with the Eastern character.'

The first two-thirds of *Vathek* is boisterous: its ferocious caliph is almost a buffoon, and at least some of the cruelties, such as the ladies' party where the guests are poisoned by vipers and scorpions, are jokes, though confessedly in a mordant humour. But the book darkens as the characters are overwhelmed by their transgressions and turn against each other. Perhaps these passages represent Beckford's experience of the Powderham crisis: shortly after the catastrophe he had reported of Courtenay, 'a certain young person I once thought my friend has proved himself the meanest traitor and the blackest enemy'. There is a famous passage in Catallus beginning '*Odi et amo*' ('I hate and I love . . . therefore I am in anguish'), foreshadowing the passage in *Vathek* where Firouzkah exclaims: 'What God have we served? How terrible the doom he has passed on us, that we who have loved so well, who have fled here that we may never cease to love, must hate each other through eternity.' In the closing scenes of the novel, the Hall of Eblis is Beckford's Piranesian picture of hell:

> In the midst of this immense hall, a vast multitude was incessantly passing; who severally kept their right hands on their hearts; without once regarding any thing around them. They had all, the vivid paleness of death. Their eyes, deep sunk in their pockets, resembled those phosphoric meteors, that glimmer by night, in places of interment. Some stalked slowly on; absorbed in

profound reverie: some shrieking in agony, ran furiously about like tigers, wounded with poisoned arrows; whilst others, grinding their teeth in rage, foamed along more frantic than the wildest maniac. They all avoided each other; and, though surrounded by a multitude that no one could number, each wandered at random, unheedful of the rest, as if alone on a desert where no foot had trod . . . They went wandering on, from chamber to chamber; hall to hall; and gallery to gallery; all without bounds or limit; all distinguishable by the same louring gloom; all adorned with the same awful grandeur; all traversed by persons in search of repose and consolation; but, who sought them in vain; for every one carried within him a heart tormented in flames.

Beckford collected beautiful objects throughout his exile, and was voracious for books, paintings and curiosities. As early as 1794 he was planning to return to his Wiltshire property and build a new house to replace Splendens. He originally recruited James Wyatt to design a ruined convent, but then demanded a more ambitious design on the highest peak of his estate. After construction began in 1799, there arose a huge building in the form of a cross with, at its centre, a tower nearly 300 feet high containing an octagonal room itself 128 feet high. Wyatt's first tower collapsed in 1800, but, undaunted, Beckford had it rebuilt. 'The rising Tower produces the most sublime effect – a truly palatial kind of castellation; the oriel is perfect – just as I imagined it', he told Franchi in 1812. From the centre under the tower the abbey was extended into halls, cloisters, passages and galleries. Recalling the Prince of Orange's Brueghel, Beckford installed an oratory with a marble statue of St Anthony and conceived such rooms as the Brown Parlour, the Yellow Room, the Cedar Boudoir, the Japan Room and the Gothic Cabinet. He filled this resplendence with books, pictures, statues and furniture. After occupying his house in 1807 he supervised further extensions and elaborations, though the sources of his father's fortune were shrivelling and he was being cheated by rascally advisers. Nevertheless, as he reported to Franchi in 1808, 'it's really stupendous, the spectacle here at night – the number of people at work, lit up by lads; the innumerable torches suspended everywhere, the immense and endless spaces, the gulph below; above, the gigantic spider's web of scaffolding – especially when, standing under the finished and numberless arches of the galleries, I listen to the reverberating voices in

the stillness of the night, and see immense buckets of plaster and water ascending, as if they were drawn up from the bowels of a mine, amid shouts from subterranean depths, oaths from Hell itself, and chanting from Pandemonium.'

He understood the part he was acting exactly. He confessed to Franchi in 1812, 'Some people drink to forget their unhappiness. I do not drink, I build. And it ruins me.' His building schemes never sufficiently sublimated his sexual energies. He was often frustrated in procuring youths who would accommodate his frolicsome lechery: 'all this would make the holiest of spirits fit for damnation', he complained in a week when his erections were 'as hard as a Carmelite': 'I cannot exist on agates, china and crystal; I need some nutriments more suitable to the human body.' Youths were not the only objects he desired. 'I was seduced by certain little Saxon tazza, certain sea-green bottles incredibly decorated with bronze, gilded in hell-fire – so bright and strong their colours,' he confided to Franchi in 1814. 'Two words breathed in my ear would have made me buy two fantastic Buhl armoire-like cabinets, magnificent, of a Solomonian richness, 400 the pair, and not dear at that.'

There was none of Strawberry Hill's frivolity in Beckford's grandiose compulsions. 'Walpole hated me,' he told Cyrus Redding. 'Mischief-making people annoyed him by saying I intended to buy up all his nic-nackery when he was dead. Some things I might have wished to possess – a good deal I would not have taken as a gift. The place was a miserable child's box – a species of gothic mousetrap – a reflection of Walpole's littleness.' Beckford was not a sincere medievalist like Walpole or Newdigate but a romantic resembling Lord Dorchester of Milton Abbey, for whom gothic was one style among other possible exoticisms. Nevertheless Beckford's abbey was a momentous event in the gothic revival, as Nikolaus Pevsner explained in 1956: 'Strawberry Hill and its successors were toys, costly elaborate toys, but the awareness of the game never leaves one outside or inside Strawberry Hill. Fonthill was the first neo-Gothic building to create sentiments of amazement, of shock, even of awe.' A fête in 1800 to honour Lord Nelson was Beckford's only social success there, but otherwise he was ostracised in a manner which increased his misanthropy. 'The very thought of all these expeditions to taverns to dance and wolf picnic suppers is enough to make me sick . . . and is a fresh proof of the degeneration of everything in this world,' he wrote to Franchi in 1811.

Blessed abbey, save and defend me from such riff-raff and riff-raffery as this! Grow, you forests, raise yourselves, you walls, and make an everlasting barrier between me and them. I shudder even at this distance – horrid, infamous, vile confusion!

Yet, with his fortune exhausted, he sold Fonthill in 1822 for £300,000 to John Farquhar, who had enriched himself supplying gunpowder in Bombay but in England lived and dressed as a miser. In 1825 Wyatt's second tower collapsed, and the abbey was ruined. Beckford lived another twenty years in Bath. His nearest historical counterpart is King Ludwig II of Bavaria, who commanded the building of the fantastical nineteenth-century castle of Neuschwanstein before becoming isolated in despairing fantasies.

James Wyatt and Lord Bridgwater

Fonthill's importance in formulating gothic aesthetics is based on Beckford's decision to employ James Wyatt as his architect. The abbey itself was a folly, but its excesses were a rich source of ideas for Wyatt's work begun in 1808 on the Earl of Bridgwater's superb seat at Ashridge in Hertfordshire. Early proponents of the gothic revival had always havered between emulating the medieval castle or the medieval abbey. There had been no doubt that Inveraray or Mitchelstown represented the castle style, that Walpole and Shenstone were attracted by cloistered monasticism or that Dorchester's schemes at Milton were compromised by this ambiguity. At Ashridge, on a site on a high ridge 640 feet above sea level, Wyatt resolved this dilemma. He achieved a superb effect by presenting a group of buildings that owed as much to the monastic as to the castellated traditions of earlier English builders. It is doubtful if he could have imagined so satisfying a solution without his experiences as Beckford's architect. The staginess of the buildings on their site, the fineness of the interior details, the successful adaptation of the monastic style proved a landmark in the revival of medieval architecture that might have been unattainable without the experience of Fonthill. Of all Wyatt's gothic work, Ashridge depended least for its effects on the surrounding scenery (its 'glorious parks and woods' laid out by Capability Brown made 'a setting which could not be more beautiful' for 'revels and pageants', according to the Marquess of Huntly, who attended festivities there in 1864).

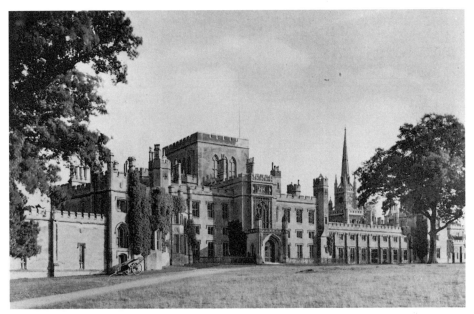

The long entrance front of Wyatt's wonderful building at Ashridge creates a splendid effect with its towers and castellations. It is a flamboyant yet never meretricious masterpiece which successfully combined monastic traditions with what Vanbrugh called the 'noble and masculine . . . castle air'.

James Wyatt (1746–1813) was taken as a boy to Rome in the special embassy of Lord Northampton. He devoted four years there to studying antiquities, followed by two years at Venice. His first gothic work was a ruin at Milton for Lord Dorchester in about 1775; he gothicised the exterior of an otherwise classically symmetrical house in Sussex for Lord Sheffield a few years later. In the early 1780s he came under Walpole's influence, and at Lee Priory in Kent was more successful in reviving gothic in a rococo style. His alterations to the cathedrals at Durham (where he destroyed England's finest surviving Norman chapterhouse), Salisbury and elsewhere led Pugin later to stigmatise him as 'the Destroyer'. Certainly some of his decisions were vandalistic, but the misjudgements of 'this monster of architectural depravity – this pest of cathedral architecture', as Pugin called him, diminished after 1789 when his conscientious study of Oxford's great medieval architect William Wykeham reduced his stylistic impurities. Though contemporaries prized Wyatt for his classical interiors, he was commissioned to build coastal castles on the isles of Wight and Portland (1799–1800), followed by Belvoir Castle for the Duke of

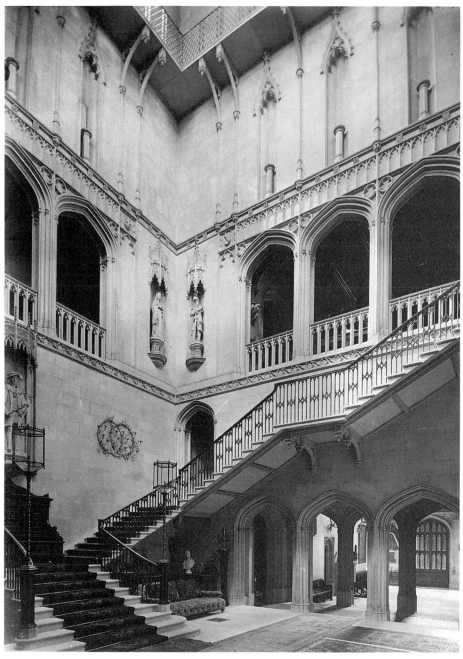

Fonthill's central staircase dominated the abbey, making Beckford's servants and rare visitors resemble the helpless figures in Piranesi's prisons. The great staircase at Ashridge was not as histrionic or extremist.

Rutland (1801), and proved himself a scenic architect who mastered the sites of his buildings. Having survived his catastrophic ecclesiastical phase, he shed genteel antiquarian gothic for an architecture that was truly inspirational. Norris, his poised and dashing pseudo-Norman castle on the the Isle of Wight, is as theatrical as a Piranesi print; but supremely his work at Ashridge provided the crucial link between the sublime, the terrible or picturesque eighteenth-century gothic and the nineteenth-century medievalism which culminated in the work of Sir Charles Barry and Pugin on the Houses of Parliament.

Ashridge's monasticism was partly suggested by the history of the site. A college of monks had been completed there in 1285. Early in the seventeenth century, after the dissolution of the monasteries, the estate was acquired by the Egertons, created Earls of Bridgwater in 1617 and dukes in 1720. The dukedom became extinct in 1803 on the death of the third duke, who had hugely augmented his family's wealth by canal-building: his profits were so enormous that his income tax return was £110,000 a year. The major part of Bridgwater's fortune passed to his nephew, who was afterwards created Duke of Sutherland, but about £2 million passed with the earldom to an Egerton cousin, who soon afterwards employed Wyatt to improve his estate. The new earl was as conceited as Beckford, and nearly as rich, but instead of the Wiltshire caliph's queerly productive sensibility he had only the sterility of harsh aristocratic pride. Having arranged a shooting party at Ashridge for a royal duke on what proved to be a freezing day in 1823, he had several toes amputated after contracting frost-bite. 'When his doctor informed him that his position was critical, he so far forgot that he had once been a General in the British Army as to offer £50,000 if the doctor could save his life, and when told that the doctor could do nothing to help him, increased this offer to £100,000.' Bridgwater's greatest vanity was reserved for his will, in which he bequeathed his fortune to his nephew Viscount Alford on the condition that he acquire a marquessate or dukedom within five years of Bridgwater's death. The House of Lords later held that this condition was void.

In Wyatt's scheme the buildings were spread across the site, with the offices on one side (based around large internal courtyards) balanced by a wing containing private rooms, with a great orangery bent at an angle. The entrance front, facing north, revealing the great length of the buildings, is particularly majestic. There is a soaring chapel tower. As at Inveraray, Alnwick, Milton and Mitchelstown, the

neighbourhood was improved with new cottages, church restoration, road-building and the encouragement of local industries. Reportedly 800 persons were employed on the estate. 'The park is one of the largest in England,' wrote Prince Püchler-Muskau after a visit in 1828, 'and the house . . . is almost endless, with all its walls, towers and courts'. It looked 'fairy-like on paper' but 'in reality . . . somewhat absurd, from its overloaded and incongruous air'. Part of the incongruity lay in 'a sort of fortress' being surrounded by 'pretty flower gardens'. The prince was more impressed by Ashridge's 'princely' interior, where Wyatt had modified some of Fonthill's designs into a less excessive, more durable form.

> The possessor has very wisely limited himself to few, but large, entertaining rooms. You enter the hall, which is hung with armour and adorned with antique furniture. You then come to the staircase, the most magnificent of its kind that can be imagined. Running up three lofty stories, with the same number of galleries, it almost equals the tower of a church in height and size: the walls are of polished stone, the railings of bright brass, the ceiling of wood beautifully carved in panels and adorned with paintings, and around each landing-place or gallery are niches with statues of the Kings of England in stone. Ascending this staircase we reached a drawing-room decorated with crimson velvet and gilded furniture, lighted in front by enormous windows which occupy nearly the whole side of the room, and disclose the view of the pleasure-ground and park. Sideways, on the left, is another room as large, in which are a billiard-table and the library.

There were anomalies at Ashridge, such as the inclusion of a gothic orangery and conservatory (Pugin later derided modern gothic castles for having 'a conservatory leading to the principal rooms, through which a company of horsemen might penetrate at one smash into the very heart of the mansion – for who would hammer against nailed portals when he could kick his way through the greenhouse?'). Overall Wyatt's adaptations of monastic ideas were resoundingly impressive: his success is even more distinct if compared with the work of his nephew Jeffrey Wyattville for the Duke of Bedford at the old monastic estate of Endsleigh in Devonshire. Built in 1810 amid grounds laid out by Humphrey Repton, Endsleigh was mocked a century later by Sir Edwin Lutyens as sham, mean and historically inept: 'an abbey which is commemorated by a mitre displayed here and there in

odd places in conjunction with the ducal coronet. A plaster Strawberry Hill Gothic with wood window frames painted to look like granite.'

Ashridge involved Bridgwater in a munificent outlay that was becoming unusual in the epoch before the Reform Bill of 1832. There were comparable extravagances, such as Belvoir Castle in Rutland and Eaton Hall in Cheshire, which was rebuilt by William Porden between 1802 and 1815 and by Sir Alfred Waterhouse between 1870 and 1882 for the Grosvenors, afterwards Dukes of Westminster. Waterhouse's Eaton, 'this Wagnerian palace', as Pevsner called it, 'was an unforgettably dramatic experience' before its demolition in the 1960s, 'the most ambitious instance of Gothic Revival domestic architecture anywhere in the country'. James Wyatt designed improvements and extensions at Belvoir in 1801–15, though building work was supervised by the Duke of Rutland's chaplain, who undertook further work after a disastrous fire in 1816. Perched dominantly on a hilltop rising steeply from the surrounding vale of Belvoir, the Rutland castle was hailed by Pevsner as 'the *beau ideal* of the romantic castle', and equally impressed the social climber 'Chips' Channon in 1935:

> The ball was a glorious Disraelian festival, and the Castle illuminations could be seen for miles. Little coloured lights lined the winding avenue: most of the men were in pink coats, which matched their shining pink huntin' faces. The women were magnificent, and Honor wore her tiara, and John Rutland looked as *dix-huitième* as only he can look, with his long gold chain on his shirtfront.

Channon was a guest when the Rutlands were on artificial display; but twenty years earlier, when Lord Crawford and Balcarres had stayed for a weekend, there were no postures. 'An amusing nondescript party', Crawford recorded. 'Lots of vague people who flitted across the background – a Master of Hounds, a young man in the City, an American actress, a pianoforte maker, an old and distinguished Jew, a young and smart Jew, together with some odds and ends whom I could not define.' Such disintegration of class exclusiveness would have been inconceivable when the previous duke had written his famous couplet in his poem 'England's Trust':

> Let wealth and commerce, law and learning die,
> But leave us still our old nobility.

But in the twentieth century the old nobility was intermingling with piano-makers and indefinable odds and ends. The *beau ideal* of a romantic castle was an unsustainable fantasy.

Ashridge, which became a training college in the 1920s, remains one of the most significant of the embattled or monasticised power houses: representing the high maturity of Wyatt's gothic ideas, it established him as the greatest gothic revivalist among architects since Kent. The expense was as futile as at Fonthill, for Bridgwater knew that the male line of his family would become extinct in his generation. By the time of Püchler-Muskau's visit, he was already dead of his frostbite: the property had passed to his clergyman brother, the eighth and last earl, a bachelor who lived in Paris surrounded by cats and dogs who were dressed as ladies and gentlemen, taken out in his carriage and fed at table. It was this Bridgwater who bequeathed a literary prize worth the huge sum of £8,000 to reward the author of the best work on the Goodness of God as manifested in the Creation.

MATURIN'S MELMOTH THE WANDERER

The Goodness of God had as its necessary counterpart the human desperation and desire which were represented in religious terms as satanic. Human evil, and its punishment, is one of the great themes of *Melmoth the Wanderer*, a novel written by an Irish clergyman named Charles Robert Maturin (1780–1824), published in 1820, and often reckoned by connoisseurs as marking the apotheosis of gothic novels. Its imaginative debt to the hells of Eblis proves that Fonthill was not the only enduring influence of Beckford on the gothic imagination. Maturin's novel opens in an Irish hovel, where a miser is dying of fright. Afterwards the skinflint's nephew reads a manuscript containing a series of gothic tales. The first of these – purportedly written by an English visitor after a trip to Spain in the 1670s – tells of a mysterious Englishman who interrupts a Spanish wedding with the result that the officiating priest dies. The horrifying sequel, 'Tale of the Spaniard', concerns a monk, Moncada, who is tormented by a mysterious being, accused of conversing with the devil and sentenced to be burnt alive among other gothic ordeals. Next, the 'Tale of the Indians' begins on a paradisiacal island in the Indian Ocean, where Melmoth discovers Immalee, a European girl epitomising Rousseau's ideal noble primitive: she goes to Spain, where she is married to Melmoth by a dead hermit with the ghost of a murdered domestic acting as witness. The ceremony occurs in a derelict

monastery, 'the crosses still visible on every ruined pinnacle and pediment, like religion triumphant amid grief and decay'. Her wild brother is soon slain by Melmoth in a duel, she is taken hostage by the Spanish Inquisition, kills her own baby in despair and dies of misery in her inquisitors' dungeon. Still infatuated with Melmoth, she declares on her deathbed, 'while I live I must love my destroyer'. Immalee's story also incorporates the 'Tale of Guzman's Family', in which a son sells his blood to a surgeon in order to buy food for his hungry relations. The novel concludes with 'The Lover's Tale'. Maturin portrays Melmoth as a modern Faustus, who has bartered his soul with demonic powers for protracted life but fails to tempt other victims to perdition. Maturin's overall effect is wearyingly phantasmagoric with its maniacs, frenzied mobs, vicious monks, dungeons of the Inquisition, subterranean passages, victimised Jews, caverns, skeletons, atrocities, benighted (in one case, immured) lovers and general excess. So intricate is the plot that analysis of one section must stand for the whole.

Maturin has a phrase, 'simplicity of profound corruption', which is the nineteenth-century counterpart to Hannah Arendt's observation that the Nazis demonstrated 'the banality of evil'. This is one of the themes of his 'Tale of the Spaniard', narrated by Moncada. The traditional gothic theme of usurpation and illegitimacy is diverted by Maturin into a more theological direction. Moncada has been prevented from inheriting a Spanish dukedom because his parents had not married until after his birth. The protesting bastard is forced into a monastery representing a repugnant Piranesian doom: 'I was like one who sees an enormous engine (whose operation is to crush him to atoms) put in motion, and, stupefied with horror, gazes on it with a calmness that might be mistaken for that of one who was . . . calculating the resistless crush of its blow.' The monastic life exemplifies to Moncada the way that desperate, frightened humans act their parts – only animals beneath human civilisation, and angels above the world, can safely be authentic. 'The whole house was in masquerade from the moment I entered it.' He finds the histrionics of the monks shallow and insincere: 'There was a *coup de théâtre* to be exhibited, and provided they played first parts, they cared little about the catastrophe.' Moncada tells Melmoth, 'In Catholic countries, Sir, religion is the national drama; the priests are the principal performers, the populace the audience; and whether the piece concludes with a "Don Giovanni" plunging in flames, or the beatification of a saint, the applause and the enjoyment is the same.' In the monastery Moncada endures many

gothic horrors: he sees a beautiful, naked youth flogged to death by monks; he is tormented, persecuted, starved and incarcerated in an underground dungeon with slimy reptiles.

Eventually he escapes through vile subterranean passages with a fellow monk whom he knows to be a parricide. 'He possessed active, and I passive fortitude. Give him something to do, and he would do it at the risk of limb, and life, and soul . . . Give me something to suffer, to undergo, to submit, and I became at once the *hero of submission.*' Moncada and his monkish abettor together suffer the hellishness of Eblis, 'that despair of incommunication which is perhaps the severest curse that can be inflicted on those who are compelled to be together'. The monk tells a horrifying story of surprising two lovers on a couch and tricking them into an underground room where he causes them to be immured until their death. With voyeuristic savagery the parricide watched in triumph as love dissolved to hate. It is another version of the way that Beckford and Courtenay were turned against one another after the scandalous accusations at Powderham, which Beckford afterwards represented in the final climax of his novel: 'Vathek beheld in the eyes of Nouronihar nothing but rage and vengeance; nor could she discern aught in his eyes but aversion and despair.' Maturin's parricidal monk relishes his power as a torturer:

> Clap me two lovers into a dungeon, without food, light or hope, and I will be damned (that I am already, by the bye) if they do not grow sick of each other within the first twelve hours . . . They shrieked for liberation, and knocked loud and long at their dungeon door . . . Then the agony of hunger increased, they shrunk from the door, and grovelled apart from each other. *Apart!* – how I watched that. They were rapidly becoming objects of hostility to each other, – oh what a feast to me . . . All the horrible and loathsome excruciations of famine had been undergone; the disunion of every tie of the heart, of passion, of nature, had commenced. In the agonies of their famished sickness they loathed each other . . . It was on the fourth night that I heard the shriek of the wretched female, – her lover, in the agony of hunger, had fastened his teeth in her shoulder, – that bosom on which he had so often luxuriated, became a meal to him now.

The monk betrays Moncada to the Inquisition to prove that 'mine is the best theology, – the theology of utter hostility to all beings whose sufferings may mitigate

mine. In this flattering theory, your crimes become my virtues.' Moncada's experiences under the Inquisition prove another hell until a fire erupts in the prison and its inmates are escorted from its cells. 'It was a subject worthy of the pencil of Salvator Rosa,' Moncado tells Melmoth:

> Our dismal garbs and squalid looks, contrasted with the equally dark, but imposing and authoritative looks of the guards and officials, all displayed by the light of torches, which burned, or appeared to burn, fainter and fainter, as the flames rose and roared in triumph above the towers of the Inquisition. The heavens were all on fire . . . like a wildly painted picture of the last day. God appeared descending in the light that enveloped the skies.

A fiery scene of hellish destruction and death follows.

PUGIN

The intensity of the 'Tale of the Spaniard' suited its period. 'In this country all is contrast,' wrote Maturin's contemporary Charles Greville, 'contrast between wealth the most enormous and poverty the most wretched, between an excess of sanctity and an atrocity of crime'. Maturin's Spanish nobles, monks and mob exhibit all these extremes and excesses. Intense sanctity was never an exclusively literary phenomenon. Fanciful jesting styles were discarded after the 1820s by most gothic revival architects: William Burges continued to design churches that were playful and benevolent-tempered; theatrical fancies were still erected as urban or suburban villas, such as the agreeably bizarre Crecy Tower, built in 1852–53 on Campden Hill in Kensington. But mostly architects succumbed to a craze for ethical uplift. They came to feel that moral environments must be created by moral architecture: they convinced themselves that the purpose of art was to serve. But when architects so eagerly accommodate the prevailing temper of their times, they cease to be goths, though they may earn large fees as gothic revivalists. Thus Sir Gilbert Scott became the preferred architect of the Victorian official classes by propounding in his *Remarks on Secular and Domestic Architecture* (1857) that building design should reflect constructive needs, and by actualising this idea with a characteristically Victorian mixture of showiness and earnestness. William Butterfield's designs were marked by his early commitment to the Cambridge Camden Society, a High Anglican body formed in 1839 to work for the conformity of ecclesiastical architecture with

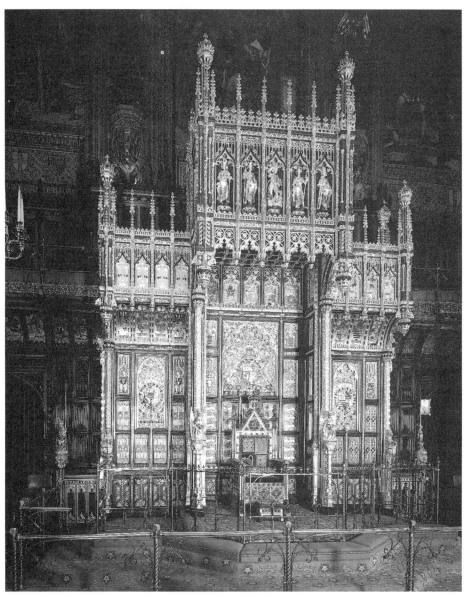

The throne in the House of Lords is an example of Pugin's superb work for the interior of the palace of Westminster.

reformed liturgies. George Edmund Street, arguably the most erudite of Victorian gothic revival architects, saw his work as a Christian mission: in his ecclesiastical masterpiece, the church built at Kingston in Dorset between 1873 and 1880, 'harmony, symmetry, nobility are the qualities he aims at. No passion is allowed, no touch of personality, let alone idiosyncrasy. It is a perfect interior but, when the light is not favourable, it becomes frigid'. The Victorians became voluptuaries in tender agonies of conscience. One of the high-minded, overstrung intellectuals of the Darwin family once lamented: 'Next week looks very black: a pleasure for every day.' This pleasure-hating trait perhaps partly explains the gothic revivalism of Butterfield, whose churches and other public buildings are harsh both in their shapes and in the redness of their brickwork.

The earnestness of the early Victorians is exemplified by the gothic architect Augustus Welby Northmore Pugin (1812–52). He had genius, and died mad; his life itself was lived with a spiritual intensity and emotional extravagance which few people could have endured without breaking down. He was turbulent, fantastic, self-destructive, ill-starred and reviled. In that sense he belongs within the gothic traditions of this book; but his resolute aesthetic idealisation of medievalism was never Salvatorian, soap-operatic or concerned with secular powers. He cast himself back into the soaring glories of medieval Roman Catholic church-building; transgressive ecstasies, the lure of decay and amusements based on camp inversion of values were horrifying to him. He was acclaimed as the most influential British gothic architect of his century, yet he was never a goth.

Pugin was the only child of a Frenchman with obscure aristocratic claims who had fled to England as a refugee. The elder Pugin was employed by the architect John Nash to study medieval forms to serve the fashion for gothic buildings. Young Pugin, like Beckford, delighted in tales of chivalry and romance; by the age of fourteen he was studying feudal castles and medieval architecture. In adolescence he developed a passion for the stage, and was specially enthralled by the complicated Piranesian contrivances of stage machinery. He constructed a model theatre in his family home,

> at much expense, removing the attic ceiling, cutting away the roof, constructing cisterns, and adapting everything necessary to his object. On this model stage he designed the most exquisite scenery, with fountains, tricks, traps, drop-scenes, wings, soffites, hilly scenes, flats, open flats and every magic

change of which stage mechanism is capable . . . every part was so admirably adjusted that the changes in the scenes, wings, and sky-pieces were effected with marvellous rapidity, for it was provided with lines, pulleys, grooves, machines for ascents and descents.

Like Piranesi, he worked as a stage designer (chiefly at Covent Garden) and he never lost the attributes of a scene-painter. Theatricality remains a hallmark of his architectural designs, particularly for interiors. As a church-builder he hankered to install an altar that would sink through a trap-door to emphasise the miracles of Holy Week. 'Pugin's etchings, with their brilliant lighting and their well-placed figures, are primarily dramatic, and his buildings belong to the old Wyatt tradition of scene-painting,' Kenneth Clark wrote in 1928. 'His most satisfactory design known to me was drawn in his Covent Garden period – an imaginary cathedral raising its gorgeous, impossible towers unembarrassed by the laws of gravity.'

Pugin had married twice by the age of twenty-one, bought a fishing-smack, went to sea, was shipwrecked in Scotland, and even on land affected a sailor's jacket, loose pilot trousers, jack-boots and a nautical hat. He made his submission to Roman Catholicism in 1835, 'perfectly convinced the Roman Catholic Church is the only true one, and the only one in which the grand and sublime style of church architecture can ever be restored'. This conversion pitched him against many contemporaries. The Roman Catholic Church was still widely regarded as the sinister machine of cruel controls depicted in *Melmoth*: the Spanish Inquisition still haunted the Protestant imagination like Fuseli's goblin, so much so that a woman alone with Pugin in a railway carriage, seeing him cross himself, cried in panic, 'You are a Catholic, sir; Guard, Guard, let me out – I must get into another carriage!'

Pugin sought salvation in gothic design, Gregorian music and old vestments ('What is the use, my dear sir, of praying for the conversion of England in a cope like that?' he expostulated to a Roman Catholic divine in cheap vestments). Gothic for him meant neither the frivolity of rococo gothic, nor sterile antiquarianism, nor the physical expression of a rich man's earthly powers. Gothic church architecture symbolised for him the Roman Catholic faith, which deserved veneration and submission. His faith resembled that of the Lisbon priest whom Beckford in 1787 heard extolling St Anthony: '"Happy," exclaimed the preacher, "were those gothic ages, falsely called ages of barbarism and ignorance, when the hearts of men, uncor-

rupted by the delusive beverage of philosophy, were open to the words of truth falling like honey from the mouths of saints and confessors."' He sought to re-create in his own words 'a sort of Catholic Utopia,' and has been well described by Mordaunt Crook as 'the man who turned the Gothic revival from a cult into a crusade.' This was only possible after he had been taken under the protection of the Earl of Shrewsbury and Waterford, Britain's leading Roman Catholic layman. This earl was a godly autocrat who once evicted a labourer on his estate from his cottage for gardening on a Sunday. Initially he used his fortune to enlarge and furnish his Staffordshire seat according to Pugin's ideas. The building was originally called Alton Abbey, evoking the Catholic Middle Ages, and perhaps indicating its conceptual links with Fonthill Abbey: for the scale of 'walls, towers and turrets, battlements and pinnacles', as Pevsner reported, 'is beyond that of any of the castellated fantasies of other noblemen, but not of the fantasy of one commoner: Beckford'. Having finished this fantastic palace, Shrewsbury chose to economise by living mainly abroad so as to finance a campaign of church-building by Pugin. His activities were on the scale of mad King Ludwig II, with the distinction that the Beckford of Bavaria built huge follies to glorify the royal dynasty of Wittelsbach, while Shrewsbury wanted to promote the powers of Roman Catholicism. (Alton, though, towers above the river Churnet like a fort above the Rhine.)

Alton Towers is an astonishing house, but the Palace of Westminster constitutes Pugin's most magnificent triumph in the picturesque. In October 1834 the old palace was destroyed by fire. The style of its replacement, which was to contain both the House of Lords and the House of Commons, caused high contention among connoisseurs, but eventually Sir Charles Barry was entrusted with a commission for a gothic palace. From 1837 Pugin assisted Barry on this work; building began in 1840. Pugin supervised the masons and craftsmen throughout. He gave perpendicular gothic interiors to both Houses of Parliament and their offices, modelling the layout on the palace of medieval monarchs, with great ceremonial chambers and more domestic, even intimate features. The interior ornamentation is Pugin's work down to the ink-pots and umbrella stands which he spent his last days in designing. There was later controversy about Pugin's responsibility for the exterior, but the instantaneously convincing antiquity of the new palace, and its glorious, intimidating magnificence as it rose over flat, marshy, low-built Westminster in the 1840s, had its heaviest debt to Pugin's conceptual imagination.

Yet again it needs to be insisted that Pugin was not a true goth. He did not admire the Dark Ages, superstition and fear, or regard human identity as a masquerade of discontinuous, improvised performances. 'The world that Pugin dreamt of re-creating in three-dimensional form was not a Dark Age, but an Age of Faith: a society still familial, communal, organic, hierarchical, credulous and theocratic,' as Mordaunt Crook has brilliantly summarised. 'Spiritually fragmented by the Reformation; intellectually undermined by the Enlightenment; physically destroyed by the Industrial Revolution, this half-forgotten universe of the mind survived as a powerful mythology – a mythology all the more seductive in a world gone secular, urban, libertarian and capitalistic.' Pugin detested Fonthill for being 'the illusion' of what he thought sacred, a 'religious community', and worse still, raised neither to glorify God nor to mortify sinners; but 'built to suit the caprice of a wealthy individual, and devoted to luxury'. He hated the transience of these mock monasteries, 'into which a religious man never enters', and which after the owner's death 'becomes the subject of some auctioneer's puff'. The Fonthills were all a degrading lie to Pugin: *the kitchens alone* are real; everything else is a deception'. Yet Fonthill was as surely the requisite precursor of Ashridge as Ashridge provided the overture to the palace of Westminster.

As these quotations show, Pugin in his writings promoted his passions with wit, abuse and exaggeration; in speech he was voluble, brusque and vehement. Not surprisingly, he was snubbed by ecclesiologists and baffled in his private life too. After his second wife's death, he proposed marriage to a niece of Lord Shrewsbury called Miss Amherst, who, when her parents broke the engagement, retired into a convent. Another intended marriage was prevented by the bride's family's hostility to Roman Catholicism. His passions, even to contemporaries, seemed displaced. In a poem of 1848 Arthur Hugh Clough ironically imagined a 'Treatise upon *The Laws of Architectural Beauty in Application to Women*' before apostrophising a successful lover: 'So the Cathedral is finished at last, O my Pugin of Women.' Always prone to nervous debility, he was easily affronted or excited, and suffered the feverish anxieties of a lifelong insomniac. He overworked ferociously, loathed alcohol and tobacco and abstained from frivolities because pleasures were contrary to his idea of God. A commission to design a medieval court at the Great Exhibition of 1851 (the pageant organised to celebrate the achievements of the railway age and to idealise the future prospects of mechanised efficiency) overtaxed him, and by the summer of

1852 he was insane. Heartbreakingly, this strange fanatic died in the asylum known as Bedlam in September of that year.

Piranesi had already depicted the haunted state and personal torture of Pugin's last year. Pugin incarcerated himself in a metaphysical *Carceri* until his mind gave way. He fell into a torment of anxiety and guilt that isolated and eventually killed him. The hectic excess of his ideas proved fatal; Pugin's death, at least, was unequivocally gothic.

This man belongs to me I want him

Higher thought originates as meditation upon death. Every religion, every scientific investigation, every philosophy, proceeds from it. Every great symbolism attaches its form-language to the cult of the dead, the forms of disposal of the dead, the adornment of the graves of the dead.

Oswald Spengler

He who most resembles the dead is the most reluctant to die.

Jean de la Fontaine

To die will be an awfully big adventure.

J. M. Barrie

SLEEPLESS SOULS

Samuel Pepys was working in his government office when his cousin Kate Joyce sent a message 'that if I would see her hus[band] alive, I must come'. He went immediately to Anthony Joyce, a tallow chandler who had lost his business two years earlier in the Great Fire of 1666 and had turned innkeeper in Clerkenwell. A few days earlier Joyce had thrown himself into a dirty pond at Islington, from which, though he was pulled out and revived, he had caught a mortal fever. On his deathbed he seemed coherent to Pepys, if a little fanciful in his explanations. 'He confessed his doing the thing, being led by the Devil; and doth declare his reason to be . . . having forgot to serve God as he ought.' Pepys had a more prosaic explanation: 'his great loss by the fire did bring him to it, and so everybody concludes'. Joyce's imminent death posed a great threat to his wife. Until 1870 the property of suicides was forfeit to the Crown: if a coroner's jury returned a verdict of *felo de se* on Joyce, his possessions would be confiscated and the family rendered destitute. Well-wishers therefore rallied to her defence. 'I stayed a while among the friends

that were there,' Pepys described, 'and they being now in fear that the goods and estate would be seized on, though he lived all this while, because of his endeavouring to drown himself, my cousin did endeavour to remove what she could of plate out of the house.' At Kate Joyce's request, Pepys took some flagons home with him, 'in great fear all the way of being seized; though there was no reason for it, he not being dead'. With energetic kindness, he then obtained an audience with King Charles II and told him of the Joyces' trouble. 'The King without more ado granted that if it were found self-murder the estate should be to the widow and children.' Even so, some mischief was made among the coroner's jury whose verdict was delayed for a fortnight 'at the suit of somebody under pretence of the King, but it is only to get money out of her to compound the matter'. Eventually Anthony Joyce was found by the jury to have died of natural causes, whereupon his safeguarded property was returned to his heirs. This commonplace domestic tragedy, with its mercenary devices, has wider, gothic ramifications, for suicides and vampires were twinned in the English historical imagination. The events at Joyce's Clerkenwell inn had their counterpart two centuries later at Castle Dracula.

Suicide is hugely threatening because it poses such a great question: is life worth living? It was therefore stigmatised by rituals that were a mixture of paganism and inverted Christian practice. Because 'the suicide lifts his guilty arms against his own sacred person', in Goldsmith's phrase, he was punished with profane burial. Self-murderers were impaled in their graves with a stake through their hearts in a rite of pagan origin, though the stake came to be seen as preventing the resurrection of suicides on Judgement Day. The suicide's corpse was buried at a crossroads in the hope that the sign of the cross would drive off the devil. Christians were buried in graves facing east–west so that they could rise up to face God on Judgement Day; they were interred among other members of their family to emphasise the community of the dead. By contrast, the burial of suicides in unconsecrated ground emphasised their exclusion from the Christian hope of resurrection. Flowers were strewn on the coffins and graves of the Christian dead as symbols of rebirth, but suicides (like vampires) had liminal or sleepless souls, neither dead nor alive, with no hope of Christian rebirth, and therefore particularly polluting. The desecration surrounding their burials dramatised the Christian revulsion from self-murder as sinful; Satan was ever-persuasive, and despair was a diabolical temptation. 'I tremble every inch of me,' a simple character in Henry Fielding's *Tom Jones* (1749) exclaims

at the mention of suicide. 'To be denied Christian burial, and to have your Corpse buried in the Highway, and a Stake drove through you . . . nothing but the Devil . . . can put such wicked Thoughts into the Head of any body.' Educated people expressed similar beliefs in a more sophisticated vocabulary. When, in 1876, Lord Lyttelton committed suicide, one family friend described his long depressive illness as 'a personal conflict with the power of evil', and Gladstone spoke of him as having 'repelled, condemned and repeatedly mastered the impulse which he knew to be upon him rather than in him, an alien and guilty thing'.

By the late eighteenth century the alien, guilty things known in England as vampires were regarded not as ghosts but as dead bodies possessed and animated by the devil in which the soul of a dead sinner was eternally trapped under diabolic control. The suicide's corpse was vulnerable to such control because in its lifetime it had forfeited the protection of Christian laws by committing self-murder. Until the devil's power had been broken, the suicide's soul was trapped in an existence which was neither living nor dead – thus cruelly, punitively foiling his self-destructive intention. Suicide and vampirism excited similar fears and penalties because they created similarly sleepless souls. Families of suicides consented to burial at crossroads because it was feared that a vampire's first victims were selected from its closest circle. Under legislation enacted in England in 1823, the corpse of a suicide could only be buried between 9 p.m. and midnight. Another law prohibited the disinterral of the body of a suicide in order to drive a stake through its heart. The last crossroads burial, in London at least, was also in 1823: the corpse of Abel Griffiths, wearing a bloodied winding-sheet, drawers and stockings, was taken in procession from the workhouse in Hanover Square to the crossroads formed by Eaton Street, Grosvenor Place and the King's Road. 'The body was then wrapped in a large piece of Russian matting, tied round with some cord' as a physical restraint against its return from the grave, 'and instantly dropped into the hole, which was . . . immediately filled up. The disgusting part of the ceremony of throwing lime over the body, and driving a stake through it, was dispensed with.' Though these barbarities ceased in 1823, the forfeiture of the property of suicides and the condemnation of their bodies to dissection in anatomy classes continued until 1870. Suicide ceased to be classed as a homicide only in 1879, when the criminal sentence for attempted suicide was reduced to two years. Not until 1882 were suicides granted the rights of burial in daylight.

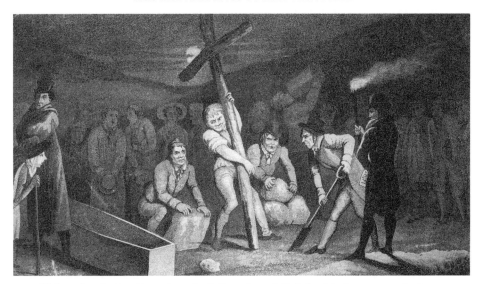

This early-nineteenth-century depiction of a suicide's burial at a crossroads shows an alien, guilty figure lurking on the left. One member of the sleepless dead is hoping to recruit another.

The importance of these burial customs is evinced in two gothic texts, James Hogg's *Private Memoirs and Confessions of a Justified Sinner* (1824) and Emily Brontë's *Wuthering Heights* (1847). In the closing section of Hogg's book a young man hangs himself with a rope tying down a hay-rick. The self-dramatiser who finds the corpse encourages supposition that the suicide was helped by Satan: 'the more to horrify the good people of this neighbourhood, the driver said, when he first came in view, *he could almost give his oath* that he saw two people busily engaged at the hay-rick, going round it and round it'. Self-murder is a recurrent theme in *Wuthering Heights*. After Hindley Earnshaw's death, Heathcliff sneers, 'that fool's body should be buried at the cross-roads, without ceremony of any kind' for 'he has spent the night in drinking himself to death deliberately'. Catherine, with whom Heathcliff is obsessed, dies as a result of self-starvation and is buried in a corner of Gimmerton churchyard, under a wall, rather than with her relations. In northern Britain, after the 1823 legalisation of the burial of suicides in churchyards, it became customary for their bodies to be laid under the churchyard wall so that no one was in peril of walking over their graves. Though it would be crude to treat the relationship between Heathcliff and Catherine as that of a vampire and his prey, their passionate, destructive involvement, his emotions during his surreptitious visits to her

grave, his midnight walking and sharp teeth invoke vampiric associations. The anomalies surrounding his death connote the same set of beliefs surrounding vampires and self-murder. Heathcliff refuses food and wastes away, but is desperate not to be considered a suicide and thus refused churchyard burial next to Catherine. 'Is he a ghoul, or a vampire?' muses his servant Nelly Dean, who 'had read of such hideous, incarnate demons'. After Heathcliff's burial without Christian rites beside Catherine, 'the country folks . . . swear on their bible' to have seen his ghost with Catherine's, but the narrator, Lockwood, is doubtful. Visiting their graves, he wonders, in Brontë's famous closure, 'how anyone could ever imagine unquiet slumbers for the sleepers in that quiet earth'. This is an instance of Lockwood's complacent fatuity: no one familiar with Georgian burial customs could expect quiet slumbers for Catherine and Heathcliff.

EARLY VAMPIRES

The ubiquity of the vampiric myth is well attested. Called Lamia in ancient Greece, Vurdulak in Russia, and Vampyr or Oupir in eastern Europe, these creatures can also be traced in Asian, Arabian and African folklore. Fear of corpses is a feature of most cultures. 'The dead are blamed for sickness and death: death comes, in other words, from the dead, who, through jealousy, anger, or longing' try to recruit the living to their realm, as Paul Barker has summarised. To prevent this, the living seek to 'neutralise or propitiate the dead – by proper funerary and burial rites, by "killing" the corpse a second time, or by sacrifice – until the dead have become powerless.' In the early modern period the primordial myths of vampirism were strengthened by stories of the blood-lust of real people. The late-fifteenth-century Wallachian prince called Vlad Dracul was caught up in the wars between European Christians and Moslems after the fall of Constantinople to the Turks in 1453. Eventually siding with the Christians, he harried, ambushed and routed Turkish forces. Any survivors he caught were impaled on stakes. His passion for this homicidal torture led to his later soubriquet 'Vlad the Impaler'. Many apocryphal tales were told of him: that he impaled 20,000 Turks near Brasov in 1459, or that he impaled the entire population of a town, including women and children, in concentric circles leading up a hill. Centuries later Bram Stoker came across his name while researching in the British Museum and adapted it for his vampiric novel.

There is no evidence that Vlad Dracul was a blood-drinker, but he was a distant

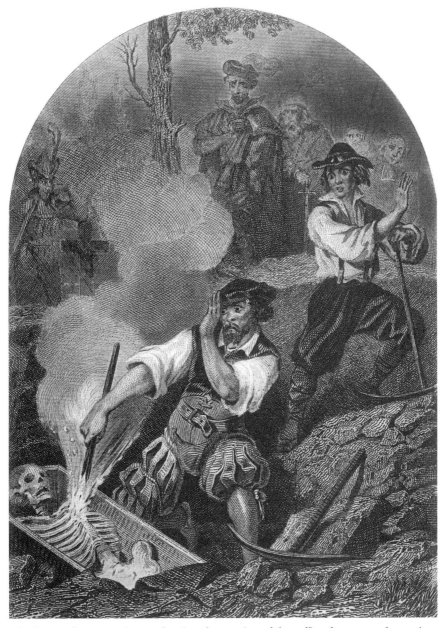

A nineteenth-century image showing the opening of the coffin of a supposed vampire in Bohemia. A red-hot stake is plunged into his evil heart.

relation of a Hungarian aristocrat named Elizabeth Báthory. A rich widow who effi-
ciently managed her late husband's vast estates, she was arrested at her castle in
Slovakia in 1610 by the Viceroy of Hungary. Allegedly she had become convinced
that she was invigorated by smearing her skin in other people's blood and had
enlisted her steward and a crazy old crone to help lure hundreds of girls to her cas-
tle, where they were pierced, forcibly bled and left to die so that she could wash
herself in blood. The charges against her were certainly exaggerated (there were no
bereaved clamouring for justice for the murders attributed to her), and they were
possibly a fabrication intended to dislodge her local economic hegemony. Though
Countess Báthory was emphatically not a blood-drinker, she became notorious as a
blood-fiend after the allegations of 1610. The word 'vampire' was coined in English
as late as 1732 after reports

> from *Medreyga* in *Hungary*, That certain dead Bodies called *Vampyres*, had kil-
> l'd several Persons by sucking out all their Blood. The Commander in Chief,
> and Magistrates of the Place were severally examin'd and unanimously
> declared, that about 5 Years ago, a certain Heyduke named *Arnold Paul*, in his
> Life Time was heard to say, he had been tormented by a *Vampyre*, and that
> for a Remedy he had eaten some of the Earth of the *Vampyre*'s Graves, and
> rubbed himself with their Blood. That 20 or 30 Days after the Death of the
> said *Arnold Paul*, several Persons complained they were tormented; and that
> he had taken the lives of 4 Persons. To put a Stop to such a Calamity, the
> Inhabitants . . . took up his Body, 40 Days after he had been dead, and found
> it fresh and free from Corruption; and that he bled at the Nose, Mouth and
> Ears, pure and florid Blood; that his Shroud and Winding Sheet were all over
> bloody; and that his Finger and Toe Nails were fallen off, and new ones
> grown in their room. By these Circumstances they were perswaded he was a
> *Vampyre*, and according to Customs, drove a Stake thro' his Heart; at which
> he gave a horrid Groan. They burnt his Body to Ashes, and threw them into
> his Grave.

The facts behind the Arnold Paul affair have been analysed by several recent
scholars but matter far less than the affair's influence on the British imagination. As
early as 1740, Alexander Pope, who was always alert to Augustan cultural trends,
was joking of a 'Vampire in Germany' that was 'such a terror to all sober & innocent

people, that many wish a stake were drove thro' him to keep him quiet in his Grave'. Britain's German-born King George II, who 'though not apt to believe more than his neighbours, had no doubt of the existence of vampires, and their banquets on the dead'. Dom Augustin Calmet, a Benedictine abbot and biblical scholar, published at Paris in 1746 a survey of folklore horrors entitled *Dissertations sur les Apparitions des Esprits, et sur les Vampires*. Its subsequent translation into English and German stimulated artistic imaginations. Heinrich August Ossenfelder's 'The Vampire' (1748) was the poetic forerunner of Gottfried August Burger's 'Lenore' (1773), in which the vampire is a revenant who returns from the dead to collect a living bride. The greatest literary working of this theme is Elizabeth Bowen's short story 'The Demon Lover', set in Kensington during the Second World War. Calmet's researches also stimulated vampiric allusions in the pictorial art of the late eighteenth century, most famously in Fuseli's *The Nightmare* (1781).

FUSELI'S GOBLIN

As a schoolboy in Zurich, Henry Fuseli (1741–1825) was passionate and extravagant in outlook; Shakespeare, Milton, Richardson, Dante and Rousseau fired his ardour. Coerced by his father into ordination as a Zwinglian minister, he left church work for a life of travel and aesthetics. He visited Italy as travelling tutor to Viscount Chewton (1766), settled in England and made his first mark with a treatise on Rousseau. He afterwards turned to pictorialism, and became professor of painting at the Royal Academy in 1799. In that year he opened a gallery of forty large paintings inspired by Milton's poems, but was disappointed in his hope of achieving artistic immortality by these works. He made many lewd drawings which were destroyed after his death, and was enough of a sinner to be nicknamed 'Principal Hobgoblin Painter to the Devil' by his contemporaries. Though he was a versatile historical painter – his first work was *The Death of Cardinal Beaufort* (1774) – he is best remembered for his hobgoblin picture *The Nightmare*, which he is said to have conceived after eating raw pork chops for dinner so as to provoke a bad dream. First exhibited in 1782, it was engraved as a print and circulated widely: Goethe was intrigued by a copy he saw at Leipzig Fair as early as 1783.

Fuseli depicted a young woman, dressed in white, sprawled in a limp, sexually receptive position on a bed. A malign, brown, staring incubus squats on her body, while in the background the head of a goggle-eyed horse glares through dark-red

curtains. Nearby stands a table of cosmetics, but there is no image reflected in the looking-glass although it is angled to catch the incubus perched on the woman's stomach. It is uncertain whether the woman is alive or dead. Fuseli's image was recognised by contemporaries as very different from any painting previously shown at the Royal Academy. It was intentionally a sublime painting illustrating the suffocating terror experienced in a nightmare. Fuseli disavowed any crude supernatural interest but sought to stretch the human imagination with an image in which pain and terror were transcended by a higher rapture. Fuseli was explicit in his gothic allegiance. 'We are more impressed by Gothic than by Greek mythology, because the bands are not yet rent which tie us to its magic: he has a powerful hold of us, who holds us by our superstition.' Peter Tomory has noted 'that Fuseli's arrangement of the horse's head, the goblin and the afflicted woman is identical to that of Rosa's "The Apparition of Samuel before Saul" in which the Witch of Endor seems to be almost sitting on the back of Samuel on all fours', but in *The Nightmare* Fuseli was trying to make an advance upon the original Neapolitan model of gothic fears. 'Terrific and grand in his conceptions of inanimate nature,' he wrote in deprecation of Salvator Rosa's witchcraft paintings, 'his magic visions [were] less founded on principles of terror than on mythological trash and caprice.' As C. Nicholas Powell has painstakingly traced, Fuseli in imagining his nightmare 'fused ancient stories – old wives' tales and folk legends – and odd lines of poetry about the devil, witches, incubi and succubi, magic steeds, love and desire and hate into one unforgettable image'. Though the squat gremlin of the nightmare is not a vampire, Fuseli was explicit in his connection between vampirism and the envy of property. 'Envy, the bantling of desperate self-love, grasps the appendages, heedless of things. Emulation embalms the dead; Envy the vampire blasts the living.'

Fuseli's goblin is the first version of innumerable monstrosities, misfits, evil spirits and haunting doppelgängers that have filled the gothic imagination: Frankenstein's monster (Mary Shelley's debt is explicit), Stevenson's Edward Hyde and vampires among literary creations; and more amiably, the innocent, blundering Herman Munster, so unattractively put together from cannibalised parts, who was the hero of one of the first and most likeable US gothic television serials of the 1960s. The image of Fuseli's goblin changed the way we think about going to sleep, and is so suggestive that Freud hung a print of *The Nightmare* in his Vienna apartment. The universality of Fuseli's image is confirmed by how widely it was travestied. As

early as 1784 (in what was probably the first English political caricature based on an existing painting), Thomas Rowlandson drew the libertine politician Charles James Fox dreaming of defeat in the Westminster election in his satirical *The Covent Garden Nightmare*. Other caricatures adapted Fuseli's picture to deride celebrities such as Napoleon and Pitt. *The Nightmare, or the Source of the Nile* (1798), for example, depicted Admiral Nelson perched on his mistress Lady Hamilton and peering lasciviously under her nightdress; the libidinous streak in Fuseli's imagination was as plain to his contemporaries as the sexual significance of the incubus. 'All his feelings & subjects were violent & horrid & disgusting,' his fellow artist Benjamin Robert Haydon noted:

> The Engines in Fuzeli's Mind are Blasphemy, lechery. His women are all whores, and men all banditti. They are whores not from love of pleasure but from . . . malignant spite against virtue, and his men are not villains from a daring desire . . . but a licentious turbulence . . . Fuzeli was engendered by some hellish monster, on the dead body of a speckled hag, some hideous form, whose passions were excited and whose lechery was fired at commingling with fiery rapture in the pulpy squashiness of a decaying corpse.

The erotic symbolism of Fuseli's incubus was stressed by his friend Erasmus Darwin in the 1780s:

> So on his NIGHTMARE through the evening fog
> Flits the squab fiend o'er fen, and lake, and bog;
> Seeks some love-wilder'd Maid with sleep oppress'd,
> Alights, and grinning sits upon her breast.
> – Such as of late amid the murky sky
> Was mark'd by FUSELI's poetic eye;
>
> . . .
>
> Back o'er her pillow sinks her blushing head,
> Her snow-white limbs hang helpless from the bed;
> While with quick sighs, and suffocative breath,
> Her interrupted heart-pulse swims in death.
> – Then shrieks of captur'd towns and widows' tears,

> Pale lovers stretch'd upon their blood-stain'd biers,
> The headlong precipice that thwarts her flight,
> The trackless desert, the cold starless night,
> And stern-ey'd Murderer with his knife behind,
> In dread succession agonize her mind.
> O'er her fair limbs convulsive tremors fleet;
> Start in her hands, and struggle in her feet;
> In vain to scream with quivering lip she tries,
> And strains in palsy'd lids her tremulous eyes;
> In vain she *wills* to run, fly, swim, walk, creep;
> The WILL presides not in the bower of SLEEP.
> – On her fair bosom sits the Demon-Ape,
> Erect, and balances his bloated shape.

The word 'erect' in this final line was not laid there with the arch self-awareness and phallic-consciousness of a twentieth-century poet, but has the same connotations.

POLITICAL BLOODSUCKERS

The crucial roles of life-blood and parasitism in vampiric myth meant that its imagery was appropriated as a metaphor for economic and political ills. *The Craftsman* (20 May 1732) identified the stories circulating about the putative Hungarian vampire Arnold Paul as 'satirical Invective' against oppression:

> This Account, you'll observe, comes from the Eastern Part of the World, always remarkable for the *Allegorical Style*. The States of *Hungary* are in Subjection to the *Turks* and *Germans*, and govern'd by a pretty hard Hand; which obliges them to couch all their Complaints under *Figures* . . . These *Vampyres* are said to torment and kill the *Living* by *sucking out all their blood*; and a *ravenous Minister*, in this part of the World, is compared to a *Leech* or *Bloodsucker*, and carries his Oppressions beyond the Grave, by anticipating the *publick Revenues*, and entailing a perpetuity of *Taxes*, which must gradually drain the Body Politick of its Blood and Spirits. In like manner, Persons who groan under the burthens of such a *Minister*, by selling or mortgaging their estates, torment their *unhappy Posterity*, and become *Vampyres* when dead. *Paul Arnold*, who is call'd a *Heyduke*, was only a *ministerial Tool*, because

it is said he had kill'd but 4 Persons; whereas, if he had been a *Vampyre* of any Rank, we shou'd probably have heard of his *Ten Thousands*.

The Craftsman listed several English historical vampyres including Piers Gaveston and the Duke of Buckingham, catamites of kings Edward II and James I, and warned that 'Private Persons may be *Vampyres*, or *Blood-Suckers*, i.e. *Sharpers, Usurers, and Stockjobbers*'. In addition to the directors of the bankrupt South Sea Company, *The Craftsman* indicated Colonel Francis Charteris, cardsharper, money-lender, convicted rapist and peculator of public funds, who had recently died, as a vampiric figure: on his deathbed he had offered £30,000 to anyone who could prove to him that there was no hell. At his funeral a mob had tried to tear his body from its coffin and had thrown dead dogs and offal into his grave. Similar political para-ble-making is evident in Oliver Goldsmith's *The Citizen of the World* (1762): 'a cor-rupt magistrate may be considered as a human hyena, he begins perhaps by a private snap, he goes on to a morsel among friends, he proceeds to a meal in public, from a meal he advances to a surfeit, and at last sucks blood like a vampyre.' Voltaire used vampiric or bloodsucking metaphors on several occasions. Shelley's sonnet 'England in 1819' similarly indicts

> Rulers who neither see, nor feel, nor know,
> But leech-like to their fainting country cling,
> Till they drop, blind in blood, without a blow.

William Elliott, who as an English official at Dublin Castle in the 1790s was nick-named the 'Castle Spectre', found on returning to Ireland as Chief Secretary in 1806 that his new soubriquet was 'Le Revenant', which shows that the word 'revenant', as well as the idea of vampires, was reaching wider currency.

Vampires in English culture, then, were originally tied to self-murder and unchris-tian conduct, secondarily used by satirists to represent financial exploitation and abuse of power, and only after Fuseli's *The Nightmare* identified with an illicit, luxuri-ous, cruel sexuality dissevered from conventional reproduction. Calmet's mid-eighteenth-century treatise on vampires, as we have seen, inspired several German poems with vampiric themes culminating in Goethe's 'The Bride of Corinth' (1797). In England the use of female vampires to denote anxiety about sexual power also dates from the 1790s. In that decade Coleridge began work on *Christabel*, which was

finally published in 1816; three years later Keats wrote *Lamia*. In cases where suicide was not involved, vampiric possession was supposedly caused by a vampire attacking and infecting victims. As Byron's *The Giaour* (1813) describes, the initial targets of a vampire were those it had loved before it was undead:

> But first, on earth as Vampire sent,
> Thy corse shall from its tomb be rent:
> Then ghastly haunt thy native place,
> And suck the blood of all thy race;
> There from thy daughter, sister, wife,
> At midnight drain the stream of life;
> Yet loathe the banquet which perforce
> Must feed thy livid living corse.
> Thy victims ere they yet expire
> Shall know the demon for their sire.

Such attacks required the collaboration if not the consent of the victim, particularly because a vampire cannot cross a threshold without invitation from its prey. As the literary imagination of vampirism developed, vampiric attack was conceived as something welcome yet fearful, like any rite of initiation; it had to be both animalistic and voluptuous. In Sheridan Le Fanu's 'Carmilla', Laura's description of being attacked in her bed is orgasmic:

> Certain vague and strange sensations visited me in my sleep. The prevailing one was of that pleasant, peculiar cold thrill which we feel in bathing, when we move against the current of a river . . . Sometimes there came a sensation as if a hand was drawn softly along my cheek and neck. Sometimes it was as if warm lips kissed me, and longer and more lovingly as they reached my throat, but there the caress fixed itself. My heart beat faster, my breathing rose and fell rapidly and full drawn; a sobbing, that rose into a sense of strangulation, supervened, and turned into a dreadful convulsion, in which my senses left me and I became unconscious.

LORD BYRON

Though woman vampires might 'vamp', exerting their powers of seduction, masculine vampires based their dominion on the ownership of property. For long periods the abusive power of property-owners has been as crucial to vampiric literature as libidinous abuse. It is significant that the model for the first male vampire in English prose was the poet Byron. He was the sixth holder of a peerage created as a reward for his family's sacrifices in the English civil war. Though he bruited his many vices, there was one virtue which he exempted from his general contempt of domestic virtues, the supreme aristocratic virtue of fortitude. Enough of an autocrat to drop £500 in the christening cup of a dead man's child, his extravagance was tempered by an aristocratic sense of proprietorship: 'I will never consent to pay away what I *earn* – that is *mine*,' he insisted. Like any other rich young man, he was eager for the money that gave him liberty, even if the details bored him. 'I am a mere child in business – & can neither count nor *account* – . . . yet I love Monies – & am like to have more always.' He placed no romantic notions of creativity or intellect above his respect for property and ownership. 'They say "Knowledge is Power" – I used to think so, but they meant "Money" – who said so – & when Socrates declared "that all he knew was that he knew nothing" – he merely intended to declare that he had not a Drachma in the Athenian world.'

In these attitudes, at least, Byron typified his class. In other ways, of course, he chose to be exceptional. His histrionics as a cynical, defiant libertine were as calculated as the posturing of Oscar Wilde or Norman Mailer to win a wider readership. 'Shakespeare and Otway had a million advantages over me – besides the incalculable one of having been *dead* for one to two centuries – and having been both born blackguards (which *are* such attractions to the Gentle living reader).' Byron tried to be a gothic desperado of the type invented by Ann Radcliffe, energetic, destructive and excessive: 'The great object in life is Sensation – to feel that we exist – even though in pain – it is this "craving void" which drives us to Gaming – to Battle – to Travel – to intemperate but keenly felt pursuits of every description whose principle attraction is the agitation.'

Byron's importance in vampire iconography derives more from his position as a lord than from his achievements as a poet. It was his superior status that riled John William Polidori (1795–1821), who wrote the story in which Byron figures as a

vampire called Lord Ruthven. This Italian-Scot was the youngest man to qualify in medicine at Edinburgh University but always hankered for literary glory. 'From his earliest childhood,' recalled his father, 'he used to get out of bed early in the day and walk impatiently around the room . . . awaiting with great anxiety the coming of daylight, and holding Dante's *Inferno* in his hands . . . he would not let the book go before reading it from cover to cover.' Polidori, who was tall, dark, turbulent, impulsive and clumsy, was recruited as Byron's travelling physician when the poet was forced abroad by scandalous gossip in 1816. As a travelling companion he proved jealous, competitive and cantankerous. Byron's intimate friend John Cam Hobhouse, afterwards Lord Broughton, described Polidori at this time as having 'a most unmeasured ambition, as well as inordinate vanity: the true ingredients of misery'. Sitting with his employer at a window overlooking the Rhine, the envious young doctor suddenly demanded, 'What is there, except writing poetry, that I cannot do better than you?' Byron's reply was cool and immediate. 'First, said he, I can hit with a pistol the keyhole of that door – Secondly, I can swim across that river to yonder point – and thirdly, I can give you a damned good thrashing.'

Settling at the Villa Diodati on the shores of Lake Geneva, Byron was joined by Shelley, Shelley's wife, Mary, and the latter's stepsister Claire Clairmont. They made a lively party, whose jokes mocked the proprieties which Polidori (as a young medical man whose future depended on maintaining his good reputation) could not afford to repudiate. 'Poor Shelley!' Byron wrote after the death of this baronet's son. 'How we used to laugh now & then – at various things – which are grave in the Suburbs.' On one occasion Polidori was so smarting with imaginary or exaggerated slights that he challenged Shelley to a duel – an incident which only underlined the tenuousness of his social position and the fragility of his pretensions. His dismissal became inevitable. 'There was no immediate cause, but a continued series of slight quarrels,' Polidori later explained. 'I believe the fault, if any, has been on my part, I am not accustomed to have a master, & therefore my conduct was not free & easy.' Mortified at losing Byron's patronage, he never recovered from the disappointment of this moment and for a time anxiously tried to maintain the connection. In 1817 he solicited Byron's opinion of his new play, *The Duke of Athens*, while fearing that Byron 'will be more inclined to laugh than anything else'. Polidori's apprehension was shrewd, for Byron's 'Epistle from Mr Murray to Dr Polidori', occasioned by another play, *Count Orlando*, shows that he thought these literary pretensions laugh-

able. Ultimately Byron despised Polidori as an emotionally extravagant and rather silly snob.

Polidori is now remembered only because it was during the three and a half months that he lived with Byron and the Shelleys near Geneva in 1816 that the famous horror-story contest was conceived. A story of incest by Polidori, Mary Shelley's *Frankenstein* and an ephemeral fragment from Byron were the only lasting results of the contest: the efforts by Shelley and Claire Clairmont were either abortive or quickly lost. Shortly afterwards, during a few lonely, bitter mornings after his dismissal from the Villa Diodati, Polidori wrote a further short story reworking the core idea in Byron's fragment as an explicitly vampiric tale. He did not strain for its publication, but in April 1819 a rascally publisher named Henry Colburn printed it as 'The Vampyre, A Tale by Lord Byron' in his *New Monthly Magazine*. The attribution to Byron was an unscrupulous ploy to promote sales by Colburn, who had obtained Polidori's manuscript by obscure means. The true author immediately protested at the misattribution and was paid £30 by Colburn, who then republished the story as purportedly 'a tale related by Lord Byron to Doctor Polidori'. The latter was much blamed for this fraud. 'A cursed trashy tale called . . . the Vampyre was lately advertised in your name – with a notice that you had written it in concert with the Shelley's who produced Frankenstein,' Hobhouse reported to Byron. 'I wrote to Polly thereupon – he said he *pretended to the rank and name of a gentleman*, poor devil, and never intended such treachery.' Polidori next threatened legal action against Colburn and repeatedly denied the attribution to his former employer – 'Lord Byron is *not* the author' – with a sarcastic emphasis which reinforced his touchiness about class: 'I was the "*Gentleman*" who travelled with his Lordship and who wrote the whole of that trifle.' Despite these denials, Colburn's ploy worked, for 'The Vampyre' went through five editions in 1819 alone. It owed its English popularity to its sensational caricature of Byron; and on the continent its attribution to Byron was never effectively contradicted. E.T.A. Hoffmann's ghoul story 'Aurelia' (1820) begins with a character deploring Byron's morbid interest in gloomy mysteries, typified by his terrible 'Vampyre'. Goethe insisted 'The Vampyre' was Byron's best work. Cyprien Berard's *Lord Ruthwen ou les Vampires* (1820) recounted the erotic adventures of '*ce Don Juan vampirique*' and was dedicated to Byron.

Byron's original fragment was published in 1819 by John Murray in an attempt to correct such misattributions. Its male narrator encounters an older 'man of

considerable fortune and ancient family', Augustus Darvell, in whose life 'there were many and irreconcilable contradictions'. Though Darvell initially shuns the narrator's advances, the two men eventually achieve something 'which is called intimacy'. They travel together in the Orient, where Darvell begins 'wasting away'. He insists on stopping at a Mahomeddan burial-ground, which he has evidently visited before. After mysterious injunctions to his younger companion, he dies at a moment of which he has foreknowledge and his corpse immediately blackens. The fragment ends here; but in the plot discussed by Byron, the Shelleys and Polidori, the surviving traveller was to return to London, where he would find the undead Darvell making love to his sister. The fact that Darvell rots immediately on his death makes it unlikely that he was intended to be a vampire, and one can only surmise Byron's meanings. Physical immortality, which provides the crux of his story, was not a welcome thought to him. Though he believed in the immortality of the soul, because he was impressed by the vigour and independence of human intelligence, 'a *material* resurrection seems strange and even absurd except for purposes of punishment – and all punishment which is to *revenge* rather than *correct* – must be *morally wrong*'. An easy and final death seemed desirable to him. 'If I had to live over again – I do not know what I would change in my life – unless it were . . . *not to have lived at all* . . . what is most to be desired is an easy passage out of it.' Byron's inconclusive Darvell fragment is a negligible part of his output; it has little significance except as a prelude to Polidori's story.

POLIDORI'S VAMPIRE

Polidori's 'Vampyre' was the first tale in which English people were attacked by vampires and introduced the first English prose vampire who was male. Its success confirmed Byron as a cultural celebrity among myriads of people who never read his poetry. Polidori called his vampire Lord Ruthven because Clarence de Ruthven, Lord Glenarvon, was the name given to the Byronic character by Byron's vengeful paramour Lady Caroline Lamb in her sensational novel *Glenarvon* (1816), also published by Colburn. But Polidori as an outsider missed the point even in this mischief. Lamb's choice of the name de Ruthven was a spiteful, even threatening jibe at an episode in her ex-lover's adolescence. Lord Grey de Ruthyn (or Ruthin) had been a country neighbour from whom Byron received homosexual initiation in 1803–4, at the age of fifteen; he afterwards recalled Grey de Ruthyn (eight years his senior)

with dislike. Polidori surely never knew the association for Byron of Ruthyn in its different spellings, though Lamb evidently did.

The vampiric Lord Ruthven is Polidori's grudging caricature of Byron as a morose, financially embarrassed lord whose 'irresistible powers of seduction rendered his licentious habits more dangerous to society'. The singularity of Ruthven – 'a man entirely absorbed in himself' who 'apparently had nothing in common with other men' – draws the admiration of a rich, innocent young man named Aubrey, who fantasises about him as 'the hero of a romance' and contrives to join him on a Continental tour. This Aubrey, in his anxiety to impress the older lord, resembles Polidori going abroad with Byron. Ruthven's quirks soon disturb the neophyte: profuse in his generosity to vicious idlers and vagabonds, Ruthven sneers at the virtuous and unfortunate. The two men separate in Rome when appalling stories of Ruthven's earlier debaucheries in London reach Aubrey. This was Polidori's allusion to the reports of Byron's incest with his half-sister and sodomising of his wife which had forced him into exile in 1816. Before leaving Rome, Aubrey warns Ruthven's lover there that she is imperilled; the woman breaks off her liasion, but soon vanishes mysteriously.

Aubrey proceeds alone to Greece, where he is rescued from a vampiric attack in which a Greek woman whom he loves perishes. After a reconciliation with Ruthven, the latter is mortally wounded by Salvatorian bandits against a Salvatorian landscape.

> 'Swear,' cried the dying man, raising himself with exultant violence, 'Swear by all your soul reveres, by all your nature fears, swear that for a year and a day you will not impart your knowledge of my crimes or death to any living being in any way, whatever may happen, or whatever you may see.' His eyes seemed bursting from their sockets. 'I swear!' said Aubrey; he sunk laughing upon his pillow, and breathed no more.

Ruthven's corpse is dragged by robbers to a nearby mountain where it vanishes after exposure 'to the first cold ray of the moon'. On returning to London, Aubrey encounters Ruthven going about in society, still very much alive, and oppressively enjoining his protégé to keep his oath. This encounter with the undead destroys Aubrey's nerves, and he is restrained as a lunatic. To his horror, Ruthven becomes engaged to his young sister (indeed seduces her); in his struggles to prevent the

marriage, Aubrey bursts a blood vessel and begins to ail. Polidori ends the story abruptly with a melodramatic climax. The year and a day named in Aubrey's oath at Ruthven's deathbed finally elapse. 'He desired his sister's guardians might be called, and when the midnight hour had struck, he related composedly what the reader has perused – he died immediately after. The guardians hastened to protect Miss Aubrey; but when they arrived, it was too late. Lord Ruthven had disappeared, and Aubrey's sister had glutted the thirst of a VAMPYRE!'

After his *congé* from Byron, Polidori's life became as frantic as the closure of his story. He aspired to be a society physician, but all his patients died. 'Being a Catholic, or passing for such, ensured him a welcome in some of the most aristocratic of the county houses,' wrote his Norfolk acquaintance Harriet Martineau. 'He was a foolish rattle, with no sense, scarcely any knowledge, and no principle; but we . . . listened to his marvellous stories.' He thought of making a fortune in Brazil, then abandoned medicine for law. Like Byron he saw life as a piece of personal theatre, and soon felt 'disgust at the scenes of meanness, perfidy and disappointed hope, which have formed the drama of our life'. Polidori produced an ambitious novel, *Ernestus Berchtold; or, The Modern Oedipus*, which sold only 199 copies, and an ambitious poem, 'The Fall of the Angels', which attracted only one known review. In depression, he went on a gambling spree in August 1821 and made losses which he could not cover. This dilemma he resolved by taking poison. 'Poor Polidori,' said Byron when he heard the news. 'When he was my physician, he was always talking of Prussic acid, oil of amber, blowing into veins, suffocating by charcoal and compounding poisons.' For a long time Polidori's posthumous claim to celebrity rested on his sister's children Christina and Dante Gabriel Rossetti, but since the 1970s he has enjoyed a revival. His most interesting reinvention is in Howard Brenton's play *Bloody Poetry* (1984), where he figures first as a pathetic, ponderous buffoon who is despised by the other English inhabitants of the Villa Diodati, then as a spy in Italy insinuating vindictive gossip about his former associates, and finally as a club bore trading drinks for inaccurate, self-inflating reminiscences about the great writers he has known. In Ken Russell's overfrenzied film *Gothic* (1987) he was played as a fat, masochistic, queer religious maniac.

Polidori's story diverged from previous gothic novels by featuring no dispossessed heirs or usurped castles. It is sensitive to status without the strong emphasis found in later vampire novels on property and power. Nevertheless Ruthven, as a

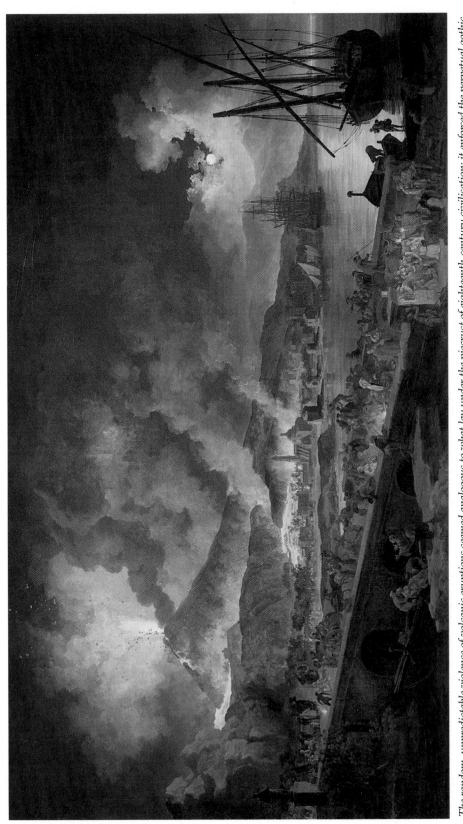

The random, unpredictable violence of volcanic eruptions seemed analogous to what lay under the piecrust of eighteenth-century civilisation: it enforced the perpetual gothic insistence that nothing is as safe as it seems. Here is Pierre-Jacques Volaire's version of Vesuvius painted in 1777.

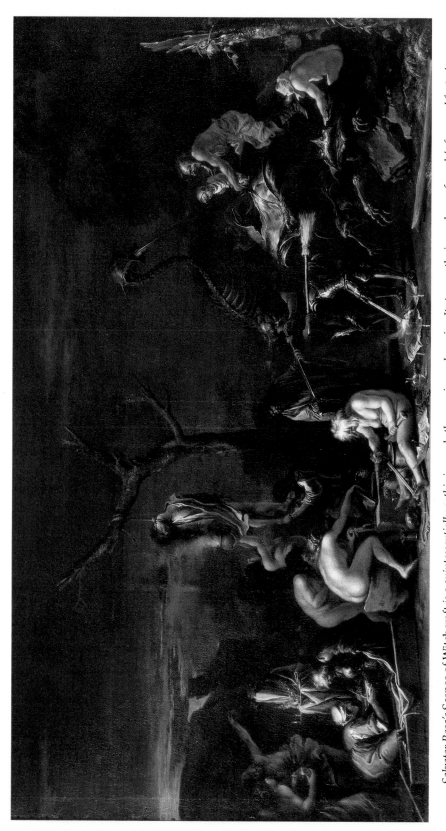

Salvator Rosa's Scenes of Witchcraft is a quintessentially gothic image, both excessive and evasive. It stresses the inwardness of people's fears and fantasies.

Conway Castle was shrouded in Plantagenet romance by Goth enthusiasts like Lord Lyttleton. Many pictures of it were made by artists catering to the English taste for Salvatorian views – this one is by Julius Caesar Ibbetson (1759-1817).

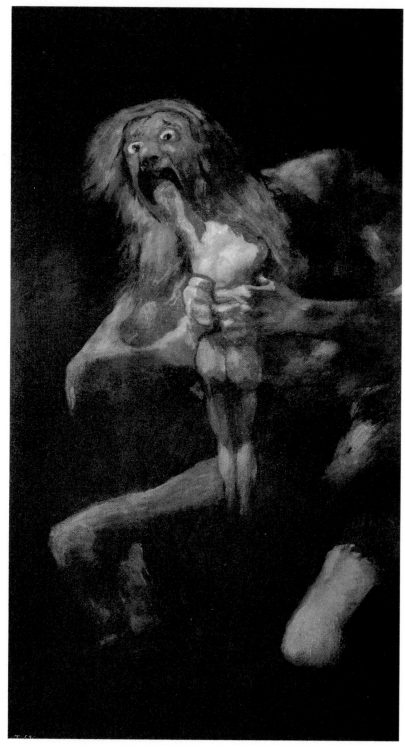

In Goya's Saturn Devouring One of his Children *the ogre is supremely inhuman: violence gives the only meaning to its existence. There can be no safety while the ogre lives. Goya allows no room for any sentimental liberal reading, one can only find hate in this picture.*

The Nightmare *by Fuseli is one of the most enduring images of the Gothic imagination. It harks back to Salvator Rosa and old folk legends, but seems also to illustrate the workings of what later became called the subconscious. This scene was emulated by poets, novelists and later film-makers.*

Goths are heavily referential. Fuseli's sensational The Nightmare *inspired many later Goth images. This wood engraving for an edition of Bram Stoker's* Dracula *is an example of the mass commercialisation in the twentieth century of old gothic fears and fantasies. Hollywood used the same idea in James Whale's pioneering Gothic film* Frankenstein.

An unattributed sixteenth-century German depiction of Vlad the Impaler. The vampirism associated with him came to represent many sorts of destructive excess or misbehaviour: political corruption, embezzlement, aristocratic parasitism, monopoly capitalism, foreign evasiveness, emotional blackmail, sexual corruption, sexual seduction and sexual infection.

The influences of Goya and Nietzsche are combined by the Chapman brothers in Great Deeds against the Dead *(1994). 'Profound optimism is always on the side of the tortured', as Gide commented in 1931.*

lord, stood as a metaphor of corrupt power for Polidori. 'The love of power is', he wrote in 1818, 'almost universal; the schoolmaster and the tyrant are but types of each other, and of all mankind.' Quoting Cicero ('What pleasures are to be compared with the gratification of authority?'), he attacked the studied viciousness of Byron – 'despised by the good, resorted to as one of themselves by the worthless, and cursed even by our flatterers'. Employing Byronic punctuation, he was equally denigratory of himself as a lord's attendant: 'when we shall have acted the part of the jackall, not to a noble lion but to a loathsome toad – to feel that its petty poison must be spit upon its friends . . . to have our skin lepered by its spittle – to bear the laughs and taunts of a set, whom, though we abhorred, we helped, and whom, though we despised, we flattered'. Polidori's envy and touchiness were peculiar to him, yet he entrenched a tradition that vampires were satanic nobility: Varney the vampire of the 1840s was a baronet; Dion Boucicault's *Vampire* (1852) is Lord Raby; Mérimée's Bey of Moina, Le Fanu's Countess Karnstein and Stoker's Count Dracula were all nobles; even the hero of W. S. Gilbert's comic opera *Ruddigore, or the Witch's Curse* (1887), which features at least one undead baronet, is Sir Ruthven Murgatroyd. American writers resorted to European aristocracy too: 'there are no towers in the land more time-honored than my gloomy, gray, hereditary halls', declares the narrator of Poe's story 'Berenice'. Bella Rolleston, living in 'a shabby street off the Walworth Road' until she is recruited as a lady's companion by 'Good Lady Ducayne' in Mary Elizabeth Braddon's story of 1896, is warned that among the aristocracy, 'considerable deference is expected', but is given no inkling that her employer is an elderly vampire.

Polidori's story had other influences. The young dramatist James Planché adapted a French version of it into the melodrama *The Vampire* (1820), set in Scotland simply because his theatrical company had a stock of kilts. As a theatrical producer and costume-designer, Planché was the first to introduce historical accuracy into stage costume; he afterwards became a herald at the College of Arms. His *Vampire* was notable for its innovation of the Vampire (or Vamp) Trap, which enabled the actor to disappear through the stage door or out of the wings as a disembodied phantom. Planché's greatest contribution was to identify vampirism with lunar powers. In his play, the vampire declares that he must marry before the full moon sets, or die; he does die at dawn, but is restored to life when the moon rises again. Polidori's Ruthven had been posthumously revived by the moon, but as a result of Planché's

further emphasis the renewal of vampires under the moon's rays became as important to mid-nineteenth-century vampire literature as blood-sucking or the piercing of a vampire's heart with a stake. Sir Francis Varney in *Varney the Vampire* (1845) and Lord Raby in Dion Boucicault's *Vampire* (1852) were both restored by the moon to their undead existence. In F. Marion Crawford's 'For the Blood Is the Life' (1911) the Calabrian undead are revived by lunar power: 'If there's any moonlight at all, from east or west or overhead, so long as it shines on the grave, you can see the outline of the body on top.'

VICTORIAN VAMPIRISM

Varney requires some mention, although it is unreadable in its entirety, sometimes thrilling, but often rambling, overblown and tedious. Usually attributed to James Malcolm Rymer (1814–81), it was written episodically, with such unevenness of style and so many contradictions of plot that some parts at least were probably churned out by a team of low-class hacks employed by *Varney*'s cheapskate publisher. Originally hawked in the streets in scrappily printed instalments, this lurid, fast-paced, foolish potboiler enjoyed great popularity among the ignorant, undiscriminating and credulous for trashily mixing gothic sensation with the criminality of Newgate fiction. The book begins with a series of vampiric attacks by Sir Francis Varney of Ratford Abbey on his beautiful neighbour Flora Bannerworth. Varney desires neither Flora's blood nor soul, but the fortune concealed in Bannerworth Hall by her father before his suicide. '"I must, I will," he said, "be master of Bannerworth Hall".' Property belongs to the living, not to the dead; old man Bannerworth taking his fortune to the grave is an outrage upon the propertied classes; Varney needs the fortune to turn Ratford Abbey into a power house of the county. '"Curses on the circumstances that so foiled me! I should have been most wealthy. I should have possessed the means of commanding the adulation of those who now hold me but cheaply."' He lusts for leadership and control: '"that greatness which I have ever panted for, that magician-like power over my kind, which the possession of ample means alone can give."' The plot hastens from one cheap horror to another, for many hundreds of pages, until Varney finally kills himself, like Empedocles in the story painted by Salvator Rosa, by hurling himself into a volcanic abyss.

These inanities are a reminder of how much more *déclassé* yet imaginatively potent vampires were than mummies. A mummy, like a vampire, is a revenant

No. 1.] Nos. 2, 3 and 4 are Presented, Gratis, with this No. [Price 1d.

VARNEY THE VAMPIRE. OR THE FEAST OF BLOOD

A ROMANCE OF EXCITING INTEREST.

BY THE AUTHOR OF
" GRACE RIVERS; OR, THE MERCHANT'S DAUGHTER."

LONDON : E. LLOYD, SALISBURY-SQUARE, AND ALL BOOKSELLERS.

'Poetic genius is dead, but the genius of suspicion has entered the world,' Stendhal complained at the end of his life. The paranoiac suspicions of the nineteenth century provided the only consistency in the plot of Varney the Vampire. Written in episodes by teams of exhausted writers, it was trashy gothic mass sensationalism.

coming back from the dead, often seeking the reincarnation of a former lover, but in the nineteenth century mummies only provided a genteel *frisson* when they made solemn appearances in noble reception rooms. 'On Monday afternoon the interesting process of unrolling a mummy was exhibited at the residence of Lord Londesborough, Piccadilly, in the presence of about 60 of his Lordship's private friends, including many of scientific, literary and antiquarian eminence,' reported *The Times* in 1860. By contrast, a bloodsucking Sumatran bat was mobbed when it was spotted by Thamesside loungers in London docks. 'A great deal of curiosity was excited yesterday among the loungers in St. Katherine's Dock by a report of the arrival of a real live vampire,' reported *The Times*:

> So many horrible associations of blood and terror are connected with the popular ideas of this extraordinary animal . . . and so many unsuccessful attempts have been made to import it alive, that when it was known that one had actually arrived, a most intense desire was manifested to obtain a peep of the 'bloodthirsty willin', as we heard him described by one of the great unwashed who was standing by.

Not all mid-nineteenth-century images of vampirism were as debased as *Varney* or as demotic as the mobbing at St Katherine's Dock. Poe's short story 'The Oval Portrait' provides a version of aesthetic vampirism in which a beautiful and vital woman marries a painter who is 'passionate, studious, austere, and having already a bride in his Art'. She pines in the turret where he paints a portrait of her, 'he *would* not see that the tints which he spread upon the canvas were drawn from the cheeks of her who sat beside him'. When the final tint has been dabbed, 'while he yet gazed, he grew tremulous and very pallid, and aghast, and crying with a loud voice, "This is indeed *Life* itself!" turned suddenly to regard his beloved:—*She was dead!*' For other writers, vampires continued to evoke seething sexuality and night-time pollution. In Lord de Tabley's poem 'Circe', a flower in a sleeping girl's bedroom, standing as erect as the demon-ape in Darwin's poem on Fuseli's *Nightmare*, is threateningly phallic:

> A giant tulip head and two pale leaves
> Grow in the midmost of her chamber there,
> A flaunting bloom, naked and undivine,

Rigid and bare,
Gaunt as a tawny bond-girl born to shame,

. . .

Unmeet for bed or bowers,
Virginal where pure-handed damsels sleep:
Let it not breathe a common air with them,
Lest when the night is deep,
And all things have their quiet in the moon,
Some birth of poison from its leaning stem
Waft in between their slumber-parted lips,
And they cry out or swoon,
Deeming some vampire sips,
Where riper love may come from nectar boon!

In such passages hinting at the secretion of vital life-juices, blood and semen seem interchangeable.

Eastern Europe became identified with blood perversions. John Paget's travel book *Hungary and Transylvania* (1839) resurrected the seventeenth-century calumny that Countess Báthory used fresh maiden's blood as an elixir for eternal youth. The countess was denigrated as exemplifying the lethal extremities of female vanity. 'Remorseless by nature, and now urged on by that worst of women's weaknesses, vanity,' according to Paget, 'three hundred maidens were sacrificed at the shrine of vanity and superstition.' In the 1830s he found her powers in suitably gothic decay – 'the castle . . . crumbles away with every shower and blast' – turning to dust like the corpse of an undead when a stake has been driven through it. Sabine Baring-Gould further popularised this story in his *Book of Werewolves* (1865). Countess Báthory's supposed elixir influenced Lord Lytton, who wrote a necrophiliac poem, 'The Vampire' (1886), about a man who reanimates a beautiful corpse with caresses:

For the misery worst of all miseries
Is Desire eternally feeding Despair
On the flesh, or the blood, that forever supplies
Life more than enough to keep fresh in repair
The death ever dying, which yet never dies.

Vampires were equally enlisted for political allegory. Russian vampire stories like Gogol's *Viy* (1835) were often couched as folk-tales masking semi-political connotations for the initiated. It is not surprising that in a materialist epoch like the Victorian age vampire stories had an emphasis on property. Indeed, Karl Marx (uninfluential though he was in his lifetime) was explicit in identifying the influential connection between capitalism and vampirism. 'Capital is dead labour which, vampire-like, lives only by sucking living labour, and lives the more, the more labour it sucks,' he famously wrote in *Das Kapital* (1867; first English translation 1887). He likened the capitalist to an unnamed Wallachian boyar (who can be traced through a footnote to be none other than Vlad the Impaler) and compared capitalism's victims with a vampire's prey: 'their limbs wearing away, their frames dwindling, their faces whitening, and their humanity sinking into a stone-like torpor, utterly horrible'.

SHERIDAN LE FANU'S VAMPIRE

The combination of political allegory and sexual nightmare reached a strange, wonderful culmination in the greatest mid-Victorian vampire tale, 'Carmilla' (1872). Its author, Joseph Thomas Sheridan Le Fanu (1814–73), who was unconscious of his own imaginative motives in writing a prose version of Coleridge's 'Christabel', produced a magnificent love story told through the analogy of vampirism (although its central character owes as much to Irish folklore traditions of the banshee as to Balkan myths of the vampire). Lately hailed as 'one of the few self-accepting homosexuals in Victorian or any literature', Carmilla became a heroine for twentieth-century feminists by invading a castle, suborning the authority of its male owner and providing a luring prototype of female intimacy. She transcends Olympia in E.T.A. Hoffmann's story 'The Sandman' or Hawthorne's 'Rappaccini's Daughter'.

Le Fanu's unconscious eroticism is balanced with deliberate political allegory. As an Irishman, he had a lifetime's experience of dead labour, dead land and moribund classes. During the 1830s, when his father was a Protestant clergyman in County Limerick, the family endured vicious attacks on their status and were assaulted by Roman Catholic peasantry resenting their role in the Protestant Ascendancy. As a young man, Sheridan Le Fanu sustained himself as a journalist in Dublin, where he cut a fashionable figure until 1858. In that year his wife, who had been exhibiting

The sensationalist crime magazine La Police Illustrée *of 6 May 1883 portrays Janssouint, the gravedigger of Vinezac, committing offences 'that our pen refuses to recount'. Janssouint was dubbed 'Le Vampire de Vinezac' for his violation of its corpses, thus acknowledging the eroticisation of vampirism.*

religious mania, died during a fit of hysterics, aged thirty-four. After this drama he became reclusive, nicknamed 'The Invisible Prince' because of his nocturnal habits. He had published some fictional stories anonymously when young; but as a widower, he began novel-writing, scribbling his stories in pencil on scraps of paper while lying in bed. For several years in the 1860s Le Fanu was proprietor and editor of the *Dublin University Magazine*, which represented the interests of middle-class Irish Protestantism, but by the publication of 'Carmilla' he was sunk in despondent political lethargy. He knew too well that the Irish Protestant caste of landowners, magistrates and clergy were damned. They could not hold on to their land: Le Fanu's cousin and friend, the Marquess of Dufferin and Ava, with whom he corresponded about Irish politics and its supreme question of land ownership, had debts of £299,000 by 1872, despaired of maintaining proprietary rights in Ireland and sold almost all his estates in the 1870s. Ireland's defeated gentry were imbued with a death-wish in Le Fanu's novels. His three heroes – Silas Ruthyn in *Uncle Silas*, Mark Shadwell in *A Lost Name*, and Francis Ware in *Willing to Die* – are debt-ridden, self-doubting and despondent: each dies by acts of suicide which do not seem despicable or cowardly.

The supernatural plot of 'Carmilla' is a social and political parable as well as a story with religious and sexual undertones. It is set in a remote corner of the Austro-Hungarian empire which is nineteenth-century Ireland encoded (Le Fanu had been advised that novels with Irish *loci* did not sell, and similarly transposed the essentially Irish story of *Uncle Silas* to northern England). The narrator, Laura, begins by stressing her Englishness. 'My father is English, and I bear an English name, though I never saw England', she declares in the first paragraph. Her father is a retired officer, living on eight or nine hundred a year, maintaining a small castle 'in this lonely and primitive place, where everything is so marvellously cheap'. He reads Shakespeare aloud to his daughter, 'by way of keeping up our English', and they take tea in the English manner. Their isolated cultural self-consciousness resembles that of besieged Anglo-Irish gentry living in the hermetic world of the great house. The analogy, however, is more extensive even than this. Laura and her father live near 'a ruined village' previously dominated by 'the proud family of Karnstein, now extinct, who once owned the equally desolate chateau which, in the thick of the forest, overlooks the silent ruins of the town'. This abandoned village suggests the grim depopulation of the Irish countryside after the great famine of 1845–49; but the extinction of the

Karnsteins, which is reiterated in the story, had a special Irish significance. Since the Act of Union of 1800, which absorbed Ireland into the newly created United Kingdom, the Irish peerage was both declining in numbers and only able to regenerate by a sort of legalistic vampirism. Under the 1800 legislation, no new Irish peerages could be created without the extinction of three old ones. The barony of Rathdonnell, bestowed in 1868 on John McClintock, was the twentieth and last Irish peerage created under this provision of the act (the three extinctions used for the purpose being the earldom of Clare, the viscountcy of Palmerston and the barony of Keith). Over sixty Irish peerages had become extinct in almost as many years, and this heavy mortality continued; in years like 1875, when the earldoms of Charleville and Aldborough were extinguished, or 1891, when the earldoms of Bantry and Milltown disappeared, the mortality was doubly grievous. The litany of extinctions has been continuously romantic, euphonious and melancholic: in the twentieth century, Howth, Sheffield, Carysfort, Mountcashell, Dartrey, Desart, Clonmell, Kenmare, Leitrim, Sefton, Wicklow, Bandon, Fitzwilliam and Fingall among earldoms alone.

In Le Fanu's story, a black stage-coach crashes near Laura's castle, injuring its passenger, a young woman called Carmilla, who moves into the castle for recuperation. Carmilla's first words to Laura are, 'Twelve years ago, I saw your face in a dream, and it has haunted me ever since.' Laura's experience of the same dream was that of a petrifying nightmare, but their intimacy proceeds apace ('"I have been in love with no one, and never shall", she whispered, "unless it should be with you"'). As Laura records,

> She used to place her pretty arms around my neck, draw me to her, and laying her cheek to mine, murmur with her lips near my ear, 'Dearest, your little heart is wounded; think me not cruel because I obey the irresistible law of my strength and weakness; if your dear heart is wounded, my wild heart bleeds with yours. In the rapture of my enormous humiliation I live in your warm life, and you shall die – sweetly die – into mine. I cannot help it; as I draw near to you, you, in your turn, will draw near to others, and learn the rapture of that cruelty, which yet is love . . .'

And when she had spoken such a rhapsody, she would press me more closely in her trembling embrace, and her lips in soft kisses gently glow upon

my cheek . . . In these mysterious moods I did not like her. I experienced a strange tumultuous excitement that was pleasurable, ever and anon, mingled with a vague sense of fear and disgust. I had no distinct thoughts about her while such scenes lasted, but I was conscious of a love growing into adoration, and also of abhorrence . . . in all lives there are certain emotional scenes, those in which our passions have been most wildly and terribly roused, that are of all others the most vaguely and dimly remembered.

Like Laura's dead mother, Carmilla is descended from the extinct family of Karnstein. (She is, in fact, the undead seventeenth-century Countess Mircalla Karnstein.) Like the Irish peerage, she needs extinctions to revive. Three young women (a gentlewoman Bertha Rheinfeldt, then a swineherd's young wife, and finally a peasant girl whose funeral hymns make Carmilla hysterical) have wasted away and died in the vicinity – a trio equivalent to the three Irish peerages required to expire before a new one can come alive. Carmilla obtains control over Laura by going to her bedroom at night in the guise of an enormous black cat, then biting her on the breast. Henceforth, Laura has delicious, feverish erotic dreams – some of them rapturously orgasmic in Le Fanu's description – and the young women's relationship intensifies as Laura's grip on life begins to ebb. 'Carmilla became more devoted to me than ever, and her strange paroxysms of languid adoration more frequent. She used to gloat on me with increasing ardour the more my strengths and spirits waned. This always shocked me like a momentary glare of insanity.' Eventually Mircalla's grave is opened in the chapel of the Karnsteins. She is found in perfect preservation in her coffin, half-immersed in fresh red blood. 'A sharp stake [was] driven through the heart of the vampire, who uttered a piercing shriek' and was then decapitated.

BRAM STOKER'S VAMPIRE

If 'Carmilla' is the finest story of a female vampire in the English language, *Dracula* is its male equivalent. *Dracula*'s author Abraham ('Bram') Stoker, who was born in Dublin in 1847, was always attracted by the theatricality which so often accompanies gothic. Destined to follow his father into the civil service, he became stagestruck at the age of nineteen after seeing Sir Henry Irving as Captain Absolute in *The Rivals*. For five years he worked both as a civil servant and as unpaid drama

critic on the *Dublin Mail*. In 1878 he was recruited by Irving as manager of his Lyceum Theatre in London, and for twenty years managed Irving's business affairs and foreign tours. In this capacity he was efficient, strenuous, unobtrusive and compliant; Irving exploited his devotion, and he endured humiliation by Irving's other toadies. Stoker accompanied Irving's company on its first visit to the USA in 1883, and on numerous return tours until 1904. The United States became a recreational interest of Stoker's, and provides a climatic resolution to *Dracula* which has seldom been noted. After the decline of Irving's career in the late 1890s Stoker wrote prolifically for money until his death of Bright's disease and syphilis in 1912, but *Dracula* is his sole masterpiece. He attributed his idea to a nightmare provoked by a dinner of dressed crab (comparable to Fuseli's raw pork chops), but it is an intensely personal book. Some readers, including Stoker's great-nephew and biographer Dan Farson, have derided close, analytical textual readings of *Dracula*, and insist that it

Staircases from The Castle of Otranto *and Piranesi's* Carceri *have provided some of the most enduring images for the gothic imagination. In Tod Browning's Hollywood film* Dracula *(1930) Bela Lugosi plays the vampire descending the stairs of his Transylvanian castle holding fast to his helpless victim.*

should be read as a superficial, exciting tale of terror. This is to mistake the seriousness of Stoker's efforts. He spent six years in plotting and writing: his surviving notes show that he was meticulous in his preparations. The resultant novel (issued in May 1897) is heavily nuanced and allusive, with great personal passion and meaning. That is why it transcends every other vampire tale.

Eroticism is persistent and exciting in Stoker's story. His text overflows with unconscious potentialities; his version of sexuality (expressed through almost fetishistic acts of vampirism) is passionate, committed, private and ritualistic; for vampires, genitals, guilt, love and explanation are dispensable. In some respects the sexual implications of his plot are not as pleasurable as those of 'Carmilla': at times, Stoker seems to invoke anxieties about sexually transmitted diseases or paranoia about bodily invasion and sexual attack. It is significant that his accounts of sexually charged acts of vampirism performed abroad – at Dracula's Carpathian castle – are experienced as delicious and exciting by those involved in them, but the equivalent acts in England are more tense, violent, dutiful and confused. This discrepancy in *Dracula* reflects the difference between the Victorian Englishman abroad, having a holiday fling that is brief, rapturous and irresponsible, and the Englishman returned home to the repressed, fraught, pleasureless yet complicated routine of bourgeois domesticity. The vampiric foreplay enjoyed in the Balkans by the young English solicitor Jonathan Harker is tantamount to the joys of a naughty spree: sybaritic group sex, in a Parisian brothel with bedroom mirrors and toys, cannot have been much different in Victorian male fantasy. This is Harker's description of the scene in which he plays a subordinate part to three dominatrices:

'He is young and strong; there are kisses for us all.' I lay quiet, looking out under my eyelashes in an agony of delightful anticipation . . .

I was afraid to raise my eyelids, but looked out and saw perfectly under the lashes. The fair girl went on her knees and bent over me, fairly gloating. There was a deliberate voluptuousness which was both thrilling and repulsive, and as she arched her neck she actually licked her lips like an animal, till I could see in the moonlight the moisture shining on the scarlet lips and on the red tongue as it lapped the white sharp teeth. Lower and lower went her head as the lips went below the range of my mouth and chin and seemed about to fasten on my throat. Then she paused, and I could hear the churning

sound of her tongue as it licked her teeth and lips, and could feel the hot breath on my neck. Then the skin of my throat began to tingle as one's flesh does when the hand that is to tickle it approaches nearer – nearer. I could feel the soft shivering touch of the lips on the supersensitive skin of my throat, and the hard dents of two sharp teeth, just touching and waiting there. I closed my eyes in a languourous ecstasy and waited – waited with beating heart.

When the Count breaks in on the vampires seducing Harker and furiously dismisses them, their intended victim, Harker, feels bereft at the non-consummation.

In England comparable acts are less pleasurable, more anxious and crudely violent, virtually pathologised under the direction of dubious medical experts. Dracula, after landing in Yorkshire, attacks Lucy Westenra, the best friend of Harker's fiancée. When she begins to weaken from bloodlessness, her male admirers summon a Dutch medical specialist, Abraham Van Helsing, who immediately institutes blood transfusions using tubes and needles in a way which in the twentieth century suggests coitus. Initially Lucy's virile fiancé, Arthur, Lord Godalming, has his blood pumped into her: 'You are a man, and it is a man we want,' he is told. But after Lucy is again bled by Dracula at night, while Arthur is away, she receives fusions from her two rejected suitors, the psychologist John Seward and the Texan Quincey Morris, as well as from Van Helsing himself. Stoker's account suggests the homoerotic bonding together of men sharing the same woman. Lucy, however, dies, and after her funeral Arthur says that because of the transfusions he felt 'as if they two had been really married, and that she was his wife in the sight of God'. If this is true, then Seward and Morris have cuckolded their best friend: 'None of us said a word of the other operations, and none of us ever shall.' As in the tulip passage of Lord de Tabley's poem 'Circe', blood and semen seem to stand for one another as the elixirs of life, and some twentieth-century Freudians interpreted the vampire myth as a fantasy about wet dreams.

There is much other suggestive imagery in *Dracula*, as when Stoker describes Van Helsing 'holding his candle so that he could read the coffin plates, and so holding it that the sperm dropped in white patches which congealed as they dropped on the metal'. Lucy, buried in a Hampstead cemetery, begins rising from her coffin at night to attack children: 'the sweetness was turned to adamantine, heartless cruelty, and

the purity to voluptuous wantonness'. After Van Helsing determines that the vampire must be destroyed, Lord Godalming exterminates his undead fiancée by hammering a stake into her as he would have pounded into her on their wedding night. The blood flows as if she is deflowered:

> Arthur placed the point over the heart, and as I looked I could see its dint in the white flesh. Then he struck with all his might. The Thing in the coffin writhed; and a hideous, blood-curdling screech came from the opened red lips. The body shook and quivered and twisted in wild contortions; the sharp white teeth champed together till the lips were cut, and the mouth was smeared with a crimson foam. But Arthur never faltered. He looked like a figure of Thor as his untrembling arm rose and fell, driving deeper and deeper the mercy-bearing stake, whilst the blood from the pierced heart welled and spurted up around it. His face was set, and high duty seemed to shine through it . . . and then the writhing and quivering of the body became less, and the teeth ceased to champ, and the face to quiver. Finally it lay still.

Stoker's *Dracula* appeared eighteen months after the verdicts in Oscar Wilde's trial of 1895 had made an instantaneously repressive impact on all literature. Eric, Count Steenbock, in 'The True Story of a Vampire' (1894) lets his vampire Count Vardaleck kiss a beautiful youth on the lips; but new taboos were enforced after Wilde's ruin, which have their counterparts in Stoker's plot. As Nina Auerbach notes: 'In constructing an absolute category that isolated "the homosexual" from "normal" men and women, medical theory confined sexuality as narrowly as Van Helsing does the vampire. More in conformity than in ferocity, Dracula takes definition from a decade shaped by medical experts.'

Dracula has a corporate ethos as well as erotic undercurrents. It is a story of appropriation which a Freudian age has read too narrowly in terms of sexuality. Stoker wrote a fable of national insecurity in which the great contemporary anxieties were externalised and destroyed; it is a reminder that the instinct of survival is, or ought to be, the strongest human urge. His vampire lives far away in the Balkans but comes to England on a campaign of inhuman conquest. Count Dracula anglicises himself, masters an English accent, studies such minutiae as the railway timetables upon which invasions depend, and keeps in his library those strategically useful reference books, the Army and Navy Lists. By the 1890s the Victorian ideal-

ism of Samuel Smiles, author of *Self-Help* (1859) and the *Lives of the Engineers* (1861–62), who had preached a creed of work, individualism and thrift, had become obsolete. One commentator predicted in 1890, at the onset of a decade of large, highly capitalised mergers in the cotton textile, brewing, cement, tobacco, chemical, soap and armaments industries, 'The future Smiles will write "The Lives of the Market Riggers" or "The History of Trusts, Syndicates and Corners".' The business combinations of the 1890s were partly a matter of imitative fashion, partly the result of unscrupulous financial juggling, but substantially a reaction to the encroaching foreign competition which resulted in Joseph Chamberlain beginning his agitation for tariff protection in 1902. 'The most notable social fact of this age is a universal outcry for efficiency,' reported the *Spectator*. 'From the pulpit, the newspaper, the hustings, in the drawing-room, the smoking-room, the street, the same cry is heard: Give us efficiency, or we die.' Dracula's opponents, too, might have taken as their motto 'give us efficiency, or we die'.

Mina Murray is expert in office efficiency and uses a new American typewriter. Harker is so up-to-date with modern methods that he writes his diary in shorthand. John Seward dictates his diary into a recording machine. They resemble British industrialists in combining together to resist the invasive competition of outsiders; their enlistment of the Texan Morris and the Dutchman Van Helsing parallels British alliances in defensive international cartels. As Van Helsing declares, despite coming from a haven of free trade, 'we have on our side power of combination – a power denied to the vampire kind'. The financial power of this combination to fight Dracula's invasion makes Mina Harker extol 'the wonderful power of money! What can it not do when it is properly applied; and what might it do when basely used!' Though the anti-Draculan combine has been forced to discard Smiles's ideals, they remain enough of bourgeois Victorian meliorists to believe that money should be used according to justice, that its continuous accumulation is not a self-justifying, perpetual good. They want money to have a morality. Monopoly by contrast has no morality; it is represented by Dracula, the feudal power and foreign threat. Gothic is a wonderfully versatile *genre*, ceaselessly permutating to reflect the anxieties of succeeding ages, but seldom losing its interest in power relations: in *Dracula*, gothic literature first became a vehicle for representing the powers of monopoly capitalism and the fearful penetrative dangers of foreign investment.

In his earliest notes for the plot, drafted in 1890, Stoker jotted down the idea for a

crucial scene: 'young man goes out – sees girls one tries – to kiss him not on the lips but throat. Old Count interferes – rage and fury diabolical. This man belongs to me I want him.' In later scribbles of the plot the phrase recurs: 'this man belongs to me'. Here is the authentic aristocratic voice of proprietorship, akin to Byron telling Kinnaird, 'what I *earn* – that is *mine*'. It recalls the nineteenth-century Duke of Newcastle, who, criticised for evicting some tenants, indignantly demanded, 'Shall I not do what I like with my own?' Dracula, says Franco Moretti in his interpretation of Stoker's text, is an odd sort of aristocrat and not just because he is aged 466 years. His castle is no power house like Inveraray or Mitchelstown: the count, though he talks proudly of his lineage, lacks all the accoutrements of aristocracy. He has no servants and cooks, cleans and drives his carriage himself. He shuns pleasure. Unlike Vlad the Impaler, Lord Ruthven or Carmilla, he has a need rather than a pleasure in sucking blood. 'He sucks just as much as is necessary and never wastes a drop,' as Moretti notices. 'His ultimate aim is not to destroy the lives of others according to whim, to waste them, but to *use* them. Dracula, in other words, is a saver, an ascetic, an upholder of the Protestant ethic.' Indeed, Dracula's preparations as described in Harker's journal are as calculated and comprehensive as those of a tycoon preparing a business coup. Harker in his exploration of the castle makes one discovery. 'The only thing I could find was a great heap of gold in one corner – gold of all kinds, Roman, and British, and Austrian, and Hungarian, and Greek and Turkish money, covered with a film of dust, and as if it had lain long in the ground.' In capitalist structures, as Marx had indicated, the stronger the untrammelled capitalist gets, the weaker becomes labour; in Stoker's story, the undead vampire grows stronger as his living victims waste away.

Vampires provide a metaphor for capital accumulation: Van Helsing says 'they cannot die, but must go on age after age adding new victims and multiplying the evils of the world'. The Draculan monopolist personifies the fears of late-nineteenth-century capitalism: he subordinates his existence to the constant, repetitive demands of accumulation and reinvestment; he is a solitary wirepuller who manipulates people across a continent, but like Manfred in *The Castle of Otranto* is weakened by his dependence on servants. The vampire kind (as Van Helsing calls them) know that their methods must be subtle, insinuating and arcane. Dracula employs a lawyer in Exeter on one piece of business, but a different legal firm in Whitby on a related matter; Coutts in London, and Klopstock and Billreuth in Budapest, are his

bankers; none of his agents know of each other, or realise that they are cogs being turned in a greater enterprise. Yet his despotism breeds treachery and rapacity for short-term advantage. On his flight back to the Carpathians, Dracula (himself a foreigner with a beaky nose) is assisted, but eventually betrayed, by an unscrupulous Romanian Jew: 'We found Hildescheim in his office, a Hebrew of rather the Adelphi type, with a nose like a sheep, and a fez. His arguments were pointed with specie – we doing the punctuation – and with a little bargaining he told us what he knew.'

During the year of *Dracula*'s publication (1897), Rudyard Kipling wrote a poem called 'The Vampire' to gratify his artist cousin Sir Philip Burne-Jones. This tiny, highly strung baronet was infatuated with the actress Mrs Patrick Campbell, whom he painted in a lurid picture of green and crimson as a tall vampire dressed in white towering triumphantly over a young man, dead or faint, with bare chest bleeding, lying on a bed before dark curtains. The picture is *fin de siècle* Fuseli with the genders reversed. Kipling had no ambitious intentions for his poem, but like Stoker saw vampirism as an analogy for commerce as well as sexual destruction. Production and consumption were emphasised. 'A fool there was and his goods he spent', Kipling writes of the lover infatuated by the vampiric woman:

> Oh, the toil we lost and the spoil we lost
> And the excellent things we planned
> Belong to the woman who didn't know why
> (And now we know that she never knew why)
> And did not understand!

Kipling expressed similar fears in his poem 'The Lesson 1899–1902' describing the British 'as business people' losing out in world competitiveness to the Americans and Germans because of 'all the obese, unchallenged old things that stifle and overlie us'.

In Stoker's early drafts the Englishmen's Texan ally was called Brutus Morris. What is the role of Morris in this intricate plot where nothing is insignificant? Like Brutus in Shakespeare's play, he is not what he seems. 'He bore himself through it all like a moral Viking,' Seward says of him. 'If America can go on breeding men like that, she will be a power in the world indeed.' The patronising complacence in the English consortium's attitude to American power reflects the smug fatuities mocked by the imperialist Ewart Grogan in a contemporary book: 'an America

80,000,000 strong, with a total trade exceeding ours, is "a promising young cousin"; the angry roar of foreign competition is "the invention of those newspaper fellows"' – commonplaces 'which fire our enemies' hopes, which start the merry jest in New York clubs, and make the overseas Briton hang his head and groan'. In Stoker's climax the anti-Draculan consortium ambushes a band of gypsies carrying the vampire in his box back to his castle. Harker and Morris prise the coffin open. Morris kills the vampire by plunging a bowie knife into his heart (as two men are involved, and Wilde had recently been imprisoned, Stoker cannot repeat Godalming's poundingly penetrative destruction of Lucy). In the skirmish, however, Morris is wounded and, a moment before dusk falls, he too dies. 'The occurrence seems inexplicable, extraneous to the logic of the narrative, yet it fits perfectly,' Moretti explains, 'because Morris is a vampire'.

None of the characters, and few readers, suspected this even when Lucy died, and became a vampire, after receiving a blood transfusion from Morris, during a night which he spent alone patrolling the house. Stoker maintains high levels of irony. 'A brave man's blood is the best thing on this earth when a woman is in trouble,' Van Helsing tells Morris when arranging his transfusion. 'You're a man and no mistake.' Yet Lucy dies after this tranfusion and becomes a vampire. Nor were suspicions aroused by two earlier scenes in which Morris connives in the vampire's escape. During the consortium's strategic meeting to plan Dracula's destruction, the crack-shot Texan inexplicably misses when he shoots at Dracula (transmuted as a bat) eavesdropping at the window; later, after Dracula has been chased from Seward's house, Morris loses track of him by inexplicably hiding in trees rather than continuing the pursuit. When Dracula is strong and successful, Morris aids him; as his powers wane, Morris becomes more strenuous in accomplishing his defeat.

Twelve years earlier Stoker had given his audience at the Royal Institution 'A Glimpse of America', and now again in *Dracula* he offered a glimpse of the future he expected. In his conclusion Stoker hints at his anticipation that the great Trusts of Uncle Sam will triumph: Mina Harker ends by commenting on the death of Morris, 'to our bitter grief, with a smile and in silence, he died, a gallant gentleman'. Her total misunderstanding of what has happened is comparable to Lockwood's complacent certainty that Heathcliff and Catherine are not undead in the closure of *Wuthering Heights*. Morris has not been recognised by the English consortium for

what he was: a malignity devoted, like Dracula, to breaking bourgeois England's individualism. Mina Harker's last words, as Moretti notes, re-emphasise that the novel's 'true ending does not lie – as is clear by now – in the death of the Romanian count, but in the killing of the American financier'. For Stoker, the future was American.

Family evil

Lord Goring: Extraordinary thing about the lower classes in England –
they are always losing their relations.
Phipps: Yes, my Lord! They are extremely fortunate.
Oscar Wilde, An Ideal Husband

Home is where you go back to when you have nothing better to do.
Margaret Thatcher

Zeppo: Dad, I'm proud to be your son.
Groucho: Son, you took the words out of my mouth. I'm ashamed to be your father.
Marx Brothers, Horse Feathers

Children are cruel, ruthless, cunning and almost incredibly self-centred. Far from cementing
a marriage children frequently disrupt it. Child-rearing is on the whole an expensive and
unrewarding bore, in which more has to be invested, both materially and spiritually, than
ever comes out in dividends.
Nigel Balchin (father of Penelope Leach)

AMERICAN GOTHIC

Gothic ought to have been reported to the House Un-American Activities
Committee. It is pessimistic, anti-progressive, reactionary. In its finest manifesta-
tions – Goya's, for example – it is anti-populist. In its funniest forms (inaugurated
by Walpole), it is keenly ironic. By contrast, American culture was puritanical, pro-
gressive, optimistic, earnest and ostensibly egalitarian. Yet despite these antago-
nisms, the gothic imagination was not peripheral but became enriched and
revivified after its incorporation into New World life. This was partly because in
America as elsewhere there were people who needed gothic to confound them with
its masterful disproportions; the United States, too, had its artistic consumers who
wished to be troubled and mystified by its excessive overstatements. For goths,
there are no middle courses or temperate reactions, only extremities. 'Life is made

up of marble and mud,' Hawthorne wrote in that gothic text, *The House of the Seven Gables*. Moreover every nationality manifests the same ugly inclinations – the passion for power or cruelty, for example – that provide unchanging gothic themes. 'There are few uglier traits of human nature than this tendency in men no worse than their neighbours,' Hawthorne noted of his fellow New Englanders, 'to grow cruel, merely because they possess the power of inflicting harm.' The gothic imagination has always been versatile in the imagery which it can provide: it was not impossible for American gothic to be distinguished by characteristics notably absent from its European precursors. Often, in Europe, gothic was anti-domestic: it rejected safety and security, its protagonists (Matthew Lewis's monk or Frankenstein's monster, for example) were excluded from family life, or subverted its structures (like Walpole's Manfred and the other usurpers), or had the self-sufficiency to live without family encumbrances (vampires and Melmoth). American gothic had an antithetical development: it became family-centred. As Americans adopted a specialised, even extremist veneration of family, some of their writers adapted gothic imagery to exemplify the destructive power of families.

Gothic excess was deployed to represent domesticity's extreme horrors. This destructiveness was inseparable from America's puritan heritage, 'the old violent vindictive mysticism', as Faulkner called it. In American gothic the 'isolated puritan country household' – the phrases again are Faulkner's – replaced Europe's 'brawling and childish and quite deadly mud-castle household in a miasmic and spirit-ridden forest' as the locus of horror. To accommodate this adjustment, American gothic novelists used imagery drawn from those 'mean incidents and poor delights' that constituted, in Hawthorne's phrase, 'this paltry rivulet of life'. Thus the narrator of Poe's story 'The Black Cat' (1842) offers a 'most wild and yet homely narrative . . . of mere household events' which he declares 'have terrified – have tortured – have destroyed me'. It was this novelty which made Henry James in 1865 praise contemporary horror literature for being 'connected at a hundred points with the common objects of life'. He rejoiced that the discovery of mysterious terror in domestic mundanities had proved 'fatal to the authority of Mrs Radcliffe, and her everlasting castle in the Apennines. What are the Apennines to us, or we to the Apennines?'

There were great Atlantic discrepancies in perceptions of the family. One English view was given by Edmund Burke, among the greatest of those intellectual figures whose big ideas touched the gothic margins. In 1777 he famously justified his

political career: 'if I have wandered out of the paths of rectitude, into those of inter-ested faction, it was in company with the Saviles, the Dowdeswells, the Wentworths, the Bentincks; with the Lenoxes, the Manchesters, the Keppels, the Saunders's; with the temperate, permanent, hereditary virtue of the whole House of Cavendish'. To Burke, the superiority was manifest of 'men the best born, and the best bred, and in those possessd of rank which raises them in their own esteem, and the Esteem of others, and possessd of hereditary settlement in the same place, which secures with a hereditary wealth, an hereditary inspection'. The alternative filled Burke with incred-ulous disgust: 'that the Virtue, honour, and publick Spirit of a Nation should only be found in its Attornies, Pettyfoggers, Stewards of Mannours, discarded officers of Police, shop boys, Clerks of Counting Houses, and rustics from the Plough, is a para-dox, not of false ingenuity, but of Envy and Malignity'. Such feelings were utterly un-American. If one needed a litany of American names comparable to the Saviles, the Dowdeswells and the temperate house of Cavendish, it would be the 'men of traffic' in Hawthorne's Salem, 'the merchants – Pingree, Phillips, Shepard, Upton, Kimball, Bertram, Hunt' whom he listed in *The Scarlet Letter* (1850).

Though family stability was considered as basic to social stability in Georgian England as in America, threats to it were seen by the English as concrete or external. Lord Ongley in 1779 blamed increasing adultery on the French, who 'had con-tributed not a little to the increase in divorces, by the introduction of their petit maîtres, fiddlers and dancing-masters, who had been allowed to turn our wives and misses to allemand, and to twist and turn them about at their pleasure'. Family dis-integration was symbolised for the English not by inner weakness but by physical disease or outward blemish. Lord Auckland declared in 1800 that adultery was 'subvert[ing] every sentiment of conjugal fidelity and female chastity, and would corrode and extend itself like cancer over the fair bosom of civil society'. Family dis-integration, too, was placed within a ritualised code of personal honour. Lord Grenville spoke of philanderers as 'men of gallantry' and Lord Eldon respected 'the honourable seducer'. At their most sensible, the English daydreamed of fulfilled affections which were serene rather than triumphant. 'Domestic happiness passes unobserved, as a thing in the ordinary course of manners,' according to Henry Phipps, Lord Mulgrave, in 1800. 'In foreign countries . . . a happy marriage is a mat-ter of some surprise, as well as praise; it is a pretty romantic occurence for discus-sion.' By contrast, in America threats to conjugal peace and domestic security were

seen as more inward, as befitted a nation fashioned by the excessively introspective and overscrupulous inner scourings of the puritan conscience. In America, indeed, introspection became a popular recreational interest.

'The doctrine of the supremacy of the individual to himself,' Henry James wrote in 1879, 'of his originality, and, as regards his own character, *unique* quality, must have been a great charm for people living in a society in which introspection – thanks to the want of other entertainment – played almost the part of a social resource.' Hawthorne's wife, Sophia, exemplified the adaptation of self-absorption into histrionic entertainment. When her head hurt she described her pain not as an unpleasant distraction but as a 'headache which seemed to exalt every faculty of my mind & everything of which I thought was tinged with a burning splendor which was almost terrible'. Apprehensions and anxieties she turned into theatrical crises of health and nerves. 'A dubious morning,' she recorded typically in her journal:

I felt rather as if a tempest had passed over & crushed my powers when I awoke – for such a violent pain – while it is on me, gives me a supernatural force – combined with an excessive excitement of all my tenderest nerves, which nearly drives me mad. Yesterday whenever a door slammed or a loud voice made me start throughout in my powerless state – I could not keep the tears – burning tears from pouring over my cheeks.

Gothic exaggerations about himself were a hallmark of Edgar Allan Poe too. Some years before he succeeded in drinking himself to death, he answered a medical student who had inquired about his alcoholism:

You say – 'Can you *hint* to me what was that terrible evil which caused the irregularities so profoundly lamented?' Yes; I can do more than hint. This 'evil' was the greatest which could befall a man. Six years ago, a wife, whom I loved as no man ever loved before, ruptured a blood-vessel in singing. Her life was despaired of. I took leave of her forever and underwent all the agonies of her death. She recovered partially and I again hoped. At the end of the year the vessel broke again – I went through precisely the same scene. Again in about a year afterward. Then again – again – again and even once again at varying intervals. Each time I felt the agonies of her death – and at each accession of the disorder I loved her more dearly & clung to her life with

more desperate pertinacity. But I am constitutionally sensitive – nervous in a very unusual degree. I became insane, with long periods of horrible sanity. During these fits of absolute unconsciousness I drank, God only knows how often or how much.

This is the ebullition of someone who thinks too much of his own feelings: someone so egocentric that he is sincere in his preposterous belief that he alone has 'loved as no man ever loved before'. Sophia Hawthorne and Poe were creative, articulate examples of self-cultivated self-centredness.

The harsh, simple pieties of puritanism provide the cultural antecedents of American histrionics. John Foxe's *Book of Martyrs* (1563), Lewis Bayly's *The Practice of Piety* (1612) and Defoe's *Family Instructor* (1715) were the most popular books in the early European settlements. The first text is a long, horrifying account of torture, denunciation, suspicion and savage punishments. Dry puritans with little know-ledge of the world or the heart found satisfaction in the *Book of Martyrs*; it made sense of the world to bigots holding fast to their stalwart lack of understanding or

'If anyone comes to me and does not hate his father and mother, wife and children, brothers and sisters, even his own home, he cannot be a disciple of mine.' (Luke 14, 26) An eighteenth-century missionary chapel, near Baton Rouge, Louisiana.

imagination. It was such people who, in the seventeenth century, compiled their jeremiads lamenting the sins and failures of their children. 'The place is joyless for him,' Hawthorne wrote of a typical inhabitant of Salem; 'he is weary of the old wooden houses, the mud, and dust, the dead level of site and sentiment, the chill east wind, and the chillest of social atmospheres'. William Faulkner similarly presented a typical nineteenth-century Puritan as 'this grim humorless yokel out of a granite heritage where even the houses, let alone clothing and conduct, are built on the image of a jealous and sadistic Jehovah'. Nor did the secular power of puritanism die out as religiosity declined. 'The atmosphere of education in which he lived was colonial, revolutionary, almost Cromwellian, as though he were steeped, from his greatest grandmother's birth, in the odor of political crime,' Henry Adams wrote of his Boston boyhood in the 1850s. 'Slavery drove the whole Puritan community back on its puritanism.'

Religiosity was often angry, recriminatory and theatrical: it could set a pattern for family life. The architect Louis Sullivan recalled (in the third person) his boyhood attendance in the 1860s at a Baptist church in rural Massachusetts:

> He greatly admired the way the minister shouted, waved his arms terrifically, and then, with voice scarcely exceeding a whisper, pointed at the congregation in dire warning of what would surely befall them if they did not do so and so or believe such and such. He roared of Hell so horribly that the boy shivered and quaked. Of Heaven he spoke with hysterical sweetness – a mush of syrupy words . . . To the child, however, as a first violent experience, the total effect was one of confusion, perturbation, and perplexity. One particular point puzzled him most: Why did the minister, when he prayed, clasp his hands together and so continue to hold them? Why did he close his eyes? Why did he bow his head and at times turn sightless face upward toward the ceiling? Why did he speak in whining tones? Why was he now so familiar with God, and then so grovelling? Why so bitter, why so violent, why so cruel as to wish these people, whoever they were, to be burnt throughout all eternity in the flames of awful hell?

Puritanism was never limited to New England. The future US president Herbert Hoover, born in small-town Iowa in 1874, attended a Quaker meeting house with his parents every First Day:

The building was divided by a low partition. On one side sat the women, dressed in bonnets and modest gray and brown gowns. On the other sat the men, clad in dark suits and broadrimmed hats. For two hours – an excruciatingly long time for active little boys – the meeting gathered in sober silence punctuated only by the prayers and exhortations of those whom the Spirit had called upon to speak. Sometimes – and this was more difficult still – no one would break the endless weighty silence. Through his life Herbert Hoover never forgot 'the intense repression' of this mode of worship on a small boy 'who might not even count his toes' . . . Herbert's brother Theodore later remarked: 'Friends did not hold with light reading, and theatres, dancing and card playing were esteemed terribly wicked. My parents did not think even the *Youth's Companion* suitable for the perusal of the young, as, apart from its intrinsic lightness, it contained fiction, which was untruth, and further it incited to adventure, which was bad for energetic little boys.'

The harshness of Puritan reality was the imaginative source for the best of American gothic fiction. Faulkner's gothic victim Rosa Coldfield was reared in rural Mississippi in a 'grim mausoleum air of Puritan righteousness and outraged female vindictiveness'. Similarly Poppy Z. Brite in her southern gothic novel *Drawing Blood* (1993) describes one of her most appealing characters, Kinsey Hummingbird, living in small-town North Carolina in the 1970s: 'A Bible-belting mother who saw her son as the embodiment of her own black sin; her maiden name was McFate, and all the McFates were psychotic delusionaries of one stripe or another.'

It is not surprising that the United States began producing soap-operatic gothic only a decade or two after the English, or that in the 1790s heyday of Radcliffe and Lewis the new republic had its first aspiring gothic novelist of quality. Royall Tyler, the future chief justice of Vermont, declared in the preface to his gothic novel *The Algerine Captive* (1797) that in America 'the dairymaid and hired hand no longer weep over the ballad of the cruel stepmother, but amuse themselves into an agreeable terror with the haunted houses and hobgoblins of Mrs. Radcliffe'. Melodrama mitigated existence for the mass of early Americans enduring material hardships and shrivelled inner lives. 'They had *no natural imagination*,' Hazlitt claimed of the Americans with patronising exaggeration. 'This was likely to be the case in a new country . . . where there were no dim traces of the past – no venerable monuments –

no romantic associations; where all (except the physical) remained to be created, and where fiction, if they attempted it, would take as preposterous and extravagent a shape as their local descriptions were jejune and servile.' Despite Hazlitt's misgivings, American gothic achieved a redemptive strength. From the first efforts of Charles Brockden Brown in the 1790s it developed into a serious, sustainable genre incorporating both Hawthorne and Poe in the nineteenth century. 'It is the gothic form that has been most fruitful in the hands of our best writers: the gothic *symbolically* understood, its machinery and decor translated into metaphors for a terror psychological, social, and metaphysical,' as the American critic Leslie Fiedler has described. 'Yet even treated as symbols, the machinery and decor of the gothic have continued to seem vulgar and contrived; symbolic gothicism threatens always to dissolve into its components, abstract morality and shoddy theater.' Later Faulkner wrote gothic short stories – 'A Rose for Emily' has been praised by Joyce Carol Oates as 'a supreme example' of 'the grotesque image as historical commentary' – and intermittently enlisted goth traditions, though it would be preposterously reductive to call Faulkner a gothic artist.

This gothic apotheosis was assisted by those Americans who enlarged and enlivened their lives by spreading ripples of apprehension on everybody else's behalf rather than suffer in emotionally arid quietude. The result was that peculiarly American phenomenon, the plaintive, self-dramatising family. The resentful tirade of the histrionic valetudinarian mother in Faulkner's *The Sound and the Fury* can represent them all:

> what have I done to be given children like these Benjamin was punishment enough and now for her to have no more regard for me her own mother I've suffered for her and dreamed and planned and sacrificed . . . yet never since she opened her eyes has she given me one unselfish thought at times I look at her I wonder if she can be my child except Jason he has never given me one moment's sorrow since I first held him in my arms I knew then that he was to be my joy . . . I look at him every day dreading to see this Compson blood beginning to show . . . who can fight against bad blood?

She represents the old jeremiads of Puritan parents that their children are sinful failures. One consequence of Mrs Compson's excessive, self-centred emotion is her equally self-absorbed, overdramatic granddaughter, who shovels responsibility for

her delinquencies onto other people: 'whatever I do it's your fault, she says. If I'm bad, it's because I had to be. You made me. I wish I were dead.' By adapting the haunted houses and hobgoblins of the Europeans as metaphors for family life, the Americans recoloured and reshaped the gothic imagination until in Faulkner 'the dungeon was mother herself'. It became a feature of American literature (to borrow a phrase of Melville's) 'to trail the genealogies of these high mortal miseries'. Grief and horror became a family concern even before the nineteenth-century industrial city provided new versions of horror, transgression, violence and venality. These genealogical miseries were tenacious: in American gothic, one cannot escape from parental powers.

In 1960 the Harvard psychologist David McClelland – a Quaker whose father was a Methodist minister and whose mother was reared in an austere Presbyterian tradition – speculated 'why psychoanalysis has had such a great appeal to American intellectuals'. He thought the explanation lay in the Puritan family heritage of the United States. Freud's 'insistence on the evil in men's nature, and in particular on the sexual root of that evil, suited the New England temperament well which had been shaped by a similar puritan emphasis. In fact, to hear Anna Freud speak of the criminal tendencies of the one and two-year-old is to be reminded inevitably of Calvinistic sermons on infant damnation.' Psychoanalytical theory, indeed, can be likened to an immense metaphysical structure intended to project the 'badness' of adults, particularly their sexual badness, onto infant children. Perhaps the best visual image to represent Freudian metaphysics is one of the immense, elaborate dungeons in Piranesi's *Carceri*, with the human figures reduced and ladders leading nowhere. In literature, the excited temper and self-victimisation of characters in American gothic fiction provide a striking counterpart to the discomposure of people in therapy.

CHARLES BROCKDEN BROWN

American gothic begins with Charles Brockden Brown (1771–1810), the first American-born professional novelist. Reared as a Quaker in Philadelphia, he witnessed the tumult and succumbed to the hopes of the revolutionary period. As a young man he was a fervid admirer of the Enlightenment; many of Godwin's ideas particularly caught his imagination. He took other literary models, including an English papermaker named Robert Bage, who achieved some renown as a novelist.

But public events, private mortifications and his own poor health turned Brown into a pessimistic conservative – a process which perhaps sharpened his interest in the decay, submission and defeats which so often provided the themes of gothic novelists. He soon recognised that neither moral high-mindedness nor legal restraints could govern human passions. He suffered all the disadvantages of an early prototype. 'His seniors had destroyed political bonds with Europe; he had nothing but patriotic enthusiasm for their service; yet he realised that the new nation needed cultural strength of its own, and the only model that he recognised for this new independent spirit was the Europe that America had rejected,' as an English critic assessed in 1950. Between 1798 and 1800 he issued seven novels with American settings, each strenuously attempting to create a distinctively American literature. Thus in *Edgar Huntly* (1799) Brown disavowed superstition, European manners and gothic castles to support his assertion that the perils of Indians and the wilderness constituted the proper subjects for American writers. Brown insisted that the abyss should be represented in America by boundless wild lands rather than a claustrophobic castle oubliette; for later American goths the wilderness provided the location of powerful terrors and sites of sexual transgression (Faulkner's 'hot hidden furious in the dark woods').

Brown's books, if only mediocre, were a daring initiation. Persecution, emotional tyranny, disintegrating identities and extreme domestic disruption provided his themes. Nevertheless, such readings need qualification. 'Although Brown's major works are often admired for their psychological depth and Gothic sensationalism, at heart they are explorations of the impact of the social and economic order on the lives of individuals,' as Emory Elliott has traced. 'His most interesting and oddly sympathetic characters are those whose poverty turns them into villains or into deluded seekers of wealth.' This preoccupation was sharpened by Brown's own acute financial disappointments. His novels indict the corrupt American rhetoric that protects the rich while proclaiming universal equality of opportunity. Bogus egalitarianism creates a crooked society in which the disempowered are driven to extreme remedies – not least the traditional gothic resorts of violence and lunacy. Brown's socio-economic preoccupations recur in American gothic. Faulkner, too, deplored the destructiveness of 'a country all divided and fixed and neat with a people living in it all divided and fixed and neat because of what color their skins happened to be and what they happened to own'.

Brown's first novel, *Wieland* (1798), is a study of family destruction. Clara and Theodore Wieland have endured gloomy, austere evangelism from their father:

> The empire of religious duty extended itself to his looks, gestures, and phrases. All levities of speech, and negligences of behaviour, were proscribed. His air was mournful and contemplative. He laboured to keep alive a sentiment of fear, and a belief of the awe-creating presence of the Deity. Ideas foreign to this were sedulously excluded. To suffer their intrusion was a crime against the Divine Majesty inexpiable but by days and weeks of the keenest agonies.

After a period of mounting depression and anxiety, this grim patriarch is burnt to death, seemingly as divine punishment for violating a vow to God. This incident provides one pointer for the rest of the book: the destructiveness of the death of a parent of young children. Tainted heredity is another. The only Wieland son, Theodore, has a character similar to his father's – 'his features and tones . . . bespoke a sort of thrilling melancholy' – but his mind was 'enriched by science, and embellished with literature.' Learning that he is heir to great estates in Europe, he rejects the opportunity of property and privilege; he fears that if he accepts 'power and riches' he will 'degenerate into a tyrant and voluptuary'. Instead he prefers to 'expatiate on the perils of wealth and power, on the sacredness of conjugal and parental duties, and the happiness of mediocrity'. Yet Brown shows that this progressive belief in individuals making autonomous choices to assert their own destiny – rejecting their inheritance whether material or psychological – is delusive. It is appropriate that *Wieland*'s atmosphere is gothicised, given gothic's antagonism to the possibility of human progress.

The extended family of Theodore, his sister Clara and his wife establish a secure, succouring 'little community' which is abruptly unbalanced by mysterious voices addressing various members with admonitions, allegations and reproaches. Wieland, like many of Radcliffe's heroines, is submissive in his torment and shows a mounting moral masochism (the heroine of Hawthorne's *Scarlet Letter* is similarly submissive to the voyeuristic controls of Roger Chillingworth). Although not a religious fanatic like his father, the conjunction of Puritan heredity with Theodore's hubristic faith in Enlightenment materialism proves lethal. His confidence in his own reasoning powers means that he never doubts the authenticity of the voices he

hears, and submits in obedience when ordered to kill his wife and four children. Clara escapes death by chance; Wieland destroys himself after it transpires that the voices have been projected by Carwin, a gothic figure resembling Radcliffe's monk Schedoni or Lewis's Ambrosio, who has been staying with the family and is a ventriloquist. Carwin is without family ties or property and evinces all the capacity of the dispossessed for envy, sly duplicity and wanton destruction; he may not be an evil medieval monk, but he has all the malignity of one, and is described as an 'imp of mischief'. In contrast to the rationalist Wieland, he is a passionate man: he represents a secularised incarnation of original sin as well as incarnating the political violence of the dispossessed: 'Bloodshed is the trade, and horror is the element of this man . . . the power and the malice of daemons have been a thousand times exemplified in human beings.' There are moments of high melodrama in the book interspersed with didactic sections in which Brown scrutinises philosophical systems or aesthetic theories. He also attached to *Wieland* an early, suitably American medicalisation of gothic perversity. 'Some readers may think the conduct of the younger Wieland impossible,' his advertisement for the book asserted. 'In support of its possibility the writer must appeal to physicians, and to men conversant with the latent springs and occasional perversions of the human mind.'

In America, Brown's fiction *début* was a critical success. He won many English admirers too. 'Very powerful,' Keats judged after reading *Wieland* in 1819. 'More clever in plot and incident than Godwin – A strange american scion of the German trunk. Powerful genius – accomplish'd horrors.' Hazlitt was less impressed. 'He was an inventor, but without materials,' he wrote of Brown in 1829:

> His strength and his efforts are convulsive throes – his works are a banquet of horrors. The hint of some of them is taken from [Godwin's] *Caleb Williams* and *St Leon*, but infinitely exaggerated, and carried to disgust and outrage. They are full (to disease) of imagination, but it is forced, violent and shocking.

He conceded that Brown had creative genius, but thought his ideas were contrived and unnatural, 'like the monster in Frankenstein, a man made by art and determined will'. Certainly Brown deserves to be remembered as a courageous forerunner. Hawthorne, perhaps, was the writer that Brown would like to have become. In Hawthorne's essays, stories and early novels, many of the preoccupations and cultural hopes of Brockden Brown are richly displayed and magnificently achieved.

NATHANIEL HAWTHORNE

Nathaniel Hawthorne (1804–64) was born in Salem, Massachusetts. When young he read Maturin, Matthew Lewis and other English goths; but his most influential reading was historical. It is a commonplace that he was the progenitor of American studies. He studied the documents and literature of America's Puritan past, analysed the role of Puritan conscience in the mass mentality of Americans and recognised that even those of his contemporaries who rejected traditional American theology were still saturated in the attitudes of puritanism. He mined the history and traditions of New England for the material in his books, but used them deviously. The ethical powers of his ancestors were violated rather than affirmed by his writings. In thus sapping patriarchial authority he devised literary schemes which inaugurated a tradition for later Americans to follow. Indeed, though the settings and details of his first novel, *The Scarlet Letter* (1850), seem saturated with seventeenth-century atmosphere, its characters, as Walter Herbert has concluded, 'have no counterparts in the colonial record, and the torments they suffer are characteristic of nineteenth-century family life'. Similarly the seventeenth-century roots of the plot of Hawthorne's *House of the Seven Gables* (1851) exist to resolve nineteenth-century family tensions. Brown's Wielands had been lethally flawed by hereditary temperament: tainted heredity similarly fascinated Hawthorne. Family antecedents were an important personal preoccupation for him as well as an aesthetic source. 'I thank Heaven I am not a Forrester', he wrote after reading Elizabeth Stoddard's family novel *The Morgessons* (1862), some of whose characters were recognisable as real individuals. 'The family is connected with mine by old Simon Forrester having married into it. He drank terribly . . . and transmitted the tendency . . . to all his sons, several of whom killed themselves by it. I know of no descendant in the male line who . . . turned out well.'

An early case of Hawthorne's family-centred American gothic is 'Anne Doane's Appeal' (1835). This signals that it is a gothic tale by being narrated from a manuscript (like the tales of Otranto, Vathek, Melmoth and many others); in this case, the narrator is carrying the manuscript in his pocket on a country walk and paraphrases it to two young women accompanying him. It is set in a prosperous town in 1692. There are three chief characters, as Hawthorne recounts:

A young man and his sister; the former characterized by a diseased imagination and morbid feelings; the latter, beautiful and virtuous, and instilling something of her own excellence into the wild heart of the brother, but not enough to cure the deep taint of his nature. The third person was a wizard; a small, gray, withered man, with fiendish ingenuity in devising evil, and superhuman power to execute it, but senseless as an idiot and feebler than a child, to all better purposes.

Leonard Doane (he of the diseased morbidity) has conceived an 'insane hatred' of Walter Brome, who is courting his sister; he has enough self-knowledge to recognise that Brome is 'my very counterpart', but his jealous resentment is kindled into such 'a volume of hellish flame' that he kills his antagonist. Hints of incestuous confusion had characterised much gothic writing since Walpole, but Hawthorne introduced a new prototype of memories recovered from childhood and had a special focus on family destinies set by early bereavement. Gazing down on Brome's corpse, Leonard Doane fancies a strong resemblance to his father and has a sudden recollection. 'A scene, that had long been confused and broken in my memory, arrayed itself with all its first distinctness. Methought I stood a weeping infant by my father's hearth; by the cold and blood-stained hearth where he lay dead.' The story reaches its climax when the two Doanes visit the graveyard where the murdered man is interred. It yields up all its dead in a long scene of accumulating terror worthy of *Vathek*. 'The countenances of these venerable men, whose very features had been hallowed by lives of piety, were contorted now by intolerable pain or hellish passion, and now by an unearthly and derisive merriment . . . The whole miserable multitude, both sinful souls and false spectres of good men, groaned horribly and gnashed their teeth, as they looked upward to the calm loveliness of the midnight sky, and beheld those homes of bliss where they must never dwell.'

'Anne Doane's Appeal' is the forerunner of a new subtle psychological treatment of gothic incest. In Faulkner's Mississippi novels there are similarly incestuous trios in which a male protagonist becomes sexually obsessed with his sister as displacement of his attraction to another man. In *The Sound and the Fury* the taking of Caddy Compson's virginity by Dalton Ames obsesses her brother Quentin, who tries to cancel out the reality of her fornication with his own fantasy ('I have committed incest I said Father it was I not Dalton Ames') until eventually he kills himself. In

Absalom, Absalom! there is a comparable tie of the passive Charles Bon to Henry Sutpen. When the two men meet at university Bon fascinates and repels. 'The very fact that, lounging before them in the outlandish and almost feminine garments of his sybaritic privacy, he professed satiety only increased the amazement and the bitter and hopeless outrage.' Bon engages to marry Sutpen's sister, Judith, although the strongest love is between the two men. Henry Sutpen yearns to play the role of each member of this trio, but ends by repeating Leonard Doane's crime: he kills his sister's suitor. Faulkner reflects,

> perhaps this is the pure and perfect incest: the brother realizing that the sister's virginity must be destroyed in order to have existed at all, taking that virginity in the person of the brother-in-law, the man whom he would . . . metamorphose into, the lover, the husband; by whom he would be despoiled, choose for despoiler, if he could become . . . the sister, the mistress, the bride. Perhaps that is what went on, not in Henry's mind but in his soul. Because he never thought.

Similarly the narrator's family in Hawthorne's first novel, *The Scarlet Letter*, has a hereditary 'persecuting spirit' dating from their 'martyrdom of witches' at Salem. The influence of the old Puritans still weighs on their descendants and crushes later generations with their censure. 'No aim, that I have ever cherished, would they recognise as laudable; no success of mine . . . would they deem otherwise than worthless, if not positively disgraceful.' *The Scarlet Letter*'s villain is old Roger Chillingworth, a prototype of the analyst who makes an earnest business of children's play in order to devise rare fancies about parental influence. 'A strange child!' Chillingworth muses of the laughing girl Pearl at play. 'It is easy to see the mother's part in her. Would it be beyond a philosopher's research, think ye, gentlemen, to analyze the child's nature, and, from its make and mould, to give a shrewd guess at the father?' There is no explanation for the drawn-out submission of Hester Prynne, Pearl's mother, to Chillingworth's controls except the masochism which characterises so many gothic heroine-victims. (Her suffering, though, brings learning and power; by the end of the story, she confidently advises her neighbours on 'the continually recurring trials of wounded, wasted, wronged, misplaced, or erring and sinful passion'.) Pearl is the result of Hester's clandestine affair with a locally revered bachelor clergyman who becomes the study and victim of the controlling

old analyst. As Hawthorne writes ironically, 'so Roger Chillingworth – the man of skill, the kind and friendly physician – strove to go deep into his patient's bosom, delving among his principles, prying into his recollections, and probing everything with a cautious touch, like a treasure-seeker in a dark cavern'. His excitements are vicarious, his outlook superior. When he discovers his patient's secret, he is as ecstatic as Satan 'when a precious soul is lost to heaven, and won into his kingdom. But what distinguished the physician's ecstasy from Satan's was the trait of wonder in it!' *The Scarlet Letter* is not gothic; its interest for us is its display of family tensions similar to those gothicised by Hawthorne in his second novel. *The House of the Seven Gables* is certainly gothic with its ghosts, unjust incarceration, mesmeritical seers, visionary trances, rapping spirits and even (like the castle of Otranto) an old portrait which sometimes comes alive.

The exterior of the decaying house of the title 'was ornamented with quaint figures, conceived in the grotesqueness of a Gothic fancy'; its interior silence was 'deep, dreary and oppressive'; by the nineteenth century it has become 'a rusty, crazy, creaky, dry-rotted, damp-rotted, dingy, dark and miserable old dungeon'. Suitably for scenes of 'chaotic' gothic histrionics, Hawthorne likened it to 'a theatre'. It is the first of many buildings of American literary gothic that achieves powerful evocations without the castellations or feudal grandeur of European gothic. Sutpen's Hundred, the mansion in Faulkner's Yoknapatawpha County designed in the 1830s for Thomas Sutpen by an architect from Martinique, suitably decked in 'sombrely theatrical clothing', is adapted for the Mississippi wilderness: 'only an artist could have borne Sutpen's ruthlessness and hurry and still manage to curb the dream of grim and castlelike magnificence at which Sutpen obviously aimed'. One cannot replicate Strawberry Hill or Alnwick 'in virgin swamp'.

Hawthorne's plot hinges on usurpation, as in *Otranto*. The gabled house stands on land which had been seized in the seventeenth century from its owner, Maule, who before being put to death as a wizard cursed the new owner, Colonel Pyncheon. On the day of festivities to celebrate the completion of his mansion, the colonel was found in his library with his beard saturated in blood: 'The iron-hearted Puritan – the relentless persecutor – the grasping and strong-willed man – was dead!' These two deaths ruin the Pyncheons as well as the Maules, for the colonel, just before his extinction, expected to be granted a vast, unexplored tract of wilderness in Maine 'more extensive than many a dukedom, or even a reigning prince's

territory, on European soil'. The surviving Maules are rumoured to have purloined a document which could enforce this claim; its disappearance, and the consequent loss of this prize, demoralises the Pyncheons; their family powers ebb, and the nineteenth-century generations, 'fed . . . from childhood with the shadowy food of aristocratic reminiscences', become weary and ineffective. 'In this republican country, amid the fluctuating waves of our social life, somebody is always at the drowning point.'

Brockden Brown's fictional family had also been offered great territorial possibilities, but whereas the Pyncheons hanker after a greatness based on ancestral achievements, the Wielands had repudiated their past. The feeling 'in all the Pyncheons' of cohesive family identity assumes 'the energy of disease'. The long contentions between the obscure but vigorous Maules and effete Pyncheons takes a new turn when the house of the seven gables acquires a young lodger, Holgrave, who is actually Maule's heir. Holgrave works as a daguerrotypist ('I make pictures out of sunshine', he says), and attends public meetings with 'reformers, temperance-lecturers and all manner of cross-looking philanthropists'. He is attracted by the youngest Pyncheon, Phoebe, who alone possesses 'the gift of practical arrangement' (not to be confused with the capabilities of 'the hard, vulgar, keen, busy, hackneyed New England woman'). Holgrave as a representative of modernity rails against the burden of history and detests the gabled house as 'expressive of that odious and abominable Past, with all its bad influences'.

'We are ghosts!' exclaims Clifford Pyncheon, whose life has been ruined by his wrongful imprisonment for murder, to the spinster sister with whom he lives under the seven gables. 'We have no right anywhere, but in this old house, which has a curse on it, and which therefore we are doomed to haunt.' Clifford, though, exemplifies the emotional retardation of those fixated on their childhood: in 'his dreams . . . he invariably played the part of a child, or a very young man'. He is as dependent, irresolute and trivially wilful as a child; a chaste man too, and weak. His adamantine enemy Jaffrey Pyncheon, by contrast, is sexual. Just as the old Puritan colonel 'had worn out three wives', so his descendant Jaffrey has an exigent masculinity: his face looks 'animal'; Phoebe recoils from his cousinly kiss because 'the sex, somehow or other, was entirely too prominent'. He is harsh, unforgiving, grasping for power and property, though a silky, benevolent hypocrite. 'Might and wrong combined, like an iron magnetized, are endowed with irresistible attraction.'

In a powerful scene, Jaffrey dies like his grim ancestor on the eve of great triumphs, in this case the state governorship. His property, in an unexpected resolution, is inherited by Clifford, whose life he has hitherto ruined; though Holgrave finds the missing document where his Maule ancestor had secreted it, this discovery comes too late for the surviving Pyncheons to possess the Maine property, but the family's neurotic pretensions to greatness are exorcised. Phoebe Pyncheon marries Holgrave/Maule, and the survivors of both families turn their backs on the decaying gabled house to live together in rural harmony.

EDGAR ALLAN POE

There are no such happy closures in the tainted world of Edgar Allan Poe (1809–49). His father was a drunken actor prone to paralysing stage fright who disappeared before the child was a year old and was never seen again; his mother died when he was two. He was taken in by a Scottish-born merchant, John Allan, and his childless wife. Allan was a pawky, ambitious *arriviste* whose interests were chiefly mercenary. Edgar Allan Poe, as the boy became known, grew up much like the playboy sons of other rich men, with a high appreciation of money but little desire or ability to make it himself. Poe, who estimated that his foster-father was worth the princely sum of $750,000, was treated generously but had one fatal symptom of American optimism, a propensity for accumulating debts. Money for Allan and Poe was the coinage in which love was doled out. There is no common understanding of love in Poe's stories – the husband's adoration in 'The Oval Portrait' so objectifies his wife that she dies – but love's place is taken by cherished or sumptuous objects, whether the oval portrait of the dying woman or the furniture and ornaments belonging to rich men so carefully detailed in other stories. This distinctive trait of Poe's prose probably derived from the money-loving, status-conscious objectifications of Allan's forceful, invasive businessman's mentality.

After briefly attending the University of Virginia, Poe enlisted in the army under a false name but was dismissed after deliberately disobeying orders in 1831. At this time he lost the protection of the Allan fortune, and henceforth sought a living as a writer pursuing a self-dramatising vagabond existence between various cities. He had fleeting flirtations with (often married) women in which he simulated the part of romantic ardour. Susan Archer Weiss recorded in *The Home Life of Poe* that in 'all Poe's accounts of himself, and especially of his feelings, is a palpable affectation and

exaggeration, with an extravagence of expression bordering on the tragic and melo-dramatic: a style which is exemplified in some of his writings'. In 1835 Poe married his thirteen-year-old cousin, Virginia Clemm. Always poorly, she was stricken with a tubercular haemorrhage in 1842, and took five years to die. Two years later, in October 1849, Poe himself expired in alcoholic delirium after being found uncon-scious in a Baltimore street. 'This death was almost a suicide – a suicide prepared from an early period,' according to Baudelaire. 'He drank not as a gourmand, but as a savage, with that time-economy altogether American, as if accomplishing a homi-cidal function.'

In 1831 Poe entered his first stories for a newspaper competition. Like Walpole with *Otranto*, his intentions in these earliest gothic stories were burlesque. 'The Duc De L'Omelette' (1831) recounts the history of a French nobleman who is also Prince de Foie-Gras: he dies of shock on being served with a nude ortolan, but is resur-rected for a card game with Beelzebub, whom he outplays (the devil's palace owes something to *Vathek*; other details are taken from a novel by Disraeli, *The Young Duke*). Poe's more suggestive gothic phase begins with 'Metzengerstein' (1832), a story which opens with a flippant account of the intense dynastic hatred of two neighbouring aristocratic families, but reaches a climax of authentic terror after the murdered Count Berlifitzing is resurrected as a giant horse in Baron Metzengerstein's tapestry, which comes to life as an avenging equestrian power and destroys the baron in the flames of his castle. The castle's décor is particularised with all the exactitude of stage-directions, and the story proceeds in a way reminis-cent of succeeding stage-acts. The doomed young Metzengerstein is, as Bryllion Fagin noted, 'a hero who in many ways – orphaned youth, nobility, impetuosity, courage, propensity toward meditation, and strange obsessive attachment – antici-pates all the protagonists of the stories which Poe was to write during his entire career.' (By no means all Poe's stories are gothic.) This allegory about a man's evil passions leading to his own destruction owes much to *Otranto* – Poe borrowed Walpole's prophecy about the castle, the work of art that comes alive gigantically, and Metzengerstein's forename Frederick – but Metzengerstein has none of Manfred's pretences at mastery. He submits immediately to the dominance of the horse: he takes an attitude of extreme passivity under the torturings of his con-science (his family physician attributes his obsessions to 'morbid melancholy, and hereditary ill-health'). He is helpless by the end:

The career of the horseman was indisputably, on his own part, uncontrollable. The agony of his countenance, the convulsive struggle of his frame, gave evidence of superhuman exertion: but no sound, save a solitary shriek, escaped from his lacerated lips, which were bitten through and through in the intensity of terror. One instant, and the clattering of hoofs resounded sharply and shrilly above the roaring of the flames and the shrieking of the winds – another, and, clearing at a single plunge the gate-way and the moat, the steed bounded far up the tottering staircases of the palace, and, with its rider, disappeared amid the whirlwind of chaotic fire.

In his gothic horror stories after 'Metzengerstein' Poe seldom paused for humour. After 1835 he intended to write stories, in his own description, depicting 'the ludicrous heightened into the grotesque: the fearful coloured into the horrible: the witty exaggerated into the burlesque: the singular wrought out into the strange and mystical'. Gothic moods suited Poe's intention to create strange realms defying natural law, common-sense perceptions and the limits of human experience. His talent was for hallucinatory impressions rather than traditional gothic terrors: the title chosen for his first book, *Tales of the Grotesque and Arabesque* (1840), shows that although he adopted the gothic scenery of castles and dungeons, the gothic furniture of portraits and tapestries from which figures come alive, the gothic claustrophobia of incarceration and the gothic odour of putresence, he intended to achieve more original effects than either Radcliffe or German *schauerromantik* horrors. Poe had a goth's interest in submission – 'we thrill . . . with the most intense of "pleasurable pain"' – joined with an American curiosity about the dark burden of ancestral powers. He determined, too, to discard causal exactitude: 'I am above the weakness of seeking to establish a sequence of cause and effect between the disaster and the atrocity.' Initially Poe's gothic *loci* are European and his characters often aristocratic. The setting of 'The Assignation' (1834) is a ducal palace in Venice, 'one of those huge structures of gloomy yet fantastic pomp', and its protagonist is modelled on Byron. (Poe was so attracted by the drama of Byron's life that he restaged Byron's famous swim across the Hellespont by swimming six miles against the tide in the James River.) The narrator of 'Berenice' (1835) lives in the 'gloomy, gray, hereditary halls' of an ancestral home at Arnheim. Later the sites become less specific.

Poe's language and décor are operatic, but he is saved from mere soap-operatics

by his characterisation. His victims and villains are never crude, instantly recognisable stereotypes, but unreal, cloudy people who represent hallucinatory states. Some of his greatest stories, like 'William Wilson' and 'The Masque of the Red Death', have masquerades as the scene of their resolutions; these masquerades emphasise how much of emotional life is overacting, posing, deceit and self-indulgent luxuriation in exaggerated feeling. Both of Poe's parents worked on the stage and he instinctively perpetuated their staginess. Bryllion Fagin in *The Histrionic Mr Poe* commented of Poe that he took on roles deliberatively: his clothes, mysterious melancholic manner, soulful love-affairs and the dramas of his working life were as theatrical as his public declamations of his work; the sadness in Poe's life 'was that he was a strolling player with no theatre, an actor with no bookings, or very few'. His protagonists were not literary versions of himself, but he acted out their fears and passions like an actor playing a role. They are seldom subdued by the fact that they are so obviously playing a losing game; they never display a cool air of self-sufficiency; instead they are emotionally overreactive and over-dependent. The villains of Walpole or Radcliffe were destroyed by the excessiveness of their passions, but it is the Puritan conscience's morbid introspection and implacable self-accusation that ruins Poe's transgressors.

'William Wilson' (1839) is his allegory about conscience presented as a sinister tale of an alter ego. 'I am the descendant of a race whose imaginative and easily excitable temperament has at all times been remarkable,' declares the man who calls himself Wilson (it is not his real name, which he dislikes as much as he condemns himself). 'I grew self-willed, addicted to the wildest caprices, and a prey to the most ungovernable passions.' Wilson first encounters his double (bearing the same name and birth date) as a fellow pupil in a gothic school-house at Stoke Newington: this alter ego (who speaks always in a whisper) dogs his life at Eton, Oxford and on cosmopolitan travels across Europe until they meet for the last time at a masquerade held by a Neapolitan duke. As Wilson declares, 'my hereditary temperament rendered me more and more impatient of control'. When his guilty flirtation with the duchess is interrupted by the whispering doppelgänger, Wilson stabs him 'with brute ferocity repeatedly through and through his bosom'. He goes to lock the door against intruders, then turns back. 'A large mirror – so at first it seemed to me in my confusion – now stood where none had been perceptible before; and, as I stepped up to it in extremity of terror, mine own image, but with

features all pale and dabbled in blood, advanced to meet me with a feeble and tottering gait.' The duplicate Wilsons have swapped identities. The other Wilson, no longer whispering, declares 'henceforward art thou also dead – dead to the World, to Heaven and to Hope! In me didst thou exist – and, in my death, see by this image, which is thine own, how utterly thou has murdered thyself.' The Wilson story suggests to readers who are steeped in Calvinism that everyone is divided in two, the observer and the observed, and that the watcher is the only half with a conscience. Poe was a student of wilful self-destruction and intimately knew how humans become disorderly to spite themselves: 'perverseness is one of the primitive impulses of the human heart,' he declared with keen self-knowledge of 'this unfathomable longing of the soul *to vex itself* – to offer violence to its own nature – to do wrong for the wrong's sake only'. The doppelgänger can just as plausibly represent conscience's mischievous tricks: the climax of the tale is a caution that self-accusation leads to self-destruction, especially if conscience is twisted into that maudlin phoniness called alcoholic remorse. 'Essentially the one great quality Poe brought to his life and art is the peculiar histrionic ambivalence to feel vicarious experience as though it were his own and to feel his own experience as though it were vicarious,' Fagin recognised; and Poe's confusion of private experience with the experience of his audience offers another reading of 'William Wilson'. The narrator is the man who goes out in the world, and impresses; the whispering Wilson is the solitary individual who reproaches the public man, the private self whom few people meet and no one else recognises (at his most disruptive appearance at Oxford, for example, he is muffled in a coat and the candles all blow out). The duplicate Wilsons foreshadow the duplicate Clare Vawdrey in Henry James's story 'The Private Life', in which an author who needs a reclusive life if he is to succeed in his creativity acquires a doppelgänger who goes out in society and dazzles his audiences.

THE MASQUE OF THE RED DEATH

Poe's greatest gothic tales, as Fagin stressed, were like one-act plays in which he acted the parts of his characters. These histrionics came more easily if prompted by personal experience, but his intentions were always superior to personal revelation. Thus shortly after his wife haemorrhaged from her tubercular lungs while singing in January 1842, he wrote 'Life in Death' (later revised as 'The Oval Portrait') and

AN ANGLO AMALGAMATED PRODUCTION
VINCENT PRICE
in
'THE MASQUE OF THE RED DEATH'
Co-starring
HAZEL COURT JANE ASHER (X)
PRINT BY TECHNICOLOR
RELEASED BY WARNER - PATHE DISTRIBUTORS LTD

Vincent Price played the doomed prince in the film adaptation of
The Masque of the Red Death *(1964).*

'The Masque of the Red Death'. Both stories reflect his experience of this warning of his wife's mortality. 'The Masque' signals the personal element by the name of its central character, Prince Prospero, which spells Poe's surname twice. The story is overwhelming not only because of its elegance and brevity but because it transcends personal incidents. His tale is set in the epoch of a plague called the Red Death ('There were sharp pains, and sudden dizziness, and then profuse bleeding of the pores, with dissolution'). Prince Prospero and his courtiers sequester themselves in a castellated abbey, 'the creation of the prince's own eccentric yet august taste', and seal its walls and gates against outside contagion:

> The external world could take care of itself. In the meantime it was folly to
> grieve, or to think. The prince had provided all the appliances of pleasure.
> There were buffoons, there were improvisatori, there were ballet-dancers,

there were musicians, there was Beauty, there was wine. All these and security were within. Without was the 'Red Death'.

Prospero is superb but not invulnerable in his flight from the world:

> The tastes of the duke were peculiar. He had a fine eye for colors and effects. He disregarded the *decora* of mere fashion. His plans were bold and fiery, and his conceptions glowed with barbaric lustre. There are some who would have thought him mad. His followers felt that he was not. It was necessary to hear and see and touch him to be *sure* that he was not.

Like true goth protagonists, the prince and his courtiers are first elated and then haunted by the forbidden. As in 'William Wilson', the final crisis is reached at a masque. After a carefree interval the prince holds a voluptuous masquerade for his followers. This is set in seven glorious interconnecting rooms decorated luxuriantly in turn: blue, purple, green, orange, white, violet and black; each chamber has imposing gothic windows with stained glass of matching colours, except the room of black velvet, where the panes are blood-crimson. 'Be sure they were grotesque,' Poe writes of the masqueraders.

> There were much glare and glitter and piquancy and phantasm . . . There were arabesque figures with unsuited limbs and appointments. There were delirious fancies such as the madman fashions. There were much of the beautiful, much of the wanton, much of the *bizarre*, something of the terrible, and not a little of that which might have excited disgust.

After an interloper appears at these revels dressed as the Red Death ('His vesture was dabbled in *blood* – and his broad brow, with all the features of the face, was besprinkled with the scarlet horror'), Prince Prospero challenges him with a dagger but immediately dies. The courtiers who then rush to seize the mummer of Red Death gasp 'in unutterable horror at finding the grave-cerements and corpse-like mask which they handled with so violent a rudeness, untenanted by any tangible form'. The story closes with a final paragraph of implacable comfortlessness:

> And now was acknowledged the presence of the Red Death. He had come like a thief in the night. And one by one dropped the revellers in the blood-bedewed halls of their revel, and died each in the despairing posture of his

fall. And the life of the ebony clock went out with that of the last of the gay. And the flames of the tripods expired. And Darkness and Decay and the Red Death held illimitable dominion over all.

'The Masque of the Red Death' is so suggestive that it is susceptible to each reader's individual meaning. At its puritan plainest it instructs that sybaritism is always punished; Prince Prospero and his courtiers receive the sort of retribution that has gratified harsh moralists ever since the pleasure-loving son of King Henry I of England drowned with his followers in the White Ship in 1119. Prince Prospero satisfies the philistine's idea of a rich aesthete: surfeited with power, supremely self-ish, not so much cruel as indifferent to the suffering of others, dangerously disdain-ful of mankind, nervous and restless in seeking after novelty and sensation. The destruction of Prince Prospero's elaborate imaginative world similarly satisfies the vindictive resentment of the unimaginative who like to disrupt what is precious or sacrosanct. For less austere Puritans, Poe's moral is that one cannot shirk responsi-bility for other people's suffering; for the critical biographer, 'The Red Death' recalls Poe's self-reproach at his reluctance to admit the illimitable dominion of decay and the red death over his wife; for other readers, it indicates that the external world will not, as Prince Prospero hopes, take care of itself but instead stresses the fragility of the internal life's semblance of security. Roger Corman in his film version of 1964 depicted the prince as a sadist and his courtiers as devil-worshippers. The hints of sexual transgression provoke other interpretations about punishment. The meaning is most, as Heidegger says, where the interpretations lie thickest: 'The Masque of the Red Death' is a masterpiece.

THE FALL OF THE HOUSE OF USHER

There is a comparable personal ingredient in the idea of Poe's best-known story, 'The Fall of the House of Usher' (1839), as well as a European goth antecedent. His French admirers, the Goncourt brothers, shrewdly nicknamed Poe 'Hoffmann-Barnum', for he always represented a conjunction of the Baltic goth with the American showman. E.T.A. Hoffmann's story 'Das Majorat' (1817), known in English as 'The Entail', had an uncomfortable autobiographical resonance for Poe. Hoffmann, who had trained as a lawyer, recounted the legalistic history of Rossitten castle, the dismal ancestral seat of the von Ross family situated on a desolate stretch

'But then without those doors did stand the lofty and enshrouded figure of the Lady Madeline of Usher.' Harry Clarke's 1919 illustration of Poe's story.

of the Baltic coast with black pines and firs encroaching on its very walls. Violent, misanthropic Roderick, Baron von Ross, affixed an entail on the Rossitten estate after being banished from his other property at Courland for practising black arts. Old Roderick was an amateur astronomer, and on the night in 1760 when he was found dead the tower containing his observatory crashed down, creating a chasm eighty feet deep through the castle. As a result of his entail his descendants cannot dispose of Rossitten. This restriction causes quarrels between his sons, Wolfgang and Hubert, until Wolfgang is killed by being kicked into the castle chasm by his father's loyal old servant Daniel, who is enraged at the attempted circumvention of the entail. Daniel's ghost subsequently disturbs generations at the castle by emitting dire groans from behind the walls.

Under the entail, Hubert succeeds Wolfgang in possession of the castle: after his death Hubert leaves a contentious document asserting that Wolfgang had contracted a clandestine marriage with a Swiss woman, and had fathered a son, young Roderick, who is the rightful holder of Rossitten. A great legal contest for inheritance ensues. Hubert's son claims that young Roderick is a pretender, not really Wolfgang's son, but Hubert's bastard child, upon whom he wished in contrition to bestow this rich entail by spurious means. After several deaths Roderick takes possession of Rossitten, and marries his first cousin Seraphine, thus uniting the discordant branches of the family. Young Roderick, however, lives in dread of disaster and Seraphine is an excessively volatile gothic victim. In 1790 the family's legal adviser, Voetheri, visits the castle accompanied by his nephew, Theodor. This youth is terrified by Daniel's groans, and fancying himself in love with Seraphine behaves like a self-important, overheated coxcomb. (There is some resemblance to Poe's own self-conscious romantic posturing with married ladies.) Seraphine is eventually destroyed by the evil of the entail – she imagines that old Roderick's ghost is in pursuit when she is out sledging and is killed by overturning the sledge – and after her widower has wasted away in apathy, the old baronial family becomes extinct and Rossitten disintegrates. 'Miserable, blind Roderick!' Theodor exclaims of the founder of the entail in closing his narrative. 'What evil powers did you conjure up, poisoning your stock in its earliest roots, that stock that you intended to plant firm-rooted for eternity!'

Sir Walter Scott in 1827 had written an article criticising Hoffmann, which Poe probably read; Scott's account of Rossitten – 'a tower built for the purpose of astrol-

ogy by one of its old possessors, the founder of the majorat in question, had fallen down, and by its fall made a deep chasm, which extended from the highest turret down to the dungeon' – is immediately suggestive of the zigzag fissure in Poe's House of Usher. There are other common points, the name of Roderick not least. Hoffmann's story (particularly the complications of the entail after the deaths of Wolfgang and Hubert) had a personal meaning for Poe. It will be recollected that Poe had been reared under the protection of a plutocrat called John Allan: though this adoption was never legally formalised, he took his protector's surname as a middle name. Allan, when he bought his fine house outside Richmond in Virginia, erected a telescope on the portico of its pillared front so that he could study the stars (evoking Roderick with his telescope in the tower at Rossitten). Poe was devoted to Mrs Allan, whom he called 'Ma' until her death in 1829; the following year, Allan remarried and swiftly fathered three children. This remarriage was a turning-point in Poe's life, for he had depended on his foster-father for attention and the money which he equated with love. But his prolonged adolescent delinquencies had over-taxed Allan, and soon they were permanently estranged. Poe turned for consolation to his Aunt Clemm, whose daughter he eventually married; but the recriminations exchanged between Poe and Allan had a sequel of terrible formality and material disaster for Poe. After Allan's death in 1834 he discovered that he had been excluded from his foster-father's will. This testament, however, was so confusingly drawn that it was overturned by Allan's widow, who resented its provisions for an illegitimate child of Allan's. Nor would she be reconciled with the foster-son. Though he continued to use the name of Allan, the usurper's pretensions were repudiated by the authentic family. His hopes of security were painfully cheated.

Ostensibly Poe's version of Hoffmann is a horror story about the decay into insanity of an old, overbred, insular and morbid family who are controlled by the property they own. The House of Usher is not a power house for the Ushers, but a house with such an overpowering atmosphere that it dominates the family. Only two members survive, twins called Madeline and Roderick, and it can seem that they and the house share a single indissoluble identity. Madeline has been long ail-ing, and after Roderick (who claims to adore her but seems merely obsessive) announces her death to the narrator, he seals her corpse in a vault of his house. She has in fact entered a cataleptic trance and has been entombed alive; Roderick can

hear her agonised cries, dares not rescue her, prowls the house in a mad extremity of terror and guilt. Finally she escapes from her coffin and breaks in on him:

> There was blood upon her white robes, and the evidence of some bitter struggle upon every portion of her emaciated frame. For a moment she remained trembling and reeling to and fro upon the threshold – then, with a low moaning cry, fell heavily inward upon the person of her brother, and in her violent and now final death-agonies, bore him to the floor a corpse, and a victim to the terrors he had anticipated.

Immediately a zigzag crack in the House of Usher rapidly widens, and splits it asunder as thoroughly as the falling tower at Rossitten. This wreck of the house can represent the final wreck of Roderick Usher's sanity. Living entombment, underground vaults, trances, stormy weather, phantasmagoric furnishings and vibrating hysteria all enforce the gothic of the tale.

It is yet another accretion to American gothic's version of family life in which professedly loving relations are a destructive evil. The reality of the Ushers, as of much family life when stripped of its religious idealisation or political sanctimony, is that hatred can be concentrated most intensely among those with blood ties; that the family is an institution potentially destructive of true affection, a nexus of possessiveness, spite and jealousy. 'Hate is as inordinate as love, and as slowly consuming, as secret, as underground, as subtle,' D. H. Lawrence commented of the Ushers. 'All this underground vault business in Poe only symbolizes that which takes place *beneath* the consciousness. On top, all is fair-spoken. Beneath, there is awful murderous extremity of burying alive.' Moreover, the House of Usher entrenched a distinct tradition of American gothic imagery. Just as their ancestral home seems to have appropriated the twins' souls, so in Faulkner's novels of Yoknapatawpha County the southerners' souls after the American Civil War take on the vacancy of empty buildings. 'Quentin had grown up with that; the mere names were interchangeable and almost myriad. His childhood was full of them; his very body was an empty hall echoing with sonorous defeated names; he was not a being, an entity, he was a commonwealth. He was a barracks filled with stubborn, backward-looking ghosts.'

Something *is* wrong in the Usher family, and it is not simply the implication of incest so familiar in gothic fiction and so swiftly identifiable by twentieth-century readers. Nor is a morbid obsession with parental power the Ushers' most irremedia-

ble fault. Their transgression is more mercenary and legalistic than erotic or psychodramatic. The inspiration for Poe's story is his own traumatically expensive rejection as a sham-Allan reworked in the light of Hoffmann's story of the entail.

Roderick Usher declares that he is suffering 'a constitutional and a family evil . . . for which he despaired to find a remedy', then immediately qualifies himself, 'a mere nervous affection', he says dismissively, as if shying away from the truth. The narrator summarises Usher's condition: 'enchained by certain superstitious impressions in regard to the dwelling which he tenanted, and whence, for many years, he had never ventured forth – in regard to an influence whose supposititious force was conveyed in terms too shadowy here to be re-stated'. Supposititious is a very arresting word. Its dictionary definition is: 'put by artifice in the place of another; fraudulently substituted for the genuine thing or person; hence, pretended (to be what it is not); not genuine, spurious, counterfeit, false . . . spec. of child, esp. one set up to displace the real heir or successor'. Though Roderick Usher may have talked of this problem in only shadowy words, we are left in no doubt of the point when shortly afterwards he recites 'The Haunted Palace', a poem which provides a crux for the story.

Hearing this recital, his friend comments, 'I perceived, and for the first time, a full consciousness on the part of Usher of the tottering of his lofty reason upon her throne.' Poe declared that 'The Haunted Palace' represented a disordered mind haunted by phantoms, yet the poem also addresses that original gothic subject, usurpation. It tells the story of a 'radiant palace' where all is joy and everyone sings 'in voices of surpassing beauty' of 'the wit and wisdom of their king'. After 'the monarch's high estate' is 'assailed', he dies and then 'a dim-remembered story' is disinterred: palace life becomes 'discordant' and 'ghastly'. The poem is written in plain language, except for one word which demands attention by being the only word in the sixth line of the third verse: 'Porphyrogene!' (meaning 'born in the purple', or specifically a male heir of the Byzantine dynasty). This obtrusive polysyllable vigorously signals that the challenge mounted to the monarch which so swiftly killed him, like the old rumours which were then recalled, was the accusation that he was a bastard usurper. Hence the laughter of the 'hideous throng' at the palace with which the poem closes is derision of legitimate rulers. Poe, then, is reverting to the anxieties surrounding illegitimacy and usurpation of property that characterised traditional English gothic; but superior layers of newer meaning are imposed upon

it too. Roderick's pun in declaring that he is 'suffering from a family and constitutional evil' refers less to his physical constitution than to the legal constitutions of documents, parchments, dynastic powers, ownership. He is Manfred, the usurper of Otranto, redesigned to conjure the anxieties of nineteenth-century Americans: a febrile, histrionic man killed by his circumstances. The severity of the Puritan conscience unites with the duplicity of his ancestors to fill him with the helpless terror of a man who is guilty at his own existence, who knows that he should not be.

Poe's psychological acuity created 'a new literary world, pointing to the literature of the twentieth century', the Goncourt brothers reflected in their journal as early as 1856. Faulkner from the 1920s provided another bridge between two centuries. His novels depict (in his own description) 'the deep South dead since 1865 . . . peopled with garrulous outraged baffled ghosts'. Individuals in the American south were tyrannised by the community with lynchings, tar-and-feather and other group barbarities, and more subtly but no less harshly controlled by the southern gentleman's code of honour. Family histories in American gothic were vampiric, destructive, implacable – and this despite the impropriety for Americans of accepting a definition of life synonymous with pain. Religion and sex raised the oppressive host of destructive anxieties and rages which one of Faulkner's characters deplores:

> the principles of honor, decorum and gentleness applied to perfectly normal human instinct which you Anglo-Saxons insist upon calling lust and in whose service you revert in sabbaticals to the primordial caverns, the fall from what you call grace fogged and clouded by Heaven-defying words of extenuation and explanation, the return to grace heralded by Heaven-placating cries of satiated abasement and flagellation, in neither of which – the defiance or the placation – can Heaven find interest or even, after the first two or three times, diversion.

SOUTHERN GOTHIC

The death-wish of the American south was exemplified in real life by the melancholy house of Percy. Its progenitor Charles Percy was an Irish footsoldier who drifted to the Mississippi Delta, where he was granted land in 1777. He already had wives in both the British Isles and the Bermudas when he married a teenage heiress in 1780. His deserted son, Robert, in fulfilment of a promise to his dying mother,

tracked his father to his plantation in 1790 and later settled nearby. Charles Percy became entangled in a fierce neighbourly feud and committed suicide in 1794 by jumping into a creek with an iron pot tied to him. Robert Percy's descendants were the legitimists, although the children of the bigamous last marriage inherited the money. Self-destructive depression became a hereditary Percy taint. Men of each generation killed themselves; their sisters more moderately were confined in the Phipps Psychiatric Clinic. For over a century, until the 1940s, the average life span of a male Percy was thirty-nine. The only male Percy to reach his sixties was Senator Leroy Percy who stopped eating after a series of family funerals in 1929 and consequently died at the age of sixty-eight. Perhaps the true hereditary taint of Charles Percy's descendants was that these early suicides represented for their children a stupefying cessation of love.

One family member notably imagined their predicament in gothicised terms. Catherine Ann Warfield explored her ancestral miseries in a popular novel of 783 pages, *The Household of Bouverie* (1860). With its depiction of isolation, madness and incest, it bore the conscious influence of Maturin and Beckford, and included scenes about the upbringing of the heroine (romantically named Lillian de Courcy) in a dismal castle in northern England intended 'to gratify American female Anglophiles who relished in their fantasies anything steeped in the high-toned customs of the English gentry'. The heroine comes to live on a plantation in a southern American state, where the servants are white and there are no slave characters. She discovers that her supposedly dead grandfather is secretly living on an upper floor of their house. Erastus Bouverie (his character is an amalgam of the author's haughty, reclusive father, her suicidal Percy grandfather and her putative kinsman, the 'Wizard Earl' of Northumberland who experimented with alchemy while imprisoned in the Tower of London after the Gunpowder Plot) is a Brontesque madman engaged in alchemical experiments with human blood and gold to find an elixir of eternal youth. Erastus Bouverie is both a tyrant and a dependent: in Bertram Wyatt-Brown's summary, he 'has murdered not one but two of his wife Camilla's suitors, poisoned her canary and her pet dog, spirited away their baby daughter (Lillian's mother) to England and staged a false funeral to deceive his wife, and rendered Camilla's later adopted two-year-old boy Jason mute with jolts of electricity from a galvanic battery'. Yet there is nothing masterful or indomitable about him. 'He is a querulous patriarch cowering in his hide-away in the upper galleries, completely

dependent upon the reluctant loyalty of a wife whose love for him had disappeared.' Warfield raised the gothic themes of vampirism, incest, masochistic secretiveness and inept masculinity, but her book's chief importance lies in its contact with Faulkner's imaginative world: Henry Sutpen secreted in Sutpen's Hundred for half a century after killing Charles Bon is Erastus Bouverie redevised by Faulkner's genius.

Faulkner was too versatile and original to be equated with goths like Lewis or Maturin, yet gothic's constituent parts are traceable in his greatest books, and he exalted its powers. His arch-villain Thomas Sutpen represents the southern states' version of European gothic's feudal absolutists, 'a baronage based upon slavery'. He is the progenitor of a family whose tainted blood and befouled souls would always 'accomplish the hereditary evil and harm under another name, and upon and

In the plantation houses of southern American gothic the last guest to arrive is terror. The best of all literature set in these mansions explores the meaning of the Fall. 'All good biography, as all good fiction, comes down to the study of original sin, of our inherent disposition to choose death when we ought to choose life.' Rebecca West (1941). A plantation residence by Isaac Hobbes and sons in Godley's Ladies Book, 1876.

among people who had never heard the right one'. Relations between Sutpen and his son, Henry, are Salvatorian: 'the inexplicable thunderhead of interdictions and defiances and repudiations out of which the rocklike Sutpen and the volatile and violent Henry flashed and glared and ceased'. The destruction from this storm overwhelms the bystanders, and still kills Faulkner's characters in the twentieth century. Although Henry 'repudiate[s] his house and birthright', he is doomed for fifty years to endure a miserable, clandestine life secreted in the property he has spurned. It is a mean and sordid gothic incarceration, though less sadistic than those of the monk's victims in Lewis's novel. Guilt and evil may recede from the wicked intentions of their originator, but they accumulate a sinister, imprecise destructive power which constitutes family destiny: free-will seems no more than a pedant's theory. Although moments before being killed with a scythe by his slave, Henry Sutpen 'realized at last that there must be some limit even to the capabilities of a demon for doing harm', he remains 'the evil's source and head which had outlasted all its victims'.

The Dark House was the title originally intended by Faulkner for the novel that became *Absalom, Absalom!* Its characters live in vicious boredom tremulous with the promise of violence. Their predicament is embodied by the house called Sutpen's Hundred: 'rotting portico and scaling walls, it stood, not ravaged, not invaded, marked by no bullet nor soldier's iron heel but rather as though reserved for something more: some desolation more profound than ruin'. Like the Wielands, Faulkner's families become disintegrated communities in which the leading members are isolated, sustained by internalised dramas, with other people merely details in their fantasy lives. Gothic histrionics reduce both people and impersonal forces to theatrical forms. Rosa Coldfield wears her body 'like a costume borrowed at the last moment and of necessity for a masquerade she did not want to attend'. Thomas Sutpen – ostensibly a powerful man in his district – is a strolling player who has not guessed his doom waiting in the final act: 'while he was still playing the scene to the audience, behind him Fate, destiny, retribution, irony – the stage manager, call him what you will – was already striking the set and dragging on the synthetic and spurious shadows and shapes of the next one'. Faulkner's family gothic resembled Poe too: he declared of the Sutpens, 'it was no tale about women, and certainly not about love'. Walpole's gothic theme of submission is perpetuated by Faulkner, though with none of the camp English nobleman's teasing irony. Thus Quentin

Compson reflects before his suicide in *The Sound and the Fury*, 'a nigger is not so much a person as a form of behaviour; a sort of obverse reflection of the white people he lives among'. The strongest character in this novel is the black servant Dilsey, an old woman resembling the servants at Otranto in her subservience to employers who, like Walpole's Manfred, cannot control themselves. Her employers surrender in life even before they are vanquished; yet she is empowered by her submission and finally, when the Compsons fall into ruins like the Ushers, Dilsey achieves mastery over the masters.

Racial doubleness became inseparable from haunted families in southern gothic. In one of Flannery O'Connor's superb short stories, 'Everything That Rises Must Converge', a snobbish and silly old woman lives in a dingy, *déclassé* neighbourhood claustrophobically confined with her conceited, despairing, irritable son, Julian. Like dispossessed Anglo-Irish gentry they are haunted by the 'decayed mansion' in which their ancestors once lived. '"You remain what you are," she said. "Your great-grandfather had a plantation and two hundred slaves."' Julian, who dreams of the 'threadbare elegance' of the old house, 'never spoke of it without contempt or thought of it without longing'. One evening, when she is bedecked in a 'hideous' purple and green velvet hat, they ride a bus on which she patronises the black passengers, 'holding herself very erect under the preposterous hat, wearing it like a banner of her imaginary dignity'. She is so appalled to find a sullen black woman sporting identical headwear that she offers a penny to her counterpart's little boy. 'The huge woman turned and for a moment stood, her shoulders lifted and her face frozen with frustrated rage, and stared at Julian's mother. Then all at once she seemed to explode like a piece of machinery that had been given one ounce of pressure too much.' She punches the old woman. Julian starts lecturing his mother:

'Don't think that was just an uppity Negro woman,' he said. 'That was the whole colored race which will no longer take your condescending pennies. That was your black double. She can wear the same hat as you, and to be sure,' he added gratuitously (because he thought it was funny), 'it looked better on her than it did on you. What all this means,' he said, 'is that the old world is gone. The old manners are obsolete and your graciousness is not worth a damn.' He thought bitterly of the house that had been lost for him. 'You aren't who you think you are,' he said.

'Tell Grandpa to come get me,' she replies, and he realises she is dying of a stroke. 'The tide of darkness seemed to sweep him back to her, postponing from moment to moment his entry into the world of guilt and sorrow.'

We'd rather have the iceberg than the ship

Unbar the Gates of Memory: look upon me
Not as another, but thy real Self. I am thy Spectre.
William Blake

Khartoum, September 25, 1884. An escaped soldier came in from the Arabs . . . He saw himself in the mirror and asked who it was; said he did not know! and really he did not seem to know. It stands to reason that in countries where there are no mirrors every one must be a complete stranger to himself and would need an introduction.
General Charles Gordon

'Good-bye,' says the dying man to the mirror they held in front of him.
'We won't be seeing each other any more.'
Paul Valéry

INTERIOR GHOSTS

'There is a devil in all of us which only needs to be let loose, and likes the letting,' the *Spectator* noted in 1886 in an article which shows the sea-change in gothic that was occurring in the late nineteenth century. It was still a prevalent feeling, so the *Spectator* reported, that the mob 'will be specially wicked, more wicked than any of its compound individuals, more thievish, more cruel, more murderous. That idea, quite universal in Europe, and the first cause of the dread of mobs, is not born of terror only, but is more or less substantially true.' Fear of mob-rule is not an exclusively gothic phenomenon: writers as various as Matthew Arnold, Baudelaire and José Ortega y Gasset have denounced the masses. Nevertheless, this horror remained central to gothic anxiety in epochs when property was recognised as more

important and exciting than sex. With the proliferating discourse on sexualities characteristic of the late nineteenth century, which reached its acme in the twentieth, horror of individuals became more pronounced. This new emphasis in the history of anxiety was reflected in the *Spectator*'s comparison of the mob to mad individuals in whom the devil had got loose:

> Scarcely any man has the nerve to face a true maniac – a most unusual character, happily – and a mob in fury either is, or to its victim seems to be, a true maniac. It is acting under an impulse which is not reason, and to which reason is no counterpoise; and to man . . . this is always terrible, and usually, unless he can in turn apply terror to his enemy, irresistibly so.

Since then, fear of the mob has ebbed, risen again and receded once more. By the late twentieth century, in western industrialised democracies at least, 'élitist' rather than 'mob' has become a word of abuse. For the Germans during the Nazi period, or for the British in the week after the death of Diana, Princess of Wales, mass hysteria was elevated to high ethical and political power.

The dread of a crowd's capacity for animality or devilry has been replaced by dread of solitary, self-involved secret selves. Individuals' strange, violent behaviour and disturbed psyches have always dominated gothic manners; gothic has had a constant histrionic appeal to the jejune orders of humanity who are always looking forward to the next emotional crisis. Goth artistic consumers have seldom recognised sanity as an aesthetic accomplishment. But American gothic's obsession with the inner springs of family life – its imagery of the haunted psyche derived from Hawthorne and Poe – developed new objects of anxiety: already in the 1860s Emily Dickinson had written:

> One need not be a Chamber – to be Haunted –
> One need not be a House –
> The Brain has Corridors – surpassing
> Material Place –

> Far safer, of a Midnight Meeting
> External Ghost
> Than its interior Confronting –
> That Cooler Host.

Far safer, through an Abbey gallop,
The Stones a'chase –
Than Unarmed, one's a'self encounter –
In lonesome Place –

Ourself behind ourself, concealed –
Should startle most –
Assassin hid in our Apartment
Be Horror's least.

The Body – borrows a Revolver –
He bolts the Door –
O'erlooking a superior spectre,
Or More—

For much of the twentieth century what we have feared most, as depicted by gothic artists, is ourselves.

Creative thinkers before Freud realised that the objective facts of human life – the birth and death dates of an individual, the nationality, the class, the religion – were mediated by the personal fantasies that subsumed them. Increasingly, the outward life has been seen as a social performance in which economic, cultural and institutional resources are treated as stage props in the drama of febrile inner subjectivity. In earlier times Bernard of Clairvaux, the self-absorbed medieval cleric of whom it was said that he could walk all day by the lake at Geneva and never notice Lake Leman, seemed eccentric. But by the twentieth century such self-centredness has become commonplace, sanctioned as a means of self-improvement, or as signs of self-approval, indeed an internalised extension to the First Amendment of the US Constitution guaranteeing liberty of thought and speech. The legitimation among English-speaking peoples of this scouring, self-conscious introspection has led to a more acute awareness of the fragmentation of inner human experiences. Gothic has thus become an aesthetic of interior disorientation and divided selves. 'The premise of Gothic's double psychology' is, as Mark Edmundson has written, 'that we are all playing a role in life, that inside a raving beast waits for the chains to loosen': in consequence 'we ought to be very afraid – and of nothing so much as ourselves'. Milena Kalinovska has similarly concluded of a recent gothic art exhibition

in Boston, 'what we fear most, and what these artists depict, is indeed ourselves'.

The last words attributed to the Mexican revolutionary bandit Pancho Villa when he was killed in 1923 are emblematic of the twentieth century. 'Don't let it end like this,' he beseeched a journalist. 'Tell them I said something.' Pancho Villa's desperation as he died was the despair of self-conscious excess. His death too was a set-piece: an ambush in the streets of Parral carefully directed by a theatrical assassin, Deputy Jesús Salas Barrazas, who had long dreamed of celebrity as 'The-Man-Who-Killed-Pancho-Villa'. Bazarras burst out from his hide-out, racing ahead of his men, to deliver the exquisite *coup de grâce*. 'Carefully, with an air of connoisseurship, he plants four pistol shots in that bowed massive head', as Edgcumb Pinchon and Odo Stade described. The aftermath was also a histrionic spectacle:

> While the gendarmerie, strangely obliging, hold back the crowd, reporters' cameras click. The death car – dripping blood in the dust like a slaughtered bull – its occupants still untouched – is snapped from every angle. Then – again most strangely – the bodies are taken to the Hotel Hidalgo, stripped, and again placed on view! Throughout the day the townsfolk surge by this dimeshow catafalque, some to gloat, some to while an idle hour, some to sate their horror-lust . . . All day sightseers' cameras snap the image of the stallion torso and unconquerable head – jaws open.

Self-consciousness had so advanced by the twentieth century that Pancho Villa, in his death-throes, was still looking at himself, worrying about the heroic figure he was making, seeing himself as the central figure in a drama, acting the heroism he had admired in other people. Pancho Villa was split into two men: he was a dying man; he was also a man watching a dying man. Twentieth-century gothic has reflected this human self-absorption, initially with fascination, and latterly with antagonism. It even provided a counterpart to the death of Pancho Villa in the film *Vampyr*, first shown in Berlin in 1932.

Devised by the Danish film-maker Carl Dreyer (1889–1968), *Vampyr* metamorphosed Le Fanu's beautifully happy aristocratic vampire Carmilla into a hideous old crone to re-emphasise one of Dreyer's cinematic themes: that the power of individual imagination changes each and every perception. *Vampyr*, with its misty, ominous photography presenting a succession of memorable, hallucinatory and alarming scenes, is an exploration of inner psychological states. In the superb phase

Georg Groddeck, whose ideas had such influence among the Berlin intelligentsia of the 1920s, declared 'Whatever you blame, you have done yourself.' The hallucinatory coffin scene from Carl Dreyer's Vampyr *was a superb evocation of traditional gothic claustrophobia, but more crucially it also conveyed the new obsessions of the twentieth-century goth: the disturbed psyches of divided selves, and the splitting of human identity.*

of the film that provides Dreyer's counterpart to the death of Pancho Villa, its hero, Nikolaus, is lying unconscious on the ground when his body suddenly divides in two. One part, representing his 'ego', remains prone, while the other (his dream) gets up. Nikolaus's splitting develops as a dream of disassociation, incongruity and unsettlement: because it is a dream sequence, Nikolaus can treat himself as a mourned object just as Pancho Villa treated himself as a heroic object. The dream Nikolaus goes to his antagonist's house where, finding a coffin, he 'draws aside the cloth covering the corpse's face' and sees the face of his ego 'rigid and open-eyed . . . wax-pale on the shavings in the black coffin'. His evil antagonists return, and dream Nikolaus retreats under a cellar trap-door to watch. The voyeurism is dual, for in his coffin the dead man can see what is transpiring, too, through a square pane of glass in the lid:

From down in the coffin Nikolaus sees the lid dropped into position over him. He hears the dull blows, first of a hand, then of a hammer, before the lid slips into the groove . . . Now Nikolaus hears, as he lies in his coffin, the lid being screwed down, hears the cutting and screeching noise of the screws, as one by one they bore into the wood. It is impossible to imagine a death sentence having a more paralysing effect than this sound. At intervals he sees through the glass the elbow of the arm turning the screw . . . now various men can be seen coming and stationing themselves on either side of the coffin.

The coffin is to be carried through the adjoining door, where at this moment Nikolaus is hiding under the trap-door. To clear the way the man with the wooden leg goes over to the trap-door. With his wooden leg he kicks away the wooden block holding the trap-door open, and the trap-door closes over Nikolaus. The man gives the door a push so that it comes directly over the trap-door, which in consequence cannot be opened.

The claustrophobic gothic closure of this phase of the film anticipates the slow, pitiless visual horror of *Vampyr*'s consummate climax in which the evil male protagonist is slowly suffocated by white flour falling down on him from an overhead sieve inside a mill.

People splitting themselves into different parts – whether Pancho Villa, Nikolaus or neurotics into self-images of the very good and the very bad – reinforced the recognition that human identity has no organic unity. Gothic had included internalised notions of punishment and metaphysical imprisonment since Piranesi and Beckford, but Hell became more intimately personal in the twentieth century. 'Hell is very likely filled with people who have not carried out what they meant to do,' Karen Blixen wrote in her gothic tale 'The Roads around Pisa'. Sin became equated with neurosis. 'The obvious aesthetic image for a damned soul is not a prisoner being tortured by sadists but a neurotic who defiantly clings to his neurosis though it makes him suffer,' Auden said in 1955. Auden was thinking of the alcoholism of his companion Chester Kallman when he formulated this thought, which raises another decisive phase of the sea-change in gothic: the substitution for the old gothic term 'haunted' of the twentieth-century catch-all 'addicted'.

JEKYLL AND HYDE: SHADOW SOULS

All these trends in twentieth-century gothic were foreshadowed by Robert Louis Stevenson (1850–94). His imaginative *tour de force*, *The Strange Case of Dr Jekyll and Mr Hyde*, sold 40,000 copies in a few months in 1886, was quoted in pulpits by sermonisers and was believed by credulous people to be a true story. It mirrored a renewed interest in arcana – the Society for Psychical Research had been founded in 1882 – but its strongest power lay in providing such a flexible, resilient model of evil duality (surpassing Théophile Gautier's 'Le Chevalier Double', which Stevenson knew, and Poe's 'William Wilson'). Stevenson had long been aware of his own duality – had 'two hand-writings', for example, expressive of different moods – and wrote his story with as much serious ambition as Bram Stoker when a few years later he meticulously planned *Dracula*. Stevenson personified *Jekyll and Hyde* as 'a gothic gnome' who 'came out of a deep mine, where he guards the fountain of tears'. He confessed in 1886 to a 'morbid preoccupation' with 'ethics' (attributable to his Scottish Presbyterianism) which 'came out plain in *Dr. Jekyll*; the XIXth century probably baffled me even there, and in most other places baffles me entirely'. Although generous in his personal life, Stevenson was severe in his ethical judgements on humanity, and enough of a puritan to write public letters to newspapers criticising aristocrats in divorce trials. He thought that humankind degraded itself by living with cowardly passive inauthenticity. 'My life is but a travesty and a slander on myself,' exclaims the title character of his gothic story, 'Markheim' (1884):

> I have lived to belie my nature. All men do; all men are better than this disguise, that grows about and stifles them. You see each dragged away by life, like one whom bravos have seized and muffled in a cloak. If they had their own control – if you could see their faces, they would be altogether different, they would shine out for heroes and saints!

His analysis of Markheim's ethical problems disturbed the public's latent fears: the posters carried by sandwich-men in the London streets advertising the story's imminent publication were suppressed by police as too horrific.

'Man is not truly one, but truly two,' Stevenson wrote in *Jekyll and Hyde*, in which he depicts 'the thorough and primitive duality of man'. Its central character, Henry Jekyll, is a Fellow of the Royal Society who holds doctorates in medicine and law.

An illustration for an early edition of The Strange Case of Dr Jekyll and
Mr Hyde *carrying the caption 'the horror of my other self'. Stevenson describes Hyde
as inscribed with 'Satan's signature' and felt that most people carried in them the germ
of satanic self-destruction. He saw the possibility of division and ruin in every cheerful
comfort: 'Marriage is a step so grave and decisive that it attracts light-headed variable
men by its very awfulness.'*

He is an intellectual power commanding a private fortune whose life has been built on self-mortifying controls. Long fascinated by the duality of human character, he devises a potion which transforms him body and soul from high-minded asceticism into vicious excess. 'My devil had long been caged, he came out roaring', Jekyll describes after he has made contact through chemical experiments with his darker self. 'The spirit of hell awoke in me and raged. With a transport of glee I mauled the unresisting body, tasting delight from every blow . . . at once glorying and trembling, my lust of evil gratified and stimulated, my love of life screwed to the topmost peg.' His double, Edward Hyde, is the ogre of latency smouldering under civilised repression. He represents Jekyll's subconscious, a haunting enemy whose monstrosity is unspecific: 'the brute that slept within me.' As the doppelgänger effect gains power, and Jekyll involuntarily becomes Hyde whenever he goes to sleep, he develops 'horror of my other self' and of sleep itself. Jekyll considers Hyde 'not only hellish but inorganic. That was the shocking thing: that the slime of the pit seemed to utter cries and voices; that the amorphous dust gesticulated and sinned; that what was dead, and had no shape, should usurp the offices of life.' Given the story's emphasis on sleep and the unconscious, it is interesting that Stevenson declared in 1885 'that the main incident occurred in a nightmare: indigestion has its uses. I woke up, and before I went to sleep again, the story was complete'. (*The Castle of Otranto* came to Walpole in a dream; Fuseli imagined his incubus in a dyspeptic nightmare after eating raw pork chops; Stoker devised his vampire during a bad night after eating crabs.)

Jekyll and Hyde was written in 'an age', as Stevenson described in 1886, 'morbidly preoccupied with sexual affairs'. (Krafft-Ebing's *Psychopathia Sexualis* was published in the same year.) He believed that without 'manly sensibility' both Britain and individuals would fall into 'ineffable shame'. Anxieties about ambiguous masculinity contributed to his theme of duality. Jekyll lives in a rich, discreet bachelor household: his servants are accustomed to 'the coming and going of my second self'. Yet some inexplicit oddness in his life has gradually isolated him from his friends. To others, his oddity seems dubious. His legal adviser fears that his attachment to the young, rough Hyde implies a secret 'disgrace'. Jekyll almost seems to confirm this: 'You must suffer me to go my own dark way. I have brought on myself a punishment and a danger that I cannot name. If I am the chief of sinners, then I am the chief of sufferers also.' Homosexuality at this time was often indicated by a Latin

tag translatable as 'a crime not to be named among Christians', and it is reasonable to suppose that the vice too dangerous to name into which Jekyll sinks is sexual. 'It is one of those affairs that cannot be mended by talking.' He calls himself 'committed to a profound duplicity of life . . . a deeper trench than in the majority of men severed in me those provinces of good and ill which divide and compound man's dual nature'. The Victorians' obsession with masculinity was vehement and over-wrought: they recoiled with fear from emotional attitudes smacking of bisexuality, let alone sexual acts. When Jekyll declares that 'it was the curse of mankind that these incongruous fagots were thus bound together – that in the agonised womb of consciousness these polar twins should be continuously struggling', the antithetical twins can be either sexual preferences or emotional tensions represented by dominance and passivity.

The novella can be read, too, as a parable about the self-immolation of alcoholism. The references to Jekyll's drinking habits and the reminders of Hyde's 'brutish, physical insensibility' point to inebriation. A drunkard is someone who, during a binge, reveals his latent ogre, and afterwards, in remorseful bouts, is shocked by what his alter ego has done. The vice of drunkenness by degrees assumes control of human character. As Jekyll takes more secret libations of his potion he has a horrible realisation that 'the balance of my nature might be permanently overthrown'. He is appalled by the violence of ogre Hyde; yet if he has to choose between his two selves, he cannot forsake vice:

> To cast in my lot with Jekyll was to die to those appetites which I had long secretly indulged, and had of late begun to pamper. To cast it in with Hyde was to die to a thousand interests and aspirations, and to become, at a blow and for ever, despised . . . while Jekyll would suffer smartingly in the fires of abstinence, Hyde would not even be conscious of all that he had lost.

There are aesthetic meanings to Jekyll's duality. By the late nineteenth century art was becoming so volatile that a clique of artists or authors (one great creator even) only had to advocate some new technique or purpose for another crowd to repudi-ate it. This volatility amounted to a constant fragmentation of aesthetics; it could seem almost pathological too. Stevenson detested such vogues. 'So long as an artist is on his head, is painting with a flute, or writes with an etchers' needle, or conducts the orchestra with a meat-axe, all is well,' he complained in 1884. 'But any plain-

man who tries to follow the obtrusive canons of his art, is but a commonplace fig-
ure: To Hell with him is the motto.' Stevenson was also concerned to show the dan-
ger, if not the contemptibility, of intellect which is not anchored in ethics. To some
extent Jekyll represents for Stevenson a version of the author of *Nana* and
L'Assommoir: 'M. Zola,' Stevenson declared in *The Times* in 1886, 'is a man of a per-
sonal and forceful talent, approaching genius, but of diseased ideals; a lover of the
ignoble, dwelling complacently in foulness, and to my sense touched with erotic
madness.' (After finishing *Jekyll and Hyde* Stevenson confessed, 'the only thing I feel
dreadful about is that damned old business of war in the members'.) Stevenson
recast Zola as the scientific-minded Jekyll; as a Scots Presbyterian he mistrusted the
scientific creed's pose of ethical neutrality: 'the ugliest word that science has to
declare is a reserved indifference to happiness and misery in the individual, it
declares . . . a marble equality, dread not cruel, giving and taking away and recon-
ciling.' The true antithesis of any feeling is not its polar opposite – love is impossible
without hatred, or loyalty without treachery – but indifference. Stevenson's story
follows in the tradition begun by Mary Shelley's *Frankenstein*, and later revived in
such early German films as *Der Golem* (1915), *Homunculus* (1916) and *Alraune* (1928),
warning that a creature's abnormality is the result of abnormal origins, and visiting
retribution on arrogant, ungodly humans who usurp Nature's prerogatives.

Few goths are true democrats: Stevenson felt a guilty aesthetic distaste for popu-
lar manifestations. 'To me the press is the mouth of the sewer where . . . everything
prurient, and ignoble, and essentially dull finds its abode and pulpit,' he told
Edmund Gosse in 1886. He found it easier to love qualities than people. 'I do not
like mankind . . . as for respecting . . . that fatuous rabble of burgesses called "the
public", God save me.' Hyde is a stunted proletarian monster familiar from gothic
iconography since the French Revolution: stigmatised as 'pale and dwarfish', giving
'an impression of deformity without any nameable malformation', bearing himself
'with a sort of murderous mixture of timidity and boldness'. ('The timidity of a
crowd is proverbial', the *Spectator* judged a few weeks after the publication of *Jekyll
and Hyde*, though in a few moments it 'rises to the heights of mania'.) Hyde is as
destructive as those other products of the hubristic eighteenth-century
Enlightenment, the French Revolution and Frankenstein's monster; he is the prod-
uct, too, of excessive repression, as Sade recognised the French Revolution to have
been. Jekyll hates the uncontrollable visions of 'a fancy brimming with images of

terror, a soul boiling with causeless hatreds' vouchsafed by Hyde's rage: they seem as uncontrollable, arbitrary and irrational as any mob fury. After Hyde 'with ape-like fury' beats to death 'an aged and beautiful' philanthropic baronet, he becomes a fugitive from the police, which prevents him from indulging his devilish self as often as he wishes; the need for discretion forces him to submit to Jekyll's restraint. Yet he is a very gothic villain, for his acts of submission are also acts of control:

> His terror of the gallows drove him continually to commit temporary suicide, and return to his subordinate station of a part instead of a person; but he loathed the necessity . . . Hence the ape-like tricks that he would play me, scrawling in my own hand blasphemies on the pages of my books, burning the letters and destroying the portrait of my father; and indeed, had it not been for his fear of death, he would long ago have ruined himself in order to involve me in the ruin.

Hyde behaves like an insurrectionary underclass, filled with rancorous cannibal malice, resenting the culture and possessions of the privileged classes.

SERIAL KILLERS

The symbolic power of Edward Hyde's random, incomprehensible violence was enhanced two years after the publication of Stevenson's novella during the panic raised by the Whitechapel prostitute murders. In fact, Jack the Ripper was as much a fiction as Edward Hyde. The soubriquet was coined in a red-inked letter of defiance received by the Central News Agency in London during September 1888; this letter was probably a hoax concocted by news agency staff but achieved world-wide notoriety in the following month, when there were no Whitechapel prostitute murders and newspapers were desperate to maintain the shrill delirium of the story. The phrase 'Jack the Ripper' represented a gothic state of mind rather than an individual – a paroxysm of horror, fear and fascinated disgust – and has remained a literary phenomenon commanding intense public interest since the publication in 1929 of Leonard Matters's *The Mystery of Jack the Ripper* initiated the massive literary phenomenon of Ripperologists. (Over 130 suspects are listed in *The Jack the Ripper A to Z* of 1991: the most plausible identification, by Stewart Evans and Paul Gainey in *The Lodger* [1995], indicates Francis Tumblety [c.1833–1903], a misogynistic American quack.) Even if Jack the Ripper was an invention, the Whitechapel

murders raised in a factual context the ethical issues that Stevenson had treated in parable. Commenting on the killings in 1888, the *Spectator* regretted

> the increase of the desire to destroy, or at all events to limit, the sense of individual responsibility for crime. Fifty years ago, a great criminal usually defended himself by pleading the instigation of the Devil; but the community, though half-believing his excuse, held that he, having free will, was none the less guilty of his own acts. At present, the Devil is disbelieved in; but not only is poverty held to be sufficient instigation for all evil acts, but society is loaded with all responsibility.

Stevenson as the Scots Presbyterian who felt baffled by nineteenth-century ethics believed in inner devils rather than community failure as a cause of crime. Moreover his novella anticipated what arguably has become the most distinctive feature of gothic entertainment in the last fifteen years of the twentieth century, serial killers.

In films and novels, serial killers have become emblems of the evil duality supposedly haunting every modern individual: they are the external embodiment of all the inner anxieties, interdictions and guilt of the age, and they are represented as behaving like soap-operatic goths. In the twentieth century their abnormality has often been twinned with sexual deviance. 'Homosexuality is a subject thrilling to me, just as sanguinary killings are,' wrote Paul Bowles in 1930, 'because they are melodramatic': certainly later in the century gay serial killers – whether the real-life Jeffrey Dahmer and Andrew Cunanan, or fictive figures such as Andrew Compton and Jay Byrne in Poppy Z. Brite's novel *Exquisite Corpse* – excited the appetites of those who feast on evil.

The instantaneous popularity of Stevenson's parable reflected public fascination with the degeneration theories of Cesare Lombroso and Max Nordau prevalent in the 1880s and 1890s. Anxiety about human decay was widespread. The Earl of Derby in 1884 reflected on a recent conversation with a fashionable physician: 'in all his experience he had never known so many women given to drink as now. Is it increased wealth? or greater nervous susceptibility from the more bustling life which most people lead?' In 1888 a retired judge called Henry Keene wrote an essay entitled 'The Disorder of the Age', lamenting that 'a common infirmity is visible throughout modern Europe; a *mal du siècle*'. Keene hankered for the robust character

of the eighteenth century: 'from their hard-living, easy-going, carnal, sensible fore-fathers, what a change to the nervous, excitable men of this century, with their restless craving for novelty and their ready despondency. And now, when their age, too, is wearing towards its close, they are learning to abandon their illusions, to classify their sufferings, and to make a science of their sickness.' Stevenson himself succumbed to these quasi-medical jeremiads of cultural and racial decline. A visit to Rodin's studio in Paris left him 'silenced, gratified, humbled', as he reported in *The Times* in 1886, 'yet with a fine sense that the age was not utterly decadent'. Oscar Wilde recognised that 'Dr. Jekyll reads dangerously like an experiment out of the *Lancet*': the novella pathologised gothic villainy – 'evil', so Jekyll declares, is humanity's 'lethal side', which had left 'an imprint of deformity and decay' upon Hyde – at a time when criminality was being pathologised too. The physician Sir George Savage, who later treated Virginia Woolf's madness, published a fascinating essay at the time of the Whitechapel murders titled 'Homicidal Mania' in which he reclassified as case-histories those great criminals who earlier would have been described as gripped by the devil, or sunk in original sin.

MONKEYS

The Darwinian vulgarisation that humanity was descended from monkeys, and was thus a hybrid of human and simian instincts, had by the 1880s collected the corollary that the reasoning self cannot always master brutal animal instincts. The apehood of Hyde, however, owed little to Darwin's monkeys, which were evolutionary rather than degenerate phenomena. Although nineteenth-century gothic writers had simian fantasies, these looked backwards to Burke's images of French revolutionary monsters rather than inwards to modern psychological concepts. This distinction is clear by contrasting the gothic monkeys devised by Sheridan Le Fanu in the 1870s and by Baroness Blixen in the 1930s.

Le Fanu's spectral monkey occurs in his story 'Green Tea' (1872). Related by a German physician, Martin Hesselius, it tells of the destruction of an intelligent and stately clergyman, Robert Jennings, 'very gentle and very kind', who has an ample private fortune and a London house in what is probably Half Moon Street. He is something of an absentee from his parish just as some Irish landlords were absentees from their estates. Whenever Jennings returns to his parish, he disintegrates in the 'agitation of a strange shame and horror'. He is being haunted by a small

gibbering black monkey which mimics his own face with looks of invincible malignity. It resembles the goblin of Fuseli's *Nightmare*, and (says Jennings) 'exhibited an atrocious determination to thwart me'. Whenever he prays, or meditates prayer, the monkey becomes 'accentuated by intense and increasing fury'. Its jabbering voice is 'always urging me to crimes, to injure others, or myself'. Jennings has been reading Emanuel Swedenborg, and has marked some passages in his copy of *Arcana Caelestia* (1749): 'there are with every man at least two evil spirits'; 'the delight of hell is to do evil to man, and to hasten his eternal ruin'; 'if evil spirits could perceive that they were associated with man, and yet that they were spirits separate from him, they would attempt by a thousand means to destroy him, for they hate man with a deadly hatred'. Jennings is haunted by this malevolent monkey, which drives him to self-destruction. 'Green Tea' can be read as a rather unspecific account of the destructiveness of the subconscious, tricking out ideas that had been prevalent since Fuseli; but so much of Le Fanu's passion and anxieties were focused on the perpetual crisis between Irish landowners and tenants that the story has a plain political reading too. In the 1790s, and during the first third of the nineteenth century, political caricaturists tended to bestow piggish features on radical agitators and revolutionary mobs, possibly in allusion to Burke's phrase 'swinish multitude'.

As Lewis Perry Curtis showed in *Apes and Angels* (1971), this was particularly the case with Irish rebels, because pigs were so crucial in agricultural Ireland. But in the late 1840s the gorilla was first positively identified in Africa, and Poe wrote his tale 'The Murders in the Rue Morgue' about an orang-utan freshly imported from Burma which apes its human master in shaving with a razor and lather before murdering two Parisians. The arrival of the first living adult gorilla at London Zoological Gardens in 1860 had a great impact on the Victorian imagination in the same year as the conference in Oxford at which Bishop Samuel Wilberforce flamboyantly denounced Darwin's observations on the resemblance shared by humankind and anthropoid apes. It was from the 1860s that Irish peasants in Victorian political cartoons became pronouncedly ape-like. *Punch* and other periodicals in the 1860s and 1870s degraded Darwinian notions to suggest that the Irish, like Australian aborigines, were evolutionarily retarded, with some physical and mental characteristics of their monkey cousins. (As late as 1935 the Tory publicist F. S. Oliver speculated 'from what branch of the human family' the southern Irish spring: 'something more primitive' than Picts or Celts, he decided, a breed that

drove out intruders 'not by valour or brains, but by sheer fecundity – the daemonic fecundity of an aboriginal stock'.) The Irish mob was thus simianised in contemporary representation. The monkey that ruined Jennings represents the vindictive, destructive, ignorant, dirty Irish poor threatening the social poise, mental equilibrium and political powers of the Anglo-Irish gentry.

The monkey connotes very different anxieties in the supreme example of twentieth-century simian gothic. Karen Blixen (1885–1962), using the pseudonym Isak Dinesen, in 1934 published *Seven Gothic Tales*. She chose this title to invoke 'the age of Horace Walpole, who built Strawberry Hill', because as a Danish aristocrat she felt estranged from the twentieth century: 'in modern life and in modern fiction there is a kind of atmosphere and above all an interior movement inside the characters' which she thought was isolating people both in life and art: 'solitude is now the universal theme'. Her stories are less psychological than philosophical, enabling her to adopt the credos of her nineteenth-century characters: 'God alone knows', declares the old countess in 'The Roads around Pisa', 'what has come over the generation of women who have been born after the Revolution of the French and the novels of that woman de Staël – wealth, position and a tolerant husband are not enough to them, they want to make love as we took the Sacrament'. Baroness Blixen loved monkeys 'in pictures, in stories, on porcelain, but not in life, they somehow look so sad'. She had herself a simian look. 'This season in New York is the season of Baroness Blixen,' Christopher Isherwood wrote in 1959. 'She is dying, weighs sixty pounds, wears a hat with black ostrich plumes, can only eat oysters, grapes and champagne, looks like a withered monkey, enchants everybody. They say she will get the Nobel Prize.'

The baroness described 'The Monkey' as 'a fantastic story' in which she leaves 'the monkey [to] resolve the mess when the plot has got too complicated for the human characters'. Her story is set in 1824 (the year of Earl Amherst's military campaign against the King of Ava) in a convent in a Baltic kingdom. The convent is not a religious house, but a retreat for aristocratic spinsters and widows to live in dignified, semi-feudal retirement. The institution is ruled by a cultivated and worldly prioress, who has been given a mischievous monkey by an admiral returning from Zanzibar. This monkey comes and goes according to inscrutable whims. The old woman is visited by her favourite nephew, Boris, a rich and handsome twenty-two-year-old lieutenant in the Royal Guards who is threatened with scandal, so the old

ladies of the convent gather, a scandal, like Jekyll's, evidently not to be named, for all the ladies can learn is that it was 'somehow [connected] with those romantic and sacred shores of ancient Greece which they had till now held in high esteem'. In order to still the scandal, the youth has reluctantly resolved to marry and seeks the prioress's advice.

She proposes a match with a neighbouring heiress, Athena Hopballehus, 'a strong young woman of eighteen, six feet high and broad in proportion, with a pair of shoulders which could lift and carry a sack of wheat', who stands in massive contrast to Boris. (Six months earlier he and 'a young friend of his had amused themselves wandering for three weeks about the country . . . in a caravan, carrying with them a little theatre of dolls, and had given performances of plays which they made up themselves in the villages that they came through. The air had been filled with sweet smells, the nightingales had been raving within the bird-cherries, the moon stood high'.) When Athena refuses Boris, the prioress falls into an alarming and unwonted rage: she no longer seems so cultivated, and her worldliness has metamorphosed strangely, for she devises a scheme of unmaidenly ruthlessness. Athena is invited to the convent for an intimate banquet after which Boris is to force himself upon her. At the banquet, against his nature, Boris finds himself attracted by Athena: 'he thought she must have a lovely, an exquisitely beautiful skeleton . . . imagined that he might be very happy with her, that he might even fall in love with her, could he have her in her beautiful bones alone . . . Many human relations, he thought, would be infinitely easier if they could be carried out in the bones alone.' Boris is fired by the prioress with an aphrodisiac philtre before going to Athena's room. 'She had taken off her frock and was dressed only in a white chemise and white pantalettes. She looked like a sturdy young sailor boy about to swab the deck.' When he embraces her, she strikes out. 'Her powerful, swift and direct fist hit him in the mouth and knocked out two of his teeth. The pain and the smell and the taste of the blood sent him beside himself . . . The old, wild love, which sympathy cannot grant, which contrast and adversity inspire, filled him together.' Their fight continues with the blood pouring out of his mouth as Athena tries to kill him. In a final effort to triumph, Boris 'forced her head forward with the hand that he had at the back of her neck, and pressed his mouth to hers. His teeth grated against her teeth.' She is so disgusted by this kiss that she falls motionless on her back, 'like a stone effigy of a mail-clad knight, felled in battle'.

But he does not seize his chance of sexual victory. Back in his room, 'he laughed to himself in the dark, and it seemed to him that a thin, shrill laughter, like to the shoot of hot steam from a boiling kettle, was echoing his own somewhere in the great house, in the dark'. In the morning the prioress calls the young people to her room and scares the naïve Athena with the assertion that she must be pregnant; Athena is just consenting to marriage, and vowing to murder Boris afterwards, when there is knocking on a window-pane, and they see the prioress's pet monkey crouching with its face pressed to the glass. The prioress begins shrieking in horror even before the monkey jumps into the room. To the astonishment of Athena and Boris, she then jumps up onto the cornice of her room, 'shivering in a horrible passion, and grinding her teeth'. The monkey chases her,

> jumped upon her, got hold of her lace cap, and tore it from her head. The face which she turned toward the young people was already transformed, shrivelled and wrinkled, and of dark-brown colour. There was a few moments' wild whirling fight . . . the old woman with whom they had been talking was, writhing and dishevelled, forced to the floor; she was scrunched and changed. Where she had been, a monkey was now crouching and whining, altogether beaten, trying to take refuge in a corner of the room. And where the monkey had been jumping about, rose, a little out of breath from the effort, her face still a deep rose, the true Prioress.

In the silence after this maelstrom, Athena fixes Boris with a commanding look: 'from now, between, on the one side, her and him, who had been present together at the happenings of the last minutes, and, on the other side, the rest of the world, which had not been there, an insurmountable line would for ever be drawn'. They have discovered the truth of Saint-Exupéry: 'Love does not consist of gazing at each other but in looking together in the same direction.' The prioress ends the story by declaring in Latin: '*Discite justitiam, et non temnere divos.*' Learn justice, and do not scorn the gods.

Blixen's simian story – indeed all of the *Seven Gothic Tales* of which it is part – constitutes the delicate apotheosis of twentieth-century gothic literature. Though it is never revolting, its scenes are as vivid and startling as its contemplative passages: they endure because Blixen savours the life of the mind as well as appealing to the sensations. To take one example, these are Boris's reflections as he travels as a suitor to the house of Athena's father:

The real difference between God and human beings, he thought, was that God cannot stand continuance. No sooner had he created a season of a year, or a time of a day, than he wishes for something quite different, and sweeps it all away . . . human beings cleave to the existing state of things. All their lives they are striving to hold the moment fast, and are up against a *force majeure*. Their art is nothing but the attempt to catch by all means the one particular moment, one mood, one light, the momentary beauty of one woman or one flower, and make it everlasting. It is all wrong, he thought, to imagine paradise as a never-changing state of bliss. It will probably, on the contrary, turn out to be, in the true spirit of God, an incessant up and down, a whirlpool of change . . . He thought with deep sadness of all the young men who had been, through the ages, perfect in beauty and vigour – young Pharaohs with clean-cut faces hunting in chariots along the Nile, young Chinese sages, silk-clad, reading within the live shadow of willows – who had been changed, against their wishes, into supporters of society, fathers-in-law, authorities on food and morals.

Boris is sensing that the greatest challenge confronting a sentient human is how to continue growing throughout life, because to stop growing is to atrophy. He is only twenty-two, still too young for his character, ideas and feelings to have set in forms so mimetic and conventionalised that they are no more authentic or original than a reflection in a mirror. His uncanny vision of the prioress and the monkey (far more than his bisexuality) saves him from lapsing into spiritual or emotional stasis: an insurmountable line has been drawn between him and the majority. As the gods know, change – especially arbitrary or unexpected change like the prioress's metamorphosis – saves our lives from the routine of little thoughts and acts. Yet change is also what distinguishes mankind from the gods: only gods can survive continual change with constant errors and wrecks; humans must fail and submit. This, perhaps, is the lesson of the gods who must not be scorned.

'THE GOTHIC THAT AGITATES AND WORRIES'

Beyond the simian there are many subtle variations of the gothic doppelgänger effect: parallel universes, for example, in science fiction, or stories where the nature of the alter ego is in doubt. For example, Henry James in his great story 'The Jolly

Corner' (1908) describes a successful, self-sufficient, loveless man returning after thirty years in Europe to live on his New York properties. At night, in the dark passages of his house, he stalks a spectral figure whom he at first believes is his doppelgänger; yet when he finally glimpses its face he sees a stranger, 'evil, odious, blatant, vulgar'. Eighty years later in the tender gaiety of his story 'The Lost Explorer' Patrick McGrath shows a lonely, resourceful girl who finds a man shouting about cannibal pygmies in the delirium of his fever camping in a tent in her suburban London garden – a projection of her own double self.

A living exemplification of the double man was the American artist Grant Wood (1892–1942). In 1930 he visited a small town in Iowa, where he saw a five-room wooden farmhouse dating from the early 1880s in the style called Carpenter Gothic. He used this farmhouse as the background for a painting of a dour, tight-lipped farmer (modelled by a dentist from Cedar Rapids) and his spinster daughter, a resolute thrifty-looking woman whom some have found sour-looking and others full of dignified integrity. The couple in *American Gothic* have become as instantly recognisable figures as *Mona Lisa*, or van Gogh's self-portrait, or Warhol's *Marilyn*; the swift and phenomenal fame of this painting trapped Wood in an irresolvable dilemma. 'His fame and the alluring invitations that went with it worked against the very principles he believed in. He could not be both a practising regionalist – staying at home and painting, serving as a model for the younger generation – and a national spokesman for Regionalism, touring the country preaching its ideals.' The division that this made in Wood's life tore him apart and hastened his death.

Despite the solitary brilliance of Baroness Blixen, gothic suffered its gravest declension in the early twentieth century. It became the preserve of maladjusted or imaginatively overspecialised bachelors, such as the Reverend Alphonsus Joseph-Mary Augustus Montague Summers (1880–1948), author of numerous books on necromancers, vampires, goths and the supernatural. The revulsion against gothic owed something to such stupidity as having the scientific laboratory in Oxford Museum carefully modelled on a thirteenth-century monastic kitchen at Glastonbury. The style could seem both pasteboard and silly, even when the resources of England's richest duke had been lavished on it. 'I am quite sure I do not like Gothic,' the politician George Wyndham wrote as early as 1885 while staying as a guest at the Duke of Westminster's new palace in Cheshire designed by Alfred Waterhouse:

The disks of porphyry and antique marble in the floor of the hall, and the panels of alabaster let into green serpentine on the walls, I like, but there is a wretched, mean, conventional cornice, that catches your eye and spoils all. This is the case all through the house. The library is a beautiful room with a really good ceiling, gold and white panels with big oak beams crossing it every 15 feet or so, all very nice, but on the gold are stencilled Fleur-de-Lys which Pamela and I could have designed in an afternoon by doubling paper and cutting out with scissors. There is a big chapel and clock-tower like the Houses of Parliament, with clock, value 20,000 guineas, that plays 48 tunes, the same tune every hour for a whole day (Maddening!); today we had 'Jenny Jones', yesterday 'Home sweet Home'.

Much artistic work with gothic evocations was either intolerably tedious – August Strindberg's novel *The Gothic Rooms* (1904), for example – or chimed hopelessly with the cultural tastes prevailing after 1910. Post-Impressionism and the English discovery of Dostoevskyan evil made gothic seem insular and tame. Interest in the mystical sides of human nature represented by Summers seemed pitifully unscientific to generations discovering the jargon of Freud.

The reaction against Victorian values expressed by Lytton Strachey in *Eminent Victorians* (1918) discredited gothic revival architecture, and its literary equivalents, even before the impact in the late 1920s of Kenneth Clark's denigratory text, *The Gothic Revival*. 'Mr Bram Stoker's *Dracula*,' jeered *Punch* in 1927, 'has for many years been a cause of frequent nightmares in the unsophisticated.' There was nothing but unintentional hilarity to be found in 'pale-faced aristocratic aliens whose bodies are not reflected in plane mirrors and whose hair is twisted into devilish horns'. *The Connoisseur* magazine for collectors in 1928 deplored the 'horrors . . . perpetrated in the Gothic Revival in the last century'. A few months later the left-wing *New Statesman* was equally derogatory: 'The Gothic Revival produced little on which our eyes can rest without pain.' Gothic became irredeemably dull and unfashionable. Edith Wharton in *The Gods Arrive* (1932) depicted 'a Museum specimen of the old New York millionairess', Mrs Glaisher. 'Once in the winter one had to hear Tristan or the Rosenkavalier from her opera box, and once to dine off gold plate in her Gothic refectory.'

In 1933 Henry Channon III, a quintessentially modish Chicago social-climber

who usually fawned on German princelings, sneered at the 'ogre's castle' of Neuschwanstein built by Ludwig II, the Bavarian monarch whose overwrought nerves, depraved passions and mysterious death seem like a fantasy of Poe's. The palace interior seemed 'ugly and dated' to Channon, who found 'something tawdry and pathetic about the vast empty throne-room with the mosaic apse, the endless corridors frescoed with teutonic legends, the plushy apartments, the gothic gloom, the Wagnerism run wild'. Channon was no more impressed by the gothic experiments of the plutocratic Guinness brewing family, into which he had meticulously plotted marriage. In 1935 he stayed at Bailiff's Court, the newly built Sussex seat of his wife's cousin, Lord Moyne. 'They have created almost a community in the Norman-Gothic style; the house, chapel, guest-house, and dependent buildings, even the garden are medieval', but Channon was depressed by these fantastic effects: 'the rooms are small, badly-lit, and there is no comfort, although every guest-room is decorated to resemble the cell of a rather "pansy" monk'.

Gothic became synonymous with a meagre melancholy. Nicholas Jenkins, narrator of Anthony Powell's *The Valley of Bones* (1964), was billeted during the Second World War in a dilapidated neo-gothic monstrosity, Castlemallock. 'At Castlemallock I knew despair,' Jenkins recalls. 'An air of thwarted passion could be well-imagined to haunt these grass-grown paths, weedy lawns and ornamental pools, where moss covered fountains no longer played.' This 'sham fortress, monument to a tasteless, half-baked romanticism' at last achieved a passing moment of authenticity because military occupancy finally 're-created the tedium as well as the architecture of medieval times'. Castlemallock in the 1940s with its quarrels, complaints and dead routine represented a microcosm of what Henry Wallace, American Vice President in the 1940s, hailed as the age of the common man. When in 1951 Denis Thatcher was taken into the depths of mediocre provincial fatuity by his fiancée, Margaret Roberts, to meet her aldermanic father for the first time,

> they passed the Gothic monstrosity that is Grantham Town Hall and Denis remarked sarcastically, 'I bet they're awfully proud of that.' Margaret misinterpreted the remark and blushed with pride. 'Daddy thinks it's wonderful.' Denis silently cautioned himself, 'Watch it, Thatcher.'

Yet gothic continued to shadow the progress of modernity. It was admired by authors as antithetical as D. H. Lawrence, John Buchan and Evelyn Waugh.

Southport and Manchester were 'vile, hateful, immense, tangled filthy places', Lawrence wrote in 1908. London he enjoyed as 'pompous, magnificent Capital of Commercialism, a place of stately individualistic ideas, with nothing Gothic or aspiring or spiritual'; but his greatest excitement was in the cathedral cities of Lincoln and Ely. 'Silence is strange and mystical and wearying . . . it is the noble, the divine, the Gothic that agitates and worries one.' The thriller writer John Buchan, afterwards Lord Tweedsmuir, in 1940 relished 'the harsh Gothic of most of the Scots landscape', and felt that Oxford graduates like himself needed 'a touch of Gothic extravagance . . . to correct our over-mellow Hellenism'. The mundane, the bland, the reasonable: gothic, it seemed to Lawrence and Buchan, was antagonistic to all these.

Gothic was also enlisted by Evelyn Waugh. His melancholy, comfortless novel *A Handful of Dust* (1934) depicts Hetton Abbey, a great country house gothicised in 1864 and generally despised as a fake, although its owner, Tony Last, loves every 'glazed brick or encaustic tile'. He (and Waugh) revel in Hetton Abbey:

> the line of its battlements against the sky; the central clock tower where quarterly chimes disturbed all but the heaviest sleepers; the ecclesiastical gloom of the great hall, its ceiling groined and painted in diapers of red and gold, supported in shafts of polished granite with vine-wreathed capitals, half-lit by day through lancet windows of armorial stained glass, at night by a vast gasolier of brass and wrought iron, wired now and fitted with twenty electric bulbs; the blasts of hot air that rose suddenly at one's feet, through grills of cast-iron trefoils from the antiquated heating apparatus below; the cavernous chill of the more remote corridors where, economizing in coke, he had had the pipes shut off; the dining-hall with its hammer-beam roof and pitch-pine minstrels' gallery; the bedrooms with their brass bedsteads, each with a frieze of Gothic text, each named from Malory, Yseult, Elaine, Mordred and Merlin, Gawaine and Bedivere, Lancelot, Perceval, Tristram, Galahad, his own dressing-room, Morgan Le Fay, and Brenda's Guinevere, where the bed stood on a dais, the walls were hung with tapestry, the fireplace was like a tomb of the thirteenth century.

Last's wife, who hates the house, employs a fashionable decorator to replace the pink granite chimneypiece of the morning-room with white chrome plating. This

vandalism, like Hetton Abbey's clocktower, recalls Waterhouse's palace in Cheshire, where in the 1930s the miserably married Loelia, Duchess of Westminster, 'endeavoured to bring it up-to-date by making it less ugly and more liveable, in fact spoiling it', as she confessed to James Lees-Milne in 1944. 'She thinks she will go down to posterity as a vandal; but she was very young, which excuses her.' When Last's marriage collapses, it seems to him that 'a whole Gothic world had come to grief'. He leaves for Brazil to search for a lost city in the Amazonian jungle, which he imagines as a fabled tropical paradise:

> Gothic in character, all vanes and pinnacles, gargoyles, battlements, groining and tracery, pavilions and terraces, a transfigured Hetton, pennons and banners floating on the sweet breeze, everything luminous and translucent; a coral citadel crowning a green hill-top sewn with daisies, among groves and streams; a tapestry landscape filled with heraldic and fabulous animals and symmetrical, disproportionate blossom.

Instead he is captured by an illiterate, self-inflated and unfeeling half-caste, who manipulates by alternate bouts of smarms and sulks. This weird and outlandish Caliban despoils Last's dreams of gothic serenity and homeliness.

The nadir of gothic art fell at the time when Freudianism was rising towards its empyrean. In the first quarter of the century the Vienna School of psychoanalysis examined the problems of human duality, offered explanations of humanity's monkey tricks, juxtaposed feelings and acts that hitherto had been severed. Some gothic imaginative themes were appropriated by theorists who pathologised them, sanitised them and tried to make them the privileged, exclusive domain of medical practitioners and other experts. 'For Freud,' as Mark Edmundson has shown in his elegant *causerie Nightmare on Main Street*, 'the psyche . . . is centrally the haunted house of terror Gothic. Freud's remarkable achievement is to have taken the props and passions of terror Gothic – hero-villain, heroine, terrible place, haunting – and to have relocated them inside the self.' Freud asserted that each and every human was constituted, defined and controlled by his or her traumas; according to him, early traumas were so deeply internalised that people were haunted by their pasts unless they endured the exorcism of psychoanalysis. His hypotheses were as much 'sensational horror fiction' as *schauerromantiks*, but as Patrick McGrath notes, he 'gave it the name of *psychoanalysis* and thus lent it a dignity and prestige'.

Freudianism had a swift impact on gothic fiction. Psychoanalytically informed writers incorporated its classifications and moods into their work. Sexual perversity became a more explicit gothic topic. The Mortmere stories on which Christopher Isherwood and Edward Upward collaborated in the mid-1920s (unmemorable in themselves, but a significant incident in literary history) were early Freudian gothic. Isherwood's 'The Horror in the Tower' (1924–25), for example, is narrated by a man visiting the cheerless ancestral seat of his friend Kester, eleventh Lord Wranvers. This noble family, whose repellent appearance has grown more extreme in each generation, is haunted by a mysterious ancestral taint which, in a melodramatically violent final revelation, is discovered to be sexual passion for being shat on and eating shit.

MIRROR-IMAGES

The gothic ideas about human nature that were written into psychoanalytical theories were also re-imagined into forms that were not pathologically modelled. The chief gothic revival of the early twentieth century was in the new genre of films. Film production and projection were first mastered around 1895 by pioneers working in Germany, France and the USA. Thomas Alva Edison's American company made the earliest monster movie, *Frankenstein*, in 1910, but it was German film directors and technicians who created the greatest gothic films of the early cinema. Fantastic subjects were attractive to film-makers like Paul Wegener because they justified the use of startling or experimental cinematic techniques; he and fellow pioneers sought to disarm hostility to the cinema by mixing themes from high literary culture as well as popular entertainment in their productions. Their work had counterparts in the gothic elements of German expressionist painting. Artists like Ernst Ludwig Kirchner wanted to liberate German artists from imaginative subjection to Parisian ideas and modes in the same way that German film-makers wanted to establish a distinctive national film-making. Kirchner drew on the pointed shapes, mystical passion and theatrical tableaux of German gothic to portray nervous instability and disharmonious living. Oskar Kokoschka's *Black Portraits* of inwardly riven intellectuals and neurotic artists had their counterparts in German cinema. Max Beckmann, who had been driven to the brink of insanity by his experiences as a medical orderly in the Flanders trenches, set out to depict the violence and deprivation of his epoch by focusing on the spiritual loneliness of its indivi-

duals. The images of German expressionist painters and gothic film-makers were attempts to exorcise horror and fear.

The apogee of German cinema began with Wegener's *The Student of Prague* (*Der Student von Prag*) in 1913, and continued with his *The Golem* (1914, 1920), Robert Wiene's *The Cabinet of Dr Caligari* (1919) and *Orlacs Hände* (The Hands of Orlac, 1925), Friedrich Wilhelm Murnau's vampiric *Nosferatu* (1922), Fritz Lang's *Destiny* (1921) and *Dr Mabuse* (1922), Paul Leni's *Waxworks* (1924), Lang's *Metropolis* (1927), and G. W. Pabst's *Pandora's Box* (1929). These films were mostly gothic: concerned with psychic crises rather than social episodes, melodramatic, violent and formulaic (the French too made horror-films in the 1920s, but their style was avant-garde art-house rather than mass-consumption gothic, and their literary debt was pre-eminently to Poe). The mood of such films was misanthropic: they repudiated faith in human progress and gratified consumers too tired to distinguish their desires from their despair. As the boycott of German films was relaxed by the Allies after 1920, their influence became international. The success of *The Cabinet of Dr Caligari* and the impact of *Metropolis* in France and the USA induced German cinematography to accentuate its distinctive national traits to secure export recognition in an inherently internationalised art form.

The violent catastrophes of the last decade of Hohenzollern rule, and its dire sequel after 1918, had intensified national anxieties. To outsiders, the Germans seemed to be a people for whom fear was a natural state. Death, desolation and decay provided many of the key-notes of German life in the heyday of its horror films from 1913 through into the 1920s. The overthrow of the Hohenzollern imperial family in 1918 did not revolutionise Germany. The Weimar Republic from its inception was dominated by social democrats who isolated the revolutionaries but never challenged the military caste, bureaucrats, land-owning junkers and the plutocracy. Punitive inflation impoverished and humiliated the German middle class. The French government made formidable demands for the payment of war reparations, and in 1923 French and Belgian troops accomplished Weimar's ruin by occupying Germany's industrialised Ruhr region and wrecking the national currency. 'Life was madness, nightmare, desperation, chaos,' Erna von Pustau said of the Weimar inflation.

All human institutions were thus discredited in Weimar Germany. Human experience was reduced to bitter mistrust and antipathies. It was a ripe period for

goths, although gothic could not be medieval and knightly in a period of sordid squabbles over percentages. Instead, with the customary supple resilience of the gothic imagination, the outward duplicities of the material world were converted into an obsession with inner dualities. This fitted very well the psychological doubleness widely attributed to Teutonic character. Viscount D'Abernon, the shrewd British ambassador in Berlin during the 1920s, reported that 'many Germans have a dual ambition to be at once Faust and Siegfried'.

As early as 1913 Paul Wegener began work on *The Student of Prague*. He collaborated on the screenplay with Hanns Heinz Ewers, a popular novelist and cinema-owner with an imagination attuned to popular sensation whose reputation was later marred by his agreement in 1933 to write the official screenplay on the Nazi hero Horst Wessel. The two men amalgamated Hoffmann's tales, the Faust myth and Poe's doppelgänger story 'William Wilson' to construct a screenplay about an improverished student called Baldwin. Baldwin ruins himself by signing a compact with the sorcerer Scapinelli, who promises a rich marriage in return for receiving the gift of the student's mirror reflection. The devil-wizard then lures Baldwin's reflection out of the looking-glass to become an independent entity. In accordance with his compact, Baldwin falls in love with the beautiful countess Margit and when her official suitor Baron Waldis-Schwarzenberg challenges him to a duel the student, who is an excellent fencer, is persuaded for love of Margit to spare his rival's life. But Baldwin is delayed by Scapinelli's machinations from punctually reaching the duelling-ground, and, in a scene that excited viewers as disparate as Graham Greene and Sigmund Freud, while hurrying thither he meets his double, who has already impersonated him and slain the baron. Baldwin's efforts to redeem his disgrace by convincing the countess of his innocence are frustrated by his double. When finally student Baldwin shoots his reflection, the bullet, like the knife-thrust of William Wilson, kills himself. In the film's closure Scapinelli tears the compact to pieces, which he discards over Baldwin's corpse.

As Siegfried Kracauer demonstrated in *From Caligari to Hitler* (1947), his history of German film-making, cinema's most popular motifs fulfilled existing 'mass desires' and reflected 'psychological dispositions – these deep layers of collective mentality which extend more or less below the dimension of consciousness'. The psychological condition of Germans, and the apparitions enlisted to express it, set a pattern for western anxieties in the twentieth century. *The Student of Prague* indeed aroused

such strong latent feelings about the inner self that it was remade in 1926, with yet more emphasis on psychological duality, and again in 1935–36 by the Nazis. To members of the intelligentsia who watched the film, Baldwin's double was recognisable as a projection of one of the two contending souls inside him. By making Baldwin and his reflection face each other, Wegener showed that the student recognises that he has a split personality and that his antagonist is nobody but himself. The external action of the film – Baldwin's ambition and despair, his wooing of Margit, his broken undertaking about the duel, his killing of the baron – symbolises his inner divisions. The governing characteristic of an inner life, perhaps, is temptation, which requires the impulses both to transgress and to feel guilt. *The Student of Prague* fascinated contemporary psychoanalysts. Freud's apostle Otto Rank in 1914 published the essay 'Der Doppelgänger', which opens with a lengthy analysis of it. Drawing on Hoffmann, Poe, Maupassant, Heine and Dostoevski, Rank examined the connections of the 'double' with mirror-reflections, shadows and guardian spirits. He suggested that the double originated as an 'energetic denial of the power of death', and that probably the first 'double' of the body was the concept of the immortal soul doubling as a preservation from extinction. Freud himself referred to Wegener's film in his paper 'The Uncanny' (1919): 'the quality of uncanniness can only come from the fact of the "double" being a creation dating back to a very early mental stage . . . The "double" has become a thing of terror, just as, after the collapse of their religion, the gods turned into demons.' Freud also recalled meeting his own doppelgänger when sitting alone in a wagon-lit. A violent jolt of the train

swung back the door of the adjoining washing-cabinet, and an elderly gentleman in a dressing-gown and a travelling cap came in. I assumed that in leaving the washing-cabinet, which lay between two compartments, he had taken the wrong direction and come into my compartment by mistake. Jumping up with the intention of putting him right, I at once realized to my dismay that the intruder was nothing but my own reflection in the looking-glass on the open door. I can still recollect that I thoroughly disliked his appearance.

Lord D'Abernon in 1923 described the funeral procession of a murdered Bolshevist whose corpse was returned to the Russian embassy in Berlin in a hearse draped in red followed by mourners in red ribbons. The large attendant crowd was of 'immaculate respectability – nothing of either the rough element or the long-

Peter Lorre playing the killer in Fritz Lang's M *(1931) is haunted by his mirrored reflection: secret divided selves were more deadly and fearful than any external spectre.*

haired Russian type . . . just ordinary Berliners – with their hair trimmed and their clothes tidy and bourgeois'. These decorous burghers following a communist cortège demonstrated the Jekyll-like ogre of latency smouldering under bourgeois repression; like characters in Eugene O'Neill's *Great God Brown* (1926), they wore masks which they only removed when alone or with a sympathetic few. Twenty years later the exiled German intellectuals Theodor Adorno and Max Horkheimer recalled national archetypes before Hitler: 'The bourgeois whose existence is split into a business and a private life, whose private life is split into keeping up his public image and intimacy, whose intimacy into the surly partnership of marriage and the bitter comfort of being quite alone, at odds with himself and everybody else, is already virtually a Nazi.' Small wonder that the submissive bourgeois is a sinister figure in German gothic cinema from the satanic Scapinelli to the serial child-murderer in bow-tie and primly furled hat played brilliantly by Peter Lorre in Fritz Lang's *M* (1931). Like Baldwin yielding to the satanic temptation to kill the baron on the duelling-ground, thus betraying and destroying his better self, so the murderer in *M* succumbs to the homicidal impulse of his devilish inner self.

GERMAN GOTHIC FILMS

German cinema's gothic revival approached the themes of power, cruelty, duplicity and decay by devices other than the doppelgänger. Wegener's second film, *Der Golem*, tells the story of a medieval rabbi in Prague who infused life into a clay statue by incising a cabalistic sign on its heart, and of this golem's revival, centuries later, by an antique dealer. It metamorphoses into a human with a soul by falling in love, but when the terror-stricken girl rejects his advances, he is confronted by his terrible isolation. He becomes enraged, like Frankenstein's monster, and in pursuit of his loved object wreaks terrible destruction until he falls from a tower and is shattered into clay fragments. Jack the Ripper was resurrected for gothic cinema in Paul Leni's *Waxworks* (*Das Wachsfigurenkabinett*). This script was written by Henrik Galeen, who had earlier scrutinised evil autocracy in Murnau's great vampiric film *Nosferatu* and had worked with Wegener on both *The Golem* and the 1926 remake of *The Student of Prague*.

In Galeen's script, a hungry young poet is employed by a circus showman to write stories about his waxwork exhibits. These stories begin with a burlesque, recalling themes of both *Otranto* and *Vathek*, in which the irritable tyrant Harun-al-

Rashid orders the death of innocent subjects and yet pardons criminals who ought to be unpardonable. His sexual oppressions, which should affirm his power, in fact render him absurd, for he degrades himself in an intrigue with the flirtatious wife of a jealous pastry-cook (perhaps Galeen recalled that Sade's downfall began in 1768 with exile from Paris after making a fool of himself flagellating a pastry-cook's widow). From this opening frivolity Galeen's poet proceeds to a parable about autocracy featuring Ivan the Terrible (played in the film by Conrad Veidt). The Russian czar incarnates the excess of lust and cruelties attributable to every maddened tyrant. He proves his power by taking a bride from her wedding party and usurping her husband's place in deflowering her. He poisons people who have vexed him with a sadistic care for detail. An hourglass is put before each of his victims, so that they can foretell exactly how swiftly dread death is advancing on them and approach the moment of death in rising terror (this is evidently not reckoned a cruel or unusual punishment in the USA of the 1990s). Eventually Ivan is tricked into believing himself poisoned and is faced with a sandglass labelled with his name; in horror, he incessantly turns it upside-down, growing ever more frantic with the fear of death, until he goes horribly mad. In the final episode of *Waxworks*, the poet falls asleep, and dreams that while walking with the circus showman's daughter, they are hunted relentlessly by Jack the Ripper, who leaves his waxwork's pedestal to haunt them through a nightmarish, claustrophobic townscape.

The incorporation of robots into the gothic imagination was the chief influence of Modernism on the older *genre*. Dehumanisation was regarded as an unmixed evil until, perhaps, the 1980s; despite all the historic and contemporary evidence of humanity's potential vileness and ethical failures, film-makers strenuously asserted the superiority of human motives, feelings, natural instincts and ethical training. For several decades the most notable example was the first-ever budget science-fiction movie, Fritz Lang's *Metropolis*, released in 1927. Set in the year 2000, it depicts a world in which humanity has become divided into two classifications: thinkers, with high conceptual powers who are mechanically inept, and workers, who can make objects but have no vision. They are two distinct and separate groups, but neither of them is wholly human without the other. To reflect their position as the brains, the thinkers live in luxury in high, futuristic towers as parasitic aristocracy, whereas the workers (the hands) live in underground vaults beneath the machinery which has enslaved them. These workers march in unison and have forfeited their

individuality. With sentimental oversimplification, the film suggests that the war-ring duality of brain and hands can be reconciled by human love between the hero-ine, a worker called Maria, and the hero, Freder, son of John Fredersen, Master of Metropolis (the monopoly capitalist). Maria tries to prevent a rebellion of the work-ers by urging the mediation of Freder, who on entering their subterranean world is horrified by what he finds. His father, though, is an autocrat who wishes to foil reform. It suits him to have outright conflict which he can crush once and for all: he is like the head of the mining multinational Rio Tinto Zinc, Sir Val Duncan, who feared trade union power and in 1969 advised the incoming Conservative prime minister Edward Heath that 'a general strike – or its equivalent – will be encoun-tered and . . . the Government should very carefully pick the timing and the issue and stage the whole thing'. Heath shirked this advice and had his government destroyed by a coal-miners' strike, which prompted the next Conservative govern-ment, under Thatcher, to pick the timing and provoke a national coal strike which enabled it to break British trade union power for a generation.

Fredersen commands the tragically flawed scientist Rotwang to build a robotic duplicate of Maria. The real Maria (a virginal figure) is imprisoned while the robot Maria (who is whorish) incites the workers to rebel rather than conciliate. The mob in smashing the machinery accidentally unleashes a flood which engulfs their homes. The pent-up power of this water – unstoppable, unrelentingly destructive – can represent political, economic or emotional repression. Freder and the real Maria, who has escaped, rescue the workers' children from the torrent, but the workers believe they have drowned, and burn the robot Maria for vengeance (a reminder that, as Goya knew, revolutions, like Saturn, devour their own children). Rotwang, who had been knocked out, is so confused on recovering consciousness that he believes he is dead, pursues the real Maria in the belief that she is his long-dead lover in Heaven, and falls to his death from a cathedral roof.

Despite flaws in the script, the film has splendid gothic details. Metropolis is an environment of Salvatorian inhumanity, though its features are industrialised rather than rustic. It is a *locus* of intangible, ubiquitous threats. It is riddled with under-ground passages; it provides the site for eruptions of mob violence. John Fredersen in his office tower is a traditional goth autocrat whose power is compromised by his dependence on an unreliable agent, Rotwang; he is, too, both sinister and perversely sympathetic. Maria's terrified flight through the underground tunnels of Metropolis

confirms her a gothic heroine-victim. There is also gothic duality: the mediator Freder is a man cut in two, representing the dual nature of industrialised humanity. Though the film is visually magnificent, its credo has never satisfied viewers: the details have become an end in themselves, which is always vitiating in gothic aesthetics. Nevertheless, it drew huge German audiences and was admired for its technical audacity in the USA. In Paris the film was seen to combine the romanticism of Wagner with the technological supremacy of the armaments manufacturer Krupp, a combination which understandably felt menacing. Lang's closure of reconciliation in which Freder, representing the power of love, persuades his autocrat father to shake hands with the workers' leader, thus consecrating a re-union of capital and labour, offended Kracauer in 1947. He recognised that though it seems as if Freder has converted his father, in reality the industrialist has outwitted his son. Fredersen's appeasement of the workers forestalls their victory and enables him to improve his knowledge of their mentality, refine his insinuations and manipulate their future. Goebbels later told Lang that he and Hitler had been impressed by *Metropolis* when they saw it; the Nazi propaganda chief declared at the Nuremberg party rally of 1934, 'Power based on guns may be a good thing; it is, however, better and more gratifying to win the heart of a people and to keep it.' As Kracauer complained, this seems to be the message of *Metropolis* too.

HOLLYWOOD GOTHIC

German gothic cinema – particularly *The Cabinet of Dr Caligari* and *Metropolis* – encouraged powerful American emulators. Tod Browning's *Dracula* (1930), in which Bela Lugosi played the title role, was adapted from a mediocre play by Hamilton Deane staged in London in 1927, bearing little resemblance to Stoker's story. It was an indifferent film, but had sufficient success for Hollywood film-makers to realise that they might make money from frightening audiences. As a result Universal Studios hired the English director James Whale (1889–1957) to make *Frankenstein*, which was released in 1931. Both Whale and the film are crucial in the cultural history of gothic. Whale himself was a divided man, with all the courage and style that characterise self-reinvented people. Born into a large, working-class Methodist family in a grim, sooty English provincial town, he was a skinny, red-haired child set apart from his peers by his reticent good manners and observant, knowing detachment. When young he worked in a cobbler's shop, and later embossed patterns on

fireplace fenders for his living, until he had saved enough to enrol in evening classes in arts and crafts. He shed his abrasive Black Country accent for the clipped inflections of a privately educated young gentleman with such success that in the First World War he was commissioned as an army officer: a formidable achievement for a furnaceman's son. In 1917 he was caught in a German ambush and spent eighteen months as a prisoner of war. His captivity was as decisive a turn in his life as his military gentrification, for his fellow prisoners tried to reduce the monotony of their lives with ambitious amateur theatricals. Whale acted in several productions and became accomplished at stage design.

After the war he found work as a stage designer, stage manager and actor, and enjoyed social success in London, for he was a superb dancer. For several years he was engaged to marry a beautiful and brilliant designer, although he knew that his sexual preferences were for men. In 1928 he appeared in Benn Levy's stage

James Whale deftly mastered cinematic gothic's cultural antecedents. In this scene filmed in 1931, Frankenstein's monster takes the role of Fuseli's goblin terrorising the prostrate woman in The Nightmare.

Frankenstein contained scenes which were momentous in cinema history and were vital in shaping the twentieth-century visual imagination, such as Victor Frankenstein's laboratory, in which his monster is brought to life.

adaptation of Hugh Walpole's startling novel *Portrait of a Man with Red Hair*, about a gothic sadist who, like the patricidal monk in Maturin's 'Spanish Tale', incarcerates two lovers in a cliff-top house. Later that year he was acclaimed as the director of R. C. Sherriff's devastating play of trench warfare, *Journey's End*: the play was set in a trench dug-out, for which his design had all the claustrophobic oppression of a gothic dungeon. After taking the play to Broadway, he was recruited by Paramount Pictures as a dialogue director for the new Hollywood talkies at the munificent salary of $500 a week. Professionally, Whale was punctiliously efficient, understated in rehearsals, working without fuss, hesitation or bullying. The ambiguities of his class allegiance, even more than his sometimes necessarily clandestine erotic experiences, gave him many insights into double lives and spectral inner secrets.

Whale cast Boris Karloff to play Frankenstein's monster (the studio had originally wanted Lugosi, who thought the part degrading). To play the part of the scientist Frankenstein he summoned to Hollywood an English actor, Colin Clive, who had

been a resounding success in the London production of *Journey's End*. Clive was married to a lesbian, and known by Whale as a man deeply troubled and fissured by his own bisexuality, which was worrying him into dipsomania. Before filming began, Whale explained his conception of the film to his friend:

> I see Frankenstein as an intensely sane person, at times rather fanatical . . . [yet] Frankenstein's nerves are all to pieces. He is a very strong, extremely dominant personality, sometimes quite strange and queer, sometimes very soft, sympathetic and decidedly romantic . . . I want the picture to be a very modern, materialistic treatment . . . something of *Doctor Caligari*, something of Edgar Allan Poe, and of course a good deal of us.

The film is thus an Anglicised treatment of the German gothic cinematic preoccupation with divided selves and irreconcilable inner contradictions, enriched by a meticulously evasive touch of queerness. 'James's feeling was that very sweet, very pretty people, both men and women, had very wicked thoughts inside,' according to his friend and colleague Elsa Lanchester. 'These thoughts could be dragons, they could be monsters, they could be of Frankenstein's laboratory.' With this imaginative complexity, Whale inaugurated a new tradition of English-language cinema: the images of *Frankenstein* have become iconic, especially in the crucial scene, over which Whale took exceptional pains, in which the monster comes alive. *The Times* reviewer in 1932 described the horror vividly: 'Thunder rolls about the old windmill, complicated machines, humming and whirring, glow with strange lights, the few aghast spectators hold their breath, the Shape on the operating table slowly rises through an opening in the roof to become the lightning's focal-point and sinks to earth again amidst a silence suddenly rent by Frankenstein's cry of triumph as the long, horrid fingers twitch to life.' Shelley's plot was altered in Hollywood with mixed success. In a twist which perhaps owed something to a 1926 German gothic film about the transplantation of a murderer's hands, Frankenstein was supplied under Whale's direction with a brain to insert in the monster without knowing that this brain came from an executed criminal and retained impulses which would drag his creation into an Edward Hyde–like degeneration into violence. There was, as Whale had promised Clive, 'a good deal of us' in this: homosexual acts were criminal offences, young inverts like Isherwood and Auden used to refer to themselves as 'crooks' in the 1930s, and the parallel with Clive's homosexual impulses, which

were dragging him into self-destructive alcoholic degeneration, is even more evident than in similar readings of *Dr Jekyll and Mr Hyde*. The climax of the film, in which the monster is trapped in a burning windmill, recalls the resolution of *Vampyr*, although Whale's monster is consumed by flames while Dreyer's vampire was suffocated in flour. In one respect Whale betrayed Shelley's vision: after deliberation, he settled that Frankenstein must outlive his monster, marry and live happily to prosperous old age. This conclusion is nearly as terrible a cheat as Rouben Mamoulian's widely admired *Dr Jekyll and Mr Hyde* (1932), in which a preposterous love-interest is injected into the story before Hyde is killed in a brawl rather than the theatrical power and tragic symbolism that provides the climax of Stevenson's novella. Whale's film, though, is intelligent and ingenious; it earned $53,000 in its first week, and induced screaming, fainting and horror-stricken insomnia. Its star became known as 'Karloff the Uncanny'. Its sequel, *The Bride of Frankenstein*, directed by Whale in 1935, again with Karloff, surpassed even the original, though its most significant themes mean that it is more aptly discussed in my next chapter.

One scene in the 1931 film had enduring impact on British censorship: Karloff as the monster playing with a pretty little village girl and floating flowers on a picturesque lake. Originally the monster was filmed running out of flowers and, in his ignorance, throwing the child into the water, expecting her to float. To forestall possible complaints by moralisers, this drowning scene was deleted shortly before the film's release and the child was strangled off-camera (a peal of thunder was also substituted for a supposedly blasphemous line of Frankenstein's, 'Now I know what it feels like to be God!'). After Whale's film was released in Britain with an 'A' certificate (meaning that it could be seen by children accompanied by adults), the National Society for the Prevention of Cruelty to Children complained to the Home Office about this lakeside scene. In response, the government instructed the British Board of Film Censors to introduce a new certificate designation, 'H' for horror. Edmund Shortt, the former Home Secretary who headed the British film censors in 1929–35, declared his intention of banning such films. The censors felt such films induced feelings in the masses which they ought not to feel, and endeavoured to regulate adult emotions under the pretence of child protection. In addition to requiring numerous cuts in gothic or horror films, they suppressed at least one masterpiece, Tod Browning's *Freaks* (1932), which was banned in Britain until 1963

(when it received an 'X' certification). Though Whale's *Frankenstein* is still cinematically powerful, *Freaks* is the only gothic film of the 1930s that remains terrifying. In Browning's plot a beautiful trapeze artiste, Cleopatra, agrees to marry her infatuated admirer Hans, a circus midget who has become heir to a fortune, but inwardly resolves to poison him. She behaves with self-destructive rashness from the outset, insulting Hans's fellow freaks during a superbly filmed wedding banquet, before carrying him away on horseback with a bravado that further degrades him. After other indiscretions, Hans and his friends discover her plot, and, on a night of Salvatorian storms, they ambush her on the road with her lover, the circus strong man, Hercules, whom they kill. They mutilate Cleo until she resembles an armless

The gothic temperament has never been a vast benevolent lethargy of well-wishing. The emotional cruelty and final display of human partibility in Tod Browning's Freaks *(1932) distressed the censors for over thirty years. The mutilation of the villainess by the circus freaks pictured in this still aroused fear and revulsion much stronger than the castration anxieties publicised by Freud.*

and legless chicken who is then exhibited as the new circus freak. Browning's use of authentic freaks, including the Siamese twins Daisy and Violet Hilton, was immensely effective and has proved intolerably offensive to some viewers ever since. The self-reliance, initiative and canniness of the despised freaks were threatening to the censors for resonating with the power of the underclass.

Shortt's mistrust was raised by other disturbing films treating gothic's tradition of the double. A notable case was *The Hands of Orlac*, originally a German silent film of 1925 and remade in 1935 as *Mad Love* in the USA. Its plot reflected a German psychological theory of the 1920s (now largely forgotten): Wilhelm Stekel and Georg Groddeck, whose ideas had considerable currency among the Berlin intelligentsia, believed that hands had a nervous life of their own, and that they would subversively perform acts abhorred or forbidden by the brain as symptoms of emotional distress: kleptomania, for example, they identified as a symptom of sexual dysfunction. Orlac is a great concert pianist whose hands have been severed in a railway accident. The depraved surgeon Gogol (played superbly in 1935 by Peter Lorre) is besotted with the pianist's wife and grafts the hands of a guillotined murderer onto Orlac's stumps. The dead man's fingers seemingly retain a life of their own, and impel the pianist to throw knives with the purpose of murder. The 1935 remake was directed by Karl Freund (1890–1969), who had been the brilliant cinematographer of a 1920 remake of *The Golem* as well as of *Metropolis*, Browning's *Dracula* and several Whale films (in the 1950s Freund was photographic director of over four hundred episodes of the television serial comedy *I Love Lucy*).

The Black Room (1935), a film set in the early nineteenth century, depicts the gruesome doom of the aristocratic family of Berghman. Boris Karloff played twin brothers, Gregor and Anton, of whom the elder is wicked and the younger is virtuous. The family are haunted by a curse that the younger brother will kill the elder in their castle's black room, which consequently has been sealed by their father. The villainous elder brother, however, knows a secret entrance. Like the *Waxworks'* Ivan the Terrible he is a sensualist with no sense of irony whose conquests are an exercise of power over women and of humiliating dominance over their menfolk. When tired of abusing a village girl he discards her body in an oubliette in the black room, which becomes the *locus* and represents the depths of his wickedness. His peasantry are outraged by his murderous lusts, and to escape their wrath as well as the curse, he stabs his younger brother, who is distinguishable from him by a paralysed arm.

In accustomed gothic manner he then usurps his dead brother's identity by shamming this paralysis, but his deception is discovered at the altar moments before he is to marry the heroine. A furious mob hunts him to his castle, where he hides in the black room, long predicted as the site of the family doom. There his brother's dog knocks him into the pit (this recalls the death of another count, Wolfgang, in Hoffmann's story 'The Entail') so that he is impaled on the dagger protruding from his brother's decaying corpse. The curse is thus fulfilled. As Graham Greene concluded in 1935, 'Mrs. Radcliffe would not have been ashamed of this absurd and exciting film, of the bones in the *oubliette*, the scene at the altar when the dog leaps and the paralysed arm comes to life in self-defence, of the Count's wild drive back to the castle, the lashing whip, the rearing horses.'

Gothic always had the propensity to breach the frontier between life and art. Its emotional excesses were imitated by those who felt an inner emotional vacuum. Ann Radcliffe's fictions of the 1790s swiftly affected the way her consumers spoke, thought and behaved in reality. To give one example, Katherine Wilmot and Countess Mountcashel (sister of Big George of Mitchelstown Castle, the doomed Earl of Kingston) dramatised themselves as Radcliffe heroines at an inn in the Apennines in 1802:

On our going upstairs, and, from the crack'd panes of the trickling windows, seeing that the rains had swell'd the water so as to moat round the inn like an island, and perceiving everything inside in frightful disorder (the long deal table overturn'd and cut and slash'd with dinner knives upon the surface – a picture of Jesus Christ revers'd upon its peg – and warnings scrawl'd with blood and charcoal against the wall) we trembled like a pair of arch cowards . . . and follow'd by two black hideous looking men, with torn mattresses on their backs, which they flumpt down in a passion in the middle of the floor, and went off growling like a pair of demons . . . You may imagine the kind of night we spent. The wind was roaring a hurricane, and the rain pattering frightfully against the windows. There were no shutters to prevent our seeing bright blue flashes of thunder breaking in hollow echoes amongst the Apennines, which eternally reminded us of these mountains being the resort of legions of *banditti*, who always find in their recesses a sanctuary from the pursuits of justice.

This only increased as cinema films, gothic cinema films not least, became accessible to mass audiences, and increased consumers' propensity to imitate bad art in both the routine and the crises of their lives. 'The middlebrow screen is more and more dictating how people ought to behave – even at a deathbed,' Graham Greene wrote in 1937:

> I remember lying in bed a few years ago in a public ward listening with fascinated horror to a mother crying over her child who had died suddenly and unexpectedly after a minor operation. You couldn't question the appalling grief, but the words she used . . . were the cheapest, the most improbable, the most untrue . . . one had heard them on a dozen British screens. Even the father felt embarrassment standing there beside her in the open ward, avoiding every eye.

Gothic's artistic consumers have in many cases similarly indulged in alarmingly tawdry fantasies. They relish in themselves the Edward Hyde, the mirror Baldwin, the irrestrainable impulses of Baroness Blixen's monkey or Orlac's hands.

Wild mood swings

Reaction is the law of life.
Benjamin Disraeli

Objection, evasion, happy distrust, pleasure in mockery are signs of health:
everything unconditional belongs in pathology.
Friedrich Nietzsche

For they breathe truth that breathe their words in pain.
William Shakespeare

GOTHIC AFTER BELSEN AND HIROSHIMA

Nazi concentration camps photographed from the air look like Hollywood film-studio lots. Perhaps this observation provoked the sarcastic complaint by an American critic, Philip Rieff, in the 1970s that Nazi atrocities were 'art transferred to life, marvellous scenarios'; but the inclusion of gothic aesthetics in the blame for genocide is unjust. At Auschwitz, Belsen, Buchenwald, Dachau and other death-camps, gothic intimations were fulfilled rather than being extreme artistic scenarios transferred to life. Gothic art had long contained apprehensions of torture and death, most distinctly in Sade's castle of Silling. The *genre* has always represented the abuse of dominion and humanity's looming vileness. The ogres of latency represented by Henry Jekyll or Weimar cinema were not fantasies but imaginary representations of real truths. Fear and horror, which together with grief were the most extreme emotions aroused by the death-camps, had always predominated in gothic; but thoughts of captives walking passively into the gas-chambers were too horrendous to provide the pleasures of melancholy. Gothic's message that pain, terror or anguish can be overcome by submission was ill-attuned for the 1940s. For a decade after 1945 literary and pictorial gothic became nearly as unfashionable as gothic revival architecture.

There were some exceptions. The artist and novelist Mervyn Peake (1911–68), who had visited Belsen in 1945 to sketch its horrors, found for his Gormenghast

trilogy of 1946–59 that gothic grotesqueries were his only route to approach the reality of concentration camps. His experiences at Belsen particularly influenced his closing volume, *Titus Alone*. The three novels are set in the vast, ugly castle of Gormenghast, which oppresses and deforms the lives of its inmates, both noble and servile; the castle is a static, immutable power, regulated by macabre rituals so precise and obsessive that they have the extremity of madness. It contains a Hall of Spiders, underground tunnels and a subterranean lake representing a swamp of the instincts. Its inmates are irritable monstrosities who were born so deformed that only evil could inhabit them. Peake's long fantasy recounts the tribulations of the castle's proprietor, Titus, 77th Earl of Groan, who struggles against the ancestral duties imposed upon him by the castle and strives to invent a new identity for himself. But Groan's new environment, after his flight from the castle, proves just as hellish:

> It was not the intrinsic and paramount mood of the Black House, although this alone was frightening enough, with the fungi like plates on the walls, and the sweat of the stones; it was not only this, but this was combined with the sense of a great conspiracy: a conspiracy of darkness, and decay; and yet of a diabolical ingenuity also; a setting against which the characters played out their parts in floodlight, as when predestined creatures are caught in a concentration of light so that they cannot move.

Reaction gives goths life: their instinct is to resist the optimistic or softening tendencies of their age. Their imaginative outlook evolved in the eighteenth century as dissent from the Enlightenment: it served as an incessant reminder that humankind cannot be liberated from fear. Since the publication of Shelley's *Frankenstein*, the gothic aesthetic has incorporated warnings that technology and science, in achieving new triumphs intended to emancipate people from fear, are likely to unleash uncontrollable forces perpetrating new atrocities. In 1896 the French scientist Henri Becquerel discovered radioactivity; in 1903 Ernest Rutherford concluded that atoms contained a vast force of energy, and as early as 1904 his colleague Frederick Soddy suggested to British military engineers that this force might be harnessed to provide annihilating armaments. Other great minds, including Einstein, contributed to the process which culminated in the detonation of the atomic bomb at Hiroshima in 1945. Humankind had at last discovered from Nature how to achieve absolute ter-

ror. Though the memory of Nazi death camps commanded an enduring cultural power from the 1940s, nuclear weapons had imaginative primacy. For the next twenty years fear, apprehension and oppressive doom provided the strongest cultural mood in the USA, and perhaps also in Britain. It seemed crucial to distinguish between real horror and Metro-Goldwyn-Mayer's factitious thrills, and to recognise why the systematic cruelty of the Nazis and the scientific devastation of Japanese cities were so much more chilling than the random violence of the marauding goths who had invaded the old Roman Empire. Yet gothic artists have found little to say of this. Poppy Z. Brite, the most impressive goth novelist to emerge in the USA in the 1990s, has said that it was crucially formative 'being a teenager during the Reagan years and spending the time pretty sure that I would die in a nuclear war', but there are few hints of this in her *oeuvre*.

Goth creativity, since Poe's time, has steadily sunk into tortured self-preoccupation. 'The dominant creative tradition in America during the last century and a half, as in England and Germany, has . . . been Gothic, transcendental, romantic, subjective,' declared the influential American critic Clement Greenberg in 1947. He was sure that intense mechanisation and dehumanised city environments were the sources of gothic resurgence: 'industrialism exacerbates and drives us to extreme positions.' One example of the gothic mood in the 1940s – sombre, inward, subjective, and opaque – is the poem about an Austrian castle by Randall Jarrell, 'Hohensalzburg: Fantastic Variations on a Theme of Romantic Character' (1948). It has the defiant mystery of a vampiric reverie. 'When I read it, I think, "What does it *really* mean?"' Jarrell wrote shortly after its completion. 'I can't answer this. It's like a dream that needs analysis to be plain.' The gothic aesthetic in Jarrell's time proceeded in a culture in which, apparently, everything needed analysis to be made plain.

The greatest goth manifestations of the 1940s were driven by idiosyncratic personal vigour. 'The most powerful painter in contemporary America . . . is a Gothic, morbid and extreme disciple of Picasso's Cubism and Miró's post-Cubism, tinctured also with Kandinsky and Surrealist imagination,' Greenberg wrote in 1947 of Jackson Pollock (1912–56). 'For all its Gothic quality, Pollock's art is still an attempt to cope with urban life; it dwells entirely in the lonely jungle of immediate sensations, impulses and notions, therefore is positivist . . . yet its Gothic-ness, its paranoia and resentment narrow it.' Pollock's painting of tortured human dancers,

Gothic (1944), influenced by Picasso but with the hypersubjectivity and intensity of characters in a Poe story, combines exuberantly thick encrustations of paint with abstracted, almost architectural lines. According to Ellen Landau, *Gothic* marked the maturation of Pollock's ideas. 'He began to move more definitely away from dependence on therapeutic sources . . . to a rapidly increasing non-objectivity and self-reliance.' The picture is his rite of passage into adulthood: it celebrates the moment when he realised that although for a child who has fallen on its knee, the pain stops when it tells a parent that it has hurt itself, one ceases to be a child when one realises that telling one's truth does not make anything better. *Gothic* suggests omens and symbols from Pollock's imagination, which he was closing off from verbal expression, understanding that painters, as Matisse said, should begin by cutting off their tongues. It is exemplary in another way: its combination of passionate excess with self-reliance proved the enduring characteristic of higher gothic after the Second World War.

Gothic is never indifferent to material power, but since the 1950s it has chiefly articulated counter-reactions to the prevailing emotional environment. Under the influence of Freudian and other therapeutic theories, the doctrinal rigour of old faiths has been displaced by the 'psychotechnics of acting out' in which role-players, as if imitating the *Student of Prague*'s doppelgänger, step outside themselves to display their dramatic abilities. The emphasis on personal fulfilment which has come to dominate the USA, the cesspool of self-absorption and self-justification which is seeping into Europe under the influence of Oprah Winfrey, idolatry of Diana, 'Queen of Hearts', and soap-operas, has increased the range of psychotechnic acting-out. These psychotechnics rest on a belief in the value of discovering 'the inner child' in each of us, and in reviving childish feelings of omnipotence which are sloppily equated with adults feeling hope or declaring themselves empowered. Though some early goth consumers, such as the readers of Ann Radcliffe, had been prone to romanticise and idealise victims, and to venerate self-victimisers, late-twentieth-century goths have resisted this infantilised culture in which human unhappiness and ills are reductively attributed to abusive parenting or poor nurturing, and under which original sin is dismissed as a cruel, obsolete superstition. As die-hard reactionaries against these progressive family-centred pieties, goths have enjoyed a new revival, especially since the early 1980s. It can seem at times as if evil and death have become their toys or fashion accessories; but the new goths are not playing with

evil: they are trespassers wandering disruptively over the neat turf of suburban conventions, graffiti artists disfiguring the antiseptic walls of the factual mentality, hecklers with a discordant idiom pitched to jangle the nerves of authority.

JAMES WHALE'S BRIDE OF FRANKENSTEIN

Perhaps the earliest distinguishable instance of twentieth-century gothic subverting family values is the film *Bride of Frankenstein*, directed by James Whale. Gothic and cinema alike are self-referential, and this film since its release in 1935 has drawn more allusions than any other of the *genre*. The pressure on Whale to make a sequel to his terrifying *Frankenstein* of 1931 proved irresistible, but he was too versatile and scrupulous to repeat a stale formula. He wanted to create sardonic and derisive new images as well as the macabre and terrifying stunts which constituted the commercial appeal of horror films. There were some similarities of procedure and structure between the two films, though. In *Frankenstein* he had gone to pains to recruit his friend Colin Clive to play the part of the scientist, and had devised a film which was partly a coded commentary on his actor's personal predicaments. In *Bride* he again cast Clive and Karloff as Frankenstein and the monster, but more significantly he created a large part for his old friend Ernest Thesiger, and enlivened the screenplay with coded allusions to him.

Unlike Whale, who was discreet in all things, Thesiger was grotesquely thin, shrilly flirtatious, improbably married to his best friend's sister and loved the smell of bad drains. He was both an aristocrat (his grandmother was the heiress of the last Duke of Dorset) and a reputed 'wizard' (he repeatedly demonstrated psychic powers). Described in 1942 by James Lees-Milne as 'an old pansy, affected, meticulous, garrulous and entertaining', he had Poe's gothic propensity for masques: at the first he ever attended, he cut a sinister figure as Death, dressed in black draperies with a skull mask wreathed in scarlet poppies, almost like Poe's spectre who kills Prince Prospero and his courtiers in 'The Masque of the Red Death'. He combined the mannerisms of a *grande dame* with consummate proficiency at fancy needlework. After the outbreak of war in 1914, Thesiger, thinking a kilt would suit him, applied to Scottish regiments, but the accent he assumed for the occasion was unconvincing, and his chief war work was teaching embroidery to disabled soldiers. His versatility as an actor was well attested: for three years he appeared in the farce *A Little Bit of Fluff* ('Mr Ernest Thesiger is a scream,' said one critic) before brilliantly portraying

Ernest Thesiger, playing Dr Pretorius in The Bride of Frankenstein *(1935), gazes intently at a homunculus offering another version of himself: a superbly costumed queen.*

Mephistopheles in Marlowe's *Dr Faustus* (though an enemy sneered that he played the part 'like a maiden lady from Balham'). George Bernard Shaw created several parts for him; he was the First Witch in a Gielgud production of *Macbeth*, and a haunting villain in *Peter Pan* ('Always remember,' Barrie advised him, 'that Captain Hook was educated at Balliol'). Somerset Maugham retorted, on Thesiger complaining that he never wrote a part for him in his plays, 'but, I am always writing parts for you, Ernest. The trouble is that somebody called Gladys Cooper will insist on playing them.' The role created by Whale for Thesiger ('my face is so queer', according to his memoirs) was that of Dr Septimus Pretorius, who is described by the housekeeper at Castle Frankenstein as 'a very queer-looking gentleman'.

Families are destroyed early in *Bride*. The grieving parents of Maria, the pretty child whose lakeside murder had so upset the British censors, visit the conflagrated mill where the monster was destroyed in the original film. Maria's father intends to gloat over the charred bones of his daughter's killer but falls into the mill's flooded

The graveyard scene in The Bride of Frankenstein *typifies the film's visual power. The ideas in the script and the interpretation of the characters are equally accomplished.*

cellar, where with startling suddenness, the burn-scarred monster looms out of the dark and holds him under the water until he is drowned. Maria's mother, on a higher storey of the mill, then grips a hand, thinking to help her husband clamber up, and dies as abruptly and shockingly as her man, thrown to her death in the cellar, now transformed into an appalling gothic charnel-house. The monster is obsessed with finding a companion to mitigate his isolation, and desperate to ape the forms and antics of heterosexual marriage. He does find perfect companionship, by chance, with a gentle blind man, who takes him to live in his cottage, despite realising that his unknown visitor is a mysterious sort of transgressive. The blind man cherishes him, without the invasive inquisitiveness and need for possessive knowledge of families: 'You needn't tell me about it if you don't want to,' says the blind man who, like Whale, realises that love, like truth in any serious sense, is reticent. The monster and the blind man are both outsiders, and together achieve some perfect moments of trust: the only ones the monster ever knows. But their version of homeliness is destroyed by two armed men who come to the cottage and, like moral vigilantes, drive the monster away. He is hunted by a furious mob which eventually captures him. Whale had been both vexed and amused by the obtuse pieties of the censors and, with characteristically quiet audacity, took pleasure in presenting the captured monster as Christ-like, brutalised, rejected, even in one scene tied to poles in the shape of a crucifix. There are other inversions of Christian imagery in the film, reminiscent of the inverted Christian *motifs* in Salvator Rosa's *Scene of Witchcraft* (described on pages 19–21); but these blasphemies were never noticed by the literal-minded ignoramuses of the Hays Office.

Meanwhile, Frankenstein has abandoned hubristic experiments for the promise of domestic bliss with his pretty fiancée, Elizabeth (played by Valerie Hobson). Their homeliness, however, is disrupted by a visit from Dr Pretorius, a camp, insinuating, waspish figure intent on mocking domesticity, and promising emotions more exciting than friendship. Pretorius dismisses Elizabeth from Frankenstein's bedroom, drinks gin and sets out to seduce the scientist's curiosity. 'Sometimes I wonder if life would not be much more amusing if we were all devils, and no nonsense about angels and being good,' Pretorius confides. Then he displays seven tiny people whom he has created, more by black arts than science, and keeps in jars. The first is a sumptuously costumed queen (like Thesiger in real life); the second is a king (modelled on Henry VIII as acted by the tormentedly homosexual Charles

Laughton in a recent film); the third a priggish bishop (like Arthur Winnington-Ingram, Bishop of London, who had recently exclaimed that he wanted to make a bonfire of all the condoms in Britain and dance around it); the fourth a devil resembling Mephistopheles as played by Thesiger in *Dr Faustus*, and to whom Pretorius claims a likeness ('I took a *great* deal of pains with *him*'); a beautiful, dull ballerina who will only dance to Mendelssohn's Spring Song; a mermaid; and a baby pulling flowers to pieces. The script suggested that this last tiny homunculus should resemble Karloff, and Pretorius predicts, 'this baby will grow into something worth watching'. Whale's figure of child evil represented original sin, the Christian belief that humanity is born innately corrupt; but by the 1930s this was becoming an unacceptable concept and outraged child-care vigilantes, with their fanatically insistent attribution of children's misconduct to psychological determinism. At the insistence of the studio, images of the corrupt baby were cut from the film before its release.

After meeting the monster in a graveyard crypt, Pretorius kidnaps Elizabeth and under this duress Frankenstein is forced to collaborate with him in making a female mate. The scene in which the two men work together to create a woman achieves a powerful whirl of gothic inversion and disorder: nearly 200 shots, tilted, outlandish, sometimes with perspectives as disorientating as Piranesi's *Carceri*. The musical score insolently mimics Mendelssohn's wedding march with the ironic sound of church-bells: the bride herself is decked in rags and shredded bandages, like a cruel parody of a wedding-gown, and perhaps as a grotesque pun on 'mummy' too. The monster is elated as his intended bride is brought to life, but when she hisses and screams her rejection at him, he realises that his yearning to ape heterosexual marriage is pitifully inappropriate, and that he cannot recover the sympathetic tranquility he enjoyed with the blind man. Frankenstein and Elizabeth escape, while the monster destroys himself, together with his misfit bride and Pretorius, by blowing up the laboratory. Universal Studio bosses would never have allowed a character of such nefarious sexuality as Thesiger's to survive; still less for the marriage of Elizabeth to be foiled or for Frankenstein's collaboration with a queer man in surrogate reproduction to succeed. Yet families do not come well out of this film, and companionate love between men does.

VAMPIRISM

Gothic's chief example of non-sexual reproduction is provided not by Pretorius but by vampires. In the fifty years since Randall Jarrell's 'Hohensalzburg' the most persistent sub-genre in mass-market gothic has been vampirism. By 1998 *Dracula* had been translated into over forty languages and its Transylvanian count had become the most filmed character after Sherlock Holmes. Indeed, vampirism has occasionally been transferred from film scenarios to criminal reality. The English serial killer John George Haigh (1909–49), who murdered at least six people for gain before destroying their corpses in drums of sulphuric acid, claimed at his trial in 1949 to have tapped blood from the necks of his victims, and to have drunk their blood from a glass. As a result journalists gave him the soubriquet of 'The Vampire Killer' in addition to that of 'The Acid Bath Murderer'. Haigh's vampiric tastes may have been shammed in order to support his plea of insanity, which was intended to save him from execution and was probably prompted by mass-market entertainments like Tod Browning's film *Dracula*. More recently, the Queensland lesbian vampire Tracey Avril Wigginton (b. 1965) was jailed for life by the Brisbane Supreme Court on 21 January 1991 after luring a male vagrant to a car, stabbing him until she had almost severed his head and drinking his blood. On 25 November 1996 Rod Ferrell (b. 1980), leader of a teenage vampire cult and organiser of blood-drinking graveyard saturnalia, allegedly bludgeoned to death the parents of one of his acolytes near Orlando in Florida. He carved or scorched with cigarettes the letter 'V' into the corpses of his victims. 'For a couple of months prior to the suicides, Ferrell had become possessed with the idea of opening the Gates to Hell, which meant that he would have to kill a large, large number of people in order to consume their souls,' according to a police report. 'By doing this, Ferrell believed he would obtain super powers.'

There have been innumerable television versions of the Dracula story, often surprisingly faithful to the spirit of Stoker's text, or deftly adapting ideas from innovative early vampire films. As one example of this ephemera, an episode of *Sliders*, the futuristic television serial of the late 1990s which has adapted gothic's doppelgänger motif into a chronicle of parallel universes, centred on a transgressive goth band called Stoker. Although the names of the 1897 protagonists were exchanged and inverted a century later, the television scriptwriters' mischievous infidelities

enhanced the rich amplitude of Bram Stoker's original ideas. The Stoker musicians were vested in *Sliders* with irresistible pulling-power over women, which reflects one version of reality. The idea of vampirism has increasingly gratified some women while distressing some men – conceivably because it is sexually suggestive but non-penetrative, or because it disarms the Freudian ideology (so powerful in the twentieth century) which equates femaleness with the absence of a penis. 'The women who flock to our Dracula and Frankenstein films are much tougher than the men,' the *Daily Herald* reported in 1962. 'During Dracula's three weeks' run in the West End 54 people fainted. 38 were men, only 16 were women. In the provinces, 75 per cent of the 5,000 fainting cases were male.' During the next decade vampirism was claimed as a sensationalised reality, and was commodified as a thrill for tourists. In 1970 a crowd of vampire hunters assembled at Highgate cemetery in London: graves were desecrated, and iron stakes driven through the hearts of mutilated corpses. A few years later, in 1974, British European Airways' subsidiary Sovereign Holidays organised the first package tour of Draculan haunts. Tourists were taken to Poenari Castle, which had been phonily restored to dupe them, and Romanian Communist authorities built the Golden Crown hotel at Bistrita, named after an inn which featured in Jonathan Harker's journey to Transylvania. The 500th anniversary of Vlad's death in 1976 was commemorated with a postage stamp: the Romanian tyrant Ceausescu hailed the Impaler as a nationalist hero. The reification of vampire myths has continued apace. Twenty-seven per cent of respondents to a scholarly survey in the USA in the 1980s believed in the possibility of vampires' existence as real entities: a figure which does not seem excessive when 69 per cent of US citizens in 1993 believed in angels, and more British people born in the 1970s believe in ghosts than in God. There are national bodies like the Australian Vampire Information Association, with its eloquent motto, 'Get a Life, Get Undead', and incarnadine newsletter, *Bloodlines*, as well as more specialist groups, such as the Santa Cruz Vampires Motor-Cycle and Scooter Club.

Vampires are nothing if not consumers. They support shops, bars and other businesses. Sabretooth Inc., based in New York, was opened in 1995 by an individual known as Father Sebastian, who has acolytes with such soubriquets as Lord Faust. Sabretooth supplies fangs to fit over teeth and gums, contact lenses of sinister tints and other vampiric accessories. It runs a society, the Sabretooth Coven, organises Vampyre Balls and publishes a magazine, *Vampyre*, exploring music, cinema, role-

playing and fetishism (the magazine's editor, Dr Katherine Ramsland, is the biographer of the phenomenally successful gothic novelist Anne Rice). In Los Angeles vampires shop along Melrose Avenue. At Necromance they can buy bat jewellery, human ribs, arm bones, wooden stakes, garlic and crosses. The Melrose Avenue designer Terri King supplies clothes in sensuous velvet, satin or black leather to the vampire set. After writing her vampiric novel *Lost Souls* (1992), Poppy Z. Brite found 'people would sidle up to me at cocktail parties and book signings to tell me how they actually *were* vampires'. She has 'met a lot of people who like to drink blood, but none whose metabolism required it'. Nevertheless in California individuals have registered with medical authorities as dependent upon drinking human blood and are therefore provided with plasma supplies. In some cases, at least, they seem to be haunted by the memory of motoring or other accidents in which they have been splashed with blood (in their attempts at pathologising their behaviour, they would describe it as an addiction after accident trauma). Others claim to have blood disorders necessitating a diet of beef blood and raw liver.

In *Red Light* (1996), a book about the sex industry in the USA, James Ridgeway and Sylvia Plachy of *The Village Voice* trace the descent of the contemporary vampire scene in the USA from the goths of the 1980s and the punks of the 1970s. Ridgeway and Plachy estimate that there are a few thousand US vampire-players, predominantly white, middle-class and in their early twenties. Dressed in black, wearing deathly white cosmetics, they congregate at specialist clubs where, in back rooms, they use razors, syringes or their eye teeth to drink each other's blood, usually piercing veins in the arm or neck. 'What we do is theatre,' Gavin Danker of the Fang Club in Los Angeles said in 1998. 'It is playing. It may be drawing blood with the consent of the person playing.' Vampires communicate via e-mail, free-voice coffin boxes or Web sites; apart from blood, their preferred drinks are red wine, absinthe and coffee. They describe the vampire scene as 'family': some are being depressingly literal in this catchphrase; others use vampirism as a way of signalling their reaction against family-centred pieties. During the Californian summer of 1997, doubtless stimulated by publicity surrounding the centenary of *Dracula*'s publication,

> dozens of teenage members of the newly fashionable 'Gothic set' have been arrested in the [Disneyland] park for drug offences and other misdeeds . . .

'It's a great way to get out of the house,' said one girl of 15 wearing white make-up, blood-red lipstick and dark eyeshadow. 'You ask your parents for a pass and they think: "Disneyland – nothing bad could happen there."'

This disruption has an odd aptness. The Disney business empire is profoundly anti-goth by sentiment and acts: its family-centredness, carrying a message of safeness and containability, provides a value-system which goths spurn. Disney's usurpation in the 1990s of one of the most authentic gothic cityscapes, Times Square in New York, and its substitution of a hygienic, infantilised theme park is part of its commercial battle to annex human fantasies.

Since the early-eighteenth-century English obsession with the Hungarian vampire Arnold Paul, vampirism has provided a means to represent ideas about property, possessions and the authority that accompanies them. In the cinema vampires have continued to denote propertied milieux as well as sexual dissidence or ungodliness. Their symbolism has been refined in a consumer age. 'Most of our people have never had it so good,' Harold Macmillan, the British prime minister, famously declared in 1957. 'Go around the country, go to the industrial towns, go to the farms, and you will see a state of prosperity such as we have never had in my life-time – nor indeed ever in the history of this country. What is beginning to worry some of us is "Is it too good to be true?" or perhaps I should say "Is it too good to last?"' This message of new prosperity and old insecurities was echoed in gothic art. Early vampires had been drawn from idle, imperious classes – based on Lord Byron, with titles and lands of their own – but their trappings now began to seem obsolete. The Hammer film *Horror of Dracula* (1958), directed by Terence Fisher and starring Christopher Lee, provided a vampiric version of this new mood. Every cin-ematic Dracula since Bela Lugosi in 1931 had lived amid fusty decay, but in this 1958 version the vampire's castle is not a claustrophobic feudal power house but a spacious, elegant headquarters with the furnishings and accoutrements of a tycoon. This newly immaculate Dracula reflected the craven loss of nerve and memory in the ruling classes of Macmillan's Britain, and the meretricious, optimistic moder-nity. Moreover, the prevailing mores of the 1950s, which made a fetish of family val-ues, held respectability as the highest good and saw the transcendence of abject middle-class snobbery, required that the anti-Draculan combination in Fisher's film be a cohesive family with a nice, respectable home. By contrast, in the 1980s, when

Whitley Strieber's vampiric novel was adapted into the film *The Hunger* (1983), the western leaders Ronald Reagan and Margaret Thatcher were promoting their invidious quasi-gothic creed of power, domination, egotism and the unbridled excess of market forces. *The Hunger* reflected the morality of the 1980s as surely as *Horror of Dracula* was a microcosm of Macmillan's Britain. Its central character, Miriam Blaylock (played by Catherine Deneuve), is Le Fanu's Carmilla redressed for Reaganite consumers. In Nina Auerbach's summary,

> She epitomizes the glamour of the 1980s, subordinating history to seductive objects; jewellery, furniture, lavish houses in glamorous cities, leather clothes. Responding to the success stories of her consuming decade, Miriam lives through her things. She kills, not with her teeth, but with her jewellery, an ankh that hides a knife. She preserves her desiccated former lovers, who age eternally once their vampirism wears off, as carefully as she does her paintings. These things, along with the music and the cityscapes over which she presides, make us envy Miriam's accoutrements instead of her immortality. Vampires in *The Hunger* are not their powers, but their assets.

Horror of Dracula and *The Hunger* were only two expressions of seething vampirism. Roman Polanski's laboriously parodic film of 1967, *The Fearless Vampire Killers* (also known as *Dance of the Vampires*), concerned a Jewish vampire-hunter pursuing a gay vampire: as the female lead he cast his wife, Sharon Tate, who soon afterwards was murdered by Charles Manson's gang. It has collected many acolytes despite its grievous clumsiness. John Rechy, who had won celebrity with his novel *City of Night* (1963) about the brutality provoked by forcing homosexuality into underworlds, depicted another subculture in *The Vampires* (1971). *Andy Warhol's Dracula* (1974, also entitled *Blood for Dracula*) was a trashy film in which the vampiric count is ailing and despondent because any blood but a virgin's makes him ill. He journeys from Romania to Italy, where in a decayed house on a country estate he finds four sisters whose blood he hopes will revivify him. Roman Polanski acted the part of a man in a local tavern, but Warhol's vampire-hunter is his priapic, poutingly handsome, wooden-acting stud Joe Dallesandro, who plays Mario Balato, a young Italian servant. Spouting Marxist clichés as he thrusts into them, he saves the virgin sisters from Dracula's desires by the obvious method. After Dallesandro's robust penetrations, his character destroys the vampire in a climax of exploitative

gore. Since Warhol, vampirism has become excruciatingly campy. In 1984 Charles Busch wrote *Theodora, She-Bitch of Byzantium*, a spoof of Cecil B. DeMille films, to perform as cabaret in Greenwich Village, before erupting with his *Vampire Lesbians of Sodom* in 1985, tracing two women's adventures from ancient Sodom through the ages to Hollywood of the 1920s and Las Vegas of the 1990s. *Vampire Lesbians of Sodom* became the longest-running Off-Broadway play in US theatrical history with over 2,000 performances over five years. Nevertheless, despite Warhol's trash and Busch's camp, vampires retain some cultural gravity. In composing *Birthday Letters*, his poetic sequence published in 1998 about his haunted relations with Sylvia Plath, the poet laureate Ted Hughes introduced vampires, bats and other ill omens.

Writers from Ray Bradbury downwards have secured commercial triumphs with vampiric tales. Chelsea Quinn Yarbro's tales of Count Saint-Germain are among the best popular vampiric serial fictions. Though much of this outpouring is unmemorable, in one respect it is suggestive. Since the 1970s vampirism has been colonised by critics seeking sexual metaphors. Le Fanu's Carmilla has been claimed as a lesbian heroine, and commentators have rejoiced that since Fuseli painted his *Nightmare*, it is the women, in many vampire tales and films, who have the wet dreams. The vampire Lestat, devised by Anne Rice in a series of immensely successful novels published since 1976, is an eighteenth-century French nobleman whose vampiric career is traced forward through the centuries. His bisexuality is central to Rice's fantasy: Lestat does not require his blood-prey to be exclusively male or female, which resembles his feelings about sexual objects too. His pleasure in women does not hinder his intellectual passion and erotic obsession with a youth, Nicholas, whom he initiates in vampirism, rather as Lord Grey de Ruthyn had initiated the young Lord Byron in homosexuality; both English barons later fathered children, and Lestat and Nicholas, by their vampiric attacks, father a progeny too.

With these chronicles, even more than with her novels about the Mayfair witches, Anne Rice has transformed the *genre* of the uncanny. Her orchidaceous tales of morbidity and coition arrange bizarre transgressions for mass consumption. Their plots, though complex, are sometimes jejune. She is not ashamed of titles like *The Queen of the Damned*, *Servant of the Bones* or *Memnoch the Devil*, but resents being dismissed as a pulp writer, partly because of the implied insult to her fans, about whom she is protective. A video is available to these admirers, entitled *A Visit with Anne Rice, an Intimate Conversation, Family, Faith, Passion*, showing the historic haunted property at

1239 First Street, where she lives in the city of her birth, New Orleans. Potential purchasers are invited on the Internet to enjoy watching the video while cosily drinking a coffee in their homes, although Rice's books themselves are consummately unhomely. Indeed, her house is not only the headquarters of her fan club, and an established part of the New Orleans tourist trail, but in her fictions is the nest of her dynasty of Mayfair witches. Rice, who comes from an Irish Roman Catholic family, dislikes progressives' notions of decorum, and enjoys flouting proprieties: under the pseudonym of A. N. Roquelaure she has reworked the story of Sleeping Beauty into S&M pornography; her vampire tales have incorporated homoeroticism into mainstream entertainment for the American heartlands.

Blood provides the chief metaphor in vampire art. Together with spunk it links life, or sex representing life-affirmation, with death. This link acquired emphatic and implacable connotations with the identification in the early 1980s of HIV, the human immunodeficiency virus transmissible by exchanges of bodily fluid which results in acquired immunodeficiency syndrome (AIDS). Gothic has always supremely been an aesthetic in which the present is paralysed or haunted by the past. In its paintings and stories humans are degraded into the playthings of impersonal Salvatorian forces, or some long, anterior error, omission or accident has a haunting sequel. The parallels with HIV are unpleasantly powerful, and were reinforced, perhaps, by the requirement in some gay subcultures of uniforms of domination, hoods for executioners and black leather which seems to drape queer bodies in sexual mourning. Fresh from the success of *Frankenstein Unbound*, of which Roger Corman made a movie in 1990, Brian Aldiss wrote his post-AIDS novel *Dracula Unbound* (1991) in which syphilis, representing all sexually transmitted diseases, is presented as a vampire preying on amorous human nature. Francis Ford Coppola's film *Bram Stoker's Dracula* (1992), starring Gary Oldman, includes magnified shots of blood cells seen through a microscope to stress the HIV metaphor (magnified blood cells most memorably appear in David Lynch's earlier movie, *Blue Velvet*, discussed below). Coppola reflects the compassionate liberal's sentiments about persons with AIDS: his vampire is not an aristocratic tyrant, vicious libertine, beast or demon, still less uncanny or hateful, but accessible, sympathetic and even sentimental.

POPPY Z. BRITE

Though they do not hang out at the same parties, Anne Rice lives in the same town as Poppy Z. Brite. Born in New Orleans in 1967, and a former resident of North Carolina and Georgia, Brite relishes her inclusion among American southern gothic writers such as Flannery O'Connor and Faulkner ('we are a bunch of sick fuckers, and that's good'). At high school she was branded as a Commie by Reaganite kids who left death threats in her locker. Afterwards she worked as a gourmet candy-maker, mouse caretaker, artists' model and exotic dancer; adoring cute boys, she performs with two in Jim Herbert's erotic film *John Five*. She returned to live in the French Quarter of New Orleans in 1993 with two cats, two boyfriends and an albino kingsnake. She is a high priestess of the Church of the SubGenius, a devotee of the music of Tom Waits and Robert Smith, and of goth and cyber subcultures. In addition to novels, she has contributed short stories to such collections as *Splatterpunks 2*. (Splatterpunk was a joke word coined in the early 1990s for the genre of graphic violence associated with such writers as David J. Schow and Nancy Collins – 'brain-numbing nonsense, every character dumber than a bag of rusty nails'.) More recently she has written a biography of Courtney Love, frontwoman of the band Hole and relict of the greatest grunge musician of the early 1990s, Kurt Cobain of Nirvana. Brite writes for 'mainstream popularity – more minds to rape' – and thrives on the antagonism of her critics: 'I eat their hate like love.'

Brite is an imaginative mix of Tom Waits and the Marquis de Sade. Her background characters (whores, singers, barmen and pallid, skinny dark-haired runaways) belong in Waits's lyrics: the ones with fortitude resonate like his 'Christmas Card from a Hooker in Minneapolis', her exhausted creatures subside like Waits's song 'Blue Valentine' and her doomed characters are destroyed like Waits's loser in '$29.00'. The vampires and serial killers in the foreground of her fictions resemble Sade's protagonists: they may temporarily relieve their cravings, but their appetites are insatiable and they never attain any peace. Like Sadean tyrants, her dominant characters are as constrained by their natures as the weak whom they despise and subdue. Their waking thoughts must all be devoted to being what they are. Sexual desire is severed from anything but egotism. The victims of her vampires and serial killers present themselves for destruction with entreating passivity, and rejoice in their acts of surrender, yet they have more free will than their killers and abusers

who are *compelled* to submit to the rituals and appetites that excite and gratify them. Just as Sade reaffirmed the existence of wickedness in the midst of Enlightenment optimism, so Brite (who is a superior stylist and has a finer imagination) reasserts that evil is a fundamental mode of existence. She seems, like Sade, to feel that society not merely constrains but criminalises instinct. Her first book was a southern gothic vampire novel, *Lost Souls*. She took vampirism as its subject because she was

> involved with the Gothic/deather subculture at the time – the music, the clothes and make-up, the affinity for graveyards, the bloodletting. *That* was what I wanted to write about, and vampires are an essential icon of that culture. Those kids are beautiful, alienated, at once craving wild experience and romanticising death. Is it any wonder they identify with vampires?

Lost Souls is as full of adolescent anxiety as the songs of Robert Smith of The Cure, to which its characters often refer; its themes echo many of The Cure's songs, such as 'Torture', in which a bottom sings about S&M abasement in a basement, or 'Burn', with its conclusion that 'the end is all that's ever true', or 'The 13th' with its confused erotic roles ('am i seducing or being seduced?'). Though many of her protagonists delight in inflicting pain, or revel in anticipation of its infliction, Britee recognises that one definition of evil is taking pleasure in another's pain. During one of the most distressing of the vampire killings, Brite's hero, with the suitably nihilistic nickname of Nothing, reflects, 'Too much faith in anything will suck you dry. In this way, all the world is a vampire.' Brite's second novel, *Drawing Blood* (1993), is a tale of displaced ambisexual youths. Prolonged by tracts of hallucinogenic bad sex reminiscent of Burroughs, it has a cybercultural underpinning which implies that liberal humanist assumptions about individual identity, power hierarchies and cognitive boundaries have been made obsolete by digital technologies. She signals her allegiance to southern gothic with an overture depicting sprawling mansions looming sepulchrally behind giant oaks, good old boys gossiping outside the Farmers' Hardware Store and family violence: Faulkner and Hawthorne are evoked among novelists.

The gothic revival of the 1980s and 1990s was always ominously self-referential: the opening scenes of *Drawing Blood* make obeisance to the white picket fence imagery which opens David Lynch's iconic gothic film of 1986, even before Brite introduces a town where 'a fried human ear had been found in a box of takeout

chicken, like some cannibalistic remake of *Blue Velvet* by way of Colonel Sanders'. Her imaginary worlds are almost exclusively peopled with men. The only significant woman character in *Drawing Blood* is a disaffected stripper: 'in no mood to shake her ass for a bunch of human dildoes, she would think of junk filled needles jabbing into putrescent veins, of swollen cocks leaking foul greenish slime, of beautiful boys fistfucking by the light of a rotten-cheese moon. It didn't make her happy, but it helped'.

In the United States there is a special obsession with the latent ogres of violence lurking under suburban and small-town proprieties. Tom Waits has a line about a neighbour in his wonderfully unsettling song 'Kentucky Avenue': 'Mrs Storm'll stab you with a steak knife if you step on her lawn.' America really is like that, as goths know. Rod Ferrell, the vampiric youth who in 1998 pleaded guilty to bludgeoning to death Richard and Ruth Wendorf in the small town of Eustis, Florida, himself came from Murray, a small town in Kentucky near the Tennessee line, the site of the National Boy Scout Museum and of a state university known chiefly for its basketball program. It resembles the small towns of Brite's books and Lynch's films. 'The secretive cult known as "The Vampire Clan" is believed to have been active in Murray,' according to one report. 'The youths were involved in a strange role-playing game that went . . . from the mutilation of animals to drinking each other's blood and eventually to murder.' The repercussions of this adolescent psycho-technical acting out were disastrous, domestic and intimate. Ferrell's mother was arrested on the fashionable supposition that so abusive a youth must be a victim too. Her father, Harold Gibson, became the most frightened man in Murray. 'What if they come after me?' he asked when cornered by journalists at his home in 1996 before breaking into tears. 'They're saying Rod's a monster. A monster! He's not a monster, he's not.'

Brite has said that 'the most *romantic* gift [she has received] was from my boyfriend, Chris – a pound of chocolate from the Ambrosia Chocolate Factory at Milwaukee, where Jeffrey Dahmer worked'. This preoccupation inspired her third novel, *Exquisite Corpse* (1996). Its title is taken from that of a song by the early-1980s goth band Bauhaus about cruel love and the corrosion of corpses, with lyrics that are unwittingly reminiscent of the Victorian vampiric poem by Lord de Tabley 'Circe'. Brite's lush, shocking and dangerous book bears as its epigraph a press report stating that during the autopsy in prison of the serial killer Jeffrey Dahmer in

1994, his corpse was kept shackled at the feet for fear of his devilry. From this glimpse of gothic fears in real life she imagined an engrossing fiction in which an English homosexual serial killer, Andrew Compton (recalling Dennis Nilsen, as represented in Brian Masters's criminal study, *Killing for Company*), feigns death, kills the physicians performing his autopsy and escapes to New Orleans. There he has a torrid affair with a serial killer, Jay Byrne, who represents Dahmer as Huysmans might have imagined him. Byrne converts Compton to his cannibalistic taste for bisexual youths and gay transients. Another leading character is an alcoholic, opium-addicted, HIV-positive New Orleans radio talk-show host who advocates killing all breeders. *Exquisite Corpse* is melodramatic, superbly repellent and as powerfully erotic as gothic has ever been. The aesthetics of putrefaction are not to everyone's taste; but the book surpasses even *Lost Souls* as one of the century's finest gothic texts. Instead of Hawthorne's 'badge of shame' in *The Scarlet Letter*, Brite declares 'horror is the badge of humanity.' In exploring the meaning of pain Brite depicts wonderful *milieux*, reasserts the existence of original sin, and defies the contemporary American fantasy that transgressors are victims, for whom bad parenting or ill-nurturing are always the culprits. Andrew Compton reflects on the usual excuses for extreme criminality:

> some pathetic concatenation of abuse, rape, soul-corrosion. As far as I can remember, this did not hold true for me. No one interfered with me, no one beat me, and the only corpse I saw during childhood was the thoroughly uninteresting one of my great-auntie . . . I had spent my life feeling like a species of one. Monster, mutation, Nietzschean superman – I could perceive no difference.

The punitiveness of bourgeois morality likes to impose a tragic fate on miscreants, as Ann Radcliffe and other early ladylike goths understood; but Brite spurns this neat routine. Her protagonists surrender to tragedy and exalt affliction. For them a story with any ethical consolation is a betrayal of human truths. They make a virtue of abandonment; they resist the ideals of homeliness and unification peddled by Disney capitalism; they resist the tedious nullity of insipid convention with a nihilism that is anything but tedious.

NEW GOTHS

Brite is a friend and literary collaborator of Christa Faust, author of *Control Freak* and contributor of stories to such anthologies as *Splatterpunks II: Over the Edge*. Faust personifies several aspects of the contemporary gothic creed. In the glorious prosopography of Marcus Cuff in 1994:

> Born on the longest day of 1969, Christa Faust grew up in New York City. She was a bad girl. A runaway. A discipline problem who endlessly confounded her teachers with lovingly detailed essays about plastic surgery and the Spanish Inquisition turned in out of nowhere after a semester of ditching class. She managed to graduate from high school after five years . . . and was able subsequently to scam her way into college.
>
> While working as a Times Square stripper and 25 cent peep girl, Faust discovered the natural Dominant tendencies that would ultimately lead her to trade her lingerie for leather and become a professional Dominatrix. She spent the next six years plying the whip at dungeons both in her native New York and in Hollywood, where she currently resides with her husband David J. Schow, a rat named Max, an iguana named Tura Iguana, and a shotgun named Charlene . . . Although she is semi-retired from the pro Domination scene, she still sees occasional clients who prove themselves worthy of her precious time. Specialties include intricate rope bondage, foot worship, crossdressing and public humiliation.

This glorification of suffering epitomised by Christa Faust is the defining characteristic of goth music, as the New York cultural critic James Hannahan has identified. The clergyman's son Vincent Furnier, cross-dressing in the early 1970s, applying thick black mascara and calling himself Alice Cooper, created the new phenomenon of shock rock, which provided pop music's earliest glamorisation of pain. Cooper's stage performances (involving simulations of blood-letting, masturbating and biting the head off a chicken) were grotesque camp parades of excess, anguish, horror and ruin. The inky-black photograph on his album *Killer* (1971), in which his stained corpse appears suspended from a thick rope around his neck, provided an eternal image of shock rock. Almost equally memorable was the occasion when, while singing 'Dead Babies', he dismembered scores of plastic dolls which he had brought

on stage. That song, and Alice Cooper's mood, are commemorated in Martin Amis's iconic novel of 1975, *Dead Babies*. Shock rock was followed by the punks, who in turn preceded the goths.

Beginning in 1978 there was a proliferation of bands whose musicians had dyed black hair and wore black lipstick, torn black lace, fishnet, crushed velvet, chains and white make-up. Their appearance was as eloquent as their lyrics. Indeed, these goths of the late 1970s vied with punks in providing visual vitality to the most dismally unstylish decade of the twentieth century. The goth heyday was around 1980–81: by 1984 the fashion was petering out, although it survived in stubborn remnants for another decade. While heavy-metal music evoked feudal militarism, with aggressive, sexist lyrics and the domineering clothes and impedimenta of tops, the goth style was more submissive. Its hallmark was intelligent cynicism. Goth bands offered dark infamy, Salvatorian brigandage (a band called Outgang was formed in 1983), Vesuvian menace, defiance, inversion. The goths of the early 1980s inhabited, according to their historian Mick Mercer, a

> violently childish dreamworld, involving immense amounts of energy and play-acting . . . Wracked with religious imagery, slippy with sexual inference, Goth onstage is rarely happy. Goth offstage is a hoot. Goth onstage cries, growls and scowls. Goth offstage goes quietly insane and wraps itself in drunken worship, pagan worship, and the loins of psychologically damaged French philosophers.

Susan Dallion, who, after leading a punk gang of Sex Pistols fans called the Bromley Contingent, became Siouxsie Sioux of the Banshees, introduced superbly apt gothicisms into her act. She dressed, for example, as a vampiric Edwardian called Theda Bara to serenade victims petrified by Vesuvian lava. In 'Candyman' she described her experience at the age of nine of being molested, but like a true goth, inverted the experience by singing from the standpoint of the predator rather than the prey. Siouxsie and the Banshees were among the most cultish of goth bands. So too, in 1979–83, were Bauhaus, whose Peter Murphy was dubbed King of the Goths, a phrase which had last been applied to the Duke of Argyll after he built Inveraray. The Bauhaus song 'Bela Lugosi's Dead' became the goth anthem, with its stressed colour scheme of black and red, its images of tombs, torturers' racks, bell-towers, dead flowers and velvet-lined coffins, and its dirge-like refrain, 'Bela Lugosi's

dead/Undead undead undead'. Other Bauhaus titles include 'Terror Couple Kill Colonel', 'Dark Entries', 'God in an Alcove', 'Rosegarden Full of Sores', 'Suburban Relapse', 'Premature Burial' and 'Carcass'. Goth lyrics were sometimes savagely angry, but more often sounded ripped, weary or inconsolable. They presented a continuous revolt against hippy shit. Like Sade, goths detested sentimentalisations of Nature or innate human goodness. Their clothes, their décor, their manners proclaimed them as people who expected to be abused. Fatality was at the centre of their beliefs. 'No Shame in Death' sang the band Danse Society in 1982. Similarly, Bauhaus's 'Antonin Artaud' honoured the junkie French playwright whose work had the delirious excess of a goth and whose life was a battle against mental illness:

> Scratch pictures on asylum walls
> Broken nails and matchsticks
> hypodermic hypodermic hypodermic
> RED FIX
> One man's poison another man's meat
> One man's agony another man's treat
> Artaud lived with his neck placed firmly in the noose
> Eyes black with pain
> Limbs in cramp contorted
> The theatre and its double
> The void and the aborted
> Those Indians wank on his bones.

Goth fashion appealed to people who were never going to be conventionally attractive. Typically, the goth musician Andrew Eldritch, of Sisters of Mercy and later The Sisterhood, was superbly photogenic because, although like other lower-middle-class escapees he resembled a nervous stick, he reinvented himself as a broody goth fop. Punk had followed the decade of love with the sounds, clothes and gestures of destructive fury; but goths sought a different sort of excess, luxuriating in death, mystery and desolation. They found both elation and shame in reducing violence, extremism, atrocities and death to aesthetic images. Their elders' sense of purpose seemed to them purposeless. Their black clothes and unnaturally pallid skin were influenced by the dawning of cybernetics. Their robotic allegiances were neither to the promotional hype of the information age nor to the omnipotence

of Schwarzenegger as the Terminator, but to the old premonitions, traceable back to *The Golem*, Frankenstein's monster and the drones of *Metropolis*, that machines are neither invulnerable nor infallible. Numerous bands achieved brief fame: their titles, and those of their songs and venues, were emblems of goth beliefs – Ian Astbury's successive bands, Southern Death Cult and Death Cult, for example, which posed in Highgate cemetery for publicity photographs outside the sumptuously imposing tomb of a ruthless vampiric plutocrat, Lord Dalziel of Wooler. Leading British venues for goth bands were a Birmingham club appropiately called Powerhouse and a Soho club, Batcave. The volatility of the old goths was recalled by the musicians who formed a band originally called Panic Button, afterwards Sex Gang Children; the inverted religiosity of goth was emphasised by their venue for rehearsals, the Elephant and Castle's atmospheric Sunday School. Goth was at its spunkiest with bands like Theatre of Hate, which released its *Revolution* album in 1982, but its greatest singer-lyricist was Robert Smith.

THE CURE

Smith was born in 1959 and grew up on a working-class estate in Surrey. As a schoolboy in Crawley he was involved with friends in two bands, Obelisk and then the punkier Malice. In 1978 they launched themselves as The Cure, which had a stunning success with its first single (written by Smith), entitled 'Killing an Arab', based on Camus's novel *The Outsider*, about a man, a gun, a beach and a boring afternoon in north Africa. 'Killing an Arab' was mistaken by the National Front in 1979 as a racist anthem, and has disquieted American broadcasting executives who miss its nuances. Throughout ten studio albums Smith has remained The Cure's chief songwriter, and still draws on literary influences; his gloomier and more macabre lyrics are redolent of his favourite poet, Emily Dickinson. His lyrics appeal to people who feel suffocated in hopelessness or crushed by helplessness. His writing may be sombre, morose and inconsolable, but in other moods he is consummately shallow, as a pop musician must be. Smith's lyrics suggest a man whose inner life is turbulent if not melodramatic; minor grievances, oversights and fears are magnified into cosmic fatalities. 'The songs had a downward spiral effect on us,' he has told an interviewer. 'The more we played them, the more despondent and desolate we became. Most of the time I left the stage crying.' The lyrics of *Pornography* (1982), one of the most resounding albums of its decade, rail against

Robert Smith of The Cure, whose gorgeous mouth reconciles one of Poppy
Z. Brite's characters to being sucked off.

hypocrisy, but Smith can be equally savage in his self-mockery or self-hate. He expresses frustrated rage at the futility and absurdity of life, but also celebrates moments of rapture, happiness and gratitude. Appropriately, The Cure's album of 1996 was entitled *Wild Mood Swings*.

Smith always looks dishevelled with his 'trademark shock of black hair [which] makes him look like Einstein's gothic bad brother'. His drummer, Boris Williams, was nicknamed the Count because of his vampiric appearance. When The Cure appeared on the BBC television music programme *Top of the Pops* in 1989, camera operators were forbidden from using close shots showing their heavy black eye-shadow, which was thought too disturbing for children to see. 'When I used to wear leather and boots it was much more of a reactionary stance . . . I've been putting on make-up since I was at school, again to inspire a reaction, which was usually against me.' He is not only as reactionary but also as personally evasive as every true goth should be: he enjoys secret devices, fibs when bored and, if forced to give several interviews in succession, will give arbitrarily different answers to similar questions. He has always been obsessed by mortality, and sees the skull beneath the skin. Briefly during the early 1980s The Cure were the biggest band in the world. They made ten studio albums together, including the spectacular triptych beginning with *17 Seconds* and concluding with one of the most brilliantly iconic records of the 1980s, *Pornography*. Though purists like Mick Mercer despise them, their cultural position is unassailable. Brite's fictions affirm their importance to the gothic imagination. In *Lost Souls* a straight boy with a nihilistic nickname reflects on the sexuality of another youth:

> Nothing had his doubts about how much Laine really liked girls. The walls of his room were plastered with posters of the Cure; he had seen them in concert three times, and once he had sneaked backstage to present Robert Smith, the singer, with a bouquet of bloodred roses into which he had tucked two hits of blotter acid. Julie wore her hair wildly teased in all directions, and she favoured lots of black eyeliner and smudged red lipstick. Nothing suspected that Laine liked her mainly because of her superficial resemblance to Robert Smith.

Nothing has read the graffiti at school – 'Laine Gives Killer Head' – and lets himself be seduced. He must recall that Robert Smith has written lyrics of mild sexual

abasement entitled 'A man inside my mouth (this won't hurt at all)'. As Laine unfastens his jeans, Nothing gazes at Smith's mouth enlarged on a Cure poster.

> The singer's lush clotted voice surrounded him, making him feel again as if he were tumbling between those lips. Laine's hand and tongue worked him with a skill born of practice. Nothing felt something twist inside him. He put his hand down to touch Laine's brittle hair, and Laine looked up at him with clear, guileless eyes.

Detachedly, Nothing reaches orgasm under the protection of Smith's mouth. For goths, sex is preferable not as repetitive acts of righteous marital union, intended to keep the children feeling secure, but as theatrical, playful, arbitrary and impious, like an interview with Robert Smith.

DAVID LYNCH

Smith will remain the most significant goth musician of the 1980s: his counterpart among film directors is David Lynch, whose *Blue Velvet* (1986) was the influential film of its decade. Lynch, who was born in Montana in 1946, grew up in small towns in Washington, Virginia, South Carolina and Idaho. As a youth he went to Europe, intending to spend three years there on a twentieth-century student's grand tour, but was so intimidated that he fled back after a fortnight; emotionally, if not physically, he was dependent upon McDonald's. His outlook can be as romantic as Poe's, or Hoffmann's, and as rooted in the uncanny, for he is concerned with the ways that mystery is incarnated in real life. His most striking antecedent, though, is Alexander Pope. Lynch is the son of an agricultural scientist, and in boyhood accompanied his father on research visits to beautiful, lonely, weird forests. These wildernesses were as formative to his imagination as old Mr Pope's tree-planting and the young poet's rides in the verdant glades of Windsor Forest. Lynch, like Pope, originally wanted to be a painter, and has always relished the way that images reflect from art to art. He attended art school, painted street scenes and admired the work of Edward Hopper. The titles of his paintings are reminiscent of those doomed gothic houses, Usher and Rossitten, *Shadow of a twisted hand across my house* (1988), for example, or *Suddenly my house became a tree of sores* (1990). His movie-making is painterly: Francis Bacon is his favourite artist, Kafka his most cherished author, so that the temper of his films is often a mixture of these two. Whereas

Pope's interest in picturesque ruins reflected his own bodily decay, Lynch gleaned his first instinctual understanding of gothic dilapidation from visiting relations in Brooklyn ('Whenever you finish something it starts decaying. Instantly. Just like New York City. The roads, the buildings, the bridges are falling apart') and from his father's experiments on tree diseases ('this sort of thrills me . . . there's a lot of slaughter and death, diseases, worms, grubs, ants'). The New York subway taught Lynch gothic anxiety: 'the wind from those trains, the sounds, the smells and the different lights and moods, that was really special in a traumatic way.' His boyhood visits to New York wrought a lasting transformation of his outlook:

> I could just *feel* fear in the air . . . It was great fuel for future fires . . . I learned that just beneath the surface there's another world, and still different worlds as you dig deeper. I knew it as a kid but I couldn't find the proof . . . There is goodness in blue skies and flowers, but another force – a wild pain and decay – also accompanies everything.

He remains interested in putrefaction, collecting organic matter, fossilised animal remains and body parts, including the uterus of a film producer friend who, having a hysterectomy, 'asked the doctor to save it for me, as something she felt I would want to have'.

He took five years to make his first major film, *Eraserhead* (1977), arguably the most important independent film of its decade. He had no money, and showed heroic single-mindedness in actualising his vision of a journey inwards to the viscous slime of sexual secrets. The film is most notable for its repulsive, unnatural baby: a mutant which elicits comparison with Frankenstein's monster. *Eraserhead* has the profanity of *Bride of Frankenstein* in representing the horrors of parenthood: the insatiable demands, invasiveness and brain-deadening routines (few people are conversationally enhanced by parenthood, and *Eraserhead*'s central figure, Henry Spencer, is reduced to a confused, ineffective wreck by his child). *Eraserhead* also contains a dream sequence about a miniature theatre, situated inside a radiator, containing a singing, dancing woman who recalls the homunculi in jars created by Dr Pretorius. Lynch followed *Eraserhead*'s success with *The Elephant Man* (1980), a film of the life of John Merrick (1863–90), an English cartographer with a rare disease which made him monstrously bloated and malformed. Merrick (played by John Hurt) is as intelligent and sensitive as Frankenstein's monster, with similar yearn-

ings for a mate. Trapped in a corrupted body, with rotting fungoid growths, he develops an excessive veneration for conventional forms, and loses his life imitating normal human beings: his head was so heavy that he had to sleep with it resting on his knees, and when he tried to sleep in an orthodox posture he broke his neck. His existence has a doubleness by night and day. In the hours of light at the hospital he is treated well, but during the dark hours he has to submit to a meanly exploitative hospital porter who exhibits and humiliates him. He endures the doubleness of Jekyll and Hyde until he is abducted by a sideshow huckster who exhibits him at freak shows.

After *The Elephant Man* Lynch had a flop with *Dune* (1984), before providing his hallucinatory view of middle America, *Blue Velvet*, a study of the uncanny which accomplished a highpoint of new gothic. *Blue Velvet* was shot in Wilmington, North Carolina, a small town like those where Lynch grew up, surrounded by woods. Lynch's Lumberton is a cinematic version of the controlled realism of an Edward Hopper townscape, but with gothic menace underneath, like Tom Waits's afore-mentioned Kentucky Avenue, where the lady next door will attack you with a steak-knife if you tread on her lawn. *Blue Velvet* opens with Lynch's camera panning across a deep blue sky, over white fence palings, down to blood-red roses and stridently yellow tulips. A sumptuously crimson fire engine moves sedately, not in alarm, along a suburban street. There is bird-song, and a scene of happy school-children with shining, eager faces. Mr Beaumont, a man in sunglasses, waters his lawn while his wife watches television. Bobby Vinton on the soundtrack sings a ballad, 'Blue Velvet', which sounds as mellifluous as the scene looks. The sounds become suddenly ominous: the camera moves into blades of grass which seem gigantic, the garden hose becomes snagged, and there is a loud hissing as the water-pressure builds up at the tap. Mr Beaumont clutches his throat before collapsing with a stroke, and water from the hose, which he still grips, spurts with pent-up random violence. The camera cuts through the earth underneath him pullulating with vile creepy-crawlies: we see the monstrous latency underneath. Then we return to small-town Lumberton, with its mindless local radio chatter ('It's a sunny day so get out those chain-saws').

A squeaky-clean, nice-mannered college boy, Jeffrey Beaumont (played by Kyle MacLachlan), finds a severed ear by a dirt road. Jeffrey resembles Lynch, who said of himself as a teenager, 'There wasn't much happening upstairs. I didn't really

Jeffrey Beaumont (played by Kyle MacLachlan) in a subordinate moment in his affair with Dorothy Vallens (Isabella Rossellini). Blue Velvet's more intelligent viewers discovered that being objectified sexually could be a release: choosing to be objectified may be a romantic form of self-expression.

think at all . . . until I was about nineteen.' Jeffrey takes the ear to the police, who seem uninterested yet enlist him in the complicity of secrecy. He involves an innocent, easily baffled high-school girl, Sandy Williams (Laura Dern), in a clandestine investigation of his own. They encounter Frank Booth (Dennis Hopper), Lumberton's sadist (and Lynch's gothic monster), who peps himself up with gas through a sinister mask (the gas is helium in the script, though its effects are more like those of a gaseous amyl nitrate). Booth is obsessed with Roy Orbison singing 'In Dreams' and with fondling blue velvet (velvet, together with satin, are the preferred goth materials). He is involved with Dorothy Vallens (Isabella Rossellini), who wearily sings in a nightclub on Route 7 and looks as wan as a vampire's prey without her make-up. Sandy tells Jeffrey, 'I don't know if you're a detective or a pervert' before he breaks into Dorothy's murky apartment, which is as claustrophobic as a gothic oubliette. He, though, is sure of his identity as the great detective. Jeffrey watches through the slats of Dorothy's closet as Booth beats and sexually abuses her. Booth's face is distorted and enflamed by the gas; he speaks in the voices of

both a baby and a daddy. He performs a private rite, inhaling the gas, chewing the blue velvet cloth, working himself against her in frenzied frottage until he climaxes in his trousers. He incarnates the inwardness of sexual obsession; though he dominates the rituals with Dorothy, he is as much a slave to his obsessions as Brite's vampires and serial killers are programmed by their own instinctual needs. Booth leaves Dorothy lying on the floor with a Parthian snarl: 'You stay alive, baby. Do it for van Gogh.' From this Jeffrey deduces that Booth has kidnapped her husband, to whom the severed ear belonged.

Dorothy is gothic's submissive eighteenth-century heroine–victim matured into a twentieth-century conundrum; she becomes a dominatrix, too, discovering Jeffrey in the closet, knowing that he has seen her naked, forcing him at knife-point to strip. Jeffrey cannot accept the reality of Booth's relationship with Dorothy, that of a top with a consensual bottom. He develops a child-centred fantasy in which Dorothy is submitting to abuse only because Booth has kidnapped her son, Donny, to take her in his power. 'I want you to hurt me,' Dorothy pleads to Jeffrey as they screw; 'hit me, hit me', she moans, and he complies. The sound effects become cathartic, with power as pent-up as the water in the snagged hose in the opening sequence: Jeffrey finds that he is as gratified by sexual violence as Dorothy: even by her fantasy of herself as a passive, empty vessel. 'Now I have your disease,' Dorothy tells Jeffrey after he is spent. 'You put your disease in me – your semen, it's hot.' She is the dumping ground for gothic destroyers. 'Men are crazy. Then they put their craziness into me. Then it makes me crazy. Then they aren't so crazy for a while. Then they put their craziness into me again.' Booth is suspicious of Dorothy's meetings with Jeffrey: 'You're like me, you fucker,' he tells the youth early on, when they are wearing similar clothes – a hint that Booth is as much an unwelcome version of Jeffrey's own ugly subconscious as Poe's William Wilson or the mirror reflection of Baldwin, the student of Prague.

With wonderfully apt inconsequence, when Booth and his henchmen beat Jeffrey to the sounds of Orbison's song, it is partly as punishment for Jeffrey's preference for drinking Heineken beer rather than Pabst Blue Ribbon. In this scene Booth applies thick red lipstick, inhales his gas, sucks blue velvet, kisses Jeffrey, groaning 'pretty, pretty', asks the boy to feel his muscles, then batters him in a deserted lumber yard. Booth spits Orbison's words at Jeffrey, 'In dreams you're mine.' As he punches Jeffrey, Booth repeats, 'We're together in dreams.' After a grisly massacre

(beginning with Jeffrey discovering the trussed, murdered body of Dorothy's husband in her apartment, his mouth stuffed with blue velvet), there is a closure of reconciliation, with vice punished (Booth and a corrupt policeman are killed in Dorothy's dungeon-apartment) and virtue rewarded. The Beaumonts' domestic idyll is restored, suburban values recover, Donny returns to Dorothy, but Jeffrey's certainty that she submitted to Booth for her child's sake is difficult to share. There is as much irony in the ending as in *Wuthering Heights* or *Dracula* when the narrators pronounce their conclusions with a comforting certainty that proves they have misunderstood. Jeffrey, though, has observed everything, and balked at nothing (pleasuring Dorothy, killing Booth). Like Boris in Baroness Blixen's story 'The Monkey', he has had an experience that sets him apart; the gods may desire incessant change, but he needs the stasis and stability of streets with white picket fences.

Blue Velvet presents a wonderfully rich variety of genres. Some people watching it have laughed aloud at scenes while the horror-struck have shushed them in horror. Both reactions are justifiable. Indeed, its protagonists are quintessentially gothic figures as they stand isolated from one another in their different perceptions of what is happening. The discrepancies are highlighted by the different renderings of the song 'Blue Velvet': Bobby Vinton in the opening scenes sings it as an innocuous ballad; Dorothy's rendering in the Slow Club is darkly ominous. The protagonists come from incompatible genres: Jeffrey and Sandy are figures from a light teenage romance; Booth and his henchmen introduce the grisly violence of a hard-core thriller; Jeffrey and Dorothy provide an eroticism that disturbs and challenges. Puritans and fundamentalists hated this film: 'the view of sexuality imparted by *Blue Velvet* – in particular that of a woman whose pleasure is dependent upon being physically beaten – is loathsome and grossly misogynistic', complained the *New Statesman* during its phase of unreconstructed 1980s feminism. The film-making is as stylised as gothic should be. It is usually naturalistic, dwelling on familiar surfaces; but this is disrupted by surrealist scenes, and unmotivated shots (such as the magnification of moving blood-cells under a magnifying-glass), which remind us that there is little logic to the action. Though Jeffrey and Sandy's suburbia is portrayed in bright light, Dorothy's apartment, like the night-club where she sings and the interior of Booth's car, is dark. Night is the time when human dreams converge. The women in Jeffrey's life are like doppelgängers in a German film. Sandy is the sweet, naïve, angelic girl he usually meets in daylight, with whom he falls romanti-

cally in love and with whom he is physically chaste. Dorothy is a whore he meets in darkness, screws and hits; she is excited by talking about his spunk.

GOTHIC DIVERSITY

American culture (even more than European) has been profoundly reinfiltrated by goth ideas. The camp gothic musical *The Rocky Horror Picture Show* (1975) was a huge commercial success and sartorial influence a decade before *Blue Velvet*. In the late 1990s the strongest goth influence on *haute couture* derives from the two versions of the blockbuster film *Star Wars* (1977; 1997). The plots of these resembled George MacDonald's classic Victorian fairy-tale *The Princess and the Goblin* (1872) in which a rebel princess and a miner's son defeat evil-minded troglodytes living in a mysteriously beautiful underground world, except that in *Star Wars* the rebel princess enlists a young farmer in her cause, and the action is transferred from a claustrophobic domain of caverns and pits to a spacious, iridescent galaxy. The evil-doers in *Star Wars* are like the sinister Italianate villains of Ann Radcliffe or Matthew Lewis relocated in outer space, and some of the costumes are goth. Nicolas Ghesquiere, who was appointed designer of the fashion house Balenciaga in 1997 at the prodigiously early age of twenty-six, made his mark with his 1998 collection of pared-down, sombre, black clothes suitable for celibate inmates of an austere seminary. As he explained, 'Balenciaga took his inspiration from Velázquez; I take mine from Princess Leia's dress in *Star Wars*.' The full-skirted, long-sleeved black Balenciaga dress worn by Madonna at the Golden Globe Awards in 1998 was a fairy-tale fantasy for a goth princess.

The comic-book heroics of *Batman*, together with the 1960s television series, were hyperactive camp, but the film of *Batman* (1989) directed by Tim Burton was a dark psychological interpretation, with clothes and settings more sombre than any design of Nicolas Ghesquiere. Its most enduring images are of a grim and jagged urban landscape – more awe-inspiring even than Fritz Lang's *Metropolis* – which depresses and reduces the contending human figures of Gotham City. It is perhaps the most powerful use of the gothic style to express estrangement from modern economic miracles.

The heritage which began with Frankenstein's monster reached a consummation with Arnold Schwarzenegger playing a time-travelling android killing-machine in the futuristic box-office hit *The Terminator* (1984). The playful inversions and artful

confusions of its sequel *Terminator 2: Judgment Day* (1991) are more profoundly gothic: in this film Schwarzenegger plays an android who has returned from the future to foil a metamorphosing robot assassin; because he has identical looks to the killer android of the previous film, both the film's boy hero and the viewers are misled into thinking he is villainous and his antagonist virtuous in what becomes a neat inversion of good and evil. The *Terminator* films marked an advance towards new cybernetic fictions and deadlier cyberpunks.

Some CD-ROM games feature streets which are dank, dark and murky; the characters in *Under a Killing Moon* are post–World War III mutants with foul skin. The elaborately ritualistic role-playing games of *Warhammer* culture, with its miniature models and battleground terrain, are not so much scary as densely atmospheric. Some of its miniatures are recognisably gothic destroyers: in the imaginary world of *Warhammer*, there is a demonic race known generically as Chaos, representative of evil. The weird and evil shapes of *Warhammer* reek of horror, monstrosity and contagion. The popular fantasy role-playing game Dungeons and Dragons or the rituals of *Tomb Raider II* represent a style that is quintessentially new gothic.

Television – more than films, CD-ROM games or *Warhammer* role-playing – has been the most important medium of gothic infiltration. Televised histrionics belong in the gothic tradition: afternoon talk-shows, with their carefully staged, emotionally intensive demonising, most signally construct gothic villains whose transgressions sustain an unbreakable cycle of despoliation and ruin. The difference between Ann Radcliffe's villains and Oprah Winfrey's is that, in modern America, when villains confess publicly, they disavow responsibility. These talk-show hosts are fickle gods whose religion is sustained by rituals of melodrama, oversimplification and delusion. As Mark Edmundson notes, 'At times, Oprah is an apostle of fate worthy of Edgar Allan Poe: if you were molested by your father, you'll be a molester in turn. There's no way out.' Less disagreeably, the charming television comedy series *The Addams Family*, which ran for sixty-four episodes in 1964–66 and was inspired by the ghoulish cartoons drawn since 1932 by Charles Addams for *The New Yorker* magazine, domesticated gothic for television (together with *The Munsters*).

By the 1980s international television soap-operas were becoming a substitute for family and friends precisely because their characters, emotions and situations are so much more dependable and safe than reality. They have become the chief source of medical and sexual information for hundreds of millions of people, and provide

baneful models of domesticity. Gothic, however, has been enlisted to subvert their formulae and spoil their dependability. After the triumph of *Blue Velvet*, Lynch made a television serial of twenty-nine episodes, *Twin Peaks* (1990–92), which was the first explicitly gothic television soap-opera, with its murk, claustrophobia, evil, haunting doppelgängers, S&M, fetishism and family doom. Set in a small lumber town in Washington State, the series opened with the discovery of the corpse of the local high-school beauty Laura Palmer, wrapped in plastic, washed up on a lake shore. She has been murdered, as eventually transpires, by her father, Leland Palmer, who is possessed by a Hyde-like alter ego with a goth taste for incest. *Twin Peaks* inverted every dependable characteristic of conventional soap-operatics while creating the impression of an alien world. Indeed, Michael Chion in his astute *David Lynch* (1992) suggests that *Twin Peak's* quasi-hero, FBI agent Dale Cooper, played by Kyle MacLachlan, may be an extra-terrestrial exiled in a human body: the aptness of gothic aesthetics for conveying anxieties about alien infiltration or invasion from outer space will doubtless be very marked in the early twenty-first century.

Twin Peaks made Lynch's influence even more pervasive. Recently the television film *Lexx – The Dark Zone Stories* provided a German–Canadian science fiction dystopia about two parallel universes, the Light Zone and the Dark Zone, featuring His Divine Shadow, a satanic villain in fetishistic leather and rubber, opposed by a pneumatic blonde, a horny robot and a dissident inventor. *Lexx* is gory, nasty, funny, diverting and brilliantly adapts imagery from the jagged psychopathic gothic cityscape of Lang's *Metropolis* and the contemporary moods and ideas of *Blue Velvet*. Comparably, the protagonists of *The X-Files* never seem to leave the dungeon-chambers of Dorothy Vallens and Frank Booth: they are almost always filmed in murky rooms, shadowy corridors or poor light; they have the frowns of the haunted or the pallor of the incarcerated. The mood of *The X-Files's* dauntless investigator Fox Mulder combines the bafflement of Lumberton's gothic paranoia with the paranormality of Dale Cooper.

Gothic literature is often best when the gothicisms are atmospheric, subdued and allusive, rather than dominant, compulsive and central. This is exemplified by the English novelist Patrick McGrath. The introduction to *The New Gothic* (1991), a collection of contemporary gothic fiction which he compiled with Bradford Morrow, is a superb credo for the goths of his generation:

We stand at the end of a century whose history has been stained perhaps like no other by the blacker urges of human nature. The prospect of an apocalypse – through human science rather than divine intervention – has redefined the contemporary psyche. The consolation that Western souls once found in religion has faded; Faustus no longer faces a Mephistopheles from divinity's antithetic underworld, nor is Ambrosio doomed to Christianity's eternal hell. Now hell is decidedly on earth, located within the vaults and chambers of our own minds.

McGrath is a dandyish stylist who depicts tumult, evil, monstrosity, disease, madness, horror and death with hallucinatory menace. Like many early goth novelists, his narratives often lead the reader into discoveries of danger within what had seemed safe. He is pitiless about human confusion and sometimes painterly in the same way as David Lynch. While McGrath's most relentlessly gothic work seems frivolous or ephemeral pastiche, he achieves superb effects when the gothicisms are relaxed. His novels are set in the 1950s, a decade which for the British denotes surface stability and security comparable to the dream-like stasis of those Eisenhower years which fascinate Lynch. One of his preoccupations reaches back to Walpole's *Castle of Otranto*: the idea that masterful figures of authority are in fact frantically dependent, their postures of control and discipline as deluded as the Earl of Kingston when he gothicised Mitchelstown Castle. In *Asylum* (1996), for example, McGrath's narrator is a psychiatrist working in a seemingly impregnable maximum-security mental hospital. He is a control-freak whose systems collapse when the wife of a colleague launches into an ardently destructive sexual affair with an inmate who represents gothic's evil destroyer: the malefactor is a sculptor specialising in 'heads' who has beheaded his wife and subjected her corpse to indignities familiar to goth readers from Matthew Lewis to Brite. The old gothic staples of tyranny, inverted hierarchies and frantic reactions are reworked with rich ingenuity and devastating knowingness. The emotional and physical violence of the book is unsparing of both its characters and readers. It is informed by the fact that McGrath was reared in the atmosphere of the Broadmoor lunatic asylum, where his father was an official.

McGrath's dead heads are highly contemporary. In the dying years of this millennium the most contentious examples of gothic celebrate putrefaction. The photographer Joel Peter Witkin (b. 1939) uses corpses and body parts, acquired from

mortuaries and morgues, in tableaux redolent with religious or historical references. His images – for example, that of the severed head of a bald, plump old man arranged on a salad salver, or of a shockingly wizened, frail old woman's corpse bedecked in a bride's clothes – can attract, repel or remind one of McGrath's asylum sculptor. They are being disseminated into the general culture, for example by the video released in 1998 to accompany a new Rolling Stones song, 'Saint of Me', on the *Bridges to Babylon* album. Witkin's tableaux supremely evoke horror, but horror mixed with sensuality, banality and objectification: this will prove a strong if uninteresting direction for gothic aesthetics in the twenty-first century. Whereas McGrath's work has a measured ethical underpinning, one can feel with Witkin's images a temper similar to Andy Warhol's 1974 films *Frankenstein* and *Dracula*. (The chapter describing these films in Victor Bockris's biography of Warhol is entitled 'To Appreciate Life You Must First Fuck Death in the Gallbladder', which is a line from his *Frankenstein*, and carries as its epigraph his declaration: 'Violence is what people want, so we're giving it to them. That's the secret of my success, just giving people what they want'.) Though Witkin claims reverent feelings in his work, others find that contempt predominates in it. Christian Action Aid cited his photograph 'Testicle Stretch with the Possibility of a Crushed Face' in a protest at Washington, D.C., in 1993 against the National Endowment for the Arts. He is weird rather than uncanny, and as a man more resembles a goth fantasy – an almost alluringly ruthless monk-miscreant in an eighteenth-century novel, or a nineteenth-century scientist obsessively harvesting body parts – than a methodical bourgeois like Stevenson or Stoker. In a famous advertisement for models Witkin has listed his interest in physical prodigies and misfits as photographic subjects in the dead-pan tone of Burroughs:

pinheads, dwarfs, giant hunchbacks, bearded women, erotic contortionists, women with one breast, people who live as comic book heroes, Satyrs, twins joined at the foreheads, anyone with a parasitic twin, twins sharing the same arm or leg, living Cyclops, people with tails, horns, wings, fins, claws, reversed feet or hands, elephantine limbs, etc. Anyone with additional arms, legs, eyes, breasts, genitals, ears, nose, lips. All people with unusually large genitals. Sex masters and slaves. Women whose faces are covered in hair or large skin lesions and who are willing to pose in evening gowns. Five androgynes willing to pose together as 'Les Demoiselles d'Avignon'. Hairless

anorexics. Human skeletons and human pincushions. People with complete rubber wardrobes. Geeks. Private collections of instruments of torture, romance; of human, animal and alien parts. All manner of extreme visual perversions. Hermaphrodites and teratoids (alive and dead). A young blonde girl with two faces. Any living myth. Anyone bearing the wounds of Christ.

With even more intense commitment the English artist Anthony-Noel Kelly (b. 1955) learnt butchery in an abattoir so as to be able to make moulds from the heads,

Anthony-Noel Kelly with examples of his work.

Dead, we become the lumber of the world,
And to that mass of matter shall be swept
Where things destroyed with things unborn are kept
Devouring time swallows us whole;
Impartial death confounds body and soul.
For hell and foul fiend that rules
God's everlasting fiery jails
(Devised by rogues, created by fools),
With his grim grisly dog that keeps the door,
Are senseless stories, idle tales,
Dreams, whimseys and no more.
 Lord Rochester's translation of Seneca.

limbs and other remains of human corpses. The fact that he paid for these remains to be pilfered from a medical college resulted in his criminal conviction in April 1998.

More discreetly, Damien Hirst (b. 1965) has had himself photographed in a Witkinesque tableau: in a mortuary, with a grin on his face, angled near the head of a man's corpse which also seems to have a smiley expression. The studies in putrefaction have been presented by some journalists as flagitious, exploitative experiments in modernity, but in fact his exploration of the aesthetics of putrefaction reaches back to old gothic revival antecedents. In *The Physical Impossibility of Death in the Mind of Someone Living* (1991) he placed a fourteen-foot dead shark in a tank of formaldehyde. In *Mother and Child Divided* (1993) he dissected a cow and a calf and preserved them in two separate formaldehyde tanks. The eeriness of these sculptures provides some spectators with new ways to confront the fear of death. It was possible to walk between the tanks and study the intricate landscape of their interiors. In his sculpture he uses tanks for theatrical effects in much the way that Batty Langley, Sanderson Miller and William Shenstone deployed tumbling piles of stones and hill-top eye-catchers. Hirst also has an instinct for gothic inversion. As a child he swallowed pills which he had mistaken for sweets, and had to have his stomach pumped: from this tawdry domestic drama he learnt the possibility of good objects, and good intentions, having evil effects; he learnt, too, that many of the worst injuries done to us are as impersonal or adventitious as the eruption of Vesuvius. In *No Feelings* (1989) he displayed a medicine cabinet containing pill bottles and pharmaceutical containers: the drugs inside had passed their 'sell-by' date, and were being corrupted by time from panaceas into poisons.

THE CHAPMAN BROTHERS: NEW GOTHIC'S SUPERMEN

The most visually exciting transatlantic goths of the late 1990s are the Chapman brothers, whose installations of mutilated mannequins have astounded or annoyed viewers in New York, London and Venice. Dinos Chapman (b. 1962) and his brother Jake (b. 1966) worked as assistants to Gilbert and George while training at the Royal College of Art. Dinos has half-joked, 'We're only good enough to make one person's work', and there are gratifying goth overtones of a split personality about their artistic development. Death, sex and mutation provide their themes. Apart from macabre skulls, they are best known for their fibreglass resin dummies with

Witkinesque mutations: twins joined at the head or limbs, erotic contortionists, people with genitals in unorthodox places, unsettling androgynes. In *Mummy Chapman* (1994), for example, they conveyed the idea of erotogenic sight by substituting a vagina for the mannequin's eye. Many of their mannequins have been castrated, desexed or genitally mutated, and this toying with sexual ambivalence distresses viewers who dislike their notions of identity to be challenged. Moreover these effigies are recognisably not human: by mixing fibreglass with resin, the Chapmans industrialise humanity, although the spirit of their monstrosities has more in common with the humorous, insinuating, waspish subversion of Dr Pretorius than the sombre and annihilating conquests of *The Terminator* or the self-pitying revenges of Frankenstein's monster. These tableaux of gothic-grotesque mutants are apocalyptic, jokey and stagey in a way that is reminiscent of Patrick McGrath's work.

The lazy journalistic catchphrase about the Chapmans – 'Bad boys of art' – misses everything that is interesting. Like other young British artists, they are determinedly knowing and watchful. They are too cynical to be ranked as nihilists, but they come from a generation which does not believe that inventiveness has much to do with progressive idealism. They do not expect the arts to change anything for the better, or to incite anyone to good actions. Auden wrote in 1942, 'Art cannot make a man want to become good, but it can prevent him from imagining that he already is; it cannot give him faith in God, but it can show him his despair.' The Chapmans' *credo* is less religious, and more consumerist, but similar. 'Make it as libidinally stupid as everything else, and walk around a supermarket in the same way you walk around an art gallery,' they adjure of art. They live and work off the Old Kent Road, south of Elephant and Castle, in one of the most visually exciting areas of London. Imaginatively it is a long way from Notting Hill Gate, where Hirst in 1998 opened his restaurant 'Pharmacy', decorated with his installations of medical containers and pill bottles, and catering to people who would never dare to travel south of Borough High Street into the most enriching backwaters of London. The Chapmans' neighbours are more familiar from films and videos with many of the Chapmans' allusions than many consumers of higher culture. Such films 'are packed with imagery that, when placed in a gallery situation, would suddenly and strangely become problematic', according to Dinos Chapman.

'We are disenfranchised aristocrats, under siege from our feudal heritage,' they

declared in a manifesto of 1994. 'But sometimes, against the freedom of work, we phantasise emancipation from this liberal polity, into a superheavyweight no-holds-barred all-in-mud-wrestling league, a scatalogical aesthetic for the tired of seeing.' Their most carefully executed intention is to convert their energy into viewers' laughter. Like true goths, they not only disbelieve in the possibilities of progress, or the curative powers of consensus, but regard reaction as a law of life. 'We made a clear decision to produce very, very reactionary work,' Jake Chapman has told an interviewer; when he and his brother were called Fascists by a notoriously volatile cultural commentator, he responded laughingly that she was a 'liberal slag-bitch'.

New gothic is Nietzschean in its disbelief in any pre-established harmony between furthering truth and the well-being of humanity. It is as illiberally pes-simistic as Brite's teenagers or Smith's lyrics. 'Man has been reared by his errors,' as Nietzsche wrote:

first he never saw himself other than imperfectly, second he attributed to himself imaginary qualities, third he felt himself in a false order of rank with animal and nature, fourth he continually invented new tables of value and for a time took each of them to be eternal and unconditional, so that now this, now that human drive and state took first place and was, as a consequence of this evaluation, ennobled. If one deducts the effect of these four errors, one has also deducted away humanity, humaneness and 'human dignity'.

The Chapmans have used mannequins to express human error in Nietzsche's terms. Their industrially produced effigies are a crucial medium for their art. 'Effigies are not just dolls and figures, but are understood in the world of the uncanny to include the deformed, the mutilated, corpses, and madmen, those poor souls who remind "normals" just how fragile, transient and partible they are,' according to William Ian Miller's *Anatomy of Disgust*:

There are few things that are more unnerving and disgust-evoking than our partibility. Consider the horror motif of severed hands, ears, heads, gouged eyes. These do not strike me as so many stand-ins for castration. Castration is merely an instance of severability that has been fetishized in psychoanalysis and the literary theoretical enterprises that draw on it. Severability is unnerv-ing no matter what part is being detached . . . Part of death's horror is that it

too is a severance of body and soul and then, via putrefaction, of the body's integrity.

The Chapmans have represented the horror of partibility in one of their most arresting, intellectually exciting creations, *Great Deeds Against the Dead* (1994). When this fibreglass, resin and paint installation was exhibited in 1997 at the Royal Academy's *Sensations* exhibition, it was denounced as obscene by prudish journalists and demotic critics. The outcry was shrillest from those who confuse art, which exists to make people uncomfortable and to spur them to new thinking, with entertainment, which is meant to gratify, relax and confirm preconceptions of decorum, prettiness or good citizenship. No art is great if it makes its consumers feel comfortable. *Great Deeds Against the Dead* is the Chapmans' reminder that the badge uniting humanity, as the shrewder goth revivalists have always known, is horror; it is their heckling cry that trust in humaneness or pride in human dignity rests on human self-infatuation. Previously, in 1993, they had exhibited their own diorama sculpture of plastic figurines, *Disasters of War*, staging scenes from Goya at the Victoria Miro Gallery in London. In this subsequent work they reworked Goya's image of mutilated corpses left exhibited on a tree during the Peninsular War (plate 39 of *Los Desastres de la Guerra* for which Goya provided the caption 'Great Courage! Against Corpses!'). Goya scorned the Spanish liberals' aspirations after what he had seen in his country's wartime killing-fields, and *Great Deeds Against the Dead* is a reaction against the bogus hopes of the 1990s represented by Hillary Rodham Clinton's manifesto *It Takes a Village: And Other Lessons Children Teach Us*. The Chapmans' quintessentially gothic image shows the cruelty that Sade imagined in the castle at Silling, the inhumanity which in the twentieth century has so ferociously been perpetrated by Nazis, Stalinists, Maoists, Pol Pot's Cambodians, Serbs in Bosnia, Argentinian secret policemen, anti-Armenian Turks, anti-Biafran Nigerians and Irish vigilantes. In *Great Deeds Against the Dead* the Chapmans have used lumber imagery in ways that Lynch has never dared. Arrayed on a stunted Salvatorian tree there is a grisly spectacle. One naked man has been severed into pieces: his head is impaled on a branch, his bound hands and wrists hang from a twig, and the rest of his mutilated, castrated cadaver is tied upside-down on the tree's limb. The tree trunk supports another bound and naked corpse, again castrated, so that although the body is that of a handsome young man, its genital area resembles a woman's. A third man,

again naked, handsome and castrated, is also inverted: he is tied upside-down to the stunted tree by his bound feet, which are delicately crossed at the end of strong legs. The installation is intensely theatrical. Though its immediate impact is of dead calm, one feels intense, nervous energy behind it. There is nothing fetid about *Great Deeds Against the Dead*, as Witkin's enemies find in his work.

It is impossible to predict how any aesthetic will develop in the twenty-first century. World starvation, with its spectral images of those ruined by hunger, might provide the next gothic focus; so might the fashion in hats. It will depend on whether the next wave of goths are feeling haunted, frivolous or caught in an intermediate, contingent mood. One can only be sure that post-millennial goths will be theatrical and excessive. In any case, it defeats the goth temper to look forward: its succour lies in the strength of backward-looking thoughts. It is for this reason that the Chapmans' installation is superbly recapitulative at the millennium's end. The regression of its title is so right. As an image, too, *Great Deeds Against the Dead* is chillingly unconsoling, and horrifies with its depiction of human partibility and moral putrefaction. It satisfies Nietzsche's paradox 'I love the great despisers, for they are the great venerators'. The Chapmans are not just a clever goth double act: Nietzsche would recognise them as goth supermen.

Acknowledgements

For allusions and quotations I am indebted to Clare Addison, Jenny Davenport, Cosmo and Hugo Davenport-Hines, the Earl of Derby, Mark Durden, Bill Hamilton, Rosemary Hill, Leo Hollis, Laurence Kennedy, Rolfe Kentish, Adam Lively, Count Randal MacDonnell of the Glens, Marina Majdalany, Guy Mannes-Abbott, Susan Neil-Smith, Michael O'Sullivan, Christopher Phips, Rupert Thomson, Sal Volatile 'Adrian Maddox' and the luncheon guests of Peter Parker.

From *Anatomy of Disgust* by William Ian Miller; copyright © 1997 by the President and Fellows of Harvard College. Reprinted by permission of Harvard University Press.

From *Lynch on Lynch*, edited by Chris Rodley; copyright © 1997 by Chris Rodley. From 'Mal de Esthétique' by Wallace Stevens from *The Collected Poems* (1947). From *The Age of Anxiety* by W. H. Auden. All reprinted by permission of Faber and Faber Ltd. From *Collected Poems* by Wallace Stevens. Copyright © 1947 by Wallace Stevens. Reprinted by permission of Alfred A. Knopf Inc.

From *Antonin Artaud* written by Bauhaus and reprinted with permission from Beggars Banquet Music/Momentum Music Ltd.

From *Our Vampires, Ourselves* by Nina Auerbach; copyright © 1995 by Nina Auerbach. Reprinted with permission of the University of Chicago Press.

From *Four Screenplays* by C. Dreyer; copyright © 1970; and from the introduction to Adrian Stokes's *An Invitation to Art* by Richard Wollheim. Reprinted with permission from Thames and Hudson Ltd.

Extract from *Gothic Rock Black Book* by Mick Mercer reproduced by permission of Omnibus Press.

Extract from *The Picador Book of the New Gothic*, edited by Patrick McGrath and Bradford Morrow. Copyright © 1991 Patrick MacGrath and Bradford Morrow. Reprinted by kind permission of Macmillan.

Sources

CL – *Country Life*.

PC – George Sherburn, ed., *The Correspondence of Alexander Pope*, 1 (1956).

WC – Wilmarth S. Lewis, ed., *The Yale Edition of Horace Walpole's Correspondence*.

Prologue

An earlier version of this chapter was published in the *London Review of Books* (1998) as 'Send More Muskets!', an essay on Christoph Grunenberg, ed., *Gothic: Transmutations of Horror in Late-Twentieth-Century Art* (MIT Press, 1997), and Mark Edmundson, *Nightmare on Main Street: Angels, Sadomasochism and the Culture of Gothic* (Harvard, 1997).

1 'The death'. Wallace Stevens, *Collected Poems* (1955), 319.

1 'Supple, resilient'. Patrick McGrath, 'Transgression and Decay', Grunenberg, *Gothic*, 153.

1 'carrying Destruction'. *The Writings and Speeches of Edmund Burke*, I (1997), 149.

2 'Gotic barbarity'. Esmond de Beer, ed., *The Diary of John Evelyn*, II (1955), 326, 329.

5 'Dracula is'. McGrath, 'Transgression', Grunenberg, *Gothic*, 156.

5 'All three'. Poppy Z. Brite, *Lost Souls* (1992), 82.

5 'a gothic serial'. Christoph Grunenberg, 'Unsolved Mysteries: Gothic Tales from *Frankenstein* to the Hair-Eating Doll', Grunenberg, *Gothic*, 210.

6 'the age'. Ronald Fuller, *Hell-Fire Francis* (1939), 56.

7 *Don't Go*. Mark Gatiss, *James Whale* (1995), 167–68.

7 *The Idiot*. Deborah Curtis, *Touching from a Distance* (1995), 133–34.

7 'It is by'. Burke, *Writings*, I, 224.

7 'Pain is'. Burke, *Writings*, I, 236.

8 'It was'. Brite, *Lost Souls*, 100.

8 'not a'. Michel Foucault, *Madness and Civilization* (1965), 97.

8 'you cannot'. Edmundson, *Nightmare*, 130.

9 'today's moral'. Poppy Z. Brite, *Drawing Blood* (1993), 32, 68.

10 'everything that'. Grunenberg, *Gothic*, 205.

11 'We can'. Jean Baudrillard, *The Transparency of Evil* (1993), 85–86.

Chapter One

14 'There, . . . there'. Arthur Norway, *Naples Past and Present* (1924), 182–87.

15 'I layd'. *Evelyn Diary*, II, 335–36.

15 'From the'. Lord Lytton, *Zanoni* (1842), third book, chapter 10; compare Richard
 Hamblyn, 'Private Cabinets and Popular Geology: The British Audience for
 Volcanoes in the Eighteenth Century', in Chloe Chard and Helen Langdon, eds.,
 Transports: Travel, Pleasure and Imaginative Geography, 1600–1830 (1996), 179–203.

16 'built on'. *Evelyn Diary*, II, 326.

16 'considerd the'. *Evelyn Diary*, II, 329.

16 'the city'. Ann Radcliffe, *The Italian* (1797), chapter 1.

16 'the panorama'. John Meade Falkner, *The Lost Stradivarius* (1895), chapter 12.

17 'all tinsel'. Sade, *Juliette*, 928, 932.

18 'If there'. John Ruskin, *Modern Painters*, V (1860), 242.

18 'wild but'. Lady Morgan, *The Life and Times of Salvator Rosa*, I (1824), 57, 96–97.

18 Stoic. Wendy Roworth, *'Pictor Succensor': A Study of Salvator Rosa as Satirist, Cynic
 & Painter* (1978), 244.

19 'what they'. Francis Haskell, *Patrons and Painters* (1980), 134.

19 'always they'. Haskell, *Patrons*, 143.

19 'to go'. Haskell, *Patrons*, 11.

19–20 *Scene of Witchcraft*. Jonathan Scott, *Salvator Rosa* (1996), 52–54.

21 'La Strega'. Roworth, *'Pictor Succensor'*, 130–39.

21 'sung on'. Scott, *Rosa*, 51.

21 'He had'. Ruskin, *Modern Painters*, V, 241.

21 'The *Specter*'. Lord Shaftesbury, *Essay on the Freedom of Wit and Humour*, vol. I, pt.
 4, sect. 2, 138–39.

21–22 'The famous'. Haskell, *Patrons*, 145.

22 'The works'. Margaret Jourdain, *The Works of William Kent* (1948), 95.

22–23 'Enthron'd amid'. Ann Radcliffe, *A Sicilian Romance* (1790), chapter 12.

23 'His images'. Lytton, *Zanoni*, third book, chapter 4.

23 'High objects'. John Dryden, dedication to *The Indian Emperour* (1665).

23 'Strange, horrid'. *Evelyn Diary*, II, 509–13.

24 'would take'. Gilbert Burnet, *History of His Own Times*, III (1818), 249.

24 'would think'. Thomas Burnet, *The Sacred Theory of the Earth* (1691), 141–42.

24 'We are'. Burnet, *Sacred*, 7.

24 'the greatest'. Burnet, *Sacred*, 9.

24 'In this'. Burnet, *Sacred*, 67–68.

25 'very gastly'. Burnet, *Sacred*, 45.

25 'nothing but'. Burnet, *Sacred*, 140.

25 'What a rude'. Burnet, *Sacred*, 151.

25 'Mount Cenis'. Duncan Tovey, ed., *The Letters of Thomas Gray*, I (1900), 38–45.

25 'lonely lords'. WC, XIII, 181.

25 'seized by'. Guy Chapman, *The Travel Diaries of William Beckford of Fonthill*, I (1928), 281–82.

25 'I am'. Lewis Melville, *Life and Letters of William Beckford* (1910), 32.

25–26 'How many'. William Lawson, *A New Orchard and Garden* (1618).

26 'What is'. William Gilpin, *Forest Scenery* (1879 edn.), 17–24.

26 'Their tall'. Ann Radcliffe, *The Mysteries of Udolpho* (1794), third book, chapter 8.

26 'under a'. Sheridan Le Fanu, 'Mr. Justice Harbottle' (1872), chapter 6.

26 'amidst the'. Tobias Smollett, *Travels through France and Italy* (1766), letter XXXIII.

27 'Such shaggy'. Elizabeth Manwaring, *Italian Landscape in Eighteenth Century England* (1925), 229–30; J. Sunderland, 'The Legend and Influence of Salvator Rosa in England in the Eighteenth Century', *Burlington Magazine*, CXV (1973), 785–89; Helen Langdon, 'The Imaginative Geographies of Claud Lorrain', in Chard and Langdon, *Transports*, 151–74.

27 'Salvator Rosa's'. Aldous Huxley, *Prisons* (1949), 21.

27 'a Country'. Shaftesbury travel diary. PRO 30/24/21/240.

28 Paolo de Matteis. J. E. Sweetman, 'Shaftesbury's Last Commission', *Journal of Warburg & Courtauld Inst.*, XIX (1956), 110–16; Robert Voitle, *The Third Earl of Shaftesbury, 1671–1713* (1984), 412–14.

28 'Nothing in'. Benjamin Rand, ed., *Anthony, Earl of Shaftesbury: Second Characters* (1914), 8–9.

28 'Virtue and'. Radcliffe, *Udolpho*, first book, chapter 5.

29 'fled to'. Rand, *Shaftesbury*, 15.

29 'rock in'. Rand, *Shaftesbury*, 156.

29 'natural ambition'. Rand, *Shaftesbury*, 156.

29 'See! with'. Shaftesbury, *Characteristicks*: 'The Moralists: a Rhapsody', vol. II (1723), part 3, sect. 1, 389–90.

29 'the wasted'. Shaftesbury, 'A Letter concerning Enthusiasm', vol. 1, sect. 2, 14–15.

29–30 'the Passion'. Shaftesbury, *The Moralists*, ii, 393.

30 'He stopped'. Jonathan Brown, *Kings and Connoisseurs* (1995), 187–88.

30 'Divers more'. *Evelyn Diary*, V, 145.

30 'old greenhouse'. *WC*, IX, 5.

30 'This country'. Jonathan Richardson, *Works* (1773), 8–9.

31 'We know'. Richardson, *Works*, 273.

32 'Lady Spenser'. R. Warwick Bond, *The Marlay Letters* (1937), 398–99.

32 'Lord Garlies'. *The Private Diary of Richard, Duke of Buckingham and Chandos, KG*, I (1862), 254.

33 'standing at'. Johnny Madge, 'A Virtuoso in Rome', *CL*, 27 January 1983, 232–33.

33 'two true-born'. Charles Rogers, *Boswelliana* (1874), 239.

33 'noisy English'. Bond, *Marlay*, 391.

33 Haggerston. Jeremy Black, *The British and the Grand Tour* (1985), 224.

33–34 'assiduous'. Nora Hardwick, ed., *The Grand Tour* (1985), 96.

34 'Would to'. Richardson, *Works*, 162.

34 'to store'. *PC*, I, 222.

34 'has Little'. Kerry Downes, *Sir John Vanbrugh* (1987), 348; Sir John Vanbrugh, *Works*, IV (1928), 30.

34 'but poor'. Lewis Theobald, *The Censor*, II (1717), 51.

34–35 'The great'. Richardson, *Works*, 247.

35 'pleasing ideas'. Richardson, *Works*, 246.

35 'a natural'. Richardson, *Works*, 334.

35 'history begins'. Richardson, *Works*, 263.

35–36 'very spirit'. Curzio Malaparte, *The Skin* (1952), 44–45, 48.

Chapter Two

Throughout this chapter I owe a heavy debt to Morris Brownell, *Alexander Pope and the Arts of Georgian England* (1978).

37 'little Aesopic'. Charles Gildon in 1718, quoted by W. H. Auden, *Complete Works*, III (1996), 141.

38 'a painted'. *PC*, 168.

38 'A tree'. Joseph Spence, *Observations, Anecdotes and Characters of Books and Men*, I (1966), 255.

38 'His poor'. Lord Mahon, *Letters of Philip Dormer Stanhope, Earl of Chesterfield*, II (1892), 463.

38 'I feel'. *PC*, I, 163.

38 'lying in'. *PC*, I, 185.

38 'seething brains'. Shakespeare, *Midsummer Night's Dream*, act 5, scene 1, lines 4, 8.

39 'the Greeks'. Thomas Hobbes, *Leviathan* (1651), part I, chapter 2.

39 'My Days'. *PC*, I, 163.

39 'there are'. *Spectator*, no. 477.

39 'Pope in'. Mahon, *Chesterfield*, II, 463.

39 'I have'. *PC*, II, 31.

39 'very innocent'. *PC*, II, 3.

39–40 'The true'. Sir William Temple, *Works*, III (1814), 227–28.

40 'With mazy'. John Milton, *Paradise Lost* (1667), book 4, lines 239–43.

40 'a certain'. Sir Henry Wotton, *Reliquiae Wottonianae* (1672 edn), 64.

40 'the sweetest'. Temple, *Works*, II, 236–38.

40 'very fine'. Christopher Morris, ed., *The Journeys of Celia Fiennes* (1947), 9.

40 'houling wilderness'. Daniel Defoe, *A Tour through the Whole Island of Great Britain*, III (1738), 55.

41 'Our forefathers'. *Spectator*, no. 419.

41 'during the'. W. H. Auden, *Forewords and Afterwords* (1973), 116–17.

41 'leading step'. Horace Walpole, 'On Modern Gardening', in *Anecdotes of Painting in England*, IV (1828), 264–65.

41 'Hedges'. Willian Shenstone, *Works*, II (1773), 125.

41 'that idea'. Spence, *Observations*, I, 254.

41 'All gardening'. Spence, *Observations*, I, 252.

41 'stark mad'. Pope, *Poems*, 831.

41 'My Building'. *PC*, II, 44.

42 'with all'. *PC*, IV, 261–62.

42 'From the'. *PC*, II, 296.

42 'images reflect'. Alexander Pope, 'Epistle to Mr. Jervas', line 20.

42 'each of'. John Butt, ed., *The Poems of Alexander Pope* (1963), 121.

42 'Nothing can'. *PC*, IV, 201.

42 'You must'. Christopher Hussey, *The Picturesque* (1927), 128.

43 'Whatever yet . . . The nearer'. Elizabeth Manwaring, *Italian Landscape in Eighteenth Century England* (1925), 20.

43 'The Gardens'. *PC*, II, 237–39.

45 'You may'. Spence, *Observations*, I, 252–53.

45 'gloominess and'. *Spectator*, no. 419.

45 'elegance of'. Thomas Warton, *Poetical Works*, I (1802), 68–95.

46 'These moss-grown'. Pope, 'Eloisa to Abelard', lines 142–43.

46 'mould'ring tow'r'. Pope, 'Eloisa to Abelard', line 243.

46 'Lord Radnor'. *WC*, XXXVII, 348.

46 '£10,000 of'. Barbara Jones, *Follies and Grottoes* (1974), 145.

46 'was not'. Richard Graves, *Columella*, II (1797), 65–67.

47 'No people'. *PC*, I, 231.

47 'a true'. *PC*, I, 319.

47 'the few'. *PC*, I, 505–11.

47 'most expensive'. *PC*, I, 432.

47 'little island'. *Correspondence between Frances, Countess of Hartford (Afterwards Duchess of Somerset), and Henrietta Louisa, Countess of Pomfret*, I (1805), 7–8.

47 'Mansion suitable'. Benjamin Ferry, *A.N.W. Pugin* (1865), 13.

48 'dingy meannness'. *The Times*, 22 August 1930, 12c; compare Sir Nikolaus Pevsner, *The Englishness of English Art* (1956), 167–68.

48 'the country'. Arthur Mee, *Hertfordshire* (1965), 68.

48 'The finest'. Lionel Munby, *The Hertfordshire Landscape* (1977), 228–29.

48 'born in'. Elizabeth Bowen, *The Heat of the Day* (1949), 99–101, 115.

49 'almost my'. *PC*, III, 500.

49 'I write'. *PC*, I, 515.

49 'Magician'. *PC*, II, 115.

49 'The finest'. Christopher Hussey, 'Cirencester House – The Park', *CL*, 23 June 1950, 1880.

49 'there is'. *Torrington Diaries*, I, 259.

49 'very romantic'. James Lees-Milne, *Earls of Creation* (1962), 46.

50 'Let not'. Pope, 'Epistle to Richard Boyle, Earl of Burlington', lines 53–58, 61–64.

50 'wild Goth'. *PC*, III, 417.

51 'only twice'. Michael Wilson, *William Kent* (1984), 39.

51 'lessened himself'. Mahon, *Chesterfield*, I (1892), 352.

51 'had been'. *Transactions of Walpole Society*, XXII (1934), 56; cf. 73, 139–41.

52 'antico-moderno'. Earl of Ilchester, *Lord Hervey and His Friends* (1950), 116.

52 Royal masquerades. R. Nisbet Bain, *Gustavus III and His Contemporaries,*
 1746–1792 (1894), 220–21.

53 'Kent is'. *PC*, III, 67.

53 'the greatest'. *PC*, IV, 153.

53 'Mr Pope'. Spence, *Observations*, I, 250.

54 'frequently declared'. Mason, *The English Garden* (1811), notes to book I.

54 'Low in'. Spenser, *Faerie Queene*, book I, canto ix, lines 294–99.

54–55 'execrable'. *WC*, IX, 116.

55 'figures issuing'. Walpole, *Anecdotes*, IV, 228.

55 'the costumes'. Wilson, *Kent*, 152.

55 'I have'. Spence, *Observations*, I, 256–57.

55 'He had'. Walpole, *Anecdotes*, IV, 270.

55 'rich glades'. *Wit and Wisdom of Benjamin Disraeli, Earl of Beaconsfield* (1883),
 195–96.

55 'was attempting'. Margaret Jourdain, *The Works of William Kent* (1948), 76.

56 'who but'. William Marshall, *A Review of Landscape* (1795), 158.

56 'Mr. Kent'. Spence, *Observations*, I, 405.

57 'where any'. Walpole, *Anecdotes*, IV, 266, 279.

57–58 'How picturesque'. Walpole, *Anecdotes*, IV, 278–79.

58 'An open'. Walpole, *Anecdotes*, IV, 280.

58 'Landskip should'. Shenstone, *Works*, II, 280–81.

58 'England's greatest'. Jourdain, *Kent*, 1.

58 'possessed by'. Cleanth Brooks and A. F. Falconer, eds., *The Correspondence of*
 Thomas Percy and William Shenstone (1977), 64.

58–59 'The place'. Sir Walter Scott, *Prose Works*, XXI (1836), 101–2.

59 'something quite'. John Harris, 'Esher Place, Surrey', *CL*, 2 April 1987, 95.

60 'sullen *Mole*'. Pope, *Poems*, 207.

60 'Kent invented'. Sir Nikolaus Pevsner, *Surrey* (1971), 57–58.

60 'Esher's peaceful'. Pope, 'Imitations of Horace'.

61 'The day was'. *WC*, X, 72–73.

Chapter Three

62–63 'The Gothic'. Henry Fielding, *Tom Jones* (1749), chapter 4.

63 'power houses'. Mark Girouard, *Life in the English Country House* (1978), 2–3.

64 'Spenserian'. Sir Nikolaus Pevsner, *Wiltshire* (1975), 304.

64 'If your'. Kerry Downes, *Sir John Vanbrugh* (1987), 272.

64 Lord Stawell. George Stawell, *A Quantock Family* (1910), 120–21.

65 'I dream'. H. C. Foxcroft, *A Character of the Trimmer* (1946), 96–97.

65 'accursed mediocrity'. *PC*, II, 263.

65 'As king'. Matthew Montagu, ed., *Letters of Mrs. Elizabeth Montagu*, IV (1813), 238.

65 'We get'. *WC*, X, 262.

66 'a very pretty'. *WC*, IX, 285.

66 'It looketh'. Foxcroft, *Trimmer*, 102.

66–68 'I am'. *Correspondence between Frances, Countess of Hartford (Afterwards Duchess of Somerset), and Henrietta Louisa, Countess of Pomfret*, I, 299–300.

68 'The situation'. Lord Lyttelton, *Works*, III (1776), 346–47.

68–69 'Adjoining is'. C. B. Andrews, ed., *The Torrington Diaries*, I (1934), 348.

69 'Castle Air'. Sir John Vanbrugh, *Complete Works*, IV (1928), 14.

69 'a great'. Roger North, *Lives of Norths*, I (1742), 272.

69 'To be'. William Shenstone, *Works*, II (1791), 189.

69–70 'Methinks there'. *Gentleman's Magazine*, IX (1739), 641.

70 'My notion' . . . 'I took'. Samuel Kliger, *The Goths in England* (1952), 8–9.

70–71 'highly finish'd'. Marjorie Williams, ed., *The Letters of William Shenstone* (1939), 253.

71 'revived gothic'. Sir Roy Strong, *The Story of Britain* (1996), 325.

72 'Arbury is'. Sir Nikolaus Pevsner and Alexandra Wedgwood, *Warwickshire* (1966), 67–68, 71.

Chapter Four

94 'If I'. Charles Maturin, preface to *The Milesian Chief* (1812).

94–95 'The craze'. Mark Girouard, 'Charleville Forest', *CL*, 27 September 1962, 710.

95 'The whole'. Terence de Vere White, *The Anglo-Irish* (1972), 95–96.

95 'the most'. Lord Gilmour of Craigmillar, *Riots, Risings and Revolutions* (1992), 424.

95–96 'ferocity of'. Charles Ross, ed., *Correspondence of Charles, First Marquess Cornwallis*, II (1859), 355, 358.

96 'All good'. Thomas Pakenham, *The Year of Liberty* (1969), 272.

96 'Bland, passionate'. Viscount D'Abernon, *An Ambassador of Peace*, I (1929), 88.

96 'The castle'. John Trotter, *Walks through Ireland* (1819), 232–33.

97 'whimsical capricious'. Countess of Ilchester and Lord Stavordale, *The Life and Letters of Lady Sarah Lennox*, II (1901), 154.

97 'to exhibit'. R. Warwick Bond, *The Marlay Letters, 1778–1820* (1937), 113.

99 'affray at'. Bond, *Marlay Letters*, 99.

99 'which unites'. *Murray's Handbook for Travellers in Ireland* (1912), 364.

100 'to the'. Mark Bence-Jones, *A Guide to Irish Country Houses* (1988), 82.

100 'diplodicus'. Bond, *Marlay Letters*, 119.

100 'by far'. Sir Herbert Maxwell, *The Creevey Papers* (1923), 630.

100 'Mania'. Death certificate, Uxbridge, 14 July 1851.

100 'Brain Disease'. Death certificate, St Thomas, 22 January 1864.

101 'gouty degeneration'. Death certificate, the Palace subdistrict of Brighton, 29 June 1875.

101 'What a'. Rosamond Lehmann, 'An Absolute Gift', *TLS*, 6 August 1954, xli.

102 'I was'. Marie-Louise Begg, ed., *The Synge Letters* (1996), 142.

102 'The tutor'. Prince von Püchler-Muskau, *Tour in England, Ireland and France in the years 1828 & 1829*, II (1832), 23.

102–3 'The road'. Arthur Young, *A Tour in Ireland* (1925), 157–58.

103 'huge, ungainly'. Anthony Trollope, Castle Richmond (1860).

103 'the *Faerie*'. Elizabeth Bowen, *Bowen's Court* (1942), 181.

103–4 'In a'. Young, *Ireland*, 161–62.

104 'The plan'. Bowen, *Bowen's Court*, 7.

104 'Now to'. Ralph Wardle, ed., *Collected Letters of Mary Wollstonecraft* (1979), 123.

104 'wild Irish'. *Wollstonecraft Letters*, 122, 126.

104 'The family'. *Wollstonecraft Letters*, 141.

104–6 'If all'. De Boigne, *Memoirs*, I, 120–24.

106–7 'The Peers'. Sir Jonah Barrington, *Personal Sketches of His Own Times*, I (1827), 198–99.

107 'had married'. Püchler-Muskau, II, 26.

107 'for the'. Pakenham, *Year of Liberty*, 191.

107 'very proud'. *Wollstonecraft Letters*, 140.

108 'must solicit'. Lord Kingston to Lord Clare, 6 July 1819, Add. ms 40268, f. 163.

108 'the rude'. Trotter, *Ireland*, 312.

108 'One of'. Sir Robert Peel to Lord Kingston, 23 January 1823, Add. ms 40353, f. 245.

108 'These old'. Kingston to Peel, 14 March 1823, Add. ms 40355, f. 91.

109 'Build me'. Aubrey de Vere, *Recollections* (1897), 53.

109 'sorely disappointed'. Püchler-Muskau, II, 21–22.

109–10 'It is'. Anthony Trollope, *Castle Richmond*, I (1860), 5–6.

110–11 'A most'. Lady Chatterton, *Rambles in the South of Ireland*, II (1839), 3–9.

111–112 'I am'. De Vere, *Recollections*, 54.

112 'The house'. De Vere, *Recollections*, 54–56.

113 'They were'. Bowen, *Bowen's Court*, 190.

113 'labouring under'. *The Times*, 23 July 1833, 6a and 6b.

113 'Complainant then'. *The Times*, 1 April 1848, 8c.

113 'a long'. *The Times*, 12 September 1860, 8f.

114 'one of'. *Murray's Handbook* (1912), 445.

114 'Wind raced'. Bowen, *Bowen's Court*, 323–24.

114 Irish irregulars. *The Times*, 3 July 1922, 10b.

Chapter Five

In this chapter I have followed certain suggestions in Timothy Mowl, *Horace Walpole* (1996), but my supreme debt is to Elizabeth Napier, *The Failure of Gothic* (1987).

115 'I have'. WC, XXXV, 355–56.

115 'Learn to'. Walpole, *The Mysterious Mother*, act III, scene iv.

115–16 'Providence'. W. S. Lewis, ed., *Memoranda Walpoliana* (Farmington, 1937), 16.

116 'power is'. Leo Tolstoy, second epilogue to *War and Peace*.

117 'are conscious'. W. H. Auden, 'The Double Focus', *Common Sense*, IX (1940), 25–26.

118 'a person'. WC, XXXV, 236.

118–19 'It is'. Richard Wollheim, preface to Adrian Stokes, *The Invitation in Art* (1965), xxx.

119 'little intrigues . . . first dear'. WC, IX, 3.

119 'very dark'. *WC*, XXX, 294.

119 'rode most'. *WC*, XVII, 91.

119 'One . . . very'. *WC*, XVIII, 199.

119–20 'I here'. *WC*, XXXV, 42–43.

120 'I have'. *WC*, XXX, 86.

120 'so nervous'. *WC*, XXV, 49, 201.

120 'I wake'. *WC*, XXXI, 35–36.

120 'my other'. *WC*, XXXV, 52.

120 'hero'. *WC*, XII, 289.

120 'After that'. *WC*, XX, 41.

120–21 'We had'. *WC*, XVII, 411–12.

121 'I dressed'. *WC*, XVIII, 167.

121 'You my'. *WC*, XXX, 41.

121–22 'I have'. *WC*, XXX, 43–44.

122 'I had'. *WC*, XXX, 173.

122 'ingratitude'. *WC*, XXX, 178–79.

122 'constantly ridiculed'. *WC*, XXXIX, 530.

123 'Perhaps those'. Walpole, *Memoirs of the Reign of King George II*, II (1846), 370.

123 'Literature . . . is'. *WC*, X, 176.

123 'Learning never'. *WC*, XXXV, 226.

123 'How, Sire'. *WC*, XXXXII, 163.

123 'The Uncle'. *WC*, XXXXII, 339, 341.

124 'I hope'. *WC*, XXV, 451.

124 'horror'. *WC*, XXXV, 178.

124 'Religion has'. *WC*, XXXV, 354.

124 'I always'. *WC*, XXXVII, 170.

124 'My dearest'. *WC*, XXXVIII, 93.

124–25 'There was'. Sir William Anson, ed., *Autobiography and Political Correspondence of Augustus Henry, Third Duke of Grafton KG* (1898), 140–41.

125 'one of'. *WC*, XXXV, 297.

125 'by nature'. William Guthrie, *A Reply to the Counter-Address* (1764), 6–7; Walpole, *Memoirs of King George III*, III (1894), 4.

125 'scurrility'. *WC*, XXXVIII, 437–38.

125 ''Tis amazing'. *WC*, XXX, 43.

126 'This dating'. Mowl, *Walpole*, 182, 186.

126 'I had'. Walpole, *Memoirs of King George III*, II, 150.

126 'I have'. *WC*, X, 177.

126 'My heart'. *WC*, XXXXI, 5.

126 *'an age'*. *WC*, XII, 453, 461; XXV, 47.

127 'Brobdignag combs'. *WC*, XXXVII, 439–40.

127 'There is'. *WC*, X, 192.

127 'a little'. *WC*, XXXVII, 269.

127 'to build'. *WC*, XX, 111.

127 'I have'. *WC*, XII, 371.

127 'Imagine the'. *WC*, XII, 380–82.

128 'you enter'. Duncan Tovey, ed., *The Letters of Thomas Gray*, II (1900), 102.

128 'introduced a'. *Gray Letters*, I, 248.

131 'bastard Gothic'. *WC*, XXXV, 233.

131 'A few'. Samuel Kliger, *The Goths in England* (1952), 27–28.

131 'it is not'. *WC*, XXVIII, 6.

131 'He liked'. Lytton Strachey, *Characters and Commentaries* (1933), 40.

131 'the Grecian'. *WC*, XII, 127.

131 'I have resumed'. *WC*, XXXV, 161.

131 'I do'. Mowl, *Walpole*, 119.

131 'He turns'. Thom Gunn, *Collected Poems* (1993), 57.

132 'Strawberry Hill'. *WC*, XXXV, 227.

132 'They allot'. *WC*, XXII, 270, 276.

132 'I waked'. *WC*, I, 88.

133 'pictures of'. *WC*, XXII, 271.

133 'Gothic runes'. Sir William Temple, 'Of Poetry', part II: *Works*, II (1754), 339–40.

133 'I have'. *PC*, II, 202–3.

133 'For the'. Edith Morley, ed., *Hurd's Letters on Chivalry and Romance* (1911), 110.

133–34 'a Gothic'. Morley, *Hurd's Letters*, 115, 117.

134 'There would'. James Beattie, 'The Minstrel', book I, lines 284–306.

134 'the castles'. James Beattie, *Dissertations*, II (1783), 278.

135 'The impulses'. Tobias Smollett, preface to *Ferdinand Fathom* (1753).

135 'I question'. Maturin, preface to *Fatal Revenge* (1807).

135 'loves grief'. *WC*, XXXIX, 94.

135 'my imagination'. Lady Mary Coke, *Journals*, III (1892), 225.

135 'She was'. Lewis, *Memoranda Walpoliana*, 10.

135–36 'some of'. *WC*, XXVIII, 6.

136 'This world'. *WC*, XXXII, 315.

136 'died extremely'. *WC*, XIX, 386.

136 *'presque tout'*. *WC*, III, 261.

136 'What's the'. *WC*, XXXV, 32.

136 'We shall'. *WC*, X, 184.

136 'fancy's gale'. Walpole's dedicatory sonnet to Lady Mary Coke.

136–37 'duped'. *WC*, XXVIII, 5.

137 'dashed to'. *Castle of Otranto* (hereafter *CoO*), chapter 1.

137 'Power and'. *CoO*, chapter 3.

138 'What! is'. *CoO*, chapter 5.

138 'Walpole's comic'. Elizabeth Napier, *The Failure of Gothic* (1987), 82–83.

138–39 'uttered a'. *CoO*, chapter 1.

139 'Well, my'. *Gothic Stories*, 16–17.

140 'Well, but'. Ann Radcliffe, *The Mysteries of Udolpho* (1794), fourth book, chapter 14.

140 'Oh, transport'. *CoO*, chapter 1.

140 'Amazement!', *CoO*, chapter 3.

140 'Ah me'. *CoO*, chapter 5.

140 'O speak'. *Gothic Stories*, 19.

140 'every mark'. Nathan Drake, *Literary Hours*, I (1820), 278.

140 'the silence'. Tobias Smollett, *The Adventures of Ferdinand Count Fathom* (1753), chapters XX and XXI.

141 'toward the'. Drake, *Hours*, I, 138–39.

141 'I could'. *WC*, XXXV, 575.

142 'A wretched'. *Parliamentary Debates* (19 April 1779), col. 598.

142 'A due'. *Parliamentary Debates* (30 March 1779), col. 594.

142 'violation of'. Maturin, *Melmoth*, 90.

143 'the hateful'. Marquis de Sade, *The Gothic Tales* (1990), 137.

144 'Love, supposed'. Maturin, preface to *Fatal Revenge* (1807).

144–45 'Mrs. S'. Lady Holland, *Journals*, 211–12.

145 'even in'. Drake, *Hours*, I, 105–6.

145 'More than'. James Lackington, *Memoirs* (1791), 243.

146 'Sir Bertrand'. *Gothic Stories* (1799), 6.

146 'trash'. Lady Holland, *Journals*, 41.

146–47 'Edwin neither'. *Gothic Stories*, 50–51.

147 'She had'. Ann Radcliffe, *Posthumous Works*, I (1833), 6, 13.

148 'This was'. Radcliffe, *Udolpho*, 30.

148 'the Shakespeare'. Drake, *Hours*, I, 273–74.

148 'Charming as'. Jane Austen, *Northanger Abbey* (1818), chapter 25.

148 'Virtue is'. WC, XXXVIII, 130–31.

148 'show the'. Charles Brockden Brown, *Wieland* (1798), chapter 1.

148 'a striking'. Clara Reeve, *The Old English Baron* (1777).

148–49 'In reviewing'. Ann Radcliffe, *A Sicilian Romance* (1790), chapter 16.

149 'His family'. *Gothic Stories*, 41–42.

149 'the drama'. Maturin, *Melmoth*, pt. III, chapter 12.

149 'to be'. Radcliffe, *Italian*, III, x.

149–50 'the man'. William Faulkner, *Absalom, Absalom!* (1936), 120.

Chapter Six

In this chapter I owe a great debt to Ronald Paulson, *Representations of Revolution (1789–1820)* (1983), and Nigel Glendinning, *Goya and His Critics* (1977).

152 'free people'. Comte de Volney, *The Ruins, or a Survey of the Revolution of Empires* (1791), chapter 19.

152–53 'I have'. Lord Gilmour of Craigmillar, *Riots, Risings and Revolutions* (1992), 15–16.

153 'The whole'. Edmund Burke, *Works*, III (1901), 521.

154 'If Macbeth'. WC, XXXV, 445–46.

155 'who can'. *Memoirs of the Life of Sir Samuel Romilly*, II (1840), 4.

156 'Absurd and'. Lady Holland, *Journals*, II, 16.

156 'to revolutionize'. *Correspondence of Charles, First Marquis Cornwallis*, II (1859), 358, 383.

156 Edward FitzGerald. Stella Tillyard, *Citizen Lord* (1997).

157 'the ruffians'. *Annual Register for 1803*, 311.

157 'drawn'. Charles Maturin, *Melmoth the Wanderer* (1820), volume 3, chapter 12.

162 'Like the'. Ronald Paulson, *Representations of Revolution* (1983), 335–37.

165 'the body'. Fred Licht, *Goya: The Origins of the Modern Temper in Art* (1979), 148.

165 'stopped to'. Holland, *Journals*, II, 69.

165 'What is'. John, chapter 18, verses 38–39.

165 'the Revolution'. Simon Schama, *Citizens* (1989), 714.

165–66 'essential to'. Licht, *Modern Temper*, 167–69.

166 'was only'. John Ruskin, *Works*, XXXVII (1909), 53.

166–67 'unique'. Joris Karl Huysmans, *A Rebours* (1884), chapter 9.

167 'the greatest exponent'. André Malraux, *Saturn* (1957), 128.

167 'this man'. Guillaume Apollinaire in 1909, quoted Geoffrey Gorer, *The Life and Ideas of the Marquis de Sade* (1953), 17.

168 'The chateaux'. Donald Thomas, *The Marquis de Sade* (1992), 20, 41.

170 'that dirty'. Marquis de Sade, *The Gothic Tales* (1990), 176.

171 'design'd rather'. Thomas, *Sade*, 25.

172 'The rabble's'. Coventry Patmore, *Poems* (1928), 424–45.

173 'Murderers, jailers'. Sade, *Aline et Valcours*, iv, 6.

173 'The true laws'. Sade, *Juliette* (1968), 481.

173 'Personal interest'. Sade, *Juliette*, 253–54.

173 'bigotry, mummery'. Sade, *Gothic Tales*, 174.

173 'I raise'. Sade, *Juliette*, 396–37.

173 'The pious'. Sade, *Juliette*, 630.

173 'You keep'. Sade, *Juliette*, 930.

174–75 'such infamous'. Sade, *Gothic*, 169–70.

175 'The great wars'. Sade, *120 Days of Sodom and Other Writings* (1966), 1.

176 'Caves, underground'. Simone de Beauvoir, 'Must We Burn Sade?', quoted *120 Days*, 37.

177 'for those'. Sade, *Juliette*, 236.

177 'the final'. Gorer, *Sade*, 81.

177 'a man'. Sade, *Juliette*, 210.

177 'He degraded'. Sade, *Juliette*, 236.

177–78 'As for'. Sade, *Juliette*, 378.

178 'he is'. Sade, *Juliette*, 255.

178 'kings are'. Sade, *Juliette*, 933.

178 'it is'. Sade, *Juliette*, 860.

178 'the new'. Sade, 'Reflections on the Novel', in *120 Days*, 108–9.

180 'the two'. Margaret Baron-Wilson, *The Life and Correspondence of M. G. Lewis*, I (1839), 77.

180 'M.G.L.'. Louis Peck, *A Life of Matthew G. Lewis* (1961), 52.

180 'Lord Kerry'. Baron-Wilson, *Lewis*, I, 132.

181 'I rent'. Matthew Lewis, *The Monk* (1796), part III, chapter iv, 412, 415.

181 'a Monster'. Lewis, *Monk*, III, i, 301.

182 'Ambrosio rioted'. Lewis, *Monk*, I, ii, 65–67, 84, 90–91.

182 'It was'. Lewis, *Monk*, II, iv, 276–77.

182 'his desires'. Lewis, *Monk*, III, i, 300.

182–83 'darted their'. Lewis, *Monk*, III, v, 442.

183–84 'They forced'. Lewis, *Monk*, III, iii.

184–85 'Did you'. Edward and Lillian Bloom, eds., *The Piozzi Letters*, II (1991), 411.

185 'talk rather'. Robert Wilberforce and Samuel Wilberforce, *The Life of William Wilberforce*, II (1838), 183–84.

185 'lust' . . . 'ravisher'. Peck, *Lewis*, 35.

185 'O exquisite'. Radcliffe, *Romance of the Forest* (1791).

186 'his mind'. Lord Stavordale, ed., *Further Memoirs of the Whig Party, 1807–1821, by Third Lord Holland* (1905), 379.

186 'I heard'. Mary Shelley, *Frankenstein* (1818), chapter 13.

188 'Dream that'. Paula Feldman and Diana Scott-Kilvert, eds., *The Journals of Mary Shelley*, I (1987), 70.

188 'Nothing could'. Mary Shelley, *History of a Six Weeks' Tour, 1817* (1991), 14.

188–89 'I was'. Muriel Spark, *Child of Light* (1951), 4–6.

189 'We talk'. Shelley, *Journal*, I, 126.

190 'unable to'. Shelley, *Frankenstein*, chapter 5.

190 'race of'. Shelley, *Frankenstein*, chapter 20.

191 'he left'. Shelley, *Frankenstein*, chapter 24.

191 'nearly in'. Shelley, *Frankenstein*, chapter 7.

191 'electricity, or'. Marilyn Butler, introduction to Shelley, *Frankenstein* (1993), xix.

192 'Voltaic agency'. Sir James Murray, *Electricity as a Cause of Cholera* (1849), 4, 9.

192 'Thanks to'. Peter Popham, 'Art, Science and Self Abuse', *The Independent*, 24 May 1997, 21c.

192 'is madly'. Shelley, *Frankenstein*, letter II.

192 'We hear'. 'A Methodist', 'Caution against a Growing Immorality of Principle', *Gentleman's Magazine* (1801), 398–39.

193 'I ought'. Shelley, *Frankenstein*, chapter 10.

193 'All men'. Shelley, *Frankenstein*, chapter 17.

193 'Do your'. Shelley, *Frankenstein*, chapter 10.

193 'I will'. Shelley, *Frankenstein*, chapter 10.

193 'a fiendish'. Shelley, *Frankenstein*, chapter 20.

194 'a race'. Shelley, *Frankenstein*, chapter 20.

194 'I, like'. Shelley, *Frankenstein*, chapter 16.

Chapter Seven

In this chapter I have a general debt to Jonathan Scott, *Piranesi* (1975). Rosemary Hill's forthcoming biography of Pugin will be unsurpassed.

195 'It is'. Maturin, *Melmoth the Wanderer*, 207.

196 'as from'. Algernon Swinburne, 'Ode to Mazzini', lines 137–38.

196 'Remember the'. Alfred Tennyson, 'Voyage of Maeldune', line 118.

196 'the severity'. Thomas Chalmers, *Works*, VII (1841), 357.

196 'Has it'. W. E. Gladstone, *Diary*, III (1974), 250–51.

197 'As he'. Samuel Taylor Coleridge, 'The Devil's Thoughts', lines 34–37.

197 'It is'. Charles Baudelaire, preface to *Les Fleurs du Mal* (1855).

197 'I don't'. Robert Musil, *The Man Without Qualities*, I (1953), 236.

197–98 'by the'. Hyatt Mayor, *Giovanni Battista Piranesi* (1952), 4.

200 'If I'. Aldous Huxley, *Prisons* (1949), 31.

200 'designs for'. Arthur Samuel, afterwards first Baron Mancroft, *Piranesi* (1910), 107–8.

200–1 'instead of'. Mayor, *Piranesi*, 16.

201 'authentic pedigree'. Angus Hawkins and John Powell, eds., *The Journal of John Wodehouse, First Earl of Kimberley for 1862–1902* (1997), 138.

201 'Salvator Rosa'. WC, XXXIII, 547.

202 'Many years'. Thomas De Quincey, *Confessions of an English Opium-Eater* (1822; 1927 edn), 117–18.

203 *'metaphysical prisons'*. Huxley, *Prisons*, 21–22, 24–25.

203–4 'The walls'. Guy Chapman, ed., *The Travel Diaries of William Beckford of Fonthill*, I (1928), 96–98.

206 'Amongst the'. Chapman, *Beckford Travel Diaries*, I, lx.

207 'I have'. Boyd Alexander, *The Journal of William Beckford in Portugal and Spain, 1787–1788* (1954), 13.

207 'Unhappy Vathek'. Louis Crompton, *Byron and Greek Love* (1985), 120.

208 'Phipps bid'. Wilfred Dowden, ed., *The Journal of Thomas Moore*, I (1983), 69; Kathryn Cave, ed., *The Diary of Joseph Farington*, VIII (1982), 2887–88.

208 'impudent Phipps'. Boyd Alexander, *Life at Fonthill, 1807–1822* (1957), 274.

208 'hopeless spectators'. Huxley, *Prisons*, 23.

208 'imprudence in'. David Hartley, *Observations on Man* (1791), part II, 242.

208 'the dwarf'. Alexander, *Fonthill*, 110.

208 'How tired'. Alexander, *Beckford in Portugal*, 41.

208–9 'To pay'. Lewis Melville, *The Life and Letters of William Beckford of Fonthill* (1910), 31–32.

209 'I had'. Melville, *Beckford*, 142.

209 'a certain'. Letter to Samuel Henley after September 1784.

209–10 'In the'. Beckford, *Vathek, an Arabian Tale* (1786), *circa finem*.

210 'The rising'. Alexander, *Fonthill*, 119.

210–11 'it's really'. Alexander, *Fonthill*, 81.

211 'Some people'. Alexander, *Fonthill*, 128.

211 'all this'. Alexander, *Fonthill*, 153–54.

211 'I was seduced'. Alexander, *Fonthill*, 152.

211 'Walpole hated'. Melville, *Beckford*, 299.

211 'Strawberry Hill'. Harold Brockman, *The Caliph of Fonthill* (1956), xii.

211–12 'The very'. Alexander, *Fonthill*, 109.

212 'glorious parks'. Marquess of Huntly, *Milestones* (1926), 53–54.

213 'the Destroyer . . . this monster'. Martin Briggs, *Goths & Vandals* (1952), 140, 157.

215 'When his'. Anthony Dale, *James Wyatt* (1956), 166.

216 'The park'. Prince Pückler-Muskau, *Tour*, III (1932), 199–201.

216 'a conservatory'. Pugin, *True Principles of Pointed or Christian Architecture* (1841), 96.

216–17 'an abbey'. Clayre Percy and Jane Ridley, eds, *The Letters of Edwin Lutyens to His Wife Lady Emily* (1985), 166.

217 'this Wagnerian'. Nikolaus Pevsner and Edward Hubbard, *Cheshire* (1971), 208.

217 'the *beau*'. Nikolaus Pevsner, *Leicestershire and Rutland* (1984), 97.

217 'The ball'. Robert Rhodes James, ed., *Chips* (1967), 21.

217 'An amusing'. John Vincent, ed., *The Crawford Papers* (1984), 272.

217 'Let wealth'. Lord John Manners, 'England's Trust', part III, lines 231–32.

219 'the crosses'. Charles Maturin, *Melmoth the Wanderer* (1820), 392.

219 'while I'. *Melmoth*, 531.

219 'simplicity of'. *Melmoth*, 111.

219 'I was'. *Melmoth*, 91.

219 'The whole'. *Melmoth*, 76.

219 'There was'. *Melmoth*, 94.

219 'In Catholic'. *Melmoth*, 165.

220 'He possessed'. *Melmoth*, 196–97.

220 'that despair'. *Melmoth*, 197–98.

220 'Clap me'. *Melmoth*, 212–3.

220–21 'mine is'. *Melmoth*, 225.

221 'It was'. *Melmoth*, 240.

221 'In this'. Henry Blyth, *The Pocket Venus* (1966), 6.

223 'harmony, symmetry'. John Newman and Nikolaus Pevsner, *Dorset* (1972), 244.

223 'Next week'. Montagu Bream, *Recollections of a Man of No Importance*, III (1888), 21.

223–24 'at much'. Benjamin Ferrey, *Life of A. N. Welby Pugin* (1861), 61.

224 'Pugin's etchings'. Kenneth Clark, *The Gothic Revival* (1928), 138.

224 'perfectly convinced'. Ferrey, 88.

224 'You are'. Ferrey, 262.

224–25 '"Happy" exclaimed'. Chapman, *Beckford Travel Diaries*, II, 43.

225 'the man'. J. Mordaunt Crook, 'Catholic Myths by Moonlight', *TLS*, 15 July 1994, 18.

225 'walls, towers'. Nikolaus Pevsner, *Staffordshire* (1974), 56; Dennis Gwynn, *Lord Shrewsbury, Pugin and the Catholic Revival* (1946).

226 'The world'. Crook, 'Catholic Myths', 18.

226 'the illusion'. A.N.W. Pugin, *The True Principles of Pointed or Christian Architecture* (1841), 59–60.

226 'Treatise upon'. A. H. Clough, *Poems* (1974), 73–74, 91.

Chapter Eight

Among several heavy debts in this chapter, I must specify Nina Auerbach, *Our Vampires, Ourselves* (1995), James Twitchell, *The Living Dead* (1981), Paul Barber, *Vampires, Burial and Death* (1988) and Nicholas Powell, *Fuseli: The Nightmare* (1973).

228 'that if'. Robert Latham and William Matthews, eds, *The Diary of Samuel Pepys*, IX (1976), 32–34, 49.

229 'the suicide'. Arthur Friedman, ed., *Collected Works of Oliver Goldsmith*, II (1966), 452.

229–30 'I tremble'. Henry Fielding, *Tom Jones* (1749), book 7, chapter 7.

230 'a personal'. Sheila Fletcher, *Victorian Girls* (1997), 196.

230 'The body'. *Annual Register 1823* (1824), 82.

231 'the more'. James Hogg, *Private Memoirs and Confessions of a Justified Sinner* (1824; 1969 edn), 242.

231 'that fool's'. Emily Brontë, *Wuthering Heights* (1847), chapter 17.

232 'Is he'. Brontë, *Wuthering*, chapter 34.

232 'how anyone'. Brontë, *Wuthering*, chapter 34.

232 'The dead'. Paul Barber, *Vampires, Burial and Death* (1988), 197.

234 Countess Báthory. Tony Thorne, *Countess Dracula* (1997).

234 'from *Medreyga*'. *Gentleman's Magazine* (1732), 681.

234–35 'Vampire in'. *PC*, IV, 227.

235 'though not'. *WC*, XXXIII, 508.

236 'We are'. John Knowles, ed., *The Life and Art of Henry Fuseli*, III (1831), 102.

236 'that Fuseli's'. Peter Tomory, *The Life and Art of Henry Fuseli* (1972), 92.

236 'Terrific and'. Knowles, *Fuseli*, II, 102–3.

236 'fused ancient'. C. Nicholas Powell, *Fuseli: The Nightmare* (1973), 96.

236 'Envy, the'. Knowles, *Fuseli*, III, 140.

237 'All his'. John Joliffe, *Neglected Genius* (1990), 22, 40.

237–38 'So on'. Erasmus Darwin, 'The Botanic Garden', pt II, canto 3, lines 51–76.

238–39 'satirical Invective'. *The Craftsman* (1732), 751.

239 'a corrupt'. Goldsmith, *CW*, II, 329.

239 'Rulers who'. Percy Bysshe Shelley, 'England in 1819', lines 3–6.

239 'Castle Spectre'. *Correspondence of Charles, First Marquis Cornwallis*, II (1859), 418.

240 'But first'. Byron, *The Giaour*, lines 755–64.

240 'Certain vague'. Sheridan Le Fanu, *In a Glass Darkly* (1872): 'Carmilla', chapter 7.

241 'I will'. Leslie Marchand ed., *Byron's Letters & Journals*, hereafter *BLJ*.

241 'I am'. *BLJ*, IX, 62.

241 'They say'. *BLJ*, IX, 108.

241 'Shakespeare and Otway'. *BLJ*, VII, 194.

241 'The great'. *BLJ*, III, 109.

242 'From his'. David L. MacDonald, *Poor Polidori* (1991), 5.

242 'a most'. Lord Broughton, *Recollections of a Long Life*, II (1909), 16.

242 'What is'. MacDonald, *Polidori*, 70–71.

242 'Poor Shelley!'. *BLJ*, X, 69.

242 'There was'. MacDonald, *Polidori*, 102; Franklin Bishop, *Polidori!* (1991), 54.

242 'will be'. Bishop, *Polidori!*, 67.

243 'A cursed'. Peter Graham, ed., *Byron's Bulldog* (1984), 270–71.

243 'Lord Byron'. MacDonald, *Polidori*, 180.

243 E. M. Butler, *Byron & Goethe* (1956), 55, 112.

243 *'ce Don'*. Christopher Frayling, *Vampyres* (1991), 9.

243–44 'man of'. Alan Ryan, *The Penguin Book of Vampire Stories* (1988), 1–6.

244 'a *material*'. *BLJ*, IX, 45.

244–45 Grey de Ruthyn. Louis Crompton, *Byron and Greek Love* (1985), 70, 82–84, 217, 230–31.

245–46 'irresistible powers'. John Polidori, *The Vampyre and Other Works* (1991), 5–20.

246 'Being a'. Harriet Martineau, *Autobiography*, I (1877), 82.

246 'disgust at'. Polidori, *Vampyre*, 33.

246 'Poor Polidori'. Thomas Medwin, *Conversations of Lord Byron*, I (1824), 139–40.

247 'The love'. Polidori, *Vampyre*, 39.

247 'there are'. Poe, 'Berenice'.

247 'a shabby'. Mary Elizabeth Braddon, 'Good Lady Ducayne', in Ryan, *Penguin Vampires*, 139.

248 '"If there's"'. F. Marion Crawford, 'For the Blood Is Life', in Ryan, *Penguin Vampires*, 190.

248 '"I must"'. James Rymer, *Varney the Vampyre, or the Feast of Blood* (1845), 151.

250 'On Monday'. *The Times*, 12 June 1860, 8e.

250 'A great'. *The Times*, 29 July 1839, 7e.

250 'passionate, studious'. Poe, 'Oval Portrait'.

250–51 'A giant'. Lord de Tabley, 'Circe', lines 22–38.

251 'Remorseless by'. John Paget, *Hungary and Transylvania*, I (1839), 68–71.

251 'For the'. Lord Lytton, 'The Vampire', lines 42–46.

252 'Capital is'. Karl Marx, *Das Kapital*, chapter X (1990 edn, 342).

252 'one of'. Nina Auerbach, *Our Vampires, Ourselves* (1995), 41.

254 'My father'. Le Fanu, 'Carmilla', chapter 1.

254 'by way'. 'Carmilla', chapter 2.

255 'Twelve years'. 'Carmilla', chapter 3.

255 '"I have"'. 'Carmilla', chapter 5.

255–56 'She used'. 'Carmilla', chapter 4.

256 'Carmilla became'. 'Carmilla', chapter 7.

256 'A sharp'. 'Carmilla', chapter 15.

258–59 'He is'. Bram Stoker, *Dracula*, chapter 3.

259 'You are'. *Dracula* (1897), chapter 10.

259 'as if'. *Dracula*, chapter 13.

259 'holding his'. *Dracula* (1897), chapter 15.

259–60 'the sweetness'. *Dracula*, chapter 16.

260 'Arthur placed'. *Dracula*, chapter 16.

260 'In constructing'. Auerbach, *Vampires*, 83.

261 'The future'. D. L. Burn, *The Economic History of Steel-Making* (1940), 304.

261 'The most'. Geoffrey Searle, *The Quest for National Efficiency* (1971), 1.

261 'we have'. *Dracula*, chapter 18.

261 'the wonderful'. *Dracula*, chapter 26.

262 'young man'. Christopher Frayling, *Vampyres* (1991), 301.

262 'this man'. *Dracula*, chapter 4.

262 'Shall I'. *The Complete Peerage*, IX (1936), 534–55.

262 'He sucks'. Franco Moretti, *Signs Taken for Wonders* (1988), 91.

262 'The only'. *Dracula*, chapter 4.

262 'they cannot'. *Dracula*, chapter 18.

263 'We found'. *Dracula*, chapter 26.

263 Burne-Jones. *The Times*, 22 June 1926, 21.

263 'A fool'. *Rudyard Kipling's Verse* (1982), 220. Italics in original.

263 'as business'. Kipling, *Verse*, 299–300.

263 'He bore'. *Dracula*, chapter 13.

263–64 'an America'. Ewart Grogan, *From Cape to Cairo* (1902 edn), xiii–xiv.

264 'The occurrence'. Moretti, *Signs*, 96.

264 'A brave'. *Dracula*, chapter 27.

Chapter Nine

266–67 'Life is'. Nathaniel Hawthorne, *Works*, II (1965), 41.

267 'There are'. Hawthorne, *Works*, I (1962), 40–41.

267 'the old'. William Faulkner, *Absalom, Absalom!* (1936), 82.

267 'isolated puritan'. Faulkner, *Absalom*, 93.

267 'mean incidents'. Hawthorne, *Works*, II, 153.

267 'most wild'. Edgar Allan Poe, *Works*, III (1978), 849.

267 'connected at'. Henry James, *Notes and Reviews* (1921), 110.

268 'if I'. W. M. Elofson, ed., *The Writings and Speeches of Edmund Burke*, III (1996), 325.

268 'men the'. P. J. Marshall and J. A. Woods, eds., *The Correspondence of Edmund Burke*, VII (1968), 62.

268 'men of'. Hawthorne, *Works*, II, 44.

268 'had contributed'. *Parliamentary Debates*, 20 (4 May 1779), col. 601.

268 'subvert[ing] every'. *Parliamentary Debates*, 35 (16 May 1800), col. 250.

268 'men of'. *Parliamentary Debates*, 35 (16 May 1800), col. 275.

268 'the honourable'. *Parliamentary Debates*, 35 (23 May 1800), col. 281.

268 'Domestic unhappiness'. *Parliamentary Debates* (16 May 1800), col. 263; see Donna Andrew, '"Adultery-à-la-Mode": Privilege, the Law, and Attitudes to Adultery, 1770–1809', *History*, 82 (1997), 5–24.

269 'The doctrine'. Henry James, 'Hawthorne' (1879), chapter 4.

269 'headache which'. T. Walter Herbert, *Dearest Beloved* (1993), 50.

269–70 'You say'. John Ward Ostrom, ed., *The Letters of Edgar Allan Poe*, II (1966), 356.

271 'The place'. Hawthorne, *Works*, I, 11.

271 'this grim'. Faulkner, *Absalom*, 109.

271 'The atmosphere'. *The Education of Henry Adams* (1907), 7, 25, 48.

271 'He greatly'. Louis Sullivan, *The Autobiography of an Idea* (1924), 49–50.

272 'The building'. George Nash, *The Life of Herbert Hoover*, I (1983), 5–6.

272 'grim mausoleum'. Faulkner, *Absalom*, 60.

272 'A Bible-belting'. Poppy Z. Brite, *Drawing Blood* (1993), 25.

272 'the dairymaid'. Edith Birkhead, *The Tale of Terror* (1921), 197.

272–73 'They had'. William Hazlitt, *Works*, VI (1903), 386.

273 'It is'. Leslie Fiedler, *Love and Death in the American Novel* (1967), 28.

273 'a supreme'. Joyce Carol Oates, *Haunted* (1994), 304.

273 'what have'. William Faulkner, *The Sound and the Fury* (1929), 87–88.

274 'whatever I'. Faulkner, *Sound*, 224.

274 'the dungeon'. Faulkner, *Sound*, 148.

274 'to trail'. Bertram Wyatt-Brown, *The House of Percy* (1994), 355.

274 'why psychoanalysis'. David McClelland, *The Roots of Consciousness* (1964), 127–28.

275 'His seniors'. 'American Gothic Novelist', *TLS*, 3 March 1950, 134.

275 'hot hidden'. Faulkner, *Sound*, 78.

275 'Although Brown's'. Emory Elliott, *Revolutionary Writers* (1982), 224–25.

275 'a country'. Faulkner, *Absalom*, 221.

276 'The empire'. Charles Brockden Brown, *Wieland and Memoirs of Carwin the Biloquist* (1991 edn), 10.

276 'his features'. Brown, *Wieland*, 25–26.

276 'degenerate into'. Brown, *Wieland*, 43.

276 'expatiate on'. Brown, *Wieland*, 49.

276 'little community'. Brown, *Wieland*, 68.

277 'imp of mischief'. Brown, *Wieland*, 140.

277 'Bloodshed is'. Brown, *Wieland*, 150.

277 'Very powerful'. Hyder Rollins, ed., *The Letters of John Keats*, II (1958), 173.

277 'He was'. Hazlitt, *Works*, X (1904), 311.

278 'have no'. Herbert, *Dearest Beloved*, 185.

278 'I thank'. Hawthorne, *Works*, XVIII (1987), 531.

279 'A young'. Hawthorne, *Works*, XI (1974), 270.

279 'insane hatred'. Hawthorne, *Works*, XI, 272.

279 'A scene'. Hawthorne, *Works*, II, 273.

279 'The countenances'. Hawthorne, *Works*, II, 276–77.

279 'I have'. Faulkner, *Sound*, 67.

280 'The very fact'. Faulkner, *Absalom*, 96.

280 'persecuting spirit'. Hawthorne, *Works*, I, 9.

280 'No aim'. Hawthorne, *Works*, I, 10.

280 'A strange'. Hawthorne, *Works*, I, 116.

281 'so Roger'. Hawthorne, *Works*, I, 124.

281 'when a'. Hawthorne, *Works*, I, 138.

281 'was ornamented'. Hawthorne, *Works*, II, 11, 14.

281 'a rusty'. Hawthorne, *Works*, II, 261.

281 'chaotic'. Hawthorne, *Works*, II, 250.

281 'a theatre'. Hawthorne, *Works*, II, 217.

281 'sombrely theatrical'. Faulkner, *Absalom*, 35, 38, 40.

281 'The iron-hearted'. Hawthorne, *Works*, II, 15.

281–82 'more extensive'. Hawthorne, *Works*, II, 18.

282 'fed . . . from'. Hawthorne, *Works*, II, 37.

282 'In this'. Hawthorne, *Works*, II, 38.

282 'in all'. Hawthorne, *Works*, II, 23.

282 'I make'. Hawthorne, *Works*, II, 91.

282 'reformers, temperance-lecturers'. Hawthorne, *Works*, II, 84.

282 'the gift'. Hawthorne, *Works*, II, 71.

282 'the hard'. Hawthorne, *Works*, II, 48.

282 'expressive of'. Hawthorne, *Works*, II, 184.

282 'We are ghosts!'. Hawthorne, *Works*, II, 169.

282 'his dreams'. Hawthorne, *Works*, II, 170.

282 'had worn'. Hawthorne, *Works*, II, 123.

282 'animal'. Hawthorne, *Works*, II, 116, 118.

282 'Might and wrong'. Hawthorne, *Works*, II, 243.

283–84 'all Poe's'. Susan Archer Weiss, *The Home Life of Poe* (1907), 132.

284 'This death'. Lois and Francis Hyslop, eds, *Baudelaire on Poe* (1952), 101.

284 'a hero'. N. Bryllion Fagin, *The Histrionic Mr. Poe* (1949), 191.

284 'morbid melancholy'. Poe, *Works*, II, 26.

285 'The career'. Poe, *Works*, II, 29.

285 'the ludicrous'. Ostrom, *Poe Letters*, I, 57–58.

285 'we thrill'. Poe, *Works*, III, 955.

285 'I am'. Poe, *Works*, III, 853.

285 'one of'. Poe, *Works*, II, 156–57.

285 'gloomy, gray'. Poe, *Works*, II, 209.

286 'was that'. Fagin, *Histrionic Poe*, 61–62.

286 'I am the'. Poe, *Works*, II, 427.

286 'my hereditary'. Poe, *Works*, II, 446.

286–87 'with brute'. Poe, *Works*, II, 447–48.

287 'perverseness is'. Poe, *Works*, III, 852.

287 'Essentially the'. Fagin, *Histrionic Poe*, 65.

288 'There were'. Poe, *Works*, II, 670.

288–89 'The external'. Poe, *Works*, II, 671.

289 'The tastes'. Poe, *Works*, II, 673.

289 'His vestures'. Poe, *Works*, II, 675.

289 'in unutterable'. Poe, *Works*, II, 676–77.

290 'Hoffmann-Barnum'. Robert Baldick, ed., *Pages from the Goncourt Journal* (1962), 100.

292 'Miserable, blind'. My rendering of *Tales from Hoffman* (1951), 221.

292–93 'a tower'. Sir Walter Scott, *Works*, XVIII (1835), 311.

294 'There was'. Poe, *Works*, II, 416–17.

294 'Hate is'. D. H. Lawrence, *Studies in Classic American Literature* (1924), 85.

294 'Quentin had'. Faulkner, *Absalom*, 12.

295 'a constitutional'. Poe, *Works*, II, 402.

295 'enchained by'. Poe, *Works*, II, 403.

295 'put by'. *Oxford English Dictionary*, XVII (1989), 265.

295 'I perceived . . . Porphyrogene!' Poe, *Works*, II, 406–7.

296 'a new'. Baldick, *Goncourt Journal*, 19–20.

296 'the deep'. Faulkner, *Absalom*, 9.

296 'the principles'. Faulkner, *Absalom*, 116.

297 'to gratify'. Bertram Wyatt-Brown, *The Literary Percys* (1994), 25.

297–98 'has murdered'. Wyatt-Brown, *Percys*, 29–30.

298 'a baronage'. Joseph Blotner, *Selected Letters of William Faulkner* (1977), 216.

298–99 'accomplish the'. Faulkner, *Absalom*, 182.

299 'the inexplicable'. Faulkner, *Absalom*, 97.

299 'realized at'. Faulkner, *Absalom*, 181.

299 'the evil's'. Faulkner, *Absalom*, 18.

299 'rotting portico'. Faulkner, *Absalom*, 136.

299 'like a'. Faulkner, *Absalom*, 65.

299 'while he'. Faulkner, *Absalom*, 72–73.

299 'it was'. Faulkner, *Absalom*, 248.

300 'a nigger'. Faulkner, *Sound*, 73.

300 'decayed mansion'. Flannery O'Connor, *The Complete Stories* (1971), 405–20.

Chapter Ten

302–3 'There is'. 'The Fear of Mobs', *The Spectator*, 13 February 1886, 219.

304 'The premise'. Mark Edmundson, *Nightmare on Main Street* (1997), 10–11.

305 'what we'. Christoph Grunenberg, ed., *Gothic* (1997), 218.

305 'Carefully, with'. Edgcumb Pinchon and Odo Stade, *Viva Villa!* (1933), 374–75.

306–7 'draws aside'. Carl Theodor Dreyer, *Four Screenplays* (1970), 116–19.

307 'Hell is'. Isak Dinesen, *Seven Gothic Tales* (1934), 30.

307 'The obvious'. Richard Davenport-Hines, *Auden* (1995), 272.

308 'two hand-writings'. Bradford Booth and Ernest Mehew, eds, *The Letters of Robert Louis Stevenson*, V (1995), 122.

308 'a gothic gnome'. *RLS Letters*, V, 163.

308 'morbid . . . ethics'. *RLS Letters*, V, 212–13.

308 'My life'. Robert Louis Stevenson, *Dr Jekyll and Mr Hyde, and Other Stories* (1992), 145.

308 'Man is'. Stevenson, *Stories*, 61.

310 'My devil . . . The spirit'. Stevenson, *Stories*, 70–71.

310 'the brute'. Stevenson, *Stories*, 75.

310 'horror of'. Stevenson, *Stories*, 76.

310 'not only'. Stevenson, *Stories*, 77.

310 'that the main'. *RLS Letters*, V, 150.

310 'an age'. *RLS Letters*, V, 288.

310 'manly sensibility'. *RLS Letters*, V, 80–81.

310 'the coming'. Stevenson, *Stories*, 68.

310 'disgrace'. Stevenson, *Stories*, 11.

310 'You must'. Stevenson, *Stories*, 34.

311 'It is'. Stevenson, *Stories*, 20.

311 'committed to'. Stevenson, *Stories*, 60.

311 'it was'. Stevenson, *Stories*, 61.

311 'brutish, physical'. Stevenson, *Stories*, 70.

311 'the balance'. Stevenson, *Stories*, 68.

311 'To cast'. Stevenson, *Stories*, 69.

311–12 'So long'. *RLS Letters*, V, 28.

312 'M. Zola'. *RLS Letters*, V, 311.

312 'the only'. Daniel Pick, *Faces of Degeneration* (1989), 166.

312 'the ugliest'. *RLS Letters*, V, 149.

312 'To me'. *RLS Letters*, V, 171.

312 'pale and dwarfish'. Stevenson, *Stories*, 15–16.

313 'with ape-like'. Stevenson, *Stories*, 23.

313 'His terror'. Stevenson, *Stories*, 76–77.

314 'the increase'. 'The Whitechapel Horrors', *The Spectator*, 6 October 1888, 1353.

314 'Homosexuality is'. Jeffrey Miller, ed., *In Touch: The Letters of Paul Bowles* (1994), 42.

314 'in all'. Liverpool Record Office, diary of fifteenth Earl of Derby, 29 December 1884.

314–15 'a common'. Henry Keene, 'The Disorder of the Age', *National Review*, XI (1888), 796.

315 'silenced, gratified'. *RLS Letters*, V, 312.

315 'Dr. Jekyll'. Oscar Wilde, *Plays, Prose Writings and Poems* (1991), 75.

315 'evil'. Stevenson, *Stories*, 64.

315 'very gentle'. Sheridan Le Fanu, *In a Glass Darkly* (1993), 37 (hereafter Le Fanu).

315 'agitation of'. Le Fanu, 7.

316 'accentuated by'. Le Fanu, 30.

316 'always urging'. Le Fanu, 32.

316–17 'from what'. F. S. Oliver, *The Endless Adventure*, III (1935), 170.

317 'the age'. *Paris Review, Writers at Work*, IV (1977), 13, 17.

317 'God alone'. Isak Dinesen (Baroness Blixen), *Seven Gothic Tales* (1934), 14.

317 'in pictures'. *Paris Review*, 14.

317 'This season'. Christopher Isherwood, *Diaries*, I (1996), 800.

317 'a fantastic'. *Paris Review*, 18.

321 'evil, odious'. Henry James, *Complete Tales*, XII (1964), 226.

321 'His fame'. Wanda Corn, *Grant Wood* (1983), 48–49.

321–22 'I am'. Guy Wyndham, ed., *Letters of George Wyndham, 1877–1913*, I (1915), 23–24.

322 'Mr Bram'. *Punch*, vol. 172, 23 February 1927, 218.

322 'horrors . . . perpetrated'. *Connoisseur*, vol. 81 (July 1928), 184.

322 'The Gothic'. *New Statesman*, 1 December 1928, supplement x.

322 'a Museum'. Edith Wharton, *The Gods Arrive* (1932), 95, 125.

323 'ogre's castle'. Henry Channon, *The Ludwigs of Bavaria* (1933), 102–3.

323 'They have'. Robert Rhodes James, ed., *Chips* (1967), 40.

323 'At Castlemallock'. Anthony Powell, *The Valley of Bones* (1964), 171–72.

323 'they passed'. Carol Thatcher, *Below the Parapet* (1996), 64.

324 'vile, hateful'. Harry Moore, ed., *The Collected Letters of D. H. Lawrence* (1962), 28–29.

324 'the harsh'. John Buchan, *Memory Hold the Door* (1940), 35, 53.

324 'glazed brick'. Evelyn Waugh, *A Handful of Dust* (1934), chapters 2, 5.

325 'endeavoured to'. James Lees-Milne, *Prophesying Peace* (1977), 108.

325 'For Freud'. Edmundson, *Nightmare*, 32.

325 'sensational horror'. Grunenberg, *Gothic*, 156.

327 'Life was'. Richard Overy, *The Penguin Historical Atlas of the Third Reich* (1996), 8.

328 'many Germans'. Viscount D'Abernon, *Ambassador of Peace*, I (1929), 12.

328 'mass desires'. Siegfried Kracauer, *From Caligari to Hitler* (1947), 5–6.

329 'Der Doppelgänger'. Otto Rank, *Psychoanalytische Beitrage zur Mythenforschung 1912 bis 1914* (1919), 268–70.

329 'the quality'. Sigmund Freud, *Works*, XVII (1955), 236.

329 'swung back'. Freud, *Works*, XVII, 248.

329–31 'immaculate respectability'. D'Abernon, *Ambassador*, II, 214.

331 'The bourgeois'. Max Horkheimer and Theodor Adorno, *Dialectic of Enlightenment* (1973), 155.

333 'a general'. Cecil King, *Diary, 1965–1970* (1972), 271–72.

334 'Power based'. Kracauer, *Caligari*, 163–64.

337 'I see'. Mark Gatiss, *James Whale* (1995), 74.

337 'James's feeling'. Gatiss, *Whale*, 113.

337 'Thunder rolls'. *The Times*, 25 January 1932, 10b.

338 'Karloff the Uncanny'. Gatiss, *Whale*, 89.

341 'Mrs. Radcliffe'. Graham Greene, *The Pleasure-Dome* (1972), 22.

341 'On our'. Elizabeth Mavor, ed., *The Grand Tours of Katherine Wilmot* (1992), 56–57.

342 'The middlebrow'. Graham Greene, *Mornings in the Dark* (1993), 248.

Chapter Eleven

343 'art transferred'. Philip Rieff, *Fellow Teachers* (1975), 137.

344 'It was'. Mervyn Peake, *Titus Alone* (1970), 225.

345 'being a'. Poppy Z. Brite: The HORROR Interview by Nancy Kilpatrick, from *Horror*, #1 (January 1994): http://www.negia.net/~pandora/pzbIVI.html. All Brite quotations in this chapter not otherwise attributed come from this source.

345 'The dominant'. Clement Greenberg, 'The Present Prospects of American Painting and Sculpture', *Horizon*, XVI (1947), 24.

345 'Hohensalzburg'. Randall Jarrell, *The Complete Poems* (1969), 86–91.

345 'When I'. Mary Jarrell, ed., *Randall Jarrell's Letters* (1985), 217.

345 'The most'. Greenberg, 'Prospects', 24.

346 'He began'. Ellen Landau, *Jackson Pollock* (1989), 146.

346 'psychotechnics'. Rieff, *Fellow Teachers*, 137.

347 'wizard'. Ernest Thesiger, *Practically True* (1927), 182.

347 'an old'. James Lees-Milne, *Ancestral Voices* (1975), 61.

347 'Mr Ernest'. Hilary Spurling, *Secrets of a Woman's Heart* (1984), 32.

349 'like a'. Thesiger, *Practically True*, 142.

349 'Always remember'. Thesiger, *Practically True*, 134.

349 'but, I'. Spurling, *Secrets*, 32.

349 'my face'. Thesiger, *Practically True*, 13.

352 'For a'. *Beloit Daily News*, 22 March 1997.

353 'The women'. *Daily Herald*, 2 November 1962, 611.

353 Highgate cemetery. *The Times*, 30 September 1970, 4c.

353 Twenty-seven per cent. Paul Barber, *Vampires, Burial and Death*, 4.

353 Sixty-nine per cent. Edmundson, *Nightmare*, 80.

354 'What we'. Tim Cornwell, 'Shopping and Sucking', *Independent on Sunday*, 8 February 1998, 1/16.

354–55 'dozens of'. 'Disney's Vampires', *Sunday Times*, 28 September 1997, 1/23.

355 'Most of'. Harold Macmillan, *Riding the Storm* (1971), 350–51.

356 'She epitomizes'. Nina Auerbach, *Our Vampires, Ourselves* (1995), 57–58.

359 'brain-numbing nonsense'. Brite, *Drawing Blood*, 36.

360 'Too much'. Brite, *Lost Souls*, 161.

360–61 'a fried'. Brite, *Drawing Blood*, 82–83.

361 'in no'. Brite, *Drawing Blood*, 71.

361 'The secretive'. *The Standard Times*, 2 December 1996.

362 'horror is'. Brite, *Exquisite Corpse*, 159.

362 'some pathetic'. Brite, *Exquisite Corpse*, 159.

363 'Born on'. http://www.negia.net/~pandora/cfbio.html.

364 'violently childish'. Mick Mercer, *Gothic Rock Black Book* (1988), 10–11.

365 'Scratch pictures'. http:/www.cs.cmu.edu/~~visigoth/music/bauhaus/antonin-artaud.html.

366 'The songs'. Robert Smith/http://miso.wwa.com/~anaconda/press/A7.html.

368 'trademark shock'. Andrew Smith, 'In the mood again', *Sunday Times*, 5 May 1996, 10/21; compare *Melody Maker*, 7 March 1992.

368 'When I'. Robert Smith,http://miso.wwa.com/~anaconda/press/198.html.

368–69 'Nothing had'. Brite, *Lost Souls*, 31–34.

370 'Whenever you'. Paul A. Woods, *Weirdsville USA* (1997), 8–9.

370 'I could'. Chris Rodley, *Lynch on Lynch* (1997), 8.

370 'asked the'. Woods, *Weirdsville*, 172.

371–72 'There wasn't'. Woods, *Weirdsville*, 9.

375 'Balenciaga took'. Ian Phillips, 'The Man Who Turned Madonna into a Goth', *The Independent*, 6 May 1998, 17.

376 'At times'. Edmundson, *Nightmare*, xiv.

378 'We stand'. Patrick McGrath and Bradford Morrow, *The New Gothic* (1991), xiv.

379 'Violence is'. Victor Bockris, *The Life and Death of Andy Warhol* (1998), 366.

379–80 'pinheads, dwarfs'.http://www.sirius.com/~aether/photo/witkin.html.

381 'We're only'. Interview with Douglas Foght of Laat. http://vpro.nl/htbin/scan/www/vpro-digitaal/laat-map.

382 'Art cannot'. John Deedy, *Auden as Didymus* (1993), 34.

382 'Make it'. Interview with James Hobbs. http://www.biblio.co.uk/etour/chapfeat.html.

382 'are packed'. Alan Jackson, 'Charm Offensive', *The Times*, 22 November 1997, M/42.

382–83 'We are'. Chapman manifesto, 'We Are Artists' (1994). Foght/Laat interview.

383 'We made'. Foght/Laat interview. See also the Institute of Contemporary Arts exhibition catalogue *Chapmanworld* (1996), with essays by David Falconer, Douglas Fogle and Nick Land.

383 'liberal slag-bitch'. Hobbs interview.

383 'Man has'. Friedrich Nietzsche, *The Gay Science*, trans. by Walter Kaufman (1974), 115.

383–84 'Effigies are'. William Ian Miller, *The Anatomy of Disgust* (1997), 27.

385 'I love'. Friedrich Nietszche, *Thus Spoke Zarathustra*, trans. by R. J. Hollingdale (1961), 3.

Picture Credits

BLACK-AND-WHITE ILLUSTRATIONS

COLOUR PLATES

Index

Page numbers in italics refer to illustrations.